D0302776

French and British Paintings from 1600 to 1800 in The Art Institute of Chicago

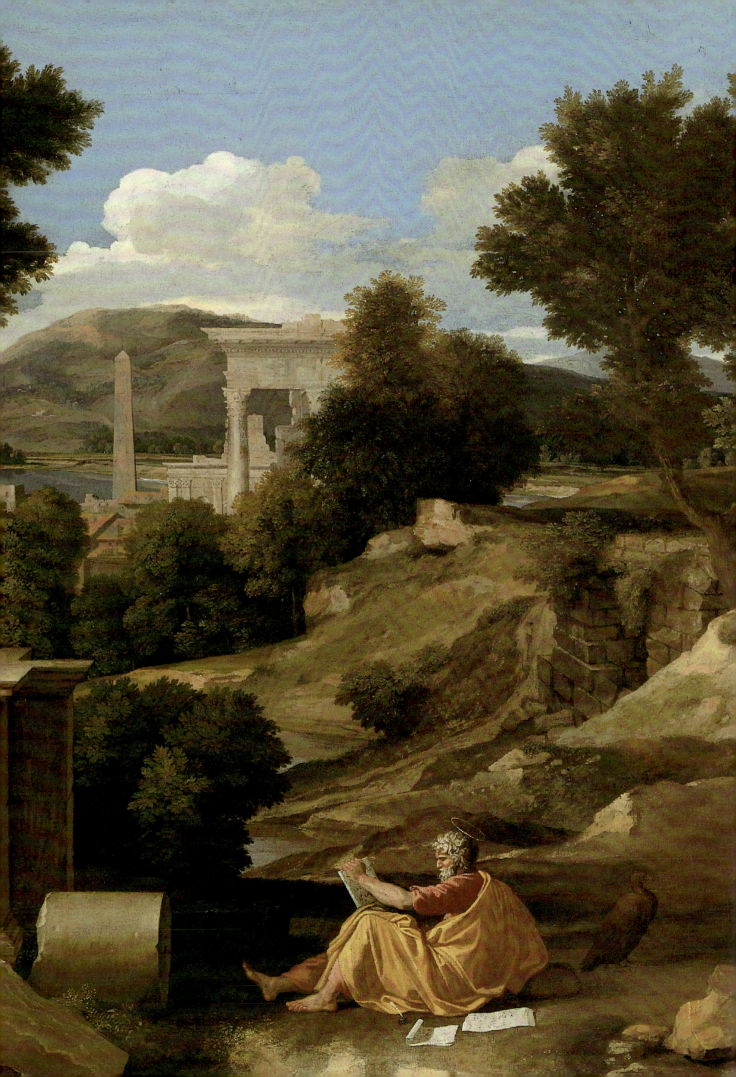

French and British Paintings from 1600 to 1800 in The Art Institute of Chicago

A CATALOGUE OF THE COLLECTION

French entries by Susan Wise
Larry J. Feinberg, *General Editor*

British entries by Malcolm Warner
Martha Wolff, *General Editor*

With contributions by Larry J. Feinberg
and Martha Wolff

The Art Institute of Chicago
in association with Princeton University Press

Published with the assistance of the Getty Grant Program, the National Endowment for the Arts, and the Andrew W. Mellon Foundation.

Executive Director of Publications: Susan F. Rossen
Editors: Margherita Andreotti, Elisabeth Dunn,
and Catherine Steinmann, assisted by Britt Salvesen
Production Manager: Daniel Frank, assisted by Sarah Guernsey

Photography credits: Unless otherwise indicated in the captions, all illustrations were produced by the Department of Imaging and Technical Services, Alan Newman, Executive Director.

LIBRARY OF CONGRESS CATALOGING-IN-PUBLICATION DATA

Art Institute of Chicago
French and British paintings from 1600 to 1800 in The Art Institute of Chicago:
a catalogue of the collection/French entries by Susan Wise; Larry J. Feinberg,
general editor; British entries by Malcolm Warner; Martha Wolff,
general editor; with contributions by Larry J. Feinberg and Martha Wolff.
p. cm.
Includes bibliographical references and index.
ISBN 0–86559–137–7: $90.00 — ISBN 0-691-015643 (Princeton): $90.00
1. Painting, French — Catalogs. 2. Painting, Modern — 17th–18th centuries — France — Catalogs.
3. Painting, English — Catalogs. 4. Painting, Modern — 17th–18th centuries — England — Catalogs.
5. Painting — Illinois — Chicago — Catalogs. 6. Art Institute of Chicago — Catalogs.
I. Wise, Susan, 1947– . II. Feinberg, Larry J. III. Warner, Malcolm, 1953– .
IV. Wolff, Martha. V. Title.
ND546.A78 1996
759.2′074773′11 — dc20 96-31742
 CIP

Cover: Detail of Jean Honoré Fragonard, *Portrait of a Man*, 1977.123 (see p. 59)
Frontispiece: Detail of Nicolas Poussin, *Landscape with Saint John on Patmos*, 1930.500 (see p. 121)
Back cover: Sir Joshua Reynolds, *Lady Sarah Bunbury Sacrificing to the Graces*, 1922.4468 (see p. 277)

Contents

Preface

With this volume devoted to the Art Institute's French and British paintings from 1600 to 1800, our commitment to provide a series of scholarly catalogues on the museum's collection of European paintings continues. This second volume follows the model of *Italian Paintings before 1600 in The Art Institute of Chicago*, written by Christopher Lloyd and published in 1993. It will soon be joined by a catalogue of the Art Institute's Italian drawings before 1600 and, it is hoped, by other volumes on its European paintings. These publications will make the collection far more accessible to both the specialized scholar and the museum visitor, and they will enable us to grasp the shape and evolution of the museum's holdings in ways not previously possible. Whereas the collection of early Italian paintings was largely formed by gifts, notably those of Martin A. Ryerson, many of the paintings in this volume were purchased, beginning in 1900 with Hubert Robert's classicizing decorations for the Château de Méréville (1900.382–85), followed in 1930 by Nicolas Poussin's great *Landscape with Saint John on Patmos* (1930.500), and continuing with numerous acquisitions in recent decades. There have been many extraordinary gifts as well, some of which are only now receiving the intense study and attention they deserve.

We are grateful to the authors of this catalogue, Susan Wise and Malcolm Warner, for the exceptional dedication each brought to the study of the Art Institute's collection. The finished product shows the fruits of their personal and intensive encounter with the pictures in Chicago. When the authors were no longer in residence here, their manuscripts were prepared for publication under the able supervision of two curators in the Department of European Painting: Larry J. Feinberg, as general editor for the French entries, and Martha Wolff, as general editor for the British entries.

The extended commitment of time and resources needed to bring this catalogue to completion would not have been possible without the support of the National Endowment for the Arts, which facilitated research and travel by Susan Wise, and the Andrew W. Mellon Foundation's Fund for Scholarly Publications at the Art Institute, which supported Malcolm Warner's residency at the museum. Generous grants from the National Endowment for the Arts and the Getty Grant Program made it possible to produce the catalogue in this beautiful and useful form.

James N. Wood
Director and President

Acknowledgments

My work on the French entries was seriously launched when I received a grant from the National Endowment for the Arts in 1980, though I had earlier begun preliminary research on the museum's French paintings. I received administrative support for this project from James N. Wood, the Art Institute's Director and President; Katharine C. Lee, former Deputy Director; Richard R. Brettell, former Searle Curator of European Painting; and Susan F. Rossen, Executive Director of Publications. Douglas W. Druick, who succeeded Mr. Brettell as Searle Curator of European Painting, was likewise very supportive.

I am especially indebted to Mr. Brettell for insuring that I had the time to research and write the catalogue. Martha Wolff, who joined the museum's staff in 1986 as Curator of European Painting before 1750, made many constructive suggestions for improving the manuscript and continued to advocate its timely publication. Above all, I am grateful to Larry J. Feinberg, Curator in the Department of European Painting, who came to the Art Institute in 1991 and oversaw the revision of the manuscript with the assistance of editors Elisabeth Dunn and Catherine Steinmann. He added pertinent, new information to the entries and, with admirable tact, shepherded this project to its completion. Martha and Larry both wrote entries for paintings acquired after my tenure at the museum, in which cases their initials are given after the entry. The following members of the Conservation Department assisted with the examination of paintings: the late William R. Leisher, formerly Executive Director of Conservation; his successor, Frank Zuccari; as well as Timothy J. Lennon, Faye T. Wrubel, and Inge Fiedler. I particularly thank Cynthia Kuniej Berry for reexamining all the paintings with Larry Feinberg and then revising all the condition reports for this publication.

Many others were helpful over the years. I will always remember with deep fondness and respect the constant encouragement and scholarly advice from two colleagues, the late Harold Joachim and the late Ilse Hecht. I am also grateful for the support of J. Patrice Marandel, now Curator of European Painting at the Los Angeles County Museum of Art. As Curator of European Painting at the Art Institute in the 1970s, he recognized the need for a reevaluation of the collection of French paintings, inspired me to undertake the project, and responded to my requests at every turn. I am deeply indebted to Pierre Rosenberg, President and Director of the Musée du Louvre, who reviewed all the paintings with me in Chicago, gave his opinion whenever sought, and opened many doors for me during the research process. In 1986 Mr. Rosenberg and Professor Donald Posner of the Institute of Fine Arts, New York, both read the preliminary draft of the catalogue. Their comments helped me reconsider numerous small problems and rectify ambiguities before preparing the final draft.

No ambitious research project is successful without the continuous and tireless efforts of library staffs. I cannot adequately thank Jack Perry Brown, Executive Director of the Ryerson and Burnham Libraries, whose sensitive and intelligent response to the demands of serious research was unfailing, and the entire library staff, including Susan Godlewsky, Maureen Lasko, Susan Perry, and Susan Walsh. I am also grateful to Catherine Stover, Jane Kenamore, John Smith, and Bart Ryckbosch, successive heads of the Art Institute's Archives. I am indebted to the staffs of many other institutions: the Cabinet des estampes at the Bibliothèque Nationale, Paris, especially to Madeleine Barbin and Maxime Préaud; the Département de documentation of the Département de peintures at the Musée du Louvre, Paris; the Bibliothèque d'art et d'archéologie, Fondation Jacques Doucet, Paris, particularly to Denise Gazier; the Rijksbureau voor Kunsthistorisch Documentatie, The Hague; the Frick Art Reference Library, New York, especially to Helen Sanger; The Joseph Regenstein Library of the University of Chicago; and The Newberry Library, Chicago.

Many colleagues responded to my calls for their opinions or assistance. At the risk of unintentional omissions, I wish to mention: Louise d'Argencourt, Colin Bailey, Joseph Baillio, Richard Born, Jean Cailleux, Alvin L. Clark, Jr., Philip Conisbee, Enzo

Costantini, Liesbeth Cremers, Beth Dettelbach, Marie Anne Dupuy, Jean Goldman, Margaret Morgan Grasselli, Katherine Haskins, François Heim, Eileen Hsia, Christophe P. Janet, Geneviève Lacambre, Evan Maurer, Nicole Parmantier Lallement, Jean François Méjanès, Marianne Roland Michel, Aileen Ribeiro, Timothy J. Standring, Alex Wengraf, Alan P. Wintermute, and Simone Zurawski. The contributions of many others are recognized in the entries.

In the Department of European Painting, Geri Banik and Theresa Slaman attended to the myriad demands of the project. Research assistants Mary Kuzniar, who assisted me with admirable devotion from the outset, and Cheryl Washer, who during 1984 brought much talent to the research phase, helped with the documentation of the paintings. The many volunteers involved with the catalogue included: Seonaid Bielinski, Susan Levine Brotman, Louise Giliberti, Emily Haliziw, Joanell McKenna, Joan Prentice, Michele Sheid, Betty Siffert, Judy Valentine, and Hal Waterman. I am especially grateful to Mary Jo Deli and Jeffrey A. Nigro, who both devoted extraordinary amounts of time to all aspects of this project. In addition, the following volunteers provided valuable assistance to Larry Feinberg in his work on the catalogue: Stephanie Bibb, Renata M. Cerny, Amy Domanowski, Annemarie Hansen Turner, Isabel Lacarrère, Whitney Templeton, and particularly Brigitte Moeckli, whose help was instrumental in completing the manuscript. Others who were helpful to me at the Art Institute include Anselmo Carini, Laura Giles, and Ian Wardropper.

I have also profited on many levels from discussions with J. Peter Berge, James Garrett Faulkner, Mac McGinnes, Louise Robertson, and David Rosen, friends and colleagues who supported and enhanced my efforts over many years. My final thanks go to my mother and late father for the countless ways they accommodated my work on this catalogue.

Susan Wise

The entries in this volume on British paintings are largely the result of work carried out in 1988 and 1989, during my appointment as Research Curator in the Art Institute's Department of European Painting. My first thanks are due to Richard R. Brettell, former Searle Curator of European Painting, for inviting me to join the distinguished group of contributors to the Art Institute's permanent collection catalogues, and for preparing the ground for my stay in Chicago. I am also grateful to Douglas W. Druick for the determined support he gave to the completion of the project since succeeding Richard in 1989. As a whole, the Department of European Painting could not have been more welcoming. I would like especially to thank Geri Banik, Department Secretary, for the friendly, quietly efficient manner in which she has helped me with the countless practical necessities of my task.

As far as the content of the entries is concerned, my greatest debt is to Martha Wolff, Curator of European Painting before 1750. In our detailed discussions of successive drafts, I have benefited enormously from Martha's breadth of experience in the preparation of scholarly catalogues, her sure sense of the uses and limitations of art-historical evidence, and her quick understanding of the strengths and weaknesses of any given argument. Every entry is the better for her participation. She and I have worked closely with members of the Art Institute's Conservation Department in producing the condition reports. Particular thanks are due to Cynthia Kuniej Berry, who undertook the technical

examinations, as well as to Frank Zuccari, Executive Director of Conservation, who supported and reviewed her efforts. Entries for two paintings accessioned after I left Chicago rely particularly heavily on the work of members of the Department of European Painting: my starting point for the entry on Philippe Jacques de Loutherbourg's *Destruction of Pharaoh's Army* (1991.5) was Gloria Groom's 1992 article on the work in *The Art Institute of Chicago Museum Studies*; and the entry on Henry Fuseli's *Heads of Damned Souls* (1992.1531) was, in essence, written by Martha Wolff. Susan Ross brought both cheerfulness and insight to

her work as Research Assistant, and her help was invaluable in bringing the manuscript to completion. Robin Asleson pursued loose ends in London research institutions with commendable efficiency.

The generosity of many fellow scholars of British art who have shared ideas and information with me is recorded in the footnotes to entries, but for help given especially freely, often, and on a variety of topics, I would single out the following: Brian Allen; Elizabeth Einberg; Judy Egerton; Desmond Fitz-Gerald, Knight of Glin; and David Mannings.

Malcolm Warner

S ince the production of a book such as this is inevitably a team effort, we would like to thank the numerous members of the museum staff who contributed greatly to the realization of the project, but who may not have worked directly with the two authors. The efforts of Deputy Director Teri J. Edelstein and the Development Department's Karen Victoria, Gregory Perry, and Gregory Cameron were instrumental in obtaining grant support. Tracie Nappi, Collections Manager in the Department of European Painting, facilitated the movement of pictures for examination and photography with the help of Reynold Bailey and his capable staff. Alan Newman, Executive Director of the Department of Imaging and Technical Services, Leslie Umberger, Christopher Gallagher, Anne Morse, and their staff were unfailingly helpful, making a stream of photographs and technical documents with the most meticulous attention to detail. We cannot thank Jack Perry Brown and the staff of the Ryerson Library fervently enough for the assistance they gave this project.

Susan F. Rossen, Executive Director of Publications, kept the project in motion with her steady encouragement. Margherita Andreotti, Editor for Scholarly

Publications, guided it through all its stages with great sensitivity and supervised the editorial work of Elisabeth Dunn, Britt Salvesen, and Catherine Steinmann. Ms. Dunn edited the French entries, a task she undertook with her customary energy and determination. Upon her departure, the final editing of this portion of the manuscript was carried out with meticulous care by Ms. Steinmann. The British entries were instead edited primarily by Ms. Andreotti, with the capable and cheerful assistance of Ms. Salvesen and Ms. Steinmann. Katherine Houck Frederickson and later Daniel Frank, assisted by Sarah Guernsey, coordinated all aspects of the book's production. Cris Ligenza, also of the Publications Department, expertly retyped major portions of the manuscript.

Finally, it was a pleasure for all of us to work with Bruce Campbell, who extended his own design for the catalogue of the Art Institute's early Italian paintings to make this, the second in the catalogue series, a beautiful book, in sympathy with the pictures discussed within its covers.

Larry J. Feinberg and Martha Wolff

Notes to the Reader

French and British entries are grouped in separate sections arranged alphabetically by artist within each section. Entries on works by unknown artists are integrated alphabetically throughout the catalogue under the chosen designation (British, French, Master of the Children's Caps, etc.). When there are several works by a given artist, entries are arranged in order of acquisition, but the arrangement of entries under the rubric of a single artist may also reflect increasing distance from the painter himself (i.e., Jean Baptiste Greuze, follower of Jean Baptiste Greuze, etc.). Basic biographical information on each artist is incorporated into the discussion section of the first entry for a work by that artist.

The following attribution terms are used to describe the work's relationship to a given artist:
Attributed to: Believed to be by the named artist, but final confirmation is needed before the attribution can be fully accepted.
Follower of: An unknown artist working in the style of the named artist, but not necessarily under the direct supervision or in the lifetime of the named artist.
After: A copy after a specific work or works by the named artist.

The following conventions for dating a work are used:
1725 if executed in 1725
c. 1725 if executed sometime around 1725
1725–30 if begun in 1725 and completed in 1730
1725/30 if executed sometime within or around the years 1725 to 1730

The descriptions of painting medium are based on visual observation, since the medium has not been analyzed. In reproducing the Art Institute's pictures, every attempt has been made to show the painted surface in its entirety, without masking the irregularities of the painted edges. The dimensions of a picture are given in centimeters, height before width, with dimensions in inches following in parentheses. Inscriptions on the front of a painting are given after the dimensions, while relevant inscriptions on the back are given in the notes, usually in connection with the description of condition. In condition notes and in descriptions of actions within a picture, left and right correspond to those of a picture's actors, although right and left may be more broadly used elsewhere according to the viewer's point of view. The descriptions of condition are followed by a list in parentheses of available technical documentation.

In the entries the names of some galleries have been abbreviated in the following ways:

Agnew	Thomas Agnew & Sons Ltd., London
Colnaghi	P. & D. Colnaghi & Co., London/New York
Duveen	Duveen Brothers, New York/London/Paris
Kleinberger	F. Kleinberger Galleries, New York/Paris
Knoedler	M. Knoedler & Co., New York/London/Paris
Wildenstein	Wildenstein & Co., London/New York/Paris

Sales and exhibition catalogues cited in the provenance and exhibition sections are generally not repeated in the list of references. Where sales and exhibition catalogues give variant attributions and titles, these have been recorded. Biblical citations refer to the King James Version. A list of abbreviations of frequently cited sources follows.

Bibliographical Abbreviations

Art Bull.	*The Art Bulletin*	AIC 1945	The Art Institute of Chicago, *An Illustrated Guide to the Collections of The Art Institute of Chicago*, 1945
AIC 1893	The Art Institute of Chicago, *Catalogue of Paintings, Sculpture, and Other Objects Exhibited at the Opening of the New Museum*, December 8, 1893 (reprint, January 1, 1894)	AIC 1948	The Art Institute of Chicago, *An Illustrated Guide to the Collections of The Art Institute of Chicago*, 1948
AIC 1894	The Art Institute of Chicago, *Catalogue of Paintings, Sculpture, and Other Objects in the Museum*, March 15, 1894	AIC 1952	The Art Institute of Chicago, *Masterpieces in The Art Institute of Chicago*, 1952
AIC 1904	The Art Institute of Chicago, *General Catalogue of Objects in the Museum*, January 1904	AIC [1956]	The Art Institute of Chicago, *An Illustrated Guide to the Collections of The Art Institute of Chicago* [1956]
AIC 1907	The Art Institute of Chicago, *General Catalogue of Sculpture, Paintings, and Other Objects*, February 1907	AIC 1961	The Art Institute of Chicago, *Paintings in The Art Institute of Chicago: A Catalogue of the Picture Collection*, 1961
AIC 1910	The Art Institute of Chicago, *General Catalogue of Sculpture, Paintings, and Other Objects*, June 1910	AIC 1993	The Art Institute of Chicago, *The Art Institute of Chicago: The Essential Guide*, Chicago, 1993
AIC 1913	The Art Institute of Chicago, *General Catalogue of Paintings, Sculpture, and Other Objects in the Museum*, 1913	*AIC Bulletin*	*Bulletin of The Art Institute of Chicago*
AIC 1914	The Art Institute of Chicago, *General Catalogue of Paintings, Sculpture, and Other Objects in the Museum*, 1914	*AIC Master Paintings*	The Art Institute of Chicago, *Master Paintings in The Art Institute of Chicago*, Chicago, 1988
AIC 1917	The Art Institute of Chicago, *Catalogue of Paintings, Drawings, Sculpture, and Architecture*, August 1917	*AIC Museum Studies*	*The Art Institute of Chicago Museum Studies*
AIC 1920	The Art Institute of Chicago, *Handbook of Sculpture, Architecture, Paintings, and Drawings*, August 1920	*AIC 100 Masterpieces 1978*	The Art Institute of Chicago, *100 Masterpieces*, Chicago, 1978
AIC 1922	The Art Institute of Chicago, *Handbook of Sculpture, Architecture, and Paintings*, May 1922	*AIC Quarterly*	*The Art Institute of Chicago Quarterly*
		Bénézit	Emmanuel Bénézit, *Dictionnaire critique et documentaire des peintres, sculpteurs, dessinateurs, et graveurs de tous les temps et de tous les pays*, 2d ed., 8 vols., Paris, 1948–55; 3d ed., 10 vols., Paris, 1960; 4th ed., 10 vols., Paris, 1976
AIC 1923	The Art Institute of Chicago, *Handbook of Sculpture, Architecture, and Paintings*, 1923		
AIC 1925	The Art Institute of Chicago, *A Guide to the Paintings in the Permanent Collection*, 1925		
AIC 1932	The Art Institute of Chicago, *A Guide to the Paintings in the Permanent Collection*, 1932	*Burl. Mag.*	*The Burlington Magazine*
		DNB	Leslie Stephen and Sidney Lee, eds., *The Dictionary of National Biography*, 22 vols., 11 suppls., London and New York, 1885–1993
AIC 1935	The Art Institute of Chicago, *A Brief Illustrated Guide to the Collections*, 1935	*GBA*	*Gazette des Beaux-Arts*
		Maxon 1970	John Maxon, *The Art Institute of Chicago*, London, 1970
AIC 1941	The Art Institute of Chicago, *A Brief Illustrated Guide to the Collections*, 1941	Maxon 1977	John Maxon, *The Art Institute of Chicago*, rev. ed., London, 1977
		Morse 1979	John D. Morse, *Old Master Paintings in North America*, New York, 1979

Louvre,
Catalogue sommaire

Musée du Louvre and Musée d'Orsay, *Catalogue sommaire illustré des peintures du Musée du Louvre et du Musée d'Orsay*, 5 vols., 1979–86

La Revue du Louvre

La Revue du Louvre et des Musées de France

Thieme/Becker

Ulrich Thieme and Felix Becker, *Allgemeines Lexikon der bildenden Künstler von der Antike bis zur Gegenwart*, 37 vols., Leipzig, 1907–50

Wright 1985

Christopher Wright, *The French Painters of the Seventeenth Century*, London, 1985

Wright 1991

Christopher Wright, *The World's Master Paintings from the Early Renaissance to the Present Day: A Comprehensive Listing of Works by 1,300 Painters and a Complete Guide to Their Locations Worldwide*, New York, 1991

CATALOGUE
French Paintings

Nicolas Bertin

1668 Paris 1736

Christ Washing the Feet of His Disciples, 1720/30

Charles H. and Mary F. S. Worcester Collection, 1979.305

Oil on panel, 49.5 x 72.1 cm (19½ x 28⅜ in.)

INSCRIBED: *Bertin* (lower left, on the edge of the platform)

CONDITION: The painting is in good condition. The wooden panel, which has been cradled, comprises three horizontal boards with two narrower vertical strips added at the right and left edges. X-radiography reveals that the horizontal boards and vertical edge strips are of different cuts, and were consequently subject to varying degrees of contraction over time. Because the horizontal boards have contracted more than the vertical strip at right, the central painted image does not align properly with that on the right strip. This vertical strip appears to have been manually shifted upward, presumably to align the figure painted across (and bisected by) the join at lower right. As a result, the arch and entablature at the upper right corner are misaligned with the central composition by approximately 0.5 cm.

The panel is prepared with two ground layers of light gray over a single layer of tan. The thinly painted surface is generally well preserved. Minor losses have occurred within the joins between boards at the right and left edges and, to a lesser degree, at the left ends of the horizontal boards. Slight tenting of the paint layer due to contraction of the grain is apparent in the center of the picture. The crimson glaze of Christ's robe, the shadows of the green costume of Saint John (standing just to the right of the main group of figures), and the pitcher appear to have been abraded by cleaning. The openings between the boards have been filled and inpainted. There is additional retouching along the right and bottom edges, on the upper left edge, and in the lower left corner. A few smaller areas of retouching are scattered on the curtain at upper left and over some cracks in Saint John's garment. There is a *pentimento* around Christ's left forefinger indicating that the finger was shifted slightly downward. (ultraviolet, x-radiograph)

PROVENANCE: Probably a private collection, Lyons.[1] Ange Laurent de Lalive de Jully, Paris, by 1757; sold Pierre Remy, Paris, May 7, 1770, no. 65, to Rémy, acting on behalf of the duc de Praslin, for 1,050 *livres*.[2] Probably César Gabriel de Choiseul, duc de Praslin (d. 1785), Paris; by descent to Louis César Renaud de Choiseul, vicomte de Choiseul (d. 1791); by descent to César Hippolyte de Choiseul, comte de Choiseul-Praslin; sold A. J. Paillet, Paris, February 18 and following, 1793, no. 152, to Clysorius for 800 *livres*.[3] Abraham Fontanel, Montpellier.[4] Sold by Fontanel, 1806, to baron Jacques Joseph de Boussairolles (d. 1814), president of the Cour des Aides et Finances, Montpellier, for 2,000 *livres*;[5] by descent to baronne de Saizieu;[6] by descent to colonel baron de Saizieu;[7] by descent to comte Joseph de Colbert-Cannet, Chevagnes.[8] Purchased from Colbert-Cannet, through the intervention of Jean Pierre Selz, by the Art Institute through the Charles H. and Mary F. S. Worcester Endowment, 1979.

REFERENCES: [Antoine Nicolas] D[ézallier d'Argenville (fils)], *Voyage pittoresque de Paris . . .* , 3d ed., Paris, 1757, pp. 149–50; reprint, Geneva, 1972, pp. 149–50; 4th ed., Paris, 1765, p. 165. *Almanach des beaux-arts*, Paris, 1762, p. 188. *Catalogue historique du cabinet de peinture et sculpture françoise, de M. de Lalive . . .* , Paris, 1764, p. 100. Hébert, *Dictionnaire pittoresque et historique*, vol. 1, Paris, 1766, p. 128; reprint, Geneva, 1972, p. 43. Bénézit, 3d ed., 1960, vol. 1, p. 615; 4th ed., 1976, vol. 1, p. 697. Thierry Lefrançois, *Nicolas Bertin (1668–1736): Peintre d'histoire*, Neuilly-sur-Seine, 1981, pp. 19–20, 68, 113–15, no. 26, p. 152, under nos. 108*–10*, p. 188, under no. 252, fig. 99. *Un Grand Collectionneur sous Louis XV: Le Cabinet de Jacques-Laure de Breteuil, bailli de l'Ordre de Malte 1723–1785*, exh. cat., Yvelines, Château de Breteuil, 1986, p. 23, under no. 101. Colin B. Bailey, ed., *Ange-Laurent de La Live de Jully: A Facsimile Reprint of the 'Catalogue historique' (1764) and the 'Catalogue raisonné des tableaux' (March 5, 1770)*, New York, 1988, pp. xxvi, xlvi–xlvii, p. 100 (1764 catalogue facsimile), p. 36, no. 65 (1770 catalogue facsimile). *Bulletin de la Société de l'histoire de l'art français*, année 1994 (1995), p. 177, no. 4 (ill.).

EXHIBITIONS: The Art Institute of Chicago, *The Art of the Edge: European Frames, 1300–1900*, 1986, no. 52.

Nicolas Bertin, a painter primarily of religious, mythological, and allegorical subjects, executed both large-scale decorative pieces and easel paintings. At the age of ten he entered the atelier of Guy Louis Vernansal and later that of Jean Baptiste Jouvenet, where he was rigorously trained in the academic tradition. Bertin was greatly influenced by Bon Boullongne, under whose guidance he developed his technical facility and a taste for meticulously rendered pictures in small formats. He traveled to Rome and Lombardy in 1685 after receiving the *Prix de Rome* at the age of eighteen, and remained in Italy until late 1688 or early 1689. Consequently, he came to emulate the paintings of sixteenth- and early-seventeenth-century Roman, Bolognese, and Venetian artists, particularly those of Titian, Veronese, and the Carracci. With the heroic style he developed, Bertin continued the grand tradition in French painting developed under Louis XIV.

This painting depicts the moment at which Christ rose from the Last Supper, girded himself with a towel, poured water into a basin, and began washing the feet

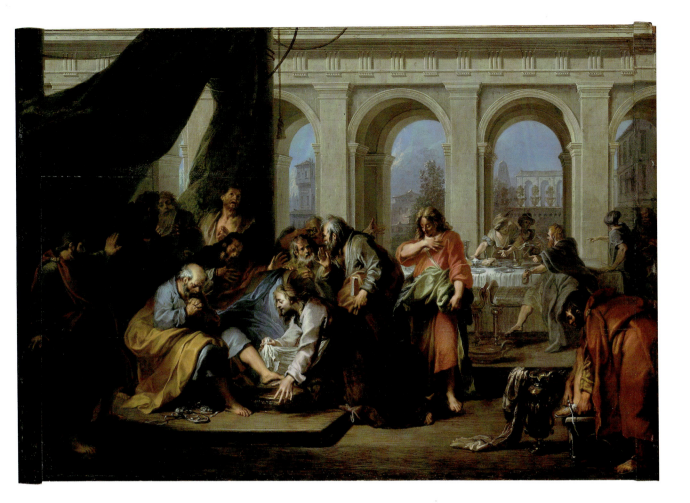

of the apostle Peter (John 13.4–5). Each gesture and expression is emphatic, and the main figural groupings, dense and compacted, are linked to one another in an elaborate rhythm of gestures and drapery folds. The setting is conceived as a series of consecutive planes leading to an arcade through which an urban landscape is visible.

Among Bertin's finest works, *Christ Washing the Feet of His Disciples* is also distinguished by its provenance, as it was apparently once in the collection of the celebrated amateur Ange Laurent de Lalive de Jully (see 1969.109). The 1764 catalogue of Lalive's collection described one of his works as follows:

> Un Tableau de BERTIN, sur bois, *d'un pied six pouces de haut sur deux pieds deux pouces de large*, représentant Notre Seigneur qui lave les pieds à ses Apôtres. Ce tableau, d'une belle composition & d'une belle couleur, est fini avec le plus grand soin. Les têtes y sont d'une belle expression, convenable au sujet, entr'autres, celle de S. Pierre, qui est de toute beauté. Il est fort bien gravé par CHEREAU le jeune.[9]

This entry, the essential points of which were reiterated in the Lalive de Jully sale catalogue,[10] seems to describe the Chicago painting. The identification of the picture as Lalive de Jully's Bertin is confirmed by the Jacques Chereau le jeune engraving (probably made when Lalive de Jully owned the painting), by which the painting was known prior to its reappearance and acquisition by the Art Institute.[11]

Bertin treated the subject of *Christ Washing the Feet of His Disciples* on other occasions. In 1704 he exhibited a painting of this subject at the Salon. Unfortunately, aside from its mention in the *livret*, all traces of this picture have been lost.[12] Another version of the theme by Bertin belonged in 1765 to Jacques Laure Le Tonnelier de Breteuil, the French *bailli* of the Order of Malta and a collector in Rome who engaged his fellow expatriate Jean Robert Ango to make a drawn inventory of his art holdings.[13] Known only through Ango's drawn copy, the lost Breteuil painting differed in numerous details from the Chicago work, including in the handling of the *staffage*, pavement, curtain, communion table, and distant buildings.[14] A fourth painting by Bertin of the subject is also now lost.[15]

Because of a lack of dated paintings and documents, Bertin's works are in many cases difficult to place chronologically. Nevertheless, a persuasive effort was made by Thierry Lefrançois, who grouped and attempted to date several paintings by Bertin that are strongly clas-

sical in their conception, represent New Testament subjects, are relatively small in size (less than two meters wide), and are horizontal in format. The Chicago work is part of this group, which includes a *Resurrection of the Daughter of Jairus* (location unknown), a *Resurrection of the Son of the Widow of Nain* (Darmstadt, Hessisches Landesmuseum), a *Resurrection of Lazarus* (Versailles, Musée Lambinet), and a *Christ Healing the Sick* (St. Petersburg, Hermitage).[16] Also characteristic of these paintings are the enamel-like finish, the placement of figures in a dense band across the foreground, and the spatially restrictive architectural backdrop in the middle distance. Using the St. Petersburg painting, which is signed and dated 1727, as a chronological linchpin, and noting Bertin's increasing tendency to tighten the arrangement of his figures after c. 1720, Lefrançois cautiously dated the Chicago work and the other three pictures to the period of 1720/30.[17]

NOTES

1 The Lalive de Jully sale catalogue (see note 2) records that the painting had been "obtained from Lyons."

2 A Bertin painting of the subject is recorded as being in Lalive de Jully's collection in D[ézallier d'Argenville (fils)] 1757, in the *Catalogue historique . . . 1764*, and in the 1770 Lalive de Jully sale catalogue. Although the title page of the Lalive de Jully sale catalogue gives the sale date as March 5, 1770, the sale was postponed until May 2–14, 1770, according to an annotated sale catalogue in the Frick Art Reference Library, New York. The catalogue itself was published in 1769. The painting is described in it as follows: "Notre Seigneur qui lave les pieds de ses Apôtres. Le possesseur de ce Cabinet a fait venir ce tableau de Lyon, sur le récit que lui firent plusieurs Artistes qui l'avoient vu; il ne fut pas trompé dans ses espérances, l'applaudissement fut général: *Chereau, le jeune*, en a gravé l'estampe. Il est peint sur bois, hauteur 1 pied 6 pouces, largeur 2 pieds 2 pouces." (Our Lord, who washes the feet of his apostles. The owner of this collection obtained this painting from Lyons, on the report made by several artists who had seen it there; he was not mistaken in his expectation, the praise was universal. Chereau the younger engraved the print of it. It is painted on wood, height 1 *pied 6 pouces*, width 2 *pieds 2 pouces*.) The measurements given are equal to 48.6 x 70.2 cm. The price and buyer are recorded in the annotated sale catalogue at the Frick; the information that Rémy was acting on behalf of the duc de Praslin is recorded in Bailey 1988, p. xlvii. For the collector Lalive de Jully, see also 1969.109 (after Greuze) and 1987.57 (Largillière). According to an unsubstantiated and probably inaccurate statement made by the baron de Boussairolles in 1806 (recorded in the Boussairolles family archives), the painting was in the collection of the "comte de Northampton" from 1770 to 1793; see Lefrançois 1981, p. 114.

3 The painting is described in the 1793 sale catalogue as follows: "Jesus-Christ faisant la Cène & lavant les pieds à ses Apôtres. Cette composition, d'une belle ordonnance & nombreuse en figures, présente un des ouvrages de choix & achevé de cet Artiste distingué dans notre Ecole. Haut. 18 p. larg. 26. B." (Jesus Christ attending the Last Supper and washing the feet of his Apostles. This composition, of beautiful arrangement and numerous figures, is one of the choice and finished works of this

distinguished artist in our school. Height 18 *p*. width 26. Panel.) The measurements given are equal to 48.6 x 70.2 cm. The price is recorded in annotated sale catalogues in the Frick Art Reference Library, New York, and at François Heim, Paris. The buyer is listed in Lefrançois 1981, p. 114.

4 According to Lefrançois 1981, p. 114.

5 According to Lefrançois 1981, p. 114. Lefrançois cited material in the archives of the Boussairolles family, now preserved in a private collection in Montpellier. The price is also recorded on an information sheet that was provided by the dealer Jean Pierre Selz at the time the Art Institute acquired the picture (in curatorial files).

6 According to the information sheet provided by Jean Pierre Selz (see note 5).

7 Ibid.

8 Ibid.

9 *Catalogue historique* . . . 1764, p. 100: "A painting by Bertin, on panel, one *pied* six *pouces* high by two *pieds* two *pouces* wide, representing Our Lord, who washes the feet of his Apostles. This painting, of beautiful composition and color, is finished with the greatest care. The heads in it are of beautiful expression, appropriate to the subject, among others, that of Saint Peter, which is of the greatest beauty. It is finely engraved by Chereau le jeune." The measurements given are equal to 48.6 x 70.2 cm.

10 See note 2.

11 Dézallier d'Argenville (fils)'s mention in *Voyage pittoresque de Paris* of Chereau's engraving (in reverse) after Bertin's painting indicates that the print was executed by 1757. There is a poor-quality painted copy after this engraving by an anonymous painter in the church of Saint-Victor, Marseilles.

12 Lefrançois 1981, p. 152, no. 109*.

13 Regarding Ango, see Marianne Roland Michel, "Un Peintre français nommé Ango . . . ," *Burl. Mag.* 123 (1981), suppl., pp. ii–viii, and Pierre Rosenberg, "La Fin d'Ango," *Burl. Mag.* 124 (1982), pp. 236–39.

14 The painting is catalogued in Lefrançois 1981, p. 152, no. 108*. The Ango drawing, executed in sanguine and dated 1765, is in the collection of the marquis de Breteuil, Château de Breteuil, Yvelines. Sylvie Yavchitz kindly provided information to the author about the drawing.

15 [Antoine Joseph Dézallier d'Argenville (père)], *Abrégé de la vie des plus fameux peintres . . .* , new ed., vol. 4, Paris, 1762, p. 351: "Pour l'Angleterre, il a peint en petit, le lavement des pieds. Ce tableau est présentement à Paris, dans le cabinet d'un amateur." (For England, he made a small picture, the washing of the feet. This painting is presently in Paris, in the collection of an *amateur*.) It is unlikely that this picture is either the Chicago or the Breteuil painting. As noted above (note 2), the family archives of the Boussairolles, who owned the Chicago panel, indicate (probably erroneously) that their picture had belonged to the count of Northampton between 1770, the year of the Lalive de Jully sale, and 1793, the year of the Choiseul-Praslin sale. Even if this were true, and the Lalive de Jully/Choiseul-Praslin provenance of the Chicago work were incorrect, it would still be improbable that the painting "for England" refers to the Chicago picture, since Dézallier d'Argenville (père)'s remark implies that the painting was in England before coming to France. If the painting "for England" were the Breteuil picture, he would have had to have acquired it while still in Paris, and then taken it to Rome, where Ango would have made the drawn copy. This also seems unlikely, since Dézallier d'Argenville (père) mentioned that the painting "for England" was in Paris in 1762, some years after Breteuil had gone to Rome. The painting "for England" is catalogued in Lefrançois 1981, p. 152, no. 110*.

16 See Lefrançois 1981, pp. 110–11, no. 16*, figs. 94–96, p. 111, no. 17, fig. 92, p. 113, no. 24, fig. 93, no. 25, fig. 91, respectively.

17 For a discussion of the dating of these pictures, see Lefrançois 1981, pp. 66–69. Bertin's drawing *Socrates Receiving the Hemlock* (Louvre, Cabinet des dessins) also should probably be assigned to this time (see Lefrançois 1981, pp. 187–88, no. 252, fig. 163).

Jacques Blanchard

1600 Paris 1638

Virgin and Child with Saint Elizabeth and the Infant Saint John the Baptist, 1630/31

Gift of Sam Salz, 1963.43

Oil on canvas, 94 x 122.4 cm (37 x 48³/₁₆ in.)

CONDITION: The painting is in fair condition. It was surface cleaned, varnished, and retouched in 1963.[1] It has an old glue paste lining.[2] The tacking margins have been cut off, but cusping is visible at all four edges. The loosely woven canvas is approximately 2 cm smaller than the stretcher on the right and left edges, and 1 cm smaller on the top and bottom edges. The exposed portions of the lining (around the perimeter of the painting) have been filled and inpainted. There is a pronounced cupped craquelure. The raised edges of the cracks have been flattened due to the lining process, imparting an irregular and disturbing appearance to the surface. The edges of the cracks have also been abraded by cleaning, revealing the light terracotta-colored ground. Numerous losses above Saint Elizabeth, along the lower edge, and to the right of the Christ child have been filled and inpainted. There is additional retouching in the upper background, between the two groups of figures, on Saint John's shoulder, on the Virgin's left hand and neck, on the drapery covering the Virgin's left arm, and on Christ's nose, left cheek and arm, and right foot. (ultraviolet, x-radiograph)

PROVENANCE: Rosa Maria Brender de Berenbau (of Montevideo, Uruguay), Paris, by 1955/56.[3] Sold by her to Sam Salz, New York, probably by 1961;[4] given to the Art Institute, 1963.

REFERENCES: Charles Sterling, "Les Peintres Jean et Jacques Blanchard," *Art de France* 1 (1961), pp. 86–87, no. 22 (ill.). "Accessions of American and Canadian Museums, January–March, 1964," *Art Quarterly* 27 (1964), pp. 205, 209 (ill.). Maxon 1970, p. 258 (ill.). Pierre Rosenberg, *La Peinture française du XVIIᵉ siècle dans les collections américaines*, exh. cat., Paris, Galeries Nationales du Grand Palais, 1982, p. 345, no. 9 (ill.). Wright 1985, p. 142. Wright 1991, vol. 1, p. 231, vol. 2, pp. 61, 566.

According to the early biographer Roger de Piles, Jacques Blanchard was one of the leading painters in France during the seventeenth century. De Piles noted that "la nouveauté, la beauté, & la force de son Pinceau attirérent les yeux de tout Paris; & il devint tellement à la mode, qu'il n'y eut pas un Curieux qui ne voulût avoir un morceau de sa main."[5] Blanchard's reputation declined after the Revolution, however, and has been revived only in recent years. He trained with his uncle Nicolas Bollery in Paris and with Horace Le Blanc in Lyons, a commercial center with strong ties to Italy. But the artist's most important formative years were spent in Rome (1624–26), Venice (1626–28), and Turin (1628). It is impossible to view Blanchard's paintings without recalling certain aspects of the works of the second school of Fontainebleau, Jacopo Bassano, Domenico Fetti, and Jan Lys. Yet as Charles Sterling (1961) convincingly demonstrated, "ce n'est . . . qu'à Venise, où il passe deux ans, que Blanchard trouve une peinture selon son coeur."[6] Above all it was Titian's influence that left an indelible impression on Blanchard's style, and the painter eventually became known as the "French Titian."

Although Blanchard painted a number of decorative schemes between 1631 and 1634, easel painting was his true métier. Within the broad range of subjects he treated, the themes of Charity and the Virgin and Child were among the most frequently represented. Sterling (1961) was the first to recognize the Chicago *Virgin and Child with Saint Elizabeth and the Infant Saint John the Baptist* as a work by Blanchard, and dated it to 1630/31 — that is, to the years immediately following Blanchard's return to Paris in 1629. It compares closely to two other compositions of that period. The model who posed for the Virgin in the Chicago picture seems to have posed also for the Virgin in the *Holy Family* in the Musée Thomas Henry, Cherbourg (fig. 1), and the figure of Saint Elizabeth in the Chicago painting probably shares a common model with the Saint Anne in the Louvre's *Virgin and Child with Saint Anne Offering an Apple.*[7] In spirit and general conception all three can be grouped with the Louvre's *Holy Family with Saint Elizabeth and the Infant Saint John the Baptist Receiving the Reed Cross* of about 1630/31.[8] The composition of this painting is organized on a strong diagonal, a device the artist abandoned in the Chicago composition, where he used a more horizontal and planar arrangement of figures.[9] As Sterling pointed out, in both Louvre paintings and in the Cherbourg *Holy Family*, the women "sont des espèces de bohémiennes, aux mèches en désordre, aux visages rubiconds et aux mains lourdes."[10] These characteristics, typical of Blanchard's works of the period, are found in the Chicago *Virgin and Child with Saint Elizabeth and the*

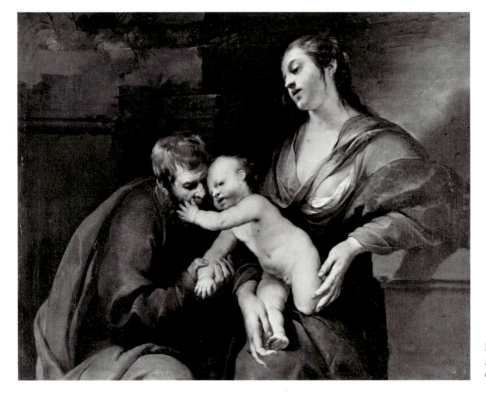

Fig. 1 Jacques Blanchard, *Holy Family*, Musée Thomas Henry, Cherbourg [photo: Giraudon]

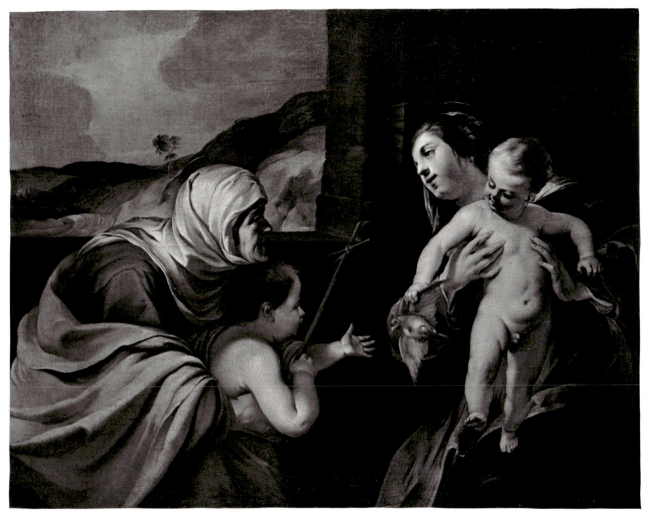

Jacques Blanchard, *Virgin and Child with Saint Elizabeth and the Infant Saint John the Baptist*, 1963.43

Infant Saint John the Baptist as well. Sterling attributed these genre types, which distinguish this group of paintings from Blanchard's earlier works, to the influence of Bernardo Strozzi. As Sterling proposed, the slightly more elegant and refined figures in the Chicago painting, with their carefully articulated profiles, more elongated hands, and supple drapery, suggest that the present composition, although dating to 1630/31, probably slightly predates the Cherbourg *Holy Family*.

The Chicago *Virgin and Child with Saint Elizabeth and the Infant Saint John the Baptist* is one of the first works in Blanchard's oeuvre in which the influence of Titian is very apparent. The warm, Titianesque colors of Blanchard's palette rivaled the icy elegance of the paintings of his contemporary Simon Vouet, the most sought-after painter in Paris in the second quarter of the seventeenth century. The robust earthiness of Blanchard's figures suggests his familiarity with the works of Bassano.

The probable influence of Peter Paul Rubens can be discerned in the Chicago canvas as well. Although it is difficult to determine which of the Flemish artist's paintings (or engravings after them) Blanchard may have seen, the Chicago picture almost certainly depends on a family type developed by Rubens and found in such paintings as the *Holy Family* in the Wallraf-Richartz Museum in Cologne.[11] Hans Vlieghe pointed to the similarity of the Virgin's pose in the Chicago painting with that of the Virgin in an engraving by Schelte Adams Bolswert after Rubens's *Virgin and Child* (1630/31) in the church of Saint Willebrordus in Antwerp, a work contemporary with the Chicago picture.[12]

NOTES

1 This treatment was performed by Alfred Jakstas.
2 The thread count of the original canvas is approximately 7 x 10/sq. cm (17 x 25/sq. in.).
3 Letter of March 20, 1981, from Charles Sterling to the author, in curatorial files.
4 According to Sterling's letter (note 3) and Sterling 1961.
5 [Roger de Piles], *Abregé de la vie des peintres . . .* , Paris, 1699, p. 463: "The novelty, beauty, and force of his brush attracted the eyes of all Paris, and he became so fashionable that there was not a collector who did not wish to have a work from his hand."
6 Sterling 1961, p. 108: "It is . . . only in Venice, where he would stay two years, that Blanchard would find a type of painting to his liking."
7 Ibid., p. 86, nos. 21 (ill.), 20 (ill.), respectively.
8 Ibid., p. 86, no. 18 (ill.).
9 One also sees this compositional scheme in the *Virgin with the Infant Christ Giving the Keys to Saint Peter*, signed and dated 1628, in the cathedral of Albi. For an illustration of this work, see ibid., p. 83, no. 1 (ill.).
10 Ibid., p. 109: "Are of bohemian type, with dishevelled hair, rubicund faces, and heavy hands." See also ibid., figs. 1, 18, 20–21, which exhibit the same qualities.
11 For an illustration of this work, see *Wallraf-Richartz-Museum Köln: vollständiges Verzeichnis der Gemäldesammlung*, Cologne, 1986, fig. 394.
12 Letter to the author of January 12, 1989, in curatorial files.

François Boucher

1703 Paris 1770

Bathing Nymph, 1745/50

Wilson L. Mead Fund, 1931.938

Oil on canvas, 42.6 x 47.1 cm (16³/₄ x 18¹/₂ in.)

CONDITION: The painting is in poor condition. In 1965 it was surface cleaned and varnished.[1] The canvas has an old glue paste lining. The tacking margins have been cut off, but cusping is clearly visible along the bottom edge, and is present, though less apparent, on the other edges. The four corners of the canvas are not original; the triangular canvas inserts are of a slightly looser weave, which runs diagonal to the weave of the original support.[2] The corner additions measure as follows (vertical dimension x horizontal dimension): top left, 5.5 x 3.5 cm; top right, 7.5 x 6 cm; lower left, 14 x 12.5 cm; and lower right, 15.5 x 13 cm. The canvas may originally have been round or oval (see discussion). The thin paint layer, applied over grounds of gray over red, is significantly worn due to overcleaning. Abrasion over the entire surface, a small scratch on the nymph's raised leg, and a series of small losses that extend for 9 cm along the figure's left forearm have been retouched. The seams at the corners (at the triangular inserts) have been overpainted, but traces of a much older paint layer visible beneath the overpaint indicate that the additions may have been painted soon after the original canvas. (ultraviolet, x-radiograph)

PROVENANCE: Possibly sold Chariot and Paillet, Hôtel d'Aligre (Baché, Brilliant, de Cossé, Quené, et al.), Paris, April 22 and following, 1776, no. 77, for 362 *livres*.[3] Possibly Louis François I de Bourbon, prince de Conti (d. 1776), Paris; sold Pierre Remy,

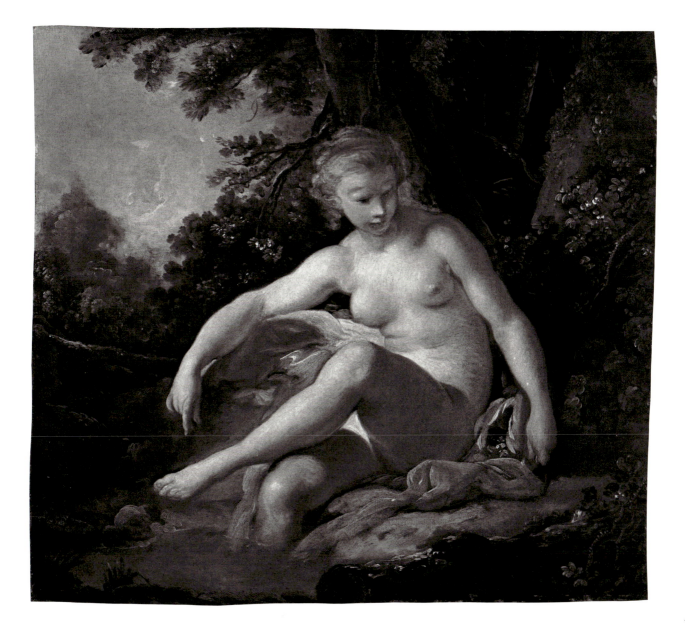

Paris, April 8 and following, 1777, no. 722, to Quenet for 330 *livres*.[4] Private collection, England.[5] Van Diemen and Co. and Dr. Benedict and Co., Berlin.[6] Van Diemen Galleries, New York. Sold by Van Diemen to the Art Institute, 1931.

REFERENCES: AIC 1932, p. 143. "Louis XV's Age Lives in Chicago's Boucher," *Art Digest* 6, 12 (1932), p. 4 (ill.). "Museum Accessions," *American Magazine of Art* 24 (1932), p. 297 (ill.). Daniel Catton Rich, "A 'Bathing Nymph' by Boucher," *AIC Bulletin* 26, 3 (1932), pp. 26–27 (cover ill.). AIC 1935, p. 26. Guillaume Lerolle, "A Review of French Painting," *Carnegie Magazine* 10 (1936), p. 6. AIC 1941, p. 32. AIC 1945, p. 34. AIC 1948, p. 32. AIC [1956], p. 32. AIC 1961, p. 29. Alexandre Ananoff with Daniel Wildenstein, *François Boucher,* Lausanne and Paris, 1976, vol. 1, p. 330, under no. 215, p. 413, under no. 304. Wright 1991, vol. 1, p. 433, vol. 2, pp. 61, 587.

EXHIBITIONS: The Art Institute of Chicago, *A Century of Progress,* 1933, no. 209. The Art Institute of Chicago, *A Century of Progress,* 1934, no. 133. Pittsburgh, Carnegie Institute, *A Survey of French Painting,* 1936, no. 18. Pittsburgh, Carnegie Institute, *French Painting, 1100–1900,* 1951, no. 87. Kansas City, Missouri, The Nelson Gallery and Atkins Museum, *The Century of Mozart,* 1956, no. 6 (cat. published as *The Nelson Gallery and Atkins Museum Bulletin* 1, 1 [1956]). The Peoria Art Museum, Illinois, *The Grand Tour: England, France, Italy, Greece, Egypt,* 1970, no. 1, under France, as attributed to Jean Honoré Fragonard. The Art Institute of Chicago, *Selected Works of Eighteenth-Century French Art in the Collections of The Art Institute of Chicago,* 1976, no. 8.

The son and pupil of a minor painter and embroidery decorator, François Boucher trained briefly with the painter François Le Moyne before entering the workshop of the printmaker Jean François Cars. The skills Boucher acquired there earned him the commission from Jean de Jullienne to make the majority of the engravings

after Jean Antoine Watteau's drawings for the *Figures de différents caractères* (see 1960.305, Watteau's *The Dreamer* [*La Rêveuse*]). With Watteau's art as a touchstone, Boucher developed his own elegant and picturesque — though often more overtly erotic — rococo style. Except for a period in Rome (1728–c. 1731) subsequent to his winning the *Prix de Rome*, Boucher spent his entire life in France. Under the patronage of Louis XV's mistress, Mme de Pompadour, Boucher became the leading decorator of royal châteaux, including Fontainebleau, Choisy, Versailles, and Bellevue. He succeeded Jean Baptiste Oudry (see 1977.486) in 1755 as the director of the Gobelins tapestry works and created designs for porcelain for the factories at Sèvres and Vincennes. In 1765 he was appointed *premier peintre* to the king and the director of the Academy.

This small *Bathing Nymph*, acquired in 1931 as a work by Boucher, was later given to Fragonard, an attribution that was subsequently dismissed.[7] In the 1976 exhibition catalogue, J. Patrice Marandel restored the picture to Boucher; this attribution, supported by Alastair Laing and Pierre Rosenberg, seems the most tenable.[8] The subject matter, pose, and landscape are all typical of Boucher, and can be compared to those of his *Diana at the Bath* in the Louvre.[9] Boucher repeated the figure type seen in the Chicago work frequently and with much variation.[10] Doubts concerning the attribution to Boucher, and the eventual tentative attribution to Fragonard, were probably prompted by the sketchy

appearance of the figures, which is somewhat uncharacteristic for Boucher. This sketchiness is to some degree the result of the abraded state of the surface (see Condition).[11] Despite its condition, the *Bathing Nymph* has a fluidity of movement and a sureness of draftsmanship that point to Boucher as the author.

It is probable, if not certain, that the picture was originally round, or possibly oval, in format, since there are triangular inserts at the four corners of the canvas (see Condition). Laing suggested that the *Bathing Nymph* might be the round painting by Boucher that seems to have passed through two eighteenth-century sales.[12] The dimensions of the picture(s) in the two sales correspond closely to those of the *Bathing Nymph*, and the descriptions of the work(s) in the catalogues as "light of touch," "silvery," and with a "hazy" background would seem to apply to the Chicago painting. Laing also observed that an annotation in one copy of the 1776 sale catalogue reads "la femme n'est qu'ébauchée."[13]

When a circle 51.4 cm in diameter is superimposed over a composite x-radiograph of the painting, its perimeter passes directly over the four diagonal corner cuts in the original canvas support. One sees also by this means that when the edges were trimmed, the greatest reduction to the painting was along the top edge, with lesser cuts along the sides and bottom edge. Additional evidence of the original shape of the canvas is provided by two miniatures entitled *Bathing Nymph* (locations unknown; see fig. 1 for one of these) by Boucher's student Jacques Charlier, who often emulated his teacher's compositions.[14] The miniatures, which are round in format, appear to be either based on the Chicago painting or derived from a common source. In Charlier's works, one can observe how well the pose, almost identical to that of the Chicago nymph, lends itself to the circular format. It should be noted that Charlier was a protégé of the Prince de Conti, who may have owned the Chicago painting at one time (see Provenance).

The Chicago *Bathing Nymph* perhaps also served as a model for a lost sculpture, *Flora*, by Etienne Maurice Falconet, which seems, in turn, to have been the prototype for a group of statuettes by Falconet entitled *Flora with a Quiver of Roses*.[15] Two of these statuettes, preserved in the Musée Cognac-Jay in Paris and The Walters Art Gallery in Baltimore (fig. 2), are extremely similar in pose and physiognomy to the Chicago nymph.[16] Such a borrowing would not have been unusual for Falconet, who, when creating biscuits for the Sèvres porcelain factory between 1757 and 1766,

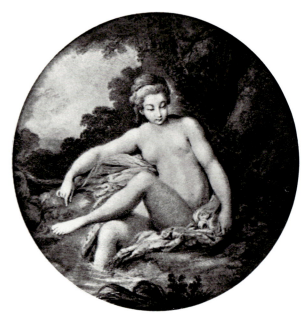

Fig. 1 Jacques Charlier, *Bathing Nymph*, location unknown [photo: sale catalogue, Hôtel Drouot, Paris, May 9, 1927, no. 3]

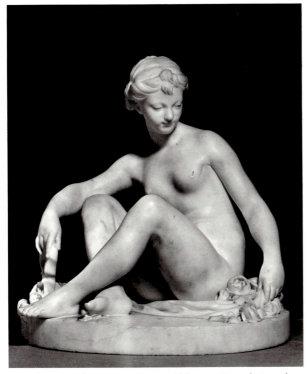

Fig. 2 Attributed to Etienne Maurice Falconet, *Nymph Seated* (also known as *Nude with a Garland of Roses* or *Flora*), The Walters Art Gallery, Baltimore

occasionally relied on Boucher's paintings or on engravings after them.[17]

The *Bathing Nymph* was dated as early as c. 1740 in the 1951 and 1956 exhibition catalogues and in the 1961 catalogue of the Art Institute's paintings, and to c. 1742 by Marandel in the 1976 exhibition catalogue. Laing proposed a still later date of c. 1750.[18] If there is an artistic link between the *Bathing Nymph* and the statuettes representing Flora, then the terminus ad quem for the execution of the Chicago painting would be 1750, the year Falconet exhibited the model for the lost *Flora*.

NOTES

1 The treatment was performed by Alfred Jakstas.

2 The thread count of the original canvas is approximately 13 x 12/sq. cm (30 x 29/sq. in.); the thread count of the corner sections is approximately 12 x 12/sq. cm (29 x 29/sq. in.).

3 The picture is described in the sale catalogue as follows: "Une Baigneuse. Elle est assise près d'un gros arbre. Le fond est un joli paysage, d'une touche légere & de goût. Ce tableau, d'un ton ferme & argentin, peut être distingué dans les meilleurs de ce Maître: il est très-agréable. Diametre, 19 pouces. T." (A bather. She is seated near a large tree. The background is an attractive landscape, light of touch and tasteful. This painting, of a firm and silvery manner, can be distinguished among the best of this Master: it is very pleasing. Diameter 19 *pouces*. Canvas.) The measurement given is equal to 51.4 cm. The sellers' names are listed in Frits Lugt, *Répertoire des catalogues de ventes publiques*, vol. 1, The Hague, 1938, no. 2533. The purchase price

is given in a letter of April 19, [1985], from Alastair Laing to the author, in curatorial files.

4 The picture is described in the sale catalogue as follows: "Une femme assise qui se lave les jambes dans une pièce d'eau; du paysage fait le fond de ce tableau qui est vaporeux: il est peint sur toile de forme ovale; hauteur 19 pouces, largeur 18 pouces." (A seated woman who washes her legs in a pool of water; some landscape makes up the background of this painting, which is hazy: it is painted on an oval-shaped canvas; height 19 *pouces*, width 18 *pouces*.) The measurements given are equal to 51.4 x 48.6 cm. Price and buyer are recorded in an annotated sale catalogue in the Bibliothèque d'Art et d'Archéologie, Paris. Quenet, the buyer, is presumably the same person as the Quené who was a vendor in the 1776 sale (see note 3).

5 According to a telegram of December 28, 1931, from Karl Lilienfeld (Van Diemen Galleries) to Robert Harshe (Archives, The Art Institute of Chicago).

6 According to a letter of February 1, 1932, from René Gimpel to Van Diemen and Co. and Dr. Benedict and Co. (Archives, The Art Institute of Chicago). A label on the stretcher reads: *imported from Germany*. Van Diemen was in partnership with Dr. Benedict and Co. in Berlin, where Gimpel had seen the picture.

7 Expertises by Hermann Voss (July 17, 1931) and C. F. Foerster (January 28, 1932), both on the backs of photographs, and a letter from René Gimpel to Van Diemen and Co. and Dr. Benedict and Co. (see note 6) supported an attribution to Boucher (Archives, The Art Institute of Chicago). By 1970 (see 1970 exhibition catalogue) the Art Institute had changed the attribution to Fragonard. In 1973 Alexandre Ananoff rejected this attribution and suggested that the painting dated from the early nineteenth century and was based on an engraving after a Boucher design (see notes on Ananoff's comments, dated October 16, 1973, and a letter of November 23, 1973, to John David Farmer, both in curatorial files).

8 Letters of April 19, [1985], and May 30, [1985], from Alastair Laing to the author (in curatorial files) and verbal communication from Pierre Rosenberg of November 15, 1986 (notes in curatorial files). Ananoff (Ananoff and Wildenstein 1976, p. 330) also supported an attribution to Boucher.

9 Louvre, *Catalogue sommaire*, vol. 3, *Ecole française, A–K*, p. 79, no. 2712 (ill.). The Louvre painting measures 57 x 73 cm.

10 For example, see Ananoff and Wildenstein 1976, vol. 1, figs. 655, 823, vol. 2, figs. 897, 976, 1095, 1107.

11 Rosenberg (verbally; see note 8) stressed that the poor condition of the painting should be taken into account when considering its attribution. Alastair Laing (letter of October 13, 1992, to Douglas Druick, in curatorial files) believed the painting to be an unfinished autograph work.

12 See Provenance, notes 3–4, and the letters from Laing cited in note 8.

13 In a letter to the author of April 19, [1985] (see note 8): "the woman is only roughly sketched."

14 Sold Heberle, Cologne, March 31–April 1, 1905, no. 130 (ill.); and Hôtel Drouot, Paris, May 9, 1927, no. 3 (ill.), respectively. Alastair Laing (letter of October 13, 1992; see note 11) kindly called attention to the painting in the Heberle sale.

15 George Levitine, *The Sculpture of Falconet*, Greenwich, Conn., 1972, p. 44.

16 Ibid., figs. 63–66.

17 A fine example of this is Falconet's biscuit *Leda and the Swan* of 1764 (London, Victoria and Albert Museum), based on an engraving after Boucher's painting of 1742 (Stockholm, Nationalmuseum). For an illustration of Falconet's *Leda and the Swan*, see Levitine (note 15), fig. 48.

18 Letter to the author of May 30, [1985], in curatorial files.

Are They Thinking about the Grape? (Pensent-ils au raisin?), 1747

Martha E. Leverone Endowment, 1973.304

Oil on canvas, oval, 80.8 x 68.5 cm (31³/₄ x 27 in.)

INSCRIBED: *f. Boucher 1747* (bottom, right of center)

CONDITION: The painting is in very good condition. It was cleaned in 1973, when an old glue paste lining was replaced with a wax resin one.[1] The tacking margins have been cut off, but cusping along the right and left edges suggests that the painting is close to its original dimensions. The paint layer, applied on a light gray ground over a warm red ground,[2] has suffered little damage. *Pentimenti* in the drapery folds of the girl's skirt and the boy's trousers are apparent. An overall craquelure is somewhat cupped, but not visually distracting. The paint surface has become slightly flattened and the canvas weave pronounced as a result of the lining process. There are a few small localized losses, in the foliage above the girl and along the edge at the top and along the left side, in the lower left foreground, and on the girl's neck and skirt. The background foliage to the left of the boy is slightly abraded, and abrasion from the frame rabbet is evident along the perimeter. There is localized retouching on the edges, in the sky at upper right, and on scattered losses that are apparent in the x-radiograph. (infrared, ultraviolet, x-radiograph)

PROVENANCE: Probably Jean Baptiste Machault d'Arnouville (d. 1794), contrôleur général des finances; by descent to Melchior, marquis de Vogüe, one of whose descendants married comte René de Rohan Chabot.[3] Comte René de Rohan Chabot, Paris; sold to Wildenstein, New York, 1959.[4] Purchased from Wildenstein by the Art Institute through the Martha E. Leverone Endowment, 1973.

REFERENCES: [Abbé Jean Bernard Le Blanc], *Lettre sur l'exposition des ouvrages de peinture, sculpture, etc., de l'année 1747...*, Paris, 1747; reprint, Geneva, 1970, pp. 81–82. "Recent Accessions of American and Canadian Museums," *Art Quarterly* 36 (1973), p. 429. "Art across North America—In the News," *Apollo* 99 (June 1974), p. 474, fig. 8. "La Chronique des arts," *GBA* 6th ser., 83 (1974), suppl. to no. 1261, p. 128, fig. 411. John David Farmer, "A New Painting by François Boucher," *AIC Bulletin* 68, 2 (1974), pp. 16–18 (ill.). Alexandre Ananoff, "François Boucher et l'Amérique," *L'Oeil* 251 (1976), pp. 18, 21. Alexandre Ananoff with Daniel Wildenstein, *François Boucher*, Lausanne and Paris, 1976, vol. 1, p. 33, under no. 299, p. 34, under no. 301, vol. 2, p. 3, under no. 309, pp. 4–5, no. 310, fig. 888, pl. opp. p. 32. Maxon 1977, pp. 62–63 (ill.). Pierrette Jean-Richard, *L'Oeuvre gravé de François Boucher dans la collection Edmond de Rothschild*, Paris, 1978, p. 323, under no. 1344. *AIC 100 Masterpieces* 1978, pp. 68–69 (ill.), no. 30. Regina Shoolman Slatkin, review of *François Boucher*, by Alexandre Ananoff with Daniel Wildenstein, in *Burl. Mag.* 121 (1979), pp. 119–20. Alexandre Ananoff with Daniel Wildenstein, *L'opera completa di Boucher*, Classici dell'arte 100, Milan, 1980, p. 111, no. 321 (ill.), pl. XXIX. Denys Sutton in *François Boucher (1703–1770)*, exh. cat., Tokyo Metropolitan Art Museum, 1982, p. 261. Pontus Grate in *François Boucher: Paintings, Drawings, and Prints from the Nationalmuseum, Stockholm*, exh. cat., Manchester, City Art Gallery, 1984, p. 21,

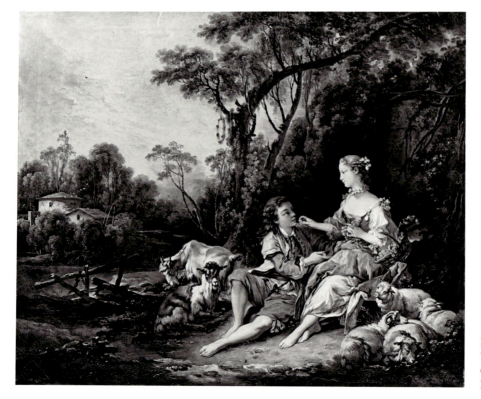

Fig. 1 François Boucher, *Are They Thinking about the Grape? (Pensent-ils au raisin?)*, Nationalmuseum, Stockholm

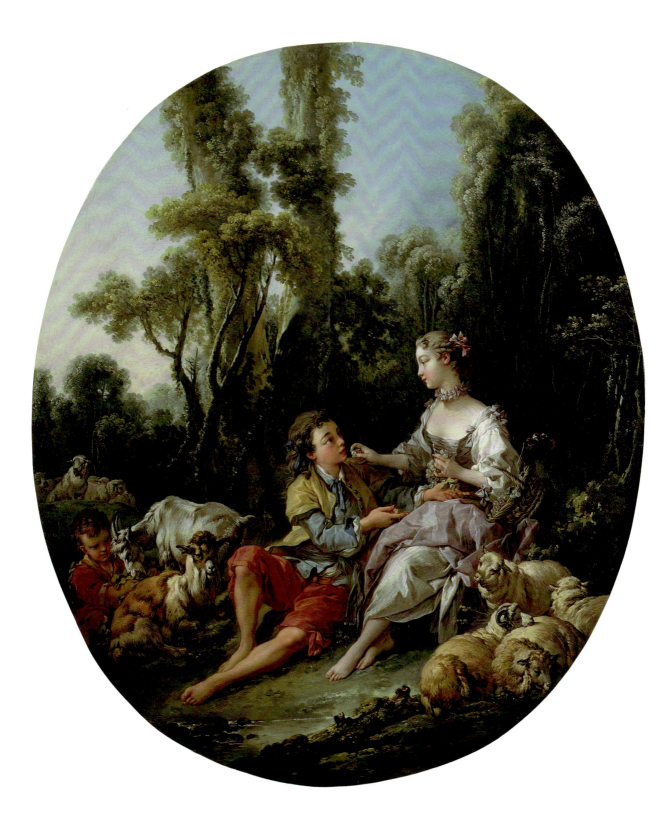

under no. P6. Alan P. Wintermute in *The First Painters of the King: French Royal Taste from Louis XIV to the Revolution*, exh. cat., New York, Stair Sainty Matthiesen, 1985–86, p. 128, no. 13 (ill.). Georges Brunel, *Boucher*, New York, 1986, p. 208. Michel Hilaire, "François Boucher, 1703–1770," *Le Petit Journal des grandes expositions* 164 (1986), n. pag. (ill.). Alastair Laing, "Boucher et la pastorale peinte," *Revue de l'art* 73 (1986), pp. 59–60, 63 n. 71, fig. 16. *L'Oeil* 374 (1986), cover ill. Carter Ratcliff, "François Boucher, Absolutist Painter," *Art in America* 74 (July 1986), p. 95 (ill.). Pierre Rosenberg and Michel Hilaire, *Boucher: 60 Chefs-d'oeuvre*, Fribourg, 1986, p. 6. Antoinette Faÿ-Hallé, "The Influence of Boucher's Art on the Production of the Vincennes Sèvres Porcelain Manufactory," in *François Boucher, 1703–1770*, exh. cat., New York, The Metropolitan Museum of Art, 1986–87, pp. 345–50. Pierre Rosenberg and Marion C. Stewart, *French Paintings 1500–1825: The Fine Arts Museums of San Francisco*, San Francisco, 1987, pp. 127–28 (ill.). Guy Stair Sainty, in *François Boucher: His Circle and Influence*, exh. cat., New York, Stair Sainty Matthiesen, 1987, p. 117. Henry Bonnier, *François Boucher dessins*, Paris, 1988, p. 42. *AIC Master Paintings 1988*, p. 41 (ill.). John Ingamells, *The Wallace Collection: Catalogue of Pictures*, pt. 3, *French before 1815*, London, 1989, p. 33 under P399, p. 61 under P482. Wright 1991, vol. 1, p. 433, vol. 2, pp. 61, 584.

EXHIBITIONS: Probably Paris, Salon of 1747, no. 33 *bis*, as one of "deux Pastorales . . . en forme ovale; sous le même No." (Two pastorals . . . in oval form; under the same number.) Stockholm, Nationalmuseum, *La Douce France (Det ljuva Frankrike)*, 1964, no. 16. The Art Institute of Chicago, *François Boucher in North American Collections: 100 Drawings*, 1973–74 (not in cat.). The Art Institute of Chicago, *Selected Works of Eighteenth-Century French Art in the Collections of The Art Institute of Chicago*, 1976, no. 9. New York, The Metropolitan Museum of Art, *François Boucher, 1703–1770*, 1986–87, no. 53, cat. by Alastair Laing et al., traveled to Detroit and Paris.

François Boucher was a painter of enormous energy, versatility, and productivity. He treated a broad array of subjects, primarily mythological and pastoral, and executed designs for engravings, tapestries, porcelain, and the theater. His pastorals, such as the Chicago *Are They Thinking about the Grape?*, were, as Alastair Laing (1986–87 exhibition catalogue) rightly remarked, "Boucher's single most influential contribution to French eighteenth-century painting." Before Boucher, French painters of pastoral subjects tended either to seize traditional subjects (from Tasso, Ariosto, Guarini, Sonnazzaro, or Honoré d'Urfé), dressing the figures in rather elaborate and often theatrical garb, or to paint landscapes in which rustic life was merely appended to the primary subject matter. Boucher was, of course, primarily influenced by the *fête galante* genre developed by Jean Antoine Watteau (see 1954.295) and his disci-

ples. But he also looked to the rustic landscapes of Northern artists working in Italy, including Pieter van Laer and the *Bamboccianti*. These latter influences can be seen in paintings by Boucher such as *Country Life* (1728/29; London, private collection), *The Farmer's Repose* (1730s; Hallandale, Florida, Mr. and Mrs. Jeffrey E. Horvitz collection), and the *Capriccio View of the Farnese Gardens* (1734; New York, The Metropolitan Museum of Art).[5] More in keeping with the French tradition are Boucher's *Le Pasteur galant* and *Le Pasteur complaisant* (both Paris, Hôtel de Soubise, Archives nationales), overdoors painted in the late 1730s, which, with their amorous protagonists in lavish garments, may be the earliest examples of the true eighteenth-century pastoral.[6]

Are They Thinking about the Grape? is known in two painted versions. One is the oval canvas in Chicago. The other (fig. 1), in the Nationalmuseum in Stockholm, is rectangular in format and was until recently considered the primary version.[7] The poses and placement of the shepherd and shepherdess and most of the animals are identical in the two pictures. There are, however, some significant differences between the works other than format. For example, a young boy and a small cluster of sheep have been included at the left of the Chicago picture, while a view of a river and a hamlet appears at the left of the Stockholm painting.

That the Chicago painting is the earlier of the two versions is suggested by its probable pendant, *The Flageolet Player* (fig. 2).[8] This painting and the work in Chicago were probably the "two Pastorals . . . in oval form" exhibited at the Salon of 1747. *The Flageolet Player*, which depicts a young shepherd playing music for a shepherdess, is signed and dated 1746. The Stockholm *Are They Thinking about the Grape?*, painted in the next year, combines elements from the oval paintings — the richly foliated landscape and the large, curved tree trunk of *The Flageolet Player* with the figures and animals of the Chicago composition. The Stockholm picture was probably painted for Boucher's friend Carl Hårleman, an architect to the Swedish crown.[9] The provenance for the oval pair is more difficult to document; because *The Flageolet Player* was once in the collection of Jean Baptiste Machault d'Arnouville, it seems likely that the Chicago pendant belonged to him as well.

The subjects of these paintings derive from the Parisian theater, with which Boucher had a long and fruitful association, frequently as a designer of sets and

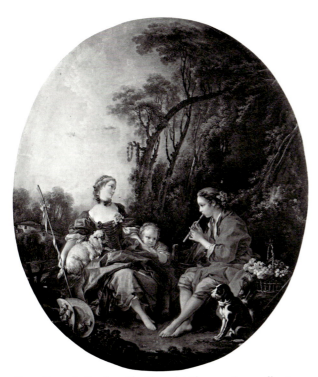

Fig. 2 François Boucher, *The Flageolet Player*, private collection, Belgium [photo: sale catalogue, Ader Picard Tajan, Paris, June 14, 1977]

costumes. *The Flageolet Player* and *Are They Thinking about the Grape?* are only two among numerous paintings he based upon a theater piece by Charles Simon Favart entitled *Les Vendanges de Tempé*. The story, set in a vineyard, concerns the awakening love of a Little Shepherd (performed *en travesti* by Mme Favart) for Lisette, a shepherdess. Their relationship is complicated by the actions of jealous relatives and rivals, but eventually all is reconciled and the young couple is happily united. Conceived as a pantomime, this well-received piece was first performed on August 28, 1745, at the Foire Saint-Laurent. It was later revived and embellished as a ballet-pantomime; the setting was changed to a cherry orchard, characters and scenes were added, and it was retitled *Vallée de Montmorency*. The first performance of this more elaborate pantomime was on February 25, 1752, at the Théâtre Italien.

The plot of the two pieces is known today only from the *Dictionnaire des théâtres de Paris* by François and Claude Parfaict, who, scene by scene, summarized the story and indicated the changes made from one version to the next.[10] The two pieces are not always clearly distinguished in the *Dictionnaire*, perhaps because, as Laing (1986–87 exhibition catalogue) suggested, the Parfaicts were not familiar with the original text

by Favart. Nonetheless, their discussion of the play is important not only because it documented the essentials of these performances, but also because they noted in their introduction that "M. *Boucher*, Peintre fameux par ses compositions gracieuses, en emprunta l'idée de quelques-uns de ses tableaux, & ce n'est point le moindre honneur qu'ait reçu la *Pantomime* des *Vendanges de Tempé*."[11] Specifically, they described a sexually allusive episode in scene 5 of *Vendages de Tempé* where "Lisette lui prend le *flageolet* dont elle veut jouer, mais elle n'y réussit pas. Le Berger touche le *flageolet* pendant qu'elle souffle dedans."[12] In their notes, the Favarts wrote that "ce badinage du flageolet, dans lequel souffle une Bergere [*sic*], pendant qu'il est touché par un Berger, est un des sujets traités par Monsieur *Boucher*."[13] The *Shepherd Piping to a Shepherdess* (London, Wallace Collection) of 1745/50 may be Boucher's earliest formulation of this episode, followed by *The Flageolet Player* of 1746 and *The Enjoyable Lesson* (*L'Agréable leçon*; location unknown) of 1748.[14]

The sexually suggestive subject of the Chicago painting seems to derive from a later scene in *Les Vendanges de Tempé* that was retained in *Vallée de Montmorency*. In their description of the opening of scene 6 of *Vallée de Montmorency*, in which "Le petit Berger propose à son amoureuse de jouer à de petits jeux sur l'herbe; ils s'asseient & jouent au *pied de boeuf*," the Parfaicts added in their notes that "Avant le pied de boeuf, ils se donnent mutuellement du raisin & des cerises, dans la *Vallée de Montmorenci*; ce sujet a aussi été saisi par M. *Boucher*."[15] It can probably be assumed that there was a grape-exchanging scene in *Les Vendanges de Tempé* as well, since the scene corresponds to that in the Chicago *Are They Thinking About the Grape?*, which predates the *Vallée de Montmorency* by five years. The Chicago canvas may, in fact, be Boucher's first treatment of the grape-exchanging theme, which he later repeated in the Stockholm version and then in *An Autumn Pastoral* (1749; London, Wallace Collection).[16] The extent to which Boucher and his friend Favart may have benefited from each other's work has been more carefully explored only in recent years. Laing has suggested that Boucher turned to Favart's theater pieces because in them he found brief and simple incidents to depict, as opposed to the lengthier dramas in classical literary pastorals. A pantomime such as *Les Vendanges de Tempé* would have provided the viewer—and artist—with a "succession of tableaux." And, just as scenes in the pantomime *Acajou* were based on paint-

ings by Boucher, so might scenes from *Vallée de Montmorency* have found their inspiration in Boucher's compositions.[17]

Boucher may have also appreciated Favart's relatively sympathetic treatment of peasant subjects, which made audiences laugh "par l'ingénuité touchante de ses rustiques protagonistes plutôt que par leur grossière stupidité."[18] It is likely, nevertheless, that even Favart's and Boucher's portrayals of idealized rustics contained an element of class derision. Moreover, the representation of the loves and frolics of the peasants, for whom the upper classes had little regard, allowed the writer and artist to avoid censorship in their treatment of risqué themes.

The playfully coy title of the Chicago picture may derive not from the pantomime, but from contemporary expressions or clichés. Variations on the remark "Pensent-ils au raisin?" appeared on another print after Boucher and on a nineteenth-century illustration.[19] Neither the Chicago painting nor its pendant was titled in the Salon *livret*, and neither was ever engraved. Presumably the Chicago and Stockholm paintings acquired their present title from the inscription on the engraving of the latter by Jacques Philippe Le Bas.[20] Such engravings attest to the immense popularity of Boucher's pastoral subjects. His shepherds and shepherdesses were reproduced with and without modification in a variety of media. The Chicago-Stockholm theme appeared in engravings and painted copies as well as on snuffboxes, fans, and potpourri jars; it was also adapted to porcelain and tapestry designs.[21]

NOTES

1 This treatment was performed by Alfred Jakstas. The thread count of the original canvas is approximately 11 x 12/sq. cm (27 x 30/sq. in.).

2 According to cross-sections taken by Inge Fiedler in 1973.

3 Alastair Laing (letter to the author of August 13, [1986], in curatorial files) proposed this line of descent based on the likely provenance of the pendant to the Chicago painting (see note 8).

4 According to Ay-Wang Hsia (telephone conversation with the author, May 4, 1982), Wildenstein acquired the picture directly from Rohan Chabot.

5 For these paintings, see, respectively, Ananoff and Wildenstein 1976, vol. 1, pp. 191–92, no. 55, fig. 278; 1986–87 exhibition catalogue, pp. 141–45, no. 20 (ill.); and Ananoff and Wildenstein 1976, vol. 1, pp. 228–30, no. 101, fig. 394.

6 See Ananoff and Wildenstein 1976, vol. 1, pp. 276–77, no. 159, fig. 513, p. 278, no. 160, fig. 518, respectively.

7 The Stockholm painting is signed and dated at lower right: *f. Boucher 1747*; see ibid., vol. 2, p. 3, no. 309, fig. 886. A third version of the subject (location unknown)—or a copy after the Chicago or Stockholm pictures—was sold at Christie's, London, on April 27, 1928, no. 127. That painting was recorded as measuring 31 x 42 in.

8 The pendant, which measures 80 x 68 cm, is signed and dated at lower right: *f. Boucher / 1746*. Provenance: Jean Baptiste

Machault d'Arnouville (d. 1794), contrôleur général des finances, who bought the picture from Boucher; by descent to Melchior, marquis de Vogüe; by descent to the comte and comtesse de la Panousse; probably sold by a descendent of the comtesse who lived at the Château de Thoiry (see letter from Alastair Lang cited in note 3); sold Pavillon Gabriel by Ader, Picard, and Tajan, Paris, June 17, 1977, no. 5 (ill.), to Etienne De Pourcq-Billiet, Deinze, Belgium (see letter of April 19, 1985, from Laing to the author, in curatorial files). A copy after *The Flageolet Player* (oval, 80 x 69 cm, with slight variations) was once in the hands of R. A. Trotti, Paris, according to a photograph in the Witt Library, London.

9 For the provenance of the Stockholm picture, see Laing in the 1986–87 exhibition catalogue, pp. 236–37.

10 [François and Claude Parfaict], *Dictionnaire des théâtres de Paris*, vol. 6, Paris, 1767, pp. 70–78; reprint, Geneva, 1967, vol. 2, pp. 69–84.

11 Ibid., p. 70: "M. Boucher, the Painter famous for his gracious compositions, took the idea of some of his pictures from here, and that is not the least of the honors paid to the *Pantomime* of the *Vendanges de Tempé*."

12 Ibid., p. 77: "Lisette takes from him [the Shepherd] the flageolet that she wants to play, but she does not succeed. The Shepherd fingers the flageolet while she blows into it."

13 Ibid., p. 78: "This badinage of the flageolet, into which the Shepherdess blows while it is fingered by the Shepherd, is one of the subjects treated by Monsieur Boucher."

14 For *Shepherd Piping to a Shepherdess*, see Ingamells 1989, pp. 33–35, no. P399; see also Ananoff and Wildenstein 1976, vol. 1, pp. 395–96, no. 283, fig. 837; for *The Enjoyable Lesson*, see ibid., vol. 2, pp. 6–7, no. 311, fig. 893.

15 Parfaict (note 10), p. 78: "The Little Shepherd proposes to his beloved to play a little game on the grass; they sit and play *pied de boeuf*; Before the *pied de boeuf* they give each other grapes and cherries in the *Vallée de Montmorency*; this subject was also seized by M. Boucher." For the sexual symbolism of grapes and cherries in French rococo paintings, see Mary D. Sheriff, *Fragonard: Art and Eroticism*, Chicago and London, 1990, pp. 110–11.

16 For the Wallace Collection painting, see Ingamells 1989, pp. 61–63 (ill.); see also Ananoff and Wildenstein 1976, vol. 2, pp. 33–34, no. 336, fig. 970.

17 Laing 1986, p. 56. Boucher was just one of many artists of the period who intermittently drew inspiration from Favart's *Les Vendanges de Tempé* and the *Vallée de Montmorency*. See Gisela Zick, "D'Après Boucher: Die 'Vallée de Montmorency' und die europäische Porzellanplastik," *Keramos* 29 (July 1965), pp. 3–47.

18 Laing 1986, p. 56: "At the touching ingeniousness of his rustic protagonists, rather than at their coarse stupidity."

19 A drawing engraved by Jourdan was entitled *Pensent-ils à ce mouton?*; see L[ouis] Soullié and Ch[arles] Masson, *Catalogue raisonné de l'oeuvre peint et dessiné de François Boucher . . .*, in André Michel, *François Boucher*, Paris, [1906], p. 96, no. 1697. Also, musicologist David Rosen (1983; verbally) pointed out to the author a cartoon published in the nineteenth century with letters reading "Pensent-t-ils à la musique?" (Paris, Bibliothèque Nationale, Cabinet des estampes, neg. no. 78.C.88967).

20 Le Bas engraved the Stockholm painting in reverse; see Jean-Richard 1978, pp. 323–24, no. 1346 (ill.), and p. 323, nos. 1344–45.

21 Two engravings of goats and sheep by Gilles Demarteau after drawings by Boucher appear to be related to animals in the Chicago painting; see ibid., p. 180, nos. 628–29 (ill.). The composition of the Chicago picture is repeated in an eighteenth-century tapestry woven at Aubusson; see Ananoff and Wildenstein 1976, vol. 2, p. 5, no. 310/4, fig. 889.

A copy of the Stockholm painting, measuring 76.2 x 90.2 cm and signed at lower left, partially legible, *F B 1749*, is in The Fine Arts Museums of San Francisco; see Rosenberg and Stewart 1987, pp. 126–29 (ill.). The provenance of the Chicago picture has sometimes been confused in the literature with that of the San Francisco painting. There exists also a gouache *Pastoral* after the Stockholm picture, which was sold in the Senator William A. Clark estate sale at the Plaza Hotel, New York, January 11–12, 1926, no. 69 (ill.), as Boucher.

Among the decorative arts objects related to Boucher's *Pensent-ils au raisin?* compositions are a Louis XV Sèvres porcelain potpourri jar, painted by Dodin, probably after the Le Bas engraving (see *Some Works of Art Belonging to Edward Tuck in Paris*, London, 1910, p. 124, no. 1 [ill.]), and a French or Netherlandish fan of 1747/50 with a gouache painting adapted from the Le Bas engraving in The Fine Arts Museums of San Francisco (see Anna G. Bennett with Ruth Berson in *Fans in Fashion*, exh. cat., The Fine Arts Museums of San Francisco, 1981, no. 8 [ill.]).

Sébastien Bourdon

1616 Montpellier–Paris 1671

Christ Receiving the Children, c. 1655

Gift of Mrs. Eugene A. Davidson, 1959.57

Oil on canvas, 100.3 x 135.2 cm (39½ x 53¼ in.)

CONDITION: The painting is in fair condition. It was cleaned in 1965, when the old glue paste lining was replaced with a wax resin one, and again in 1993.[1] The tacking margins have been cut off, but cusping is visible at all four edges of the tightly woven canvas. There is a 2.5 cm tear in the upper right background and a smaller hole near the edge at the top center. The warm reddish ground is visible through the paint surface, which has been abraded by cleaning. This abrasion accounts for a loss of definition in the distant foliage, in Christ's face, and in the group of standing male figures. More severe abrasion has made the distant figures at the far left faint and has reduced the three figures at the far right to ghosts. During surface treatment in 1965, a later addition, a tunic worn by the taller child standing left of center, was removed. Retouching compensates for abrasion around the four edges, along the left vertical quarter of the painting (particularly in the dark areas), and in scattered areas throughout the surface. The figures of Saint James (standing before Christ with his hand outstretched) and of the seminude child in the central foreground, the architecture above Christ and to the left, and the drapery of the female figures at the far left have all been inpainted. Examination of the painting with infrared reflectography revealed that the artist made slight changes to the steps in the background, to the foot and lower leg of Saint Peter (seated in the foreground), and to Saint James's right shoulder. A *pentimento* indicates that Saint James's right hand once extended toward Christ. (infrared, ultraviolet, x-radiograph)

PROVENANCE: Probably Chiquet de Champ-Renard, Paris; sold Joullain fils, Paris, March 14 and following, 1768, suppl. 3, to Joullain fils, Paris, for 815 *livres*.[2] Probably John Joshua Proby, first earl of Carysfort (d. 1828), Elton, Huntingdonshire, and London; sold Christie's, London, June 14, 1828, no. 38, to Gilmor for 35 gns. 14 s.[3] Robert Frank, Bristol, by 1938.[4] Seligmann, New York, by 1947.[5] Robert D. Brewster, New York.[6]

Stuart Preston, New York, by 1956.[7] Consigned by Preston to Knoedler, New York, 1958–59.[8] Purchased from Knoedler for the Art Institute by Mrs. Eugene A. Davidson (the former Mrs. Suzette Morton Zurcher), 1959; intermittently on loan to Mrs. Davidson, 1959–73.

REFERENCES: Anthony Blunt, "A Bristol, une exposition d'art français du XVIIe siècle," *Beaux-Arts* 75, 38 (1938), p. 3 (ill.). "Accessions of American and Canadian Museums," *Art Quarterly* 22 (1959), pp. 274, 280 (ill.). M. Boris Lossky with J. M. Girard, *Das 17. Jahrhundert in der französischen Malerei*, exh. cat., Bern, Kunstmuseum, 1959, under no. 13. AIC 1961, p. 30. Geraldine Elizabeth Fowle, "The Biblical Paintings of Sébastien Bourdon," Ph.D. diss., University of Michigan, 1970 (Ann Arbor, Mich., University Microfilms, 1970), pp. 113–15, under no. 36, fig. 73. Pierre Rosenberg, *La Peinture française du XVIIe siècle dans les collections américaines*, exh. cat., Paris, Galeries Nationales du Grand Palais, 1982, p. 346, no. 8 (ill.). Sylvain Laveissière in *Le Classicisme français: Masterpieces of Seventeenth-Century Painting*, exh. cat., Dublin, The National Gallery of Ireland, 1985, p. 12, under no. 7. Wright 1985, p. 149. Wright 1991, vol. 1, p. 232, vol. 2, pp. 61, 554. Gilles Chomer with Sylvain Laveissière, *Autour de Poussin*, exh. cat., Paris, Musée du Louvre, 1994, p. 102, under no. 25.

EXHIBITIONS: Bristol Museum and Art Gallery, *French Art, 1600–1800*, 1938, no. 3A. New York World's Fair, *Masterpieces of Art: European and American Paintings, 1500–1900*, 1940, no. 63. New Haven, Yale University Art Gallery, *Pictures Collected by Yale Alumni*, 1956, no. 7.

Sébastien Bourdon has often been unfairly described as a mere eclectic. Though his style is indebted to many painters, Nicolas Poussin among them (see 1930.500),

he possessed a considerable talent and eventually developed a distinctive personal style. Born in Montpellier, he moved at an early age to Paris, where he became a student of the artist Jean Barthélemy. In 1634 he went to Rome, where he came to be influenced not only by the classicism of his compatriots Poussin and Claude Lorrain (see 1941.1020), but by the genre paintings of Pieter van Laer and the *Bamboccianti*. About three years later, he returned to Paris, where, in 1648, he was one of the founders of the French Academy. He later worked at the court of Queen Christina of Sweden (see 1975.582). *Christ Receiving the Children* represents a particularly Poussinesque phase of Bourdon's activity, characterized by classical order, restraint, and rigorously structured compositions.

Recorded in three of the four Gospels (Matthew 19.13–14, Mark 10.13–16, Luke 18.15–17), the story of Christ receiving the children conveys the theme of innocence as a virtue and suggests that even those too young to have developed faith will receive divine grace.

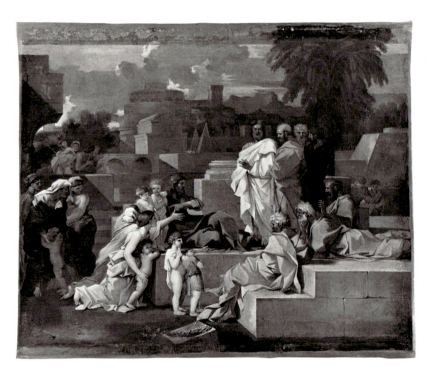

Fig. 1 Sébastien Bourdon, *Christ Receiving the Children*, Musée du Louvre, Paris [photo: © Agence photographique de la Réunion des musées nationaux, Paris]

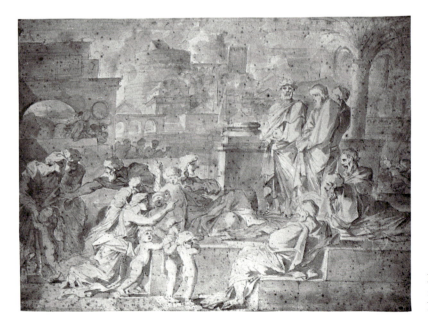

Fig. 2 Sébastien Bourdon, *Christ Receiving the Children*, Ecole nationale supérieure des Beaux-Arts, Paris

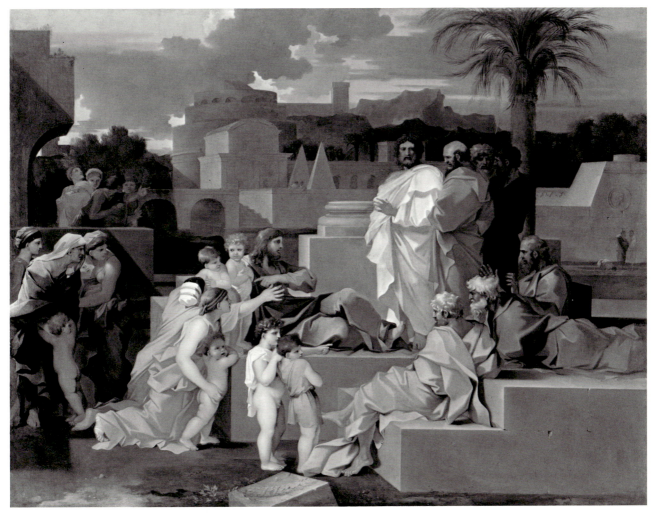

Sébastien Bourdon, *Christ Receiving the Children*, 1959.57

Bourdon's treatment of the subject seems to depend primarily on the passage in Mark:

13 And they brought young children to him, that he should touch them: and his disciples rebuked those that brought them.

14 But when Jesus saw it, he was much displeased, and said unto them, Suffer the little children to come unto me, and forbid them not: for of such is the kingdom of God.

15 Verily I say unto you, Whosoever shall not receive the kingdom of God as a little child, he shall not enter therein.

16 And he took them up in his arms, put his hands upon them, and blessed them.

Within a grand setting, organized by austere antique architecture, the artist placed groups of anxious mothers and children on the left and the disapproving apostles on the right. Joining the two halves of the composition is

Christ, humbly seated with legs outstretched, embracing the children with one arm and gesturing toward them with the other.

Among the works related to the Chicago canvas are a smaller version of the same composition in the Louvre (fig. 1) and a drawing of the subject in the Ecole nationale supérieure des Beaux-Arts in Paris (fig. 2).[9] The sketch has long been regarded as a preparatory study for the Louvre painting, which is undoubtedly the case, but it appears to have been used for the Chicago work as well. Numerous changes and modifications were made between the drawn and painted stages of the composition: in the paintings, the two women at left in the drawing were increased to three; an apostle who prevents the women at left from approaching Christ was eliminated, as was a group of background figures directly above him; the gestures and configuration of the group

surrounding Christ have been reworked; the three standing apostles have become four in the paintings; the entire architectural setting has been simplified, although an ornamented masonry block was added; and the overall movement and sense of urgency seen in the drawing have been tempered. Some details in the drawing appear only in the Louvre painting, such as the two figures in the right background entering the scene from behind a wall. Other elements in the drawing appear only in the Chicago picture, such as the thinly branched palm (a much fuller tree is in the Louvre picture) and the triangular structure (rectangular in the Louvre painting) atop the round building. Thus, it seems that both compositions depend directly on the drawing, and that the Chicago version is not merely a copy of the Louvre painting, as Geraldine Elizabeth Fowle (1970) suggested.

A few other changes in the Chicago composition also indicate that the painting is not a copy. In the Chicago painting there are three distant figures at far right (as opposed to two men in the drawing and Louvre canvas), there are alterations in the architecture (perhaps to accommodate the larger format), and a relief medallion appears on the structure at the right. In addition, Saint James's right hand, clearly present in the drawing, is revealed by *pentimenti* in both the Chicago and Louvre pictures, suggesting that the two versions were produced at the same time. Rather than regarding the small Louvre canvas as a *modello* for the Chicago painting, Sylvain Laveissière persuasively argued that either the two versions were painted for two different clients or Bourdon executed the smaller version for himself.[10]

The Chicago *Christ Receiving the Children* should probably be dated to c. 1655, that is, within a couple of years after Bourdon's return to Paris from Sweden (see 1975.582 below) and before a departure for Montpellier in 1657. By 1655 Bourdon's association with the Academy had recommenced, and he became a *recteur* on July 3 of that year. During this period his style shows the strong influence of Poussin, though it retained many characteristics that are peculiar to Bourdon. In the Chicago painting, the figures are clustered in groups in a Poussinesque architectural landscape. They are confined mainly to two distinct foreground planes, reminiscent of antique friezes. These spatial tiers, emphasized by masonry blocks placed parallel to the picture plane, are repeated throughout the composition. While the geometric framework (surely learned from Poussin) gives a somewhat dry and calculated quality to the scene, it is relieved by the complex rhythm of drapery folds and

outlines rippling across the composition. One finds this sort of multilayered, horizontal, angular composition in other Bourdon canvases of the period, such as the *Massacre of the Innocents* (Worcester Art Museum, Massachusetts) and one of the artist's finest works, *The Finding of Moses* (Washington, D.C., National Gallery of Art).[11]

From Poussin, Bourdon derived not only these compositional principles, but also his palette of strong reds, blues, and golds. In addition, he occasionally borrowed specific figures from the works of that artist. For instance, the woman wearing a banded headdress and kneeling with arms outstretched in the Chicago and Louvre paintings is probably based on the "rightful" mother in Poussin's *Judgment of Solomon* (Louvre) painted for the Parisian banker Pointel in 1649.[12] Bourdon also reused his own figural types, as in the case of the figure of Saint James in the Chicago picture, which is very similar to the figure of Christ in his *Christ and the Centurion* (location unknown).[13]

NOTES

1 The painting was cleaned by Alfred Jakstas in 1965; the present wax resin lining covers the initials *H^DIO* on the back of the original canvas. Jill Whitten cleaned the picture in 1993. The thread count of the original canvas is approximately 14 x 14/sq. cm (36 x 36/sq. in.).

2 This work is described in the sale catalogue as follows: "J. C. recevant les petits enfans; ce Tableau peint sur toile par Sébastien Bourdon, & de son meilleur tems, est clair & brillant; il réunit la beauté de la composition & la noblesse des figures, à l'harmonie de la couleur & à la richesse de l'architecture & du paysage, ce qui le rend digne d'occuper un rang distingué dans les plus grands Cabinets; il porte 36 p. & demi de haut sur 48 de large." (Jesus Christ receiving the little children; this painting on canvas by Sébastien Bourdon, from his best period, is clear and radiant; it joins beauty of composition and nobility of figures with harmony of color and richness of architecture and landscape, which makes it worthy of occupying a distinguished rank in the greatest cabinets; it measures 36 *pouces* and a half in height and 48 in length.) The measurements given, which might refer to the sight size, are equal to 98.7 x 129.8 cm. Price and buyer are listed in an annotated sale catalogue in the Rijksbureau voor Kunsthistorische Documentatie, The Hague.

3 This work is described in the sale catalogue as: "Christ receiving the little Children, surrounded by many Figures, and Buildings in the back ground." Price and buyer are recorded in an annotated sale catalogue at Christie's, London.

4 According to the 1938 exhibition catalogue.

5 According to Fowle 1970, p. 113.

6 According to Knoedler's information sheet on the painting, enclosed with a letter of December 11, 1981, from Katherine Moore (Knoedler) to the author, in curatorial files.

7 According to the 1956 exhibition catalogue.

8 According to a letter from Katherine Moore to the author (see note 6).

9 The Louvre painting measures 50 x 61 cm; the drawing measures 358 x 502 mm. Another work presumably related to the Louvre and Chicago paintings is the *Little Children Presented*

to Our Savior (painting on copper, dimensions unknown), once in the collection of Horace Walpole (sold by George Robins at Strawberry Hill [Twickenham, near London], April 25 and following, 1842, no. 15, as Sébastien Bourdon).
10 Letter of August 21, 1985, from Sylvain Laveissière to the author, in curatorial files. For the view that the Louvre picture is a preliminary version of the Chicago work, see Blunt 1938, p. 3, and Lossky and Girard 1959, p. 13.

11 For illustrations of these two paintings, see Pierre Rosenberg, *France in the Golden Age: Seventeenth-Century French Paintings in American Collections*, exh. cat., New York, The Metropolitan Museum of Art, 1982, p. 348, nos. 4, 2, respectively.
12 Louvre, *Catalogue sommaire*, vol. 4, *Ecole française, L–Z*, p. 142, no. 7277 (ill.).
13 Sold Christie's, London, December 17, 1981, no. 3 (ill.).

Portrait of a Man, c. 1653

Charles H. and Mary F. S. Worcester Collection, 1975.582

Oil on canvas, 104.2 x 88.1 cm (41 1/16 x 34 11/16 in.)

CONDITION: The painting is in very good condition. The finely woven canvas has an old glue paste lining that was consolidated in 1981.[1] The tacking margins have been cut off, but cusping is visible at all four edges, indicating that the painting is close to its original dimensions. The ground is a warm red color. The paint surface has been somewhat flattened by the lining process and the canvas weave is pronounced. The shadows of the sitter's left shirtsleeve are slightly abraded from cleaning. There are a few small localized areas of retouching on the sitter's face, left shoulder (on the cloak), and right shirtsleeve and cuff, and scattered in the upper right background. X-radiography and examination in raking light reveal, beneath the surface image, a shield-shaped form in the area around the head and shoulders of the sitter. The crestlike shape has no apparent relationship to the present image, and may suggest that the canvas was cut from a larger painting. Several *pentimenti* visible in the x-radiograph indicate a change in the folds of the right shirtsleeve and a slight shift in the position of the right eye. (infrared, ultraviolet, x-radiograph)

PROVENANCE: Private collection, England.[2] Heim Gallery, London, 1975. Purchased from Heim by the Art Institute through the Charles H. and Mary F. S. Worcester Endowment, 1975.

REFERENCES: "La Chronique des arts: Principales Acquisitions des musées en 1975," *GBA* 6th ser., 89 (1977), suppl. to no. 1298, p. 49, no. 194 (ill.). Dominique Vasseur, "Portrait of a Man by Sébastien Bourdon," *AIC Bulletin* 71, 3 (1977), pp. 2–5 (ill. and cover ill.). J. Patrice Marandel in *Frédéric Bazille and Early Impressionism*, exh. cat., The Art Institute of Chicago, 1978, p. 12 (ill.). *AIC 100 Masterpieces* 1978, p. 62, no. 24 (ill.). Jean Pierre Cuzin, "Current and Forthcoming Exhibitions: New York, French Seventeenth-Century Paintings from American Collections," *Burl. Mag.* 124 (1982), pp. 529, 530. J. V. Hantz, "La Peinture française du XVIIe siècle dans les collections américaines," *L'Amateur d'art* 680 (1982), p. 20. Claude Lesné, "La Peinture française du XVIIe siècle dans les collections américaines," *Le Petit Journal des grandes expositions* 116 (1982), n. pag. (ill.). Ekkehard Mai, "La Peinture française du

XVIIe siècle dans les collections américaines," *Pantheon* 40 (1982), p. 153. Pierre Rosenberg, "A Golden Century in French Painting," *Connaissance des arts* 25 (February 1982), p. 74. Wright 1985, p. 149. Wright 1991, vol. 1, p. 232, vol. 2, pp. 61, 501.

EXHIBITIONS: The Art Institute of Chicago, *European Portraits, 1600–1900, in The Art Institute of Chicago*, 1978, no. 4. Paris, Galeries Nationales du Grand Palais, *La Peinture française du XVIIe siècle dans les collections américaines*, 1982, no. 10, cat. by Pierre Rosenberg, traveled to New York and Chicago.

Although this painter worked in many genres, he was particularly gifted as a portraitist, as the elegant *Portrait of a Man* attests. Few portraits from Bourdon's early years in Montpellier, Paris, and Rome are known. With the support of André Félibien, in 1652 the artist became the court painter to Queen Christina of Sweden, who commissioned him to make portraits of her important military officers and members of the court; among those Bourdon painted were the Swedish field marshalls active during the Thirty Years' War. Unfortunately, many portraits of the numerous courtiers he painted in Stockholm are lost. The artist's royal appointment lasted just one year; the queen converted to Catholicism and, following other Protestant foreigners, Bourdon left the court in late 1653, some months before the queen abdicated in June 1654. He returned to Paris, working there from 1654 to 1656, and then accepted a commission that took him to Montpellier from 1657 to 1658. During these years Bourdon continued to paint portraits, enjoying a primarily Calvinist clientele in Montpellier, his native city.

A comprehensive chronology of Bourdon's portraits has never been established, and although most of them fall between 1653 and 1658, many are difficult to date precisely.[3] The problems in dating his works are in part due to Bourdon's receptiveness to outside influences. His portraits not only recall those of sixteenth-century Venetian artists with which he became familiar during an Italian sojourn (1634–37),[4] but also are indebted to contemporary Dutch portraits and to the work of Philippe de Champaigne.[5] Above all, Bourdon emulated the portraits of Anthony Van Dyck, some of which he saw in Paris and Stockholm and in engraved reproductions. Van Dyck's portrait style was probably also transmitted to Bourdon through the Dutch artist David Beck, an assistant to Van Dyck in London, and, concurrently with Bourdon, a court painter to Queen Christina.[6]

Several portraits dating from Bourdon's stay in Sweden relate closely in style and pose to the Chicago *Portrait of a Man*, particularly the half-length, Raphael-esque *Queen Christina of Sweden* (fig. 1), the *Portrait of Ebba Sparre* (Washington, D.C., National Gallery of Art), and the *Portrait of Johan Leijoncrona (?)* (fig. 2).[7] The men in these portraits are dressed in the fashionable clothing worn by wealthy and middle-class Swedish professionals and minor nobility in the 1650s. Their costumes consist of short-sleeved black doublets with buttons down the front, exposed billowing sleeves orna-mented in lace and tied at the cuff, and broad shirt collars fastened with linen tassels. The Chicago sitter and Leijoncrona (?) are seen with their natural hair, indicating a date in the early 1650s for both works, since wigs became fashionable for men only late in the decade.[8] The costumes and the stylistic similarities between the Chicago painting and the portraits of Queen Christina, Ebba Sparre, and Leijoncrona (?) from Bourdon's year in Sweden suggest a date of 1653 for the Chicago work as well.

NOTES

1 This treatment was performed by Bruce Stephen, who was an intern at the Art Institute at the time. The thread count of the original canvas is approximately 18 x 18/sq. cm (45 x 45/sq. in.).

2 Letter of January 13, 1981, from Andrew S. Ciechanowiecki (Heim Gallery) to the author, in curatorial files. According to Asbjorn R. Lunde (letter of June 15, 1984, to the author, in cura-torial files), Heim "sold the picture for another dealer."

3 For the chronology of Bourdon's paintings, see Charles Ponsonailhe, *Sébastien Bourdon: Sa Vie et son oeuvre*, Mont-pellier, 1883; Thomas Head Thomas, "Sébastien Bourdon por-traitiste," *GBA* 4th ser., 7 (1912), pp. 5–18; August Hahr, "Deux Nouveaux Portraits de Sébastien Bourdon, retrouvés en Suède," *La Revue de l'art ancien et moderne* 43 (1923), pp. 303–09; Karl Erik Steneberg, *Kristinatidens Måleri*, Malmö, 1955; Geraldine

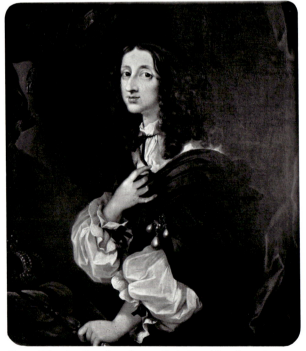

Fig. 1 Sébastien Bourdon, *Queen Christina of Sweden*, private collection, Härige, Sweden [photo: Svenska Porträttarkivet, Nationalmuseum, Stockholm]

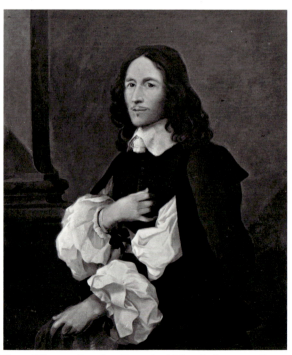

Fig. 2 Sébastien Bourdon, *Portrait of Johan Leijoncrona (?)*, Söderfors Stora Kopparberg, Sweden

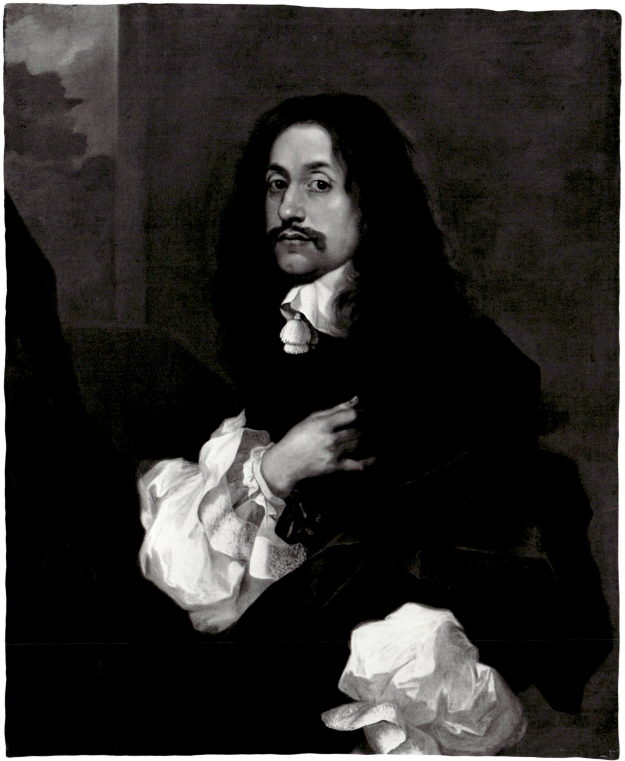

Sébastien Bourdon, *Portait of a Man*, 1975.582

Ph.D. diss., University of Michigan, 1970 (Ann Arbor, Mich., University Microfilms, 1970).

4 Queen Christina also had a large collection of sixteenth-century Venetian paintings that would have been accessible to Bourdon.

5 See Vasseur 1977.

6 Karl Erik Steneberg, "The Portrait Collection of Queen Christina," *Connoisseur* 95 (March 1935), pp. 130–34.

7 For an illustration of the *Portrait of Ebba Sparre*, see Vasseur 1977, fig. 2.

8 According to a letter of September 2, 1985, from Aileen Ribeiro

to the author, in curatorial files. When the Chicago portrait was with the Heim Gallery, the sitter was presumed to be Pierre d'Autheville, seigneur de Montferrier, baron de Vauvert (1612–1663), a friend of Bourdon who commissioned the artist to produce six scenes for tapestries depicting the life of Moses. The identification is unproven; but, as Rosenberg (1982 exhibition catalogue) commented, if the man is in fact the baron de Vauvert, the painting would have been created slightly later than suggested above, and should be dated to c. 1657, which is when the Moses commission was received.

Jean Baptiste Siméon Chardin

1699 Paris 1779

The White Tablecloth, 1731/32

Mr. and Mrs. Lewis Larned Coburn Memorial Collection, 1944.699

Oil on canvas, 96.8 x 123.5 cm (38^{1}/$_{8}$ x 48^{5}/$_{16}$ in.)

CONDITION: The painting is in fair condition. Initially painted as an irregularly shaped firescreen (see fig. 1), the canvas has been altered to fit a rectangular stretcher. The painting was cleaned and inpainted in 1972, when an old glue paste lining was replaced with a wax resin one.[1] The tacking margins have been flattened and incorporated into the surface of the painting, as is apparent from the holes at the edges and the fold lines visible in the x-radiograph. There is a 1.5 cm vertical tear at the center, a 2.5 cm square loss near the top center edge, and two

1 cm losses, in the upper right background and near the center of the bottom edge. The paint layer, applied over an off-white ground, is severely abraded in several areas, especially in the upper background, in the shadows under the table, and in the shadows of the drapery folds and the bread on the table. The surface appears to have lost glazes that once helped to define the volumes of the forms and the background. Due to the lining process, the paint layer has lost some of its original texture. The retouching is confined primarily to the edges, especially

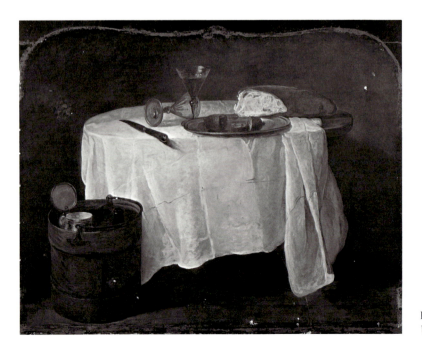

Fig. 1 Mid-treatment photograph of *The White Tablecloth,* 1944.699

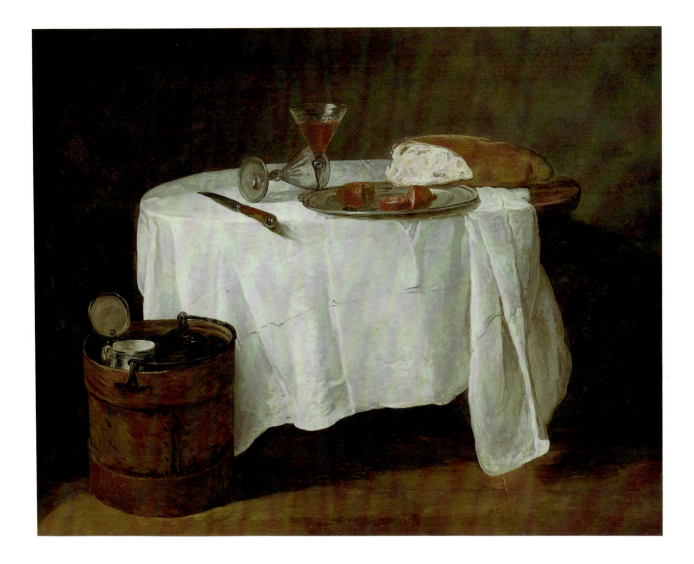

along the top addition, and is scattered in the background and on the bucket at the left. (infrared, mid-treatment, ultraviolet, x-radiograph)

PROVENANCE: Probably Alexandre Gabriel Decamps, Paris; sold Hôtel des Ventes Mobilières, Paris, April 21, 1853, no. 28, as *Nature morte*, for Fr 600.[2] Sold Hôtel des Commissaires-Priseurs, Paris, December 20–21, 1858, no. 40.[3] Laurent Laperlier, Paris, by 1860, to at least 1865.[4] Léon Michel-Lévy, Paris, by 1907;[5] sold Galerie Georges Petit, Paris, June 17–18, 1925, no. 125 (ill.), to Wildenstein, Paris, for Fr 202,000.[6] Sold by Wildenstein to David David-Weill, Paris, 1925/26.[7] Sold by David-Weill to Wildenstein, New York, by 1938.[8] Sold by Wildenstein to the Art Institute, 1944.

REFERENCES: P[ierre] J[ean] Mariette, *Abécédario de P. J. Mariette et autres notes inédites de cet amateur sur les arts et les artistes*, vol. 1, in *Archives de l'art français*, vol. 2, Paris, 1851–53, p. 357. W. Bürger [Théophile Etienne Joseph Thoré], "Exposition de tableaux de l'école française, tirés de collections d'amateurs," pt. 3, *GBA* 1st ser., 8 (1860), p. 234. Théodore Lejeune, *Guide théorique et pratique de l'amateur de tableaux: Etudes sur les imitateurs et les copistes des maîtres de toutes les écoles dont les oeuvres forment la base ordinaire des galeries*, vol. 1, Paris, 1864, p. 440. Charles Blanc, *Histoire des peintres de toutes les écoles*, pt. 3, *Ecole française*, vol. 2, Paris, 1865, Chardin p. 16. Philippe Burty, "Profils d'amateurs, I, Laurent Laperlier," *L'Art* 16 (1879), p. 148. Edmond and Jules de Goncourt, *L'Art du dix-huitième siècle*, 3d ed., vol. 1, Paris, 1880, p. 73. Armand Dayot and Jean Guiffrey, *J.-B. Siméon Chardin*, Paris, [1907], pp. 36–37, no. 351, p. 54, no. 19, pp. 82–83, no. 165. Armand Dayot and Léandre Vaillat, *L'Oeuvre de J.-B.-S. Chardin et de J.-H. Fragonard*, Paris, [1907], p. IX, no. 53 (ill.). Jean Guiffrey, "L'Exposition Chardin-Fragonard," *La Revue de l'art ancien et moderne* 22 (1907), pp. 95 (ill.), 102. Pierre de Nolhac, "Fragonard et Chardin," *Les Arts* 16 (July 1907), pp. 42–43. Maurice Tourneux, "Exposition Chardin et Fragonard," *GBA* 3d ser., 38 (1907), pp. 97–98 (ill.). Jean Guiffrey, *Catalogue raisonné de l'oeuvre peint et dessiné de J.-B. Siméon Chardin*, Paris, 1908, pp. 36–37, no. 351, p. 54, no. 19, pp. 82–83, no. 165. Edmond Pilon, *Chardin*, Paris, [1909], p. 167. Herbert E. A. Furst, *Chardin*, London, [1911], pp. 30, 127. Seymour de Ricci, "Les Ventes," *Beaux-arts* 3, 13 (1925), p. 216, no. 125. Gabriel Henriot, *Collection David-Weill*, vol. 1, *Peintures*, Paris, 1926, pp. 31–33 (ill.). Jean Babelon, review of *Chardin*, by Georges Wildenstein, in *Beaux-Arts*, n. s. 72, 50 (1933), p. 1 (ill.). Georges Wildenstein, *Chardin*, Paris, 1933, p. 235, no. 1057, fig. 159. Alfred M. Frankfurter, "The Dix-Huitième in Full Glory: French Masters in the David-Weill Collection," *Art News* 36, 6 (1937), pp. 13 (ill.), 22. Doris Brian, "Sources of Modern Painting: N.Y. Sees a Notable Show from New England," *Art News* 37, 31 (1939), pp. 10 (ill.), 20. Henry de Courcy May, "The Spirit of the Eighteenth Century," *Art News* 41, 15 (1942), p. 15 (ill.). *Art News* 44, 7 (1945), p. 15 (ill.). Ernst Goldschmidt, *Jean-Baptiste-Siméon Chardin*, Stockholm, 1945, p. 116, fig. 47. Frederick A. Sweet, "The White Tablecloth by Chardin," *AIC Bulletin* 39, 4 (1945), pp. 50–53 (ill., cover ill.). "Recent Important Acquisitions of American Collections—The White Tablecloth by Chardin," *Art Quarterly* 8 (1945), pp. 163–67 (ill.), excerpt from 1945 article by

Sweet (above). Frederic Taubes, "Pictorial Composition," *American Artist* 10 (October 1946), p. 30 (ill.). AIC 1948, pp. 31–32 (ill.). Michel Florisoone, *La Peinture française: Le dix-huitième siècle*, Paris, 1948, pl. 72. Francis Jourdain, *Chardin, 1699–1779*, Paris, [1949], pl. 44. Bernard Denvir, *Chardin*, New York, 1950, pl. 32. AIC 1952, n. pag. (ill.). Aline B. Louchheim, "A New Yorker Visits the Art Institute," *AIC Quarterly* 46 (1952), pp. 23–24 (ill.). Charles Sterling, *La Nature morte de l'antiquité à nos jours*, Paris, 1952, p. 78, pl. 69. G[eorges] de Lastic Saint-Jal, "Des Découvertes à faire les devants de cheminée," *Connaissance des arts* 39 (May 15, 1955), pp. 29, 31 (ill.). AIC [1956], pp. 31–32 (ill.). Stéphane Faniel, ed., *French Art of the Eighteenth Century*, Collection Connaissance des Arts 1, New York, 1957, p. 21 (ill.). James Barrelet, "Chardin du point de vue de la verrerie," *GBA* 6th ser., 53 (1959), pp. 309, 311. Georges Wildenstein, "Le Décor de la vie de Chardin d'après ses tableaux," *GBA* 6th ser., 53 (1959), p. 100, fig. 5. AIC 1961, pp. 75–76, 229 (ill.). Georges Wildenstein, *Chardin*, Zurich, 1963, pp. 149–50, no. 73 (ill.); rev. ed. by Daniel Wildenstein, tr. by Stuart Gilbert, Greenwich, Conn., 1969, p. 157, no. 73, fig. 34. René Huyghe, *La Peinture française des XVIIe et XVIIIe siècles*, Paris, 1965, p. 78 (ill.). Viktor N. Lazarev, *Jean-Baptiste Siméon Chardin*, tr. by Monica Huchel, Dresden, 1966, p. 17, pl. 8. Sacheverell Sitwell, "The Pleasures of the Senses," *Apollo* 87 (February 1968), p. 132. Maxon 1970, p. 262 (ill.). Jean Cailleux, "Three Portraits in Pastel and Their History," *Burl. Mag.* 113 (1971), suppl. p. iii. Hal N. Opperman, *Jean-Baptiste Oudry*, vol. 1, New York and London, 1977, p. 57. Dewey F. Mosby, *Alexandre-Gabriel Decamps, 1803–1860*, vol. 1, New York and London, 1977, pp. 98, 315 n. 57. Gerrit Henry, "New York Reviews: The Object as Subject," *Art News* 74, 5 (1975), p. 92. Michel Faré and Fabrice Faré, *La Vie silencieuse en France: La Nature morte au XVIIIe siècle*, Fribourg and Paris, 1976, pp. 154, 156. Axelle de Gaigneron, "Un Nouveau Regard sur les natures mortes de Chardin," *Connaissance des arts* 323 (January 1979), p. 33. Morse 1979, p. 48. Pierre Rosenberg, *Chardin, 1699–1779*, exh. cat., Paris, Galeries Nationales du Grand Palais, 1979, pp. 10, 194, under no. 54. Miriam Milman, *Les Illusions de la réalité: Le Trompe-l'oeil*, Geneva, 1982, pp. 90 (ill.), 124. Pierre Rosenberg, *L'opera completa di Chardin*, Classici dell'arte 109, Milan, 1983, p. 85, no. 78 (ill.). Philip Conisbee, *Chardin*, London, 1985, pp. 94, 106–07, fig. 88. George Steiner, review of *Chardin*, by Philip Conisbee, in *The New Yorker*, November 17, 1986, p. 146. Wright 1991, vol. 1, p. 434, vol. 2, pp. 62, 677. James Yood, *Feasting: A Celebration of Food in Art*, New York, 1992, p. 12 (detail ill.), no. 10 (ill.).

EXHIBITIONS: Paris, [Galerie Martinet], boulevard des Italiens, *Tableaux et dessins de l'école française principalement du XVIIIe siècle tirés de collections d'amateurs*, 1860, no. 351, as *Le Cervelas*. Paris, Galerie Georges Petit, *Exposition Chardin et Fragonard*, 1907, no. 19, as *La Table servie* (cat. in *L'Art et les artistes*, special issue [June–July 1907]). New York, Wildenstein, *David-Weill Pictures*, [1937], no. 3 (no cat.). New York, Wildenstein (organized by The Institute of Modern Art, Boston), *The Sources of Modern Painting: A Loan Exhibition Assembled from American Public and Private Collections*, 1939, no. 9. New York, Parke-Bernet, *French and English Art*

Treasures of the XVIII Century, 1942, no. 6. The Art Institute of Chicago, *Masterpiece of the Month*, February 1949 (no cat.). New York, Wildenstein, *Jubilee Loan Exhibition 1901–1951: Masterpieces from Museums and Private Collections*, 1951, no. 22. The Minneapolis Institute of Arts, *French Eighteenth-Century Painters*, 1954, no. 7 (no cat.). London, Royal Academy of Arts, *Winter Exhibition, 1968: France in the Eighteenth Century*, 1968, no. 139. New York, Wildenstein, *The Object as Subject: Still Life Paintings from the Seventeenth to the Twentieth Century*, 1975, no. 22. The Art Institute of Chicago, *Selected Works of Eighteenth-Century French Art in the Collections of The Art Institute of Chicago*, 1976, no. 7.

Chardin spent his entire career in Paris, where he became the most accomplished painter of still lifes and genre subjects of his time. He studied first with the history painter Pierre Jacques Cazes and then with Noël Nicolas Coypel before gaining admission in 1728 to the Academy. At the Salons, he regularly exhibited his still lifes and sensitive, intimate portrayals of middle-class domestic life. Though he received few royal commissions, he was highly regarded by critics such as Denis Diderot and enjoyed considerable success until about 1770, when his Dutch-influenced style went out of fashion.

A well-known anecdote, first recorded by Pierre Jean Mariette in 1749, describes an important turning point in Chardin's career and has special relevance for the Chicago painting:

Il [Chardin] continuoit de s'occuper de pareils ouvrages [still lifes], lorsqu'un incident lui fit faire un pas de plus dans la peinture. M. Aved, peintre de portraits, étoit son amy, comme il l'est encore, et ils se voyoient souvent. Un jour, une dame étoit venue trouver M. Aved pour avoir son portrait; elle le vouloit jusqu'aux genoux et elle ne préten-doit en donner que quatre cents livres. Elle sortoit sans avoir conclu son marché, car, quoyque M. Aved ne fut pas alors aussy employé qu'il l'a été depuis, cette offre lui paroissoit de beaucoup trop modique; M. Chardin, au contraire, insistoit pour qu'il ne laissât pas échapper cette occasion, et lui vouloit prouver que quatre cents livres étoit bonnes à gagner pour quelqu'un qui n'étoit encore qu'à demi connu. Ouy, lui dit M. Aved, si un portrait étoit aussy facile à faire qu'un cervelas. C'est que M. Chardin étoit pour lors occupé à peindre un tableau de devant de cheminée, dans lequel il en représentoit un dans un plat.[9]

Because *The White Tablecloth* is Chardin's only known still life with a "saveloy [sausage] on a dish," and was conceived as a firescreen, it is believed to be the painting that occupied Chardin at the time of the Aved incident, a connection first made by Bürger (Thoré) in 1860 and then by the Goncourt brothers in 1880.[10] The exchange between the two artists seems to have had a significant impact on Chardin's career. Prior to Aved's challenge, Chardin's work had consisted, with few exceptions, of still lifes. Apparently moved by the portraitist's remarks, Chardin abandoned still-life painting and made his first representation of the human figure, probably the *Lady Sealing a Letter* (Berlin, Schloss Charlottenburg).[11]

The White Tablecloth has been dated in connection with the Aved episode, which according to Charles Nicolas Cochin occurred in 1737 and according to Haillet de Couronne in "about 1737."[12] Pierre Rosenberg dem-onstrated, however, that the chronologies of the painter's life and work provided by these two Chardin biographers were incorrect.[13] Reading the date on Chardin's *The Water Urn* (Stockholm, Nationalmuseum) as 1733, and assigning its possible companion piece, *The Washer-woman* (Stockholm, Nationalmuseum), as well as the *Lady Sealing a Letter*, to the same year, Rosenberg suggested that, since all of these are figure paintings, 1732 or 1733 were likely dates for the Aved episode.[14] Therefore, *The White Tablecloth*, preceding these figure paintings, must have been executed around 1731 or 1732, relatively early in Chardin's career.

Chardin's early canvases reveal his debt to seventeenth-century Netherlandish still-life painting. Philip Conisbee has pointed to similarities between the Dutch artist Pieter van Boucle's *The Butcher's Table* and *Fruit and Vegetables*, part of the French royal collections in the eighteenth century, and Chardin's *The Ray-Fish* and a slightly later canvas, *The Buffet* (all four pictures are in the Louvre).[15] Chardin assimilated many devices commonly found in Northern still lifes, such as the foreshortened knife with handle protruding over a table edge, the overturned glass, the remains of a meal, and the partially folded tablecloth. All of these motifs are found in the Chicago painting.

The White Tablecloth was, as mentioned, a *devant de cheminée*, that is, a firescreen placed in the opening of a fireplace, normally in the summer. The size and unusual shape of the painting were clearly determined by this function. Unfortunately, the specific fireplace opening it was meant to cover is not known. However, J. Patrice Marandel's proposal (in the 1976 exhibition catalogue) that Chardin painted it for his own dining room is very plausible. The meal the artist has depicted—a modest repast of bread, sausage, and wine, accompanied by simple utensils—is in keeping with Chardin's own then-humble, middle-class existence. Moreover, as

Conisbee (1985) noted, the painting appears to have been rather rapidly executed, with broadly applied brush strokes that are uncommon to Chardin's refined early still lifes intended for sale.

Devants de cheminée had been produced for over a century but became especially popular as decorative *objets d'art* in the eighteenth century, often as splendid exercises in trompe l'oeil.[16] It is likely that the table in the Chicago picture would have been more convincingly illusionistic when framed by the fireplace mantlepiece. A shadow covers the rear half of the table, presumably to create the impression that the table is standing within a darkened, low-positioned alcove. The perspective in the composition (less effective when the canvas is seen at eye level) augments this pictorial deception. Chardin adroitly calculated the perspective of the painting to extend the space of the room and tilted the table so that the viewer, when looking at the screen at its normal floor level, would read the form of the table as recessed into the fireplace.

Notes

1 This treatment was performed by Alfred Jakstas. The thread count of the original canvas is approximately 14 x 13/sq. cm (35 x 32/sq. in.).

2 Philippe Burty, who was familiar with Decamps and his collection, and who began a monograph on that artist the year following his death (see Philippe Burty, "Notes sur Decamps," 4 vols., unpub. MS, Département de documentation des peintures, Louvre), was the first to connect the picture with Decamps (1860 exhibition catalogue). He cited a non-existent 1851 Decamps sale, presumably an error for the 1853 sale. The price paid at the 1853 sale is recorded in an annotated sale catalogue at the Frick Art Reference Library, New York. Between the years 1845 and 1853, the market value of Chardin canvases averaged Fr 200–500 (Lejeune 1864, p. 241).

3 The painting is described in the sale catalogue as follows: "Sur une table recouverte d'une nappe blanche, un déjeuner est servi." (On a table covered with a white tablecloth, a luncheon is spread out.)

4 See Bürger 1860, Lejeune 1864, and Blanc 1865. Laperlier wrote from Algiers to his friend Thomas Couture, and said of the Chardin painting he had left behind in France: "ce qui domine c'est une nappe blanche si admirable que je ne la changerais pour celle de Léonard dans sa fresque de la scène . . . c'est un peu Rembrand." (The dominant element is a white tablecloth so admirable that I would not exchange it with that of Leonardo in the fresco of *The Last Supper* . . . it is a little Rembrandt.) Letter

from Laperlier to Couture of March 8, 1873, preserved in the Musée National du Château de Compiègne, Oise (copy in curatorial files).

5 Lent by him to the 1907 Paris exhibition.

6 According to de Ricci 1925.

7 Letter of December 11, 1987, from Joseph Baillio (Wildenstein) to the author, in curatorial files.

8 Ibid.

9 Pierre Jean Mariette, MS, 1749, Cabinet des estampes, Bibliothèque Nationale, Paris; published in Mariette 1851–53: "He [Chardin] was continuing to work on similar compositions [still lifes] when an incident occurred which caused him to advance one more step in painting. M. Aved, a portrait painter, was his friend, as he still is, and they saw one another often. One day a lady had come looking for M. Aved to have him do her portrait; she wanted it to extend as far as the knees and insisted she could give only 400 *livres* for it. She left without having struck a deal, for, although M. Aved was not then as busy as he has been since, her offer seemed to him much too modest; M. Chardin, on the contrary, urged him not to let this opportunity pass, and tried to convince him that 400 *livres* was a good price for someone who was not yet widely known. 'You'd be right,' answered M. Aved, 'if a portrait were as easy to do as a saveloy [sausage].' He said that because at the time M. Chardin was painting a work for a firescreen in which he was depicting a saveloy on a dish." English translation from Rosenberg 1979 (English ed.), p. 194. An account of this incident, based on an essay by Charles Nicolas Cochin (see note 12), also appeared in Haillet de Couronne, "Eloge de M. Chardin [1780]," in *Mémoires inédits sur la vie et les ouvrages des membres de l'Académie royale de peinture et de sculpture*, vol. 2, Paris, 1854, p. 436.

10 The painting has frequently been cited with the following titles: *Le Cervelas, La Table servie, La Nappe blanche, Déjeuner servie*, and so on. Mosby (1977) declared this still life a copy, an opinion he later reversed (letter to the author of May 9, 1986, in curatorial files).

11 Not all scholars agree that this was Chardin's first figural painting. See Rosenberg 1979, pp. 193–95, no. 54 (ill.), pp. 198–200, no. 56, pp. 205–07, no. 59.

12 Charles Nicolas Cochin, "Essai sur la vie de Chardin," 1780, published in André Pascal [Henri James Nathaniel Charles, baron de Rothschild] and Roger Gaucheron, *Documents sur la vie et l'oeuvre de Chardin*, Paris, 1931, p. 8; for Haillet de Couronne, see note 9.

13 See Rosenberg 1979, pp. 193–200, nos. 54–56. See also Pierre Rosenberg, *Chardin: New Thoughts*, The Franklin D. Murphy Lectures 1, Lawrence, Kansas, 1983, p. 30.

14 For *The Water Urn* and *The Washerwoman*, see Rosenberg 1979, pp. 195–98, no. 55 (ill.), pp. 197–200, no. 56 (ill.), respectively. The date on *The Water Urn* had previously been read as 1735.

15 Conisbee 1985, pp. 69–70. For illustrations of these works, see ibid., figs. 62, 63, and Wildenstein 1963, pls. 4, 5, respectively.

16 See Lastic Saint-Jal 1955, pp. 26–31.

Claude Gellée, called Claude Lorrain

1600 or 1604/05 Chamagne–Rome 1682

View of Delphi with a Procession, 1673

Robert A. Waller Memorial Fund, 1941.1020

Oil on canvas, 101.6 x 127 cm (40 x 50 in.)

INSCRIBED: *CLAVDIO[. . .]* (lower right, barely legible)

CONDITION: The painting is in fair condition. The twill-weave canvas has an old glue paste lining.[1] The tacking margins have been cut off, and cusping is visible at the bottom edge. The lining canvas extends 0.3 cm beyond the original support on all sides. There is a 2.5 cm diagonal tear at the upper right corner in the sky. The paint surface has undergone considerable change due to severe blanching, which affects more than fifty percent of the image, including the landscape at left and the foreground figures. The dark red ground is visible through cracks in the paint surface and on the perimeter. The paint layer is somewhat flattened and the canvas weave has become pronounced due to the lining process. There are traction cracks in the foliage along the right edge. The surface is somewhat abraded due to past cleaning, and the damage is particularly notable in the foreground figures. There are several areas of loss: a large loss (12.5 x 6.5 cm) in the paint and ground layers in the sky at upper right; a smaller loss (1.5 x 1.0 cm) in the lower sky near the horizon line; a long, narrow loss (9 x 2 cm) at the upper left corner; and minor losses along the bottom edge. Retouching covers the filled losses in the sky, in the architecture at upper left, and in the bull in the central foreground. X-radiography indicates that there may have been some changes in the contour of the landscape at upper left, which appears fuller and rounder on the surface of the painting. (x-radiograph)

PROVENANCE: Commissioned by Cardinal Carlo Camillo Massimi (d. 1676), Rome, 1673;[2] at his death to his younger brother, Fabio Camillo Massimi.[3] Possibly John Drummond, first earl of Melfort, London, by c. 1690; possibly sold White-hall, London, June 21, 1693.[4] Humphrey Edwin, by 1746; probably sold by his widow, c. 1750.[5] Edward Geoffrey Smith Stanley (d. 1869), fourteenth earl of Derby, from at least 1854;[6] by descent to Edward George Villiers, seventeenth earl of Derby; sold Christie's, London, July 26, 1940, no. 9, to (Max?) Rothschild for £126, as *Priests Proceeding with a Sacrificial Bull towards a Fortified City.*[7] Arnold Seligmann, Rey, and Co., New York. Purchased from Seligmann, Rey, and Co. by the Art Institute through the Robert Alexander Waller Memorial Fund, 1941.

REFERENCES: John Smith, *A Catalogue Raisonné of the Works of the Most Eminent Dutch, Flemish, and French Painters . . . ,* vol. 8, London, 1837, p. 293, under no. 178, p. 295, no. 182. Owen J. Dullea, *Claude Gellée Le Lorrain,* New York, 1887, p. 81. Tancred Borenius, "A *Liber Veritatis* Claude," *Burl. Mag.* 77 (1940), p. 195 (frontispiece ill.). "In the Auction Rooms," *Connoisseur* 106 (October 1940), p. 176. "Sale Notes," *Apollo*

32 (October 1940), p. 108. Anthony Blunt, *The French Drawings in the Collection of His Majesty the King at Windsor Castle,* Oxford and London, 1945, p. 22, under no. 47. Marcel Röthlisberger, "Les Pendants dans l'oeuvre de Claude Lorrain," *GBA* 6th ser., 51 (1958), p. 225. Marcel Röthlisberger, "The Subjects of Claude Lorrain's Paintings," *GBA* 6th ser., 55 (1960), p. 221. AIC 1961, pp. 172, 230 (ill.). Francis Haskell, *Patrons and Painters: A Study in the Relations between Italian Art and Society in the Age of the Baroque,* London, 1963, p. 118, pl. 19b. Marcel Röthlisberger, "Claude's 'View of Delphi,'" *AIC Museum Studies* 1 (1966), pp. 85–95, fig. 1. Linda Lee Boyer, "The Origin of Coral by Claude Lorrain," *Metropolitan Museum of Art Bulletin* 26 (1968), p. 372. Marcel Röthlisberger, *Claude Lorrain: The Drawings,* vol. 1, Berkeley and Los Angeles, 1968, pp. 389–90, under nos. 1057–59. I[an] G. Kennedy, "Claude and Architecture," *Journal of the Warburg and Courtauld Institutes* (1972), pp. 265–66, pl. 42b (detail ill.). Marcel Röthlisberger and Doretta Cecchi, *L'opera completa di Claude Lorrain,* Classici dell'arte 83, Milan, 1975, pp. 121–22, no. 258 (ill.). Denis Coekelberghs, *Les Peintres belges à Rome de 1700 à 1830,* Brussels and Rome, 1976, pp. 110–11, fig. 83 bis. Jean Devaux, *Les Trésors de l'art classique,* Geneva, 1978, p. 175, pl. XXVII B (in reverse). Michael Kitson, *Claude Lorrain: Liber Veritatis,* London, 1978, p. 166, under no. 182. *AIC 100 Masterpieces* 1978, pl. 26 (in reverse); 2d ed., 1983, pl. 26. Morse 1979, p. 52. Marcel Röthlisberger, *Claude Lorrain: The Paintings,* vol. 1, New York, 1979, pp. 20, 240–41, under LV 86, pp. 428–31, LV 182, p. 434, under LV 184, vol. 2, fig. 296. J. V. Hantz, "La Peinture française du XVIIᵉ siècle dans les collections américaines," *L'Amateur d'art* 680 (1982), p. 20. Nicole Lamothe, "Les Caravagesques français," *L'Amateur d'art* 680 (1982), p. 15 (ill.). Claude Lesné, "La Peinture française du XVIIᵉ siècle dans les collections américaines," *Le Petit Journal des grandes expositions* 116 (1982), n. pag. Ekkehard Mai, "La Peinture française du XVIIIᵉ siècle dans les collections américaines," *Pantheon* 40 (1982), p. 153. Pierre Rosenberg and Marc Fumaroli, "La mostra del mese: L'arte s'impara a Roma," *Bolaffiarte* 12, 116 (1982), p. 24. H. Diane Russell in *Claude Lorrain, 1600–1682,* exh. cat., Washington, D.C., National Gallery of Art, 1982–83, pp. 63, 162, 166, under no. P39, pp. 188–89, no. P50, p. 285, under no. D68, p. 286, under no. D69, p. 294, under no. D73, p. 459. Marcel Röthlisberger, *Im Licht von Claude Lorrain: Landschafts-malerei aus drei Jahrhunderten,* exh. cat., Munich, Haus der Kunst, 1983, p. 140, under no. 78, pp. 224–25, under no. 149, p. 258, under no. 178, p. 287. Marcel Röthlisberger, "Claude Lorrain: Some New Perspectives," in *Claude Lorrain, 1600–1682: A Symposium,* Studies in the History of Art 14, Washington, D.C., 1984, p. 48. Marcel Roethlisberger, "A Panoramic View by Claude Lorrain," *AIC Museum Studies* 11 (1985), p. 114 n. 6. Wright 1985, p. 160. Marcel Röthlisberger, "Claude Lorrain: Nouveaux Dessins, tableaux, et lettres,"

Bulletin de la Société de l'histoire de l'art français, année 1986 (1988), p. 50. Marc Sandoz, "Essai sur le paysage de montagne dans la peinture française du XVIIᵉ siècle," *Cahiers du paysage de montagne et de quelques sujets relatifs à la montagne 1* (1987), p. 50, fig. 67. Carlo del Bravo, "Letture di Poussin e Claude," *Artibus et Historiae* 18 (1988), pp. 162, 167 n. 124. Helen Langdon, *Claude Lorrain*, Oxford, 1989, pp. 142, 144, fig. 110. Colin Eisler, *Paintings in the Hermitage*, New York, 1990, p. 36. Margaretha Rossholm Lagerlöf, *Ideal Landscape: Annibale Carracci, Nicolas Poussin, and Claude Lorrain*, New Haven and London, 1990, pp. 91–92, fig. 71. Marcel Röthlisberger, "More Drawings by Claude Lorrain," *Master Drawings* 28 (1990), p. 424 n. 25. Wright 1991, vol. 1, p. 234, vol. 2, pp. 62, 562. Humphrey Wine, *Claude: The Poetic Landscape*, exh. cat., London, The National Gallery, 1994, p. 92. Rosemary Maclean, "'O Gran Principe, O Gran Prelato': Claude's Roman Patrons and the Appeal of His Landscape Easel Paintings," *GBA* 6th ser., 126 (1995), p. 228, fig. 6, pp. 230, 233 nn. 23, 26.

EXHIBITIONS: London, British Institution, *Pictures by Italian, Spanish, Flemish, Dutch, French, and English Masters . . .*, 1854, no. 49, as *Temple at Delphi*. Nottingham, Midland Counties Art Museum, *Pictures and Objects in the Midland Counties Art Museum*, 1878, no. 91, as *Landscape*. New York, Wildenstein, *Gods and Heroes: Baroque Images of Antiquity*, 1968–69, no. 9, as *Landscape with Sacrificial Procession*. Paris, Galeries Nationales du Grand Palais, *La Peinture française du XVIIᵉ siècle dans les collections américaines*, 1982, no. 62, cat. by Pierre Rosenberg, traveled to New York and Chicago. Washington, D.C., National Gallery of Art, *Claude Lorrain, 1600–1682*, 1982–83, no. P50, cat. by H. Diane Russell, traveled to Paris.

During the late seventeenth century, Claude Lorrain was among the most celebrated and sought-after artists in Europe. Although born in the Duchy of Lorraine (hence Claude Lorrain), he spent most of his life in Rome, where he distinguished himself as a landscape painter. Influenced by Italian artists and by other Northern European painters in Rome, including his fellow countryman Nicolas Poussin, Claude developed an idealized, idyllic vision of the Roman *campagna*, into which he often introduced scenes from ancient history and mythology. While his sole royal commission came from Philip IV of Spain, Claude enjoyed an illustrious clientele, largely French and Roman, which included members of the high clergy and aristocracy as well as other prominent collectors.

View of Delphi with a Procession (LV [*Liber Veritatis*] 182) was commissioned by Cardinal Carlo Camillo Massimi (1620–1676), a learned antiquarian who was a major figure in Roman society, then dominated by a group of highly cultivated intellectuals. Over the years, Massimi, a quarter of whose collection comprised landscapes, ordered at least four paintings from Claude. In the 1640s, he commissioned *Landscape with Argus Guarding Io* (1644/45; LV 86; The Earl of Leicester and The Trustees of the Holkham Estate) and its probable pendant, *Coast View with Apollo and the Cumaean Sibyl* (1646/47; LV 99; St. Petersburg, Hermitage), and,

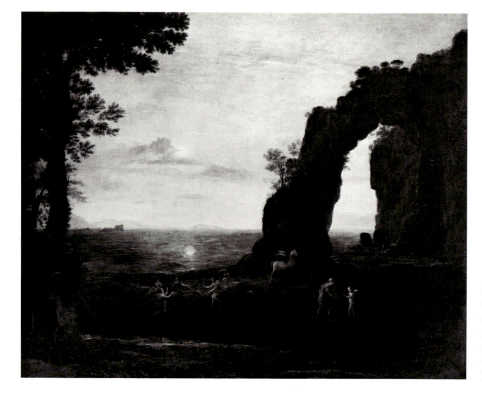

Fig. 1 Claude Lorrain, *Coast View with Perseus and the Origin of Coral*, The Earl of Leicester and the Trustees of the Holkham Estate [photo: Courtauld Institute of Art, London]

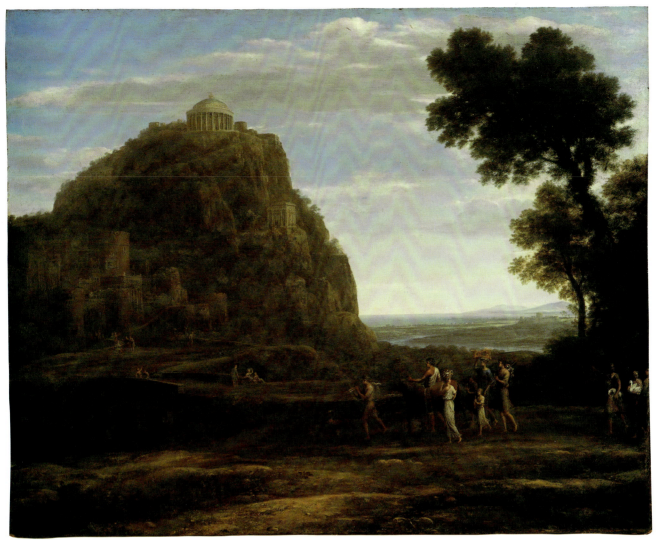

Claude Gellée, called Claude Lorrain, *View of Delphi with a Procession*, 1941.1020

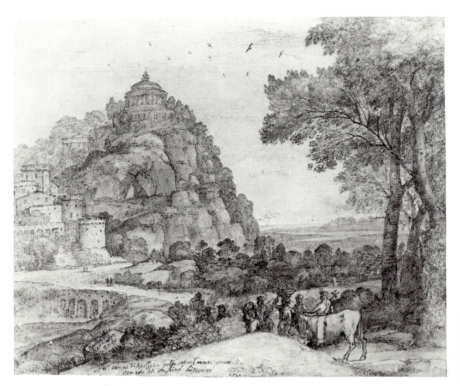

Fig. 2 Claude Lorrain, preparatory drawing for *View of Delphi with a Procession*, The Royal Collection [photo: © Her Majesty Queen Elizabeth II]

nearly thirty years later, he engaged the artist to paint *View of Delphi with a Procession* and its probable pendant, *Coast View with Perseus and the Origin of Coral* (fig. 1; LV 184).[8] He commissioned the first two paintings while in the service of Pope Innocent X. Following a lengthy period of political disfavor (1658–70), Massimi was elevated to cardinal in 1670 when his relative Emilio Altieri was elected Pope Clement X.[9] Soon thereafter, the Chicago painting and its pendant were ordered from Claude; the *View of Delphi with a Procession* was completed in 1673, and the *Coast View with Perseus and the Origin of Coral* in the following year.

Claude very often conceived scenes as pendants, which he used as a means to explore contrasting subjects and times of day, such as coast or harbor views with inland landscapes, or morning with evening scenes.[10] *View of Delphi with a Procession*, in which the landscape is revealed by a cool, indirect light, was intended to hang to the left of *Coast View with Perseus and the Origin of Coral*, which seems to be set at sunrise. When the two paintings are viewed together, the horizon is continuous and rock masses — at the left in *View of Delphi with a Procession* and at the right in *Coast View with Perseus and the Origin of Coral* — frame the compositions. These monumental forms are balanced within each composition by tall, leafy trees. Despite this carefully conceived interplay, it is possible that each of the pictures was intended to function also as a pendant to one of the

earlier two paintings — that is, the *View of Delphi with a Procession* may have been coupled with *Landscape with Argus Guarding Io*, and *Coast View with Apollo and the Cumaean Sibyl* may have been joined with *Coast View with Perseus and the Origin of Coral*. Because of the similar dimensions, compositional compatibility, and like moods of the four paintings, Röthlisberger speculated that Massimi intended to mix these two sets of pictures when he ordered the second pair.[11] This hypothesis is supported by an inventory taken at Massimi's death, which listed only *Coast View with Apollo and the Cumaean Sibyl* and *Coast View with Perseus and the Origin of Coral* among the possessions in his Roman residence.[12]

Most of Claude's known early landscapes were coast views with pastoral scenes. By the mid-1640s, the artist had begun to introduce literary, biblical, and mythological subjects into his landscapes. Three of the four Massimi pendants illustrate passages from Ovid's *Metamorphoses*, while *View of Delphi with a Procession* follows a historical text.[13] As suggested by Röthlisberger, the rarefied subjects of the *View of Delphi with a Procession* and *Coast View with Perseus and the Origin of Coral* probably indicate the involvement of the refined and erudite Massimi, whose broad knowledge of ancient culture is suggested by his art collection and his important library.[14] The Chicago canvas is Claude's only known painting based on the historical writings

of Marcus Justinus, and though he often treated Ovidian scenes, he painted the story of Perseus and the origin of coral only once.[15] It is difficult to determine the thematic connection between the two pendants, but one may assume that for Massimi there was a significant association—perhaps even biographical or linked to his lineage.[16]

Claude painted Delphi, the ancient Greek religious center located in Phocis, twice. The first painting, which dates from 1648/50 and is now in the Galleria Doria-Pamphili in Rome, was commissioned by Prince Camillo Pamphili (1622–1665), nephew of Pope Innocent X.[17] Röthlisberger (1966) suspected that Massimi proposed the subject for the Chicago canvas because he knew of the earlier *View of Delphi* owned by Camillo Pamphili, a rival patron of Claude. The earlier depiction of Delphi, a place Claude had never seen, would seem to be largely the product of the artist's imagination. However, a literary source for the later painting is specified in Claude's

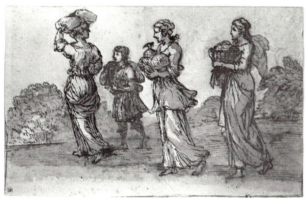

Fig. 3 Claude Lorrain, *Three Women and a Boy*, Musée Bonnat, Bayonne

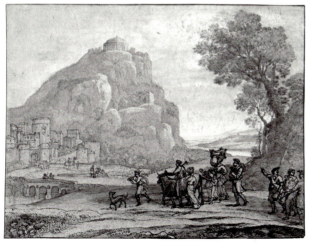

Fig. 4 Claude Lorrain, *View of Delphi with a Procession*, from the *Liber Veritatis*, no. 182, British Museum, London [photo: © British Museum, London]

inscription on a preparatory drawing at Windsor Castle (fig. 2): *il tempio di Apollo in delfo sopra l'monte parnaso / cavata da giustino historico.*[18] It was probably in the third century that Justinus wrote his Latin epitome of the *Historiae Philippicae* by Pompeius Trogus, a principal source on antiquity for scholars and artists of the sixteenth and seventeenth centuries. *View of Delphi with a Procession* seems to illustrate the following passage from Justinus (24.6):

> The temple of Apollo at Delphi is situate [sic] on Mount Parnassus, on a rock steep on all sides. A concourse of people, who, collecting from the parts around, through veneration for the majesty of the god, settled on the rock, formed a city there. Thus, not walls, but precipices, not defences formed by the hand, but by nature, protect the temple and the city; so that it is utterly uncertain whether the strength of the place, or the influence of the deity residing in it, attracts more admiration. The central part of the rock falls back in the shape of an amphitheatre; and, in consequence, if ever shouts are raised, or if the noise of trumpets is mingled with them, the sound, from the rocks echoing and re-echoing to one another, is heard many times repeated, and louder than it was made at first. This effect, on those who are ignorant of its cause, and are struck with wonder at it, produces a greater awe of the power of the god. In the winding of the rock, about half way up the hill, there is a small plain, and in it a deep fissure in the ground, which is open for giving oracles; for a cold exhalation, driven upwards by some force, as it were by a wind, produces in the minds of the priestesses a certain madness, and compels them, filled with the influence of the god, to give answers to such as consult them. Hence many rich presents of kings and nations are to be seen there, which, by their magnificence, testify the grateful feelings of those that have paid their vows, and their belief in the oracles given by the deity.[19]

Claude normally made detailed preparatory drawings for his late paintings, and two are known for the Chicago work. The Windsor drawing, which is an elaborate study of the whole composition, may have been the *modello* submitted to Massimi for approval. A sketch in the Musée Bonnat in Bayonne (fig. 3) is related to the four figures behind the bull.[20] In the Windsor sheet and in the *Liber Veritatis* drawing of 1673 (fig. 4),[21] the *ricordo* executed upon the painting's completion, one can observe both Claude's fidelity to Justinus's text and the evolution from the sketch to the finished composition. A comparison of the two drawings reveals that the foreground, procession, verdure, and the city were all changed between the preparatory sketch and the painting, possibly to suit the patron's taste. Such details from

the text as the architectural aspect of the rocks and the small plain in front of a "deep fissure" are clearly decipherable in the drawings though no longer discernible in the painting, due to its condition.[22] Although Justinus does not describe a sacrificial procession, its presence in the painting could be inferred from the last line of text quoted above.

While many of the landscape elements in the present painting were developed by Claude in earlier works, others reflect his knowledge of outside sources. The procession, temple, and road over the bridge all appear in his earlier, Pamphili *View of Delphi*,[23] and other processions (such as those present in Roman reliefs and Renaissance descriptions) are depicted in his *Landscape with the Father of Psyche Sacrificing at the Milesian Temple of Apollo* of 1663 and *Landscape with Bacchus at the Palace of the Dead Staphylus* of 1672.[24] Whereas the temple in the Pamphili canvas is based on Italian Renaissance structures, the temple in the Chicago painting seems to depend not only on those but on antique models as well. Ian Kennedy has suggested that it derives specifically from the temple of Jupiter Feretrius on the Capitol, an engraving of which was published in the *Roma Vetus ac Recens . . .* of 1635 by Alexandro Donato.[25] Kennedy (1972) also noted Claude's increasing tendency to classicize the architecture in his paintings.[26] As Röthlisberger (1966) has pointed out, certain landscape elements in the Chicago work, particularly the monumental rocks, seem to have been influenced by Polidoro da Caravaggio's fresco *Landscape with the Magdalen* (c. 1527; Rome, San Silvestro al Quirinale), copied by Claude in drawings, and Annibale Carracci's Aldobrandini *Landscape with the Entombment of Christ* (c. 1604; Rome, Galleria Doria-Pamphili).[27]

Typical of Claude's late works, the deep recession of the Chicago landscape is revealed by a clear, even light. This illumination, the result of his lifelong study of the light of the Roman *campagna*, binds the compositional elements, creating a continuity of space and a calm, ethereal ambiance. Also characteristic of the late paintings is Claude's elongation of the figures, whose actions seem implied rather than explicit, and whose presence blends into the fabric of the landscape. It is perhaps the harmonious marriage of subject and landscape that constitutes the most distinguishing aspect of Claude's late works. Röthlisberger has observed that "the mature works of Claude are, above all, a function of the subject represented in the figures. The story is the primary element; the landscape, its exact equivalent."[28]

NOTES

1 The thread count of the original canvas is approximately 22 x 11/sq. cm (55 x 30/sq. in.). There are two layers of linen lining canvas behind the original.

2 According to the inscription that accompanies the drawing after the painting (fig. 4) in the *Liber Veritatis* (no. 182), the book of drawn copies Claude made after his paintings for protection against forgeries (see Kitson 1978). Claude inscribed on the recto: *CLAVDIO fecit IV / Roma 1673*, and, on the verso: *quadro facto per lemin^mo e Reve.^ro / sig^re Cardinale Massimo / A Roma 1673* and *Claud fecit / IV*. (Kitson 1978, p. 166, no. 182).

3 Röthlisberger 1979, vol. 1, p. 240, under LV 86.

4 The Chicago picture is probably one of four paintings that could be hung as pendants in various combinations (see discussion below). All four works were in English collections by 1746/47. Röthlisberger (1979, vol. 1, pp. 239–41, under LV 86, pp. 428–31, LV 182) suggested that the earl of Melfort had bought the paintings while he was in Rome, between 1689 and 1691. Many of Melfort's possessions were seized in 1691 and then sold on June 21, 1693; see *DNB*, vol. 6, under "Drummond, John." A 1693 supplement to the 1692 Melfort inventory lists "a landskip of Glaude Loraneze with a white cow in it and a Temple" (see *Calendar of Treasury Books, January 1693 to March 1696, Preserved in the Public Record Office*, vol. 10, pt. 1, London, 1935, p. 248). If this refers to *Landscape with Argus Guarding Io* (see note 8), one of the four probable pendants, then it is possible that Melfort also owned the other three. However, Coekelberghs (1976) noted that Hendrick Frans Van Lint, called Studio, often borrowed from Claude's compositions, and several figures in Studio's *Bull Led to Sacrifice* (Turin, Galleria Sabauda) seem to be based on the Chicago painting (for an illustration of the Turin painting, see Coekelberghs 1976, fig. 83). Coekelberghs consequently concluded that either they were copied from a now-lost work by Claude, or the *View of Delphi with a Procession* was still in Rome sometime between the beginning of the eighteenth century (when Van Lint arrived there) and 1726 (when he painted his *Bull Led to Sacrifice*). If the latter is correct, then the Melfort provenance is doubtful.

5 According to Röthlisberger 1979, vol. 1, p. 430, under LV 182.

6 The painting was lent by the earl of Derby to the 1854 London exhibition.

7 Price and buyer are recorded in an annotated catalogue of the Derby sale preserved at Christie's, London.

8 The four paintings are all roughly the same size. For *Landscape with Argus Guarding Io* (102 x 127 cm), see Röthlisberger 1979, vol. 1, pp. 239–41, LV 86, vol. 2, fig. 164. For *Coast View with Apollo and the Cumaean Sibyl* (99 x 136.5 cm), see ibid., vol. 1, pp. 261–62, LV 99, vol. 2, fig. 180. For *Coast View with Perseus and the Origin of Coral* (100 x 127 cm; fig. 1), see ibid., vol. 1, pp. 433–36, LV 184. Massimi may have ordered a fifth painting, *View of La Crescenza* (1648/49; LV 118; New York, The Metropolitan Museum of Art); see Russell, 1982–83 exhibition catalogue, pp. 161–62, no. P38 (ill.).

9 In the 1640s, Massimi also commissioned pendants from Poussin: *Moses Trampling on Pharoah's Crown* and *Moses Changing Aaron's Rod into a Serpent* (1645/46), both in the Louvre. See Anthony Blunt, *The Paintings of Nicolas Poussin: A Critical Catalogue*, London, 1966, pp. 14–15, no. 15 (ill.), p. 17, no. 19 (ill.).

10 See Röthlisberger 1958, pp. 215–28, on the subject of pendants.

11 Röthlisberger 1979, vol. 1, pp. 428–31, LV 182.

12 Ibid., p. 430. For the 1677 inventory of Massimi's collection, see J[ohannes] A[lbertus] F[ranciscus] Orbaan, *Documenti sul barocco in Roma*, Rome, 1920, p. 519. Presumably the other two (*View of Delphi with a Procession* and *Landscape with Argus Guarding Io*) were among the contents of another of Massimi's residences.

13 For the *Landscape with Argus Guarding Io*, the *Coast View with Apollo and the Cumaean Sibyl*, and the *Coast View with Perseus and the Origin of Coral*, see Ovid, *Metamorphoses* (1.664–67, 14.132–53, and 4.740–49, respectively).

14 For the working relationship between Claude and his patrons, see Marcel Röthlisberger, "Les Dessins de Claude Lorrain à sujets rares," *GBA* 6th ser., 59 (1962), pp. 153–64. For additional information on Massimi, see Russell, 1982–83 exhibition catalogue, p. 459.

15 Ovid, *Metamorphoses* (4.740–49). According to Ovid, Perseus, carrying the head of Medusa as a protective talisman, slew a sea monster in order to rescue the beautiful Andromeda. Freeing his hands to cleanse them of the monster's blood, Perseus placed Medusa's head on some seaweed. The blood that flowed from her head onto the seaweed immediately hardened into coral. Sea nymphs who saw this added more seaweed and the coral spread. Claude depicted the nymphs surrounding the head, Perseus's winged horse Pegasus, and a putto pouring water over Perseus's hands. For more information on the *Coast View with Perseus and the Origin of Coral*, see Boyer 1968, pp. 370–79.

16 On Claude's subjects and the interpretation of them, see Röthlisberger 1960, pp. 209–24, and Russell, 1982–83 exhibition catalogue, pp. 81–96. It is noteworthy that Massimi also owned a drawing of the Perseus story by his friend Poussin, from whom he had learned to draw. The sheet is now in Windsor Castle; see Anthony Blunt, "The Massimi Collection of Poussin Drawings in the Royal Library at Windsor Castle," *Master Drawings* 24 (1976), no. 23 (ill.). Konrad Oberhuber has suggested that the Windsor drawing is a copy after a lost original; see Konrad Oberhuber, *Poussin, the Early Years in Rome: The Origins of French Classicism*, exh. cat., Fort Worth, Kimbell Art Museum, 1988, no. D190.

17 Röthlisberger 1979, vol. 1, pp. 293–97, LV 119, vol. 2, fig. 207.

18 "The temple of Apollo on top of Mount Parnassus / contained in Justinus historian." This preparatory drawing also bears the inscription *Claudio ivf. / Roma. 1672 / roma*. See Röthlisberger 1968, vol. 1, p. 389, no. 1057. F. C. Lewis made a colored engraving after the drawing, which was published in John Chamber-

laine, *Original Designs of the Most Celebrated Masters of the Bolognese, Roman, Florentine, and Venetian Schools . . . in His Majesty's Collection . . .* , London, 1812, pl. 50.

19 *Justin, Cornelius Nepos, and Eutropius*, tr. by John Selby Watson, London, 1853, pp. 195–96. See also *Justini in historias trogi pompeii epitomarum*, new ed., Strassburg, 1662, Book XXIV, Chapter 6.

20 For this drawing, entitled *Three Women and a Boy* (fig. 3), see Röthlisberger 1968, vol. 1, pp. 389–90, no. 1059. On the verso of the sheet is a study for the *Coast View with Perseus and the Origin of Coral* (Röthlisberger 1968, vol. 1, pp. 389–90, no. 1059, vol. 2, fig. 1059V), the pendant to the Chicago painting. It is also possible that the Bayonne drawing was preparatory for Claude's *Landscape with Bacchus at the Palace of the Dead Staphylus* (1672) in the Pallavicini collection, Rome (Röthlisberger 1979, vol. 1, pp. 418–20, LV 178, vol. 2, fig. 291).

21 See notes 18 and 2 above.

22 See Condition above and Martin Wyld, John Mills, and Joyce Plesters, "Some Observations on Blanching (with Special Reference to the Paintings of Claude)," *National Gallery Technical Bulletin* 4 (1980), pp. 49–63.

23 See note 17 above.

24 See Röthlisberger 1979, vol. 1, pp. 369–73, LV 157, vol. 2, fig. 259; and note 19 above.

25 See Kennedy 1972, pl. 42e, and Alexandri Donati, *Roma vetus ac recens utriusque aedificiis ad eruditam cognitionem expositis auctore Alexandro Donato . . .* , 2d ed., Rome, 1648, fold-out page between pp. 108–09 (first published in 1635).

26 Kennedy observed that the architecture of Claude's city in the Chicago painting includes "a triumphal arch (of Constantine?), a round tower decorated with a plaque like the tomb of Cecilia Metella, and a ruined circular temple," and that the temple located on the plain in the mountainside "with its outer walls divided up by pilasters into three bays, is of a type which recurs in other [of Claude's] paintings and drawings."

27 For illustrations of these works, see Röthlisberger 1966, figs. 6, 9.

28 Marcel Röthlisberger, "New Light on Claude," *Connoisseur* 145 (March 1960), p. 58.

Jacques Louis David

1748 Paris–Brussels 1825

Madame François Buron, 1769

Restricted gift of Mrs. Albert J. Beveridge in memory of her mother, Abby Louise Spencer (Mrs. Augustus Eddy), 1963.205

Oil on canvas, 66.3 x 55.5 cm (26⅛ x 21⅞ in.)

INSCRIBED: *J. L. David 1769* (at right, above sitter's shoulder)

CONDITION: The painting is in very good condition. When it was cleaned in 1963, an old glue paste lining was removed and replaced with a wax resin one.[1] The tacking margins have been cut off, but cusping visible at all four edges suggests that the canvas is close to its original dimensions. The lining canvas extends 0.75 cm beyond the original support on all sides. The

impasto of the paint layer is slightly flattened due to the lining process; the thickly painted surface is otherwise generally well preserved. The painting has been selectively cleaned, leaving a natural resin varnish over the background. The grayish white ground is visible through cracks in the paint surface. There is a slight abrasion along the sitter's jaw line and in her left eyebrow near the nose. There is a 2.5 cm vertical tear in the upper right background. Additionally, there are two small losses to the ground and paint layers, near the center of the top edge (1 x 1 cm), and in the dress ruffle at lower right (1 x 1.3 cm). The losses have been filled and inpainted, and there is localized retouching over the abrasions on the sitter's jaw and eyebrow,

on the right side of her face under the fingers, along the left edge, at the lower left corner, and over several cracks in the upper left background. The signature and date have been reinforced. X-radiography indicates that the artist may have made some changes in the contour of the sitter's right hand. (infrared, ultraviolet, x-radiograph)

PROVENANCE: Possibly in the sitter's possession.[2] Possibly by descent to her daughter, Marie Françoise Buron, who married François Charles Seigneur. Possibly by descent to their daughter, Alexandrine Marie Louise, who married Charles François Baudry. Possibly by descent to their son, A. Baudry, and his wife (both d. 1903), by 1879. Possibly at their deaths to Mme Baudry's brother, M. Dussault (or Dussaud), and his wife.[3] Probably by descent to M. Regnault, a family member, Paris, until 1925; offered for sale, Hôtel Drouot, Paris, June 22, 1905, no. 2 (ill.), bought in.[4] Wildenstein, New York, probably by 1925.[5] Sold by Wildenstein to the Art Institute, 1963.

REFERENCES: E[dme] F[rançois] A[ntoine] M[arie] Miel, "David," *Le Plutarque français, vies des hommes et femmes illustres de la France, avec leurs portraits en pied*, vol. 7, Paris, 1840, p. 3. J. L. Jules David, *Le Peintre Louis David, 1748–1825: Souvenirs et documents inédits*, Paris, 1880, pp. 7, 631. Paul Marmottan, *L'Ecole française de peinture (1789–1830)*, Paris, 1886, p. 368. Charles Saunier, *Louis David*, Paris, [1903], p. 12. "La Chronique des arts et de la curiosité," *GBA* 3d ser., 33 (1905), suppl. no. 24, p. 200. Prosper Dorbec, "David portrait-iste," *GBA* 3d ser., 37 (1907), pp. 308–09 (ill.). N. Péreire, in "Séance du 3 mai 1907," *Bulletin de la Société de l'histoire de l'art français, année 1907* (1907), pp. 49–50. Camille Gronkowski, "*David et ses élèves* at the Petit Palais—I," *Burl. Mag.* 23 (1913), p. 78. Léon Rosenthal, "L'Exposition de David et de ses élèves au Petit Palais," *La Revue de l'art ancien et moderne* 33 (January–June 1913), p. 338. Charles Saunier, "David et son école au Palais des Beaux-Arts de la Ville de Paris," *GBA* 4th ser., 9 (1913), p. 273. Robert de la Sizeranne, "A L'Exposition David: L'Instinct et l'intelligence chez l'artiste," *Revue des deux mondes* 15 (1913), p. 90. Gabriel Henriot, *Collection David-Weill*, Paris, 1926, vol. 1, *Peintures*, p. 59. Richard Cantinelli, *Jacques-Louis David, 1748–1825*, Paris and Brussels, 1930, p. 8, no. 3. Klaus Holma, *David: Son Evolution et son style*, Paris, 1940, pp. 21, 111 n. 5, 125, no. 2. Jorge Romero Brest, *Jacques Louis David*, Buenos Aires, 1943, p. 11. Douglas Cooper, "Jacques-Louis David: A Bi-Centenary Exhibition," *Burl. Mag.* 90 (1948), p. 277. David Lloyd Dowd, *Pageant-Master of the Republic: Jacques-Louis David and the French Revolution*, University of Nebraska Studies, Lincoln, 1948, p. 7, pl. III. Philippe Huisman, "Au Musée de l'Orangerie: J.-L. David, 1748–1825," *Arts* 172 (June 25, 1948), p. 8 (ill.). Wildenstein and Company, *French XVIIIth-Century Paintings*, New York, 1948, n. pag. (ill.). Louis Hautecoeur, *Louis David*, Paris, 1954, pp. 24–25, 286. "Accessions of American and Canadian Museums, April–June, 1963," *Art Quarterly* 26 (1963), pp. 358 (ill.), 363. "La Chronique des arts," *GBA* 6th ser., 63 (1964), suppl. to no. 1141, p. 61, fig. 207. Jacques Wilhelm, "David et ses portraits," *Art de France* 4 (1964), p. 163. John Maxon, "Some Recent Acquisitions," *Apollo* 84 (September 1966), p. 221, pl. VIII. John Maxon, "J. L. David's Portrait of the Marquise de Pastoret," *Art News* 66, 7 (1967), p. 46, fig. 6.

Maxon 1970, p. 262 (ill.). J[ohn] M[axon], "Mrs. Morton's Bequest," *AIC Calendar* 64, 1 (1970), n. pag. René Verbraeken, *Jacques-Louis David jugé par ses contemporains et par la postérité*, Paris, 1973, pp. 23, 106, 248. Morse 1979, p. 96. Anita Brookner, *Jacques-Louis David*, London, 1980, pp. 42–43, 169, fig. 5. Antoine Schnapper, *David: Témoin de son temps*, Fribourg, 1980, pp. 27–29, fig. 7. Hans Körner and Friedrich Piel, "'A Mon Ami A. Quatremère de Quincy': Ein unbekanntes Werk Jacques-Louis Davids aus dem Jahre 1779," *Pantheon* 43 (1985), p. 93, fig. 8. Luc de Nanteuil, *Jacques-Louis David*, New York, 1985, p. 11, fig. 6. Antoine Schnapper in *1770–1830: Autour du néo-classicisme en Belgique*, exh. cat., Musée Communal des Beaux-Arts d'Ixelles, 1985–86, p. 28. Lorenz Eitner, *An Outline of 19th-Century European Painting: From David through Cézanne*, vol. 1, New York, 1987, pp. 17–18. Philippe Bordes, *David*, Paris, 1988, p. 8 (ill.). Régis Michel and Marie Catherine Sahut, *David: L'Art et la politique*, Paris, 1988, p. 12 (ill.). Jean Jacques Lévêque, *La Vie et l'oeuvre de Jacques-Louis David*, Paris, 1989, pp. 20, 22 (ill.). John McEwen, "Paint and Politics," *Country Life* 183, 47 (1989), p. 66. Bernard Noël, *L. David*, New York, 1989, p. 93. Antoine Schnapper in *David*, special issue of *Connaissance des arts* (1989), p. 8, fig. 2. "La Chronique des arts: Musées, monuments historiques, expositions," *GBA* 6th ser., 132 (1990), suppl. to no. 1453, p. 1, fig. 1. Barbara Scott, "Letter from Paris: David's Portaits," *Apollo* 131 (February 1990), p. 115, fig. 1. Paul Spencer-Longhurst, "State of the Art David," *Apollo* 131 (February 1990), p. 106. Maxine Schur, *The Reading Woman: A Journal*, Rohnert Park, Calif., 1991, p. 87 (ill.). Wright 1991, vol. 1, p. 437, vol. 2, p. 62.

EXHIBITIONS: Palais des Beaux-Arts de la Ville de Paris (Petit Palais), *David et ses élèves*, 1913, no. 2. New York, Wildenstein, *Fashion in Headdress, 1450–1943*, 1943, no. 53. The Toledo Museum of Art, *The Spirit of Modern France: An Essay on Painting in Society, 1745–1946*, 1946–47, no. 10, traveled to Toronto. London, Tate Gallery, *David, 1748–1825*, 1948, no. 1, cat. by Michel Floorisoone, traveled to Manchester. New York, Wildenstein, *French Painting of the Eighteenth Century*, 1948, no. 8. Paris, Musée de l'Orangerie, *David: Exposition en l'honneur du deuxième centenaire de sa naissance*, 1948, no. M.O.1, cat. by Michel Floorisoone. New Orleans, Isaac Delgado Museum of Art, *Masterpieces of French Painting through Five Centuries, 1400–1900*, 1953–54, no. 50. The Toledo Museum of Art, *The Age of Louis XV: French Painting, 1710–1774*, 1975–76, no. 24, cat. by Pierre Rosenberg, traveled to Chicago and Ottawa. The Art Institute of Chicago, *Selected Works of Eighteenth-Century French Art in the Collections of The Art Institute of Chicago*, 1976, no. 16. Paris, Musée du Louvre, and Versailles, Musée National du Château, *Jacques-Louis David, 1748–1825*, 1989–90, cat. by Antoine Schnapper, Arlette Serullaz, et al., no. 3.

An activist during the French Revolution, Jacques Louis David became its most powerful artistic spokesman and, afterward, First Painter to Napoleon Bonaparte. Although his early student works were painted in the then-prevalent rococo manner, David, following the

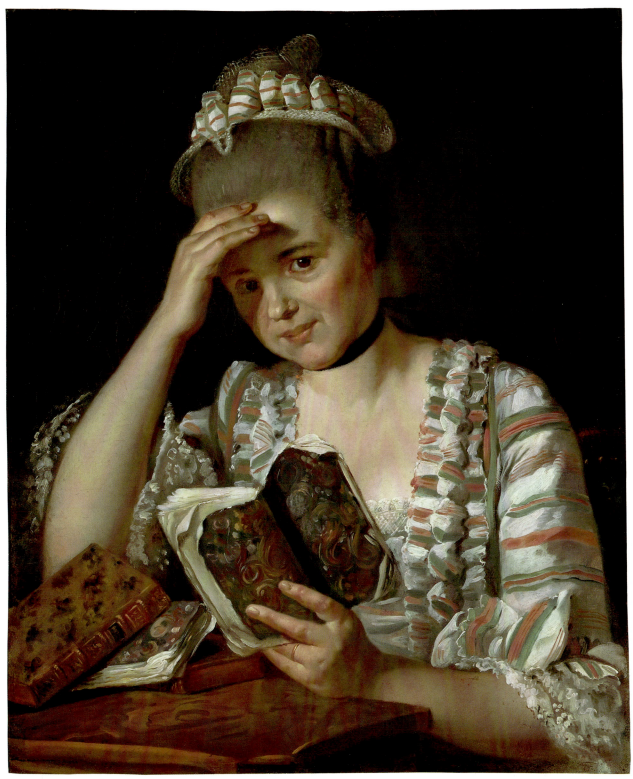

Jacques Louis David, *Madame François Buron*, 1963.205

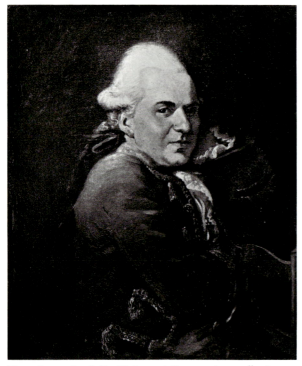

Fig. 1 Jacques Louis David, *François Buron*, private collection [photo: sale catalogue, Hôtel Drouot, Paris, April 23, 1909, no. 27]

example of his teacher, Joseph Marie Vien, and inspired by what he saw during an extended stay in Rome (1775–80), came to fashion an austere neoclassical style of painting. In 1783 he was admitted to the Academy and in the next year began — and traveled to Rome to complete — his *Oath of the Horatii* (Louvre), a contemporary Republican manifesto invested in a subject from Roman history and presented in a severe classicizing manner. David subsequently produced a number of paintings, in the 1780s and early 1790s, of similar, Spartan simplicity and political force, such as the *Death of Socrates* (1787; New York, The Metropolitan Museum of Art) and the *Death of Marat* (1793; Brussels, Musées Royaux des Beaux-Arts/Koninklijke Musea voor Schone Kunsten). This heroic style also lent itself, later, to the propaganda needs of Napoleon, whose imperial intentions were announced and reign glorified in grand paintings by David (e.g., *Napoleon at Saint-Bernard* [1801; Rueil-Malmaison, Musée National du Château de Malmaison], and *Coronation of Napoleon and Josephine* [1805–07; Louvre]). Although at times distracted by his political activities — for which he was arrested and imprisoned for several months in 1794 — he maintained throughout his career a practice as a portraitist. His works ranged from the intimate and informal to the classically restrained. In 1815, David —

like other accused regicides who were allied with Napoleon — was banished from France. He settled in Brussels in 1816, where he assembled a group of pupils and continued painting to the very end of his life.

Significant for David's early life and work was the support of the guardians who cared for him. After his father's death by duel in 1757, David moved to the house of his maternal uncle, the architect François Buron, who encouraged him to undertake an architectural career.[6] Unable to dissuade David from becoming a painter, in late 1764 Buron introduced him to the aging François Boucher, who acted as an advisor to the young man while he received primary training from Vien at the Academy. In 1767 David took up residence with Mme Desmaisons, a maternal aunt, and her husband, Jacques François, an architect. Two years later, in 1769, David moved again, settling with the family of his godfather, Michel Jean Sedaine, a comic dramatist and librettist.

Among his early works are a few portraits of his first adopted family. *Madame François Buron* depicts his aunt Mme François Buron (Marie Josèphe Fromont), born around 1732 and still living in 1821. David also painted portraits of François Buron (fig. 1)[7] and of his cousin, Marie Françoise Buron (Algiers, Musée National des Beaux-Arts).[8] These precocious works attest to the sensitivity and freshness of David's early approach, qual-

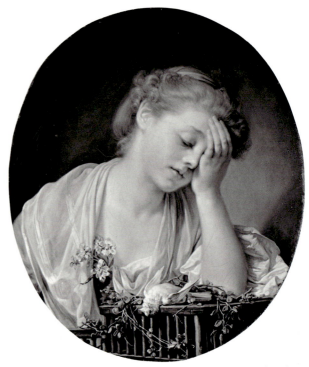

Fig. 2 Jean Baptiste Greuze, *Girl Weeping over Her Dead Bird*, The National Gallery of Scotland, Edinburgh

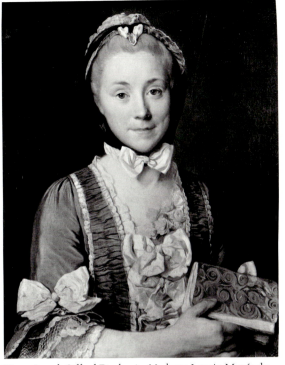

Fig. 3 Joseph Siffred Duplessis, *Madame Lenoir*, Musée du Louvre, Paris [photo: Agence photographique de la Réunion des musées nationaux, Paris]

Girl Weeping over Her Dead Bird (fig. 2), an immensely popular work the young David surely knew from the Salon of 1765 and from Jean Jacques Flipart's widely circulated engraving after it. As Brookner noted, the pose and style of the Chicago picture also seem to depend on Joseph Siffred Duplessis's *Madame Lenoir* (fig. 3), a painting that was enthusiastically received at the Salon of 1769. In that portrait, Mme Lenoir similarly holds a book with marbled binding, her arm establishing a strong horizontal across the base of the composition as she gazes directly at the viewer. David's adaptation of this image appears more casual and spontaneous, as he depicts his aunt with her elbow resting on a pile of books and at the moment her reading is interrupted. It is a simple statement, quiet, thoughtful, and without flattery. Mme Buron is depicted with tenderness, indicative of the affection the artist had for this woman who gave him essential sympathetic support. According to David's own testimony, it was she who interceded on his behalf when his family wanted the determined painter to become an architect.[9]

ities that would often be repressed in his more severe, later works and in his official portraits.

The engaging portrait of Mme Buron and that of M. Buron were executed in 1769, when David was just twenty or twenty-one years old. Both portraits, in their awkwardness, betray the hand of an inexperienced artist. The arms of M. Buron are rendered in an ungainly fashion, and the handling of his wig and clothing, as well as the modeling of his face, are somewhat coarse. Although *Madame François Buron* is superior in quality to its pendant, its draftsmanship is somewhat faulty, particularly in the unclear perspective of the table and in the untenable arrangement of the books. Anita Brookner (1980) has pointed out that the pose of Mme Buron is indebted to that of the sitter in Jean Baptiste Greuze's

NOTES
1 The treatment was performed by Alfred Jakstas. The thread count of the original canvas is approximately 14 x 12/sq. cm (35 x 30/sq. in.).
2 See Schnapper, 1989–90 exhibition catalogue, p. 44, under no. 2. Péreire (1907) claimed that David gave a number of paintings, among them *Madame François Buron*, to the Baudry family, who saw him during his exile.
3 See the 1948 London exhibition catalogue and Péreire 1907.
4 A price of Fr 8,500 paid at the 1905 sale is indicated in "La Chronique des arts . . ." 1905, but the painting must have been bought in, since Regnault lent the painting to the 1913 exhibition.
5 Wildenstein (1948) recorded that the painting had been in the Regnault collection until 1925. The gallery's records do not specifically state, however, that the gallery purchased the painting from Regnault in that year.
6 Daniel Wildenstein and Guy Wildenstein, *Documents complémentaires au catalogue de l'oeuvre de Louis David*, Paris, 1973, p. 4, no. 13.
7 The portrait, signed and dated (on the chair) *L. David / 1769*, remained with *Madame François Buron* through the Regnault sale in 1905. This sitter is often erroneously identified as Jacques Buron.
8 Illustrated in the 1989–90 exhibition catalogue, p. 46, no. 4.
9 Wildenstein and Wildenstein (note 6), pp. 155–58, no. 1368.

Madame de Pastoret and Her Son, mid-1791/mid-1792

Clyde M. Carr Fund and Major Acquisitions Endowment, 1967.228

Oil on canvas, 129.8 x 96.6 cm (51⅛ x 38 in.)

CONDITION: The painting is in very good condition. The picture is unfinished and the mottled quality of the image is indicative of the manner in which the artist laid in the composition. The painting was surface cleaned and revarnished in 1967, and local consolidation and retouching were done in 1989.[1] The finely woven canvas has an old glue paste lining.[2] X-radiography reveals that the canvas is approximately 1.5 cm smaller on all sides than the present stretcher, and that remnants of the tacking margins have been incorporated into the surface of the painting. The off-white ground is visible through the thinly painted surface. The sitter's skirt and the back of her chair are visible as *pentimenti* through the cradle and the child's head, indicating that the latter were added in the course of the work. There are a few small areas of localized retouching in the upper left background, on the contour of the sitter's left wrist, on the left side of the sitter's face, particularly on the shadow of her nose, lips, cheek, and chin, and in an area 1 cm in diameter on the center of her skirt. The entire perimeter has been overpainted to integrate the tacking edge. (infrared, ultraviolet, x-radiograph)

PROVENANCE: Possession of the artist; inventoried on February 27, 1826, at the apartment of his son Eugène, rue Cadet no. 11, Paris; sold in David's atelier sale, rue du Gros-Chenet no. 4, Paris, April 17, 1826, no. 16, for Fr 400, to Révile, acting on behalf of Emmanuel de Pastoret.[3] Claude Emmanuel Joseph Pierre, marquis de Pastoret (d. 1840), Château de Fleury-Meudon, Seine-et-Oise; by descent to his granddaughter, Marie de Pastoret (d. 1890), who in 1835 married Hervé de Rougé, marquis du Plessis-Bellière; sold Hôtel Drouot, Paris, May 10–11, 1897, no. 21, for Fr 17,900, to Chéramy.[4] Paul Alfred Chéramy, Paris; sold Galerie Georges Petit, Paris, May 5–7, 1908, no. 44 (ill.), for Fr 41,000, to Georges Petit, Paris, probably acting on behalf of Murat.[5] Comtesse Joachim Murat (née Thérèse Bianchi; d. 1940), Paris, by 1909;[6] at her death to her sister, vicomtesse Fleury (née Renée Bianchi; d. 1948); at her death to vicomte Fleury.[7] Sold by the vicomte Fleury to Wildenstein, New York, c. 1965.[8] Purchased from Wildenstein by the Art Institute through the Clyde M. Carr Fund and the Major Acquisitions Fund, 1967.

REFERENCES: A. Mahul, *Annuaire nécrologique, ou complément annuel et continuation de toutes les biographies, ou dictionnaires historiques . . . , année 1825*, Paris, December 1826, p. 141. P[ierre] A[lexandre] Coupin, *Essai sur J. L. David, peintre d'histoire, ancien membre de l'Institut, officier de la Légion-d'Honneur*, Paris, 1827, p. 55. Alexandre Lenoir, "David: Souvenirs historiques," *Journal de l'Institut historique* 3 (November 1835), p. 9. Jean du Seigneur, "Appendice à la notice de P. Chaussard sur L. David (1)," *Revue universelle des arts* 18 (1864), p. 367. Charles Blanc, *Histoire des peintres de toutes les écoles*, pt. 3, *Ecole française*, vol. 2, Paris, 1865, David p. 15. J. L. Jules David, *Le Peintre Louis David, 1748–1825: Souvenirs*

et documents inédits, Paris, 1880, p. 644. *Château de Moreuil: Collections*, Abbeville, 1884, pp. 169–70, no. 223. Spire Blondel, *L'Art pendant la révolution: Beaux-Arts, arts décoratifs*, Paris, [1887], p. 55. Emile Delignières, *Notice sur des tableaux de Louis David et d'Ingres au Château de Moreuil en Picardie*, Paris, 1890, pp. 7–9, ill. opp. p. 7; also published in *Réunion des Sociétés des Beaux-Arts des départements* 14 (1890), pp. 491–93, pl. XIX. "La Chronique des arts et de la curiosité," *GBA* 3d ser., 17 (1897), suppl. no. 20, p. 186. Charles Saunier, "La 'Mort de Sénèque' par Louis David," *GBA* 3d ser., 33 (1905), p. 236. Louis Vauxcelles, "La Collection Chéramy," *L'Art et les artistes* 1 (1905), ill. opp. p. 124. Prosper Dorbec, "David portraitiste," *GBA* 3d ser., 37 (1907), pp. 314, 327 (ill.), 329. Louis Rouart, "La Collection de M. Chéramy," *Les Arts* 6 (April 1907), p. 17 (cover ill.). Gilbert Stenger, *La Société française pendant le consulat*, 5th ser., *Les Beaux-Arts—La Gastronomie*, Paris, 1907, pp. 88, 103. *American Art News* 6, 31 (1908), p. 7. "La Chronique des arts et de la curiosité," *GBA* 3d. ser., 39 (1908), suppl. no. 19, p. 187. J[ulius] Meier-Graefe and E[rich] Klossowski, *La Collection Chéramy: Catalogue raisonné précédé d'études sur les maîtres principaux de la collection*, Munich, 1908, p. 70, no. 75 (ill.). "Sales —Art in France," *Burl. Mag.* 13 (1908), p. 180. Léon Rosenthal, "Exposition de portraits de femmes à Bagatelle," *GBA* 4th ser., 2 (1909), p. 52. Baron Roger Portalis, *Henry-Pierre Danloux: Peintre de portraits, et son journal durant l'émigration (1753–1809)*, Paris, 1910, p. 24. Gustav Pauli, "David im Petit Palais," *Kunst und Künstler* 11 (1913), pp. 542 (ill.), 546. Léon Rosenthal, "L'Exposition de David et ses élèves au Petit Palais," *La Revue de l'art ancien et moderne* 33 (January–June 1913), p. 342. Charles Saunier, "David et son école au Palais des Beaux-Arts de la Ville de Paris (Petit Palais)," *GBA* 4th ser., 9 (1913), pp. 274, 277. Robert de la Sizeranne, "A L'Exposition David: L'Instinct et l'intelligence chez l'artiste," *Revue des deux mondes* 15 (1913), pp. 90–91. Louis Réau in *Histoire de l'art depuis les premiers temps chrétiens jusqu'à nos jours*, vol. 8, Paris, 1925, pt. 1, p. 92. Richard Cantinelli, *Jacques-Louis David, 1748–1825*, Paris and Brussels, 1930, p. 118, no. 193, pl. LVI. Klaus Holma, *David: Son Evolution et son style*, Paris, 1940, pp. 65, 130, no. 206. Jorge Romero Brest, *Jacques Louis David*, Buenos Aires, 1943, p. 20. Jacques Maret, *David*, Monaco, 1943, p. 118, pl. 71. Louis Hautecoeur, *L'Art sous la révolution et l'empire en France, 1789–1815*, Paris, 1953, p. 84. Louis Hautecoeur, *Louis David*, Paris, 1954, pp. 105–06, 107, 187, 281. "La Chronique des arts," *GBA* 6th ser., 70 (1967), suppl. to no. 1187, p. 4, fig. 4. John Maxon, "J. L. David's Portrait of the Marquise de Pastoret," *Art News* 66, 7 (1967), pp. 44–46 (ill.). "Accessions of American and Canadian Museums, July–September, 1967," *Art Quarterly* 31 (1968), pp. 94, 101 (ill.). "La Chronique des arts," *GBA* 6th ser., 71 (1968), suppl. to no. 1189, fig. 266. John Maxon, "A David Portrait for Chicago," *Apollo* 87 (January 1968), p. 65, fig. 1. Fernande Bassan, *Politique et haute société à l'époque romantique: La Famille Pastoret d'après sa correspondance (1788 à 1856)*, Paris, 1969, p. 22, pl. IVb. Pierre Angrand and Hans Naef, "Ingres et la famille de Pastoret, correspondance inédite," pt. 1, *Bulletin du Musée Ingres* 27 (July 1970), pp. 9–11 (ill.). Maxon 1970, pp. 65–66 (ill.). J[ohn] M[axon], "Mrs. Morton's Bequest," *AIC Calendar* 64, 1 (1970), n. pag. C[harles] C. C[unningham],

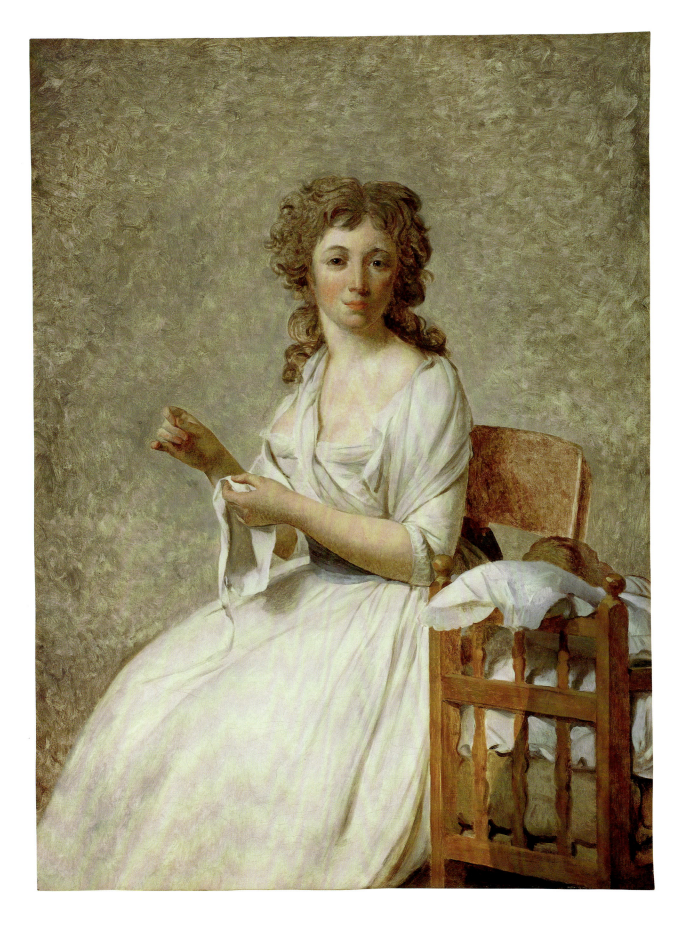

"Ingres—Portrait of the Marquis de Pastoret," *AIC Calendar* 66, 3 (1972), p. 4 (ill.). Michel Laclotte and Arlette Sérullaz in *The Age of Neo-Classicism*, exh. cat., London, Royal Academy of Arts and Victoria and Albert Museum, 1972, pp. LXX and 44, under no. 66. René Verbraeken, *Jacques-Louis David jugé par ses contemporains et par la postérité*, Paris, 1973, pp. 102, 248, fig. 47. Daniel Wildenstein and Guy Wildenstein, *Documents complémentaires au catalogue de l'oeuvre de Louis David*, Paris, 1973, p. 238, no. 2042 (80), 244, no. 2062 (16), 274, no. 2420. Pierre Rosenberg, "De David à Delacroix: La Peinture française de 1774 à 1830," *La Revue du Louvre* 24, 6 (1974), p. 443. Jean Cailleux, "La Grande Peinture de 1774 à 1830: Le Portrait," *Art et curiosité* 55 (January–February 1975), p. 22, fig. 14. Charles McCorquodale, "From David to Delacroix," *Art International* 19, 6 (1975), p. 26. Arlette Calvet-Sérullaz, "David," *Le Larousse des grands peintres*, Paris, 1976, p. 89. *AIC 100 Masterpieces* 1978, pl. 35. Antoine Schnapper, "David revisité," *Commentaire* 1 (1978), pp. 397–98. Morse 1979, p. 96. Anita Brookner, *Jacques-Louis David*, London, 1980, pp. 100, 105, 109, 144, 169, fig. 57. Antoine Schnapper, *David: Témoin de son temps*, Fribourg, 1980, pp. 127–28, 151, fig. 71. Régis Michel in *David et Rome*, exh. cat., Académie de France à Rome, 1981–82, p. 175. Matthias Bleyl, *Das klassizistische Porträt: Gestaltungsanalyse am Beispiel J.-L. Davids*, Frankfurt am Main and Bern, 1982, pp. 131–34, no. 2, figs. 20–22. Philippe Bordes, *Le Serment du Jeu de Paume de Jacques-Louis David: Le Peintre, son milieu et son temps de 1789 à 1792*, Paris, 1983, pp. 23, 96 n. 52. Michael Wilson, "A New Acquisition for the National Gallery: David's Portrait of Jacobus Blauw," *Burl. Mag.* 126 (1984), p. 698. Anthony M. Clark, *Pompeo Batoni: A Complete Catalogue of His Works with an Introductory Text*, ed. by Edgar Peters Bowron, Oxford, 1985, p. 363, under no. 456. Luc de Nanteuil, *Jacques-Louis David*, New York, 1985, pp. 25, 56, 108, pl. 19. Antoine Schnapper in *1770–1830: Autour du néo-classicisme en Belgique*, exh. cat., Musée Communal des Beaux-Arts d'Ixelles, 1985–86, p. 33. Lorenz Eitner, *An Outline of 19th-Century European Painting: From David through Cézanne*, vol. 1, New York, 1987, p. 23. John Leighton in *Jacques-Louis David: Portrait of Jacobus Blauw*, exh. cat., London, The National Gallery, 1987, pp. 9, 11. Jean Jacques Lévêque, *L'Art et la révolution française: 1789–1804*, Neuchâtel, Switzerland, 1987, p. 184 (ill.). Jérémie Benoit, "Temps historique et temps artistique durant la révolution," in *Les Images de la révolution française*, ed. by Michel Vovelle, Actes du Colloque des 25–26–27 Oct. 1985, Paris, 1988, p. 83. Régis Michel and Marie Catherine Sahut, *David: L'Art et le politique*, Paris, 1988, pp. 76 (ill.), 113. Aileen Ribeiro, *Fashion in the French Revolution*, London, 1988, fig. 45. Germain Bazin, "Eloge de David," *L'Oeil* 411 (1989), fig. 7. Alain Jouffroy, *Aimer David*, Paris, 1989, pp. 104–05. Jean Jacques Lévêque, *La Vie et l'oeuvre de Jacques-Louis David*, Paris, 1989, pp. 66–67 (ill.), 86. John McEwen, "Paint and Politics," *Country Life* 183, 47 (1989), pp. 66, 68. Bernard Noël, *L. David*, New York, 1989, pp. 42 (ill.), 44, 93. Warren Roberts, *Jacques-Louis David, Revolutionary Artist: Art, Politics, and the French Revolution*, Chapel Hill and London, 1989, pp. 57–58, fig. 23. Antoine Schnapper in *David*, special issue of *Connaissance des arts* (1989), p. 22, fig. 15. Antoine Schnapper and Arlette Sérullaz, "Jacques-Louis David (1748–1825)," *La Revue du Louvre* 39, 4 (1989), p. 210. Colin Bailey, "David in Paris—Classicism's Most Compelling Defender," *Art International* 11 (summer 1990), p. 98 (ill.). José Augusto França, "David," *Colóquio* 85 (June 1990), p. 42. Denis Milhau, "Discours d'histoire, discours d'actualité: Quelques Remarques à propos de David et de la modernité," *Bulletin du Musée Ingres* 61–62 [1990], p. 99. Robert Rosenblum, "Reconstructing David," *Art in America* 78 (May 1990), pp. 190–91 (ill.). Zbigniew Herbert, "Jacques-Louis David: Mord und Schönheit," *Pan* (December 1991), p. 51 (ill.). Wright 1991, vol. 1, p. 437, vol. 2, pp. 62, 639. AIC 1993, p. 142 (ill.). Claude Yvel, *Le Métier retrouvé des maîtres: La Peinture à l'huile*, Paris, 1991, p. 130, fig. 78. James Henry Rubin, "Jacques-Louis David et la main du peuple: Saisir le site de la représentation," in *David contre David*, Actes du colloque organisé au musée du Louvre par le service culturel du 6 au 10 décembre 1989, Paris, 1993, p. 788.

EXHIBITIONS: Paris, Palais du Domaine de Bagatelle, *Exposition rétrospective de portraits de femmes sous les trois républiques*, 1909, no. 48. Palais des Beaux-Arts de la Ville de Paris (Petit Palais), *David et ses élèves*, 1913, no. 39. Amsterdam, Rijksmuseum, *Exposition rétrospective d'art français*, 1926, no. 35. Paris, Galeries Nationales du Grand Palais, *De David à Delacroix: La Peinture française de 1774 à 1830*, 1974–75, no. 34, traveled to Detroit and New York. The Art Institute of Chicago, *Selected Works of Eighteenth-Century French Art in the Collections of The Art Institute of Chicago*, 1976, no. 17. The Art Institute of Chicago, *European Portraits, 1600–1900, in The Art Institute of Chicago*, 1978, no. 12. Paris, Musée du Louvre, and Versailles, Musée National du Château, *Jacques-Louis David, 1748–1825*, 1989–90, no. 116.

The sitter in this restrained and intimate portrait is Adélaïde Anne Louise Piscatory de Vaufreland, an important civic philanthropist and founder of the first day nursery in Paris, at the turn of the eighteenth century. Born in 1765 to an aristocratic family from Marseilles, Louise lived, until age twenty-two, with her maternal grandmother, Mme Rouillé de l'Etang, who had a great fondness for the arts and literature. In 1787 Louise was received in Paris by her childless uncle, David Etienne Rouillé de l'Etang, a man of wealth and position who hosted one of the most distinguished salons in Paris. With this move to Paris and her subsequent marriage, Louise entered fashionable society. On the day the Bastille fell, July 14, 1789, she wedded the gifted and ambitious Claude Emmanuel Joseph Pierre de Pastoret, also from Marseilles, of prestigious ancestry and considerable means. His brilliant career as a man of state, jurist, and writer began in his early twenties and continued until his retirement from official life in 1834.[9] The Pastorets had two children, Amédée David (1791–1857) and Maurice (1798-1817).[10]

Louise and her family lived at her uncle's residence on place Louis XV (now place de la Concorde). Her educa-

tion and passion for literature were encouraged by her role as hostess at her uncle's salon, which was praised by Jacques de Sainte-Beuve for its free exchange of ideas among celebrated aristocrats, financiers, philosophers, and writers. In addition, Louise was engaged in much charitable work, and expended considerable sums assisting the unfortunate, particularly indigent mothers and children. Louise decided to establish a day nursery for working mothers following an incident in which, upon hearing screams from a locked apartment, she rescued a two-year-old boy, who had broken his arm, and his five-year-old sister. The concept eventually became nationalized and was introduced to England by the distinguished English economist Sir Richard Edgeworth and his daughter Maria, who visited the nursery in Paris. Maria Edgeworth later based the heroine of her successful novel *Madame de Fleury* (1802) on Louise de Pastoret.[11] In 1800 Louise helped restore the Société de Charité Maternelle (founded in 1784) and became its secretary; ten years later she became its vice president. Her other civic benevolences, including visiting the ill, continued after 1830, though at that time she relinquished her official role. She died on September 27, 1843.

The tumultuous political events in late-eighteenth-century France touched the lives of the Pastorets and the artist David. By the time French politics had reached the revolutionary stage, David's position had changed from painter to political activist. He became the spokesman for a more democratic Academy, and in 1790 headed the newly formed Commune des Arts, an organization that challenged Academic authority. As deputy (beginning September 17, 1792) for Paris to the National Convention, David was associated with the most extreme revolutionary figures in France. He spent much of his time organizing official celebrations, which probably accounted for the decline in the number of paintings he produced during these years. Yet from this unsettled period emerged a number of important portraits, including *Madame de Pastoret*, which was probably painted between mid-1791 and mid-1792.[12] Certain events in the life of the Pastorets point to this date for the work's execution. The cradled infant in the painting is Amédée David, born on January 2, 1791. Only a year and a half later, in August 1792, Emmanuel de Pastoret went into political exile, and Louise, with her son and uncle, was imprisoned briefly. Allowing for Louise's convalescence after her son's birth, the earliest date for the execution of the painting would be mid- to late 1791. Because of Emmanuel de Pastoret's political situation

and Louise's imprisonment, the painting must date from before August 10, 1792.

These events may explain in part why the portrait was left unfinished. The canvas was abandoned before David had worked up the highly finished paint surface that characterizes his completed paintings. Matthias Bleyl (1982) observed that David's original conception evidently did not include an infant and crib; the large arched outline of Louise's dress is visible through the left side of the crib, and the vertical support of the chair back can be seen through the child's head and pillow. Antoine Schnapper, stressing the connection between David's politics and numerous unfinished canvases, drew attention to parallels between this painting and two other portraits by the artist, *Louise Trudaine* (Louvre) and *Philippe-Laurent de Joubert* (Montpellier, Musée Fabre), which also date to 1791–92. All are three-quarter length, of similar format and pose, and were left unfinished in David's studio at his death. Schnapper suggested that the artist never completed the Louvre and Musée Fabre pictures because, in the case of Trudaine's portrait, there was a political breach of friendship between the sitter's husband and David, and in the case of Joubert's portrait, because of the sitter's death (March 3, 1792).[13]

It was probably for similar reasons that the portrait of Mme de Pastoret was never completed. Emmanuel de Pastoret, an ardent Royalist, was David's opponent in the political arena. Emmanuel especially, but his wife also, lived in the shadow of the guillotine. Emile Delignières claimed that "après le 10 août 1792, le tableau représentant la grande dame fut abandonné, David refusant de terminer le portrait de la femme d'un 'aristocrate' qui ne partageait pas ses idées."[14] The prudent Louise may have felt anxious about David's associations and was perhaps unwilling to linger in the company of an antagonistic political figure. Whatever the precise circumstances, the breach between painter and sitter was final. During the Terror, David denounced Louise's friend Mme Chalgrin, mistress of the baron Piscatory, Louise's brother. After Mme Chalgrin was sent to the guillotine, Louise refused to take the painting while David was alive.[15]

Emmanuel de Pastoret finally purchased his wife's portrait at the David sale of 1826. Bleyl (1982) proposed that he did this to make the portrait part of a family gallery, since at some point an inscription with the sitter's name was added to the Chicago work to make it conform to other portraits of the Pastorets. Describing Louise's portrait when it hung in the Château de Moreuil in Picardie, Delignières wrote in 1890 that "le tableau

porte en haut, à gauche, les armes accolées des Piscatory et des Pastoret, surmontées de la couronne de marquis, et à droite cette inscription, mise évidemment après 1826; le titre de marquis n'avait été conféré à M. de Pastoret qu'en 1817: *Louise Adelaïde Piscatory, marquise de Pastoret, fondatrice des salles d'asyle (sic) en France.*"[16] When the portrait was sold in 1908, the inscription and coat of arms had been removed; today no trace of them remains. Ingres's portrait of Louise's first son, *Amédée David, Marquis de Pastoret* (1826), also in the Art Institute (1971.452), is inscribed with his name and age at the upper left, and Delaroche's portrait of her husband, *Emmanuel de Pastoret* (1829; Boston, Museum of Fine Arts), bears a coat of arms at upper left, together with sitter's name and titles.[17] Since Louise's portrait came up for sale at about the time her son Amédée David commissioned his portrait from Ingres, Bleyl concluded that it was probably then that the idea of a family gallery was conceived and the painting was given an inscription.[18]

With her unpowdered dark auburn hair parted in the center so that her dense curls tumble to her back, Mme de Pastoret is seen in an informal white cotton robe (a morning toilette or negligée), the bodice of which exposes a matching shift embellished at the top. A fichu (a long scarf, usually made of cotton with linen) is draped around her shoulders and a blue sash is tied at the back. This style of dress, derived from England, was worn by fashionable middle- and upper-class women during this period. In this relatively plain attire, Louise de Pastoret embodied the then-new Rousseauean notion of simplicity. In an intimate domestic scene, she attends to her maternal responsibilities.[19] Presumably there is no wet nurse, since the casual arrangement of the fichu and unfastened bodice (if one can thus interpret the forms in this unfinished work) suggests that she breast-feeds her own infant, who is apparently being raised at home. This approach to child-rearing was encouraged by Rousseau in his *Emile, ou de l'éducation*, which for decades after its publication, in 1770, was much in vogue among upper-class women. Rousseau's suggestions that mothers should nurse their own children became increasingly popular. Given that Louise de Pastoret had many liberal ideas, and that she had demonstrated extraordinary interest in matters of child care, it is appropriate that she appears in the Chicago picture as a progressive Rousseauean mother.

NOTES

1 The 1967 treatment was performed by Alfred Jakstas, and the 1989 treatment by Frank Zuccari.

2 The thread count of the original canvas is approximately 18 x 18/sq. cm (35 x 35/sq. in.). A label attached to the back of the stretcher reads: *Haro & C[ie] / PEINTRE EXPERT / Restaurateur de Tableaux.*

3 According to Wildenstein and Wildenstein 1973; price and buyer were recorded in David 1880. The 1897 sale catalogue (see below) indicated that the painting had been acquired by the Pastoret family at the artist's estate sale.

4 According to "La Chronique des arts . . ." 1897. For the buyer's name, see Meier-Graefe and Klossowski 1908.

5 The price is recorded in an annotated sale catalogue at the National Gallery of Art, Washington, D.C., and in *American Art News* 1908. According to M. Roy Fisher, then of Wildenstein, New York (letter of December 6, 1977, to the author, in curatorial files), and Schnapper (in the 1974–75 and 1989–90 exhibition catalogues), Georges Petit was the buyer at the 1908 sale; Fisher suggested that Petit was acting as an agent for Murat.

6 According to the 1909 exhibition catalogue and Holma 1940. Comtesse Joachim Murat's grandmother was Pauline Jeanne, baronne Jeanin, one of David's twin daughters.

7 According to Fisher (see note 5).

8 According to Joseph Baillio of Wildenstein, New York (telephone conversation of March 4, 1988, with the author; note in curatorial files).

9 The marquis de Pastoret was made a comte in 1808, and during the Restoration became successively a peer, marquis (1817), member of the Academy, Minister of State, and Chancellor of France (1829). After 1834 he became tutor to the royal children.

10 See Bassan 1969 for biographical information on the Pastorets. For Louise, see also the vicomte de Falloux, "Biographie de Madame Pastoret," *Annales de la charité* 2 (1846), pp. 224–50.

11 The name Fleury derives from the Château de Fleury, the Pastoret home near Meudon (Seine-et-Oise).

12 Angrand and Naef (1970) suggested that Quatremère de Quincy, a mutual friend of the Pastorets and of David in 1791, may have arranged the portrait sitting.

13 Schnapper 1980, pp. 126–30, figs. 70–72.

14 Delignières, *Notice sur des tableaux . . .* 1890, p. 492: "After the 10th of August 1792, the painting representing the great lady was abandoned, David refusing to finish the portrait of the wife of an 'aristocrat' who did not share his ideas." This is also reported in *Château de Moreuil* 1884.

15 Bassan 1969, p. 22.

16 Delignières, *Réunion des Sociétés . . .* 1890, p. 493, pl. XIX: "The painting bears at upper left the joined coat of arms of the Piscatory and Pastoret families, surmounted by the crown of the marquis, and at right this inscription, evidently put there after 1826; the title of marquis had been conferred on M. de Pastoret only in 1817: *Louise Adelaïde Piscatory / marquise de Pastoret / fondatrice des salles d'asyle (sic)/ en France.*"

17 The inscription on the Boston painting reads: *CLAUDE EMMANUEL JOSEPH PIERRE / MARQUIS DE PASTORET / CHANCELIER DE FRANCE / TUTEUE DES ENFANE / DE FRANCE.* This and the coat of arms are now only partially visible. They also appear in an oil sketch for the portrait (Bayonne, Musée Bonnat). For an illustration of the Boston Painting, see Jules d'Auriac and Raphael Pinset, *Histoire du portrait en France*, Paris, 1884, p. 219; for the portrait of the marquis de Pastoret, see Norman Ziff in the 1974–75 exhibition catalogue, pp. 385–86, no. 43, pl. 202.

18 Bleyl 1982, p. 132. Henri Haro, who wrote the introduction to the 1897 Plessis-Bellière sale catalogue, may have removed the inscription from the painting; see note 2.

19 Such scenes were more common to English portraits of the 1780s than to French works of the same period. However, a fine French example is the *Portrait of a Woman Nursing Her Child* (Mâcon, Musée Municipal des Ursulines) of 1762 by Jean Laurent Mosnier.

Jean Baptiste Deshays

1729 Colleville (Seine-Maritime)–Paris 1765

Saint John the Baptist Preaching in the Desert, 1758/64

Gift of Mrs. Eugene A. Davidson, 1979.540

Oil on canvas, 42.2 x 26.5 cm (16⅝ x 10⁷⁄₁₆ in.)

CONDITION: The painting is in good condition. The canvas has an old glue paste lining.[1] The tacking margins have been cut off, but cusping is visible at the bottom and right edges. The canvas is approximately 0.5 cm smaller than the stretcher at all edges, except on the lower half of the left edge, which has been jaggedly cut, where it is 1 cm smaller. The composition extends beyond the left edge of the canvas, suggesting that the painting may have been cut down on this side. The off-white ground and the overlying light gray imprimatura are visible through the somewhat abraded paint surface in the lower right background and near the bottom edge. The paint layer is slightly flattened and the canvas weave pronounced due to the lining process. Losses along the perimeter have been filled and inpainted, and there is localized retouching in the upper left background covering some of the cracks, in the shadows to the right of Saint John, and in the shadows of the angels' heads.[2] (ultraviolet, x-radiograph)

PROVENANCE: Eugène Féral (d. 1900), Paris; sold Hôtel Drouot, Paris, April 22–24, 1901, no. 13, as François Boucher, for Fr 320.[3] Bourdier.[4] Alphonse Kann, Paris; sold Galerie Georges Petit, Paris, December 6–8, 1920, no. 5, as François Boucher, to Jules Strauss, for Fr 19,000. Jules Strauss (d. 1943), Paris; sold Galerie Charpentier, Paris, May 27, 1949, no. 14 (ill.), as François Boucher, to his grandson, Michel Strauss, London, for Fr 340,000.[5] Sold by Michel Strauss to Mrs. Sterling Morton (d. 1969), Santa Barbara and Chicago, 1963;[6] by descent to her daughter, Suzette Morton Davidson, Chicago; on loan to the Art Institute, 1978; given to the Art Institute, 1979.

REFERENCES: L[ouis] Soullié and Ch[arles] Masson, *Catalogue raisonné de l'oeuvre peint et dessiné de François Boucher . . .*, in André Michel, *François Boucher*, Paris, [1906], p. 41, no. 729. Georges Pannier, "Catalogue des oeuvres peintes de François Boucher qui ont passé en vente publique depuis 1770 jusqu'en 1906," in Pierre de Nolhac, *François Boucher: Premier Peintre du roi, 1703–1770*, Paris, 1907, p. 107. Regina Shoolman Slatkin, "François Boucher: *St. John the Baptist*, A Study in Religious Imagery," *Minneapolis Institute of Arts Bulletin* 62 (1975), pp. 20–21, fig. 30. Alexandre Ananoff with Daniel Wildenstein, *François Boucher*, Lausanne and Paris, 1976, vol. 2, p. 220, no. 560, fig. 1525. Alexandre Ananoff with Daniel Wildenstein, *L'opera completa di Boucher*, Classici dell'arte 100, Milan, 1980, p. 133, no. 591 (ill.).

EXHIBITIONS: Paris, Galerie Cailleux, *Esquisses, maquettes, projets et ébauches de l'école française du XVIIIᵉ siècle, peintures et sculptures*, 1934, no. 2. The Art Institute of Chicago, *Chicago Collectors*, 1963, p. 4, pl. 46.

A precocious talent, Jean Baptiste Deshays was instructed successively by his father, by Collin de Vermont, and by Jean Restout (see 1982.1378). In 1754 he went to Rome, where he stayed for four years. There he came in contact with Carle Vanloo, from whom he acquired a certain preciosity of style and tenderness of expression, and Charles Joseph Natoire, who directed the Academy in Rome. On his return to France, he became the protégé of François Boucher, whose oldest daughter (Jeanne Elisabeth Victoire) he married in 1758. By the early 1760s, Deshays had developed a reputation for his paintings of religious themes. He died at age thirty-five, but his place in the history of French painting had been secured by the works he exhibited at the Salons of 1759–65.[7] Continuing in the grand style of the previous century, Deshays's art had its roots in the elevated manners of Jean Jouvenet, Eustache Le Sueur (see 1974.233), and Restout. Deshays had learned the rhetoric of this tradition and captured its spirit so well that in 1761 Diderot proclaimed him "le premier peintre de la nation."[8] Deshays's art also reveals his admiration for the Bolognese painters Domenichino, Guercino, Guido Reni, and especially the Carracci, artists whose works he saw during his sojourn in Rome.[9]

The artist is best known for his Saint Andrew canvases of 1758 and 1761 (both Rouen, Musée des Beaux-Arts); a *Saint Peter Delivered from Prison* (Versailles, cathedral of Saint-Louis) and a *Saint Benedict Receiving Last Rites* (Orléans, Musée des Beaux-Arts, on deposit at the church of Saint-Paterne), both shown in the Salon of 1761; and a *Marriage of the Virgin* (Douai, church of Saint-Pierre), shown at the Salon of 1763.[10] He also executed historical paintings, notably *Hector Exposed on the Banks of the Scamandre* (shown in the Salon of 1759 and now in the Musée Fabre, Montpellier), mythological and allegorical canvases, and, occasionally, portraits, landscapes, and genre scenes.[11]

Deshays particularly studied and emulated the work of Boucher, to whom the Chicago *Saint John the Baptist Preaching in the Desert* was attributed from at least 1901 (see Provenance) until the 1980s. In 1980 Pierre Rosenberg suggested instead that the painter of this sketch was Deshays.[12] The assignment of the Chicago painting to Boucher is understandable if one compares it

to three works by Boucher that depict the same subject: a small grisaille sketch (fig. 1) in the Musée de Picardie, Amiens, that was probably known to Deshays; an oil sketch executed in gray and pink (Paris, private collection) that was in Deshays's possession when he died; and a finished painting in the cathedral of Saint-Louis at Versailles.[13] While these works by Boucher demonstrate Deshays's reliance on Boucher, they also help to clarify the differences between the two artists' manners. Deshays's application of paint is broader and more fluid, the space in his painting less clearly defined, and the rendering of detail less meticulous. These qualities are typical of Deshays's sketches, as can be seen in *Shepherds Dreaming of the Flight into Egypt* (New York, The Metropolitan Museum of Art), *The Infancy of Bacchus* (Paris, Galerie Cailleux), *The Assumption of the Virgin* (The Minneapolis Institute of Arts), and *The Liberation of Saint Peter from Prison* (Paris, Jean Claude Serre and Jacques Leegenhoek).[14] The last two pictures, also once given to Boucher, are similar to the Chicago canvas in the free handling of paint, summarized facial features, swirling clouds, and flowing but heavy brush strokes.

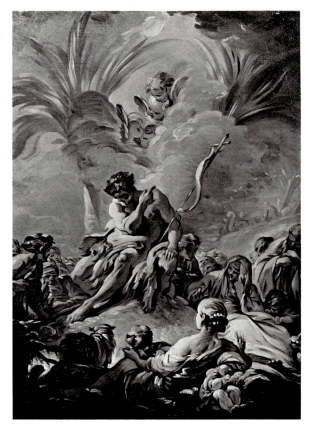

Fig. 1 François Boucher, *Saint John the Baptist Preaching in the Desert*, Musée de Picardie, Amiens [photo: Giraudon]

The overall effect is one of soft, undulating forms.

Previous attempts to date the Chicago *Saint John the Baptist Preaching in the Desert* have been made on the assumption that the work was by Boucher. Regina Shoolman Slatkin (1975) suggested that it and the Amiens and Paris sketches date to the early 1750s. She asserted that Boucher's *Saint John the Baptist* in The Minneapolis Institute of Arts was a work commissioned c. 1750 by Mme de Pompadour (and listed in the inventory of her estate) and that these sketches, the Chicago sketch, and a drawing by Boucher in the Musée Magnin, Dijon, are close to the Minneapolis painting and should be "regarded as preliminary steps in the working out of a planned composition based on an episode from the life of Saint John the Baptist."[15] She also noted that the Paris sketch had been used as a study for Boucher's painting in the cathedral at Versailles (installed in 1764).[16] Alexandre Ananoff dated the three sketches to c. 1762, pointing out that notes in *L'Avant-coureur* of February 16 and May 25, 1761, do not mention Boucher among the artists who would contribute to the decoration of the cathedral of Saint-Louis at Versailles.[17] However, when the Chicago work is reatttributed to Deshays, an approximate date for the picture, which was clearly inspired by the Boucher sketches cited above, can be established from the dates of Deshays's association with Boucher. Deshays was Restout's student until 1751, and, though acquainted with Boucher before going to Rome, it was only when he returned to Paris in 1758 that he became closely associated with that artist. The Chicago sketch was thus probably executed sometime after 1758.

In his *Essay sur la vie de M. Deshays* (1765), Charles Nicolas Cochin fils mentioned a *Saint John the Baptist Preaching*, which could be connected with the Chicago painting.[18] Marc Sandoz, however, pointed out that Cochin gathered information for his *Essay* from manuscripts and may not have had access to the actual works of art, and suggested that the work Cochin noted was a sketch entitled *Beheading of Saint John* that appeared in the Nourri sale, Paris, February 24, 1785.[19] Unfortunately, no finished work by Deshays of either subject has ever been found.

The iconography of Deshays's *Saint John the Baptist Preaching in the Desert* is traditional. Saint John, depicted as a young man, preaches penitence in the Judean wilderness. Elevated above the multitude, he assumes a standard academic pose — seated with one leg forward and the other bent back at the knee. At his foot stands

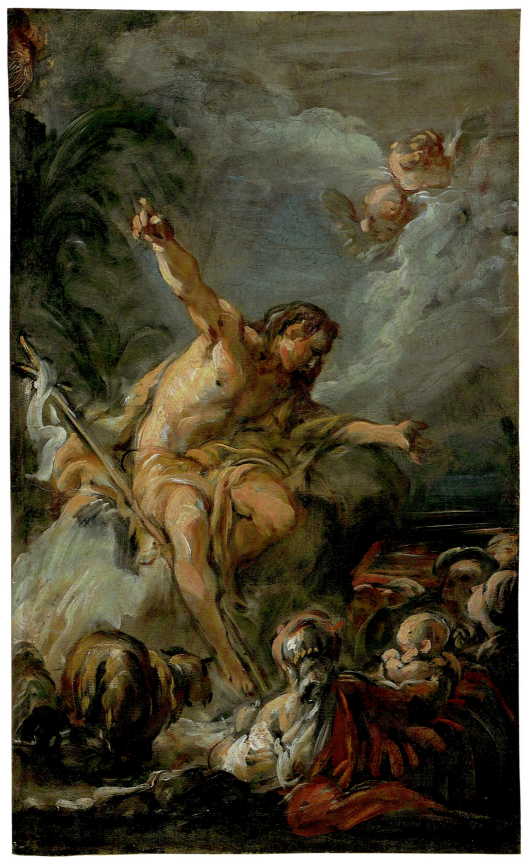

Jean Baptiste Deshays, *Saint John the Baptist Preaching in the Desert*, 1979.540

the lamb, symbol of Christ and his divine sacrifice for humanity. With arms broadly extended, the saint offers a warning while pointing toward heaven: "Repent ye: for the kingdom of heaven is at hand" (Matthew 3.2).

NOTES
1 The thread count of the canvas is approximately 13 x 15/sq. cm (32 x 37/sq. in.).
2 Minor insecurities and small losses were consolidated and retouched by Alfred Jakstas in 1970.
3 It is described in the sale catalogue as follows: "Il est assis sur un rocher, le corps incliné et entouré d'une draperie jaune, les bras étendus, sa croix et un mouton près de lui. Des femmes, l'une portant un enfant, écoutent sa parole. Dans le ciel, deux têtes de cherubins se détachent sur les nuages. Très belle esquisse, vigoureusement traitée. Toile. Haut., 42 cent.; larg., 25 cent." (He is seated on a rock, the body inclined and wrapped in yellow drapery, the arms outstretched, his cross and lamb near him. The women, one carrying a child, listen to his words. In the sky, two heads of cherubs emerge from the clouds. Very beautiful study, vigorously treated. Canvas. Height, 42 cm; width, 25 cm.) The price is recorded in an annotated sale catalogue in the Resource Collection of the Getty Center for the History of Art and the Humanities, Santa Monica, and in Pannier 1907.
4 According to a letter of November 26, 1962, from Michel Strauss to John Maxon, in curatorial files.
5 According to an annotated sale catalogue at Galerie Heim, Paris.
6 According to registrar's records, Michel Strauss first sent the painting to the Art Institute in 1962; it was subsequently acquired by Mrs. Sterling Morton.
7 The regret occasioned by this young artist's death was best expressed by Charles Nicolas Cochin fils in his sympathetic and eulogizing *Essay sur la vie de M. Deshays* of 1765 (reprinted in Marc Sandoz, *Jean-Baptiste Deshays, 1729–1765*, Paris, 1977, pp. 13–16), which, together with critics' reviews, is an important contemporary source on the artist.
8 Jean Seznec and Jean Adhémar, eds., *Diderot Salons*, vol. 1, Oxford, 1957, p. 120.
9 In the September 1761 *Mercure de France*, M. Voy called Deshays the most brilliant representative of the Bolognese school in the eighteenth century; see Jean Locquin, *La Peinture d'histoire en France de 1747 à 1785: Etude sur l'évolution des idées artistiques dans la seconde moitié du XVIIIe siècle*, Paris, 1912, p. 207.

10 See Sandoz (note 7), pp. 71–73, nos. 48–49, pl. II, pp. 77–78, no. 59, pl. I, pp. 79–80, no. 61, pl. III, p. 80, no. 62, fig. 29, pp. 85–87, no. 77, pl. III, respectively.
11 For the Montpellier painting, see Sandoz (note 7), pp. 74–76, no. 51, pl. I.
12 Letter of March 26, 1980, from Pierre Rosenberg to the author, in curatorial files. Marianne Roland Michel and Jean Cailleux also accepted this attribution (both verbally, 1983; notes in curatorial files). Slatkin (1975, p. 20) had earlier noted that the Chicago painting "has all of the loose, free manner of the work of his son-in-law Deshayes." Ananoff (Ananoff and Wildenstein 1976, vol. 2, p. 220, no. 560, fig. 1525) had attributed the painting to Boucher; Sandoz (letter to the author of December 24, 1982, in curatorial files) rejected the attribution to Deshayes, believing the painting to be closer to Boucher.
13 For the last two works, see, respectively, Ananoff and Wildenstein 1976, vol. 2, p. 220, no. 559, fig. 1523 (for this work see also the catalogue of the Deshays sale, held at the artist's residence, rue Neuve des Petits Champs, Paris, March 26 and following, 1765, no. 121; a copy of this catalogue is in the British Museum, London), and Ananoff and Wildenstein 1976, vol. 2, p. 221, no. 562, fig. 1528.
14 For illustrations of these works, see, respectively, The Metropolitan Museum of Art, New York, *Notable Acquisitions 1983–1984, Selected by Philippe de Montebello, Director*, New York, 1984, p. 72; *Oeuvres de jeunesse de Watteau à Ingres*, exh. cat., Paris, Galerie Cailleux, 1985, no. 11; Donald A. Rosenthal, *La Grande Manière: Historical and Religious Painting in France, 1700–1800*, exh. cat., Memorial Art Gallery of the University of Rochester, 1987, no. 17; and *Exposition de tableaux des XVIIe et XVIIIe siècles*, exh. cat., Paris, Jean Claude Serre and Jacques Leegenhoek, 1988, no. 18.
15 Slatkin 1975, pp. 17–21. For the Minneapolis painting and the Dijon drawing, see Ananoff and Wildenstein 1976, vol. 2, p. 63, no. 361, figs. 1061, 1062, respectively. Slatkin's opinion is partially based on her belief that the Paris sketch is dated 1751; according to Ananoff (Ananoff and Wildenstein 1980), the sketch is not dated.
16 Slatkin cited differences between Boucher's finished painting for Versailles and the Amiens and Paris sketches in supporting her assertion that the sketches were probably preliminary thoughts for the earlier depiction of Saint John, commissioned by Mme de Pompadour.
17 Ananoff and Wildenstein 1980, no. 593.
18 Cochin, in Sandoz (note 7), p. 15.
19 Sandoz (note 7), p. 104, no. 162; and letter of December 24, 1982, from Marc Sandoz to the author, in curatorial files.

Jean Baptiste François Desoria

1758 Paris–Cambrai 1832

Portrait of Constance P., 1797

Simeon B. Williams Fund, 1939.533

Oil on canvas, 130 x 99.1 cm (51¼ x 39 in.)

INSCRIBED: *DESORIA* / *1797 an V* (lower left, on the edge of the wall)

CONDITION: The painting is in very good condition. It was cleaned and lined in 1967.[1] The tacking margins are worn but intact. The ground is off-white. Aside from several small, scattered losses around the edges, on the sitter's right sleeve, and behind the left shoulder, the paint layer is generally well preserved. It has been flattened by lining, and the canvas weave is pronounced on the paint surface. Compression cracking, possibly caused by shrinkage of the original canvas due to lining, is visible throughout, and is particularly evident in the blue background. Passages of discolored overpaint, as wide as 2.5 cm at the left edge, extend around the perimeter of the painting. The craquelure at the lower left corner and parts of the signature have been retouched. X-radiography seems to reveal that Desoria lowered the neckline of the dress from its original position. (infrared, ultraviolet, x-radiograph)

PROVENANCE: Possibly Jacques Doucet, Paris.[2] Arnold Seligmann, Rey, and Co., New York. Sold by Seligmann, Rey, and Co. to the Art Institute, 1939.

REFERENCES: AIC 1941, p. 32. Frederick A. Sweet, "Judith by Giovanni Martinelli," *AIC Bulletin* 36, 1 (1942), p. 6. AIC 1961, p. 126. Jean Cailleux, "La Grande Peinture, de 1774 à 1830: Le Portrait," *Art et curiosité* 55 (January–February 1975), p. 23. Jean François Garmier, "Mâcon, Musée des Ursulines: Dernières Acquisitions," *La Revue du Louvre* 29, 5/6 (1979), p. 432. Aileen Ribeiro, *Fashion in the French Revolution*, London, 1988, fig. 83.

EXHIBITIONS: San Francisco, California Palace of the Legion of Honor, *Vanity Fair: An Exhibition of Styles in Women's Headdress and Adornment through the Ages*, 1942, no. 33, as *Portrait of Mme Elisabeth Dunoyer*. Decatur Art Center, Illinois, *Masterpieces of the Old and New World*, 1948, no. 8, as *Mme Elizabeth Dunoyer*. The Detroit Institute of Arts, *French Painting from David to Courbet*, 1950, no. 6, as *Portrait of Mme Elisabeth Dunoyer*. Paris, Galeries Nationales du Grand Palais, *De David à Delacroix: La Peinture française de 1774 à 1830*, 1974–75, no. 47, traveled to Detroit and New York, as *Madame Elisabeth Dunoyer*. The Art Institute of Chicago, *Selected Works of Eighteenth-Century French Art in the Collections of The Art Institute of Chicago*, 1976, no. 20, as *Madame Elisabeth Dunoyer*. New York, The Metropolitan Museum of Art, *The Age of Napoleon: Costume from Revolution to Empire, 1789–1815*, 1989–90 (no cat.).

A painter of distinction who enjoyed some success during his career, Jean Baptiste François Desoria fell into obscurity late in life. He studied with Jean Bernard Restout and went to Rome, probably in the late 1780s. Although devoted primarily to historical subjects, Desoria also executed religious works and, under the Directoire, Empire, and Restoration, painted portraits such as *Charles Louis Letourneur* (Château de Versailles), which was executed a year after *Portrait of Constance P.*[3] After teaching successively in the *lycées* of Evreux, Rouen, and Metz, he became director of the Academy of Cambrai, a post he held for only seven months before his death.

The young woman in the Chicago portrait has not been identified. At the time the picture was acquired by the museum, the name Elisabeth Dunoyer was connected with the sitter, but no evidence has been found to substantiate this.[4] Furthermore, the preparatory drawing for this portrait (fig. 1), also in the Art Institute, is inscribed along the bottom *croquis du portrait de Constance P. . . Princesse De.*[5] Unfortunately, the sitter indicated in the inscription, which appears to be in Desoria's hand, has yet to be identified.[6]

Desoria's drawing varies slightly from the finished portrait. In both works the sitter is posed before a landscape, but in the drawing she sits behind a wall, while in the painting she is placed before it. In addition, the landscape, chair, and coiffure are more elaborately developed in the painting than in the drawing. Other refinements, in the angle of the chair back, the hand loosely holding a book, and the sitter's neck, are also evident in the finished portrait.

The resemblance of the Art Institute's portrait to Jacques Louis David's *Madame de Verninac* (1799; Louvre) and to a *Young Woman in White* ascribed to the circle of David (Washington, D.C., National Gallery of Art) has been noted by Jacques Vilain, who believed the Chicago picture to be the prototype for *Madame de Verninac*.[7] In both the Louvre and Chicago portraits, the figure sits in the center of the composition, close to the picture plane, with legs extending beyond the edge of

the painting at lower right. Strong horizontal and vertical axes are established in each painting, but Desoria extends the spatial depth by introducing a landscape, while David places the sitter against a monochromatic background. The *Portrait of Constance P.* cannot be linked with any of the portraits exhibited by Desoria at the Salon. David probably saw the painting in Desoria's atelier, since both artists resided at the Louvre when this portrait was executed.[8]

The sitter wears a white chemise dress — a cotton tube gathered by drawstrings around the moderate décolletage and under the bust. This type of dress, which Marie Antoinette popularized during the 1780s (hence "chemise de la reine"), was derived from those worn by aristocratic Creole women of the French West Indies.[9] According to Aileen Ribeiro, "by the 1790s the chemise lost the neck frill and three-quarter length sleeves and assumed the 'classical' form. . . . It was both fashionable and relatively inexpensive; it was thus adopted by women of all classes except the poor, for as it was usually white it was inappropriate for working women."[10] Cotton, an affordable fabric for most social classes, was considered politically acceptable during the revolutionary years; expensive fabrics such as silk, on the other hand, were used less frequently. Simple attire was at once a form of republican — that is, egalitarian — expression and a manifestation of neoclassical trends and ideals. X-radiography seems to indicate that during the course of the portrait's execution, the sitter had the painter change her costume from a dress (or blouse) with a higher collar without gathers to the more modish chemise gown (see Condition).

NOTES

1 The treatment was performed by Alfred Jakstas. The thread count of the original canvas is approximately 10 x 12/sq. cm (25 x 30/sq. in.).

2 According to a letter of September 25, 1939, from Paul M. Byk (Seligmann, Rey, and Co.) to Daniel Catton Rich (in curatorial files), the painting belonged to the collector Doucet. However, no records pertaining to this painting have been found in Doucet sales; nor is it recorded in the photographic files or papers left by Doucet and now housed in the Bibliothèque Littéraire Jacques Doucet (letter of November 20, 1985, from François Chapon to the author, in curatorial files).

3 For a list of works by Desoria, see Emile Bellier de la Chavignerie and Louis Auvray, *Dictionnaire général des artistes de l'école française, supplément*, Paris, 1887, pp. 196–97.

4 In a letter of December 19, 1939, from Paul M. Byk to Frederick A. Sweet (in curatorial files), the sitter is described as a sister of Guillaume Anne-Marie, maréchal Brune, and the mother of the economist and administrator Barthélemy Dunoyer.

5 "Sketch of the portrait of Constance P. . . Princess of." The sketch is signed at lower left, in black chalk: *DeSoria*; see Harold Joachim and Sandra Haller Olsen, *French Drawings and Sketchbooks of the Eighteenth Century*, Chicago, 1977, no. 1D7 (microfiche).

6 Harold Joachim (verbally, 1983; notes in curatorial files) suggested that the signature and inscription on this drawing are by Desoria and that the drawing is preparatory for the painting. Jacques Vilain (1974–75 exhibition catalogue) and Pierre Rosenberg (verbally, June 1985; notes in curatorial files) have also expressed this view.

7 See the 1974–75 exhibition catalogue (where the *Young Woman in White* was identified as a *Portrait of Madame Hamelin* by David). For an illustration of *Young Woman in White*, see National Gallery of Art, Washington, D.C., *European Paintings: An Illustrated Summary Catalogue*, Washington, D.C., 1975, p. 97, no. 1782; for *Madame de Verninac*, see Lawrence Gowing, *Paintings in the Louvre*, New York, 1987, p. 593. Also similar are the *Madame Servan* (Springfield, Mass., Museum of Fine Arts; see Springfield Museum of Fine Arts, *From David to Cézanne: Paintings and Drawings*, Springfield, Mass., 1935, no. 11 [ill.]), by an unidentified painter but probably based on David's *Madame de Verninac*, and François Gérard's *Madame Récamier* (1802; Château de Versailles; see Jürgen Schultze, *Art of Nineteenth-Century Europe*, New York, 1970, p. 20 [ill.]).

8 A letter of November 29, 1802, from David to Desoria, in which David replied to Desoria's request for his help in obtaining a teaching position, clearly indicates that David had some regard for Desoria's ability (see Daniel Wildenstein and Guy Wildenstein, *Documents complémentaires au catalogue de l'oeuvre de Louis David*, Paris, 1973, p. 162, no. 1394).

9 Letter of April 12, 1983, from Aileen Ribeiro to the author, in curatorial files.

10 Ibid. See also Aileen Ribeiro, *Dress in Eighteenth-Century Europe, 1715–1789*, London, 1984, p. 153.

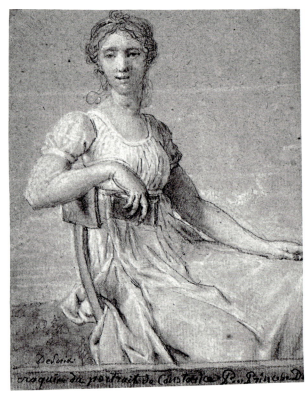

Fig. 1 Jean Baptiste François Desoria, *Sketch of the "Portrait of Constance P.,"* The Art Institute of Chicago, Gift of Mr. and Mrs. Carl Weinhardt in memory of Edna Hart Hubon, 1960.855

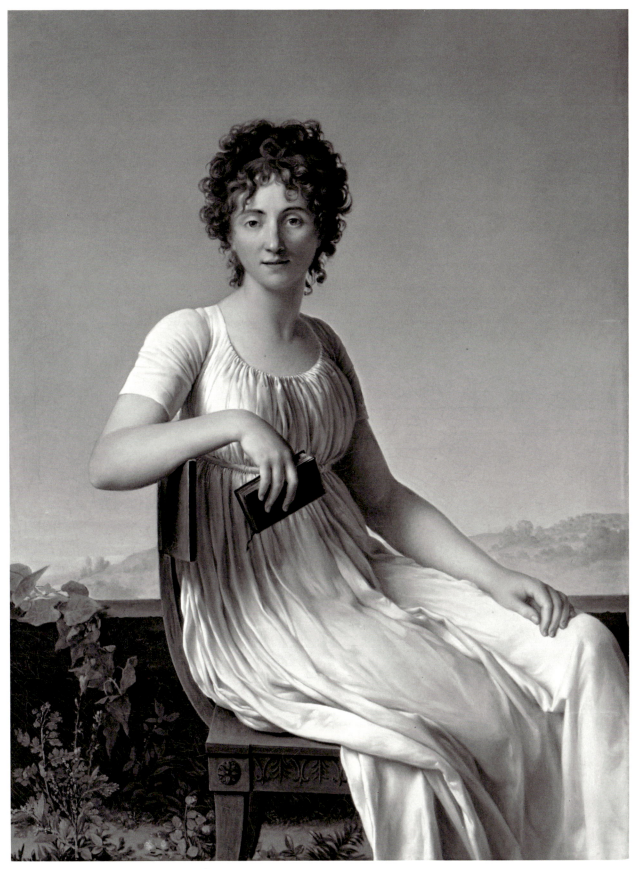

Jean Baptiste François Desoria, *Portrait of Constance P.,* 1939.533

Gaspard Dughet

1615 Rome 1675

Landscape with a Herdsman and Goats, c. 1635

Restricted gift of Mrs. Albert J. Beveridge, 1973.669

Oil on canvas, 68 x 120.4 cm (26³/4 x 47⁷/16 in.)

CONDITION: The painting is in fair condition. It was cleaned in 1973.[1] The twill-weave canvas has an old glue paste lining.[2] The tacking margins have been cut off, and the top edge was once folded over a stretcher bar and used as a tacking edge, as can be seen by the continuous crack and tack holes evident in the x-radiograph. The thin paint layer, applied over a warm brownish red ground, has suffered considerable damage and loss along the top edge. Past restoration and relining procedures account for the general abrasion of the paint surface. This abrasion is most evident in the green ground cover at the lower left. Blanching of the green foliage at the center foreground and in the upper right sky have contributed to a loss of form and definition in the landscape. Extensive retouching is visible throughout the painting, especially in the goats, the herdsman's left leg and drapery, and the sky, and along a damaged 2.5-cm strip at the painting's top edge. (infrared, ultraviolet, x-radiograph)

PROVENANCE: Sold Sotheby's, London, April 8, 1970, no. 80, as The Master of the Silver Birch, to Julius Weitzner, London.[3] Sold by Weitzner to the Art Institute, 1973.

REFERENCES: J. V. Hantz, "La Peinture française du XVIIᵉ siècle dans les collections américaines," *L'Amateur d'art* 680 (1982), p. 20. Ekkehard Mai, "La Peinture française du XVIIᵉ siècle dans les collections américaines," *Pantheon* 40 (1982), p. 153. Wright 1985, p. 179. Marie Nicole Boisclair, *Gaspard Dughet: Sa Vie et son oeuvre (1615–1675)*, Paris, 1986, pp. 35–36, 172, no. 11, fig. 15. Marc Sandoz, "Essai sur le paysage de montagne dans la peinture française du XVIIᵉ siècle," *Cahiers du paysage de montagne et de quelques sujets relatifs à la montagne* 1 (1987), p. 51, fig. 74. Nicholas H. J. Hall in *Claude to Corot: The Development of Landscape Painting in France*, exh. cat., New York, Colnaghi, 1990, p. 71. Alain Mérot, *Nicolas Poussin*, Paris, 1990, p. 206 (ill.).

EXHIBITIONS: Paris, Galeries Nationales du Grand Palais, *La Peinture française du XVIIᵉ siècle dans les collections américaines*, 1982, no. 26, cat. by Pierre Rosenberg, traveled to New York and Chicago.

In an article published in 1950, Anthony Blunt identified a group of thirteen paintings and two drawings as the work of an artist whom he called the "Silver Birch Master," an appellation he derived from the inclusion in this painter's landscapes of "a tree with a white striped bark like a silver birch."[4] Subsequently, in a letter published in 1980, Blunt stressed the similarities between the landscapes of the Silver Birch Master and those of Gaspard Dughet, and proposed that most of the Silver Birch paintings were in fact by the young Dughet, an hypothesis now accepted by most scholars.[5] The Chicago painting, sold in 1970 as a work by The Master of the Silver Birch, was acquired by the Art Institute in 1973 as a Dughet.[6]

Gaspard Dughet, the son of a French pastry cook and an Italian mother, was born in Rome and spent his entire life there. In 1630 Nicolas Poussin (see 1930.500) married Dughet's sister, and the following year Dughet entered the Poussin's atelier, where he remained for four years.[7] There is ample indication in Dughet's paintings that throughout the next few decades he remained continuously in contact with his brother-in-law. Although Dughet drew much from the classical nostalgia of Poussin's arcadian landscapes, the independent style he developed was less rational and exalted. Dughet's manner was also informed by the works of Paul Bril, Adam Elsheimer, and Herman Swanevelt as well as by Pietro da Cortona and Claude Lorrain (see 1941.1020), and shared, in some respects, the spirit of works by Salvator Rosa. His ability to paint very rapidly enabled him to keep up with the growing demand for his work, and he remained widely patronized and collected throughout his career.

The chronology of Dughet's works, much disputed by scholars, is difficult to establish because of the lack of dated works by the artist. An early biographer of Dughet, Lione Pascoli, distinguished three periods in the painter's development:

> Ma quelle della seconda maniera più belle ancora della terza, e della prima. Imperocchè questa dà alquanto nel secco, quella è vero, che è vaga, ed amena; ma nell'altra si trova più semplicità, più verità, e più dottrina.[8]

The *Landscape with a Herdsman and Goats* is probably from Dughet's first period, the early phase of which includes the Silver Birch pictures, executed before his frescoes of 1635–37 in the Palazzo Muti Bussi in Rome.[9] During this first period, which culminated with the frescoes for the Roman church of San Martino ai Monti

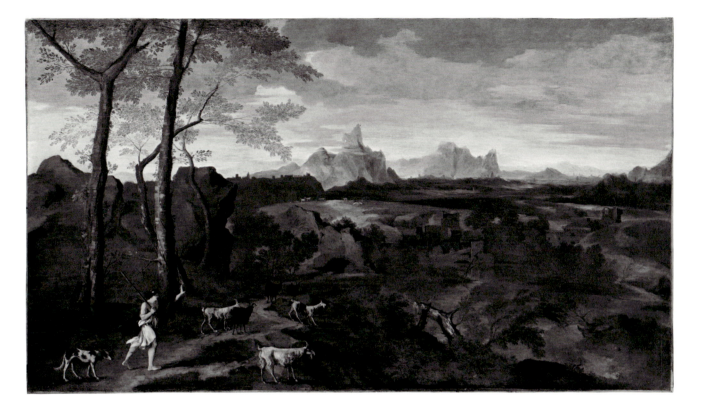

(begun 1645/46), the prolific young Dughet earned his reputation as an artist of considerable merit.

Marie Nicole Boisclair (1986) dated the Chicago landscape to the years 1633–35, when Dughet was still in Poussin's atelier. In style and execution, this canvas is closest to paintings generally dated to Dughet's early period of the 1630s, such as *The Sea* (Rome, Galleria Corsini), the pendants *Landscape with a Cowherder* and *Landscape with a Goatherder* (both Chantilly, Musée Condé), *Landscape with Bathers and Fishermen* (Columbus, Ohio, private collection), *Landscape of the Italian Countryside* (private collection), and *The Squall with a Solitary Voyager* (Florence, Fondazione Roberto Longhi).[10] In these, too, Dughet moved away from the spatially constricted compositions of his very early works, such as the *Landscape with a Path in a Forest* (London, Victoria and Albert Museum), toward panoramic landscape views.[11] Boisclair also placed two other pictures in this period: *Landscape with a Goatherder Feeding His Dog* (London, formerly Colnaghi) and *Landscape with a Cowherder* (London, The National Gallery). A Dughet attribution for these works is not unanimously accepted, but the paintings deserve mention in connection with the Chicago canvas.[12] The three pictures share a common manner of execution, particu-

larly in the rendering of figures and animals. In addition, idiosyncratic, sharply pointed mountains appear in the backgrounds of both the Chicago and ex-Colnaghi canvases. However, the compact compositions of the two London landscapes (due in part to their smaller formats) recall the early landscape manner of Poussin, as distinct from the freer spatial organization of the Chicago landscape. This suggests that the Chicago picture dates closer to 1635, after Dughet had developed his own more expansive landscape style, as seen in the Palazzo Muti Bussi frescoes.

Numerous features in *Landscape with a Herdsman and Goats* are typical of Dughet's early works, although they came to be repeated throughout his oeuvre. At the left of the composition is the characteristic row of trees with white striped bark and foliated high branches silhouetted against the sky. Cumbersome, loosely drawn figures and animals occupy the fore- and middle grounds, while picturesque elements such as architecture, broken or dying tree branches, and sharp, craggy mountains rising distinctively in the distance define the landscape. Forms are summarized in broad, flat brush strokes that emphasize contour more than texture; and the thin application of paint produces the "dry" quality observed by Pascoli. Also characteristic of Dughet is the

rendering of the background from an incongruously high vantage point.[13] The repetition of these traits led Denys Sutton to observe:

> Gaspard's more or less constant fidelity to an approach . . . was in keeping with his personality; the formula achieved suited an artist mainly concerned with landscape and to whom the higher ranges of heroic composition did not appeal. The small scale ideal landscape with a romantic tinge was his stock in trade.[14]

NOTES

1 The painting was cleaned by Alfred Jakstas.
2 The thread count of the original canvas is approximately 8 x 14/sq. cm (18 x 40/sq. in.).
3 According to letters of December 20, 1982, and June 27, 1983, from Brendan Tyrrell (Sotheby's) to Mary Kuzniar, in curatorial files.
4 Anthony Blunt, "Poussin Studies V: 'The Silver Birch Master,'" *Burl. Mag.* 92 (1950), pp. 69–73. In fact, the tree is probably not a silver birch, as Blunt later acknowledged in a published letter (Anthony Blunt, "The Silver Birch Master, Nicolas Poussin, Gaspard Dughet, and Others," *Burl. Mag.* 122 [1980], p. 582), but perhaps a mountain ash or, as Clovis Whitfield suggested, a poplar or aspen (Clovis Whitfield, "Poussin's Early Landscapes," *Burl. Mag.* 121 [1979], p. 19).
5 Blunt 1980 (note 4), pp. 577–78. Whitfield (note 4), pp. 10–19, did not agree with Blunt's attributions, and has ascribed many of Blunt's original fifteen works to Poussin. Blunt's response to Whitfield is in his published letter of 1980 (note 4).
6 In a letter of April 14, 1977, to the author (in curatorial files),

Pierre Rosenberg stated that he believed the Chicago picture to be by Dughet.
7 Gaspard is said to have assumed his brother-in-law's surname. He was called "il Posino," but always signed "Gasparo Duchè" in official documents (Boisclair 1986, p. 19).
8 Lione Pascoli, *Vite de' pittori, scultori ed architetti moderni*, Rome, 1730, vol. 1, p. 61: "His second manner is even finer than the first and third; for the first is somewhat dry; the last, admittedly, is fair, and lovely; but the second shows greater simplicity, truth, and compositional excellence." Translation from Marcel Roethlisberger, *Gaspard Dughet, Rome, 1615–1675*, New York and London, 1975, p. 12.
9 Boisclair 1986, pp. 180–81, nos. 37–50, figs. 56–68, 71.
10 For these paintings, see ibid., p. 171, no. 7, fig. 12 (also titled *Landscape without Figures*), p. 173, nos. 13–14, figs. 24–25, p. 174, no. 17, fig. 27, p. 175, no. 21, fig. 29, p. 175, no. 22, fig. 30 (also titled *The Gust of Wind*), respectively.
11 Ibid., p. 170, no. 5, fig. 8.
12 Ibid., pp. 169–70, no. 3, fig. 7, p. 170, no. 6, fig. 10, respectively. Roethlisberger (note 8), no. 1, attributed *Landscape with a Goatherder Feeding his Dog* to Dughet; Whitfield (note 4), p. 16, gave it to Poussin; Blunt 1980 (note 4), p. 578, rejected attributions to either Poussin or Dughet; and Michael Kitson ("Current and Forthcoming Exhibitions: London, Gaspard Dughet at Kenwood," *Burl. Mag.* 122 [1980], p. 648) gave qualified support to a Poussin attribution. Blunt 1950 (note 4), p. 69, attributed *Landscape with a Cowherder* to the "Silver Birch Master." Whitfield (note 4), p. 16, attributed it to Poussin; and Blunt 1980 (note 4), p. 578, tended toward Dughet.
13 John Shearman ("Gaspard, not Nicholas," *Burl. Mag.* 102 [1960], pp. 326–29) discerned this characteristic in early Dughet drawings.
14 Denys Sutton, "Gaspard Dughet: Some Aspects of his Art," *GBA* 6th ser., 60 (1962), p. 297.

Joseph Siffred Duplessis

1725 Carpentras–Versailles 1802

Portrait of a Lady, c. 1787

Mrs. Arma Wyler restricted gift, 1975.137

Oil on canvas, oval, 73 x 59 cm (28 3/4 x 23 1/4 in.)

CONDITION: The painting is in poor condition. The canvas has an old wax resin lining and a loose cosmetic lining.[1] The original tacking margins have been cut off, and the canvas is slightly smaller than the stretcher at the top curve. Minor cusping at all four edges suggests that the painting is close to its original dimensions. There is a 5 x 8 cm complex tear in the background at the right. The smooth paint surface, applied over a white ground, has suffered considerably from past treatment, and has been notably flattened due to the lining process. Extensive abrasion in the face, chest, hair, and background has contributed to a loss of definition and volume in the forms. An area of losses 6 cm in length is located at the lower left background, and there are several smaller losses in the sitter's left cheek, her upper left shoulder, the gold drapery at the

bottom right, and scattered across the background; the largest measures approximately 2 cm across. Retouches cover these losses, craquelure in the face, cracks from the stretcher bar in the chest, and large abraded passages throughout the background. (ultraviolet, x-radiograph)

PROVENANCE: Probably Michel Nicholas Benisovich, 1948.[2] Wildenstein, Paris.[3] Paris art market, 1970s.[4] Heim Gallery, London. Sold by Heim to the Art Institute, 1975.

REFERENCES: J. Patrice Marandel, "A Portrait by Duplessis," *AIC Bulletin* 70, 1 (1976), pp. 2–3 (ill., cover ill.). Pierre Rosenberg and Marion C. Stewart, *French Paintings, 1500–1825: The Fine Arts Museums of San Francisco*, San Francisco, 1987, pp. 161–62 (ill.).

EXHIBITIONS: The Art Institute of Chicago, *Selected Works of Eighteenth-Century French Art in the Collections of The Art Institute of Chicago*, 1976, no. 12. The Art Institute of Chicago, *The Art of the Edge: European Frames, 1300–1900*, 1986, no. 51.

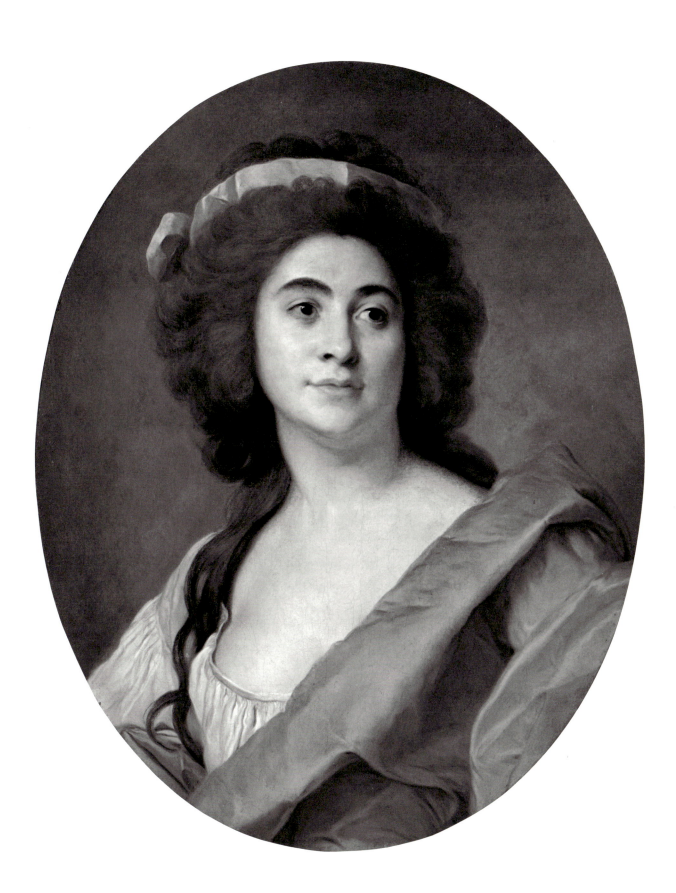

Educated in Carpentras (near Avignon), Joseph Siffred Duplessis traveled in 1745 to Rome, where he studied the paintings — particularly the portraits — of Pierre Hubert Subleyras. After moving to Paris in 1752, he became a fashionable portrait painter and, eventually, the official painter of Louis XVI, who appointed him director of the galleries at Versailles. During the Revolution, he fell into disfavor and seems virtually to have abandoned painting. Although perhaps the most successful portraitist of his generation, Duplessis died destitute and is known today primarily for his official portraits of Louis XVI (1775; Palais de Versailles; and 1776/77; Moscow, Pushkin Museum) and his portrait of the German composer Christoph Gluck (1775; Vienna, Kunsthistorisches Museum).[5]

The Chicago *Portrait of a Lady* is known in two other versions. The first, attributed by Pierre Rosenberg and Marion Stewart to a painter working in the studio of Duplessis, is in the M. H. de Young Memorial Museum in San Francisco; its dimensions are close to those of the Chicago painting.[6] The second painting (location unknown) passed through the Camille Groult sale in Paris in 1952.[7] The three portraits differ in format, in the sitter's expression and in the details of her clothing and coiffure, and in the degree of finish and general handling of paint.[8] It is not possible to determine whether one of these three works served as a model for the other two, or whether all three derive from a (now lost) fourth portrait.

All three versions display features that are typical of Duplessis: the direct presentation of the sitter, the smooth, finished paint surface, the soft treatment of the hair, and the accentuation of the mouth and of the bridge of the nose. The casual yet dignified air of the sitter is also characteristic of Duplessis's portraits.[9] One aspect that distinguishes the Chicago picture from the artist's other portraits is the manner in which the flesh is rendered. The modeling in the present portrait is somewhat flat and insensitive, and the flesh does not have the palpable quality typical of Duplessis. This may be due primarily to the painting's condition and to restoration (see Condition), or may indicate that the Chicago painting is a repetition, albeit autograph.

The arrangement of the sitter's costume in the Chicago painting is unusual and provides some information about the picture's date. The fashionable white linen chemise gown is only partly visible under the gold scarf casually cast across one shoulder. A white bandeau ribbon adorns her coiffure, in imitation of antique clothing styles. Aileen Ribeiro called attention to the costume's "deliberate element of déshabillé," and

noted that the sitter wears the chemise, unconventionally, as an undergarment. Ribeiro explained that in the 1780s, the chemise gown (usually with ruffled collar) became high fashion, but when a chemise with a low neckline was worn, a white, fill-in chemisette was usually worn beneath it.[10] Although all three versions can be dated between 1785 and 1790, the costume in the Chicago portrait suggests, according to Ribeiro, a more specific date of c. 1787 for that painting.[11]

The woman portrayed in these paintings was long thought to be Mme de Staël.[12] That identification is refuted, however, by comparison with known portraits of the French writer such as those by Elisabeth Louise Vigée-Le Brun (Geneva, Musée d'Art et d'Histoire), Marie Eléonore Godefroy (Château de Versailles), and Baron François Gérard (Canton de Vaud, Switzerland, Château de Coppet).[13] The provocative décolleté and casual presentation have led some scholars to explore the possibility that the sitter was an actress, but efforts to identify her as a specific stage personality have not proven successful.[14]

Notes
1 The thread count of the original canvas is approximately 12 x 9/sq. cm (30 x 22/sq. in.).
2 Handwritten on a photocopy of the reverse of an old photograph from Wildenstein, preserved in curatorial files.
3 The Wildenstein stock number, 50198, appears on the reverse of an old photograph of the painting preserved in curatorial files.
4 According to a note written by Joseph Baillio, July 28, 1977, on the reverse of an old photograph (see note 3).
5 See Jules Belleudy, *J.-S. Duplessis, peintre du roi, 1725–1802*, Chartres, 1913, ill. opp. p. 65, p. 327, no. 96; and ill. opp. p. 48, p. 323, no. 71, respectively.
6 See Rosenberg and Stewart 1987, pp. 160–62 (ill.). The San Francisco painting measures 61 x 50 cm.
7 Camille Groult, Paris; sold Paris, Galerie Charpentier, March 21, 1952, no. 75 (ill.), as a work by Henri Pierre Danloux. This *Portrait of a Lady* measured 72 x 57 cm. On the basis of the reproduction in the sale catalogue, it seems that the picture could be by Duplessis.
8 The San Francisco painting is heavily restored throughout the drapery, and the upper corners of its canvas were originally rounded.
9 For style and presentation, it is useful to compare these portraits with Duplessis's signed *Portrait of an Unknown Woman*, formerly in the collection of Mme Rogers-Doucet (see Belleudy [note 5], p. 336, no. 151, ill. opp. p. 256).
10 Letter from Aileen Ribeiro to the author of March 16, 1984, in curatorial files.
11 Ibid.
12 This identification was proposed by Georges Wildenstein in his article "An Unknown Portrait of Mme. de Staël by J. S. Duplessis in the de Young Museum," *Pacific Art Review* 3 (1944), pp. 1–15.
13 For illustrations, see ibid., figs. 9–11.
14 See Rosenberg and Stewart 1987, pp. 161–62. The San Francisco picture bears the inaccurate inscription on its reverse: *Portr de Mlle Dumesnil Actrice du Théâtre Français(e) au 17e par Mme Lebrun.*

Jean Honoré Fragonard

1732 Grasse–Paris 1806

Portrait of a Man, 1768/70

Gift of Mary and Leigh Block in honor of John Maxon, 1977.123

Oil on canvas, 80.3 x 64.7 cm (31⅝ x 25½ in.)

CONDITION: The painting is in very good condition. The canvas has an old glue paste lining.[1] The picture was cleaned and varnished and received minor inpainting in 1986.[2] The tacking margins have been cut off, but cusping visible at all four edges suggests that the painting is close to its original dimensions. The off-white ground is visible through the thinly painted surface of the costume. The impasto in the face is slightly flattened due to the lining process, but the thickly painted surface is otherwise generally well preserved. X-radiography reveals a 4 cm wide, C-shaped loss near the center of the bottom edge and a 1 cm loss at the lower right edge. The painting has been selectively cleaned in the face and background, leaving a natural resin varnish over the costume. The losses have been filled and inpainted. There is additional retouching in the background at the top center and upper right corner, in the center and left sleeve of the costume, and in the left eye and beard. *Pentimenti* in the sitter's costume are especially apparent under infrared light. (infrared, ultraviolet, x-radiograph)

PROVENANCE: Possibly Mauperin, Paris; sold A. Paillet, Hôtel de Bullion, Paris, December 4, 1780, no. 38, for 100 *livres*.[3] Sold Hôtel Drouot, Paris, April 20, 1885, no. 14, for Fr 2,900.[4] Camille Groult (d. 1953), Paris.[5] Purchased from the Groult collection by Wildenstein, New York, 1954.[6] Sold by Wildenstein to Leigh Block, Chicago, 1954;[7] given to the Art Institute by Mary and Leigh Block, 1977.

REFERENCES: Baron Roger Portalis, *Honoré Fragonard: Sa Vie et son oeuvre*, vol. 2, Paris, 1889, pp. 277, 286. Georges Wildenstein, *The Paintings of Fragonard: Complete Edition*, London, 1960, pp. 14, 256, no. 247, pl. opp. p. 42. Charles Sterling in *Portrait of a Man (The Warrior), Jean Honoré Fragonard*, exh. cat., Williamstown, Mass., Sterling and Francine Clark Art Institute, 1964, n. pag., fig. 17. Daniel Wildenstein and Gabriele Mandel, *L'opera completa di Honoré Fragonard*, Classici dell'arte 62, Milan, 1972, p. 97, no. 264 (ill.). "New Accession," *Apollo* 106 (October 1977), p. 311, fig. 6. *AIC 100 Masterpieces*, 1978, pp. 25, 77, no. 37. Denys Sutton in *Fragonard*, exh. cat., Tokyo, The National Museum of Western Art, 1980, n. pag. Jacques Vilain in *French Painting: The Revolutionary Decades, 1760–1830*, exh. cat., Sydney, Art Gallery of New South Wales, 1980, p. 87, under no. 38. Mary Sheriff Jones, "The *Portraits de Fantasie* [sic] of J.-H. Fragonard: A Study in Eighteenth-Century Art and Theory," Ph.D. diss., University of Delaware, 1981 (Ann Arbor, Mich., University Microfilms, 1984), pp. 85–86, 198, no. 14, fig. 29. Pierre Cabanne, *Fragonard*, Paris, 1987, pp. 63, 65. Jean Pierre Cuzin, *Jean-Honoré Fragonard: Vie et oeuvre, catalogue complet des peintures*, Fribourg and Paris,

1987, pp. 123, 294, no. 184 (ill.), fig. 149; English ed., New York, 1988, pp. 125, 295, no. 184 (ill.), pl. 149. Heinrich Hahne, "Der Vielgeliebte," *Weltkunst* 57 (1987), p. 3695. Barbara Scott, "Letter from Paris: Fragonard at the Grand Palais," *Apollo* 126 (November 1987), p. 443. Mary D. Sheriff, "Invention, Resemblance, and Fragonard's *Portraits de Fantaisie*," *Art Bull.* 69 (1987), p. 77 n. 1. *AIC Master Paintings* 1988, p. 42 (ill.). Dore Ashton, *Fragonard in the Universe of Painting*, Washington, D.C., and London, 1988, p. 201, fig. 55. Philip Conisbee, "New York: Fragonard," *Burl. Mag.* 130 (1988), p. 319. Heinrich Hahne, "Fragonard," *Das Kunstwerk* 41 (February 1988), p. 43. Pierre Rosenberg, *Tout l'Oeuvre peint de Fragonard*, Paris, 1989, p. 93, no. 200 (ill.). Mary D. Sheriff, *Fragonard: Art and Eroticism*, Chicago and London, 1990, p. 241. Barbara Stafford, *Artful Science: Enlightenment, Entertainment, and the Eclipse of Visual Education*, Cambridge, Mass., and London, 1994, pp. 114–15 (ill.).

EXHIBITIONS: The Minneapolis Institute of Arts, *French Eighteenth-Century Painters*, 1954 (not in cat.). The Art Institute of Chicago, *Great French Paintings: An Exhibition in Memory of Chauncey McCormick*, 1955, no. 16, as *An Actor as Don Quixote*. Kansas City, Missouri, The Nelson Gallery and Atkins Museum, *The Century of Mozart*, no. 35, as *An Actor in the Role of Don Quixote* (cat. published as *The Nelson Gallery and Atkins Museum Bulletin* 1, 1 [1956]). Washington, D.C., National Gallery of Art, *100 European Paintings and Drawings from the Collection of Mr. and Mrs. Leigh B. Block*, 1967, no. 1, as *Portrait of a Man as Don Quixote*, traveled to Los Angeles and Boston. The Art Institute of Chicago, *Masterpieces from Private Collections in Chicago*, 1969, not numbered, as *Portrait of a Man as Don Quixote*. The Art Institute of Chicago, *European Portraits, 1600–1900, in The Art Institute of Chicago*, 1978, no. 9, as *Portrait of a Man* or *Don Quixote*. Houston, The Museum of Fine Arts, *A Magic Mirror: The Portrait in France, 1700–1900*, 1986–87, no. 15, as *Portrait of a Man (Don Quixote)*. Paris, Galeries Nationales du Grand Palais, *Fragonard*, 1987–88, no. 128, cat. by Pierre Rosenberg, traveled to New York.

The repertoire of Jean Honoré Fragonard, one of the most inventive artists of the rococo period, ranged from history paintings to landscape and genre subjects, often of an erotic nature. First trained by Chardin (see 1944.699) and Boucher (see 1931.938), Fragonard won the *Prix de Rome* of the Academy in 1752 (though he was not yet a student there) with his painting *Jeroboam Sacrificing to the Idols* (Paris, Ecole nationale supérieure des Beaux-Arts). He then entered the Ecole

royale des elèves protégés, where students prepared for their studies in Italy. In 1756 Fragonard arrived in Rome, where he entered the Academy under the watchful eye of Charles Joseph Natoire, its director, and met such artists as Hubert Robert (see 1900.382–85). He also became acquainted with the illustrious amateur Jean Claude Richard, abbé de Saint-Non (1727–1791), who gave the young painter every artistic encouragement (and often financial support as well). Fragonard and the abbé traveled together through Italy and France, returning in 1761 to Paris. There Fragonard became something of a sensation at the Salon of 1765 with his monumental *Coresus and Callirhoe* (Louvre), the picture that gained him acceptance into the Academy as an associate member *agréé*. It was probably around this time that Fragonard began his celebrated group of paintings known as the *figures de fantaisie*, with which the Chicago *Portrait of a Man* is usually grouped.

Few eighteenth-century paintings arouse curiosity and impress so much as Fragonard's exuberantly painted *portraits de fantaisie*.[8] The appellation applies generally to a group of five female and ten male portraits, the Chicago picture among them.[9] The paintings are of comparable formats (approximately 80 by 65 cm), and

most of the sitters are depicted in half length, wearing fanciful costumes, usually with white ruffs or high collars.[10] Each figure stands either behind or beside a parapet or other prop, and most have attributes.[11] Perhaps the most distinguishing characteristic of these pictures is the rapid, virtuosic manner of their execution; the works are summarily painted in daubs, slashes, and undulating strokes. Not all of the sitters for the *figures de fantaisie* have been identified. Some were Fragonard's friends, and many, such as Denis Diderot, the abbé de Saint-Non, and La Guimard, were connected with the arts.

The *Presumed Portrait of La Bretèche* (Louvre) of 1769, one of two signed pictures and the only one clearly dated of the *figures de fantaisie*, provides a chronological linchpin for the group of portraits, which have been variously dated between 1764 and 1773.[12] This period, before Fragonard's second trip to Italy, in October 1773, was marked by his stylistic assimilation of Italian models, in the *figures de fantaisie* and in other works. The *figures de fantaisie* may also be regarded as a natural progression from the artist's studies of old men, a series begun after his first stay in Italy and probably executed over many years. One of these studies, the *Bust of an Old Man Wearing a Cap* (Paris, Musée Jacquemart-André),[13] betrays the influence of Giovanni Battista Tiepolo, whose works Fragonard copied on his return to France in 1761.

Little is known about the *figures de fantaisie*, and it has not been determined whether they form a single series or several smaller groups, or were conceived as individual portraits. Some are easily seen as pairs, such as two paintings in the Louvre, the *Presumed Portrait of the abbé de Saint-Non* and the *Presumed Portrait of La Bretèche*, his brother.[14] Charles Sterling (1964) suggested that the *figures de fantaisie* might be grouped by color or attribute, and that the female and male portraits perhaps comprised two separate series. Jacques Vilain believed the pictures formed two series, one created for the duc d'Harcourt, the other for the abbé de Saint-Non.[15] Given the inconsistencies among the pictures, it is also possible that Fragonard did not intend the *figures de fantaisie* as a coherent group (or as groups). For instance, the sitters in Fragonard's *Presumed Portrait of the abbé de Saint-Non* and *Presumed Portrait of La Bretèche* assume a twisted *contrapposto*, while the woman in *The Reader* (Washington, D.C., National Gallery of Art) is presented in profile, and the man in the Chicago work in a more frontal manner.[16] Some of

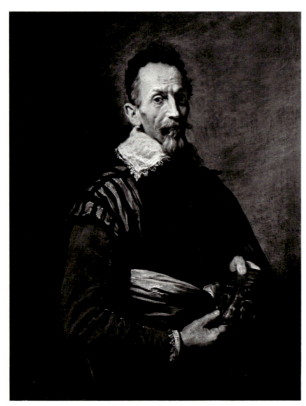

Fig. 1 Domenico Fetti, *Portrait of an Actor (Tristano Martinelli?)*, Hermitage, St. Petersburg

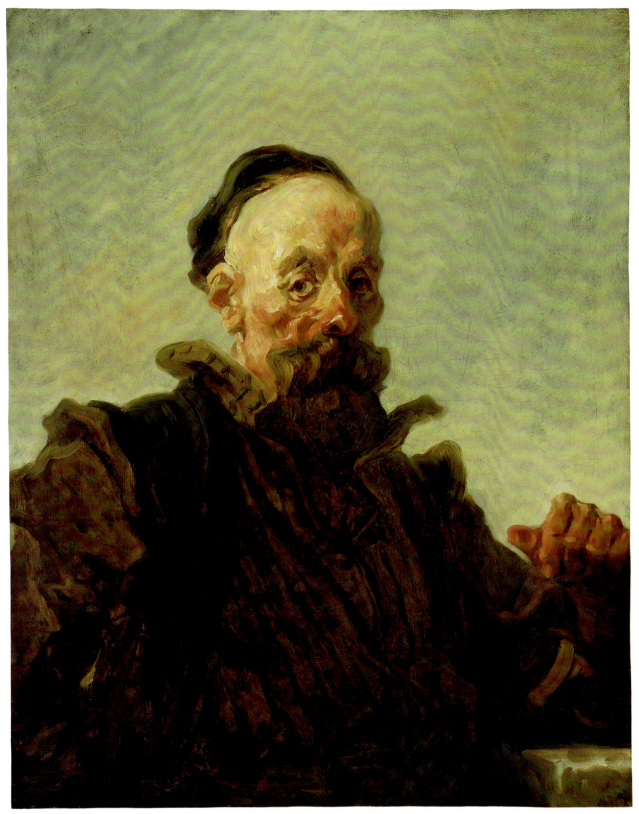

Jean Honoré Fragonard, *Portrait of a Man*, 1977.123

the portraits have dark backgrounds, others light.

In 1847 Théophile Fragonard, the artist's grandson, wrote that "il [Fragonard] recevait chez lui les étrangers de distinction qui n'avaient pas tout vu, quand ils n'avaient pas vu la galerie de tableaux qu'Honoré s'était faite. . . . Cette galerie de tableaux, tout entière de sa main, lui fut enlevée par le duc de Luynes, qui lui paya une somme considérable en or, c'était la condition du marché."[17] Pierre Rosenberg cautiously connected the figures de fantaisie with this galerie, noting that Théophile's declaration gives us no idea how many paintings Fragonard may have had there.[18] But such a gallery would explain why the pictures went unmentioned in the eighteenth century. The unusually direct, sketchlike quality of the figures de fantaisie, as well as their fanciful presentation, which were departures from traditional decorum for formal or official portraiture, also probably account for the dearth of contemporary documentation.

One clue concerning the figures de fantaisie is perhaps provided by the miniaturist Pierre Adolphe Hall, who, in the inventory of his collections, recorded "une tête d'après moi, dans le temps qu'il [Fragonard] faisait les portraits au premier coup pour un louis."[19] This statement is revealing in its implication that Fragonard painted many such sketched portraits. Furthermore, old inscribed labels on the back of the Abbé de Saint-Non and La Brèteche portraits record that each of these likenesses were painted "in one hour."[20] Whether this can be taken literally is not certain, but the portraits obviously were painted with great speed. Such competent, spontaneous pieces would have attracted much attention, and the dazzling display of technical facility would undoubtedly have become a sought-after commodity. Probably conceived as a pair, Fragonard's portraits de fantaisie of the d'Harcourt brothers, now in a Swiss private collection and in the Louvre, remained in the family until the early 1970s, and an oral history concerning the execution of these paintings was passed down through the generations.[21] In 1964 the duc d'Harcourt recalled that "d'après une tradition de sa famille Fragonard aurait peint à Harcourt (Calvados) six portraits ou plutôt six personnages déguisés à l'occasion d'une de ces fêtes qui s'y donnaient fréquemment."[22] Though the statement is not contemporary, it does raise the question as to whether at least some of the portraits were executed as a form of amusement, in the presence of other people.[23] From these accounts, it would seem that Fragonard did not conceive these portraits with an overall scheme, but executed them over many years, and in a manner suited to his own creative enterprise. The variations of presentation and technique can probably be attributed to circumstances of patronage. While some became the possessions of the sitters, others may have been executed for Fragonard's personal gallery. Stylistically, the Chicago work corresponds most closely to the Presumed Portrait of La Bretèche (dated 1769) of the figures de fantaisie, and so the Portrait of a Gentleman should probably be cautiously assigned to 1768/70.

Fragonard was quite conversant with earlier art works and styles, and one can find antecedents for much of his work. From the portraits of the sixteenth-century Venetian painters Titian and Tintoretto, Fragonard derived a warmth of color and the use of architectural props such as parapets. The darker hues and exotically costumed sitters of Rembrandt also left their imprint on the French painter, as did Rubens's Medici Cycle, which Fragonard studied at the Luxembourg Palace. Fragonard's debt to earlier sources is particularly evident in several of the figures de fantaisie for which precise prototypes have been identified.[24] The Chicago Portrait of a Gentleman derives from Domenico Fetti's Portrait of an Actor (Tristano Martinelli?) (c. 1623; fig. 1), itself Venetian-inspired, which belonged to Pierre Crozat in Paris until 1772, when it entered the Russian Imperial collection.[25] Fragonard borrowed the pose and striped costume, and imitated Fetti's semitransparent browns and handling of paint. In its flowing strokes and thick impasto, Fragonard's essay seems an exaggeration of Fetti's painterly technique.

NOTES

1 The thread count of the original canvas is approximately 11 x 13/sq. cm (28 x 32/sq. in.).
2 The treatment was performed by William Leisher.
3 It is described in the sale catalogue as follows: "Un Portrait d'homme ajusté selon le costume espagnol. Ce morceau Etude & d'une touche savante est d'un grand effet. Hauteur 30 pouces, Largeur 24. T." (A portrait of a man dressed in a Spanish costume. This work, sketched and of a sure touch, is of great effect. Height 30 pouces, width 24. Canvas.) The measurements given are equal to 81 x 64.8 cm. The price is recorded in an annotated sale catalogue at the Frick Art Reference Library, New York.
4 An annotated sale catalogue at Galerie Heim, Paris, records the price and indicates that the painting was part of the "Succession de Me de X—."
5 According to Wildenstein 1960; confirmed by Ay-Wang Hsia of Wildenstein, New York (telephone conversation with the author of May 4, 1982; note in curatorial files).
6 According to records at Wildenstein, New York (see note 5).
7 According to records at Wildenstein, New York (see note 5).
8 Regarding the usage of the term figures de fantaisie or portraits de fantaisie in the eighteenth century, see Sheriff (1987, esp.

pp. 81–87), who discussed it in the strictest sense, and Ashton (1988, p. 124), who justified a broader use of the term. For the most comprehensive discussions of the Fragonard paintings, see Wildenstein 1960, pp. 13–15; Sterling 1964; Pierre Rosenberg and Isabelle Compin, "Quatre Nouveaux Fragonards au Louvre, I," *La Revue du Louvre* 24, 4/5 (1974), pp. 183–92; Pierre Rosenberg and Isabelle Compin, "Quatre Nouveaux Fragonard au Louvre, II," *La Revue du Louvre* 24, 4/5 (1974), pp. 263–78; Vilain 1980, pp. 87–88; Sheriff Jones 1981, pp. 79–195; Sheriff 1987, pp. 77–87; Rosenberg in the 1987–88 exhibition catalogue, pp. 255–93; and Cuzin 1988, pp. 102–25.

9 Cuzin 1988, pp. 292–95, nos. 169–82, 184 (ill.). Sterling (1964) and Vilain (1980) did not believe that the Chicago work should be included among the *figures de fantaisie*. From at least the mid-1950s until the mid-1980s, the sitter was often identified either as Don Quixote or as an actor or a man dressed as Don Quixote (according to registrar's records, The Art Institute of Chicago, and exhibition catalogues from those years); however, there is no basis for its association with this literary hero.

10 See Sterling 1964 and François Pupil, *Le Style troubadour, ou la nostalgie du bon vieux temps*, Nancy, 1985.

11 The positioning of many of the figures, so that they are seen from slightly below, prompted Sterling (1964) to suggest that they may have been intended as overdoors. Two more portraits, *A Cavalier Seated by a Fountain* (Barcelona, Museu d'Art Modern) and the *Portrait of Jérôme de Lalande* (Paris, Musée du Petit Palais), are usually discussed in connection with the group, but differ in format; for these see Cuzin 1988, p. 295, no. 183 (ill.), p. 313, no. 279 (ill.), respectively. Only Wildenstein (1960, p. 14) included the *Portrait of François de Bourbon, Count d'Enghien* (Cuzin 1988, p. 300, no. 209 [ill.]) in the group. *A Cavalier Seated by a Fountain*, a considerably larger picture, is the only full-length figure, and the *Portrait of Jérôme de Lalande*, of smaller format, is more highly finished than the other *figures de fantaisie*. Cuzin (1988, p. 313, no. 279 [ill.]) persuasively dated the latter portrait to c. 1775. Rosenberg (1987–88 exhibition catalogue, pp. 261–63, no. 126 [ill.]) included it among the *figures de fantaisie*.

12 For dating see Wildenstein 1960, pp. 13–14; Sheriff Jones 1981, pp. 89–90; Rosenberg in the 1987–88 exhibition catalogue, pp. 255–93; and Cuzin 1988, p. 120.

13 For an illustration of this work, see Cuzin 1988, p. 291, no. 166.

14 Ibid., pp. 292–93, nos. 173 (ill.), 172 (ill.), respectively. Most scholars accept this pairing. They were together in the La Caze collection, and possibly even earlier, and once bore similar eighteenth-century labels identifying the sitters and dating the portraits.

15 Vilain 1980, p. 88.

16 For an illustration of *The Reader*, see Cuzin 1988, p. 294, no. 179.

17 Théophile Fragonard, quoted in Catherine Valogne, "Fragonard, mon grand-père," *Les Lettres françaises* (February 17, 1955), p. 9: "He [Fragonard] received many distinguished foreigners, who had not seen everything if they had not seen the gallery of paintings that Honoré had made for himself. . . . This gallery of paintings entirely by his own hand was acquired from him by the Duc de Luynes [probably Louis Joseph, 1748–1807], who paid him a considerable sum of gold; those were the conditions for the deal."

18 See the 1987–88 exhibition catalogue, p. 256.

19 See Frédéric Villot, *Hall, célèbre miniaturiste du XVIIIe siècle: Sa Vie, ses oeuvres, sa correspondance*, Paris, 1867, p. 74: "A head of me, from the time when he [Fragonard] used to make portraits in one fell swoop for a louis." The location of the portrait of Hall (Cuzin 1988, p. 291 [ill.], p. 347, no. L64) is unknown.

20 Cuzin 1988, pp. 292–93, nos. 172–73 (ill.).

21 For one portrait, *François Henri, Duke d'Harcourt* (Switzerland, private collection), see Cuzin 1988, p. 293, no. 176 (ill.); for the other, *Portrait of Anne François d'Harcourt, Duke de Beuvron* (Louvre), see ibid., p. 293, no. 177 (ill.).

22 Renseignements communiqués par le duc d'Harcourt, Novembre 1964 (Louvre, Service d'etude et de documentation, Département des peintures): "According to family tradition Fragonard had painted at Harcourt [Calvados] six portraits, or rather six persons disguised on the occasion of one of these entertainments which were given there frequently." A more extensive quote from the duc d'Harcourt is published in Vilain 1980, p. 88. See also Sheriff 1987, p. 86.

23 Vilain (1980, p. 88) also suspected this.

24 For instance, the *Portrait of Diderot* (Louvre) after Louis Michel Vanloo's portrait of the same sitter (Musée de Langres). See Cuzin 1988, p. 293, no. 174 (ill.), and Yann le Pichon, *Le Musée retrouvé de Denis Diderot*, Paris, 1993, p. 4 (ill.), respectively. For further discussion of prototypes for the *figures de fantaisie*, see Sheriff 1987, pp. 81–83.

25 See Boris Piotrovsky, *The Hermitage: Its History and Collections*, tr. by Ludmila N. Lezhneva, New York, 1982, p. 124, fig. 5; and *Da Leonardo a Tiepolo: Collezioni italiani dell'Ermitage di Leningrado*, exh. cat., Milan, Palazzo Reale, 1990, p. 92, no. 29 (ill.). Fragonard is said to have copied this painting in pastel (sold Hôtel Drouot, Paris, February 5, 1912, no. 47 [ill.]; location unknown); Sterling (1964) believed the copy was by Fragonard, but Georges Wildenstein did not accept his authorship (letter of September 29, 1983, from Daniel Wildenstein to Mary Kuzniar, in curatorial files).

French

Still Life with Eggs and a Leg of Mutton, 1780/90

The Stickney Fund, 1924.1042

Oil on canvas, 79.9 x 92.2 cm (31⁷/₈ x 36⁵/₁₆ in.)

CONDITION: The painting is in poor condition. It was cleaned in 1961.[1] The canvas has an old glue paste lining. The tacking margins have been cut off, and cusping is visible at all but the left edge of the lightweight canvas.[2] The off-white ground is visible through the paint surface, which has been severely abraded by cleaning. This abrasion accounts for the thinness of the paint surface and loss of definition in the forms. There are several small localized losses along the bottom third of the picture, particularly in the table at the bottom left and center and in the tablecloth. A few smaller losses, on the side of the

frying pan, have been filled and inpainted, and there are scattered areas of minor retouching in the upper half of the picture. (infrared, ultraviolet, x-radiograph)

PROVENANCE: Camille Groult (d. 1908), Paris; sold Galerie Georges Petit, Paris, June 21–22, 1920, no. 49, as attributed to Chardin, to Delaborderie for Fr 15,000.[3] Ehrich Galleries, New York, by 1923, to 1924; sold Anderson Galleries, New York, November 12, 1924, no. 56 (ill.), as Chardin, to William Macbeth, Inc., New York, for $2,200.[4] Purchased from Macbeth by the Art Institute through the Stickney Fund, 1924.

REFERENCES: AIC 1925, pp. 44 (ill.), 130, no. 56. R[ose] M[ary] F[ischkin], "A Still Life by Chardin," AIC Bulletin 19, 3 (1925), pp. 33–34 (ill.). Ella S. Siple, "Art in America: The Art Institute of Chicago—The Ryerson Collection," Burl. Mag. 51 (1927), p. 240, pl. II. AIC 1932, pp. 40 (ill.), 146. Alfred M. Frankfurter, "Art in the Century of Progress," Fine Arts 20, 2 (1933), p. 61. Georges Wildenstein, Chardin, Paris, 1933, p. 228, no. 953, fig. 225. AIC 1935, pp. 26–27. Margaret Breuning, "Current Exhibitions," Parnassus 8, 7 (1936), p. 31. R[eginald] H[oward] Wilenski, French Painting, rev. ed., Boston, 1949, p. 124. AIC 1961, p. 164. Daniel Wildenstein and Gabriele Mandel, L'opera completa di Honoré Fragonard, Classici dell'arte 62, Milan, 1972, p. 112, no. 580 (ill.). Pierre Rosenberg, L'opera completa di Chardin, Classici dell'arte 109, Milan, 1983, p. 115, no. R10 (ill.). Wright 1991, vol. 1, p. 440, vol. 2, pp. 62, 664.

EXHIBITIONS: Paris, Galerie Georges Petit, Exposition Chardin et Fragonard, 1907, no. 69 (cat. in L'Art et les artistes, special issue [June–July 1907]). The Art Institute of Chicago, A Century of Progress, 1933, no. 212, as Chardin. New York, Marie Harriman Gallery, Chardin and the Modern Still Life, 1936, no. 5, as Chardin. Poughkeepsie, New York, Vassar College Art Gallery, Problem Pictures: Paintings without Authors, 1965, no. 19, as attributed to Fragonard. The Art Institute of Chicago, Selected Works of Eighteenth-Century French Art in the Collections of The Art Institute of Chicago, 1976, no. 21.

Partly because it bore a spurious "Chardin" signature (removed by 1950), this painting was believed in the first decades of this century to be by that artist.[5] The experts of the 1920 sale hesitatingly described it as only "attribué à" Chardin, but the 1924 sale catalogue listed the painting as a Chardin, and it was with that attribution that it was acquired by the Art Institute.[6] Georges Wildenstein (1933) rejected the Chardin attribution, and in 1939 Charles Sterling stated that the painting was "not by Chardin but some follower influenced by Fragonard."[7] By 1950 the Chardin attribution had been dropped by the museum and the painting was designated simply as "French, eighteenth century."[8] From 1961 to 1976, the painting, which probably dates from the 1780s, was given to Fragonard, presumably because of its fluid, sketchlike technique; this was, however, a

dubious assertion, since no still lifes from that artist's hand are known.[9]

As early as 1969, Pierre Rosenberg advanced the name Michel Honoré Bounieu (1740–1814) as the artist responsible for this painting.[10] Bounieu was a painter and engraver who treated a wide variety of subjects. A student of Jean Baptiste Marie Pierre, he was agréé in 1767, but never became an académicien. Briefly, between 1792 and 1795, he also was keeper of the Cabinet des estampes in the Bibliothèque Nationale.[11] Bounieu's Preparation of the Pot-au-feu in the Louvre, which also once bore a false Chardin signature, is the artist's only known signed still life.[12] Michel Faré, who agreed with the Bounieu attribution for the Chicago canvas, assigned several other still lifes to this artist: The Kitchen Table (Paris, private collection), Still Life with a Cabbage and Chunks of Meat (Neuilly, "A. G." collection), and the Kitchen Table (Caen, Musée des Beaux-Arts).[13] While there is some affinity between the Chicago canvas and these four still lifes, the former cannot be convincingly associated with Bounieu's oeuvre. The four Bounieu still lifes are stylistically homogenous and show (as do many still lifes of the period) the influence of Chardin's still lifes of the late 1720s, especially in the tightly organized, dense groupings of objects placed against monochromatic backdrops. The Chicago picture is somewhat different. The space in this predominantly horizontal composition is less clearly indicated, the execution freer, and the forms more suggested than defined, especially toward the rear where the carrots and pot lid are partially obscured by steam. Neither the cloth nor the vegetables have the palpable qualities of those rendered by Bounieu.

NOTES
1 This treatment was performed by Alfred Jakstas.
2 The thread count of the original canvas is approximately 10 x 12/sq. cm (25 x 30/sq. in.).
3 Although this was an anonymous sale, an annotated sale catalogue in the Rijksbureau voor Kunsthistorisches Documentatie, The Hague, identifies the sale as that of Groult (see also Frits Lugt, Répertoire des catalogues de ventes publiques, vol. 4, Paris, 1987, p. 549, no. 80812). Price and buyer are also recorded in the catalogue.
4 In 1923 Ehrich Galleries sent the painting to the Art Institute for consideration for purchase by Martin A. Ryerson (according to registrar's records). Anderson Galleries sold the contents of the Ehrich Galleries when that business dissolved. Price and buyer are recorded in an annotated sale catalogue at the Frick Art Reference Library, New York.
5 According to a memorandum of March 2, 1950, from Frederick Sweet to Margaret Bush (registrar), in curatorial files.
6 The author of the 1933 exhibition catalogue suggested that the

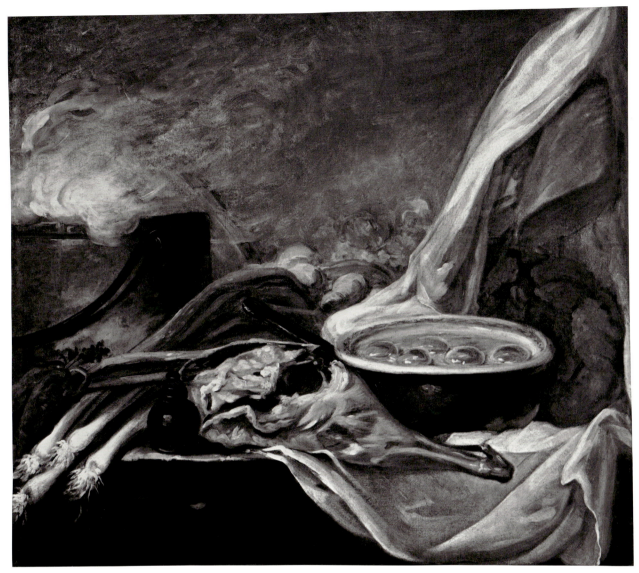

French, *Still Life with Eggs and a Leg of Mutton*, 1924.1042

Chicago picture might have been the painting that appeared in the 1859 Houdelot sale (Paris, Hôtel Drouot, December 12–14, 1859, no. 22), but the Houdelot painting has since been identified as Chardin's *Cauldron, a Pot, Some Eggs, and a Pepper Mill* (Louvre).

7　According to registrar's records.

8　According to a memorandum from Frederick Sweet to the registrar (see note 5).

9　It is not clear who first proposed the name Fragonard, but the painting was listed as "attributed to Fragonard" in the 1961 catalogue of the Art Institute's paintings. According to a letter of April 18, 1966, from John Maxon to Daniel Wildenstein (in curatorial files), Georges Wildenstein had thought the Fragonard attribution plausible. As noted above, the suggestion of Fragonard's influence had also been made by Charles Sterling in 1939. The painter of the Chicago still life must have been familiar with Fragonard's style, but had neither the painter's sure touch nor his economy of brushwork. Donald Posner (letter of October 16, 1986, to Martha Wolff, in curatorial files) has suggested that the painting may have been executed in the

nineteenth century, a product of the "rediscovery" of Fragonard in that century.

10　According to a memorandum of April 16, 1969, from Charles C. Cunningham to Joseph Rishel, in curatorial files.

11　The principal sources of information on Bounieu are the reviews from the years he exhibited at the Salon (1769, 1771, 1775, 1777, 1779). See also the *Oeuvre de Bounieu*, Paris, 1785 (Bibliothèque Nationale, Cabinet des estampes, AA1 Suppl. rel/Dc 19 in fol), a catalogue of his works drawn up when he relinquished his atelier in 1785. That sale, of March 24, 1785, is noted in Emile Bellier de la Chavignerie and Louis Auvray, *Dictionnaire générale des artistes de l'école française*, vol. 1, Paris, 1882, p. 143.

12　For an illustration of Bounieu's *Preparation of the Pot-au-feu*, see Musée du Louvre, *Catalogue illlustré des peintures: Ecole français, XVIIᵉ et XVIIIᵉ siècles*, Paris, 1974, p. 41, fig. 67.

13　Letter of June 25, 1982, from Michel Faré to the author, in curatorial files; see also Michel Faré and Fabrice Faré, *La Vie silencieuse en France: La Nature morte au XVIIIᵉ siècle*, Fribourg and Paris, 1976, figs. 307–08, 310.

French

Woman in a Straw Hat, c. 1790

Gift of John Wentworth, 1942.308

Oil on canvas, 81.4 x 64 cm (32 1/16 x 25 13/16 in.)

CONDITION: The painting is in fair condition. The canvas has an old glue paste lining.[1] Areas of lifting paint were consolidated in 1956.[2] The picture was cleaned, varnished, and retouched in 1962.[3] The original tacking margins have been cut off, but cusping is visible at all four edges, suggesting that the painting is close to its original dimensions. A narrow strip of canvas has been added to square the canvas along the top edge. There is a vertical tear, 3 cm in length, in the background to the left of center. The ground is off-white. The paint layer has been slightly flattened and the canvas weave has become pronounced due to the lining process. There is abrasion in the face (especially in the shadows under the brim of the hat), in the feather plume, on the blue satin ribbons, and in the gold drapery of the stole. There are two large areas of loss at the upper left corner and along the bottom center edge of the picture; the largest measures 14 cm in length. Numerous additional small losses are scattered around the perimeter of the picture. There are localized, discolored retouches over these losses and scattered in the background, face, and drapery. (infrared, mid-treatment, ultraviolet, x-radiograph)

PROVENANCE: Possibly the New York art market.[4] Lizzie Shaw Hunt Wentworth, Chicago, by 1923; by descent to her son, Hunt Wentworth (d. 1929), Chicago; at his death to his brother, John Wentworth;[5] given to the Art Institute, 1942.

REFERENCES: AIC 1961, p. 462.

EXHIBITIONS: Iowa, Sioux City Art Center, 1949 (no cat.). The Denver Art Museum, *History of Costume Exhibition*, 1956 (no cat.). The Art Institute of Chicago, *Selected Works of Eighteenth-Century French Art in the Collections of The Art Institute of Chicago*, 1976, no. 24.

An attribution for *Woman in a Straw Hat* has not been satisfactorily determined, nor is the sitter's identity known. The painting has been at various times given to Elisabeth Louise Vigée-Le Brun and to Adélaïde Labille-Guiard.[6] In 1982 Jean François Méjanes advanced the name Jean Laurent Mosnier (1743/44 [?]–1808), an intriguing but not altogether convincing suggestion.[7] A successful portraitist and painter of miniatures, Mosnier divided his career among four cities: his years in Paris were followed by a period in London, where he took refuge during the French Revolution; from 1796 to 1800,

he worked in Hamburg; and he spent the last years of his life in St. Petersburg.

Méjanes based his attribution on the resemblance of *Woman in a Straw Hat* to a portrait, presumed to be by Mosnier, entitled *Elisabeth Hudtwalcker* (Hamburg, Kunsthalle) of c. 1798.[8] There are several similarities between these two works, specifically the sitter's pose, the rendering of drapery and of the mouth and eyes, and, especially, the way in which the figure is strongly lit from above to create a shadow over the sitter's forehead and eyes. These portraits can in turn be compared with Mosnier's *Portrait of a Lady (probably Lady Granard)* (California, private collection), a signed and dated work of 1792, in which the light source also comes from above, causing a hand to cast a shadow over the bridge of the sitter's nose, her forehead, and her left eye, and with the *Portrait of Friederike Leisching* (Kiel, Kunsthalle), painted in 1799.[9] All these portraits exhibit the influence of English painting, particularly that of Romney, in their soft modeling and broadly brushed, translucent draperies.

The attribution of the Chicago picture to Mosnier is problematic, however, in that the work lacks certain characteristics of Mosnier's paintings, such as the artist's imposition of harsh linear details on a very sculptural rendering of the sitter, and his typically thick application of paint. These discrepancies may be due to the condition of the Chicago portrait, which is badly abraded (see Condition). The forms at lower right, apparently a fur muff and blue ribbon, are difficult to read, and the paint in the shadowed area of the face is so thinned that one cannot adequately compare the manner of the execution of the eyes — a distinguishing feature of Mosnier's portraits — to that in paintings known to be by Mosnier. In light of its condition, it seems preferable to catalogue the painting simply as eighteenth-century French.

Although the authorship of *Woman in a Straw Hat* remains a question, an approximate date of around 1790 for the execution of the painting can be deduced from

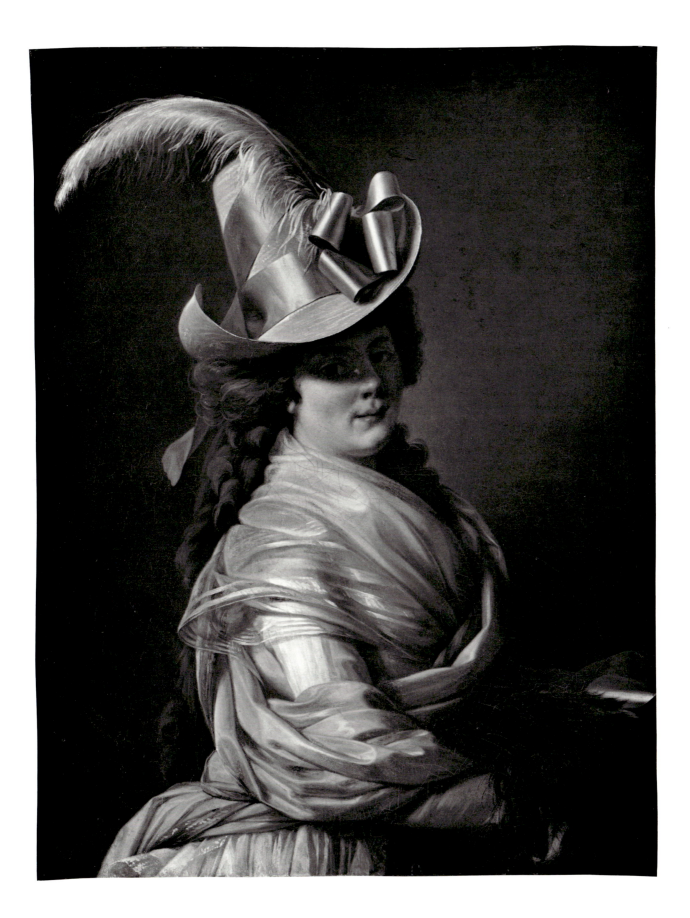

the sitter's costume. The unidentified woman wears a tall-crowned straw hat wrapped with a broad blue satin ribbon, the bow of which secures a tall, white plume. The dress was probably made of muslin or lightweight silk, and the kerchief of muslin or silk gauze; the rich golden stole, embellished with pink and blue stripes along its edge, would probably have been cashmere. The sitter's hat and hairstyle, the stole tied at the back, and the apparently low waistline of the skirt were all in fashion around 1790.[10]

NOTES

1 The thread count of the original canvas is approximately 11 x 12/sq. cm (27 x 30/sq. in.).
2 This treatment was performed by Leo Marzolo.
3 This treatment was performed by Alfred Jakstas.
4 According to registrar's records, the picture may have been with Anderson Gallery "before 1936" or with the Ehrich-Newhouse Gallery.
5 The Wentworth provenance is confirmed by Lizzie Shaw Hunt Wentworth's deed of gift, dated May 9, 1923, by Carroll N. Anderson's appraisal of paintings in the estate of Hunt Went-

worth, dated May 16, 1930 (copies of both are in curatorial files), and by conversations on February 17 and 22, 1988, between the author and Eric Wentworth, son of John Wentworth (notes in curatorial files).
6 In Lizzie Shaw Hunt Wentworth's deed of gift and in an appraisal of paintings in the estate of Hunt Wentworth (see note 5), the Chicago painting was identified as *Madame Raymond* by Vigée-Le Brun, but this identity has never been confirmed. In 1942 the painting was accessioned as *Portrait of a Lady with Straw Hat*, attributed to Vigée-Le Brun. By 1974 the attribution had been changed to Labille-Guiard. In 1976 J. Patrice Marandel (1976 exhibition catalogue) changed the attribution to "French School." Joseph Baillio (letter of April 24, 1981, to the author, in curatorial files) also suggested the name of Louis Landry.
7 Verbal communication to the author.
8 See Hamburg, Kunsthalle, *Katalog der alten Meister der Hamburger Kunsthalle*, 1966, p. 117, no. 485 (ill.).
9 For illustrations of these works, see *From Watteau to David: A Century of French Art*, exh. cat., New York, Christophe P. Janet and Maurice Segoura Gallery, 1982, no. 15 (ill.); and Kunsthalle zu Kiel, *Katalog der Gemäldegalerie*, Kiel, 1958, p. 106, pl. 9, respectively.
10 Letter of February 15, 1982, from Aileen Ribeiro to the author, in curatorial files. Waistlines began to rise around 1792. For a brief discussion of hats, see Aileen Ribeiro, *Dress in Eighteenth-Century Europe, 1715–1789*, London, 1984, p. 160.

French

Architectural Landscape with Belisarius Receiving Alms, probably after 1760

Bequest from the Estate of Agnes W. Stern, 1967.587

Oil on canvas, 81.1 x 124.3 cm (31^{15}/₁₆ x 48^{15}/₁₆ in.)

CONDITION: The painting is in good condition. The canvas has an old glue paste lining.[1] The original tacking margins have been cut off, but cusping is visible on the right and left edges, suggesting that the painting is close to its original dimensions. The relatively thick paint layer, applied over a white ground, has been somewhat abraded by past cleaning, especially in the shadows of the columns on the left side of the arch and in the reddish urn at right. *Pentimenti* are visible in the capitals within the arch. There are three areas of loss. The largest is 7 x 1.3 cm long and extends vertically upward from the lower right of the arch. Another measures 6 x 3 cm and extends vertically over the upper right of the arch. The smallest, located at the lower right of the arch, is 2 x 1.5 cm. A few smaller losses are scattered throughout the painting. There are localized retouches over these losses, covering the *pentimenti* within the arch, along a stretcher bar crack at the top edge, and along the perimeter. (ultraviolet, x-radiograph)

PROVENANCE: Agnes W. Stern (d. 1967), Chicago; bequeathed to the Art Institute, 1967.

The painting entered the museum's collection with an attribution to an unknown imitator of Giovanni Paolo Pannini. Because the numerous followers of Pannini have not been carefully studied, it is difficult to determine whether the artist responsible for the Chicago picture was an Italian or a French painter, working in Rome or elsewhere. The scale and disposition of the figures and monuments, as well as the heroic subject matter, are clearly inspired by the works of Pannini. However, the somewhat cool colors and the dryness of execution suggest a painter familiar with the works of Charles Louis Clérisseau (1721–1820), who was in Rome from 1749 until 1767, or with those of Pierre Antoine De Machy (1723–1807), who probably never visited Italy but absorbed Panniniesque elements from his teacher, Jean Servandoni (1695–1766).[2] Although a French attribution seems likely, an Italian origin for this painting should not be excluded.

The subject of Belisarius receiving alms became popular in the seventeenth and eighteenth centuries, when it was depicted as an example of the transience of fame.

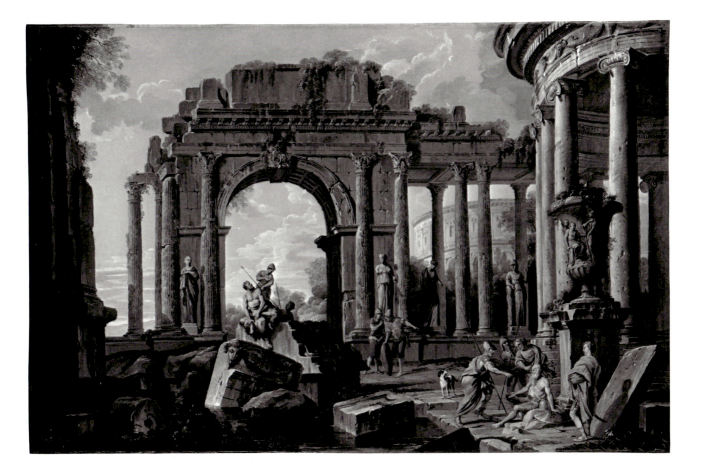

Belisarius, a sixth-century general under the Byzantine emperor Justinian, won great acclaim during his campaigns against the Goths. He was later wrongly accused of conspiracy, deprived of his honors, and imprisoned. According to legend, he was subsequently reduced to poverty. In this painting we see him represented as an elderly, blind beggar at the moment he is recognized by a passing soldier. The ruins underscore the themes of mutability and decay.

NOTES
1 The thread count of the original canvas is approximately 12 x 16/sq. cm (30 x 40/sq. in.).
2 John D. Bandiera (letter of September 15, 1986, to the author, in curatorial files) stated that he believed the work to be French, adding that the "rather dry execution reminds me of De Machy and I recognize elements that are commonly found in his works as well as those of Clérisseau and Delafosse."

French

Portrait of a Woman Artist, c. 1735

Restricted gift of Mrs. Harold T. Martin in honor of Patrice Marandel, 1981.66

Oil on canvas, 101.7 x 82 cm (40 x 32 5/16 in.)

CONDITION: The painting is in very good condition. The canvas has an old wax resin lining.[1] The tacking margins have been cut off, but cusping is visible at all edges, indicating that the painting is close to its original dimensions. The lining canvas extends approximately 0.7 cm beyond the original support on all sides. The tan- or cream-colored ground is visible through the paint surface in some areas. A 2.5 x 1.3 cm hole in the green robe in the area of the figure's right breast has been filled with a canvas insert. There is another small hole, measuring approximately 1 cm square, in the robe at the lower left. The paint surface is somewhat abraded in the whites of the swansdown tippet, on the figure's right sleeve, on the paper she holds, and in the dark shadows of the drapery folds. There are retouches over the two filled losses and over a 13 cm vertical line on the robe at lower left. A few small areas of minor retouching are scattered in the white tippet, on the figure's left arm, on the palette, and on the robe. (infrared, ultraviolet, x-radiograph)

PROVENANCE: Augustin Alexandre Dumont, to 1880; at his death to Mme Léon Ginain, his first wife; by descent to her son-in-law, Dr. E. Audard, Paris.[2] Sold by Audard to Wildenstein, 1925.[3] Wildenstein, Paris, to at least 1935.[4] Virginia M. (Mrs. Moritz) Rosenthal (d. 1945), New York, by 1942; sold Parke-Bernet, New York, April 13–14, 1945, no. 202 (ill.), as Carle Vanloo, *Anne Coypel*, for $7,500.[5] Sold Christie's, London, June 29, 1973, no. 14 (ill.), as Carle Vanloo, *Portrait of a Lady Artist Said to Be Madame Coypel*, to LeJeune for $13,125.[6] Sold Christie's, London, May 3, 1974, no. 71, as Carle Vanloo, *Portrait of a Lady Artist Said to Be Madame Coypel*, to Anton for $7,728.[7] Sold Palais Galliera, Paris, June 7, 1974, no. C (ill.), as Carle Vanloo. Galerie Heim, Paris, by 1975.[8] Sold by Heim to the Art Institute, 1981.

REFERENCES: G[ustave] Vattier, *Une Famille d'artistes: Les Dumont, 1660–1884*, Paris, 1890, p. 10 n. 1. Le comte Arnauld Doria, *Louis Tocqué*, Paris, 1929, p. 100, no. 60. Pierre Berthelot and G. Brunon-Guardia, "Notes from Paris," *Antiquarian* 17, 2 (August 1931), p. 52 (ill.). S[amuel] Rocheblave, *French Painting in the XVIIIth Century*, tr. by George Frederic Lees, Paris, [1937], pl. 28 (ill. in error as Aved).

EXHIBITIONS: Copenhagen, Palais de Charlottenborg, *Exposition de l'art français au XVIIIe siècle*, 1935, no. 234, as Carle Vanloo, *Anne Coypel peignant*. New York, Parke-Bernet, *French and English Art Treasures of the XVIII Century*, 1942, no. 61, as Carle Vanloo, *Anne Coypel*. Paris, Galerie Heim, *Le Choix de l'amateur, 1975: Sélection de peintures et sculptures du XVe au XIXe siècle*, 1975, no. 31, as Carle Vanloo.

The Dumont family and heirs, who owned this rich and complexly animated portrait from the late eighteenth century until 1925, traditionally ascribed the work to Louis Tocqué (1696–1772), an attribution rejected by Arnauld Doria in 1929. When Wildenstein acquired the picture, he proposed Carle Vanloo (1705–1765), whose name the portrait bore until it was acquired by the Art Institute in 1981. But this attribution has also been questioned, as relatively few documented female portraits by Vanloo are known, and none compares closely with the Chicago canvas.[9]

The provenance of the painting has prompted speculation that the artist was Jacques Dumont, called Dumont le Romain (1701–1781), the younger brother of the better-known sculptor François Dumont.[10] In fact, the Dumont family believed that the sitter was Anne Françoise Coypel, born in 1686 (the first child of Noël Coypel and his second wife, Anne Françoise Perin), and married to François Dumont. Though little studied today, Dumont le Romain enjoyed position and celebrity during his long career. His portrait style is particularly well exemplified by the large painting *Madame Mercier Surrounded by Her Family*, signed and dated 1731 (Louvre).[11] Displaying the greatest affinity with the Chicago portrait is Dumont's *Music Lesson*, signed and dated 1733 (location unknown).[12] However, despite physiognomic similarities between the women in the *Music Lesson* and the *Portrait of a Woman Artist*, the styles of the two works are significantly different. Among the other names advanced as the possible author of the Chicago painting have been Louis Michel Vanloo (the nephew of Carle Vanloo), Jacques André Joseph Aved, and, more recently, Jean François Colson, Alexandre Roslin (whose wife was an artist who died young), and Gilles Allou.[13] Unfortunately, the Chicago portrait cannot be connected with certainty to any of these artists.

The sumptuous yet casual attire of the sitter offers some indication of the painting's date. The swansdown tippet contrasts strikingly with the woman's *robe volante*, or morning dressing gown, a garment that originated in the late seventeenth century. A more formal version of this robe developed in the early 1730s, but the wrapping gown with loose pleats and pyramidal

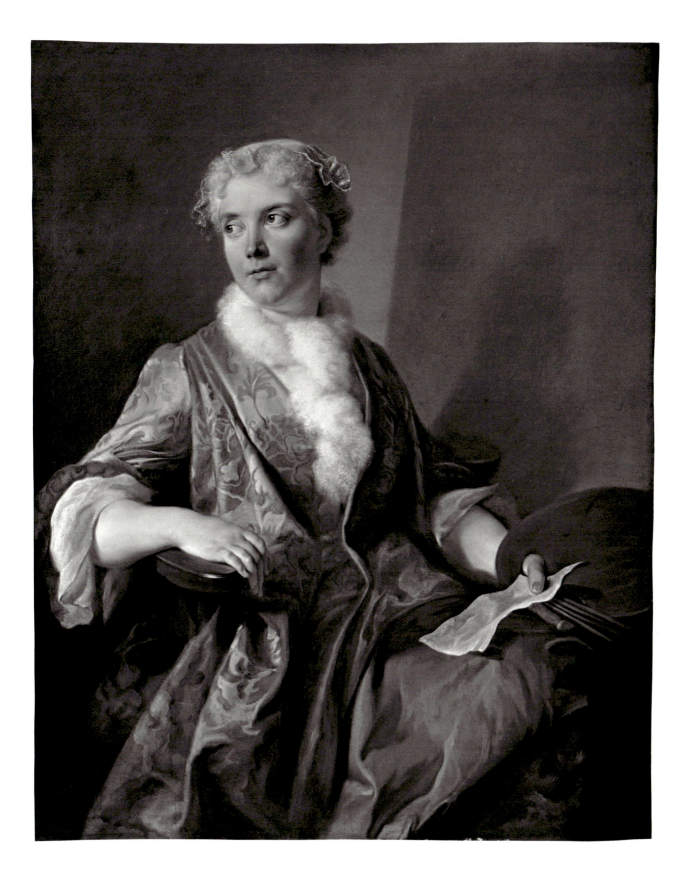

shape remained popular for some years, particularly among women of literary and artistic inclination, and so its presence does not help to narrow the dating of the picture. However, the sitter's short, curled hair, lace-trimmed cap with its barbes pinned to the crown, and large-patterned damask gown (dark green on a background of gray-green) point to a date in the mid-1730s.[14] This date is in keeping with the style of the painting, but would seem to cast doubt on the traditional identification of the sitter as Anne Françoise Coypel, who would have been age forty-nine in 1735; the woman portrayed appears younger than that.

NOTES

1 The thread count of the original canvas is approximately 12 x 10/sq. cm (30 x 25/sq. in.).
2 See Doria 1929; letter of December 11, 1981, from Daniel Wildenstein to the author (in curatorial files); and the 1935 exhibition catalogue.
3 Letter from Daniel Wildenstein to the author (see note 2).
4 Wildenstein lent the painting to the 1935 exhibition.
5 Rosenthal lent the painting to the New York exhibition in 1942. The price paid at the 1945 sale is recorded in an annotated sale catalogue in the Ryerson Library, The Art Institute of Chicago.
6 According to the price list to the catalogue provided by Christie's.

7 According to the price list to the catalogue provided by Christie's.
8 See the 1975 exhibition catalogue.
9 See Carle Vanloo, premier peintre du roi . . . , exh. cat., Nice, Musée Chéret, 1977, which includes a catalogue of the artist's paintings.
10 Suggested by Joseph Baillio, verbally, 1982 (notes in curatorial files). Pierre Rosenberg rejected this attribution in a letter to the author of March 12, 1984, in curatorial files.
11 See Louvre, Catalogue sommaire, vol. 3, Ecole française, A–K, p. 238, no. 511 (ill.).
12 Sold Palais Galliera, Paris, June 18, 1965, no. 135 (ill.).
13 Rosenberg (letter of September 6, 1985, to the author) favored an attribution to Louis Michel Vanloo, although he entertained as well the early attribution to Tocqué. Christine Buckingham Rolland (letter of January 3, 1986, to the author) could not confidently assign the painting to this artist, who was the subject of her doctoral dissertation ("Louis Michel Van Loo [1707–1771]: Member of a Dynasty of Painters," Ph.D. diss., University of California at Santa Barbara, 1994) and has suggested instead that it might be the work of Aved. Sylvain Laveissière (letter of April 18, 1991, to Douglas Druick) associated Colson with the painting. Ann Sutherland Harris (verbally, March 12, 1991, to Martha Wolff, notes in curatorial files) suggested Roslin. Humphrey Wine (letter of July 20, 1994, to Larry Feinberg) tentatively proposed Gilles Allou. All of the letters cited here are preserved in curatorial files.
14 Costume identification and date were provided by Aileen Ribeiro in a letter to the author of February 15, 1982, in curatorial files.

Jean Baptiste Greuze

1725 Tournus–Paris 1805

Lady Reading the Letters of Heloise and Abelard, 1758/59

Mrs. Harold T. Martin Fund; Lacy Armour Endowment; Charles H. and Mary F. S. Worcester Collection, 1994.430

Oil on canvas, 81.3 x 64.8 cm (32 x 25.5 in.)

INSCRIBED: *HELOISE, ABEL* (on the leaves of the open book); *LART / DAIME / DE / BERNA* (on the spine of the closed book)

CONDITION: The painting is in excellent condition. The plain-weave canvas remains unlined and is mounted on what appears to be its original keyed stretcher.[1] The presence of a cream-colored ground on the tacking margins suggests that the canvas was pre-primed. The painting was cleaned in 1994 after its acquisition by the Art Institute.[2] Before this time it had undergone only minimal treatment, which included partial cleaning of the flesh tones and light areas of the dress, probably before the twentieth century, as well as occasional revarnishings. The tactile quality of the paint and the balance of light and dark

tones are exceptionally well preserved. A minute local paint loss in the upper right background has been filled and inpainted. A few vertical striations to the right of the knee may have been caused by drips of a cleaning agent, perhaps during the partial cleaning mentioned above. These have been inpainted. A network of fine age cracks with slightly cupped edges is not visually disturbing. (mid-treatment, verso)

PROVENANCE: David David-Weill, Neuilly-sur-Seine, 1919. Wildenstein, Paris and New York, 1919–24.[3] Albert J. Kobler, New York (d. 1937). Heirs of Albert J. Kobler; sold Parke-Bernet, New York, April 22, 1948, no. 16 (ill.).[4] Private collection, South America, until 1994. Sold by Simon Dickinson, Inc., New York, to the Art Institute, 1994.

EXHIBITIONS: The Art Institute of Chicago, *A Passion for Virtue: An Eighteenth-Century Masterpiece by Greuze*, 1995 (no cat.).

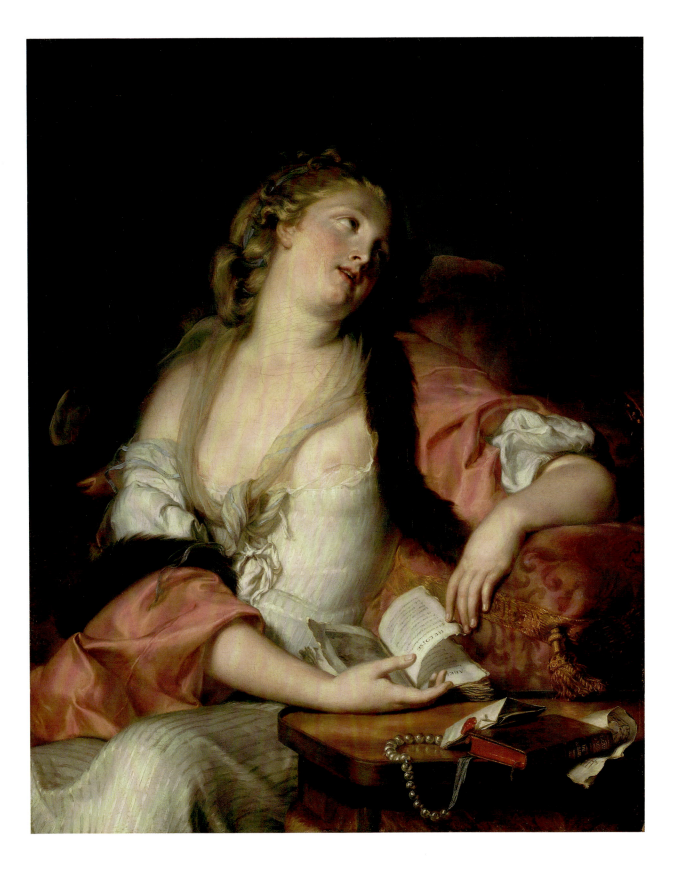

One of the most influential French painters of the third quarter of the eighteenth century, Greuze developed a new type of genre painting that presented critical moments of everyday life with the didactic clarity of history painting. He also excelled as a portrait painter. The son of a master roofer of Tournus, Greuze studied with Charles Grandon in Lyons before settling in Paris in about 1750. He was accepted as an associate member of the Academy in 1755, attracting favorable notice in that year's Salon for paintings that included moralizing genre scenes treated in a Dutch manner, several of which were purchased by the noted amateur Ange Laurent de Lalive de Jully (see 1969.109). Shortly thereafter Greuze traveled to Italy in the company of the abbé Gougenot, returning to Paris in 1757. At the Salon of 1761, the high expectations of his patrons were justified with the critical and popular success of *The Village Bride* (Louvre), painted for the marquis de Marigny.[5] Greuze showed his independence and ambition when, in 1769, he sought full membership in the Academy in the highest category, that of history painter, with the submission of *Septimius Severus Reproaching Caracalla* (Louvre) as his long-awaited reception piece.[6] The Academy members humiliated him, however, by accepting him only in the lesser category of genre painter. Apart from their desire to repay Greuze for his pride, his colleagues criticized the lack of decorum in *Septimius Severus*, which recasts a classical subject as an emotionally charged encounter akin to his moralizing genre scenes. Greuze refused to participate in the Academy exhibitions until after the Revolution, holding separate exhibitions in his studio. Though he remained prolific and financially successful for many years, his career never fully regained its luster.

The *Lady Reading the Letters of Heloise and Abelard* shows Greuze's ability to embody the emotional life of his time, in this case the exaggerated responsiveness of *sensibilité*. A young woman is shown reclining against a generous brocade pillow. She is dressed in elegant *déshabillé*—a white chemise beneath a loosely tied striped wrap with a fur-lined robe slipping from her shoulders. She has been reading an illustrated volume devoted to the ill-fated medieval lovers Heloise and Abelard, whose names are prominently printed on successive pages of text. Her hands no longer grasp the book, however, but relax as she abandons herself to a reverie inspired by her reading. The other objects on the table — a pearl necklace, a letter, a sheet of music, and a volume of Pierre Joseph Bernard's elegantly erotic poem,

L'Art d'aimer— are evidence of refined pastimes with amorous associations.[7] Her absorbed expression and informal dress imply that she is unaware of the viewer and suggest that these pastimes are enjoyed in private, though probably with the consciousness of an absent lover.

The picture has, until now, escaped mention in the literature on Greuze, but must date from about 1759 or even earlier. Edgar Munhall compared it to *The Woolwinder* (New York, Frick Collection) in the handling of the paint, particularly in the striped skirt.[8] The sinuous elaboration of the pose and the treatment of the drapery also relate to the *Portrait of Ange Laurent de Lalive de Jully* in the National Gallery of Art, Washington, D.C., which, like *The Woolwinder*, was exhibited in the Salon of 1759.[9] With the portrait of Lalive de Jully and several other works from the late 1750s, the *Lady Reading* shows Greuze moving away from a painting style and rustic atmosphere influenced by the little Dutch and Flemish masters. Instead he here pays homage to the history paintings of Peter Paul Rubens and Anthony Van Dyck, in the painting technique, with its attention to transparent shadows and reflected light, and also in the lady's pose. The head thrown back, the arm resting on a plump cushion, and the fur-trimmed robe derive from Rubens's depiction of the queen resting after the birth of her child in the Marie de Medici series, then in the Palais du Luxembourg (fig. 1). The diary of Johann Georg Wille testifies to Greuze's admiration for this series and indicates that the two friends had special permission to study the pictures in July 1760, although Greuze could also have studied the series before that date.[10] In addition to his reference to Rubens's painting, his treatment of the figure is indebted to Van Dyck, particularly in the coiling blond hair, the delicate facial type, and the play of rose drapery against flesh, which recall Van Dyck's *Venus at the Forge of Vulcan*, then also in the French royal collection and now in the Louvre.[11]

By quoting from the figure of Marie de Medici in Rubens's *Birth of Louis XIII*, Greuze associated his *Lady Reading* with history painting and its capacity to instruct and generalize about human nature. This particular performance by Rubens was cited by several mid-eighteenth century critics, among them Denis Diderot, as an exemplary visual formulation of the mixture of pleasure and pain.[12] Diderot's reference to the Rubens actually occurs in the context of his description of the troubling sensuality of Greuze's later portrait of his wife, exhibited in the Salon of 1765. Diderot medi-

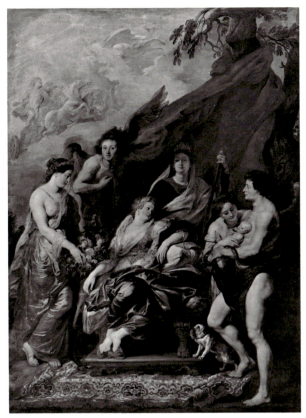

Fig. 1 Peter Paul Rubens, *The Birth of Louis XIII*, Musée du Louvre, Paris [photo: © Agence photographique de la Réunion des musées nationaux, Paris]

tated on Greuze's ability to paint women as occupying a border region between decency and lasciviousness and compared Greuze's virtuosic portrayal of contradictory emotions to Rubens's representation of Marie de Medici resting after the birth of her child.[13] The work described by Diderot, a study of the artist's wife in pastel, is lost, but it is significant that in the Art Institute picture Greuze painted what must be a comparable rapturous sensuality at an earlier date and with overt reference to Rubens's formulation.[14]

Anita Brookner argued that Greuze paid little attention to such titillating subjects between what she considers his first essay in that vein, the *Jeune fille dans la chaleur de la nonchalance*, a lost painting included in the Salon of 1761 among several heads exhibited under a single number, and the middle years of his career.[15] However, the Art Institute's picture shows the care with which he could treat this type of subject as early as 1758/59. It is arguably the earliest, most elegant, and most carefully explicated of Greuze's single figures combining sensuality with an elevated moral tone, a combination that would become increasingly artificial in his later work.

In the case of the Art Institute's picture, the lady's rapturous expression is justified by the work's literary associations, which are both explicit and timely. The story of Heloise and Abelard is represented as the inspiration for her emotion. Greuze depicts the book she is reading with some specificity; it has an engraved illustration facing a page with ten lines of widely spaced text. Their arrangement suggests that the book is verse rather than prose. It could therefore be one of the several French translations of Alexander Pope's *Eloisa to Abelard*, the most renowned of which was Charles Pierre Colardeau's *Lettre d'Héloïse à Abailard*, first published in 1758.[16] The act of reading was an important subject in Greuze's early work, but this picture goes further than his *Father Reading the Bible to his Children*, still in a private collection, or *The Schoolboy Studying his Lesson Book*, in the National Gallery of Scotland,[17] by embodying the reader's response as a generalized state of mind through the allusion to history painting.

The vivid combination of sensuality and high-mindedness in the *Lady Reading* even evokes Jean Jacques Rousseau's use of the prototype of Heloise in his immensely popular novel *Julie, ou la Nouvelle Héloïse*, published at the end of 1760 but written in 1756/58 and known thereafter in manuscript to a limited circle of the author's intimates.[18] Rousseau referred to Heloise and Abelard in several ways apart from his subtitle. He makes it clear that his lovers have read the letters of Heloise and Abelard[19] and offers parallels in the use of the epistolary form, in the situation of the lovers as pupil and teacher, and in the tension that he sets up between passion and virtuous intentions. It is not impossible that Greuze knew of Rousseau's novel, since his patrons and champions, including Lalive de Jully and Diderot, were connected to those friends of Rousseau who had access to the manuscript.[20] Without knowing the exact date of the picture or its patron it cannot be associated directly with Rousseau's novel, but at the least it demonstrates Greuze's ability to touch the vein of contemporary feeling that would also make possible the immediate and extraordinary success of *La Nouvelle Héloïse*.

M. W.

Notes

1 The canvas has a thread count of 16 x 14/sq. cm (40 x 35/sq. in.). For the adoption of keyed stretchers in the 1750s, see Thomas Brachert, "Historische Keilrahmensysteme," *Maltechnik/Restauro* 79 (1973), pp. 234–38. In the lower left corner of the back of the stretcher is a red wax seal with three fleurs-de-lis.

2 The cleaning was performed by Frank Zuccari.

3 According to a letter (in curatorial files) of September 23, 1994, from Joseph Baillio, who also kindly confirmed that Wildenstein acquired the picture from the David-Weill collection.

4 The painting does not appear in the Caroline Greuze sale, Alliance des Arts, Paris, January 25–26, 1843, as claimed in the 1948 sale catalogue. No. 77 in Caroline Greuze's sale, entitled *L'Amoureux Désir*, is a drawing and not a painting.

5 Edgar Munhall, *Jean-Baptiste Greuze, 1725–1805*, exh. cat., Hartford, Conn., Wadsworth Atheneum, 1976, no. 34 (ill.).

6 Ibid., no. 70 (ill.).

7 The book can be identified by the inscription on the spine. Pierre Joseph Bernard (1710–1775) is also known as Gentil Bernard, a flattering epithet bestowed on him by Voltaire. Although the poem is sometimes considered to have been published posthumously, it appeared in several editions in his lifetime. The preface to *L'Art d'Aimer, nouveau poeme en six chants, par Monsieur *****, London, 1760, p. iv, states that it first appeared in 1745 in four cantos and was followed by five editions. The author is very grateful to Bernadette Fort for bringing a copy of this edition to her attention.

8 Verbal communications to Martha Wolff, June 13, 1994, and March 23, 1995. For *The Woolwinder*, see *The Frick Collection: An Illustrated Catalogue*, vol. 2, New York, 1968, pp. 130–33 (ill.). An oval reduction of the Art Institute's picture was sold in Berlin, Keller and Reines, November 1–3, 1904, no. 165 (ill.), and again in New York, Sotheby's, July 17, 1991, no. 147 (ill.).

9 Munhall (note 5), no. 22 (ill.).

10 *Memoires et journal de J.-G. Wille, graveur du roi*, ed. by Georges Duplessis, vol. 1, Paris, 1857, p. 139; see also Munhall (note 5), under no. 25. During this period the Luxembourg was accessible to the public; see Andrew McClellan, *Inventing the Louvre: Art, Politics, and the Origins of the Modern Museum in Eighteenth-Century Paris*, Cambridge and New York, 1984, pp. 13–15, 43–44.

11 *Anthony van Dyck*, exh. cat., Washington, D.C., National Gallery of Art, 1990, no. 56.

12 *Diderot Salons*, ed. by Jean Seznec, Oxford, 1979, vol. 2, p. 37.

13 Ibid., p. 151, describing the effect of the Greuze: "dont la couleur blême, le linge de tête étalé en désordre, l'expression mêlée de peine et de plaisir, montrent un paroxisme plus doux à éprouver que honnête à peindre." (Of which the wan color, the headdress arrayed in disorder, the mixed expression of pleasure and pain, show a paroxysm more sweet to experience than it is decent to paint.)

14 This raises the question of whether the features of Anne Gabriel Babuti, whom Greuze married early in 1759, can also be traced in the idealized figure of the Art Institute painting. Greuze's splendid chalk drawing in the Staatliche Kunsthalle, Karlsruhe, of the head of his sleeping wife does show the same pointed nose, dimpled chin, and bowed lips, but on a woman who is certainly older and presented without idealization; see Munhall (note 5), fig. 11.

15 Anita Brookner, *Greuze: The Rise and Fall of an Eighteenth-Century Phenomenon*, London, 1972, p. 90. For the pictures exhibited in 1761 under a single heading as *Plusieurs Têtes peints*, among them the *Jeune fille dans la chaleur de la non-chalance*, see Jean Seznec and Jean Adhémar, *Diderot Salons*, Oxford, 1975, vol. 1, pp. 98–99.

16 The author is indebted to Bernadette Fort for the suggestion that Greuze here depicts a verse treatment of the exchange between Heloise and Abelard. For various retellings of the story published in France in the late 1750s, see Robert Lauri Anderson, "The Heloise Motif and La Nouvelle Héloïse," Ph.D. diss., University of North Carolina, Chapel Hill, 1969, pp. 41–53.

17 Brookner (note 15), fig. 6 and pl. 1, respectively.

18 See Jean Jacques Rousseau, *Julie, ou la Nouvelle Héloïse*, intro. by René Pomeau, Paris, 1988, pp. lxxxvii–lxxxviii, for a summary of the novel's gestation.

19 Ibid., pt. I, letter 24, and pt. VI, letter 7.

20 Diderot had read the manuscript by 1757; his friendship with Rousseau was at an end by spring 1758, however, and the first firm evidence of his friendship with Greuze dates from 1760. Lalive de Jully, Greuze's patron, was the brother of Elisabeth Sophie, comtesse d'Houdetot, who inspired in Rousseau a passion that was crucial for the composition of the novel and who received a manuscript copy from the author. Further, their cousin and sister-in-law, Louise Florence Lalive d'Epinay, was Rousseau's patroness during the novel's composition, before a rupture in their relations at the end of 1757, precipitated in part by her desire that Rousseau accompany her on a trip to Geneva in the company of Lalive de Jully. The book was eagerly anticipated in court circles after Rousseau read it in manuscript to the duchesse de Luxembourg, his new patroness, for whom he also made a manuscript copy. See *Correspondance complète de Jean Jacques Rousseau*, ed. by K. A. Leigh, vols. 5–7, Geneva, 1967–69, for these manuscript copies and the degree of anticipation the novel aroused.

Follower of Jean Baptiste Greuze

1725 Tournus–Paris 1805

Little Girl Pouting, 1775/1800

Mr. and Mrs. Martin A. Ryerson Collection, 1933.1079

Oil on canvas, 42 x 33 cm (16½ x 13 in.)

CONDITION: The painting is in fair condition. It was cleaned at the Art Institute in 1921, and again in 1962.[1] It has a glue paste lining. The tacking margins have been cut, but 0.7 cm of unpainted canvas remains along the perimeter of the painting.[2] The paint layer, applied over a white ground, has been thinned by cleaning in various areas, especially in the girl's face, neck, and right arm. An age craquelure is visible overall. There is selective inpainting on the chin, nostrils, eyebrows, left eye, left cheek, and the hair above the right shoulder. (x-radiograph)

PROVENANCE: Gustave Rothan (d. 1890), Paris; sold Galerie Georges Petit, Paris, May 29–31, 1890, no. 153 (ill.), as Greuze, to Durand-Ruel. Sold by Durand-Ruel, Paris, to Mr. and Mrs. Martin A. Ryerson, Chicago, 1890;[3] on loan to the Art Institute from 1893; given to the Art Institute, 1933.

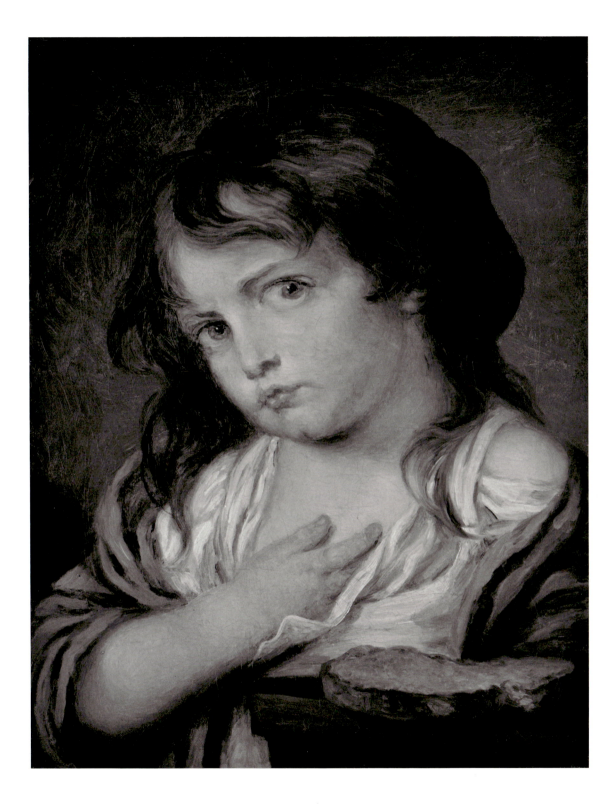

REFERENCES: AIC 1893, p. 10, no. 3. AIC 1894, p. 73, no. 303. Jean Martin, *Oeuvre de J.-B. Greuze*, Paris, 1908, p. 30, no. 438. AIC 1925, p. 160, no. 2042. Rose Mary Fischkin, *Martin A. Ryerson Collection of Paintings and Sculpture, XIII to XVIII Century, Loaned to The Art Institute of Chicago*, unpub. MS, 1926, Ryerson Library, The Art Institute of Chicago, p. 150. AIC 1932, p. 180. Wilhelm R. Valentiner, *Paintings in the Collection of Martin A. Ryerson*, unpub. MS, [1932], Archives, The Art Institute of Chicago, n. pag. AIC 1961, p. 206. Wright 1991, vol. 1, p. 443, vol. 2, pp. 62, 630.

EXHIBITIONS: Chicago, *World's Columbian Exposition*, 1893, revised cat., no. 3111, as Greuze, *The Pouting Child*.

This small picture was previously thought to be by Jean Baptiste Greuze, an attribution rejected by Edgar Munhall.[4] Greuze's moralizing and often saccharine representations of children were very popular in the third quarter of the eighteenth century. Particularly in the latter part of Greuze's career, this type of picture became a staple of his production. As the demand for such pictures grew, the number of painters producing subjects of this type and in the manner of Greuze also increased. Like the painter of the Chicago canvas, most of these imitators possessed neither Greuze's technical skill nor his artistic conviction. In the Chicago work, the drapery is illogical or amorphous in places, and the child's head lacks Greuze's firm modeling.

NOTES
1 The latter treatment was performed by Alfred Jakstas.
2 The thread count of the original canvas is approximately 13 x 11/sq. cm (30 x 27/sq. in.).
3 Shipping order from Durand-Ruel dated July 16, 1890 (Archives, The Art Institute of Chicago).
4 Letter of October 19, 1981, to the author, in curatorial files.

After Jean Baptiste Greuze

1725 Tournus–Paris 1805

Ange Laurent de Lalive de Jully, 1759/70

Given in memory of Forsyth Wickes by Mrs. Forsyth Wickes and Mrs. Ralph Poole, 1969.109

Oil on canvas, oval, 64.3 x 53 cm (25 5/16 x 20 7/8 in.)

CONDITION: The painting is in good condition. It has an old glue paste lining.[1] It was surface cleaned, varnished, and inpainted in 1969.[2] A small, irregularly shaped tear is located right of center, above the sitter's left shoulder. The tacking margins have been cut off. Cusping is present on the top, bottom, and side edges, but not on the curves, indicating that the painting, though close to its original dimensions, may have been modified from a rectangular to an oval format. Horizontal and vertical cracks through the center of the image indicate that the canvas was originally mounted on a stretcher with cross supports; the present stretcher has none. The paint layer, applied over a warm red ground, is generally well preserved. Losses at the tear and in two small areas below the left arm at the lower back of the coat have been filled and inpainted. A large area of discolored overpaint extends above and to the right of the head, and appears to have altered the contour of the hair. This may conceal an artist's *pentimento*, or may be an alteration to the original outline of the hair, made by a later hand (see discussion). (infrared, ultraviolet, x-radiograph)

PROVENANCE: E. Sichel, Paris, 1898.[3] Mrs. Henry Walters, Baltimore, 1941; sold Parke-Bernet, New York, April 30–May 3, 1941, vol. 2, no. 977 (ill.), to A. Cohen, as Greuze.[4]

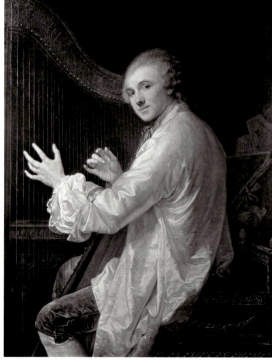

Fig. 1 Jean Baptiste Greuze, *Ange Laurent de Lalive de Jully*, National Gallery of Art, Washington, D.C., Samuel H. Kress Collection [photo: © 1995 Board of Trustees, National Gallery of Art, Washington, D.C.]

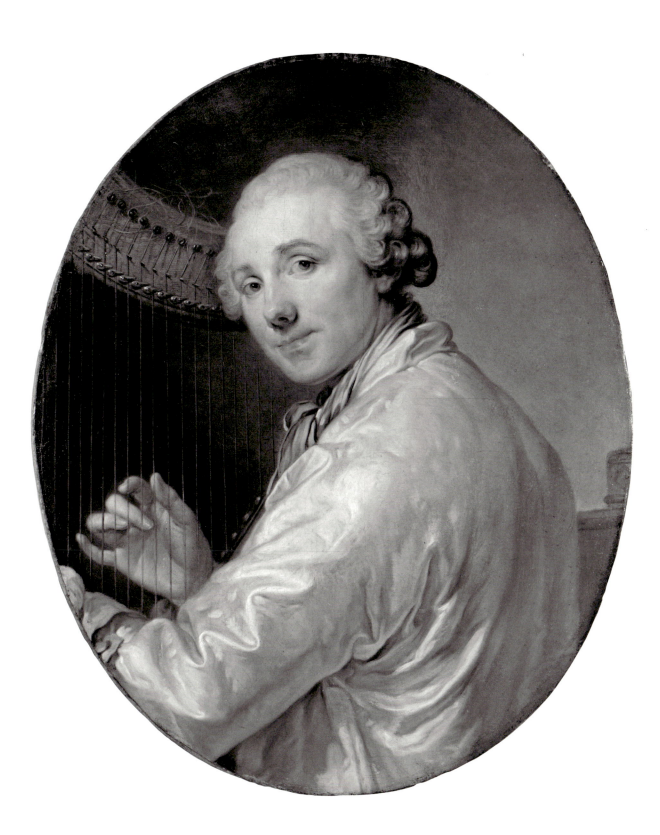

Sold Christie's, London, March 8, 1968, no. 112, to Perman, for 240 gns., as Greuze.[5] Julius Weitzner, London, by 1969; sold by Weitzner to the Art Institute, 1969.

REFERENCES: "Art Institute of Chicago Gets French Collector's Portrait," *New York Times*, May 25, 1970. Ruth Davidson, "Museum Accessions," *Antiques* 98 (1970), p. 704 (ill.). "La Chronique des arts," *GBA* 6th ser., 75 (1970), suppl. to no. 1213, p. 71, no. 328 (ill.). "Recent Accessions," *Apollo* 91 (May 1970), p. 400 (ill.). "Recent Accessions of American and Canadian Museums, January–March 1970," *Art Quarterly* 33 (1970), pp. 322, 329 (ill.). Colin Eisler, *Paintings from the Samuel H. Kress Collection: European Schools Excluding Italian*, Oxford, 1977, pp. 325–26, under no. K1326.

EXHIBITIONS: The Art Institute of Chicago, *Selected Works of Eighteenth-Century French Art in the Collections of The Art Institute of Chicago*, 1976, no. 13, as Greuze.

Sometime after his return to Paris from Italy in the summer of 1757, Greuze painted the impressive three-quarter-length *Ange Laurent de Lalive de Jully* (fig. 1), exhibited at the Salon of 1759 and now in the National Gallery of Art, Washington, D.C.[6] Greuze's relationship with Lalive de Jully (1725–1779; see 1969.109) was an important one and began with Lalive de Jully's acquisition of Greuze's *Father Reading the Bible to His Children* (Paris, private collection) before the picture was sent to the Salon of 1755, where its moralizing subject, treated in the Dutch manner, was highly praised. Eventually Lalive de Jully, one of the most important amateurs in eighteenth-century France, acquired numerous paintings, drawings, and sketches by Greuze.

With a fortune inherited upon his father's death, in 1751, and the estate received from his first wife, who died in 1752, Lalive de Jully was able to indulge his taste for the arts. Upon his second marriage in 1762, he moved to lodgings in the rue de Richelieu, where his collection was open to visitors.[7] Also on display was his influential collection of furniture in the *goût grecque* (Greek or antique style), some of which appears in the background of the Washington portrait.[8] Lalive de Jully's distinguished collection probably included Nicolas Bertin's *Christ Washing the Feet of His Disciples* (1979.305) and possibly Nicolas de Largillière's *Self-Portrait* (1987.57).

The Chicago portrait of Lalive de Jully appears to be a contemporary copy after the Washington work.[9] Greuze generally did not execute portrait studies, and the painting bears the traits of a copy.[10] A large *pentimento* around the figure's head seems to indicate that it was first painted with the fuller hairstyle of the Washington portrait, and was then altered and given a less

sensitively rendered coiffure. Particularly revealing are the details at the right of the Chicago work: the edge of a portfolio and a portion of another, unidentified object have no significance in the Chicago portrait, and can only be interpreted through reference to the Washington painting. The rendering of the right hand and harp lacks the refinement of that in the larger work. The foreshortening of the hand is awkward and the harp strings lack the vibrant illumination seen in the Washington painting. In addition, the objects at the right in the Chicago work are flat and somewhat amorphous. However, in light of the delicate and sensitive handling of the face in the present painting, the possibility should not be ruled out that Greuze at some point intervened in its execution. Whether the Chicago copy was made in Greuze's studio, in Lalive de Jully's house before his collection was sold in 1770, or at some later time is difficult to determine.[11]

NOTES

1 The thread count of the original canvas is approximately 12 x 12/sq. cm (30 x 30/sq. in.).

2 The treatment was performed by Alfred Jakstas. His condition and treatment report of August 20, 1969, indicates that the painting had already been relined and stretched on a four-member oval "frame" when the Art Institute received it.

3 According to the 1941 Parke-Bernet sale catalogue and a letter of March 31, 1969, from Julius Weitzner to John Maxon (Archives, The Art Institute of Chicago).

4 Verbal communication of October 25, 1982, from Sotheby's, New York, to the author (notes in curatorial files).

5 Price and buyer are recorded in an annotated sale catalogue in the Ryerson Library, The Art Institute of Chicago. Perman may have been bidding for Weitzner.

6 The Washington painting measures 117 x 88.5 cm. See Eisler 1977, pp. 325–28, no. K1326, fig. 289. Greuze executed at least two other portraits of his patron: an oil sketch of Lalive de Jully and a female companion in an interior (private collection), reproduced in Edgar Munhall, *Jean-Baptiste Greuze, 1725–1805*, exh. cat., Hartford, Conn., Wadsworth Atheneum, 1976, no. 6 (ill.); and a pastel portrait shown at the Salon of 1765 (location unknown), illustrated in Jean Martin, *Oeuvre de J.-B. Greuze*, Paris, 1908, no. 1185, and engraved by Lalive de Jully and Gabriel de Saint-Aubin (see Svend Eriksen, "Lalive de Jully's Furniture 'à la grecque,'" *Burl. Mag.* 103 [1961], p. 345, fig. 16).

7 Probably to benefit his visitors, Lalive compiled and published a catalogue of his collection, with Pierre Jean Mariette's assistance. It attests to his interest in contemporary French painting and Dutch and Flemish painting as well as sculpture, drawings, prints, decorative arts, and shells. For Lalive de Jully's collection, see Colin B. Bailey, ed., *Ange-Laurent de La Live de Jully: A Facsimile Reprint of the 'Catalogue historique' (1764) and the 'Catalogue raisonné des tableaux' (March 5, 1770)*, New York, 1988, pp. vii–xliii.

8 This furniture of about 1756/57, designed by Louis Joseph Le Lorrain, may be the earliest known neoclassical furniture produced in France. See Eriksen (note 6), pp. 340–47.

9 Despite mention of a Greuze signature in the literature (see the 1941 sale catalogue, the 1976 exhibition catalogue, and Eisler

1977, p. 325), the painting is unsigned. An x-radiograph of the Washington painting reveals that its canvas was originally closer in size to the Chicago picture, but that extending strips were added to all four sides, probably at the time of its execution. In the x-radiograph the ground of the central, original canvas appears denser than that of the later strips, indicating that they were attached after the ground had been applied to the canvas. Because the brush strokes cross the seams between the

pieces of canvas, it can be assumed that the strips were attached before the artist began to paint.

10 Another oval copy of the Washington painting, of lesser quality, is in a French private collection (photo in curatorial files).

11 In about 1766 Lalive de Jully began to suffer from melancholy, which eventually became incapacitating. The following year, he retired from public life. Although he did not die until 1779, Lalive de Jully's family sold his collection in 1770 for the benefit of his children; see Bailey (note 7), pp. xxxii–xxxiv.

Baron Antoine Jean Gros

1771 Paris–Meudon 1835

Portrait of the Maistre Sisters, 1796

Charles H. and Mary F. S. Worcester Collection, 1990.110

Oil on canvas, 43.2 x 31.2 cm (17 x 12¼ in.)

INSCRIBED: *a Génes 1796* (lower right, inscribed in the wet paint with the butt end of the brush)

CONDITION: The painting is in excellent condition. The medium-weight canvas is unlined, and appears to be on its original stretcher.[1] The painting was surface cleaned and varnished at the Art Institute in 1990.[2] The thin paint layer was applied over an off-white ground that was toned to a warm ochre color. There are small areas of retouching on several losses: on a small loss measuring approximately 0.8 cm and located about halfway down the left edge of the white veil, on the left thigh of the sister on the left, on the hair to either side of the neck of the sister on the right, and on the latter's dark dress, above and below her left arm. (x-radiograph)

PROVENANCE: David Maistre, father of the sitters, Genoa, until 1810.[3] At his death to Mlle Aubry, cousin of the sitters, Paris, 1810–17. M. Legoux (d. 1847), Dijon; at his death to Emil Vincens (d. 1850), husband of Rosine, another of the Maistre sisters; at Vincens's death to Pauline Frat (d. 1863), the only surviving sister of the Maistre family; at her death to the Legoux family, Paris. Portalès family, Paris. François Delestre, Paris. Purchased from Delestre by the Art Institute through the Charles H. and Mary F. S. Worcester Endowment, 1990.

REFERENCES: "La Chronique des arts," *GBA* 6th ser., 117 (1991), suppl. to no. 1466, p. 56, no. 242 (ill.).

Baron Antoine Jean Gros is known chiefly for large, heroic paintings that glorified Napoleon and his campaigns, such as *Napoleon Visiting the Plague-Stricken at Jaffa* (Salon of 1804) at the Louvre and the battle pictures *The Battle of Aboukir* and *The Battlefield at Eylau* (Salons of 1806 and 1808) at Versailles and the Louvre, respectively.[4] Prior to his role as propagandist, Gros established a successful practice in Italy, particularly

Genoa, where he received numerous commissions for portraits, both large-scale and miniature.[5] In fact, Gros's gifts as a portraitist so impressed Josephine Bonaparte when she encountered him in Genoa in 1796 that she invited the artist to her palace in Milan and engaged him to paint the famous portrait *Bonaparte Crossing the Bridge at Arcole* (1796; Louvre). This masterpiece inaugurated Gros's distinguished career in the service of Napoleon, both as a chronicler of Napoleonic conquests and as part of the imperial commission appointed to acquire works of art in Italy for the Musée Napoléon.[6]

The son of two painters of miniatures, Gros was only fifteen years old when he entered the studio of Jacques Louis David (see 1963.205, 1967.228) in 1785. After studying at the Academy, where he won honors for figure painting, he was denied the *Prix de Rome* in 1792. His failure to win the Rome prize, together with his fear of the political climate in Paris, which had ruined his family, prompted him to leave Paris for Italy in February 1793. After a brief stay in Genoa, the young artist traveled to Florence, where he lived for the next year and a half. Failing to find sufficient work there, he returned to Genoa under the aegis of the Swiss banker Jean Georges Meuricoffre and his wife, the former mezzo-soprano Céleste Cotellini.[7] Through the Meuricoffres, Gros received portrait commissions from members of their social circle—wealthy bankers, merchants, shipping magnates, and diplomats who had been sent to Genoa by the French Republican government.

Nevertheless, Gros was somewhat ambivalent about the path of his career. Since he wished to create classical compositions in the tradition of his earliest teacher, David, he was discouraged to find himself limited mainly to portraiture; in his letters home, he referred to these early commissions disparagingly as *pacotilles*, or

works of little importance.[8] Yet the few known portraits from his second Genoese period, 1794–96, belie the artist's assessment. In their lightness of touch they display the influence of David (see, for example, David's *Madame de Pastoret and Her Son*, 1967.228) as well as of Gros's constant mentor, Elisabeth Louise Vigée-Le Brun, whose stylish self-portraits and portraits of women posed in landscapes were much in vogue throughout the 1780s and '90s. Gros's bust-length *Madame Bruyère* (1796; Bristol, City Art Museum and Gallery), which portrays the wife of the president of the French Chamber of Commerce in Genoa, and *Céleste Meuricoffre* (c. 1796; Louisville, J. B. Speed Museum), which portrays his Genoese hostess, exhibit the warmth and intimacy with which the young artist approached his bourgeois patrons.[9]

Unfortunately, not many of the portraits executed during the artist's three-year stay in Italy have come to light; presumably a number of these early commissions have remained in the families for which they were created. Until very recently, this was the case with the Chicago double portrait of the two daughters of David Maistre, painted by Gros in Genoa in 1796.[10] Undocumented, this delicate and intimate portrait was rediscovered by François Delestre, descendant of Gros's first biographer, J. B. Delestre, one of the artist's most devoted students. The painting represents Suzette Maistre (later Mme Delon) on the left, in white, accompanied by her sister, Ninette (later Mme Delarue), in black. Both sisters wear the simple high-waisted muslin gowns gathered at the neckline that had been popularized by the English-inspired costumes first worn in France by Marie Antoinette around 1783.[11] Their delicate gold jewelry is accented with the kind of light impasto touches found also in Gros's contemporary portraits *Madame Pasteur* (1795; Louvre) and *Céleste Meuricoffre*.[12] Despite her black costume, it is unlikely that Ninette is in mourning, since she wears an extravagant triple-chain gold necklace and double-band ring. Indeed, such free-flowing muslin gowns were as fashionable in black as in white during this period, and can also be seen on Francisco de Goya's *majas*.

The two young women are shown informally in the Chicago picture, with arms entwined around each other's waists. This casual pose may have hardened into convention by the turn of the century, as other pairs of sisters, such as those in a painting attributed to François Gérard (Europe, private collection), are similarly portrayed.[13] The Maistre sisters stand before a languorous and vaporous landscape that seems in keeping with the gentle and harmonious appearance of the sitters. The sense of correspondence between the fresh innocence of the young women and the hazy, proto-Romantic landscape anticipates that between the verdant setting and sitter in one of Gros's most celebrated Romantic female portraits, that of Jerome Bonaparte's first wife, Christine Boyer, painted shortly after her death in 1800 (Louvre).[14] These landscapes may have been inspired by the English landscape tradition, with which Gros perhaps became acquainted through his friend Anne Louis Girodet-Trioson, who also stayed for a time in Genoa in 1893 and had an interest in English art and themes.[15]

L. J. F.

NOTES

1 The thread count of the original canvas is approximately 12 x 14/sq. cm (30 x 35/sq. in.).

2 The treatment was performed by Frank Zuccari.

3 The provenance below is based on an information sheet provided by François Delestre in a letter of November 21, 1989, to Douglas Druick, in curatorial files.

4 See, respectively, Lawrence Gowing, *Paintings in the Louvre*, New York, 1987, p. 600 (ill.); Raymond Escholier, *Gros: Ses amis et ses élèves*, Paris, 1936, pl. 6; and Gowing (this note), p. 601 (ill.).

5 Philippe Bordes has suggested that many of Gros's early works have been either wrongly attributed or overlooked by his biographers, and remain to be discovered; see Philippe Bordes, "Antoine-Jean Gros en Italie (1793–1800): Lettres, une allégorie révolutionnaire, et un portrait," *Bulletin de la Société de l'histoire de l'art français, année 1978* (1980), p. 221.

6 For the earliest accounts of Gros's career, see J. B. Delestre, *Gros: Sa Vie et ses ouvrages*, Paris, 1847, pp. 1–487, and J. Tripier le Franc, *Histoire de la vie et de la mort du Baron Gros*, Paris, 1880, pp. 13–172. For *Bonaparte Crossing the Bridge at Arcole*, see Escholier (note 4), pl. 1.

7 For information on the Meuricoffres, see Tripier le Franc (note 6), pp. 86–89, and Bordes (note 5), pp. 228, 231 n. 36.

8 Tripier le Franc (note 6), p. 115.

9 For these paintings, see, respectively, *France in the Eighteenth Century*, exh. cat., London, Royal Academy of Arts, 1968, fig. 343; and *Portraits and Figures in Paintings and Sculpture, 1570–1870*, exh. cat., London, Heim Gallery, 1983, no. 23 (ill.).

10 Although Gros painted at least two portraits of men while in Italy, he is better known for his portraits of women, including that of Mme Pasteur (see note 11) and the large-scale portrait of Mme Favrega dressed in white muslin and seated on a red divan (c. 1795; Marseilles, Musée des Beaux-Arts); for an illustration of the latter painting, see Escholier (note 4), pl. 14.

11 See Doris Langley Moore, *Fashion through Fashion Plates, 1771–1970*, New York, 1971, pl. 9 (ill. lower left).

12 For the portrait of Mme Pasteur (née Madeleine Alexandre), see Louvre, *Catalogue sommaire*, vol. 3, *Ecole française, A–K*, p. 293, no. 1948–42; for an illustration, see Jean Pierre Cuzin and Michel Laclotte, *The Louvre: European Paintings*, New York, 1993, p. 114 (ill. top right).

13 See sale catalogue, Phillips, London, July 7, 1992, no. 29 (ill.).

14 Illustrated in Escholier (note 4), pl. 16.

15 James Henry Rubin, "Gros and Girodet," *Burl. Mag.* 121 (1979), pp. 716–21. Also see Paul Joannides, "Some English Themes in the Early Work of Gros," *Burl. Mag.* 117 (1975), pp. 784–85.

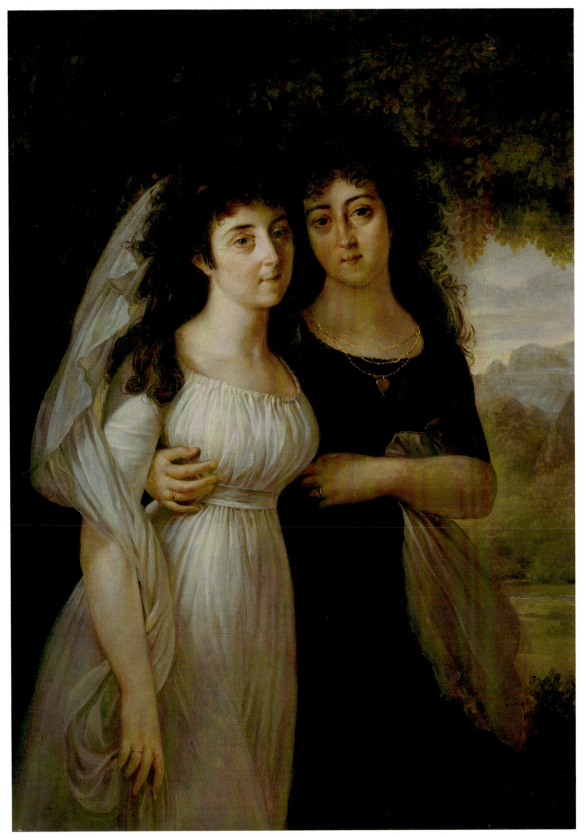

Baron Antoine Jean Gros, *Portrait of the Maistre Sisters*, 1990.110

Laurent de La Hyre

1606 Paris 1656

Panthea, Cyrus, and Araspas, 1631/34

Major Acquisitions Centennial Endowment, 1976.292

Oil on canvas, 141.9 x 102 cm (55⅞ x 40⅛ in.)

CONDITION: The painting is in very good condition. Minor insecurities in the fill material at the lower right corner were consolidated and retouched in 1989.[1] The canvas has a glue paste lining.[2] The original tacking margins have been cut off, but cusping at all four edges indicates that the painting is close to its original dimensions. X-radiography reveals two horizontal tears, 10 and 11 cm in length, in the architecture near the top center edge, and a series of small holes on the perimeter that indicate that the painting may previously have been attached to a smaller stretcher. The generally well-preserved paint layer is applied over a dark red ground. There is some abrasion in the tunics of Cyrus and Araspas and in the faces of Panthea and Araspas. The painting appears to have been selectively cleaned in the light areas of the foreground figures and sky, leaving a natural-resin varnish residue over the architecture and in selected areas of the figures. The canvas weave has become somewhat pronounced due to the lining process. There is a band of losses around the perimeter of the painting, extending as much as 4 cm into the picture at the bottom and right sides. All of the losses have been filled and inpainted.[3] There is additional retouching on Panthea's right arm, on Araspas's chest, and scattered throughout the background. The retouching around the tears near the top edge appears to extend beyond the areas of loss. There are several *pentimenti* around Cyrus and Araspas: in the sleeve of the man in the middle ground where Cyrus points; on Araspas's right leg, tunic, and dangling sash; and in Cyrus's right shoulder, left leg, and sword. (ultraviolet, partial x-radiograph)

PROVENANCE: Art market, Germany.[4] Sold at a public sale, Milan, to Ettore Viancini, Venice.[5] Sold by Viancini to Gilberto Algranti, Milan and London.[6] Sold by Algranti to Silvano Lodi, Campione d'Italia, and Bruno Meissner, Zurich, 1973;[7] passed solely into Meissner's possession;[8] sold by Meissner to the Art Institute, 1976.

REFERENCES: [Georges de Scudéry], *Le Cabinet de M^r de Scudery, gouverneur de Nostre Dame de la Garde,* pt. 1, Paris, 1646, p. 51; reprint, Geneva, 1973. P[ierre] J[ean] Mariette, *Abécédario de P. J. Mariette et autres notes inédites de cet amateur sur les arts et les artistes,* vol. 3, in *Archives de l'art français,* vol. 6, Paris, 1854–56, p. 45 n. 1. *Burl. Mag.* 118 (1976), p. xcviii (ill.). "La Chronique des arts: Principales Acquisitions des musées en 1975," *GBA* 6th ser., 89 (1977), suppl. to no. 1298, p. 49, no. 192 (ill.). *AIC 100 Masterpieces* 1978, p. 25, no. 19. André Chastel, "Les Etats-Unis et la peinture française: Entre Rome et Paris," *Le Monde,* February 2, 1982, p. 13. Jean Pierre Cuzin, "New York: French Seventeenth-Century Paintings from American Collections,"

Burl. Mag. 124 (1982), pp. 529–30. Patrice Dubois, "La Première Ecole de Paris," *L'Amateur d'art* 680 (1982), pp. 9–10 (ill., cover ill.). Robert Fohr, *Tours, Musée des Beaux-Arts; Richelieu, Musée Municipal; Azay-le-Ferron, Château: Tableaux français et italiens du XVII^e siècle,* Inventaire des collections publiques françaises 27, Paris, 1982, p. 50, under no. 41. J. V. Hantz, "La Peinture française du XVII^e siècle dans les collections américaines," *L'Amateur d'art* 680 (1982), p. 19. Ekkehard Mai, "La Peinture française du XVII^e siècle dans les collections américaines," *Pantheon* 40 (1982), p. 153, fig. 2. Pierre Rosenberg, *"France in the Golden Age*: A Postscript," *Metropolitan Museum Journal* 17 (1982), p. 27, no. 31. Pierre Rosenberg, "A Golden Century in French Painting," *Connaissance des arts* 25 (February 1982), p. 74 (cover ill.). Pierre Rosenberg, "La Peinture française du XVII^e siècle dans les collections des Etats-Unis," *La Revue du Louvre* 31, 1 (1982), p. 74, pl. 3. Pierre Rosenberg and Marc Fumaroli, "L'arte s'impara a Roma," *Bolaffiarte* 12, 116 (1982), p. 33 (ill.). Erich Schleier, "La Peinture française du XVII^e siècle dans les collections américaines: France in the Golden Age, part 1," *Kunstchronik* 36 (1983), pp. 191–92. Erich Schleier, "La Peinture française du XVII^e siècle dans les collections américaines: France in the Golden Age, part 2," *Kunstchronik* 36 (1983), p. 231. Jacques Thuillier, "Poètes et peintres au XVII^e siècle: l'Exemple de Tristan," *Cahiers Tristan L'Hermite* 6 (1984), pp. 17, 22. Sylvain Laveissière, in *Le Classicisme français: Masterpieces of Seventeenth-Century Painting,* exh. cat., Dublin, The National Gallery of Ireland, 1985, p. 28. Wright 1985, p. 192. *AIC Master Paintings* 1988, p. 32 (ill.). C[atherine] Chevillot, "Laurent de La Hyre (1606–1656)," *La Revue du Louvre* 38, 5/6 (1988), p. 448. Guy Boyer, "La Hyre: La Rhétorique de l'image," *Beaux-Arts* 65 (February 1989), p. 41 (ill.). Raoul Ergmann, "La Hyre: Le Retour en grâce," *Connaissance des arts* 443 (January 1989), p. 104. Barbara Scott, "Letter from Paris: Homage to Laurent de

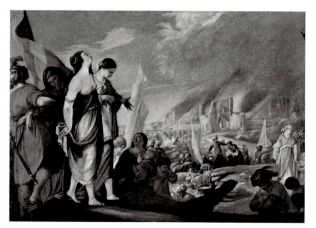

Fig. 1 Copy after Laurent de La Hyre, *Panthea Led into Captivity,* Musée des Beaux-Arts, Tours [photo: Bulloz]

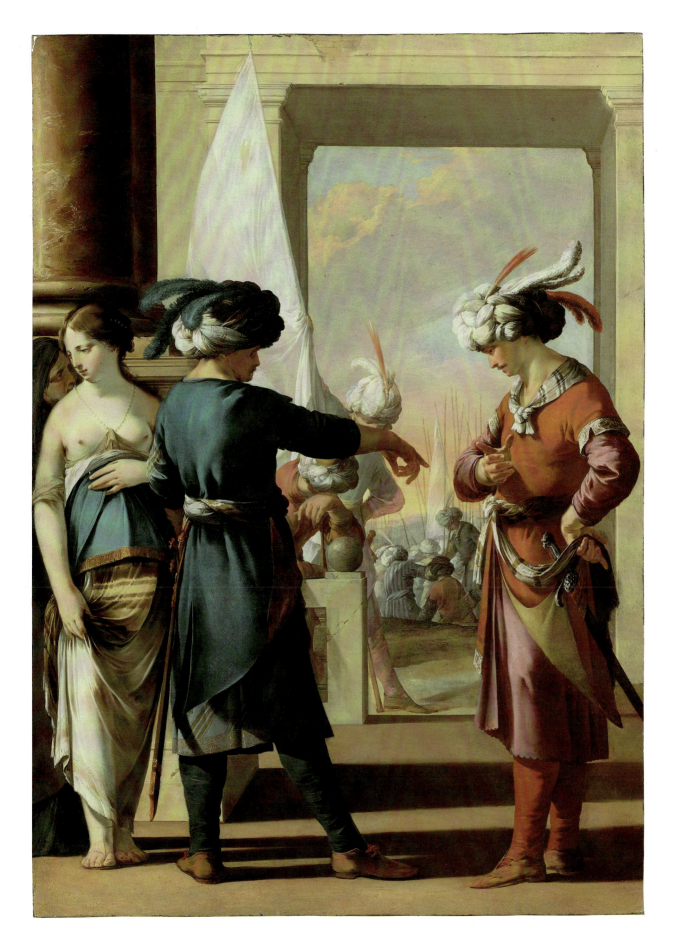

la Hyre," *Apollo* 129 (April 1989), p. 280. Richard Verdi, "Grenoble, Rennes, Bordeaux: Laurent de La Hyre," *Burl. Mag.* 131 (1989), p. 734. Wright 1991, vol. 1, p. 240, vol. 2, pp. 62, 446.

EXHIBITIONS: Paris, Galeries Nationales du Grand Palais, *La Peinture française du XVIIe siècle dans les collections américaines*, 1982, no. 31, cat. by Pierre Rosenberg, traveled to New York and Chicago. Musée de Grenoble, *Laurent de La Hyre, 1606–1656: L'Homme et l'oeuvre*, 1989, no. 104, cat. by Pierre Rosenberg and Jacques Thuillier.

Son of the painter Etienne de La Hyre, who worked in an international mannerist style, the Parisian Laurent de La Hyre was himself much influenced in his youth by the art he viewed on a visit to Fontainebleau in about 1624. The animated and calligraphic manner of his early years was modified, however, in the second quarter of the century, when he began to study the grand, glamorous style of Simon Vouet. Following the examples of Vouet and, later, of Jacques Stella and Nicolas Poussin, in the early 1640s La Hyre began to render his figures with a greater gravity of gesture and to organize his compositions in a more rigorously rectilinear fashion. The presence of Poussin in Paris in 1640 also seems to have inspired La Hyre to devote more time to landscape painting. In his mature paintings, such as *Cornelia, Mother of the Greeks, Refusing the Crown of Ptolemy* (1646; Budapest, Szépmüvészeti Múzeum), the artist's arrangement of monumental figural groups within expansive architectural settings recalls not only the works of Poussin, but those of Raphael.[9] It was this severe classical style that La Hyre practiced when the French Academy was founded in 1648 and he became one of its first *anciens*, or professors.

La Hyre's *Panthea, Cyrus, and Araspas* was probably one of a suite of paintings depicting episodes from the history of Cyrus the Great, founder of the Persian empire.[10] Three other paintings from this series have been identified, but the original number of works in the group is not known. *Panthea Led into Captivity* is known only from a copy (fig. 1).[11] *Panthea Brought before Cyrus* (fig. 2) is a painting of the same height but slightly wider than the Chicago canvas.[12] A fourth picture, *Araspas Rejected by Panthea*, is known only from an engraving after it by Pierre Daret (fig. 3), which was destined to be the frontispiece for Tristan l'Hermite's drama *Panthée*. Neither the Chicago nor the Montluçon canvas is signed or dated, but we are assured, at least for the painting *Araspas Rejected by Panthea*, a terminus

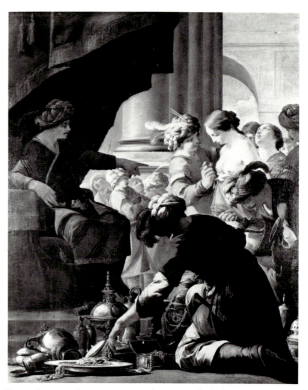

Fig. 2 Laurent de La Hyre, *Panthea Brought before Cyrus*, Château de la Louvière, Musées de Montluçon

ante quem of 1639, the year Augustin Courbé published Tristan's play. That these four works were conceived as a series is suggested by the repetition of certain figures and the consistency of figure scale and color schemes, especially for the costumes that distinguish the protagonists.

Pierre Rosenberg and Jacques Thuillier have dated the *Cyrus and Panthea* series to 1631/34, based on the artist's bright and broad palette, which is found in other pictures from these years, such as the two versions of *Theseus and Aethra*, in Caen (Musée des Beaux-Arts) and Budapest (Szépmüvészeti Múzeum), the former signed and dated 1634.[13] Before 1631 the artist employed a darker, more somber palette, as in his *Pope Nicholas V Visiting the Tomb of Saint Francis of Assisi* (Louvre) of 1630.[14] Characteristic of La Hyre's works of the early thirties, and particularly evident in the Chicago painting, is the placement of heavy but graceful figures with sharply defined silhouettes against ponderous architectural backdrops.

The only early reference to the series is a verse in *Le Cabinet de Mr de Scudery . . .* of 1646:

L'HISTOIRE / DE PANTHEE / EN DIVERS TABLEAUX. / Par la Hire. / Ie confesse, Peintre excellent, / Qu'Araspe

PANTHEE, TRAGEDIE, DE TRISTAN
1639.

Fig. 3 Pierre Daret, engraving after Laurent de La Hyre, *Araspas Rejected by Panthea*, frontispiece of Tristan L'Hermite, *Panthée*, Paris, 1639, Bibliothèque Nationale, Paris [photo: © cliché Bibliothèque Nationale de France, Paris]

fut un insolent, / D'oser adorer une Reine: / Mais si cette Princesse eut les mesmes attraits, / Que tu donnes à ses portraits, / Elle fut iniuste en sa haine; / Car quel coeur voyant ses appas / Eust pû ne les adorer pas?[15]

Unfortunately, Georges de Scudéry revealed neither the total number of paintings nor where he had seen them. One can suppose from this passing reference that they were in a collection of some prominence, hence familiar to Scudéry's readers. The editors of Mariette (1854–56), upon reading the verse, suspected that the suite was one of the numerous histories La Hyre had painted for private cabinets. Certainly, the scale of the pictures in the suite suggests that they would have been displayed in a private setting.

There are several accounts of the life of Cyrus, the most relevant to La Hyre's series being Xenophon's *Cyropaedia* (fourth century B.C.), a didactic novel in which this ruler's deeds, magnanimity, and good judgment are recounted.[16] Cyrus's life and actions, amplified by legend and carrying strong moral implications, came to be celebrated not only in literature of the seventeenth century, but in the visual arts as well, particularly in Italian, Dutch, and French paintings of the period.[17] La

Hyre probably knew the *Cyropaedia*, where the following account of the story of Cyrus and Panthea is given.

After a victory in battle, Cyrus, the king of Persia, had his boyhood friend Araspas choose his booty for him. Araspas seized for Cyrus the beautiful Panthea, wife of Abradatas, the king of Susa. In order to resist her charm, Cyrus entrusted her to the care of Araspas, who, ironically, became infatuated with her himself. Panthea, loyal to her husband, repulsed Araspas's advances and finally appealed to Cyrus to intervene. Fearing Cyrus and repenting his weakness, Araspas agreed to infiltrate the enemy camp in order to inform Cyrus of their plans. Meanwhile, Panthea, grateful to Cyrus, offered him her husband's allegiance. At Panthea's urging, Abradatas took up arms for Cyrus and was subsequently killed in battle. The distraught Panthea, having exhorted him to bravery, stabbed herself and died on her husband's body.

The account by Xenophon served as the basis for several French plays, which were probably also familiar to La Hyre. These theater pieces were considerably varied in their adaptation of the essential elements of the story as told by Xenophon, and the dramatic emphasis shifted from play to play.[18] In some versions, the beauty and fidelity of Panthea are paramount, while in others the moral strength of Cyrus is the principal theme. In some plays, Araspas is the principal character, perhaps because his love for Panthea provided the opportunity to develop a compelling dramatic role. It is also possible that the historical characters were meant to be associated with prominent contemporary persons and that the story of Cyrus and Panthea was deliberately altered to allude to specific events of the day.[19] Of course, the question can also be raised as to whether La Hyre's paintings carried contemporary political overtones. It is difficult to speculate on this matter, however, because the series cannot be linked to a specific text and because the patron is not known.

In fact, La Hyre's paintings seem to synthesize several texts, and may well have been influenced by theatrical productions, particularly in the protagonists' costumes. The same can be said of an earlier group of drawings of the Cyrus story executed by La Hyre around the time Alexandre Hardy's *Panthée* was published.[20] Without a direct literary source, it is unclear which moment of the story La Hyre intended to represent in the Chicago picture. One interpretation, offered by J. de Vazelhes, is that Cyrus, who refuses to look upon Panthea and instead points to his soldiers, is meant to be seen as choosing responsibility over love.[21]

1 This treatment was performed by Cynthia Kuniej Berry.

2 The condition of the lining and its type suggest that it was probably added just before the painting was acquired by the museum. The thread count of the original canvas is approximately 6 x 10/sq. cm (15 x 25/sq. in.).

3 Most of these restorations were probably carried out when the picture was lined (see note 2).

4 Rosenberg, 1982 exhibition catalogue, p. 248, no. 31.

5 According to a letter of August 24, 1976, from Pierre Rosenberg to J. Patrice Marandel, in curatorial files.

6 Ibid.

7 According to J. Patrice Marandel, verbally, April 20, 1981 (notes in curatorial files).

8 According to a letter of May 18, 1981, from Bruno Meissner to the author, in curatorial files.

9 See the 1989 exhibition catalogue, pp. 266–67, no. 230 (ill.). The painting measures 143 x 120 cm (56⁵/₁₆ x 47¹/₄ in.).

10 The subject of this painting was first identified by Rosenberg (1982 exhibition catalogue). The painting was acquired by the Art Institute as *The Slave Market*.

11 Fohr 1982, pp. 49–50, no. 41 (ill.).

12 See the 1989 exhibition catalogue, pp. 174–75, no. 103 (ill.). The painting measures 143 x 120 cm (56⁵/₁₆ x 47¹/₄ in.).

13 See the 1989 exhibition catalogue, p. 172; for the Caen and Budapest works, see ibid., pp. 179–82, nos. 109–10 (ill.).

14 See the 1989 exhibition catalogue, pp. 151–53, no. 63 (ill.).

15 P. 51: "The Story / of Panthea / in Various Paintings. / By La Hyre. / I confess, excellent painter, / That Araspas was insolent, / To dare to love a Queen: / But if this Princess had the same attractions, / Which you give to her portraits, / She was unjust in her hatred; / For which heart on seeing her charms / could not but have adored them?"

16 Xenophon, *Cyropaedia*, Loeb Classical Library, tr. by Walter Miller, vol. 2, Cambridge, Mass., and London, 1979, pp. 2–13, 136–47, 190–97, 244–491.

17 A[ndor] Pigler, *Barockthemen: Eine Auswahl von Verzeichnissen zur Ikonographie des 17. und 18. Jahrhunderts*, Budapest, 1956, vol. 2, p. 295. As Rosenberg and Thuillier pointed out, La Hyre almost certainly would also have been acquainted with the description of Panthea's death in Philostratus's *Imagines* (third century), a book of rhetorical descriptions of paintings both real and imaginary. The *Imagines* had been translated into French and was widely read by painters in the early seventeenth century. See the 1989 exhibition catalogue, p. 119, and Philostratus, *Les Images ou tableaux de platte peinture des deux Philostrates sophistes grecs et les statues de Callistrate, Mis en françois par Blaise de Vigenere . . .* , Paris, 1615, pp. 353–60.

18 The *Panthée* of Gaye Jules de Guersens was published in 1571, and that of Charles Guérin Daronnière in 1608; in the latter year, Claude Billard de Courgenay's version was staged. Alexandre Hardy's *Panthée* was staged in 1604 and published in 1624, and Jean Gilbert Durval, rivaling Tristan, saw his tragedy staged in 1638 and published the following year. See [François and Claude Parfaict], *Dictionnaire des théâtres de Paris*, vol. 4, Paris, 1767, pp. 71–72; reprint, Geneva, 1967, vol. 4, pp. 24–25.

19 For instance, Claude Kurt Abraham (*Gaston d'Orléans et sa cour: Etude littéraire*, rev. ed., Chapel Hill, 1964, p. 78), discussing Tristan's *Panthée*, drew parallels between Gaston d'Orléans and Abradatas, who, for love of his wife, carried arms against his country.

20 See note 18. A group of eleven drawings is cited in the 1657 inventory of La Hyre's estate (Pierre Rosenberg and Jacques Thuillier, *Laurent de La Hyre, 1606–1656*, Cahiers du dessin français 1, Paris, 1985, n. pag. [see "Documents"]). Four drawings are known today (see Rosenberg and Thuillier in the 1989 exhibition catalogue, pp. 118–19, nos. 7–10 [ill.]). There exists a drawing entitled *St. Catherine*, attributed to Jacques Blanchard, that depends on *Panthea Brought before Cyrus* for its grouping of figures; see the 1989 exhibition catalogue, no. 103, fig. 103c.

21 See Rosenberg, "*France in the Golden Age*: A Postscript" 1982, p. 27, under no. 31. Since Panthea appears in the Chicago canvas, Vazelhes's alternative suggestion that the scene depicts Cyrus being persuaded by Araspas to visit the captive Panthea is unconvincing.

Nicolas Lancret

1690 Paris 1743

The Beautiful Greek Woman, 1731/36

Gift of Mrs. Albert J. Beveridge in memory of her aunt, Delia Spencer Field (Mrs. Marshall Field), 1948.565

Oil on canvas, 70 x 51.6 cm (27⁹/₁₆ x 20⁵/₁₆ in.)

CONDITION: The painting is in good condition. It was grime cleaned in 1969, and then cleaned more thoroughly in 1971, when an old glue paste lining was removed and replaced with a wax resin one.[1] The tacking margins have been cut off and the lining canvas extends approximately 0.35 cm beyond the original support on all sides. X-radiography reveals that a 7 cm wide vertical strip was stitched to the right edge of the canvas prior to the execution of the painting.[2] Cusping is visible at all edges, indicating that the painting is close to its original dimensions. The painting has an off-white ground that has been toned to a warm reddish color. The seam between the sections of canvas has been filled. The paint surface is somewhat flattened due to the lining process. There is considerable abrasion in the strip along the right, particularly at the bottom. Additional abrasion is notable in the sky near the top of the painting, in the woman's hair, hat, and in the sleeve suspended from her left wrist, and on the fur trim along the bottom edge of the dress, where some of the artist's changes in the contour of the skirt have become apparent. The dark green shadows of the foliage

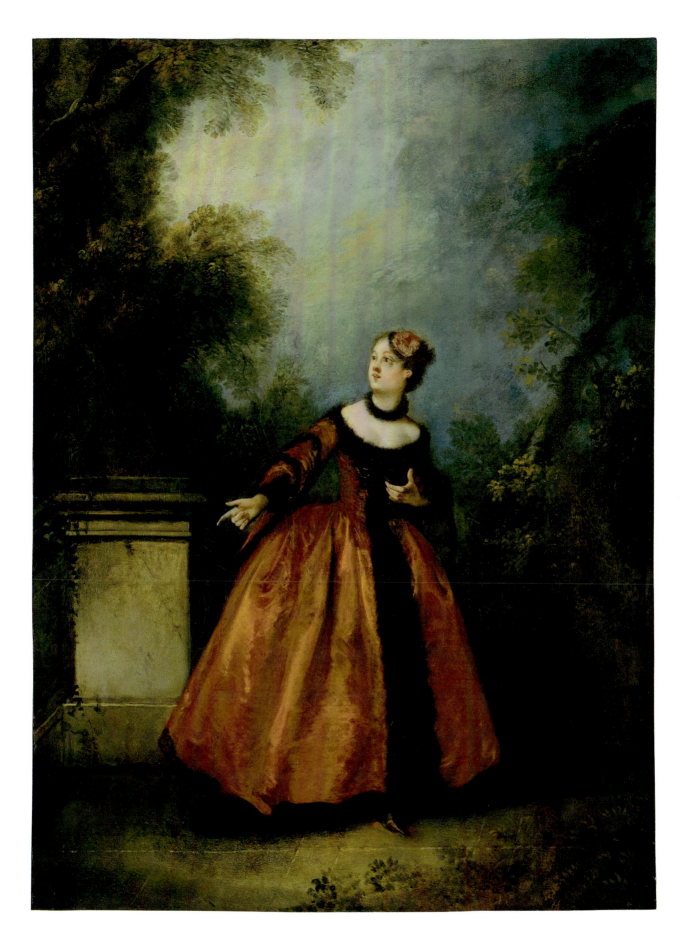

at left and the other fur details of the costume are also slightly abraded. There are a few localized areas of retouching to the left of the woman's face, beneath her eyes, on her right hand and left shoulder, at the back of her head, on the fur details of the collar at the back of her neck, around her left hand, on the seam between the joined canvas sections, and on a few small losses to either side of the seam. The foliage at the upper left corner may have initially extended further into the sky; clouds appear to have been painted over this foliage.[3] (infrared, ultraviolet, x-radiograph)

PROVENANCE: Charles Fox, Rutland, England, probably by 1847; possibly sold in 1849.[4] E. Gimpel and Wildenstein, New York, by 1920.[5] Sold by Gimpel and Wildenstein to Mrs. Marshall Field, Washington, D.C., by 1920.[6] Probably by descent to Mrs. Albert J. Beveridge, by 1938; on loan to the Art Institute, 1938, 1940;[7] given to the Art Institute, 1948.

REFERENCES: Georges Wildenstein, *Lancret*, Paris, 1924, p. 117, no. 700. AIC 1961, p. 254. Mary Tavener Holmes, "Nicolas Lancret and Genre Themes of the Eighteenth Century," Ph.D. diss., New York University, 1986 (Ann Arbor, Mich., University Microfilms, 1986), Appendix, p. 27, under no. 26. John Ingamells, *The Wallace Collection: Catalogue of Pictures*, pt. 3, *French before 1815*, London, 1989, p. 237, under no. P450. Wright 1991, vol. 1, p. 446, vol. 2, pp. 62, 587.

EXHIBITIONS: The Art Institute of Chicago, *Selected Works of Eighteenth-Century French Art in the Collections of The Art Institute of Chicago*, 1976, no. 5.

A follower of Watteau (see 1954.295), Nicolas Lancret was primarily a painter of *fêtes galantes* and other genre subjects. After studying with Pierre Dulin, Lancret trained briefly at the Academy, and eventually worked in the shop of Claude Gillot. There he acquired a taste for the commedia dell'arte and may have met Watteau, who, also influenced by Gillot, treated subjects from the Italian theater. Lancret was received into the Academy in 1719 as a painter of *fêtes galantes*. Though Watteau offered advice to Lancret on numerous occasions, their friendship was not lasting. Lancret, nevertheless, was much influenced by Watteau's elegant arrangements of figural groups and by the poetic quality of his lush park settings. He also imitated Watteau's delicate manner of painting with flickering brush strokes and shared the master's attention to gestures and minute details.[8] Distinguishing Lancret's work from Watteau's are the former's livelier and more robust presentation of his subjects, his vigorous colors, and his emphasis on narrative.

Lancret repeated the single-figure composition of *The Beautiful Greek Woman* numerous times, usually with a pendant, *The Amorous Turk*. The two figures appear together in just one painting, the *Sultan and His*

Consort of c. 1728 (New York, Mr. and Mrs. Felix G. Rohatyn collection).[9] Several versions of *The Beautiful Greek Woman* appeared in early sales, although only two can be located now.[10] Of the various treatments of the theme of *The Amorous Turk*, the earliest seems to have been in Lancret's decorations of 1728/29 for the salon of M. de Boullongne's Paris residence (transferred to the Musée des Arts Décoratifs, Paris), where the exotic figure appears at the center of a panel.[11] Georg Friedrich Schmidt engraved both subjects in 1736, but because his prints vary in some details from the known versions of the paintings, it is not certain which works he used as models.[12]

Although it is difficult to determine in some cases which of the *Beautiful Greek Woman* and *Amorous Turk* paintings form pendants, it is likely that the Chicago picture was originally paired with *The Amorous Turk* (fig. 1) in the collection of the Sarah Campbell Blaffer Foundation in Houston. Both works belonged at one time to Charles Fox. They have virtually the same dimensions and were both widened by approximately

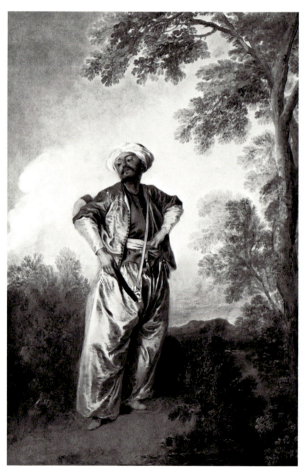

Fig. 1 Nicolas Lancret, *The Amorous Turk*, Sarah Campbell Blaffer Foundation, Houston, Texas

seven centimeters — the Houston painting on the left, the Chicago canvas on the right.[13] It seems that the paintings were separated by 1911, when Jacques Péreire lent only *The Amorous Turk* to an exhibition in Paris.[14]

Turkish and other oriental subjects had appeared in French art and literature since the sixteenth century (see, for example, La Hyre, 1976.292), but this interest in the East and Near East intensified after 1721, when Méhémet-Effendi, the Ottoman ambassador, made a much-publicized visit to Paris. Reports, tales, and sketches brought back to France by travelers to the Near East found enthusiastic audiences. Such images and stories inspired countless theater pieces, which further disseminated and popularized these oriental themes. Lancret's two paintings were probably influenced by one of the numerous plays in which a Turk rescues his beloved, a Greek slave, from the seraglio; but the works cannot be connected with a specific theater piece. It only remains apparent that, as Mary Tavener Holmes observed, "the idea of the two of them, one a slave and the other her gallant lover, and their obviously theatrical attitudes, must surely have been inspired by their proliferation in the theater in just such roles."[15]

Popular French prints, particularly costume pieces, also may have contributed to Lancret's conception of *The Beautiful Greek Woman* and its pendant. Lancret could have referred not only to the costume prints of Sébastien LeClerc and Jacques Callot, but also to the many single-figure engravings after costume designs by Watteau (see 1960.305). A plate in one of the myriad costume books published in eighteenth-century France, Jean Baptiste Van Mour's *Receuil de cent estampes représentant divers nations du Levant tirées sur les tableaux peints d'après nature en 1707, et 1708* (Paris, 1714), appears to have been a source for Lancret's *The Amorous Turk*.[16]

There was also an expanding market for painted and engraved theater pieces in the early eighteenth century. These as well as "role" pictures, in which figures were depicted in character, as they would have appeared on stage, seem to have influenced Lancret's art. In fact, *The Beautiful Greek Woman* and *The Amorous Turk* also appear to be related to this last form. As Donald Posner has noted, these "role" pictures were not necessarily accurate portraits of individual actors, but portrayed "a special professional aspect of a person, rather than what one might call his 'true' self."[17] Occasionally, Lancret fused the unreality of the stage with actual portraits, as in his depictions of the dancers Mlle Sallé and Mlle

Camargo and of the actor Grandval in their professional roles.[18] It is uncertain whether *The Beautiful Greek Woman* and *The Amorous Turk* represent specific individuals or merely types. The figures have never been identified, and Lancret seems to have used for *The Beautiful Greek Woman* the same model he employed for the woman who sits in the left corner of his painting *The Ball* (Berlin, Schloss Charlottenburg), in his *Music Party in a Landscape* (Cambridge, Fitzwilliam Museum), in two drawings formerly in the Groult collection, and in a drawing sold anonymously in 1955.[19]

NOTES

1 Both treatments were performed by Alfred Jakstas. The thread count of the original canvas is approximately 8 x 7/sq. cm (21 x 18/sq. in.).

2 The thread count of the added strip is approximately 8 x 8/sq. cm (21 x 21/sq. in.).

3 Some *pentimenti* to the left of the head, in the eyes, and in the fur details were noted in the March 1969 examination report by Alfred Jakstas, but none are now apparent on the surface or in the x-radiograph.

4 According to old handwritten labels formerly on the stretcher (one glued on top of the other). The top one reads *Actress / by Lancret / bought at Charles F*; the one underneath partially reads *[Char]les Foxs auction / [1849]* (preserved in curatorial files). According to Hans Huth (note in curatorial files), a label (now missing) on the back of the canvas read *Bought at Charles Fox's auction April 1849*. The painting does not appear in the catalogue of the Fox sale, Sotheby's, London, April 21, 1849, but may have been sold in that year. According to the catalogue of a sale at Christie's, London, July 10, 1987, *The Amorous Turk* (no. 147), the probable pendant to *The Beautiful Greek Woman*, was once in Fox's possession and exhibited in *The First Exhibition of the Paintings of Ancient and Celebrated Deceased Masters*, at the Royal Irish Art-Union, Dublin, in 1847.

5 According to a label removed from the stretcher (preserved in curatorial files).

6 Wildenstein (1924) listed Delia Spencer Caton, second wife of Marshall Field I, as the buyer. The presence of the Gimpel and Wildenstein label indicates that she probably acquired the painting before 1921, since Gimpel and Wildenstein were in business together in New York from 1914 until 1920 (telephone conversation of May 4, 1982, between Ay-Wang Hsia [Wildenstein] and the author; notes in curatorial files).

7 According to registrar's records and letters from Robert B. Harshe to Mrs. Albert J. Beveridge of December 10, 1937, and from Catherine Beveridge to Potter Palmer of May 19, 1938 (letters in Archives, The Art Institute of Chicago). Mrs. Albert J. Beveridge was Mrs. Field's niece.

8 See Holmes 1986, ch. 1, in which Lancret's indebtedness to Watteau is discussed.

9 Wildenstein 1924, p. 118, no. 708. For an illustration, see Mary Tavener Holmes, *Nicolas Lancret, 1690–1743*, exh. cat., New York and Fort Worth, The Frick Collection and Kimbell Art Museum, 1991, p. 65, no. 4 (ill.).

10 In addition to the Chicago work, there are the following paintings: (1) Oil on canvas, 72.9 x 59.4 cm; formerly abbé de Gévigney, Paris; sold Paillet, Hôtel de Bullion, Paris, December 1–29, 1779, no. 540, with its pendant, to Detouche le jeune (Wildenstein 1924, p. 116, no. 689; its pendant is p. 116, no. 688). This may be the same as the following painting: (2) Oil on canvas, 70 x 56 cm; Wallace Collection, London (Wildenstein

1924, p. 117, no. 699; for an illustration, see Ingamells 1989, p. 235, no. P450). (3) Oil on canvas, 89.1 x 35.1 cm; location unknown, formerly M. Beaujon, sold Remy and Julliot, fils, Hôtel d'Evreux, Paris, April 25 and following, 1787, no. 119, with its pendant (Wildenstein 1924, pp. 116–17, no. 693; the pendant is pp. 116–17, no. 692). (4) Oil on canvas, 91.8 x 97.2 cm; location unknown, formerly abbé de Gévigney, Paris, sold Paillet, Hôtel de Bullion, Paris, December 1–29, 1779, no. 539 (Wildenstein 1924, p. 117, no. 701). (5) Medium and dimensions unknown; location unknown, formerly H. Decaisne, sold Petit, at Decaisne's atelier, rue de la Rochefoucauld 15, Paris, April 4–7, 1853, no. 154 (Wildenstein 1924, p. 117, no. 702).

There are also drawings of the subject: (1) *Study of a Woman, Full-Length* (study for *The Beautiful Greek Woman*), drawing in *trois crayons*, 185 x 145 mm; location unknown, sold Hôtel des Commissaires-Priseurs, Paris, May 16–17, 1898, no. 218 (ill.), as Pater. (2) *The Beautiful Greek Woman*, two studies in *trois crayons*, 190 x 240 mm; location unknown, formerly Georges Dormeuil, Paris, when exhibited in Paris, Musée des Arts Décoratifs, *Exposition de la turquerie au XVIIIᵉ siècle*, 1911, no. 173 *bis* (Wildenstein 1924, p. 117, no. 703). (3) *Study for The Beautiful Greek Woman*, sanguine drawing, 200 x 250 mm; location unknown, formerly Pierre Defer and Henri Dumesnil, sold Hôtel Drouot, Paris, May 10–12, 1900, no. 169.

11 Wildenstein 1924, p. 120, no. 733, fig. 184.

12 See Emmanuel Bocher, *Les Gravures françaises du XVIIIᵉ siècle ou catalogue raisonné des estampes, eaux-fortes, pièces en couleur, au bistre, et au lavis, de 1700 à 1800*, pt. 4, *Nicolas Lancret*, Paris, 1877, p. 13, no. 15, p. 63, no. 84. While Bocher believed that the engravings reproduced pendants belonging to the comte de la Béraudière (now to the duc and duchesse de Mouchy), Wildenstein (1924, p. 116, nos. 684–85) questioned this because of differences between the paintings and engravings. More recently, Marianne Roland Michel proposed that Schmidt worked from pendants belonging to Mme Lancret; see Marianne Roland Michel, "Observations on Madame Lancret's Sale," *Burl. Mag.* 111 (October 1969), suppl. 23, pp. iii–iv.

13 For the Houston painting, see Wildenstein 1924, p. 117, no. 697. Its provenance is as follows: Charles Fox, Rutland, England, by 1847 (according to the 1987 sale catalogue; see this note below); Jacques Péreire, Paris, by 1911 (see discussion and note 14); private collection, England, to 1987; sold Christie's, London, July

10, 1987, no. 147 (ill.), to Colnaghi, New York (see letter of November 15, 1988, from Jennifer A. Lunan [Colnaghi] to the author, in curatorial files); sold by Colnaghi to the Blaffer Foundation, 1989 (letter of May 24, 1989, from Alan P. Wintermute [Colnaghi] to the author, in curatorial files). The added canvas strip was removed from the Blaffer Foundation picture in 1988 (according to an information sheet provided by Colnaghi, New York, in curatorial files).

14 *Exposition de la turquerie au XVIIIᵉ siècle*, exh. cat., Paris, Musée des Arts Décoratifs, 1911, no. 43.

15 Holmes 1986, ch. 3, p. 9. Although she did not associate it with the Chicago painting and its pendant, Holmes mentioned the play *Polichinelle Grand Turque* (Bibliothèque Nationale, Paris, MS 9312, no. 1306), in which Polichinelle holds a "turkish costume ball, where he appears 'en grand turque,' and frees a 'charmante Brunette' from the seraglio, and marries her." Interestingly, this play has been attributed to Lancret's teacher, Claude Gillot. See also Holmes 1986, ch. 3, pp. 8–9 nn. 21–22.

16 The derivation of the figure in *The Amorous Turk* is discussed by Holmes 1986, ch. 3, pp. 16–18, n. 49, figs. 181–83; see also Holmes (note 9), p. 66, fig. 24.

17 Donald Posner, *Antoine Watteau*, London, 1984, p. 208.

18 *Mademoiselle Sallé as Venus with the Three Graces*, sold Christie's, New York, June 3, 1987, no. 90 (ill.); *La Camargo Dancing*, Washington, D.C., National Gallery of Art (illustrated in Holmes [note 9], pp. 67–69, pl. 9); *Portrait of the Actor Grandval*, Indianapolis Museum of Art (illustrated in Holmes [note 9], pp. 94–95, pl. 21).

19 For the other paintings of this model, see, respectively, Holmes (note 9), p. 40, fig. 16; J[ack] W[eatherburn] Goodison and Denys Sutton in *Fitzwilliam Museum Cambridge: Catalogue of Paintings*, vol. 1, Cambridge, 1960, pp. 180–81, no. 329, pl. 94; sale catalogue, Charpentier, Paris, March 21, 1952, no. 45 (ill.), which is a study for the figure in *The Ball*, and no. 44 (ill.); and sale catalogue, Charpentier, Paris, March 24, 1955, no. 7 (ill.). Anonymous notes in the Art Institute's Archives refer to the Chicago painting as a portrait of the actress Mlle Dangeville or, tentatively, as the dancer Mlle Camargo; but these identifications seem to be groundless. *Wallace Collection Catalogues: Pictures and Drawings*, 16th ed., London, 1968, p. 168, no. P450, notes that among the "Belle Grecques" in later times were Countess Sophie Potocka and Mrs. Baldwin.

Nicolas de Largillière

1656 Paris 1746

Self-Portrait, c. 1725

Charles H. and Mary F. S. Worcester Collection, 1987.57

Oil on canvas, 81.1 x 64.8 cm (31¹⁵⁄₁₆ x 25½ in.)

CONDITION: The painting is in very good condition. The canvas is unlined, but an adhesive residue on the reverse suggests that it previously had a glue paste lining.[1] The original tacking margins have been cut off and fabric strips added to the edges, but cusping visible at all edges suggests that the painting is close to its original dimensions. The painting was prepared with a double ground, of pale gray over red. A locally applied red imprimatura is laid over the gray in the area beneath the blue coat and is visible through the garment's thinly painted surface. The loss of definition in the folds of this blue drapery is due to a fine-network drying craquelure that exposes the red imprimatura. Otherwise the surface is largely intact and its textural qualities well preserved. X-radiography suggests that the hair may originally have extended further above the head but was subsequently adjusted by the artist. There are a few small losses, ranging from 0.8 to 2 sq. cm, in the background near the neck and in the lower right corner. The losses have been filled

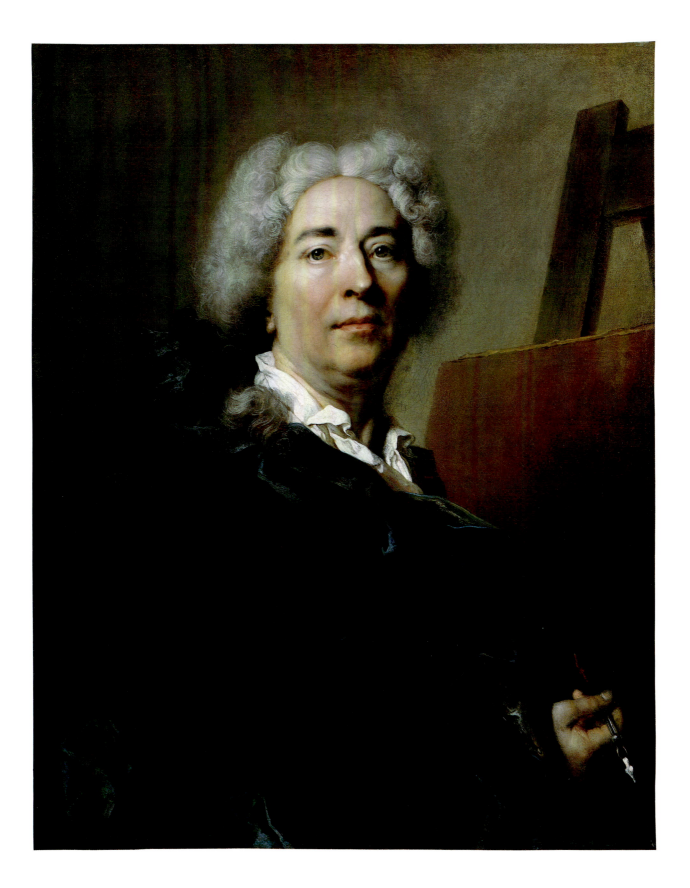

and inpainted. There is retouching in some of the cracks in the face and in the background on either side of the head. (partial x-radiograph)

PROVENANCE: Possibly Ange Laurent de Lalive de Jully, Paris; sold Paris, March 5 (sale postponed until May 2–14), 1770, no. 54,[2] possibly to Métra (or Mettra), for 130 *livres*.[3] Smirnoff Gallery, Moscow.[4] Alfred Edwards, Paris, by 1878; sold Hôtel Drouot, Paris, May 25, 1905, no. 28 (ill.) to Ducrey, for Fr 18,200.[5] Jacquinot, Paris, from the 1920s.[6] Sold by Jacquinot to Galerie Pardo, Paris, 1987.[7] Purchased from Galerie Pardo by the Art Institute through the Charles H. and Mary F. S. Worcester Endowment, 1987.

REFERENCES: Pierre Rosenberg in *Pittura francese nelle collezioni pubbliche fiorentine*, exh. cat., Florence, Palazzo Pitti, 1977, p. 45, under no. 12. Myra Nan Rosenfeld in *Largillierre and the Eighteenth-Century Portrait*, exh. cat., Montreal Museum of Fine Arts, 1981, pp. 43, 48, 51–52 under nos. 1, 2 (version 3). Georges de Lastic, "Largillierre à Montréal," *GBA* 6th ser., 102 (1983), p. 37. Georges de Lastic, "Propos sur Nicolas de Largillierre en marge d'une exposition," *Revue de l'art* 61 (1983), p. 74. *AIC Master Paintings* 1988, pp. 9, 38 (ill.).

EXHIBITIONS: Paris, Palais du Trocadéro, *Exposition Universelle de 1878*, no. 594 (cat. published as *Notice historique et analytique des peintures, sculptures, tapisseries, miniatures, émaux, dessins, etc.*, by Henry Jouin, Paris, 1879).

A painter of subjects ranging from landscape and still life to religious scenes, Largillierre was most famous for his portraiture. During the reigns of Louis XIV and Louis XV, and at a time when the power of the wealthy bourgeoisie was expanding, he was among the most gifted, versatile, and sought-after portrait painters in France. He apprenticed with Antoni Goubau in Antwerp, where his family had moved from Paris, and in 1675 went to London, where he restored paintings for the royal collections. In 1679 Largillierre returned to Paris where, except for a brief return to London in about 1686, he settled and launched his career. He had considerable academic success, and his ability to synthesize the two principal portrait conventions of his time—the allegorical court portrait and the realistic bourgeois portrait—gained him a reputation that endured until the rise of neoclassicism in the late eighteenth century.

Largillierre had a broad and distinguished clientele. While the other important contemporary French portraitist, Hyacinthe Rigaud, primarily painted royalty and members of the court, Largillierre offered his services mainly to the haute bourgeoisie, his preferred clientele. Nevertheless, he also recorded the likenesses of members of the royal family, nobles, financiers, high clergy,

aldermen, writers, and artists. Largillierre painted his own portrait on several occasions; some of these he copied himself, and others were replicated by members of his large and well-organized workshop. The present work is one of three self-portraits in which the artist presents himself in his studio. The earliest one, signed and dated 1707 (Paris, private collection), portrays the artist, wearing a turban and silk dressing coat, seated in his atelier with sculptures behind him and a portfolio in his lap.[8] In the second, a bust-length depiction of 1711 (Château de Versailles), he holds a *porte-crayon* with his right hand and gestures toward a canvas on which he has sketched the Annunciation.[9] The Chicago picture shows the artist at approximately the age of seventy, grasping a *porte-crayon*, before a blank canvas. Largillierre is amply draped in a blue velvet coat (see Condition), from beneath which emerge the folds of a white linen shirt. Neatly tied back with a gray and black bow, the artist's fashionable silvery-gray wig shimmers against the gray-green background and contrasts delicately with his vibrant and fresh complexion. All is bathed in the soft light of the atelier and the radiant presence of the seasoned and self-assured painter. Given the work's high quality and refinement, it seems very possible that it was the prime canvas from which numerous copies were made and that, as Georges de Lastic suggested, it once belonged to the illustrious collector Ange Laurent de Lalive de Jully (see After Greuze, 1969.109, and Bertin, 1979.305).[10]

Lastic proposed a date of c. 1725 for the Chicago work, since he owned a replica, which he believed to be autograph, that was signed and dated 1726.[11] An autograph replica now in the Uffizi was executed in 1729 and sent by the artist to the grand duke of Tuscany for his portrait gallery.[12] Such works indicate the unabated popularity the painter enjoyed throughout Europe, even in his later years.

NOTES

1 The thread count of the canvas is approximately 14 x 13/sq. cm (35 x 32/sq. in.). The back of the canvas is inscribed: *paint* [sic] *par. / N. de. Largillierre. / peintre Ord*re */ du Roy. / Directeur. Chan.*"[er] */ Recteur. / En son / Academie. Roy.*le *de Peinture / Et. Schulpture.* A sticker with a number "7" is attached to the stretcher (an identical sticker was attached to the frame previously on the painting, according to a handwritten note in curatorial files).
2 A self-portrait by Largillierre is described in the Lalive sale catalogue as follows: "Le Portrait de ce Peintre tenant un porte-crayon, il est à mi corps & peint sur toile de 2 pieds 6 pouces de haut, sur 2 pieds de large." (The Portrait of this Painter holding a *porte-crayon*, he is bust length and painted on canvas of 2

pieds 6 *pouces* high by 2 *pieds* wide.) The measurements given are equal to 81 x 64.8 cm. Georges de Lastic's suggestion that the Chicago picture is the work once owned by Lalive de Jully (letter to the author of October 13, 1987, in curatorial files) has not been substantiated. Although the dimensions of the two pictures are virtually the same, there are many other Largillière self-portraits whose whereabouts and dimensions are not known (such as one listed in the 1763 inventory of Evrard Titon du Tillet; see Rosenfeld 1981, pp. 38–39 n. 80), which may have been the work in Lalive de Jully's collection. For the Largillière *Self-Portrait* owned by Lalive de Jully, see *Catalogue historique du cabinet de peinture et sculpture françoise, de M. de Lalive . . .*, Paris, 1764, p. 5; Charles Blanc, *Histoire des peintres de toutes les écoles*, pt. 3, *Ecole française*, vol. 1, Paris, 1865, Largillierre p. 8; Lazare Duvaux, *Livre-journal de Lazare Duvaux, marchand-bijoutier ordinaire du roy, 1748–1758*, vol. 1, Paris, 1873, p. cclxxxi; H[ippolyte] Mireur, *Dictionnaire des ventes d'art faites en France et à l'étranger pendant les XVIIme et XIXme siècles*, vol. 4, Paris, 1911, p. 185; and Colin B. Bailey, ed., *Ange-Laurent de La Live de Jully: A Facsimile Reprint of the 'Catalogue historique' (1764) and the 'Catalogue raisonné des tableaux' (March 5, 1770)*, New York, 1988, pp. lvi–lvii, 5, 31, no. 54. Without offering evidence, Lastic also stated that he believed the Chicago picture had passed from Lalive de Jully to Catherine II of Russia. Myra Nan Rosenfeld (letter to the author of February 7, 1989, in curatorial files), who in 1979 examined the painting inventories of Catherine II, found no record of a Largillière *Self-Portrait*.

3 According to an annotated sale catalogue in the Bibliothèque Nationale, Cabinet des estampes, Paris. See also Bailey (note 2), p. lvii.

4 According to the catalogue of the 1878 exhibition.

5 The picture belonged to Edwards at the time of the 1878 exhibition. Edwards was the director of a large newspaper and sold his old master paintings in order to amass a collection of contemporary art (see *Gazette de L'Hôtel Drouot* 14, nos. 143–44 [May 23–24, 1905], n. pag.). The painting is described in the 1905 sale catalogue as follows: "*Portrait du Maître*. Il s'est représenté à mi-corps, debout devant son chevalet, tenant à la main droite un porte-crayon. Les cheveux poudrés, bouclés sur les oreilles, noués sur la nuque d'un large ruban noir, il est couvert d'un manteau de soie bleu foncé drapé sur l'épaule. Toile. Haut., 79 cent.; larg., 63 cent." (*Portrait of the Master*. He is represented bust length, standing in front of his easel, holding a *porte-crayon* in his right hand. Powdered wig, curled over his ears, tied at the back of the neck with a large black ribbon, he

is dressed in a dark blue silk coat draped over the shoulder. Canvas. Height, 79 cm; width, 63 cm.) Price and buyer are recorded in an annotated sale catalogue (New York, Frick Art Reference Library), and in the *Gazette de L'Hôtel Drouot* 14, nos. 147–49 (May 27–29, 1905), n. pag.

6 Letter of April 7, 1987, from R[obert] Pardo to Martha Wolff, in curatorial files.

7 Ibid.

8 This canvas measures 93 x 74 cm. See Georges de Lastic, "Portraits d'artistes de Largillierre," *Connaissance des arts*, special no. 9 (1979), p. 21; for an illustration, see Rosenfeld 1981, p. 48, fig. 1c.

9 The Versailles canvas measures 80 x 65 cm, and is inscribed on the portfolio, lower right: *Nicolaus. de Largilliere / seipsum. pinxit aet. sae. 55 / Ann. dom 1711*; see Rosenfeld 1981, p. 46, no. 1 (ill.). The painting was engraved by François Chereau; for an illustration, see Rosenfeld 1981, p. 47, fig. 1a.

10 See note 2 for the Lalive de Jully provenance.

11 Verbal communication to the author, 1987 (notes in curatorial files). Lastic's version measured 81 x 65 cm and was inscribed on the back of the canvas. See Lastic (note 8), p. 22, fig. g. There is some doubt about the autograph status of the Lastic picture.

12 Of the autograph and presumed autograph paintings related to the Chicago picture, only the Uffizi work, which measures 81 x 65 cm, is inscribed on the back. The inscription reads as follows: *Nicolas. de. Largillierre / pientre [sic] Ordinaire. / du. Roy. / En. son. Académie. / Royalle. de peinture. et. Sch^{re·} / Et. Recteur. Chancellier. garde des. Sceaux. / de la Sus. ditte. Academie. / Né. / à. paris. Le. 10. Octobre. / 1656 / peint. par. Luy. Même / En / 1729.* See Rosenberg 1977, p. 45, no. 12 (ill.). According to Rosenfeld (1981, no. 2, pp. 50–52), there are two other autograph versions of the portrait, one in the Musée Fabre, Montpellier, measuring 79 x 63 cm (see Rosenfeld 1981, p. 51, fig. 2a), and the other, in the collection of Paul Desmarais, Canada, measuring 77.7 x 63.7 cm (see Rosenfeld 1981, p. 50, fig. 2). Georges de Lastic (1983) and Pierre Rosenberg (verbally, to the author, 1987) considered the Desmarais picture to be a product of Largillière's workshop. Rosenfeld cited also a third autograph version, now lost, that was formerly in the Musée Fabre. Among the many other workshop replicas of this portrait type are: *Self-Portrait*, 98 x 74 cm, sold Hugo Helbing, Frankfurt am Main, June 12, 1928, no. 38 (ill.); *Self-Portrait*, 81 x 65 cm, English private collection, sold Sotheby's, London, July 5, 1989, no. 158 (ill.), unsold (possibly the same as one of the previously listed paintings).

Eustache Le Sueur

1616 Paris 1655

Meekness (*Douceur* or *Mansuétude*), 1650

Charles H. and Mary F. S. Worcester Collection, 1974.233

Oil on panel, 100.7 x 67 cm (39⁷⁄₈ x 26³⁄₈ in.)

CONDITION: The painting is in fair condition. A 1983 examination report in the conservation file indicates that the paint

and ground layers have been transferred from the original wooden support to the present, cradled wooden backing.[1] A 1 cm wooden strip has been added to the perimeter, which makes viewing of the original edges impossible. The wood grains of the previous and new supports run vertically. The painting has an off-white ground that was applied with broad, horizontal brush strokes. The moderately thick paint layer was applied

over an oil gilt background. This background is covered with a painted geometric triangular pattern that continues under the edges of the figure. X-radiography reveals two continuous vertical cracks through the ground, paint, and gold background that originate at 26.6 and 50.7 cm from the left edge and extend the length of the panel, and two large losses (4 x 3 cm and 11 x 1.5 cm) intersecting these cracks, in the figure's right knee and at the back of her robe. Six shorter vertical cracks, ranging from 26 to 73 cm in length, originate at 17.7, 24.1, 39.3, 45.7, and 55.8 cm from the left edge. There are two circular losses, each approximately 2 x 3 cm, in the drapery and pedestal at lower right. A few small losses are scattered along the bottom edge of the panel. There is some abrasion in the yellow drapery and in the gold background surrounding the cracks. The lamb and the lighter colors of the figure and her drapery have been selectively cleaned. There are localized areas of retouching over the fills within the cracks and losses, in the lamb's face, in the back of the figure's robe, and in her hair, forehead, right arm, hands, and right knee. Much of the triangle pattern has been reinforced. (infrared, ultraviolet, x-radiograph)

PROVENANCE: Commissioned by Guillaume Brissonnet (or Briçonnet; d. 1674) in 1650 for the chapel of his town house (now destroyed), 12 rue de Portefoin, Paris.[2] The house passed to his elder son, Jean Baptiste Brissonnet (d. 1698), upon whose death it was sold to conseiller Vincent d'Invault. Sold to Jacques Turgot (d. 1722), maître des Requêtes, 1714. Bequeathed to his son, Michel Etienne Turgot (d. 1751), upon whose death the house passed to his widow. By descent to their son, Anne Robert Jacques Turgot, 1757. The house was sold in 1775, and the decorations dismantled. Etienne François Turgot (d. 1789), marquis de Sousmont, to at least 1784, when he resided on the quai d'Orléans, Paris.[3] Vincent Donjeux, Paris; sold LeBrun et Paillet, Paris, April 29 and following, 1793, no. 330, to Jouberton, with *Justice*, for 1,550 *livres*.[4] Lafontaine, Paris; sold Chariot, Paris, May 28-June 2, 1821, no. 128, as *L'Innocence*, for Fr 480. M. de Mauméjan, Paris; sold Lacoste, Paris, June 29–July 2, 1825, no. 40, as *L'Innocence*. Jean Toussaint Arrighi de Casanova (d. 1853), duc de Padoue, Château de Courson-Monteloup, Essonne; by descent to Ernest Louis Hyacinthe Arrighi de Casanova (d. 1888), duc de Padoue; by descent to comte Ernest de Caraman. Comte de Gramont; sold Hôtel Drouot, Paris, December 4, 1967, no. 81, to Heim Gallery, London, as school of Eustache Le Sueur, *La Charité*. Purchased from Heim by the Art Institute through the Charles H. and Mary F. S. Worcester Endowment, 1974.

REFERENCES: [Georges] Guillet de Saint-Georges, "Eustache Le Sueur [1690]", in *Mémoires inédits sur la vie et les ouvrages des membres de l'Académie royale de peinture et de sculpture*, vol. 1, Paris, 1854, p. 164. Florent Le Comte, *Cabinet des singularitez d'architecture, peinture, sculpture, et gravure*, vol. 3, Paris, 1700, p. 98. [Antoine Nicolas] D[ézallier d'Argenville (fils)], *Voyage pittoresque de Paris . . .*, 2d ed., Paris, 1752, p. 207; reprint, Geneva, 1972, p. 49. [Antoine Joseph Dézallier d'Argenville (père)], *Abrégé de la vie des plus fameux peintres . . .*, new ed., vol. 4, Paris, 1762, p. 116. Hébert, *Dictionnaire pittoresque et historique*, vol. 1, Paris, 1766, p. 152; reprint, Geneva, 1972, p. 49. L[ouis] Dussieux and A[natole] de Montaiglon, *Nouvelles recherches sur la vie et les ouvrages*

d'Eustache Le Sueur, Paris, 1852, pp. 26, 63. Charles Blanc, *Histoire des peintres de toutes les écoles*, pt. 3, Ecole française, vol. 1, Paris, 1865, Eustache Le Sueur p. 4. J[ules] J[oseph] Guiffrey, "Lettres et documents sur l'acquisition des tableaux d'Eustache Le Sueur pour la collection du roi (1776–1789)," *Nouvelles Archives de l'art français, année 1877*, reprint, Paris, 1973, pp. 337–41. Edmond Bonnaffé, *Dictionnaire des amateurs français au XVIIe siècle*, Paris, 1884, p. 44. Gabriel Rouchès, *Eustache Le Sueur*, Paris, 1923, p. 73. Denys Sutton, "Richness of Old Masters," *Financial Times*, London ed., June 25, 1974, p. 3. The Toledo Museum of Art, *European Paintings*, Toledo, 1976, p. 97. Dominique Vasseur, "*Mansuétude* by

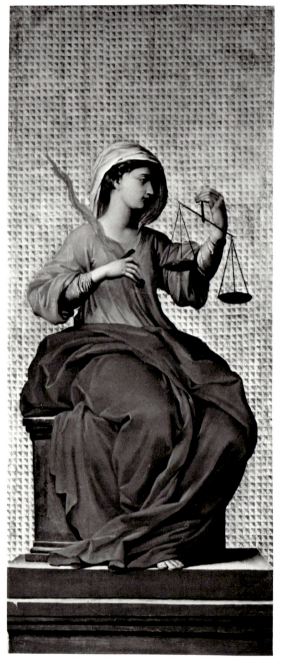

Fig. 1 Eustache Le Sueur, *Justice*, private collection [photo: courtesy of Christie's, Monaco]

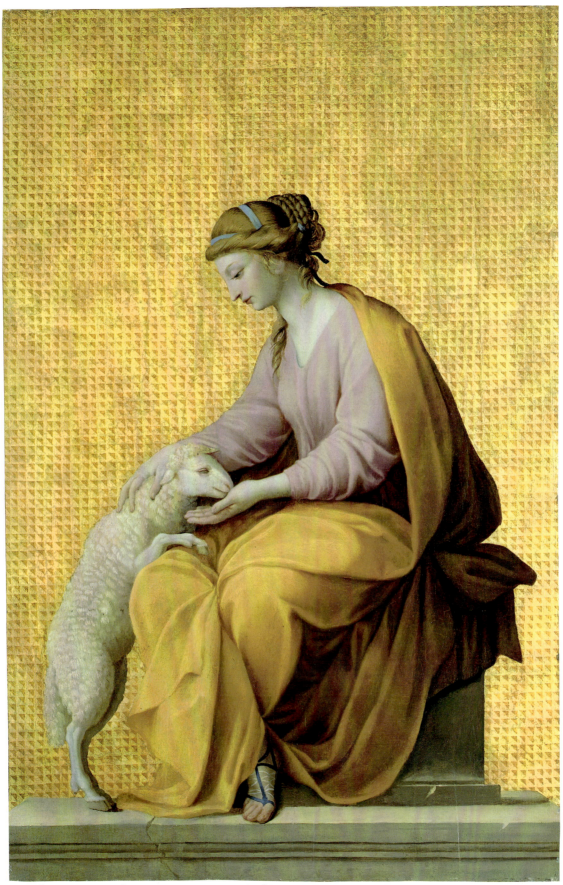

Eustache Le Sueur, *Meekness* (*Douceur* or *Mansuétude*), 1974.233

Eustache Le Sueur," *AIC Bulletin* 71, 4 (1977), pp. 8–11 (ill.).
Pierre Rosenberg, *La Peinture française du XVIIᵉ siècle dans
les collections américaines*, exh. cat., Paris, Galeries Nationales
du Grand Palais, 1982, p. 357, inv. no. 2 (ill.). Wright 1985,
p. 218. Marguerite Sapin, "Précisions sur l'histoire de quel-
ques tableaux d'Eustache Le Sueur," *Bulletin de la Société de
l'histoire de l'art français*, année 1984 (1986), p. 62, no. 16,
pp. 62–63, under no. 17, p. 76, under no. 49, fig. 9. Alain Mérot,
Eustache Le Sueur (1616–1655), Paris, 1987, pp. 33, 244–45,
under nos. 98–105, p. 247, no. 100, fig. 318. Wright 1991, vol. 1,
p. 243, vol. 2, p. 62.

EXHIBITIONS: London, Heim Gallery, *Religious and Biblical
Themes in French Baroque Painting*, 1974, no. 7.

One of the few highly acclaimed French artists of the
seventeenth century who never visited Italy, Eustache Le
Sueur remained throughout his life in Paris, where at an
early age (probably in 1630/32) he entered the thriving
atelier of Simon Vouet. In the first part of his career, Le
Sueur emulated Vouet's style, so much so that it is at
times difficult to distinguish his early works from those
of his famous teacher. Abandoning Vouet's style in the
early 1640s, Le Sueur developed a refined, classical
manner that reflected the influence of Raphael, whose
works he knew primarily through engravings. In 1648
he played a prominent role as a founding member of the
Academy. Le Sueur died at age thirty-eight, having won
recognition that had earned him many commissions and
a reputation that endured into the nineteenth century.[5]
That reputation has been partially revived in recent
scholarly literature as his works and contributions have
been carefully reexamined and reappraised.

At the time Le Sueur began his artistic career, Paris
saw the ascent of a new social class comprising aristo-
crats and nouveau-riche financiers and parliamentarians.
They engaged many painters, Le Sueur among them,
to decorate their lavish châteaux and hôtels. Today
Le Sueur's decorations are unfortunately known only
through fragments, remnants that survive from the
destruction of these buildings and the dismantling of
their decorations. *Meekness* is a case in point.

The Chicago painting was once part of a decorative
scheme in a chapel in the house of the distinguished
Parisian magistrate Guillaume Brissonnet, *conseiller au
Parlement de Paris* in 1635, *maître des Requêtes* in
1641, and, later, *président au Grand Conseil*. His hôtel
(now destroyed), located in the fashionable Marais dis-
trict, was acquired by the Turgot family and passed
eventually to Anne Robert Jacques Turgot, finance min-
ister under Louis XVI.[6]

Le Sueur's decorations for Brissonet were first men-
tioned in 1690 by Guillet de Saint-Georges. Then, in
1700, Florent Le Comte, a reliable early biographer of
Le Sueur, listed them under the year 1650 and verified
that Le Sueur painted "chez Monsieur le President
Brissonnet plusiers ouvrages dans son logis."[7] In 1752
Dézallier d'Argenville (fils) provided a description of the
chapel, then in Turgot's possession:

> Le tableau d'Autel qui représente l'Annonciation de la
> Vièrge, est sur toile à l'exception des autres morceaux qui
> son sur bois. Sur le devant d'Autel se voient S. Guillaume
> & Sainte Marguerite en deux tableaux. Les huit Béati-
> tudes se remarquent sur les lambris du pourtour, dont
> les fonds sont dorés, ce qui forme huit morceaux carrés
> ou oblongs. . . . Au-dessus sont autant de Camayeux
> octogones, dont il n'y en a que six qui soient de *le Sueur*.
> Le premier est la Naissance de la Vièrge. Le second sa
> Purification. Le troisiéme le Mariage de Saint Joseph.
> Le quatriéme la Visitation. Le cinquiéme la Nativité de
> Notre Seigneur. Le sixiéme la Présentation au Temple.[8]

When, ten years later, the elder Dézallier d'Argenville
described the grisaille paintings, he did not mention the
Marriage of Saint Joseph but remarked that "ces beaux
morceaux font regretter la ruine du plafond de l'anci-
enne chapelle, où l'on voyoit l'assomption de la Vièrge
soutenue par trois anges, des grouppes d'enfans ornoient
le haut du plafond, & il y avoit quatre têtes de Chérubins
dans le bas."[9] Although these early reports are vague, it
is possible to surmise from them that the *Annunciation*
served as an altarpiece, flanked by *Saint William* and
Saint Margaret on the altar frontal, and that the Beati-
tude panels, each surmounted by a grisaille, were per-
haps symmetrically and horizontally distributed across
the lateral walls. The space may have been domed, with
the *Assumption* visually extending the vertical space.

When the hôtel was sold in 1775 and the chapel deco-
rations dismantled, Turgot's heirs attempted to sell the
paintings to the king.[10] Not long before, the royal collec-
tions had been enhanced by the acquisition of two of Le
Sueur's most notable painted ensembles: the decorations
for the Hôtel Lambert executed between 1646 and 1649,
which included the Cabinet de l'Amour, the Cabinet des
Muses, and the cycle of twenty-two paintings devoted
to the life of Saint Bruno painted between 1645 and
1648 for the cloister of the Charterhouse of Paris (all
of these works are now in the Louvre). The Brissonnet-
Turgot paintings were dispersed after the king decided
not to purchase them, and only three are known today.
Two Beatitudes, *Meekness* and *Justice* (fig. 1), remained

together until the former entered the Art Institute, and the altar *Annunciation* (fig. 2) is in the Toledo Museum of Art.[11]

Although Le Sueur never left France, his works were inspired by Italian Renaissance painting and antique art. In an artistic culture of contending tastes and fashions, a style emerged in the early 1630s that eschewed both the dramatic realism of Caravaggio and the decorative ebullience of Vouet. This new manner, developed by Le Sueur and others, was characterized by a clarity and elegance, as the artists strove to achieve a classical purity. Vouet's swirling designs and vivid, luminous colors, like those seen in Le Sueur's early works, were replaced in his mature paintings by decoratively graceful elements (such as elongated figures) derived from the school of Fontainebleau and by an increasingly neutral palette. In *Meekness*, the subtle harmony of colors is enhanced by the even and diffused illumination of the figure.

Although Vouet had introduced his student to a broad range of Italian art, Le Sueur seems to have been most attracted to the works of Raphael. For instance, the Italian artist's tapestry cartoon *The Death of Ananias* (1515) and his *School of Athens* (1510/11) in the Vatican's Stanza della Segnatura clearly inspired Le Sueur's *Saint Paul Preaching at Ephesus* (1649; Louvre). Similarly, *Meekness* and *Justice* recall the four rectangular ceiling frescoes (*Astronomy*, *The Judgment of Solomon*, *Adam and Eve*, and *Apollo and Marsyas*; 1508) on the springing of the vault of the Stanza della Segnatura. *Meekness* and *Justice* follow Raphael's frescoes in placing voluminous, rounded and polished figures against a gold background imitative of mosaic. Despite Le Sueur's tendency to simplify forms more than Raphael did and to delineate contours more sharply, he generally captured the spirit of Raphael's paintings and their quality of studied calm. Le Sueur employed similar, Raphael-inspired gold backgrounds in his decorations for the Chambre de Madame of the Hôtel Lambert and the Chambre du roi and the Cabinet des bains at the Louvre (1653–55).[12]

The personification in the Chicago picture represents one of the ethical strengths taught by Christ in his Sermon on the Mount: "Blessed are the meek: for they shall inherit the earth" (Matthew 5.5). Such allegorical figures frequently appeared in French seventeenth-century decorations, including those of the Cabinet des bains, for which Le Sueur provided designs for several Virtues. For his depiction of Meekness, Le Sueur seems

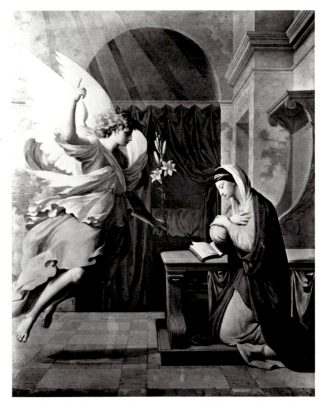

Fig. 2 Eustache Le Sueur, *Annunciation*, The Toledo Museum of Art, Toledo, Ohio; Purchased with funds from the Libbey Endowment, Gift of Edward Drummond Libbey

to have depended on Jean Baudoin's 1664 translation of Cesare Ripa's *Iconologia*, in which *Mansuétude* is described as follows:

> La douceur des esprits debonnaires est representée par cette Fille, qui semble caresser un Agneau, & au dessus de laquelle se lisent ces mots tirez de Salomon, MANSUETI HAEREDITABUNT TERRAM. L'Agneau, qui dans les sainctes Lettres est le symbole d'une Ame pure, & qui n'a point de malice, nous fait souvenir de n'avoir contre nostre Prochain aucune forte d'aigreur ny d'amertume; & les paroles de Salomon, Que pour recompense de cette douceur d'esprit envers un chacun, nous heriterons asseurement, non pas d'une terre perissable, & pleine de travaux, mais de celle où est le repos eternel, & que Dieu nous a promise luy-mesme.[13]

The other Beatitudes in the Brissonnet decorations — *Justice* and two lost allegorical figures, *Charity* and *Compassion* (known from nineteenth-century sales) — also appear to have been based on descriptions in the Baudoin edition of Ripa.[14]

NOTES

1 See report by Diane Dwyer (then at The Metropolitan Museum of Art, New York), Timothy Lennon, and Faye Wrubel, in conservation files, The Art Institute of Chicago.

2 Guillet de Saint-Georges 1690. See also Mérot 1987, pp. 244–49, nos. 98–105. The provenance given here follows that published by Mérot.

3 He was perhaps acting as trustee of the paintings while the heirs of Anne Robert Jacques Turgot attempted to sell them to the king. See Guiffrey 1877, pp. 337–43. See also Jacques Hillairet, *Dictionnaire historique des rues de Paris*, 6th ed., vol. 1, Paris, 1963, p. 193, which gives the address as 30 quai de Béthune. Guiffrey (1877, p. 340) noted the existence of a letter of July 21, 1784, from comte Charles Claude Labillarderie d'Angiviller to Jean Baptiste Marie Pierre, in which Turgot's residence is said to be on the quai d'Orléans.

4 The buyer's name is recorded in an annotated sale catalogue at the Bibliothèque Nationale, Cabinet des estampes, Paris.

5 See Paul Sandblom, "Eustache LeSueur's Critical Fortunes," *Marsyas* 18 (1975–76), pp. 37–43.

6 See Guillet de Saint-Georges 1690 and Mérot 1987.

7 Le Comte 1700, p. 98: "At the residence of President Brissonnet several works in his house."

8 D[ézallier d'Argenville (fils)] 1752, pp. 207–08: "The altar painting that depicts the *Annunciation of the Virgin* is on canvas, unlike the other small paintings, which are on wood. On the altar frontal are *Saint William* and *Saint Margaret* in two paintings. The eight *Beatitudes*, on gold backgrounds and of square or oblong format, are on the surrounding wall panels.... Above are the same number of octagonal grisailles of which there are only six by Le Sueur. The first is the *Birth of the Virgin*. The second her *Purification*. The third the *Marriage of Saint Joseph*. The fourth the *Visitation*. The fifth the *Nativity of Our Lord*. The sixth the *Presentation at the Temple*."

9 [Dézallier d'Argenville (père)] 1762, vol. 4, p. 116: "These beautiful little paintings make one regret the ruined state of the ceiling of the old chapel, where one saw the Assumption of the Virgin held up by three angels, a group of infants embellishing the top of the ceiling, and four Cherub heads at the bottom." See also Mérot 1987, pp. 244–49, nos. 98–105.

10 Guiffrey 1877, pp. 337–43.

11 *Justice* was sold at Christie's, Monaco, December 4, 1992, no. 42 (ill.), and is now on the European art market. For the *Annunciation*, see Mérot 1987, pp. 245–46, no. 98, fig. 316.

12 Guillet de Saint-Georges 1690, pp. 152, 154, 156–57. Alain Mérot (letter to the author of January 10, 1984, in curatorial files) suggested that the gold triangle pattern is a later addition, perhaps dating from the eighteenth century, when many works by Le Sueur were badly restored. However, the patterning can be seen in many places passing beneath layers of original paint, particularly in areas at the edge of the figure that are abraded or have become somewhat transparent with age (see Condition), and thus is known to be part of the original design.

13 Cesare Ripa, *Iconologie . . . tirée des recherches et des figures de Cesar Ripa, moralisées par J. Baudoin*, Paris, 1644, pt. 2, p. iii, no. II: "The sweetness of the compliant soul is represented in this girl, who seems to caress a lamb, and above which one reads the words taken from Solomon, MANSUETI HAERED-ITABUNT TERRAM. The lamb, who in the Holy Scriptures is the symbol of a pure soul, and who is without malice, makes us remember not to have any animosity or bitterness against our neighbor; and [in] the words of Solomon, that as a reward for such a sweetness of spirit toward everyone, we will surely inherit, not a perishable land filled with labor, but one where tranquillity is eternal, and which God himself has promised us."

14 See Sapin 1986, pp. 76–77, nos. 48–49, for a description of the two Beatitudes when they passed through sale; they correspond to Ripa (note 13), pt. 2, p. 113, nos. VI, VIII. Le Sueur also turned to Ripa when creating his Muses for the Hôtel Lambert and *Allegory of Magnificence* (Dayton Art Institute; see Mérot 1987, no. 182, fig. 445) for Louis XIV's apartment in the Louvre.

The Master of the Children's Caps (Le Maître aux Béguins)

Peasant Family at a Well, 1650/60

Robert A. Waller Memorial Collection, 1923.415

Oil on canvas, 97.5 x 103.2 cm (38³/₈ x 40⁵/₈ in.)

CONDITION: The painting is in fair condition. The picture was cleaned in 1931, treated for bloom in 1938, and cleaned again in 1972, when an old glue paste lining was replaced with a wax resin one.[1] X-radiography reveals that the top, bottom, and right edges of the painting were once folded over a smaller stretcher and used as tacking margins. A 3.5 cm wide band of overpaint along the top edge covers what appears to be an original tacking margin.[2] There is a 2 cm wide band of overpaint along the bottom edge.

The thin paint layer, applied over an off-white ground, has suffered extensive abrasion because of past cleaning. This accounts for a loss of definition in the figures, especially in the male figures in the left background and in the bottom of the woman's and girls' skirts in the foreground. The paint surface has been flattened and the canvas weave has become more pronounced due to the lining process. There is a considerable amount of overpaint on the standing male figures, the dog, the skirts, and the right edge, as well as along the top and bottom edges. Retouches are scattered on the cap of the boy in the foreground and throughout the upper portions of the sky, tree, and well. (ultraviolet, x-radiograph)

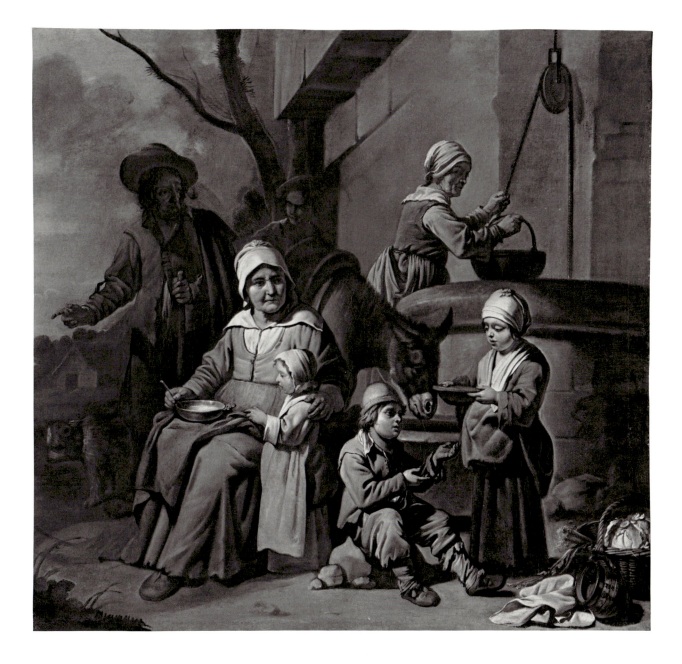

PROVENANCE: Victor Henri de Rochefort-Lucay, Paris, by 1905.³ Charles Sedelmeyer, Paris; sold Galerie Sedelmeyer, Paris, May 16–18, 1907, no. 223 (ill.), for Fr 2,800.⁴ Ehrich Galleries, New York.⁵ Osvald Sirén, New York; sold by Sirén to the Art Institute, 1923.

REFERENCES: Henri Rochefort, "La Collection de M. Henri Rochefort," *Les Arts* 4, 43 (July 1905), p. 14 (ill.). "La Chronique des arts et de la curiosité: Mouvement des arts — Collection Ch. Sedelmeyer, première vente," *GBA* 3d ser., 37 (1907), suppl. no. 21, p. 194. London, Burlington Fine Arts Club, *Illustrated Catalogue of Pictures by the Brothers Le*

Nain, London, 1910, pp. 15, 27. W[illiam] A. P[reyer], "A Painting by the Brothers Le Nain," *AIC Bulletin* 17, 8 (1923), pp. 82–84 (ill.). "Chicago Institute Acquires a Work by the Brothers Le Nain," *Art News* 22, 21 (1924), p. 6 (ill.). AIC 1925, pp. 43 (ill.), 143, no. 59. R[eginald] H[oward] Wilenski, *French Painting*, Boston, 1931, p. 49; rev. ed., 1949, p. 46. AIC 1932, pp. 39 (ill.), 160. Alfred M. Frankfurter, "Art in the Century of Progress," *Fine Arts* 20, 2 (1933), pp. 29 (ill.), 61. George Isarlo, "Les Trois Le Nain et leur suite," *La Renaissance* 21, 1 (1938), p. 34, fig. 52. Assia Visson, "Les Le Nain au Toledo Museum of Art," *Arts, beaux-arts, littérature* 142 (November 28, 1947), p. 3. AIC 1961, p. 165. Anthony Blunt, "The Le Nain Exhibition

at the Grand Palais, Paris: 'Le Nain Problems,'" *Burl. Mag.* 120 (1978), p. 873. Irina Kuznetsova and Evgenia Georgievskaya, *French Painting from the Pushkin Museum: Seventeenth to Twentieth Century*, New York and Leningrad, 1979, under no. 14. Jacques Thuillier, "Le Nain: Leçons d'une exposition," *La Revue du Louvre* 29, 2 (1979), pp. 161–62. Pierre Rosenberg, *La Peinture française du XVIIᵉ siècle dans les collections américaines*, exh. cat., Paris, Galeries Nationales du Grand Palais, 1982, p. 362, no. 9 (ill.). Wright 1991, vol. 1, p. 243, vol. 2, pp. 62, 518. Gregory Martin, "Abraham Willemsens (again): More News of Attributions in Flemish Painting," *Apollo* 137 (February 1993), p. 100 n. 10.

EXHIBITIONS: The Art Institute of Chicago, *A Century of Progress*, 1933, no. 221, as Louis Le Nain. The Art Institute of Chicago, *A Century of Progress*, 1934, no. 145, as Louis Le Nain. Kansas City, Missouri, The Nelson-Atkins Museum of Art, *French Art of Two Centuries*, 1939–40 (no cat.), as Le Nain assistant. The Toledo Museum of Art, *The Brothers Le Nain*, 1947, no. 16, as School of Le Nain. The Montreal Museum of Fine Arts, *Héritage de France: French Painting, 1610–1760*, 1961–62, no. 44, traveled to Ottawa and Toronto, as School of Le Nain. University of Notre Dame, Indiana, Art Gallery, 1965 (no cat.). Paris, Galeries Nationales du Grand Palais, *Les Frères Le Nain*, 1978–79, no. 76.

Over the years, *Peasant Family at a Well* was variously attributed to the brothers Le Nain, to Louis Le Nain, to Mathieu Le Nain, and to the school of Le Nain.[6] It was also once given to Jean Michelin, along with a similar painting now in the Pushkin Museum in Moscow.[7] In all likelihood, both are the work of a single artist for whom a corpus of some ten canvases was assembled by Jacques Thuillier.[8] Unable to identify the painter, Thuillier called him "Le Maître aux Béguins," since many of the children he portrayed wear a cap known as a *béguin*. Thuillier pointed out numerous other features that characterize this painter's work, such as wells, distant hilly landscapes with thatched houses, and certain figure types — among them old men with small beards, weathered old women, and broad-faced, expressionless children.

Peasant Family at a Well presents all of these features in a narrow foreground space. Thuillier also noted that, in this painter's work, "les personnages sont réunis par quelque prétexte vague — repas devant la maison, repos auprès du puits."[9] In the Chicago painting, the women and children of the family have paused to join together for a meal, and the father, walking stick in hand, seems to have just arrived. Despite such activities, the composition is generally static, the figures and animals immobile, and the expressions emotionless. These somewhat banal qualities distinguish the paintings of the Master of

the Children's Caps from those of the brothers Le Nain, whose paintings are typically more animated and seem more deeply spiritual.

It is not known whether the Master of the Children's Caps was of French or Flemish origin. Because peasant scenes were popular in the Low Countries and there were artistic exchanges between French and Flemish painters, it has been suggested that this painter was a Fleming who settled in Paris and followed a formula for genre painting.[10] Evidently he knew the paintings of the Le Nain brothers well and found them a source of inspiration and figure types. There was a lucrative market in France not only for works by the Le Nains themselves, but for paintings in their manner. Thuillier observed that in the 1750s many paintings by the Master of the Children's Caps turned up in Paris and that they were frequently mistaken for works by the Le Nains.[11] Some of these pictures may have been fraudulently sold under the brothers' names.

Many factors contributed to the development of French genre depictions of peasants. In Northern Europe such subject matter was well established by the late sixteenth century, and works of this type came to be known in France. The powerful realism of Caravaggio also found a French following, as did the genre paintings of Pieter van Laer, called Il Bamboccio, and those under his influence, the *Bamboccianti*. However, following the example of the brothers Le Nain, who were from a provincial background and so knew the details of rural life intimately, French genre painting developed a quiet restraint that distinguishes it from the dramatic realism of the Caravaggists and the gentle mockery of Northern European painters. The reception of Italian genre pictures in France was no doubt conditioned as well by a century-old tradition of pastoral and "street" subjects in French literature.[12]

Among the many attempts to interpret the rural subjects painted by the Le Nain brothers and their followers, Neil MacGregor's analysis of several canvases given to Louis Le Nain is the most sensitive to issues of economics and social status.[13] MacGregor proposed that the man depicted in Le Nain's *Resting Peasants* (c. 1640; London, Victoria and Albert Museum)[14] represents a *fermier*, a man hired to manage and cultivate an estate probably owned by an urban dweller. He noted that, in the changing socioeconomic climate of seventeenth-century France, the *fermier*'s horse was a "source and symbol of his earning power and status," that "the possession of a horse [allowed] 'fermiers' to contract in this

privileged way with the urban land-owners," and that *fermiers* became "the elite of the rural community."[15] In some cases, *fermiers* were quite prosperous and were able to provide ample food, clothing, and shoes to their families. In this respect, a parallel can be drawn between the *fermier* of Le Nain's painting and the man with his family in the Chicago canvas — they are rural, to be sure, but not necessarily poor peasants. MacGregor also observed that several paintings by Le Nain might be the visual expression of the ideas of Charles Estienne and Olivier de Serres, as published in their respective books, *L'Agriculture et maison rustique* (1564) and *Théâtre d'agriculture* (1660). These widely circulated books, in which the agricultural worker was viewed respectfully and the ideals of rural family life heralded, may have been read and their opinions shared by those who originally purchased the Chicago painting and similar works by the Le Nains and their followers.

Notes

1 Leo Marzolo treated the painting in 1931 and 1938, and Alfred Jakstas treated it in 1972. The thread count of the original canvas is 8 x 8/sq. cm (20 x 20/sq. in.).

2 The x-radiograph indicates that the top edge of the canvas is frayed and, in its preparation and paint layers, is of a lesser density than the bottom and right edges, suggesting that it may originally have been a tacking margin.

3 Rochefort 1905.

4 The sale price was recorded in annotated sale catalogues in the Frick Art Reference Library, New York, and the Bibliothèque d'Art et d'Archéologie, Paris.

5 According to registrar's records.

6 The painting was acquired by the museum as a work by the brothers Le Nain. The attribution was revised to Louis Le Nain when the picture was published in the Art Institute's 1932 guide to the collection. Isarlo (1938) assigned the work to Mathieu Le Nain. When the painting appeared in the 1947 Le Nain exhibition in Toledo, it was described as "School of Le Nain." A copy of this painting (100 x 82 cm) is in the Musée des Beaux-Arts, Mirande.

7 Illustrated in Kuznetsova and Georgievskaya 1979, no. 14.

8 For illustrations of the ten paintings grouped under this anonymous artist, see the 1978–79 exhibition catalogue, pp. 318–29. In his review of the exhibition, Blunt (1978) stated that he believed that only eight of these were by the same hand.

9 See the 1978–79 exhibition catalogue, p. 319: "The figures are brought together under some vague pretext — a meal in front of a house, a rest near the well."

10 See the 1978–79 exhibition catalogue, p. 319. Gregory Martin has unconvincingly identified the Master of the Children's Caps with the Flemish painter Abraham Willemsens (active 1627–72); see Gregory Martin, "The Maître aux Béguins: A Proposed Identification," *Apollo* 133 (January 1991), pp. 112–15, and Martin 1993, pp. 97–101.

11 See the 1978–79 exhibition catalogue, p. 319.

12 See Bernard Dorival, "Expression littéraire et expression picturale du sentiment de la nature au XVIIᵉ siècle français," *La Revue des arts* 3 (1953), pp. 46–47; and Thuillier in the 1978–79 exhibition catalogue, p. 135.

13 Neil MacGregor, "The Le Nain Brothers and Changes in French Rural Life," *Art History* 2 (1979), pp. 401–12. See also Jacques Thuillier, "Histoire de la création artistique en France, I. Les Frères Le Nain et l'inspiration réaliste à Paris au temps de Louis XIII et de Mazarin," *Annuaire du Collège de France, 1978–1979: Résumé des cours et travaux*, Paris, 1979, pp. 649–62, and Hélène Adhémar, "Les Frères Le Nain et les personnes charitables à Paris sous Louis XIII," *GBA* 6th ser., 93 (1979), pp. 69–74.

14 Illustrated in MacGregor (note 13), pl. 20.

15 MacGregor (note 13), p. 408.

Attributed to Philippe Mercier

1689 Berlin–London 1760

Pierrot Catching a Fly, 1740s

Bequest of Mrs. Sterling Morton, 1969.333

Oil on canvas, 58.6 x 74 cm (23 1/16 x 29 1/8 in.)

CONDITION: The painting is in fair condition. The canvas has an old glue paste lining. The tacking margins have been cut off. A 4.1 cm horizontal tear through the figure's left hand occurred in 1959 during shipment to the United States from London. The tear was patched with wax and linen in 1959. In 1969 the patch was removed and the painting was cleaned, relined with wax, varnished, and inpainted.[1] The paint layer, applied over a warm tan ground, has been thinned by cleaning in some of the areas of dark shadow. The tear mentioned above has been filled and

inpainted. Extensive retouching is visible on the left side of the figure's face, in his left arm, and in the background behind his right arm. There is minor retouching in the fingertips of the figure's right hand, under his right arm, in the shadows of his hat brim, and at the upper and lower left corners. (infrared, ultraviolet, x-radiograph)

PROVENANCE: Noel Hill, first baron Berwick (d. 1789), Attingham Hall, near Shrewsbury, Shropshire;[2] by descent to Thomas Noel, second baron Berwick; sold Attingham Hall, August 6, 1827, no. 23, as Watteau, *Pantaloon, in the act of catching a Fly upon his hand*, to Thomas Kenyon (d. 1851);[3] by descent to Lt. Col. Herbert Edward Kenyon, Pradoe, Oswestry, Shropshire; sold Christie's, London, November 23,

1956, no. 97, as Watteau, to Arcade Gallery, London, for £400.[4] Sold by Arcade Gallery to Colnaghi, London, 1957.[5] Sold by Colnaghi to Sterling Morton, Chicago, 1959;[6] Mrs. Sterling Morton (d. 1969); bequeathed to the Art Institute, 1969.

REFERENCES: J[acques] Mathey, *Antoine Watteau: Peintures réapparues, inconnues, ou négligées par les historiens, identification par les dessins, chronologie*, Paris, 1959, pp. 37–38, 77, no. 89, fig. 89. *Colnaghi's, 1760–1960*, London and Bradford, 1960, fig. 45. Ettore Camesasca and John Sunderland, *The Complete Paintings of Watteau*, New York, 1968, p. 128, no. 2°v (ill.). J[ohn] M[axon], "Mrs. Morton's Bequest," *AIC Calendar* 64, 1 (1970), n. pag., fig. 1. "La Chronique des arts: Musées et monuments historiques," *GBA* 6th ser., 76 (1970), suppl. to no. 1221, p. 4. "Musées: Heureux Centenaires," *Connaissance des arts* 218 (April 1970), p. 7 (ill.). "Recent Accessions of American and Canadian Museums, January–March 1970," *Art Quarterly* 33 (1970), p. 323. [Francis Watson], review of *The Complete Paintings of Watteau*, by Ettore Camesasca and John Sunderland, in *Times Literary Supplement* 3626 (August 27, 1971), p. 1019. Jean Ferré et al., *Watteau*, Madrid, 1972, vol. 1, p. 33, vol. 4, pp. 1110, 1118. Morse 1979, p. 298. André Chastel, "De la 'burla' au 'lazzo della mosca,'" in *Scritti in onore di Giuliano Briganti*, Milan, 1990, pp. 236, 240, fig. 3.

EXHIBITIONS: The Art Institute of Chicago, *Selected Works of Eighteenth-Century French Art in the Collections of The Art Institute of Chicago*, 1976, no. 3, as Watteau, *Pantaloon Catching a Fly*.

From the time it passed through the Berwick sale in 1827 until the 1980s, *Pierrot Catching a Fly* was thought to be by Watteau. Subsequently its authorship has been much disputed. While Jacques Mathey, followed by John Maxon, Francis Watson, and J. Patrice Marandel, maintained the Watteau attribution, Ettore Camesasca and Jean Ferré doubted it.[7] The painting has not been included or even mentioned in recent monographs and other literature on the artist. The Watteau attribution seems doubtful — as Camesasca has pointed out, *Pierrot Catching a Fly* is of a poorer quality than one generally associates with Watteau's oeuvre.

The provenance prior to the first baron Berwick is unknown, and it is not clear exactly when the painting came to bear a Watteau attribution. It is known that in the eighteenth and nineteenth centuries, Watteauesque paintings were much in vogue in England; works by the artist's imitators were often sold under his name, and myriad copies of his works were marketed.[8] Among the artists who emulated Watteau's manner and sold works on the London market was Philippe Mercier, who also made engravings after the master's paintings.

Born in Berlin of Huguenot parentage, Mercier's poorly documented early years included training in Berlin under Antoine Pesne, travels to France, Italy, and London and, as a practicing painter, connections with the court at Hanover. In the early 1720s, Mercier settled in England, where he enjoyed considerable patronage and made an important art-historical contribution by introducing the artistic genre known as the conversation piece into that country (see entries on Arthur Devis in the British paintings section, 1951.203, 1951.206, 1951.207, 1956.130). Mercier's works were also indebted to those of seventeenth-century Dutch genre painters and of Chardin. The anecdotal nature of Mercier's subject matter, his grayish palette, and his figure scale probably derive from Dutch painting. Certain works, such as *The Bible Lesson* (Newark, Nottinghamshire, Flintham Hall, Myles Hildyard Collection), were modeled after paintings by Chardin.[9]

Pierrot Catching a Fly shares many characteristics with Mercier's paintings, such as the strong illumination of the figure against a dark, abstract background, the scale of the figure, and the particular characteristics of his features: the sharply defined bridge of the nose, puffy eyes, pinched mouth, and roughly drafted large hands. Also typical of Mercier are the long, broad sweeps of paint that define the drapery and the generally gray palette. The Chicago picture can be compared to two Mercier paintings of about 1738 that include representations of Pierrot — *The Italian Comedians*, in the Cincinnati Art Museum, and *The Letter Writer*, in the collection of the Greater London Council, Marble Hill House. Especially similar in conception is Mercier's *Three Children Blowing Bubbles* (fig. 1), which dates to c. 1747.[10]

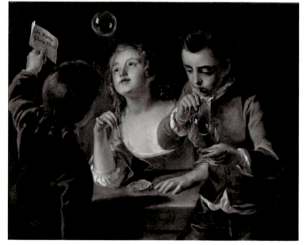

Fig. 1 Philippe Mercier, *Three Children Blowing Bubbles*, Collection of Mrs. J. T. Christie, England

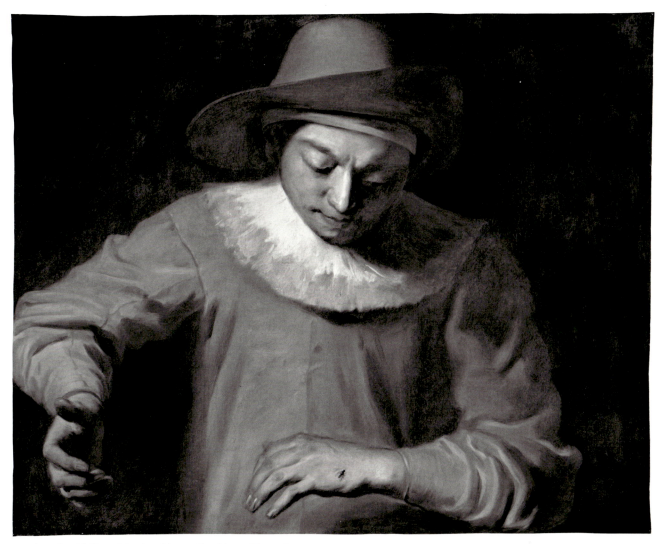

Attributed to Philippe Mercier, *Pierrot Catching a Fly*, 1969.333

The attribution of *Pierrot Catching a Fly* to Mercier is problematic in that the painting's quality is distinctly higher than that of Mercier's works. The fullness of the Pierrot figure and the smooth, adept handling of paint in this canvas do not correspond with Mercier's generally more precious figures or with his less economical application of paint, typically brushed on in daubs and slashes. Moreover, *Pierrot Catching a Fly* lacks the sentimentality that is so characteristic of Mercier's paintings of the 1730s and 1740s. Despite these discrepancies, the Mercier attribution has been supported by John Ingamells and Robert Raines, and, with reservation, by Pierre Rosenberg; others, including Francis Watson and Martin Eidelberg, have firmly rejected it.[11] If the painting can be assigned to Mercier, then it should probably be dated to the 1740s, the period of *Three Children Blowing Bubbles*.[12]

It is difficult to interpret the subject of the painting and to determine whether it depends on a literary source, represents an anecdotal moment from a theatrical performance, or refers to a popular song. It may depict, as André Chastel suggested, "some proverb about idle occupation," or, borrowing a general theme from earlier Dutch or French painting, it may carry moralizing overtones — the pending doom of the insect connoting the fragility or brevity of life.[13] Perhaps both interpretations are valid in that, to some extent, Pierrot represented those whose pleasures were both meager and short-lived.

NOTES

1 The 1959 repair was made by Louis Pomerantz. The 1969 treatment was performed by Alfred Jakstas. The thread count of the original canvas is approximately 12 x 14/sq. cm (32 x 36/sq. in.).

2 [Watson] 1971.

3 A label removed from the back of the stretcher and preserved in the conservation file indicates that Kenyon was the buyer at the Berwick sale.

4 According to an annotated sale catalogue in the Ryerson Library, The Art Institute of Chicago. At Arcade Gallery the picture was attributed to Mercier (letter of June 2, 1981, from Monika Wengraf [Arcade Gallery] to Mary Kuzniar, in curatorial files).

5 According to a letter from Wengraf (see note 4).

6 According to Grizelda Grimond (Colnaghi), the painting was sold to Sterling Morton (letter to the author of April 8, 1981, in curatorial files).

7 Mathey 1959, p. 37; Maxon 1970; [Watson] 1971; Marandel in the 1976 exhibition catalogue; Camesasca in Camesasca and Sunderland 1971; Ferré 1972, p. 33. While Mathey regarded *Pierrot Catching a Fly* as a relatively early Watteau, from about 1712/13 (see Watteau's *The Dreamer* of about this date, 1960.305), Watson placed the painting among Watteau's late works. Apparently, the work was briefly attributed to Mercier when it was in the possession of the Arcade Gallery (see letter from Wengraf, note 4).

8 Robert Raines, "Watteaus and 'Watteaus' in England before 1760," *GBA* 6th ser., 89 (1977), pp. 51–64.

9 John Ingamells and Robert Raines, "A Catalogue of the Paintings, Drawings and Etchings of Philip Mercier," *Walpole Society* 46 (1976–78), no. 232; see also Robert Raines, "Philip Mercier's Later Fancy Pictures," *Apollo* 80 (July 1964), p. 27, fig. 1.

10 For these three paintings, see Ingamells and Raines (note 9), p. 59, no. 250 (ill. in the *Catalogue of Paintings Forming the Private Collection of P. A. B. Widener, Ashburne—near Philadelphia*, pt. 2, *Early English and Ancient Paintings*, Paris, 1885–1900, no. 281); p. 53, no. 226 (ill. in *To Preserve and Enhance . . .*, exh. cat., Greater London Council, Kenwood, The Iveagh Bequest, 1975, no. 15); p. 55, no. 236, respectively.

11 Letters of April 19, 1982, and January 24, 1986, from John Ingamells to the author; Pierre Rosenberg, verbally, November 15, 1986; letter of May 7, 1982, from Francis Watson to the author; and letter of March 21, 1983, from Martin Eidelberg to the author (letters preserved in curatorial files).

12 In a letter to the author of April 19, 1982 (see note 11), John Ingamells stated that the painting, if by Mercier, would probably date to the later 1730s.

13 Letter of August 8, 1986, from André Chastel to the author, in curatorial files.

Attributed to Jean François Millet, called Francisque Millet I

1642 Antwerp–Paris 1679

Classical Landscape with Two Women and a Man on a Path, 1660/70

Gift of Mrs. Dellora A. Norris, 1970.1008

Oil on canvas, 29.5 x 44.1 cm (11⅝ x 17⅜ in.)

CONDITION: The painting is in fair condition. It was cleaned in 1971, when an old glue lining was replaced with a wax resin one.[1] The tacking margins have been cut off, and substantial losses to the canvas and paint layers at the perimeter have been filled and inpainted. The paint layer, applied over a warm red ground, has been flattened by lining, and an overall cupped craquelure is visually disfiguring. The paint surface has been damaged by past cleaning, and is abraded throughout. In particular, the dark shadows of the rocks in the lower left foreground and of the larger tree trunks at the right have been thinned. The curves of the path and the edge of the water in the lower left foreground have been altered by overpainting. The retouching on the perimeter is discolored, particularly in the area of the sky near the upper left corner. (infrared, ultraviolet, x-radiograph)

PROVENANCE: John Warne Gates (d. 1911), St. Charles, Illinois; at his death to his widow, Dellora Baker Gates (d. 1918);[2] at her

death to her niece, Dellora Angell, who married Lester J. Norris in 1923; on loan to the Art Institute, 1923–70; given to the Art Institute, 1970.

REFERENCES: W. A. P., "The Angell Collection," *AIC Bulletin* 17, 6 (1923), p. 52. AIC 1925, p. 170, no. 2308. AIC 1932, p. 190. Pierre Rosenberg, *La Peinture française du XVIIᵉ siècle dans les collections américaines*, exh. cat., Paris, Galeries Nationales du Grand Palais, 1982, p. 365, inv. no. 8 (ill.). Wright 1985, p. 231. Wright 1991, vol. 1, p. 245, vol. 2, pp. 62, 497.

This painting, which entered the museum as a work by Gaspard Dughet, appears to be the work of Jean François Millet, called Francisque Millet I.[3] Little is known about this painter of classical landscapes, whose works are sometimes confused with those of his son (Jean Millet, 1666–1723) and his grandson (Joseph Millet, c. 1700–1777), who were also called Francisque; Jean François and Jean both painted landscapes. Francisque Millet I was born in Antwerp, the city to which his French father had emigrated, and in 1662 married the daughter of

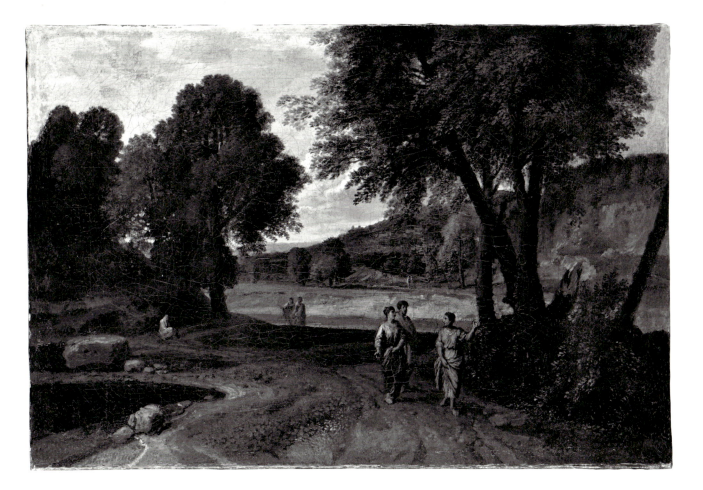

Laureys Franck, his teacher. The date of his arrival in Paris is not known, but the artist was *agréé* by the Academy in 1673. His travels seem to have taken him

Fig. 1 Jean François Millet, called Francisque Millet I, *Pastoral Landscape*, Musée du Louvre, Paris [photo: © Agence photographique de la Réunion des musées nationaux, Paris]

through Flanders, Holland, and England, but never to Rome. Although he apparently did not visit Italy, he emulated the classical Roman landscapes of Nicolas Poussin, especially those of the 1640s (see 1930.500). He probably became acquainted with the numerous works of Poussin (and of that artist's student, Gaspard Dughet) that were exported to Paris. Francisque I generally favored broad, expansive landscapes seen from a high viewpoint with clearly delineated, intact antique architecture (rather than ruins and fragments) and craggy mountains in the distance. His scenes are usually sparsely populated with figures in classical garb.

There are no known signed paintings by Francisque I, but a corpus of the artist's work has been compiled from two sources.[4] The first is an inventory of the Everard Jabach collection made in 1696, which records fifty-seven paintings by Francisque I; twenty-one were presumably the painter's own compositions, while the rest are listed as copies after Poussin and others.[5]

Such a large collection of Millet pictures suggests that Francisque I may have spent a period of time solely in the employ of Jabach. The second source is more substantial and reliable. Twenty-eight engravings were made by a certain (as yet unidentified) "Théodore" after paintings by Francisque I, and these visual documents provide the basis for many Millet attributions.[6] The Chicago *Classical Landscape with Two Women and a Man on a Path* cannot be connected with any of the landscapes listed in the Jabach inventory, nor does it correspond exactly to any of the Théodore engravings. However, the work does compare closely to other paintings that can be securely given to Francisque I.

Although the Chicago landscape does not contain Francisque I's typical classical architecture, the figures are entirely consistent — in their casual attitudes, summarily described drapery, and scale in relation to the landscape — with those appearing in other paintings by the artist, such as the *Landscape with Christ and the Woman of Canaan* (Toledo Museum of Art) and the *The Daughters of Cecrops* (Brussels, Musées Royaux des Beaux-Arts de Belgique).[7] The somewhat nervous brush strokes, dense foliage, and gently upward-sloping fore- and middle grounds are also characteristic of Francisque I's style and can be seen in his *Landscape with a Flock of Sheep on the Road* (Moscow, Pushkin Museum) and *Pastoral Landscape* (fig. 1).[8] The latter, in composition and figure type, particularly resembles the Chicago canvas.

NOTES

1 The painting was treated by Alfred Jakstas. The thread count of the original canvas is approximately 14 x 16/sq. cm (28 x 36/sq. in.).

2 According to registrar's records and letter of December 9, 1970, from Dellora A. Norris to Charles C. Cunningham, in curatorial files.

3 The attribution to Millet advanced here, first suggested by Getz in 1940 (notes of a visit to the Art Institute, April 17, 1940, Archives, The Art Institute of Chicago), has been accepted by Marie Nicole Boisclair (letter of June 9, 1982, to the author, in curatorial files), tentatively by Pierre Rosenberg (1982), and by Christopher Wright (1985).

4 A landscape at Petworth, England, presumed to be by Francisque I, bears the initials "F. M." See C. H. Collins Baker, *Catalogue of the Petworth Collection of Pictures in the Possession of Lord Leconfield*, London, 1920, no. 79. For an illustration, see Marcel Roethlisberger-Bianco, *Cavalier Pietro Tempesta and His Time*, University of Delaware Press, 1970, p. 132, no. 428.

5 The inventory entries for the twenty-one paintings were published by Martin Davies, "A Note on Francisque Millet," *Bulletin de la Société Poussin* 2 (December 1948), pp. 13–26. This seminal article remains the only major study devoted to Millet. Marcel Roethlisberger added important information on this artist in "Quelques Nouveaux Indices sur Francisque," *GBA* 6th ser., 76 (1970), pp. 319–23.

6 The twenty-eight engravings are reproduced in Davies (note 5) with notes on their corresponding paintings (when known).

7 For these paintings, see The Toledo Museum of Art, *European Paintings*, Toledo, 1976, pp. 111–12, pl. 193; and Marguerite Devigne, *Musées Royaux des Beaux-Arts de Belgique: Collection Della Faille de Leverghem*, Brussels, [1944], pp. 31–32, no. 21, pl. XXVII (as *Classical Landscape with Hermes and Herse*), respectively. These works were among the group engraved by the mysterious Théodore.

8 For the Moscow painting, see Irina Kuznetsova and Evgenia Georgievskaya, *French Painting from the Pushkin Museum: Seventeenth to Twentieth Century*, New York and Leningrad, 1979, p. 393, no. 392, pl. 20.

Louise Moillon

1610 Paris 1696

Still Life with a Basket of Fruit and a Bunch of Asparagus, 1630

Wirt D. Walker Fund, 1948.78

Oil on panel, 53.3 x 71.3 cm (21 x 28½ in.)

INSCRIBED: *Louyse' Moillon. 1630* (lower right, on edge of table)

CONDITION: The painting is in very good condition. The panel was thinned substantially and reinforced with a heavy cradle prior to entering the Art Institute's collection. The picture was surface cleaned and varnished in 1975.[1] The basket of fruit and the bunch of asparagus appear to have been selectively cleaned prior to this treatment; ultraviolet light reveals a thinning of the underlying natural resin varnish in these areas. The panel consists of a single board with a horizontal grain. Cross-grain battens were once slotted into the back of the panel at the right and left edges. These have been removed and replaced with

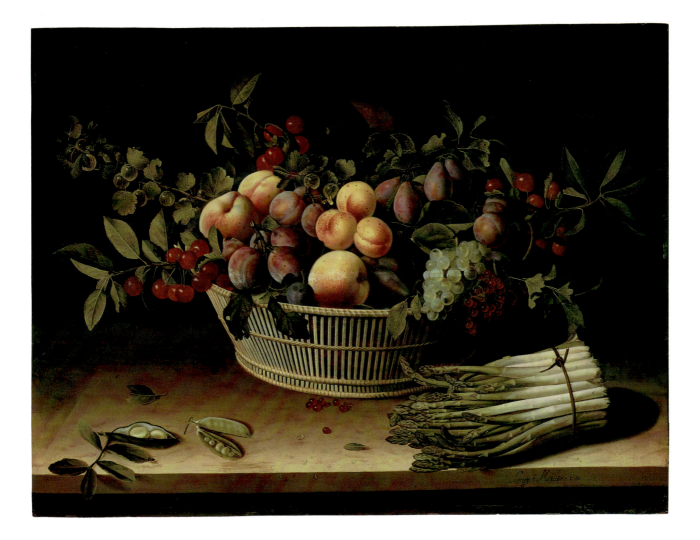

wood-dough fills. Subtle distortions caused by these additions are apparent on the surface. There is a continuous horizontal split through the panel approximately 27 cm from the top. The off-white ground has been toned to a warm ochre color. The relatively thin paint layer is well preserved aside from damage at the split and a few minor losses, a paint and ground loss (2.5 x 3.8 cm) at the lower right edge, a cluster of small (0.1 x 0.2 cm) losses at the lower left of the basket, and two small losses in the background above and to the left of the basket. These losses have been filled and inpainted. The inpainting through the center of the fruit basket has become notably discolored. (x-radiograph)

PROVENANCE: Gertrude D. Webster, Massachusetts, probably to 1947.[2] Sold Plaza Art Galleries, New York, November 6–8, 1947, no. 234, as Dutch School, to Kleinberger, New York, for $600.[3] Purchased from Kleinberger by the Art Institute through the Wirt D. Walker Fund, 1948.

REFERENCES: AIC 1961, p. 316. Michel Faré, *La Nature morte en France: Son Histoire et son évolution du XVII^e au XX^e siècle*, vol. 2, Geneva, 1962, fig. 33. Michel Faré, *Le Grand Siècle de la nature morte en France: Le XVII^e Siècle*, Fribourg and Paris, 1974, p. 55 (ill.). James A. Schinneller, *Art: Search and Self-Discovery*, 3d ed., Worcester, Mass., 1975, p. 28 (ill.). Ann Sutherland Harris in *Women Artists: 1550–1950*, exh. cat., Los Angeles County Museum of Art, 1976–77, p. 141. Claude Lesné, "La Peinture française du XVII^e siècle dans les collections américaines," *Le Petit Journal des grandes expositions* 116 (1982), n. pag. (ill.). J. V. Hantz, "La Peinture française du XVII^e siècle dans les collections américaines," *L'Amateur d'art* 680 (1982), p. 19. Erich Schleier, "La Peinture française du XVII^e siècle dans les collections américaines: France in the Golden Age, part 2," *Kunstchronik* 36 (1983), p. 232. André Chastel, *Musca depicta*, Milan, 1984, p. 30, pp. 100–01 (ill.). Wright 1985, p. 233. Beatrijs Brenninkmeyer-de Rooij in *De Rembrandt à Vermeer: Les Peintres hollandais au Mauritshuis de La Haye*, exh. cat., Paris, Galeries Nationales du Grand Palais, 1986, p. 62, fig. 29. Gerardo Casale, *Giovanna Garzoni: "Insigne miniatrice" 1600–1670*, Milan and Rome, 1991, p. 28 (ill.). Wright 1991, vol. 1, p. 246, vol. 2, pp. 62, 427. Humphrey Wine and Olaf Koester, *Fransk Guldalder: Poussin og Claude og maleriet i det 17. århundredes Frankrig (Poussin and Claude and French Painting of the Seventeenth Century)*, exh. cat., Copenhagen, Statens Museum for Kunst, 1992, p. 50, fig. 17, p. 54. James Yood, *Feasting: A Celebration of Food in Art*, New York, 1992, p. 7, no. 3 (ill.). Alain Mérot, *La Peinture française au XVII^e siècle*, Paris, 1994, pp. 238–39 (ill.).

EXHIBITIONS: Paris, Galeries Nationales du Grand Palais, *La Peinture française du XVII^e siècle dans les collections américaines*, 1982, no. 73, cat. by Pierre Rosenberg, traveled to New York and Chicago.

Forced from Flanders in the late sixteenth century by the religious intolerance of the Catholic Spanish regime, many Protestants settled in Paris. During the reigns of Henry IV and Louis XIII, a colony of refugee Northern artists gathered in the neighborhood of Saint-Germain-des-Prés. Among them was Nicolas Moillon, the father and first teacher of Louise Moillon. Like numerous other artists, merchants, and craftsmen (many of them junk dealers, forgers, and copyists), Nicolas established a business as a painter and picture vendor on the pont Notre-Dame.[4] After he died, in 1620, his widow married François Garnier, also a picture dealer and successful still-life painter.

An agreement drawn up when Louise Moillon was only ten years old, prior to her mother's marriage to Garnier, stipulated that half the profits from her pictures were to go to her future stepfather.[5] This contract indicates that the stepfather-to-be was confident of Moillon's talents and anticipated her success. While this appears a somewhat callous business arrangement, it was probably intended to compensate Garnier for giving Moillon additional training. Family apprenticeships were a common practice at that time, and family alliances and marriages between practitioners of the same business or craft were a means of preserving or enlarging one's clientele.[6] Moreover, the productive life of children began very early. Little else is known about Louise Moillon's life, except that in 1640 she married Etienne Girardot de Chancourt, who was from a Calvinist family of wood merchants, and that she lived into her eighties. Moillon was given a Catholic burial.[7]

While most of Moillon's known works can be dated between 1630 and 1642, an inventory of 1630, drawn up after Moillon's mother's death, records more than fourteen paintings, and it is probable that some were created before that year.[8] Moillon's production waned after her marriage, perhaps due to domestic duties (she had three children) or to financial circumstances that permitted her to relinquish her occupation as a painter, or possibly because, as Rosenberg (1982 exhibition catalogue) proposed, her style went out of vogue.[9] Moillon never adopted the more dynamic and elaborate Baroque compositions of later seventeenth-century still-life paintings. Her work always retained the directness of presentation seen in the Chicago panel, an approach perhaps owed to her association with the craftsmen-painters on the pont Notre-Dame.

The Chicago *Still Life with a Basket of Fruit and a Bunch of Asparagus* is similar to works by Moillon's contemporaries Sébastien Stosskopff, Jacques Linard, and René Nourrison, and also to works by François Garnier, whose technical accomplishments she surpassed.[10] The influence of Northern still-life paintings,

particularly those of Daniel Soreau, Jacob van Huls-donck, and Floris van Schooten, is evident in Moillon's placement of elements; there is little overlapping, and each object is rendered (contrary to natural vision) in perfect focus. This so-called archaic style, which had its roots in northern Europe, had become international by the time Moillon began painting. Also Northern in origin are certain trompe l'oeil details in her paintings such as flies, torn or dying leaves, and water droplets — motifs that are meant to suggest the fragility and transitory nature of life, and that derive from the moralizing symbolism of Northern still-life painting.[11]

Remarkable is Moillon's exquisite and sure execution of the Chicago painting, in which she used a loaded brush to lay on an impasto ridge along the leaf and stem edges to create a beautiful relief effect. The oval arrangement is typical of the artist's still lifes, as are the horizontal orientation and black background. This background and the elegant order of the composition give the painting its austere clarity and qualities of calm and silence.

NOTES

1 This treatment was performed by Alfred Jakstas to correct blanching in the retouching along the bottom edge.
2 According to the Kleinberger archives, Department of European Paintings, The Metropolitan Museum of Art, New York.
3 See note 2. The price paid is recorded in an annotated sale catalogue at the Frick Art Reference Library, New York.
4 Nicolas's rental contracts and purchases of space, as well as a stock inventory of June 30–September 16, 1620, drawn up after his death, reveal that he prospered there (see Faré 1974, pp. 51–53).
5 The contract was dated June 30, 1620. See E[rnest] Coyecque, "Notes sur divers peintres du XVIIe siècle, II: Nicolas et Louise Moillon," *Bulletin de la Société de l'histoire de l'art français, année 1940* (1941), p. 81.
6 Jacques Wilhelm, "Louise Moillon," *L'Oeil* 21 (1956), p. 7.
7 Sutherland Harris 1976–77.
8 Inventory dated August 23, 1630 (Faré 1962, vol. 1, p. 42). Unfortunately none of the works listed in this document can be identified as the Chicago panel, which dates from 1630.
9 The fact that Georges de Scudéry mentioned Moillon as late as 1646 suggests she was still known and was perhaps still painting at that time. See [Georges de Scudéry], *Le Cabinet de Mr de Scudery, gouverneur de Nostre Dame de la Garde*, pt. 1, Paris, 1646, p. 150; reprint, Geneva, 1973.
10 See Faré 1974, pp. 44–48, and Sutherland Harris 1976–77.
11 Ingvar Bergström (*Dutch Still-Life Painting in the Seventeenth Century*, tr. by Christina Hedström and Gerald Taylor, London, [1956]) discussed the development of this genre.

Jean Baptiste Oudry

1686 Paris–Beauvais 1755

Still Life with Monkey, Fruits, and Flowers, 1724

Major Acquisitions Centennial Fund, 1977.486

Oil on canvas, 141.6 x 144.8 cm (55³/₄ x 57 in.)

INSCRIBED: *J. B. Oudry 1724* (on the base of the architecture, to the right)

CONDITION: The painting is in good condition. The canvas has an old glue paste lining. The tacking margins have been cut off, but cusping is visible at all four edges. The evenly woven canvas consists of two parts, the smaller a vertical band of canvas, 21 cm wide, joined along the right edge of the picture. X-radiography reveals that this strip is of a slightly different weave than the larger section, and that it was attached before the painting was executed.[1] A 17 cm vertical tear extends from the left end of the architectural ledge through the center of the grapes. The paint layer, applied over a warm reddish ground, is generally well preserved. The foliage above and to the right of the monkey is slightly abraded from cleaning. There is retouching on the tear, the seam between the two canvas sections, the monkey, the foliage at the right, along the top and bottom edges, and scattered in the upper background. (x-radiograph)

PROVENANCE: Louis Aubert, Lyons; sold Hôtel des Ventes, Lyons, April 12–13, 1886, no. 43. Private collection, Paris, c. 1970.[2] Heim Gallery, London; sold by Heim to the Art Institute, 1977.

REFERENCES: Hal N. Opperman, *Jean-Baptiste Oudry*, vol. 1, New York and London, 1977, pp. 78–79, p. 528, under no. P446, pp. 528–29, no. P447, p. 535, under no. 465, vol. 2, fig. 100. *AIC 100 Masterpieces* 1978, p. 69, pl. 31. "La Chronique des arts," *GBA* 6th ser., 93 (1979), suppl. to no. 1323, p. 77. Amina

Okada, "J.-B. Oudry, 1686–1755: La Tentation de la nature morte," *Le Petit Journal des grandes expositions* 122 (1982), n. pag. "Une Ténébreuse Affaire," *Apollo* 117 (January 1983), p. 2, fig. 1. James Yood, *Feasting: A Celebration of Food in Art*, New York, 1992, n. pag., no. 9 (ill.).

EXHIBITIONS: Paris, Galeries Nationales du Grand Palais, *J.-B. Oudry, 1686–1755*, 1982–83, no. 32 (no. 17 in English cat.), traveled to Fort Worth, Texas, and Kansas City, Missouri.

Jean Baptiste Oudry, whose oeuvre was immense and diverse, enjoyed considerable success and recognition in his time, particularly as an *animalier*. He trained first with his father, Jacques Oudry, then with Michel Serre. Between 1705 and 1707, Oudry entered the atelier of Nicolas de Largillière (see 1987.57), where he was introduced to the Flemish and Dutch painting tradition. Oudry's early style derived primarily from Largillière's and from the decorative manner developed during the reign of Louis XIV by such painters as Jean Baptiste Monnoyer, whose *Decorative Still Life with Flowers, a Silver Platter, and a Monkey* (Quimper, Musée des Beaux-Arts) has been cited in connection with the Chicago canvas.[3] Oudry quickly rose in the academic ranks to a professorship at the Academy of Saint Luke after his reception there in 1719 with his painting *Abundance with Her Attributes* (Château de Versailles).[4] While this painting was indebted in character and convention to Largillière's works, it also included fruits, vegetables, and animals, heralding Oudry's later penchant for still-life painting. In fact, *Abundance with Her Attributes*, which preceded the Chicago canvas by five years, signaled the beginning of Oudry's second period, during which he began to paint the type of works for which he is best known today—still lifes, hunt pieces including dogs with their quarry, and canine portraits, including those of the royal dogs. In the early 1720s, Oudry also pursued other artistic activities such as engraving, illustration, the creation of interior decorative schemes, and tapestry design. Around 1724, the year that the Chicago still life was executed, Oudry received his first royal commission, which he followed with many depictions of one of the favorite royal pastimes, the chase.

Many copies and variations of Oudry's paintings were produced in the artist's atelier, some retouched to varying degrees by him. By 1724 his works were greatly sought after—to such an extent that the artist was able to offer paintings to his clients at inflated prices.[5] As Hal Opperman has pointed out, when a prospective buyer declined a purchase, Oudry would offer to supply him with a copy or variant of the original tailored to the client's needs and means.[6] Two pictures that seem to exemplify this practice are the *Still Life with Monkey, Fruits, and Flowers* in Chicago and a *Decorative Panel with a Monkey, Fruits, Dead Game, and a Ham* (location unknown),[7] both of which are probably variants by Oudry of a lost *Buffet* exhibited at the Exposition de la Jeunesse in 1723 and, when it hung in the Salon of 1725, described in the *Mercure de France* as follows:

> Un grand Buffet ceintré de 8. pieds de haut sur 6. d'un arrangement aussi pittoresque que singulier. Sur une table de marbre on voit une corbeille pleine de fruits, dont une partie est renversée par un Singe qui tire des grapes de raisin. Sur le même plan, à droite, se trouve un jambon, des laituës, un seau où il y a une bouteille de vin au frais; de l'autre côté une jatte remplie de figues. Une décoration d'Architecture sert de fond au-dessus de la table, avec des consoles ornées de masques; un surtout imité de vermeil est au milieu, & derriere trois grand plats d'argent chantournez, un vase de porcelaine, deux vases de porphire canelez, remplis de fleurs. Le haut est terminé par un Buste de bronze, d'où sortent deux guirlandes de raisins de toute espece, qui entourent les côtez presque jusques au bas.[8]

This picture was also included in two lists of paintings for sale that Oudry drew up in 1732 and 1735, in which the work was handsomely priced at 1,200 *livres*.[9]

The lost *Buffet* can be dated to 1722/23, since it was first exhibited in 1723. Apparently the earliest variant of that picture is the highly animated Chicago still life, of 1724, which retains several features from the original: the monkey snatching grapes, the bowl of figs, and the flowers in a porphyry vase. The *Decorative Panel with a Monkey, Fruits, Dead Game, and a Ham* repeated even more features, including a monkey stealing grapes from a fruit-filled container, a bowl of figs, a porphyry vase, a ham, and the bottle cooling in a bucket. While Opperman believed this second variant to be mostly studio work, he noted that the Chicago canvas "is of Oudry's very best quality, and . . . is probably completely autograph, or at least so completely retouched that no studio work is visible in it. Moreover, it is fully signed and dated, a distinction Oudry seems to have reserved only for his originals and for thoroughly retouched copies."[10] Opperman also speculated that the Chicago still life was adapted from the *Buffet* to accommodate a client who wanted a smaller picture, perhaps for a dining room, a frequent destination for Oudry's still lifes.[11]

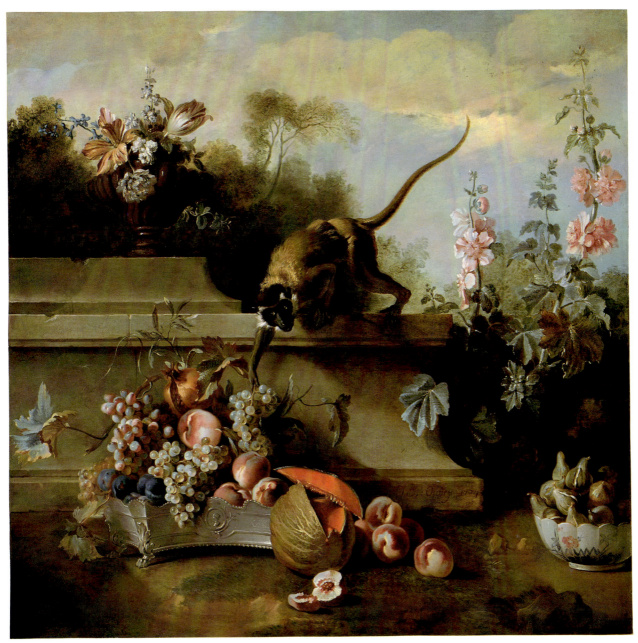

Jean Baptiste Oudry, *Still Life with Monkey, Fruits, and Flowers*, 1977.486

1 The thread count of the larger section of canvas is approximately 12 x 12/sq. cm (30 x 30/sq. in.); the thread count of the vertical strip is 12 x 9/sq. cm (30 x 22/sq. in.).
2 According to Hal N. Opperman in the 1982–83 exhibition catalogue, p. 84, no. 32.
3 See the 1982–83 exhibition catalogue, fig. 32a.
4 See Opperman 1977, vol. 2, p. 1006, fig. 68.
5 Opperman 1977, vol. 1, pp. 76–78.
6 Ibid.
7 The latter painting measures 173 x 111 cm; see Opperman 1977, vol. 1, p. 535, no. P465.
8 Opperman 1977, vol. 1, p. 180, p. 528, no. P446: "A large curved buffet, 8 *pieds* high by 6, an arrangement as picturesque as [it is] unusual. On a marble table one sees a basket filled with fruits, some of which are being overturned by a monkey who pulls out a bunch of grapes. On the same plane, to the right, are a ham, heads of lettuce, a bucket with a bottle of wine cooling;

on the other side is a bowl of figs. Architectural decoration serves as the background above the table, with consoles decorated with masks; a reddish silver-gilt epergne is in the center, and behind it three large silver plates with curving edges, a porcelain vase, and two vases of fluted porphyry, filled with flowers. At the upper part is a bronze bust, from which hang two garlands of all kinds of grapes, which surround the sides almost to the bottom." The measurements given for the *Buffet* are equal to 260 x 195 cm. A variant of this *Buffet*, probably from Oudry's workshop, painted on a canvas with a rounded top and measuring 264 x 172 cm, was in the collection of Eric Vidal, Paris, in 1989; major elements of the Chicago composition appear in this painting.
9 Opperman 1977, vol. 1, p. 221.
10 Ibid., p. 79.
11 In the 1982–83 exhibition catalogue, p. 86.

After Jean Baptiste Pater

1695 Valenciennes–Paris 1736

Love in the Open Air, after c. 1731

Bequest of Mrs. Florence Thompson Thomas in memory of her father, John R. Thompson, Sr., 1973.312

Oil on canvas, 45.7 x 56.2 cm (18 x 22⅛ in.)

CONDITION: The painting is in good condition. The twill-weave canvas has a wax resin lining.[1] The tacking margins have been cut off. The paint layer is generally well preserved. The painting was retouched, but not cleaned, in 1981.[2] There is a

large area of retouching in the lower center foreground. Smaller passages are scattered around the edges, in the landscape and figures at the left, and in the two women at the right. (ultraviolet, x-radiograph)

PROVENANCE: Boussod, Valadon, and Co., New York.[3] George J. Gould, New York.[4] Duveen, New York.[5] Sold by Duveen to John R. Thompson, Sr., 1926.[6] John R. Thompson, Sr. (d. 1927), Lake Forest, Illinois; at his death to his widow, Mrs. John R. Thompson, Sr., Lake Forest, Illinois; sold Parke-Bernet, New

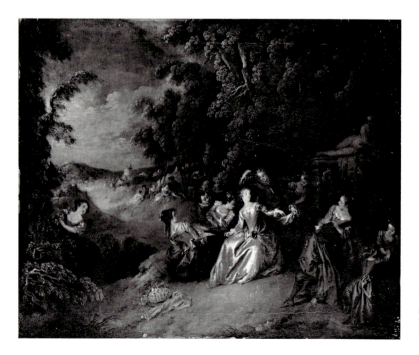

Fig. 1 Jean Baptiste Pater, *Love in the Open Air*, Schloss Charlottenburg, Berlin [photo: Preussische Schlösser und Gärten, Berlin-Brandenburg]

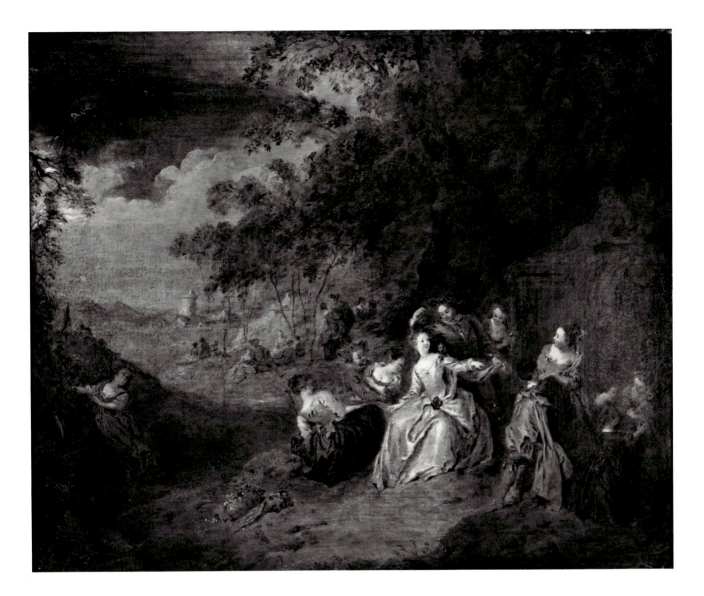

York, January 15, 1944, no. 31 (ill.),[7] to her daughter, Florence Thompson Thomas (d. 1972), Palm Beach, Florida; bequeathed to the Art Institute, 1973.

REFERENCES: "Recent Accessions of American and Canadian Museums, January–April, 1973," *Art Quarterly* 36 (1973), p. 429. Museu de Arte de São Paulo assis Chateaubriand, *Catálogo 1979, I—França e Escola de Paris*, São Paulo, 1979, p. 24, under no. 52.

EXHIBITIONS: The Art Institute of Chicago, *Selected Works of Eighteeth-Century French Art*, 1976, no. 6.

This work entered the museum as a work by Jean Baptiste Pater, an attribution supported by J. Patrice Marandel in the 1976 exhibition catalogue. Although Pierre Rosenberg initially believed the work to be by Pater, when he re-examined the picture in November

of 1986, he rejected the attribution, which now seems untenable.[8] The painting lacks Pater's refinement of execution—the highlights on the costumes do not suggest texture, and the patches of deep shadow are not effectively applied.

Son of the sculptor Antoine Pater, Jean Baptiste Pater was apprenticed in 1704 to the Valenciennes painter Jean Baptiste Guidé. Probably between 1713 and 1716, Jean Baptiste traveled to Paris, where at first he was coolly received by his fellow artist Jean Antoine Watteau (see 1954.295). Watteau finally relented, however, and, in the last month of his life, took Pater on as a pupil. Pater, by his own admission, benefited immensely from this brief but intense period of tutelage under Watteau, and based his style largely on that of the older painter. Distinguishing Pater's manner from Watteau's is the former's

quicker, more summary application of paint, his use of bright colors, and his tendency to be more explicit, even overtly sensual, in his *fêtes galantes* and in his depictions of other amorous themes.

The Chicago composition is ultimately based on Pater's *Love in the Open Air* of 1731/36 in the Schloss Charlottenburg in Berlin (fig. 1),[9] a work from which two other canvases derive as well: a *Fête champêtre*, attributed to Pater, in the Sinebrychoff Art Museum in Helsinki,[10] and *L'Amour en plein air*, which passed through a Paris sale in 1964 as a work from the school of Pater.[11] The Chicago canvas appears to be an unrefined copy after the Helsinki variant. The essential components of the Berlin picture and its variants were repeated in other paintings by Pater, namely, *Fête in a Park* in the Wallace Collection, London, and *Fêtes champêtres* in The Iveagh Bequest, Kenwood, London, and sold at Sedelmeyer Gallery in 1907.[12]

In 1979 the Chicago painting was erroneously published as the pendant to *An Elegant Party or Gathering before a Wall in a Park* (*Fête galante ou Réunion devant le mur d'un parc*) in São Paulo.[13] In fact, the São Paulo painting is much larger and cannot be considered a pendant to the Chicago work.

NOTES

1 The thread count of the original canvas is approximately 18 x 20/sq. cm (40 x 46/sq. in.).
2 This treatment, performed at the Art Institute, was recorded by photography, but no treatment report was found in the conservation files. An ultraviolet photograph from 1975, as well as the nature of the lining and stretcher, suggest that the painting underwent treatment between the time it was acquired and the 1981 treatment.
3 According to the 1944 sale catalogue.
4 Ibid.
5 Ibid.
6 Ibid., and a letter of December 4, 1981, from Cynthia Thomas Morehouse (Florence Thompson Thomas's daughter) to the author, in curatorial files.
7 Letter of November 13, 1981, from John R. Thomas to the author, in curatorial files.
8 Rosenberg initially examined the painting in March 1974 (note in curatorial files). Alastair Laing has also rejected the Pater attribution and suggested a possible connection to Bonaventure de Bar (note dated November 12, 1990, in curatorial files).
9 The Berlin canvas, which measures 65 x 80 cm, is signed; see Florence Ingersoll-Smouse, *Pater*, Paris, 1928, pp. 40–41, no. 35, fig. 31 (its pendant is the *Fête galante*, p. 41, no. 38, fig. 29).
10 The Helsinki painting measures 47 x 56.5 cm; see Ingersoll-Smouse (note 9), p. 50, no. 172.
11 This work was listed as measuring 45 x 56 cm; sold Palais Galliera, Paris, March 14, 1964, no. 13, pl. XI.
12 See Ingersoll-Smouse (note 9), p. 41, no. 36, fig. 32, no. 36 *bis*, fig. 30, and no. 37, fig. 70, respectively.
13 Museu de Arte de São Paulo assis Chateaubriand 1979, p. 24, under no. 52. The São Paulo painting measures 65 x 81 cm.

Attributed to Charles Poërson

1609 Metz–Paris 1667

Christ on the Cross with Mary Magdalen, 1640/50

Restricted gift of the Harold T. Martin Trust, 1978.423

Oil on canvas, 74.4 x 55.6 cm (29 5/16 x 21 7/8 in.)

INSCRIBED: *INRI* (at top of cross)

CONDITION: The painting is in good condition. The loosely woven canvas has an old glue paste lining.[1] The tacking margins have been cut off, and the canvas is slightly askew on the stretcher. The canvas consists of two parts, the smaller being a 7.5 cm wide horizontal band of fabric at the bottom. The paint layer, applied over a dark red ground, is generally well preserved, aside from filled and inpainted losses in small clusters on the crucifix above Christ's right arm, on his upper left thigh, and in the white drapery and clouds to the right. A larger area of loss and two narrow vertical strips of retouching are located near the lower right edge. Minimal retouching extends along the right and bottom edges. There is slight abrasion of the

dark rocks in the background near the center of the left edge. (ultraviolet, x-radiograph)

PROVENANCE: Private collection, Zurich, to 1974.[2] Sold to Colnaghi, London, 1974.[3] Sold by Colnaghi to the Art Institute, 1978.

REFERENCES: Pierre Rosenberg, "*France in the Golden Age*: A Postscript," *Metropolitan Museum Journal* 17 (1982), p. 46. Pierre Rosenberg, *La Peinture française du XVIIe siècle dans les collections américaines*, exh. cat., Paris, Galeries Nationales du Grand Palais, 1982, p. 375, no. 6 (ill.).

At the time of its acquisition, *Christ on the Cross with Mary Magdalen* was believed to be by Michel Dorigny, Simon Vouet's son-in-law, but this attribution was subsequently rejected.[4] Pierre Rosenberg (1982) more

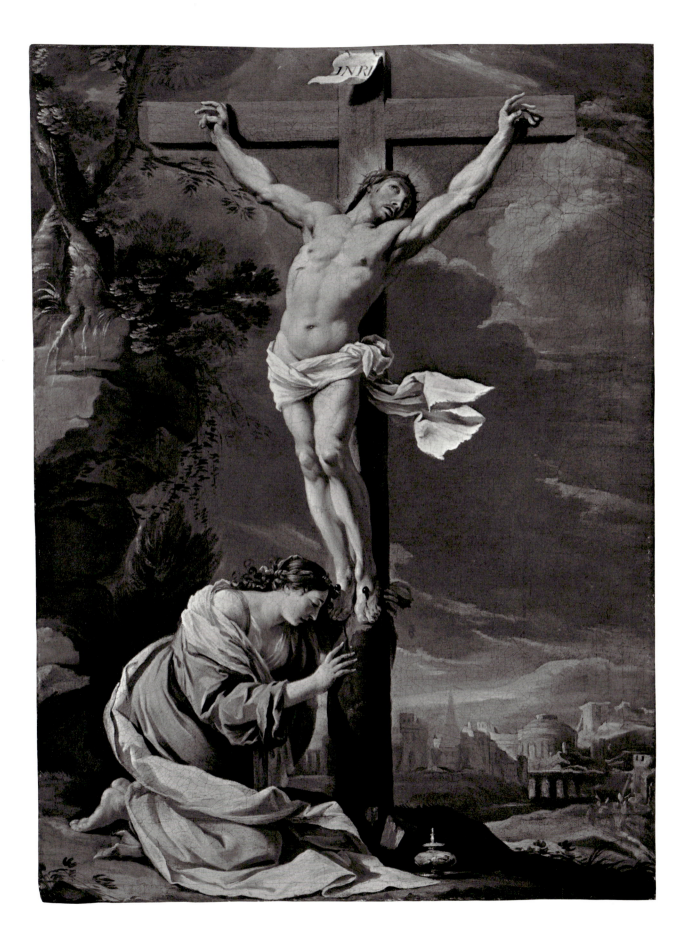

cautiously identified the painting as a work by a pupil of Vouet, although he later noted its particular affinity with the works of the Vouet disciple François Perrier.[5] However, no known paintings by Perrier, or engravings after his work, compare closely with the Chicago picture. Richard E. Spear tentatively proposed an attribution to Charles Poërson, a student of Vouet who devoted himself largely to sacred subjects.[6] Most of Poërson's works are now lost, but we know that the artist executed numerous easel paintings and tapestry cartoons, and collaborated on decorations with both Vouet and Eustache Le Sueur (see 1974.233).[7] Spear compared the Chicago painting to Poërson's *Saint Peter Preaching in Jerusalem* (Los Angeles County Museum of Art), which is probably a replica after (rather than a sketch for) his 1642 painting of the subject (Paris, Notre Dame), noting the "rich palette and technique, exaggerated postures, and ropey anatomy" common to the two.[8] The figures of Christ and Mary Magdalen in the Chicago picture also exhibit the bulging draperies and musculature and the awkward, swaying poses typical of Poërson's figures. According to Clementine Gomez, who also believes that the painting is probably by Poërson, the background architecture, rocks, and vegetation are characteristic of the painter.[9] She has called attention to similar features and figure types in Poërson's *Rape of the Sabines* (Paris, Musée Hébert), *Deposition* (location unknown), and *Minerva and Neptune* (Paris, private collection).[10] Alain Mérot has pointed to the existence of what appears to be a preparatory study for the figure of the Magdalen in the Louvre, where it is assigned to an artist in Vouet's atelier.[11]

Another, more freely executed version of the Chicago picture was sold in 1978 with an attribution to Tadeusz Kuntze.[12]

NOTES

1 The thread count of the original canvas is approximately 8 x 10/sq. cm (18 x 24/sq. in.).
2 Letter of March 19, 1981, from Grizelda Grimond (Colnaghi) to the author, in curatorial files.
3 Ibid.
4 The pose of the Magdalen is similar to that of the figure before the cross in Dorigny's *Crucifixion* in the Louvre; see Jacques Thuillier, *Vouet*, exh. cat., Paris, Galeries Nationales du Grand Palais, 1990, p. 54 (ill.).
5 Rosenberg related the painting to Perrier in a letter of September 6, 1985, to the author, in curatorial files.
6 Richard E. Spear, "Reflections on 'France in the Golden Age,'" unpub. MS, p. 12 (lecture delivered October 30, 1982, at a symposium held at the Art Institute in conjunction with the exhibition *France in the Golden Age*, 1982); and letter of February 21, 1983, from Richard E. Spear to the author, in curatorial files. Erich Schleier (letter to the author of December 19, 1984, in curatorial files) and Stéphane Loire (letter to Martha Wolff of June 18, 1992, in curatorial files) also thought that the picture could be by Poërson.
7 Three articles by Jeanne Lejeaux provide most of the scant information available on Poërson: "Charles Poërson, 1609–1667, and the Tapestries of the *Life of the Virgin* in the Strasbourg Cathedral," *GBA* 6th ser., 30 (1946), pp. 17–29; "La Tenture de la *Vie de la Vierge* à la Cathédrale de Strasbourg," *GBA* 6th ser., 34 (1948), pp. 405–18; and "Contrat de mariage de Charles Poërson dressé par les notaires Beaufort et de Beauvais le 25 septembre 1638," *Bulletin de la Société de l'histoire de l'art français*, année 1953 (1954), pp. 117–19. See also Thuillier (note 4), pp. 49–50.
8 For the Los Angeles painting, see Rosenberg 1982, p. 301, no. 83 (ill.).
9 Verbally to Larry Feinberg, January 7, 1994 (notes in curatorial files).
10 For an illustration of the *Deposition*, see Thuillier (note 4), p. 50.
11 Verbal communication (via Mary Jane Harris) to Larry Feinberg, March 9, 1993. For the drawing, see Barbara Brejón de Lavergnée, *Dessins de Simon Vouet, 1590–1649*, Paris, 1987, no. 191 (ill.).
12 Christie's, London, July 6, 1978, no. 41 (pl. 23 in catalogue). This work (formerly in the collection of Anthony Clark) and the Chicago canvas may share a common source.

Nicolas Poussin

1594 Les Andelys–Rome 1665

Landscape with Saint John on Patmos, 1640

A. A. Munger Collection, 1930.500

Oil on canvas, 100.3 x 136.4 cm (39½ x 53⅝ in.)

CONDITION: The painting is in very good condition. The original tacking margins of the finely woven canvas have been cut off, but cusping visible at all edges indicates that the painting is close to its original dimensions. In 1958 the glue paste lining, which, according to a conservation report, was causing a distortion in the original canvas, was treated with an infusion of wax adhesive.[1] The painting was surface cleaned in 1962, and was cleaned more thoroughly in 1966, when the glue paste lining was replaced with a wax resin one and areas of damage were inpainted. In 1988 the painting was cleaned, varnished, and inpainted.[2] There are two tears; one is straight, 17.8 cm in length, and runs diagonally across the landscape above and to the left of the figure of Saint John; the other is a compound tear, approximately 15.2 cm in length, and extends across the bridge and hill above and to the right of the figure of Saint John. The thin paint layer is applied over a dark reddish-brown ground. The paint surface has been flattened by lining, but still retains some of its textural quality. In the areas surrounding the tears, there is abrasion and damage to the paint texture. The surface is somewhat abraded in the brown foreground tones. (infrared, ultraviolet, x-radiograph)

PROVENANCE: Commissioned with its pendant by abate Gian Maria Roscioli (d. 1644), Rome, 1640, for 40 écus.[3] Probably in a French collection by c. 1680.[4] Robit, Paris; sold Paillet and Delaroche, Paris, May 11 and following, 1801, no. 91, probably to Bryan, for Fr 7,100.[5] Michael Bryan, London, 1801 to at least 1802.[6] Sold by Bryan, by 1824, to Sir Simon H. Clarke, Bt. (d. 1832), Oakhill, Hertfordshire, for 1,000 gns.;[7] sold Christie's, London, May 8–9, 1840, no. 39, to Geddes for 86 gns.[8] Andrew Geddes, A.R.A. (d. 1844), London, 1840–44; offered for sale, Christie's, London, April 12, 1845, no. 651, presumably bought in.[9] Mrs. Andrew Geddes, London, probably from 1844 to at least 1861.[10] Possibly sold on the London art market to Max Rothschild, 1918 or 1928.[11] E. A. Fleischmann Gallery, Munich. Purchased from Fleischmann by the Art Institute through the A. A. Munger Fund, 1930.

REFERENCES: W[illiam] Buchanan, *Memoirs of Painting, with a Chronological History of the Importation of Pictures by the Great Masters into England since the French Revolution*, vol. 2, London, 1824, pp. 59, no. 91, p. 67, no. 29. John Smith, *A Catalogue Raisonné of the Works of the Most Eminent Dutch, Flemish, and French Painters*, vol. 8, London, 1837, pp. 161–62, no. 316. Charles Blanc, *Histoire des peintres de toutes les écoles*, pt. 3, *Ecole française*, vol. 1, Paris, 1865, Poussin p. 24. Emile Magne, *Nicolas Poussin, premier peintre du roi, 1594–1665*, Brussels and Paris, 1914, p. 214, no. 267. Algernon Graves, *Art Sales from Early in the Eighteenth Century to Early in the Twentieth Century*, vol. 2, London, 1921, pp. 347, 349. Walter Friedlaender in *Das unbekannte Meisterwerk in öffentlichen und privaten Sammlungen*, ed. by Wilhelm R. Valentiner, Berlin, 1930, no. 74 (ill.). Hans Posse, "Johannes auf Patmos, ein wiedergefundenes Gemälde des Nicolas Poussin," *Pantheon* 5 (1930), pp. 62, 64–65 (ill.). Daniel Catton Rich, "Poussin and Cézanne," *AIC Bulletin* 24, 9 (1930), pp. 114–17 (cover ill. and detail ill.). "Chicago Buys a Poussin," *Art Digest* 5, 7 (1931), p. 8. Staatliche Museen zu Berlin, *Beschreibendes Verzeichnis der Gemälde im Kaiser-Friedrich-Museum und Deutschen Museum*, 9th ed., Berlin, 1931, p. 372, under no. 478A. AIC 1932, p. 38 (ill.). C[larence] J[oseph] Bulliet, *Art Masterpieces in a Century of Progress Fine Arts Exhibition at The Art Institute of Chicago*, vol. 2, Chicago, 1933, no. 88 (ill.). Alfred M. Frankfurter, "Art in the Century of Progress," *Fine Arts* 20 (June 1933), pp. 28 (ill.), 61. Walter Friedlaender in Thieme/Becker, vol. 27, 1933, p. 326. AIC 1935, pp. 26–27 (ill.). "Robert B. Harshe," *AIC Bulletin* 32, 4 (1938), p. 49 (ill.). Walter Friedlaender, "America's First Poussin Show: The Great Classicist Illustrated by His Cisatlantic Works," *Art News* 38, 23 (1940), p. 14. AIC 1941, pp. 32–33 (ill.). Anthony Blunt, "The Heroic and the Ideal Landscape in the Work of Nicolas Poussin," *Journal of the Warburg and Courtauld Institutes* 7 (1944), p. 156. AIC 1945, p. 34 (ill.). Anthony Blunt, "Two Newly Discovered Landscapes by Nicolas Poussin," *Burl. Mag.* 87 (1945), pp. 186, 189. AIC 1948, p. 31 (ill.). Thérèse Bertin-Mourot, "Addenda au catalogue de Grautoff depuis 1914," *Bulletin de la Société Poussin* 2 (December 1948), p. 52, no. XXXIII (ill.). Assia Visson, "Aux Etats-Unis: Le Cinquantième Anniversaire de la fondation du Worcester Art Museum," *Arts, beaux-arts, littérature, spectacles* 168 (May 28, 1948), p. 3 (ill.). *Worcester Art Museum News Bulletin and Calendar* 13, 7 (1948), p. 27 (ill.). Kenneth Clark, *Landscape into Art*, London, 1949, p. 66, pl. 65; rev. ed., New York, 1976, p. 129, fig. 82. AIC 1952, n. pag. (ill.). Aline B. Louchheim, "A New Yorker Visits the Art Institute," *AIC Quarterly* 46 (1952), pp. 23, 26 (ill.). Theodore Rousseau, Jr., "Cézanne as an Old Master," *Art News* 51, 2 (1952), pp. 29, 33 (ill.). Fred Stephen Licht, *Die Entwicklung der Landschaft in den Werken von Nicolas Poussin*, Basler Studien zür Kunstgeschichte 11, Basel and Stuttgart, 1954, pp. 140–41. AIC [1956], pp. 31–32 (ill.). Georges Wildenstein, *Les Graveurs de Poussin au XVIIᵉ siècle*, Paris, 1957, p. 250, under no. 186. Louis Réau, *Iconographie de l'art chrétien*, Paris, 1958, vol. 3, *Iconographie des saints*, pt. 2, p. 716. Jean Grenier, "L'Esthétique classique vue à travers Poussin," *L'Oeil* 58 (1959), pp. 48, 51 (ill.). Malcolm Vaughan, "Poussin in America," *Connoisseur* 143 (April 1959), p. 127, fig. 14. Pierre du Colombier, "The Poussin Exhibition," *Burl. Mag.* 102 (1960), p. 287. "Inaccessible Poussins," *Connoisseur* 146 (September 1960), p. 44, fig. 6. John Shearman, "Les

Dessins de paysages de Poussin," in *Nicolas Poussin*, ed. by André Chastel, vol. 1, Paris, 1960, p. 181 (ill. opp. p. xii). AIC 1961, pp. 231 (ill.), 360–61. "Exhibitions," *Smith College Museum of Art Bulletin* 41 (1961), p. 45. Denis Mahon, "Réflexions sur les paysages de Poussin," *Art de France: Revue annuelle de l'art ancien et moderne* 1 (1961), p. 120. *L'ideale classico del seicento in Italia e la pittura di paesaggio*, exh. cat., Bologna, Palazzo dell'Archiginnasio, 1962, pp. 192–93, under no. 72. Charles Gates Dempsey, "Nicolas Poussin and the Natural Order," Ph.D. diss., Princeton University, 1963 (Ann Arbor, Mich., University Microfilms, 1986) pp. 9–10. Walter Friedlaender and Anthony Blunt, eds., *The Drawings of Nicolas Poussin: Catalogue Raisonné*, vol. 4, London, 1963, p. 46, under no. 279. Malcolm R. Waddingham, "The Dughet Problem," *Paragone* 14, 161 (1963), p. 43. A[leksandr] S[emenovich] Glikman, *Nicolas Poussin* (in Russian), Leningrad and Moscow, 1964, pp. 79–80, fig. 31. Anthony Blunt, "Poussin and His Roman Patrons," in *Walter Friedlaender zum 90*, Berlin, 1965, p. 59. Anthony Blunt, *The Paintings of Nicolas Poussin: A Critical Catalogue*, London, 1966, pp. 59–60, no. 86 (ill.). Walter Friedlaender, *Nicolas Poussin: A New Approach*, New York, [1966], pp. 78, 174, pl. 38. Anthony Blunt, *Nicolas Poussin*, The A. W. Mellon Lectures in the Fine Arts, 1958, Bollingen Series 35, 7, Washington, D.C., 1967, vol. 1, pp. 248, 272–73, 283, 285 n. 10, vol. 2, pls. 151–52. Kurt Badt, *Die Kunst des Nicolas Poussin*, Cologne, 1969, vol. 1, pp. 573–75, vol. 2, pl. 120. Frances Vivian, "Poussin and Claude Seen from the Archivio Barberini," *Burl. Mag.* 111 (1969), p. 722. Maxon 1970, p. 48 (ill.). Howard Hibbard, *Poussin: The Holy Family on the Steps*, New York, 1974, p. 35, fig. 12. Jacques Thuillier, *L'opera completa di Poussin*, Classici dell'arte 72, Milan, 1974, pp. 102–03, no. 137 (ill.). Anthony Blunt, "'Landscape by Gaspard, Figures by Nicolas,'" *Burl. Mag.* 117 (1975), p. 607. Marcel Roethlisberger, "Guillerot," *GBA* 6th ser., 85 (1975), p. 125. Annie Jolain in *Bénézit*, 4th ed., vol. 8, 1976, p. 460. Jacques Thuillier, "Poussin et le paysage tragique: 'L'Orage Pointel' au Musée des Beaux-Arts de Rouen," *La Revue du Louvre* 26, 5/6 (1976), p. 354 n. 25. Shuji Takashina, *Poussin* (in Japanese), Tokyo, 1977, p. 113, pl. 44. *AIC 100 Masterpieces* 1978, pl. 20. Anthony Blunt, "Poussin at Rome and Düsseldorf," *Burl. Mag.* 120 (1978), p. 421. Yvonne Friedrichs, "Nicolas Poussin," *Das Kunstwerk* 31, 2 (1978), p. 77. Marianna Minola de Gallotti, "Nicolas Poussin, 1594–1665," *Goya* 146 (1978), p. 125 (ill.). Robert Lebel, "Poussin chez lui ou non à Rome," *XXe siècle*, n. s., 40, 50 (1978), p. 6 (ill.). Marisa Volpi Orlandini, "Poussin a Roma e a Düsseldorf," *Antologia di belle arti* 2, 7/8 (1978), p. 312. Erich Schleier, "Die Poussin-Ausstellung in Rom und Düsseldorf," *Kunstchronik* 31 (1978), p. 281. András Szilágyi, *Poussin* (in Hungarian), Budapest, 1978, p. 22, fig. 37. Clovis Whitfield, "Poussin at Rome and Düsseldorf," *Connoisseur* 197 (April 1978), p. 305. Liliana Barroero, "Nuove acquisizioni per la cronologia di Poussin," *Bollettino d'arte* 6th ser., 4 (1979), pp. 69–72, fig. 4. Anthony Blunt, *The Drawings of Poussin*, New Haven and London, 1979, p. 122. Sandro Corradini, "La quadreria di Giancarlo Roscioli," *Antologia di belle arti* 3, 9/12 (1979), pp. 192, 194, no. 81, p. 195 n. 16, p. 196 n. 66. Morse 1979, p. 206. Clovis Whitfield, "Poussin's Early Landscapes," *Burl. Mag.* 121 (1979), p. 10.

Simonetta Prosperi Valenti Rodinò in *Disegni di Guglielmo Cortese (Guillaume Courtois) detto Il Borgognone nelle collezioni del Gabinetto Nazionale delle Stampe*, exh. cat., Rome, Villa alla Farnesina alla Lungara, 1979–80, p. 97, under no. 260. Doris Wild, *Nicolas Poussin: Leben, Werk, Exkurse*, Zurich, 1980, vol. 1, pp. 108, 128, 130–31, vol. 2, p. 107, no. 114 (ill.), p. 108, under no. 115. John D. Bandiera, "The Pictorial Treatment of Architecture in French Art, 1731 to 1804," Ph.D. diss., New York University, 1982 (Ann Arbor, Mich., University Microfilms, 1984), pp. 2–3, pl. 1. Anthony Blunt, "French Seventeenth-Century Painting: The Literature of the Last Ten Years," *Burl. Mag.* 124 (1982), p. 707. Hugh Brigstocke, "France in the Golden Age," *Apollo* 116 (July 1982), p. 12. André Chastel, "Les Etats-Unis et la peinture française: Entre Rome et Paris," *Le Monde*, February 2, 1982, p. 13. JoLynn Edwards, "Alexandre Joseph Paillet (1743–1814): Study of a Parisian Art Dealer," Ph.D. diss., University of Washington, 1982 (Ann Arbor, Mich., University Microfilms, 1984), p. 214, fig. 143. J. V. Hantz, "La Peinture française du XVIIe siècle dans les collections américaines," *L'Amateur d'art* 680 (1982), p. 17. Nicole Lamothe, "Les Caravagesques français," *L'Amateur d'art* 680 (1982), p. 14. Pierre Rosenberg, "Edinburgh: Poussin Considered," *Burl. Mag.* 124 (1982), p. 376. Pierre Rosenberg, "A Golden Century in French Painting," *Connaissance des arts* 25 (February 1982), p. 71. Pierre Schneider, "L'Ombre du soleil," *L'Express*, March 12–18, 1982, pp. 18–19. Erich Schleier, "La Peinture française du XVIIe siècle dans les collections américaines," *Kunstchronik* 36 (1983), pp. 194, 228. Gemäldegalerie, Berlin, *Meisterwerke Gemäldegalerie Berlin*, Berlin, 1985, p. 362; English ed., *Masterworks of the Gemäldegalerie, Berlin*, New York, 1986, p. 362. Sylvain Laveissière in *Le Classicisme Français: Masterpieces of Seventeenth-Century Painting*, exh. cat., Dublin, The National Gallery of Ireland, 1985, p. 55. Wright 1985, pp. 71, 249. Christopher Wright, *Poussin Paintings: A Catalogue Raisonné*, New York, 1985, pp. 99, 101–02, 182, under no. 92, p. 206, under no. 145, p. 207, under no. 148, p. 208, under no. 150, no. 151, pp. 252, 270, 273–74, 277, fig. 79. Jean Clair, "L'Obélisque," in *"Il se rendit en Italie": Etudes offertes à André Chastel*, Rome and Paris, 1987, pp. 692, 697 (ill.). Marc Sandoz, "Essai sur le paysage de montagne dans la peinture française du XVIIe siècle," *Cahiers du paysage de montagne et de quelques sujets relatifs à la montagne* 1 (1987), p. 46, fig. 60. *AIC Master Paintings* 1988, p. 33 (ill.). Burton B. Fredericksen, ed., *The Index of Paintings Sold in the British Isles during the Nineteenth Century*, vol. 1, *1801–1805*, Santa Barbara, Calif., and Oxford, 1988, pp. 568, 979. Sergio Guarino in *La pittura in Italia: Il seicento*, vol. 2, Milan, 1988, p. 850. Jean Jacques Lévêque, *La Vie et l'oeuvre de Nicolas Poussin*, Paris, 1988, p. 193. *Nicolas Poussin, Claude Lorrain: Zu den Bildern im Städel*, exh. cat., Frankfurt, Städtische Galerie im Städelschen Kunstinstitut, 1988, p. 14. Jacques Thuillier, *Nicolas Poussin*, Paris, 1988, pp. 153, 254. Yuri Zolotov, *Poussin* (in Russian), Moscow, 1988, pp. 130–31, 253, pl. 233. Oskar Bätschmann, *Nicolas Poussin: Dialectics of Painting*, London, 1990, pp. 124, 147 n. 13. Michael Kitson in *Claude to Corot: The Development of Landscape Painting in France*, exh. cat., New York, Colnaghi, 1990, p. 22. Alain Mérot, *Nicolas Poussin*, Paris, 1990, pp. 112–13, 115 (ill.), 291, no. 213

(ill.), 305; English ed., tr. by Fabia Claris and Bridget Mason, New York, 1990, pp. 112–13, 115 (ill.), 291, no. 213 (ill.), 306. Margaretha Rossholm Lagerlöf, *Ideal Landscape: Annibale Carracci, Nicolas Poussin, and Claude Lorrain*, New Haven and London, 1990, pp. 54–55, 64–65, 114, 138, 140, 236 n. 26, fig. 30. Nadejda Petroussevitch and Yuri Zolotov in *Nicolas Poussin*, Leningrad and Paris, 1990, pp. 18–19, p. 127, under no. 18 (ill.). Richard Verdi, *Cézanne and Poussin: The Classical Vision of Landscape*, exh. cat., Edinburgh, National Gallery of Scotland, and London, 1990, pp. 26, 39, 42, 50, 73, under no. 5, p. 113, under no. 25, fig. 9. Daniel Wheeler, *Art Since Mid-Century: 1945 to the Present*, New York, 1991, p. 9, fig. 5. Wright 1991, vol. 1, p. 248, vol. 2, pp. 62, 495. Angelika Grepmair-Müller, *Landschaftskompositionen Von Nicholas Poussin*, Ars Faciendi: Beiträge und Studien zur Kunst-geschichte 2, Frankfurt, Bern, New York, and Paris, 1992, pp. 55, 58–61, 65. Robert J. Loescher, "Landscape Painting," in *Academic American Encyclopedia*, Danbury, Conn., 1992, p. 190 (ill.). Christopher Braider, *Refiguring the Real: Picture and Modernity in Word and Image, 1400–1700*, Princeton, 1993, pp. 239–40, fig. 73. Malcolm Bull, "Poussin's Snakes," in *Cézanne and Poussin: A Symposium*, ed. by Richard Kendall, Sheffield, England, 1993, p. 40. Larry Silver, *Art in History*, New York, London, and Paris, 1993, pp. 250–51, fig. 6.27. Marc Fumaroli, *L'Ecole du silence: Le Sentiment des images au XVIIe siècle*, Paris, 1994, pp. 122, 420–21, fig. 224. Jacques Thuillier, *Poussin*, Paris, 1994, pp. 96, 119, 127 (ill.), p. 257, no. 148. Richard Verdi with Pierre Rosenberg, *Nicolas Poussin, 1594–1665*, exh. cat., London, Royal Academy of Arts, 1995, pp. 235–36, no. 47 (ill.). Richard Francis and Sophia Shaw, "A Travel Guide to the Exhibition," in *Negotiating Rapture: The Power of Art to Transform Lives*, exh. cat., Chicago, Museum of Contemporary Art, 1996, pp. 68, 134–35 (ill.), 194.

EXHIBITIONS: London, British Institution, *Works of Ancient Masters and Deceased British Artists*, 1861, no. 22. The Art Institute of Chicago, *A Century of Progress*, 1933, no. 226. The Art Institute of Chicago, *A Century of Progress*, 1934, no. 147. The Art Institute of Chicago, *Masterpiece of the Month*, October 1939 (no cat.). The Arts Club of Chicago, *Origins of Modern Art*, 1940, no. 35. Worcester Art Museum, Massachusetts, *Fiftieth Anniversary Exhibition of the Art of Europe during the XVIth–XVIIth Centuries*, 1948, no. 7. The Toledo Museum of Art, *Nicolas Poussin, 1594–1665*, 1959, pp. 27–28, traveled to Minneapolis. Paris, Musée du Louvre, *Exposition Nicolas Poussin*, 1960, no. 68, traveled to Rouen. Northampton, Massachusetts, Smith College Museum of Art, 1961 (no cat.). New York, Wildenstein, *Works of Art Lent from American Collections: The Italian Heritage*, 1967, no. 68. The Art Institute of Chicago, *The Artist Looks at the Landscape*, 1974 (no cat.). New York, Wildenstein, *Nature as Scene: French Landscape Painting from Poussin to Bonnard*, 1975, no. 51. Accademia di Francia a Roma, Villa Medici, *Nicolas Poussin, 1594–1665*, 1977–78, no. 28, traveled to Dusseldorf (no. 27 in German cat.). Paris, Galeries Nationales du Grand Palais, *La Peinture française du XVIIe siècle dans les collections améri-caines*, 1982, no. 91, cat. by Pierre Rosenberg, traveled to New York and Chicago. Paris, Galeries Nationales du Grand Palais, *Nicolas Poussin, 1594–1665*, 1994–95, no. 94, cat. by Pierre Rosenberg, traveled to London. Chicago, Museum of Contemporary Art, *Negotiating Rapture: The Power of Art to Transform Lives*, cat. by Richard Francis et al., 1996, no. 68.

The *peintre-philosophe* Nicolas Poussin was perhaps the most influential of all French painters, his art an eloquent and compelling expression of classicism and its ideals. In 1624 Poussin went to Rome and, except for a brief period in Paris from 1640 to 1642 as Louis XIII's *premier peintre*, spent the remainder of his life there. He received commissions from the most important patrons of art in Rome, including the Barberini and Cassiano dal Pozzo, who became a champion of the artist, drawing him into elite Roman intellectual circles. Poussin also became associated with a group of atheist intellectuals, known today as *libertins*, who apparently introduced him to neo-Stoic philosophy and ethics. Poussin's study of these subjects seems to have exerted considerable influence on both the themes and style of his paintings. While his art was devoted primarily to history painting and to biblical and mythological subjects, Poussin was also a supreme master of landscape, as the *Landscape with Saint John on Patmos* attests (see frontispiece for detail ill.).

It was traditionally believed that the Chicago painting and its pendant, the *Landscape with Saint Matthew* (fig. 1), were ordered by Antonio Barberini.[12] Documents published by Liliana Barroero and Sandro Corradini in 1979 revealed, however, that Gian Maria Roscioli, a member of Poussin's small circle of patrons, commissioned the two works.[13] The pendants were separated early in their history. The *Landscape with Saint Matthew* was given by Roscioli to cardinal Antonio Barberini di Sant'Onofrio, and eventually descended to Antonio Barberini, in whose 1671 inventory it was listed.[14] The *Landscape with Saint John on Patmos* was presumably sold either by Roscioli's brothers, Dionisio and Vincenzo, who executed his will, or by the cathedral of Foligno, the eventual recipient of Roscioli's collection. How and when the picture left Italy is not known, but it was apparently in France by c. 1680, when Louis de Châtillon engraved it (in reverse) as the first of a suite of six landscapes after Poussin paintings (fig. 2).[15]

The Roscioli documents also indicate that the pendants were completed by October 28, 1640, when Roscioli paid for them.[16] Poussin left Rome with Paul Fréart de Chantelou on this same day to journey to Paris. This departure may explain why Poussin painted only two evangelists. In the absence of documentary

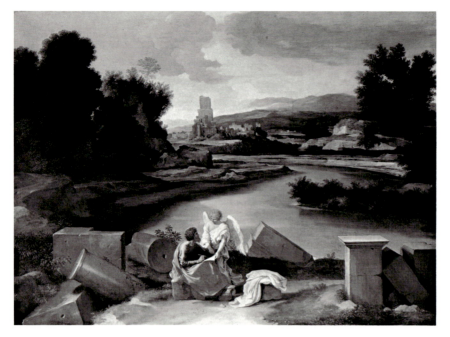

Fig. 1 Nicolas Poussin, *Landscape with Saint Matthew*, Staatliche Museen zu Berlin, Preussischer Kulturbesitz, Gemäldegalerie [photo: Jörg P. Anders]

evidence, Anthony Blunt reasonably hypothesized that the original commission probably included all four evangelists.[17] Certainly the delivery of only two evangelists, after four were ordered, would account for the low price of 40 *scudi* paid for the paintings. This relatively modest sum may also reflect that the paintings are primarily landscapes rather than figure paintings. There is no evidence to support Frances Vivian's (1969) suggestion that the four landscapes were intended as overdoors. In fact, it is not unusual to find pairs or series of paintings in Poussin's oeuvre.[18]

The dating of the Chicago and Berlin canvases provided by the Roscioli documents requires a reassessment of Poussin's development as a landscape painter.[19] It is now evident that he began to paint compositions in which landscape was the primary subject earlier than has generally been believed—that is, before he went to Paris rather than after his return to Rome. In most of Poussin's works of the 1620s, the landscape was merely a backdrop subordinated to the figures; he seems to have derived the shallow, planar landscape of these early works from the paintings of Titian. By the 1630s, when the first written references to Poussin as a "landscape painter" appeared, he had begun to compose more clearly defined landscapes with deeper spatial recessions.[20] This gradual evolution can be traced through the *Numa Pompilius and the Nymph Egeria* (1631/33; Chantilly, Musée Condé), the *Landscape with Juno, Argus, and Io* (1636/37; Staatliche Museen zu Berlin, Gemäldegalerie), and the *Landscape with Saint Jerome* (1636/37; Prado)[21] to the *Landscape with Saint John on Patmos* and *Landscape with Saint Matthew*. The Chicago canvas and its pendant are thus important transitional works between Poussin's early landscapes and those better-documented ones he produced in 1648 and after, such as the heroic *Landscape with the Body of Phocion Carried out of Athens* (1648) in the National Museum of Wales in Cardiff (on loan from the earl of Plymouth) and the *Landscape with the Gathering of the Ashes of Phocion* (1648) at the Walker Art Gallery in Liverpool.[22]

Blunt observed that Poussin's landscape style developed from a succession of influences, including, early

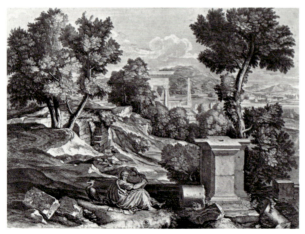

Fig. 2 Louis de Châtillon, engraving after Nicolas Poussin, *Landscape with Saint John on Patmos*, Bibliothèque Nationale, Paris [photo: © cliché Bibliothèque Nationale de France, Paris]

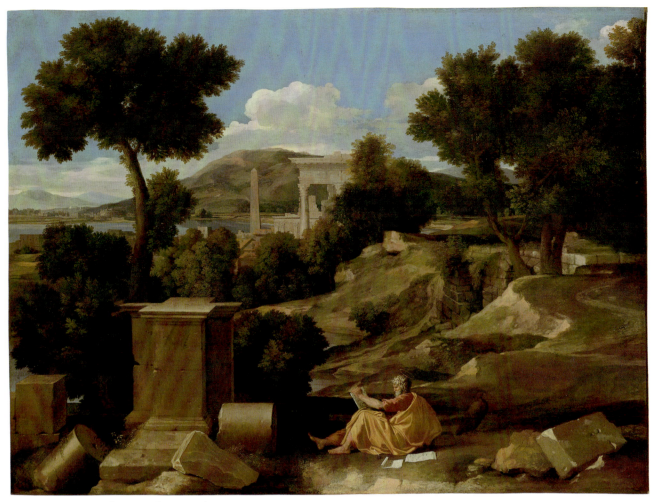

Nicolas Poussin, *Landscape with Saint John on Patmos*, 1930.500

Fig. 3 Nicolas Poussin, *Classical Landscape with Figures*, Hermitage, St. Petersburg

on, the landscapes of Giovanni Bellini and Titian, and, later, the idealized landscapes of Annibale Carracci and his student Domenichino. Blunt also pointed out that Polidoro da Caravaggio's *Christ Appearing to Mary Magdalen* and *The Mystic Marriage of Saint Catherine* (both c. 1525; Rome, San Silvestro al Quirinale) demonstrated to Poussin ways of introducing architecture into landscape compositions and of structuring or layering the landscape elements.[23] In keeping with his neo-Stoic belief in the Logos, an inherent order or harmony in nature governed by the Word, or soul of the world, Poussin imposed a rigorous order on the natural scenery he painted; his expressive means were wholly bound to a mathematical precision of design.[24] In the *Landscape with Saint John on Patmos*, spatial recession is conveyed through a series of stages that parallel the picture plane and are connected by a system of canted diagonals. A clear, even illumination reinforces the composition's clarity and order. Poussin's subtle handling of light is especially apparent in his drawings, such as the *Classical Landscape with Figures* of c. 1640 (fig. 3) in the Hermitage, which Blunt suggested is related to the Chicago canvas, noting that this drawing is "not a direct study from nature, but a first scheme for the finished composition."[25] He pointed out its stylistic similarity to another drawing, *View of the Tiber Valley* (Holkham Hall, collection of the earl of Leicester), which may be related to the distant landscape in *Landscape in the Roman Campagna with a Man Scooping Water* in The National Gallery, London.[26] Also tentatively linked with the Chicago painting are two sheets depicting birds' heads that resemble the head of the eagle beside the Evangelist.[27]

While the *Landscape with Saint Matthew* includes a recognizable site on the Tiber River near the Milvian Bridge, the setting of the *Landscape with Saint John on Patmos* is an imaginary Greek island into which

Poussin has introduced Roman architectural monuments. Several structures on the far bank can be identified (from left to right): the Torre delle Milizie, an adaptation of the Basilica of Maxentius and Constantine, the Ponte Sant'Angelo and the Castel Sant'Angelo with its fortifications. Poussin included this last structure in several of his paintings, such as the *Landscape with the Body of Phocion Carried out of Athens* in Cardiff and the *Landscape with Orpheus and Eurydice* in the Louvre.[28] Some of the other architectural elements are more difficult to identify. Because Poussin has not articulated the details of the obelisk, it is impossible to determine whether it is based on a particular monument in Rome. Though it lacks a pediment, the tall structure to the right of the obelisk is reminiscent of the porch of the Pantheon with its unfluted columns, Corinthian capitals, and similarly rendered architrave.[29]

The scene that unfolds before the viewer is one of expansive quiet and solitude. Within this carefully constructed setting, Saint John is seated in the foreground, parallel to the picture plane, his pose as rectilinear as the pedestal he faces. The apostle and evangelist had been banished to the Aegean isle of Patmos during the reign of Emperor Domitian for disseminating Christian beliefs. There, alone in his religious fervor, he received his apocalyptic visions, recording them in the book of Revelation. An eagle stands in noble profile behind the saint, a traditional symbol of his elevated inspiration. The opening passage of the gospel of Saint John embodies the notion — central to neo-Stoic philosophy — of the preexisting Logos at the core of the universe: "In the beginning was the Word, and the Word was with God, and the Word was God" (John 1.1).

Landscape with Saint John on Patmos is thus intended to suggest the profound philosophical continuity between the old order of the Greco-Roman world and the new vision of Christianity. The classical ruins

around Saint John serve as reminders that the beliefs of the Evangelist emerged from those of classical civilization, extending and transforming them. At the same time, this painting is one of Poussin's first attempts to express, as Blunt wrote, "the parallel between the two productions of the supreme reason: the harmony of nature and the virtue of man."[30]

NOTES

1 This treatment was performed by Louis Pomerantz. The thread count of the original canvas is approximately 15 x 15/sq. cm (38 x 38/sq. in.).

2 The 1962 and 1966 treatments were performed by Alfred Jakstas. The 1988 treatment was performed by Frank Zuccari.

3 According to documents published by Barroero (1979) and Corradini (1979), Roscioli paid for the painting on October 28, 1640. The painting and its pendant were recorded in a Roman inventory of 1641 as being at Montecavallo, where Roscioli, as papal cupbearer, was lodged. See Corradini 1979, pp. 192, 194.

4 It was engraved in France by Louis de Châtillon c. 1680 (see discussion).

5 The price paid at the Robit sale is recorded in an annotated sale catalogue at the Rijksbureau voor Kunsthistorische Documentatie, The Hague. See also Smith 1837 and Blanc 1865. Although the annotated sale catalogue in The Hague indicates that the picture was sold to Nadou[x?], Bryan was probably the buyer.

6 See note 5. The painting was listed in Bryan's 1801–02 catalogue of Robit's collection (published in Buchanan 1824); and was exhibited by Bryan in his Pall Mall gallery in 1801–02 (see Buchanan 1824, pp. 36–37, and Fredericksen 1988, p. 12, no. 62).

7 See Buchanan 1824 and Fredericksen 1988. Sir Simon H. Clarke and George Hibbert had provided Bryan with financial backing for his purchases at the Robit sale. See Buchanan 1824, pp. 35–37, and Fredericksen 1988, p. 12, no. 62.

8 According to an annotated sale catalogue at the Frick Art Reference Library, New York.

9 Graves (1921) recorded that the painting had been sold for "367 gns. 10," but the picture was still in the possession of Geddes's widow when it was exhibited at the British Institution in 1861, and so was probably bought in at the 1845 sale.

10 See note 9.

11 In the 1960 exhibition catalogue, Anthony Blunt wrote that Rothschild had purchased the painting in London in 1928, and that it had then belonged to Hadeln before Fleischmann acquired it. Later, however, Blunt (1966) stated that Max Rothschild had purchased the painting in London in 1918. Posse (1930) indicated that the painting had surfaced at a London auction in 1928. A *Saint John at Patmos* by Poussin (40 x 52½ in.) was sold at Christie's, London, on December 16, 1927, as no. 86, but it cannot be positively identified as the Art Institute picture. According to an annotated 1927 sale catalogue (Ryerson Library, The Art Institute of Chicago), the painting was sold to Leger for £21 (see also *Art Prices Current*, n. s., vol. 7, London, 1928, p. 105).

12 The early Barberini provenance of *Landscape with Saint Matthew* led to this assumption (see Marilyn Aronberg Lavin, *Seventeenth-Century Barberini Documents and Inventories of Art*, New York, 1975, p. 303, no. 245).

13 See Barroero 1979 and Corradini 1979, in which Roscioli's account book, various inventories of his collection, and his will are published and discussed. Born on May 26, 1604, to a provincial family from Foligno, Roscioli studied ecclesiastical law

before assuming control of his family's abbacy of Collestatte in 1624. He then went to Rome, where he completed his studies and became acquainted with the Barberini family. He gained access to this pontifical entourage through his father, Bartolomeo, who served the Barberini, and through his uncle, Monsignor Angelo Giori, *maestro di camera* to Pope Urban VIII. In 1629 Roscioli was appointed canon of Saint Peter's; in 1630 he became cupbearer to the pope; and in 1643, upon his uncle's elevation to the cardinalate, *maestro di camera*. Roscioli died the following year, two months after the pope. The extensive library he left behind reveals his strong interests in literature and music, and the documents brought to light in 1979 prove him to have been a passionate and tasteful collector of art.

14 See Barroero 1979 and Corradini 1979. See also Aronberg Lavin (note 12).

15 Two copies of this painting are known: (1) *Saint John on Patmos*, possibly Lord Berwick, sold Phillips, London, June 6–7, 1825, no. 163, as "A grand Landscape with Architectural Buildings, and Saint Luke writing the Gospel"; Sir Thomas Baring, 1837 (see Blunt 1966, p. 59, under no. 86, copy 1); (2) *Saint John on Patmos*, 101.5 x 133.3 cm; Thomas C. Hinde, sold Christie's, London, January 8, 1876, number unidentifiable; sold Christie's, London, October 29, 1948, no. 146, as "A Landscape, with a classical figure seated writing," to Agnew, London (see Blunt 1966, p. 59, under no. 86, copy 2). Andreas Andresen (*Nicolaus Poussin: Verzeichniss der nach seinen Gemälden gefertigten gleichzeitigen und späteren Kupferstiche, etc.*, Leipizig, 1863, p. 118, no. 454), followed by Otto Grautoff (*Nicolas Poussin: Sein Werk und sein Leben*, vol. 2, Munich and Leipzig, 1914, p. 259), erroneously believed the Baring picture to be the model for Châtillon's engraving. The Baring picture has also been the source of some confusion regarding the provenance of the Art Institute's painting. Baring was mistakenly listed as a former owner of the Chicago painting in Friedlaender 1930, Posse 1930, Rich 1930, the 1933 and 1934 exhibition catalogues, Bertin-Mourot 1948, and the 1959 exhibition catalogue. Also, Smith (1837) and Magne (1914) both incorrectly identified the Baring picture with the painting by Poussin in the Robit collection (see Provenance). Blunt (1966) was the first to cite the Baring picture as a copy of the Art Institute painting.

The foreground of the engraved composition (fig. 2) is narrower than that of the painting, an adjustment presumably made by the engraver to standardize the format of all six landscapes (see Blunt 1975). A later line engraving by Mme Soyer (née Landon), perhaps after Châtillon, was published in Charles Paul Landon, *Vies et oeuvres des peintres les plus célèbres—Ecole française: Oeuvre complet de Nicolas Poussin*, vol. 2, Paris and Strasbourg, 1814, pl. CCXXIV.

16 See Barroero 1979 and Corradini 1979. Barroero dated the execution of the paintings to the year of the payment, 1640.

17 See the 1960 exhibition catalogue, p. 100, under no. 66; Blunt 1965; and Blunt 1966.

18 See, for instance, Blunt 1966, nos. 3–6, 15, 19, 29–30, 105–11, 112–18, 136–38, 173–74, 213–14.

19 Previously, Blunt (1966) had assigned *Landscape with Saint Matthew* to c. 1643 and *Landscape with Saint John on Patmos* to 1644/45. This dating had been accepted by Mahon (in *L'ideale classico del seicento . . .* 1962, no. 72) and Whitfield (1979).

20 See Cassiano dal Pozzo's letter of 1630 in S[heila] Somers-Rinehart, *Cassiano dal Pozzo (1588–1657): Some Unknown Letters*, Italian Studies 16, 1961, pp. 43, 57.

21 For illustrations of these works, see Blunt 1966, nos. 168, 160, 103, respectively.

22 For illustrations of these works, see Blunt 1966, nos. 173–74. Among the transitional paintings that should be grouped with the Chicago work are *Landscape in the Roman Campagna*

with a Man Scooping Water and *Landscape in the Roman Campagna* (1638/40) in The National Gallery, London (illustrated in Blunt 1966, nos. 213–14).

23 For a discussion of the landscape tradition that influenced Poussin, see Blunt 1967, vol. 1, pp. 273–85.

24 For Poussin's interest in neo-Stoic philosophy and the concept of Logos, see ibid., vol. 1, pp. 157–76.

25 See Blunt 1967, vol. 1, pp. 283–84.

26 For the Holkham Hall drawing, see Walter Friedlaender and Anthony Blunt, eds., *The Drawings of Nicolas Poussin: Catalogue Raisonné*, vol. 5, London, 1974, p. 125, no. 455 (ill.). For *Landscape in the Roman Campagna with a Man Scooping Water*, see Wright, *Poussin Paintings: A Catalogue Raisonné* 1985, p. 100, fig. 76.

27 Both drawings are preserved in the Gabinetto Nazionale delle Stampe, Rome, and are executed in black chalk; see Friedlaender and Blunt (note 26), pp. 58–59, nos. 381–82, pl. 283. Scholars have disagreed about the authorship of these studies. Friedlaender and Blunt cautiously retained the traditional attribution of the drawings to Poussin. Valenti Rodinò (1979–80, p. 97, nos. 260–61) believed the sheets to be by Guglielmo Cortese and associated them with two volumes of drawings that were probably in the collection of Cardinal Neri (1685–1770) and that Neri's librarian, Giovanni Gaetano Bottari, labeled "tutti di Nic. Possino." Although in the 1977–78 exhibition catalogue Pierre Rosenberg suggested a connection between the drawings and the Chicago painting, he has more recently ascribed the sheets to an anonymous artist (1994–95 exhibition catalogue).

28 For an illustration of the Louvre painting, see Blunt 1966, no. 170.

29 A porch similar to that in the Chicago painting forms an imposing architectural backdrop in Poussin's *Capture of Jerusalem by Titus* in the Kunsthistorisches Museum in Vienna (illustrated in Blunt 1966, no. 37), which dates from the same period.

30 Blunt 1967, vol. 1, p. 285.

After Jean Restout

1692 Rouen–Paris 1768

Saint Hymer in Solitude, c. 1735

Restricted gift of the Old Masters Society, 1982.1378

Oil on canvas, 59.4 x 75.1 cm (23³⁄₈ x 29¹³⁄₁₆ in.)

CONDITION: The painting is in very good condition. The canvas has an old glue paste lining, and an edge lining that was added in 1986 at the Art Institute.[1] The original tacking margins have been cut off, but cusping is visible at all four edges, suggesting that the painting is close to its original dimensions. The paint layer, applied over a cream-colored ground, is well preserved. The overall cupped craquelure is somewhat visually distracting. There are three losses along the bottom edge of the picture; the largest measures no more than 3 cm in length. There is localized retouching over these losses and scattered in the upper left background and along the right edge. (infrared, ultraviolet, x-radiograph)

PROVENANCE: Possibly the church of Saint-Hymer, Calvados.[2] Galerie Cailleux, Paris.[3] Sold by Cailleux to the Art Institute, 1982.

EXHIBITIONS: University of Rochester, Memorial Art Gallery, *La Grande Manière: Historical and Religious Painting in France, 1700–1800*, 1987, no. 45, as Restout, cat. by Donald A. Rosenthal, traveled to New Brunswick and Atlanta.

Jean Restout had a highly successful academic career (*agréé* in 1717, *reçu* in 1720, professor in 1734, *recteur* in 1752, and *chancelier* in 1761) and was a frequent exhibitor at the Salon. His works form part of the tradi-tion in French religious painting that began with his uncle and teacher, Jean Jouvenet, and passed from Restout to his student Jean Baptiste Deshays (see 1979.540). Restout established himself as one of the foremost French painters of religious subjects with his celebrated pendants of 1730, *The Ecstasy of Saint Benedict* and *The Death of Saint Scholastica* (both in

Fig. 1 Jean Restout, *Saint Hymer in Solitude*, Saint-Hymer, Calvados

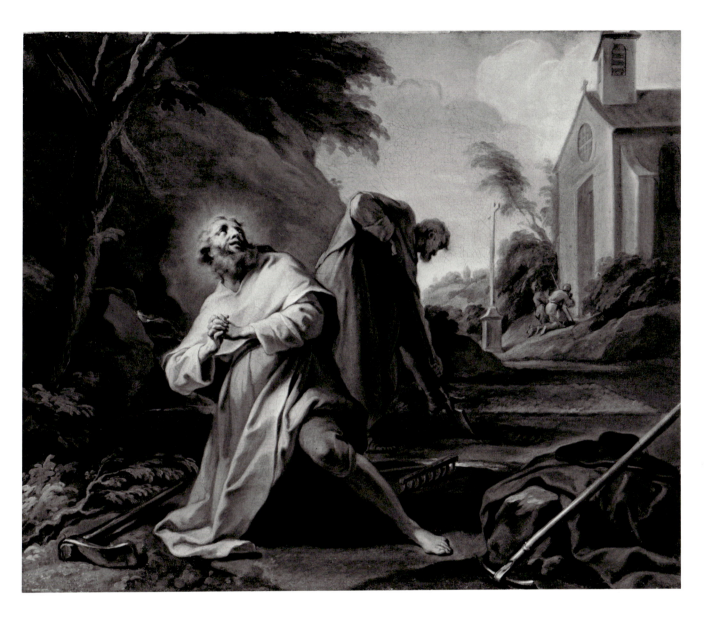

Tours, Musée des Beaux-Arts). He was also an accomplished portraitist, as his sensitive and probing paintings *Dom Louis Baudouin du Basset* (1716; Musée des Beaux-Arts de Rouen) and *Abbé Tournus* (c. 1730; Vire, Musée des Beaux-Arts) attest.[4]

In 1735 Restout executed two paintings for the distinguished Jansenist Henri de Roquette (1699–1789), the *abbé commendataire* of the abbey of Saint-Hymer in Calvados: *The Charity of Saint Martin* and *Saint Hymer in Solitude* (fig. 1), both of which are now in the parish church of Saint-Hymer, Calvados.[5] The first depicts the moment at which, as a young soldier, Saint Martin shared his cloak with a beggar; the pendant por-

trays a comparably humble episode from the life of the seventh-century Swiss hermit Saint Hymer. After a pilgrimage to the Holy Land, Saint Hymer settled in the Jura Mountains, in the valley of Susengau, where he built a chapel in honor of Saint Martin. To accommodate his many disciples, Saint Hymer later founded a monastery that came to bear his name. In Restout's painting, the saint kneels in prayer, surrounded by gardening tools, while a servant just behind him digs with a shovel. In the distance, other figures kneel before entering the Chapel of Saint-Martin. Saint Hymer's agricultural labor was emphasized in the legends of his life. According to Genoud, he cultivated a small field and "lorsqu'il

était dans son champ, dit une légende, il regardait son âme comme le champ du Seigneur et la cultivait par de fréquentes prières."[6]

Although the small, unsigned Chicago painting was acquired as a Restout, and Donald Rosenthal (1987 exhibition catalogue) argued that it is an autograph study for the large Calvados painting, Pierre Rosenberg and Antoine Schnapper have suggested that it is probably a studio replica of the canvas in Calvados.[7] The composition of the Chicago picture extends further to the right and left, and slightly further at the bottom. Such minor alterations in format could easily have been made by an assistant looking at Restout's original work. Certainly the Chicago work lacks the delicacy of touch of the Calvados painting; the forms in the reduced version, particularly the saint's face, the foliage, and the clouds, have been broadened and flattened. Moreover, it appears that Restout rarely painted preparatory sketches or finished *modelli* for his works (and that most of the few small-scale works he did were portraits). Although many studio copies after his paintings exist, he does not seem to have made reductions of his own work. [8]

Richard Brettell proposed that the Chicago reduction may have been executed for the patron Roquette.[9] It is also possible that the Chicago *Saint Hymer in Solitude* was, together with a pendant, once in the church of Saint-Hymer. A small copy of *The Charity of Saint Martin* with approximately the same measurements as the Chicago picture (57 x 72 cm) was in the possession of the church until at least 1970, when it appeared in an exhibition in Rouen.[10] Like the Chicago work, the reduction of *The Charity of Saint Martin* shows some alterations of format—the composition has been broadened on the left side and slightly reduced along the top. Unfortunately, the present location of this copy is not known.[11]

The Calvados *Saint Hymer in Solitude* and the Chicago replica exhibit Restout's characteristic solemnity of expression and strong diagonals, which he derived from Jouvenet. Restout himself wrote that "suivant M. Jouvenet, la forme pyramidale, dans la forme générale d'une composition, est la plus heureuse."[12] As Jean Locquin pointed out, Restout also "avait hérité de son oncle, avec un goût très prononcé pour le réalisme, une certaine ampleur de manière."[13] These traits can be observed in Restout's careful attention to the objects and clothing scattered through the foreground. The Calvados and Chicago canvases seem to be indebted as well to Louis de Boullogne's *Rest on the Flight into Egypt* (1715;

Arras, Musée des Beaux-Arts), from which the pose of Saint Hymer appears to derive.[14]

NOTES

1 The edge lining, which reinforces the weakened tacking margins of the lining fabric, was added by Faye Wrubel. The thread count of the original canvas is approximately 11 x 13/sq. cm (28 x 33/sq. in.). The upper left corner of the stretcher bears the inscription *Peint par J. B. Marie Pierre 1er. peintre de Louis XV / né à Paris en 1714 mort en 1789.*

2 See discussion.

3 Marianne Roland Michel indicated that Cailleux had purchased the painting at a public sale (letter to the author of February 25, 1983, in curatorial files).

4 For these paintings, see Pierre Rosenberg and Antoine Schnapper, *Jean Restout (1692–1768)*, exh. cat., Musée des Beaux-Arts de Rouen, 1970, pl. VIII, pl. IX, pl. I, p. VII, respectively. For the artist's life and work, see Rosenberg and Schnapper (this note) and *Essai sur les principes de la peinture par Jean Restout, peintre ordinaire du roi Louis XV; publié avec des notes par A.-R. R. de Formigny de La Londe*, Caen, 1863.

5 *The Charity of Saint Martin* measures 183 x 191 cm and is signed and dated at lower left: *Restout 1735; Saint Hymer in Solitude* measures 185 x 191 cm and is signed and dated at lower right: *Restout 1735*. See Rosenberg and Schnapper (note 4), pp. 47–48, nos. 12–13, pls. XII–XIII, and P. Lepaysant, *Le Port-Royal de Normandie: Saint-Himer-en-Auge et son prieur— Henri de Roquette (1699–1789)*, Paris, 1926, p. 55. Roquette presumably commissioned the paintings while living in Paris; he had been officially expelled from the parish of Saint-Hymer by its pastor in 1731. For his expulsion, see Lepaysant (this note), pp. 11–14. Simone Zurawski (verbally, June 9, 1994, to Larry Feinberg) has speculated that Roquette may have contributed the paintings to Saint-Hymer in the hope of being reinstalled at the abbey.

6 M. l'abbé J. Genoud, *Les Saints de la Suisse française*, vol. 1, Paris, Bordeaux, Bar-le-duc, and Fribourg, 1882, p. 184: "When he was in his field, according to one legend, he looked upon his soul as the field of the Lord and cultivated it through frequent prayers." See also ibid., p. 183, and P. Mamie, *Saint Himier: Ermite et premier apôtre de la vallée de la Suze*, Saint-Hymer, 1882, p. 27.

7 Rosenberg, verbally, when he examined the painting, November 15, 1988 (notes in curatorial files); Antoine Schnapper in a letter to the author of September 8, 1988, in curatorial files. Inscriptions on an old label removed from the back of the picture indicate that Eustace Le Sueur, Jean Jouvenet, and Jean Baptiste Marie Pierre have in the past been considered as possible authors of the painting. The label is preserved in curatorial files. See also note 1, for an inscription that refers to Pierre.

8 Several copies are cited in Rosenberg and Schnapper (note 4).

9 Unpublished information sheet on the painting, in curatorial files.

10 See Rosenberg and Schnapper (note 4), pp. 47–48, under no. 12. The reduction of *The Charity of Saint Martin* is illustrated in J[acques] Pougheol, "Liste des oeuvres exposées," *Art de Basse-Normandie* 34 (summer 1964), p. 30, no. 75, p. 33 (ill).

11 According to Alain Tapie (letter of May 2, 1989, to the author, in curatorial files), the replica of *The Charity of Saint Martin* apparently disappeared during the renovation of the church in 1976; the Archives Départementales du Calvados no longer records the work among the church's possessions.

12 *Essai sur les principes de la peinture par Jean Restout . . .* (note 4), p. 42: "Following M. Jouvenet, the pyramid form, in the general configuration of a composition, is the most favorable."

13 Jean Locquin, *La Peinture d'histoire en France de 1747 à 1785: Etude sur l'évolution des idées artistiques dans la seconde moitié du XVIIIᵉ siècle*, Paris, 1912, pp. 175–76: "Had inherited from his uncle a very pronounced taste for realism, a certain amplitude of manner."

14 For an illustration of Boullogne's painting, see Hélène Guicharnaud, "Les Dessins préparatoires conservés au Louvre, des tableaux de Louis de Boullogne pour le vœu de Louis XIII au chœur de Notre-Dame de Paris," *GBA* 6th ser., 114 (1989), p. 129, fig. 2.

Hubert Robert

1733 Paris 1808

Four Architectural Caprices for the Chateau de Mereville

The Old Temple, 1787/88

Gift of Adolphus C. Bartlett, 1900.382

Oil on canvas, 255 x 223.2 cm (100³/₈ x 87⁷/₈ in.)

CONDITION: The painting is in very good condition. It was surface cleaned, varnished, and retouched in 1962.[1] The canvas has an old glue paste lining. The tacking margins appear to have been cut off, but cusping visible at all four edges indicates that the painting is close to its original dimensions.[2] There is a 12.7 cm vertical tear near the upper right corner of the painting on the outer wall, and a 7.7 cm diagonal tear on the entablature above the foremost column at left. The painting has an off-white ground. The paint surface is generally well preserved; however, there is slight surface abrasion in the lower part of the statue of Psyche and in the sculpture of an Egyptian lion, both on the right. The losses within the tears have been filled and inpainted. There is overpaint on some of the shadows in the lower foreground: behind the head of the statue of Thusnelda and on the pedestal beneath the lion, both at left, behind the woman on the stairs, on the underside of the fountain basin at right, and in the shadows of the broken steps near the lower center edge.

PROVENANCE: See below.

REFERENCES: See below.

EXHIBITIONS: See below.

The Obelisk, 1787

Gift of Clarence Buckingham, 1900.383

Oil on canvas, 255.6 x 223.5 cm (100⁷/₈ x 88 in.)

INSCRIBED: *H. ROBERT / 1787* (lower left, beneath column), and *H ROBERT / [. . .] / [. . .] / Lᵉ[. . .] / MEREVILLE / DE LABORDE / [. . .]* (lower right of center, on a stone held by a man)

CONDITION: The painting is in very good condition. It was surface cleaned and varnished in 1962.[3] The canvas has an old glue paste lining.[4] The tacking margins appear to have been cut off, but cusping visible at all four edges indicates that the painting is close to its original dimensions. The canvas appears to be slightly smaller than the present stretcher, which was probably added when the painting was lined.[5] The ground is off-white. The paint layer is generally well preserved. Some local surface abrasion is apparent in the sculpture of the lion on the left side of the stairs. There are several areas of loss: a 1.7 cm vertical loss halfway up the left edge of the painting, a smaller loss in the wall to the right of the statue of Pudicity (in the niche at the center of the composition), and a few minor losses scattered on the perimeter. There is retouching over the losses. Certain areas of dark shadow in the foreground have been overpainted with glazes, notably, the center of the stairs, the pedestal supporting the column at right, and the red drapery of the men on the stairs. Additional retouching covers vertical cracks (probably caused by a previous stretcher) at the right and left edges. There are a few disturbances in the surface near the lower right corner of the painting; these include two white drip stains in front of the men with the inscribed tablet, numerous small white splashes, and a clouded area of varnish over the base of the column.

PROVENANCE: See below.

REFERENCES: See below.

EXHIBITIONS: See below.

The Landing Place, 1788

Gift of Richard T. Crane, 1900.384

Oil on canvas, 255 x 222.9 cm (100⁷/₈ x 87³/₄ in.)

INSCRIBED: *H. ROBERT / IN ÆDIBUS / MEREVILLÆ / PRO / D. DE LABORDE / PINXIT / A.D. 1788.* (lower center, on statue pedestal)

CONDITION: The painting is in very good condition. It was surface cleaned and varnished in 1962.[6] The canvas has an old glue paste lining.[7] The tacking margins appear to be intact, and there is cusping at all four edges.[8] The ground is off-white. The

paint layer is generally well preserved. The surface is slightly abraded in the entablature near the right edge and in some of the dark foreground shadows. There is a 2.5 cm vertical loss in the seated figure at the top of the stairs at left and a few smaller losses (0.5 to 1.2 sq. cm) along the left edge and at the lower right corner. There is discolored retouching over these losses and in the sky visible through the arch at right. What appears to be a *pentimento* indicates that there may have been a slight shift in the position of the masonry around the keystone of the arch at left.

PROVENANCE: See below.

REFERENCES: See below.

EXHIBITIONS: See below.

The Fountains, 1787/88
Gift of William C. Hibbard, 1900.385

Oil on canvas, 255.3 x 221.2 cm (100 1/2 x 88 1/8 in.)

CONDITION: The painting is in very good condition. It was surface cleaned, varnished, and inpainted in 1962.[9] The canvas has an old glue paste lining.[10] The tacking margins appear to have been cut off, but cusping visible at all four edges indicates that the painting is close to its original dimensions. The canvas appears to be slightly smaller than the present stretcher.[11] There is a 12 cm vertical tear at the top of the stairs near the lower right corner. The ground is off-white. The paint layer is generally well preserved. Some local surface abrasion is apparent around the tear and on the lower right base of the arch. There is some paint loss within the tear and there are a few minor losses at the lower left corner of the painting. These losses have been retouched. Certain areas of dark shadow in the foreground have been overpainted with glazes, notably, the shadows of the ruins at lower left, the statue pedestal and fountain basin at lower right, and the left leg of the statue of Castor, at left, and the torso of Pollux, at right.

PROVENANCE: Commissioned by Jean Joseph, marquis de Laborde (d. 1794), in 1787 for the Château de Méréville (near Etampes); the château was sold by Mme de Laborde, 1819.[12] The château was owned successively by: M. Ters and Mme d'Espagnat (sold 1824); comte de Saint-Roman (sold 1866); duc de Sessa (sold 1868); M. and Mme Beleys (sold 1869); Sté. Cail (sold 1874); M. Heddle (sold 1889); Adam Natanson (sold 1890); M. Hériot (sold 1896); Prudent Carpentier (sold 1897, at which time the contents of the house were dispersed and the paintings probably sold).[13] M. L. François; sold Galerie Georges Petit, Paris, June 13, 1900, nos. 1–4 (ill.), to Durand-Ruel, acting on behalf of the Art Institute.[14]

REFERENCES: C. Gabillot, *Hubert Robert et son temps*, Paris, 1892, p. 168. "La Chronique des arts et de la curiosité," *GBA* 3d ser., 24 (1900), suppl. no. 26, p. 267. AIC 1904, p. 210, nos. 425–28 (1900.383 ill.). AIC 1907, p. 220, nos. 425–28 (1900.385 ill.). Armand Dayot, "Le Centenaire d'Hubert-Robert," *L'Art et les artistes* 7 (1908), p. 204. AIC 1910, pp. 196–97, nos. 425–28 (1900.385 ill.). Pierre de Nolhac, *Hubert Robert, 1733–1808*, Paris, 1910, pp. 58, 153–54, nos. 1–4. AIC 1913, p. 139, nos. 425–28 (1900.382 ill.). Tristan Leclère, *Hubert Robert et les paysagistes français du XVIIIe siècle*, Paris, 1913, p. 92. AIC 1914, p. 145, nos. 425–28. AIC 1917, p. 142, nos. 347–50. AIC 1920, p. 37, nos. 347–50. AIC 1922, p. 38, nos. 347–50. AIC 1923, p. 38, nos. 347–50. AIC 1925, pp. 45 (1900.385 ill.), 151, nos. 347–50. [Pierre] Paul-Sentenac, *Hubert Robert*, Paris, 1929, pp. 52–53. AIC 1932, pp. 41 (1900.385 ill.), 169. *Hubert Robert, 1733–1808*, exh. cat., Paris, Musée de l'Orangerie, 1933, p. 71, under no. 82. Daniel Catton Rich, "The Paintings of Martin A. Ryerson," *AIC Bulletin* 27, 1 (1933), p. 4. Thieme/Becker, vol. 28, 1933, p. 420. AIC 1935, p. 27. AIC 1941, p. 32. R[eginald] H[oward] Wilenski, *French Painting*, rev. ed., Boston, 1949, p. 160, pl. 69 (1900.385). AIC 1952, n. pag. (1900.385 ill.). George Isarlo, "Hubert Robert," *Connaissance des arts* 18 (August 1953), p. 28, under no. 27 (1900.384), p. 32, under no. 35, fig. 9 (1900.382), p. 32, under no. 46 (1900.383). Bénézit, 2d ed., vol. 7, 1954, p. 276. AIC 1961, pp. 401–02. Ferdinand Boyer, "Les Collections et les ventes de Jean-Joseph de Laborde," *Bulletin de la Société de l'histoire de l'art français, année 1961* (1962), p. 147. Hubert Burda, *Die Ruine in den Bildern Hubert Robert*, Munich, 1967, pp. 44, 67, fig. 26 (1900.385), pp. 67, 97, 99, figs. 131, 134 (1900.382, 1900.384). Olivier Choppin de Janvry, "Méréville," *L'Oeil* no. 180 (1969), p. 83. Jean de Cayeux, "Hubert Robert dessinateur de jardins et sa collaboration au parc de Méréville d'après des documents inédits," *Bulletin de la Société de l'histoire de l'art français, année 1968* (1970), p. 128 (1900.384). Maxon 1970, pp. 15, 61–63 (1900.383 ill.). Annette Vaillant, *Le Pain polka*, Paris, 1974, p. 69. Marianne Roland Michel in *Piranèse et les français, 1740–1790*, exh. cat., Rome, Villa Medici, 1976, p. 321, under no. 181. Victor Carlson, *Hubert Robert: Drawings and Watercolors*, exh. cat., Washington, D.C., National Gallery of Art, 1978, p. 134, under no. 54 (1900.384). André Corboz, *Peinture militante et architecture révolutionnaire: A propos du thème du tunnel chez Hubert Robert*, Basel and Stuttgart, 1978, pp. 15–17, figs. 12, 18 (1900.382, 1900.385). Jean Cailleux in *Un Album de croquis d'Hubert Robert (1733–1808)*, exh. cat., Geneva, Galerie Cailleux, 1979, n. pag., under no. 73. Sotheby's, London, *Important Old Master Paintings*, sale cat., June 23, 1982, n. pag., under no. 30. Annie Scottez in *Autour de David: Dessins néo-classiques du Musée des Beaux-Arts de Lille*, exh. cat., Musée des Beaux-Arts de Lille, 1983, pp. 193, under no. 144. George Bernier in *Hubert Robert: The Pleasure of Ruins*, exh. cat., New York, Wildenstein, 1988, p. 88. John D. Bandiera, "Form and Meaning in Hubert Robert's Ruin Caprices: Four Paintings of Fictive Ruins for the Château de Méréville," *AIC Museum Studies* 15 (1989), pp. 21–37 (all ill.), 82–85. Jean de Cayeux in *Hubert Robert et la Révolution*, exh. cat., Musée de Valence, 1989, p. 12 (1900.384, 1900.385 ill.). Jean de Cayeux with Catherine Boulot, *Hubert Robert*, Paris, 1989, pp. 153, 158, 162–64, 262. Günter Herzog, *Hubert Robert und das Bild im Garten*, Worms, 1989, pp. 105, 222 nn. 333, 335–37. Wright 1991, vol. 1, p. 458, vol. 2, pp. 62, 600. Joseph Baillio, "Hubert Robert's Decorations for the Château de Bagatelle," *Metropolitan Museum Journal: Essays in Memory of Guy C. Bauman* 27 (1992), pp. 149, 176, 179 n. 1. AIC 1993, p. 140 (1900.385 ill.). Jean de Cayeux in Cara D. Denison, Myra Nan Rosenfeld,

and Stephanie Wiles, *Exploring Rome: Piranesi and His Contemporaries*, exh. cat., New York, The Pierpont Morgan Library, and Montreal, Canadian Centre for Architecture, 1993, p. 186, under no. 105, fig. 2. Gloria Groom, *Edouard Vuillard: Painter-Decorator*, New Haven, 1993, p. 124, pl. 198 (1900.385).

EXHIBITIONS: The Art Institute of Chicago, *A Century of Progress*, 1933, no. 227 (1900.385 only). The Art Institute of Chicago, *A Century of Progress*, 1934, nos. 330–33. The Art Institute of Chicago, *Selected Works of Eighteenth-Century French Art in the Collections of The Art Institute of Chicago*, 1976, nos. 14a–d.

The four large Robert canvases in Chicago were painted for the Château de Méréville near Etampes. In 1784 the château was acquired by the French financier Jean Joseph de Laborde. Born at Jaca in Aragon, the marquis de Laborde had begun a brilliant commercial career in Bayonne, and by age thirty-four went to Paris, where he became the last banker to the court. Through a multitude of financial enterprises and good fortune, Laborde became one of the wealthiest men in France. He supported charitable institutions and became a noteworthy patron of the arts. Upon purchasing Méréville, Laborde immediately began to enlarge the château and to enhance and modernize the grounds. For this project, he marshalled the services of architects, sculptors, and artisans, and of Hubert Robert, who was then at the apex of his career. Work on the château continued almost until the marquis was guillotined on April 18, 1794.

By the 1780s Robert had established himself as the foremost exponent of ruin painting in France. Though many painters worked in this genre, Robert's grand yet casual and lyrical depictions of classical ruins seem to have particularly suited the neoclassical taste for antiquity. While this talent won him both reputation and broad patronage, he was also recognized for his gifts in garden design, which he demonstrated at Ermenonville and the Petit Trianon. Indeed, his abilities as a *peintre d'architecture*, the genre into which he had been received by the Academy in 1766, and as a *dessinateur des jardins du roi*, the title accorded him in 1778 after he transformed the Bosquet des bains d'Apollon at Versailles, eminently qualified him for the task at Méréville. In this dual capacity Robert participated in the interior decoration of the Château de Méréville and collaborated on the design of the gardens, for which Méréville was much celebrated.[15]

When Robert began to work on the Méréville project in 1786, he was already engaged as the *garde des*

tableaux du roi, a post bestowed upon him in 1784 by Charles Claude Labillarderie d'Angiviller, *directeur général des bâtiments et jardins*, and was employed at Rambouillet under d'Angiviller's direction. In connection with Méréville, Robert produced a number of paintings that fall into two groups: those that depict the surrounding park, and those that served as decoration for the château interior. Of the former, it is noteworthy that some of the most accomplished, finished canvases representing the grounds of Méréville with their monuments and bridges were not inspired by the park in its finished state, as was once believed, but were painted proposals for the redesigning of it.[16] The other group consists of six large canvases commissioned by Laborde for the château.[17] Two landscapes, *The Cascade* and *The Craggy Rock* (locations unknown),[18] hung in the billiard room, while the four architectural ruin paintings now in Chicago were placed in the salon d'hiver (fig. 1). A letter from Robert to Mme de Laborde of August 26, 1788, indicated that he planned to install the paintings in the

Fig. 1 The salon d'hiver at the Château de Méréville, with *The Fountains* and *The Old Temple* in their original setting [photo: courtesy of B. Binvel, Société historique et archéologique du Canton de Méréville, collection Madame Andrée Sainsard]

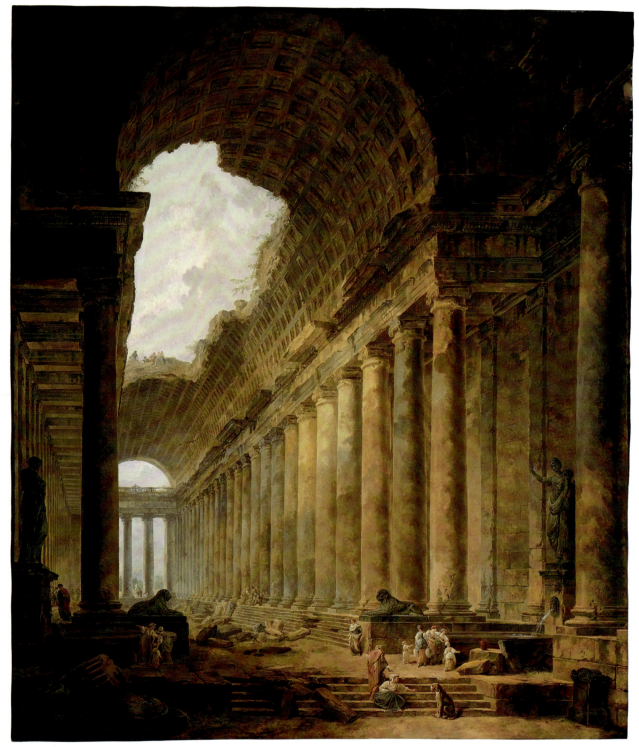

Hubert Robert, *The Old Temple*, 1900.382

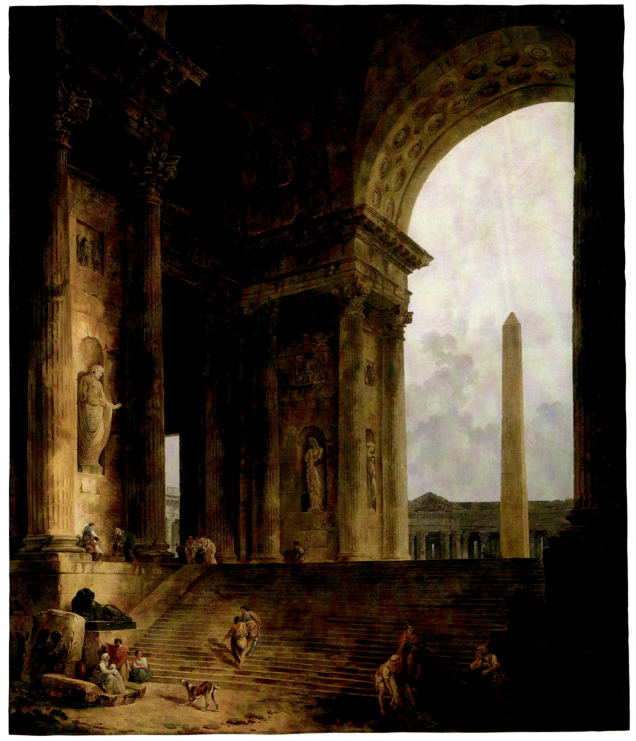

Hubert Robert, *The Obelisk,* 1900.383

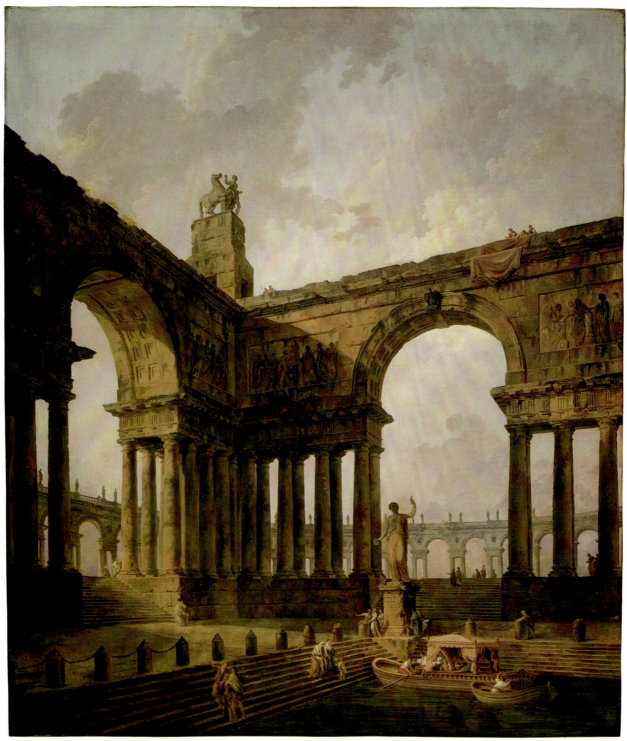

Hubert Robert, *The Landing Place*, 1900.384

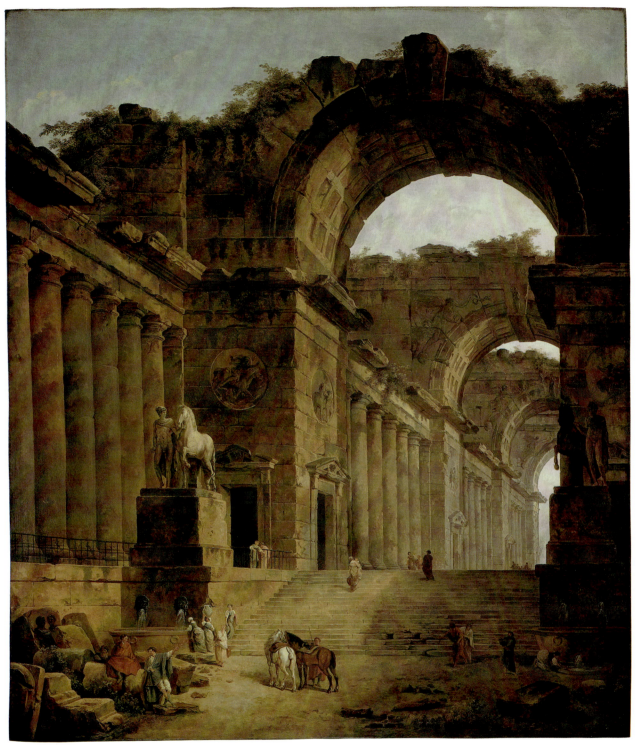

Hubert Robert, *The Fountains,* 1900.385

salon in September (between the 10th and the 15th).[19] These six works seem to have remained at Méréville until 1897 (see Provenance).

The subject matter of the Chicago canvases was much in vogue when they were painted in 1787 and 1788. The works reveal Robert's very individual response to the antique and his subtle inventiveness in recasting it, talents cultivated during and after his study in Italy. In 1754 the artist had traveled to Rome in the company of Etienne François de Choiseul, comte de Stainville, later the duc de Choiseul, who arranged a place for him at the French Academy in Rome. There the young Robert's penchant for portraying ruins was stimulated by two great practitioners of architectural landscapes: the painter Gian Paolo Panini, who taught perspective at the French Academy, and the engraver Giovanni Battista Piranesi, whose workshop was near the Palazzo Mancini, where the Academy students lived. The works of these artists were principal sources of inspiration for Robert, and their influence can be discerned throughout his oeuvre. Robert also gained considerable firsthand knowledge of antique art, which he studied in various parts of Italy. He remained in Rome for eleven years, traveled to Naples and its environs in 1760 with the abbé de Saint-Non, possibly joined Fragonard and the abbé at the Villa d'Este at Tivoli, and visited Florence. Almost two decades after his return to France in 1765, Robert journeyed to Provence. There, in response to the widening attention given to French artistic patrimony, he recorded classical antiquities that would later appear in a number of important compositions he painted between 1783 and 1789.

The Chicago paintings are not archaeological recreations of the classical world, but imaginatively combine characteristic features of classical architecture and certain well-known monuments with genre scenes. The edifice in *The Old Temple* consists of a massive structure with a damaged, coffered barrel vault supported by an Ionic colonnade. In the foreground, groups of people engage in mundane activities amidst a litter of masonry fragments. While Charles Sterling believed the grand edifice to have been inspired by the Baths of Diocletian,[20] Hubert Burda (1967) looked instead to contemporary prototypes and, pointing to the inflated dimensions of Robert's structure, compared the building to a design for the Bibliothèque Royale by the architect Etienne Louis Boullée.[21] André Corboz (1978), who explored the "tunnel theme" in Robert's work, saw the artist as a mediating spokesman between contemporary

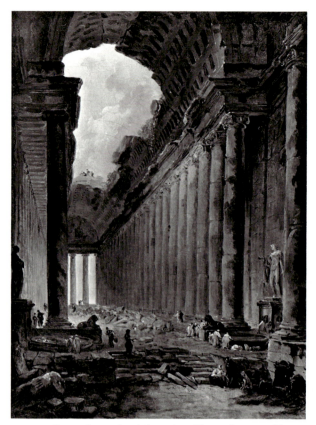

Fig. 2 Hubert Robert, *Sketch for "The Old Temple,"* Gemälde-galerie der Akademie der bildenden Künste, Vienna

architects and the public. He suggested that Robert had assimilated contemporary architectural innovations and, by couching them in the already familiar classical terms, fostered public acceptance of them.[22] At left in *The Old Temple*, Robert recast the Roman marble figure *Thusnelda* (c. 100; Florence, Loggia dei Lanzi), and complemented her, at right, with a statue probably derived from the *Psyche* in the Galleria dei Candelabri in the Vatican.[23] The pair of Egyptian lion sculptures seems to be based on those that once flanked the stairs leading to the Campidoglio and are now in the Capitoline Museum.[24] Robert used a vaulted gallery with an extended colonnade as a central motif in a number of works, including a small canvas (fig. 2) in the Gemälde-galerie der Akademie der bildenden Künste in Vienna that appears to be a preparatory sketch for *The Old Temple*.[25] After the Vienna sketch, the works closest to the Chicago painting are a watercolor dated 1780 in the Musée des Beaux-Arts de Lille, a smaller drawing almost identical to the one in Lille owned in 1933 by Mme Fournier, and a red chalk drawing, *A Vaulted Chamber with the Statue of Menander* (1775/80), in a Toronto private collection.[26]

The Obelisk focuses on a monumental cross vault, its soffits decorated with octagonal coffers.[27] Through an arch an obelisk is visible, and, behind that, a peristyle. A similar architectural arrangement appears in a variant of *The Obelisk* in the Pushkin Museum in Moscow.[28] The lions on each side of the stairs in the Chicago painting are modeled on an Egyptian pair inscribed for Pharaoh Nectanebo I. At one time the sculptures stood before the Pantheon and, subsequently, in front of the Fountain of the Acqua Felice; they are now housed in the Museo Egizio of the Vatican.[29] In the niche at the center of the composition, Robert has inserted a figure based on the famous first-century Roman sculpture *Pudicity*, in the Vatican.[30]

In *The Landing Place*, Robert presents a grand peristyle, with arches and Tuscan Doric columns, through which a distant, freestanding arcade is visible. Before this monumental architectural backdrop a group of people departs in a pleasure boat while others loiter and converse on the steps. Variants of this composition are known, namely in *Architectural Landscape with a Canal* (St. Petersburg, Hermitage), which was exhibited at the Salon of 1783, and in a drawing once belonging to Léon Roux.[31] There are several direct quotations from antique art in *The Landing Place*, including the sculpture above the peristyle, which is one of the horse tamers from the second-century Roman marble sculptural group *Alexander and Bucephalus* (alternately identified as the *Dioscuri*) in the Piazza del Quirinale in Rome, and the female figure on a pedestal at the water's edge, which is based on an antique statue of Juno now in the Capitoline Museum in Rome.[32] Most of the reliefs appear to be invented, but at least one figure, the *Victory with a Shield* at the left in the upper right relief, is derived from Trajan's Column, and the leaning female at the middle of the central relief may have been inspired by a similarly posed figure in the famous first-century *Aldobrandini Wedding* fresco, in the Vatican.[33]

The Fountains, an imaginative series of triumphal arches connected by Tuscan Doric colonnades, also contains erudite quotations. The sculptures flanking the stairs are based on the first-century-B.C. figures *Castor and Pollux* that stand at the summit of the Campidoglio steps. This same figural motif, transcribed into relief, reappears in the second medallion from the left. The two other relief medallions, on either side of the first arch, probably depend on antique representations of Marcus Curtius flinging himself into the gulf.[34] In creating these, Robert may have studied the well-known medal-lion relief of the subject in the Villa Borghese in Rome or perhaps one of the other sculpted versions of the legend in that collection.[35] The Winged Victories that ornament the spandrels of Robert's arches were possibly inspired by those on the Arch of Titus. A variant of *The Fountains*, entitled *Roman Baths with Laundresses* (after 1766), is preserved in the Philadelphia Museum of Art.[36]

When the Chicago paintings hung in the salon d'hiver of the Château de Méréville, the immensity of their architectural fantasies would have been emphasized by the physical space of the room (see fig. 1). The pictures were framed rather than installed directly into the walls, and the architectural perspective in the paintings differed from that of the room itself. In this respect, Burda viewed the decoration as an instance in which architecture functioned in the service of paintings; Robert's works were not trompe l'oeil exercises designed to extend the space of the room, but were placed there to add historical reference to it.

NOTES

1 The treatment was performed by Alfred Jakstas.

2 Based on surface examination, the thread count can be estimated as 10 x 8/sq. cm (25 x 20/sq. in.).

3 The treatment was performed by Alfred Jakstas.

4 Based on surface examination, the thread count can be estimated as 10 x 8/sq. cm (25 x 20/sq. in.).

5 Investigation of the lower right and left edges revealed that a 0.5-cm-wide band of fill material has been added to the edges. Examination of the entire perimeter was not possible because it is covered with paper tape; however, if the fill material extends continuously around the edges of the painting, the dimensions of the original canvas are approximately 254.6 x 222.5 cm (100 1/4 x 87 5/8 in.).

6 The treatment was performed by Alfred Jakstas. In 1989 small accretions were removed from the lower right corner of the painting by Cynthia Kuniej Berry and the area was then locally varnished.

7 Based on surface examination, the thread count can be estimated as 10 x 8/sq. cm (25 x 20/sq. in.).

8 Examination of the lower right corner revealed that part of the worn tacking edge remains, but examination of the entire perimeter was not possible because the perimeter is covered with paper tape.

9 The treatment was performed by Alfred Jakstas.

10 Based on surface examination, the thread count can be estimated as 10 x 8/sq. cm (25 x 20/sq. in.).

11 Investigation of the lower right corner revealed that a 0.5 cm band of fill material has been added to the edges. Examination of the entire perimeter was not possible because it is covered with paper tape; however, if the fill material extends continuously around the edges of the painting, the dimensions of the original canvas are approximately 254.2 x 220.2 cm (99 3/4 x 88 1/4 in.).

12 [Baronne] Simone de Lassus, "Quelques Détails inédits sur Méréville," *Bulletin de la Société de l'histoire de l'art français, année 1976* (1978), p. 286 n. 1.

13 Ibid. Bernard Binvel (letter of May 5, 1987, to the author) wrote, perhaps erroneously, that Hériot sold the paintings in July of 1896.

14 The purchase was arranged by the Art Institute trustees and made possible through donations from Adolphus C. Bartlett, Clarence Buckingham, Richard T. Crane, and William C. Hubbard.

15 For additional information on Méréville, see Alexandre de Laborde, *Description des nouveaux jardins de la France et de ses anciens châteaux mêlée d'observations sur la vie de la campagne et la composition des jardins*, Paris, 1808; Baronne [Simone] de Lassus, "Les Fabriques de Méréville et de Jeurre," *L'Information d'histoire de l'art* 20, 1 (1975), pp. 32–36; Jean de Cayeux, *Hubert Robert et les jardins*, Paris, 1987, pp. 102–12; and Herzog 1989, pp. 95–117. See also note 12.

16 Cayeux 1970, p. 131–33, and Lassus (note 12), p. 273–87.

17 Two contracts by Robert, now in the possession of the duc de Mouchy, Paris, document Robert's agreement with Laborde. In the first, dated May 19, 1787, Robert promised to execute four paintings for 4,000 *livres* each, and four smaller pictures for 1,400 *livres* each. He also recorded in the document that he had already received a down payment of 9,000 *livres* and expected to receive the balance of 13,000 *livres* upon delivery of the pictures. Robert amended the agreement in a subsequent contract, dated October 27, 1787, as follows:

> Au lieu des quatre grands tableaux mentionés en l[']autre part je m[']engage d[']en faire Six à peu pres de 9 pieds de haut et 7 pieds de large dont 4 pour le petit Salon de Mereville, et deux pour la pièce de Billiard qui la preçede que je promets lui délivrer dans le mois d[']avril prochain, et par Cet arrangemen[t] Les quatre petit tableaux mentionés en l'autre part Sont Suprimés. Mr. de La Borde m[']ayant payé a Compte le 19 may suivant la quit[t]ance en l'autre part neufmille livres, et ayant porté les Six grands tableaux a vingt et quatre mille livres[.] J'ai recu les quinze mille livres restantes qu'il ma payé d[']avance tout pour la tableaux que pour les modeles ou desseins des vues de Mereville et voyages que j'ai fait[,] me tenant pour Satisfait de tout jusqu à ce jour et moyenant Les Six tableaux que je m[']engage à lui livrer Comme Il est dit ci dessus[.] Tout Sera en regle & soldé à Paris ce 27 8bre 1787./ approuvé L'ecriture / Robert. (Instead of the four large paintings previously mentioned, I contract to make six approximately 9 *pieds* high and 7 *pieds* wide of which four are for the small salon at Méréville and two for the billiard room that precedes it, which I promise to deliver to him in the month of April next, and by this agreement the four small paintings mentioned in the other part are cancelled. Mr. de Laborde has paid 9,000 *livres* to my account May 19 according to the receipt in the other part, and has taken the six large paintings for 24,000 *livres*. I have received the remaining 15,000 *livres* which he paid in advance, everything for the paintings as well as the models and drawings of views of Méréville and for my travel, which makes me satisfied for everything up to this day and having the six paintings which he hired me to deliver as stated above. Everything will be in order and the balance paid in Paris this October 27, 1787. / examined and found correct / Robert.)

Transcriptions of the two documents were provided to the author by Jean de Cayeux in a letter of April 28, 1986. Excerpts from these documents appear in Cayeux and Boulot 1989, pp. 162–66.

18 These two paintings (246 x 219 cm and 247 x 219 cm, respectively) were sold, with the four now in Chicago, at the L. François sale in 1900, as nos. 5 and 6 (both ill.), and bought by baron Le Vavasseur for Fr 29,500 (letter of May 14, 1987, from baronne Simone de Lassus to the author, in curatorial files). They were later in the sale of the marquise de X . . ., Hôtel Drouot, Paris, February 19–20, 1932, nos. 25–26 (ill.), and bought by Mme Gilbert Hersent. They last appeared in a sale at Galerie Charpentier, Paris, March 21, 1958, nos. 187–88 (ill.).

19 Cayeux and Boulot 1989, p. 164.

20 *Hubert Robert . . . 1933*, under no. 69.

21 Burda 1967, p. 97.

22 For the relationship of painting and architecture in the eighteenth century, see John D. Bandiera, "The Pictorial Treatment of Architecture in French Art, 1731 to 1804," Ph.D. diss., New York University, 1982 (Ann Arbor, Mich., University Microfilms, 1984), ch. 3.

23 See Georg Lippold, *Die Skulpturen des vaticanischen Museums*, vol. 3, Berlin, 1956, pt. 2 (text), p. 433, no. 29, pt. 2 (plates), pl. 181.

24 For a drawing by Robert of one of these lions, see Cailleux 1979, no. 30 (ill.).

25 See Roland Michel 1976, pp. 320–21, no. 181, and Scottez 1983, pp. 192–94, no. 144, for a discussion of other works incorporating this architectural motif.

26 For the Lille watercolor, see Scottez 1983, p. 193 (ill.). For the Fournier sheet, see *Hubert Robert . . . 1933*, no. 70; the pendant is no. 69. For the Toronto drawing, see Denison, Rosenfeld, and Wiles 1993, no. 105. These works were acquired from Robert in 1795 by the architect Henri Trou.

27 In 1976 the Galerie Pardo in Paris possessed an oil sketch similar to this painting; based on examination of a photograph, the picture's attribution to Robert seems questionable.

28 See Irina Kuznetsova and Evgenia Georgievskaya, *French Painting from the Pushkin Museum, Seventeenth to Twentieth Century*, New York and Leningrad, 1979, no. 486 (ill.).

29 A drawing Robert made around 1780/85 after one lion is preserved in a sketchbook; see Cailleux 1979, no. 73 (ill.). For these lions, see also *Egyptomania: L'Egypte dans l'art occidental, 1730–1930*, exh. cat., Paris, Musée du Louvre, 1994–95, no. 208, pp. 345–47.

30 Francis Haskell and Nicholas Penny, *Taste and the Antique: The Lure of Classical Sculpture, 1500–1900*, New Haven and London, 1982, pp. 300–01, no. 157 (ill.).

31 The Hermitage painting is reproduced in A[lexandre] Troubnikoff, "L'Oeuvre de Hubert Robert en Russie," *Stariye Gody* 1 (1913), following p. 8. For the Roux drawing, see the Hôtel Drouot sale catalogue, Paris, April 20–22, 1903, no. 134 (ill.). A brush-and-wash preliminary study for the St. Petersburg painting is preserved in the Musée Fabre, Montpellier. See Carlson 1978, no. 54 (ill.).

32 A drawing of 1785/86 in one of Robert's sketchbooks depicts the horse tamer on the left of the *Alexander and Bucephalus* group; see Cailleux 1979, no. 102 (ill.). For the statue of Juno in the Capitoline Museum, see Haskell and Penny (note 30), p. 242, fig. 124.

33 For a detail of the relevant relief on Trajan's Column, see Margarete Bieber, *Ancient Copies: Contributions to the History of Greek and Roman Art*, New York, 1977, pl. 22, fig. 117.

34 For *Castor and Pollux*, see Haskell and Penny (note 30), p. 175, no. 90 (ill.). For an antique representation of Marcus Curtius flinging himself into the gulf, see Haskell and Penny, p. 192, fig. 99.

35 Ibid., pp. 191–93.

36 See *Philadelphia Museum of Art Bulletin* 60, 283–84 (1965), p. 26 (ill.).

Jean Baptiste Santerre

1651 Magny-en-Vexin (Seine-et-Oise)–Paris 1717

Portrait of a Sculptor, 1700/10

Max and Leola Epstein Collection, 1954.303

Oil on canvas, 81.3 x 65.4 cm (32 x 25 3/4 in.)

CONDITION: The painting is in fair condition. The canvas has an old glue paste lining. The picture was surface cleaned in 1964, and more thoroughly cleaned in 1969, when it was also relined with a wax adhesive.[1] Parts of the tacking margins have been incorporated into the picture; the dimensions of the original painted surface are 80.3 x 64.8 cm.[2] Cusping is visible at all edges. The paint layer, applied over a warm red ground, has been severely abraded in the dark background and the shadows of the drapery folds, causing the figure to appear flat. The face and hands are better preserved and remain somewhat more volumetric. The paint layer has been flattened by the lining process, especially in the costume. Retouching is visible in the shadows of the dressing gown, at the sides of the head under the edge of the hat, around the knife, and scattered in the background and around the perimeter. The left eye and nose of another portrait, painted beneath the present one on the inverted canvas, are visible in the x-radiograph. X-radiography also indicates that the artist may have shifted the position of the sculptor's cap slightly upward and to the right. (infrared, ultraviolet, x-radiograph)

PROVENANCE: Vermeer Gallery, London, by 1931.[3] Sold by Vermeer Gallery to Max Epstein (d. 1954), Chicago, 1935; bequeathed to the Art Institute, 1954; on loan to Leola Epstein, Chicago, 1962–68.

REFERENCES: Hélène Adhémar, Watteau: Sa Vie—son oeuvre, Paris, 1950, p. 239, no. 295. AIC 1961, p. 479. Ettore Camesasca and John Sunderland, The Complete Paintings of Watteau, New York, 1968, p. 129, no. 3E. Claude Lesné, "Jean-Baptiste Santerre (1651–1717)," Bulletin de la Société de l'histoire de l'art français, année 1988 (1989), pp. 82, 95, under no. 25.

EXHIBITIONS: The University of Chicago, The Renaissance Society, Max Epstein Memorial Exhibition, 1955, no. 15, as Watteau, The Sculptor, Jean François Pater. The Art Institute of Chicago, Selected Works of Eighteenth-Century French Art in the Collections of The Art Institute of Chicago, 1976, no. 1, as attributed to Antoine Pesne, Portrait by [sic] Jean-François Pater. The Art Institute of Chicago, The Art of the Edge: European Frames, 1300–1900, 1986, no. 48.

Attributed in the past to Antoine Watteau and to Antoine Pesne, the Chicago Portrait of a Sculptor was recently associated by Claude Lesné with the work of Jean Baptiste Santerre, a painter of history and genre subjects and a skillful portraitist.[4] Lesné suggested that the Chicago painting is a copy after the signed Portrait of a Sculptor (fig. 1) in the National Gallery of Prague, a work of greater refinement and sensitivity.[5]

The Prague Portrait of a Sculptor is one of Santerre's most dynamic portraits. The relaxed, natural pose of the sitter (unusual for Santerre's portraits), the luxurious rendering of drapery, and the finely modulated flesh tones are reminiscent of some of the painter's most accomplished works, such as Susanna and the Elders (Louvre), the reception piece he presented to the Academy in 1704, and Geometry (Calvados, Château de Vassy, Benoist d'Azy Collection), exhibited at the Salon in the same year.[6] The sureness and ease of composition anticipate Santerre's mature works, such as the portrait Michel Richard Delalande (known only from an engraving), which also appears to have been quite sumptuous and expansive in pose. Yet the Prague work is even closer in style to the signed and dated Letter (Paris, private collection) of 1703, in which the drapery and hands are rendered in a particularly similar manner.[7] The Prague painting should thus cautiously be assigned to the first decade of the eighteenth century.

It is difficult to determine whether the Chicago painting is an autograph copy of the Prague Portrait of a Sculptor. Although Santerre is known to have worked very slowly and carefully, there are numerous known copies of his paintings, as well as many more copies that are untraced but that are mentioned in eighteenth- and nineteenth-century sale catalogues. Some copies may be autograph, while others may have been painted in part or wholly by Geneviève Blanchot, Santerre's student, mistress, and eventual residuary legatee, whose biography and works have almost completely eluded art historians.[8] Lesné (1989) was undecided about the authorship of the Chicago painting, cataloguing it as "une copie ou réplique autographe?" In view of its high quality, it seems likely that the present work is an autograph copy of the Prague original.

The sculptor represented in the two paintings was once thought to be Jean François Pater (b. 1700), brother

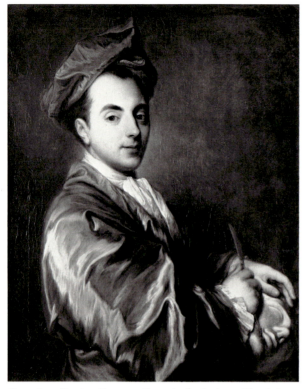

Fig. 1 Jean Baptiste Santerre, *Portrait of a Sculptor*, Narodní Galeri v Praze, Prague

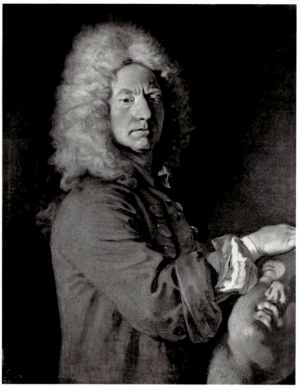

Fig. 2 Attributed to Jean Antoine Watteau, *Portrait of Antoine Pater*, Musée des Beaux-Arts, Valenciennes [photo: Bulloz]

of the painter Jean Baptiste Pater and son of the sculptor Antoine Joseph Pater. This untenable identification, proposed when the Chicago picture was still attributed to Watteau, was apparently prompted by its similarity to the *Portrait of Antoine Pater* (fig. 2), traditionally given to Watteau.[9]

NOTES

1 Both treatments were performed by Alfred Jakstas.
2 The thread count of the original canvas is approximately 14 x 16/sq. cm (35 x 40/sq. in.).
3 Jules Féral, in a letter to Anthony F. Reyre (Vermeer Gallery), June 29, 1931 (in curatorial files), remarked on having viewed the painting when it was in Reyre's possession. See also the Art Institute registrar's records.
4 Lesné kindly made her research (published in 1989; see References) available to the author in 1985. The Watteau attribution was supported by Féral (see note 3); Karl Parker (letter to Max Epstein of June 12, [1930s], in curatorial files); August L. Mayer, in 1935 (according to Adhémar 1950); and Tancred Borenius, July 1935, on the verso of a photograph (in curatorial files). Adhémar (1950) and Camesasca (1968) rejected the Watteau attribution. J. Patrice Marandel (1976 exhibition catalogue) attributed the picture to Pesne. On January 11, 1993, J. F. Heim and E. Brêton

both verbally suggested the Swiss painter Alexis Grimou as the author (notes in curatorial files).
5 See Lesné 1989, pp. 82, 95, and Boris Lossky, "L'Art français à la Galerie d'Etat de Prague," *La Revue française de Prague* 14 (March 1935), pp. 14–15, 22, no. 15, ill. f. p. 16. The Prague painting measures 80 x 64 cm.
6 Santerre's *Susanna* is illustrated in Louvre, *Catalogue sommaire*, vol. 4, *Ecole française, L–Z*, Paris, 1986, p. 204; and *Geometry* in Lesné 1989, p. 101, fig. 53.
7 See Lesné 1989, pp. 102–03, no. 46, and Paris, Galerie Sedelmeyer, *Catalogue des tableaux composant la collection Ch. Sedelmeyer*, Paris, 1907, no. 243 (ill.).
8 According to Charles Blanc, *Histoire des peintres de toutes les écoles*, pt. 3, *Ecole française*, vol. 1, Paris, 1865, p. 364. See also Guillaume Janneau, *La Peinture française au XVIIe siècle*, Geneva, 1965, p. 369.
9 The two paintings seem to have been first associated in a letter to Max Epstein dated May 10, 1935 (in curatorial files, signature unidentified), in which it is suggested that "Watteau [may have] also painted a portrait of the son who [had] always been and lived at Valenciennes helping his father in his work." The attribution of *Antoine Pater*, maintained by the earlier owners of the picture (the Pater family), has been challenged in recent years; see Camesasca and Sunderland 1968, p. 112, no. 148 (ill.); Donald Posner, *Antoine Watteau*, London, 1984, pp. 243–45, 289, fig. 173; and Nicole Parmantier in *Watteau, 1684–1721*, exh. cat., Washington, D.C., National Gallery of Art, 1984–85, p. 44. As Posner noted, Antoine Pater's daughter seems to have referred to the painting as a Watteau in 1769.

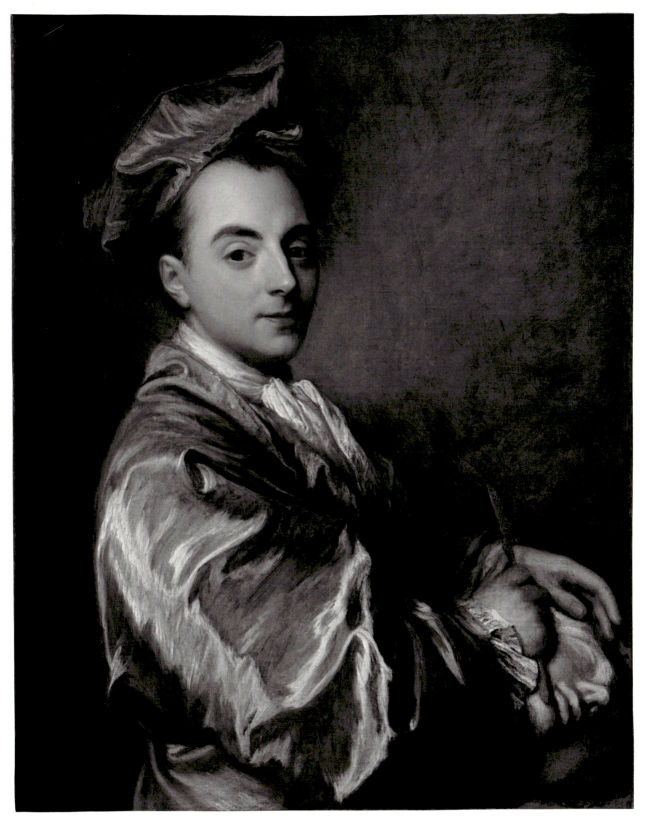

Jean Baptiste Santerre, *Portrait of a Sculptor*, 1954.303

Nicolas Antoine Taunay

1755 Paris 1830

The Show (*La Parade*), 1784/87

Bequest of Mrs. Florence Thompson Thomas in memory of her father, John R. Thompson, Sr., 1973.313

Oil on panel, 37.5 x 43.7 cm (14³/₄ x 17³/₁₆ in.)

CONDITION: The painting is in poor condition. It was cleaned in 1975.[1] The back of the walnut panel is beveled on all but the right edge; it is thus possible that the panel (and composition) originally extended further on the right. The panel, which has a slight convex warp, is composed of a single board with horizontal grain. It has been reinforced on the reverse with three fabric strips attached along the grain. There is a pronounced craquelure that runs both parallel and perpendicular to the grain. The thin paint layer, applied over an off-white ground, has suffered extensive abrasion due to cleaning. This accounts for a loss of definition in the figures and landscape, especially in those figures in the center and right foreground, and in the tree at the upper right. Traction craquelure has disfigured the surface of the entire painting and is most exaggerated in the lower foreground and in the landscape at right. Extensive overpaint covers all of these traction cracks, and there are scattered retouches on the tree branches at the upper right and throughout the sky. (infrared, mid-treatment, ultraviolet, x-radiograph)

PROVENANCE: George J. Gould, New York.[2] Duveen, New York.[3] Sold by Duveen to John R. Thompson, Sr., 1926.[4] John R. Thompson, Sr. (d. 1927), Lake Forest, Illinois; at his death to his widow, Mrs. John R. Thompson, Sr., Lake Forest, Illinois; sold Parke-Bernet, New York, January 15, 1944, no. 32 (ill.), as Pater, *Commedia dell'arte*,[5] to her daughter, Florence Thompson Thomas (d. 1972), Palm Beach, Florida; bequeathed to the Art Institute, 1973.

REFERENCES: "Recent Accessions of American and Canadian Museums, January–April, 1973," *Art Quarterly* 36 (1973), p. 429.

EXHIBITIONS: The Art Institute of Chicago, *Selected Works of Eighteenth-Century French Art in the Collections of The Art Institute of Chicago*, 1976, no. 18, as Hilair, *Scene of Commedia dell'arte*.

W hen it entered the Art Institute's collection, this painting was believed to be by Jean Baptiste Pater. In 1974 Pierre Rosenberg rejected the Pater attribution and advanced the name Jean Baptiste Hilair, a proposal supported by J. Patrice Marandel in 1976.[6] In fact, however, the panel almost certainly belongs to the oeuvre of Nicolas Antoine Taunay, whose long career spanned the changing politics and aesthetics of Paris in the late eighteenth and early nineteenth centuries.

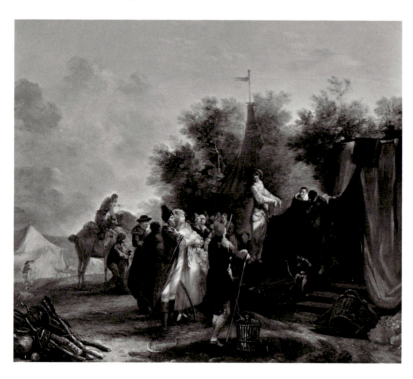

Fig. 1 Nicolas Antoine Taunay, *La Parade*, location unknown [photo: *Connaissance des Arts* 364 (June 1982), p. 15]

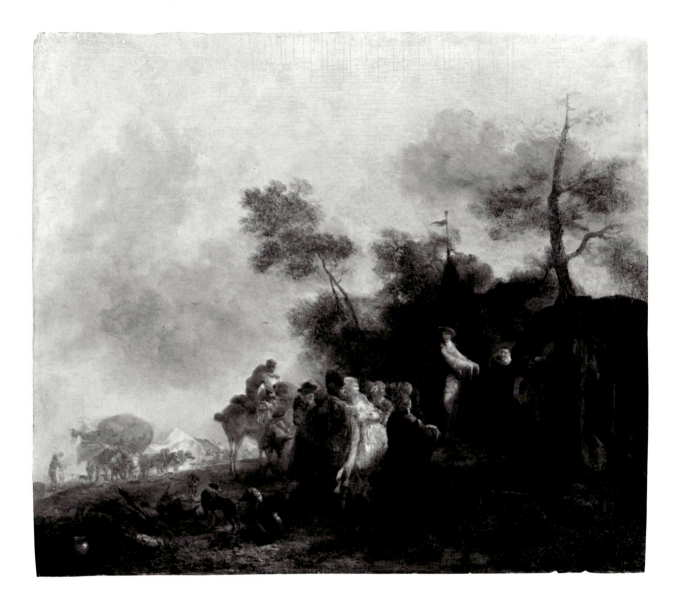

The son of a chemist and enamel painter who worked for the Sèvres porcelain factory, Taunay trained successively with Nicolas Bernard Lépicié, Nicolas Guy Brenet, and François Casanova. Taunay was *agréé* by the Academy in 1784 and then became a *pensionnaire* in Rome. Soon after returning to Paris in 1787, he exhibited in his first of many Salons. During the Reign of Terror, Taunay retreated to Montmorency, but under the Empire he received numerous commissions for battle scenes and became a favorite of Empress Josephine. When the Empire fell, and upon invitation from the Portuguese ambassador, he went to Rio de Janeiro (1816–21) where he and some other artists founded a fine arts academy; for this reason many

of his paintings are preserved in the Museu Nacional de Belas Artes there.

Prolific and popular during his lifetime, Taunay treated almost all genres of painting: religious, historical, and mythological subjects, as well as battle scenes, genre pieces, portraits, and landscapes. Among his most renowned works are his gouache illustrations for Jean Racine's *Les Plaideurs* (engraved by Duval and published by Pierre Didot in 1801) and his paintings *The Scuffle*, *The Village Wedding*, *The Mountebanks*, and *The Village Fair*, reproduced c. 1788 in four-color engravings by Charles Melchior Descourtis.[7]

The Chicago panel compares closely to two other paintings by Taunay: a small gouache formerly in the

Louvre and a panel painting (location unknown) once owned by the Galerie Bailly in Paris (fig. 1).[8] Both are entitled *La Parade*, and, with the Chicago panel, represent variations on a single theme. All three works depict a small crowd gathered at a commedia dell'arte performance taking place on a makeshift stage. It appears that the Italian players and curious onlookers have assembled on the outskirts of a military encampment or at a fair. Pierrot stands in his characteristic white costume with hands obscured by dangling sleeves, Crespin is seated in the center, and, at right, the masked Harlequin, with parti-colored and spangled tights, carries a drum. The background of the Chicago version combines elements from the Louvre and Bailly compositions: a heavily laden, horse-drawn wagon in the distance at left; and a large tent, from which the stage platform emerges, at right. The meticulously executed and well-preserved Bailly version probably provides an accurate notion of how Chicago's now-damaged picture (see Condition) once looked. Taunay's painting *La Parade foraine* (location unknown) also relates to the Chicago, Louvre, and Bailly pictures in its portrayal of a group of commedia dell'arte players performing at right before a tent.[9] The three principal players in those three works are almost identical in gesture and pose to those in *La Parade foraine*, although in *La Parade foraine* Harlequin stands to address the audience, Pierrot is seated where we found Crespin, and, in place of Harlequin, Scaramouche holds the drum. The style of the Chicago, Louvre, and Bailly pictures and of *La Parade foraine*, which is very similar to that of the four paintings engraved by Descourtis, places them early in Taunay's oeuvre, about 1784/87, during his stay in Rome or soon after his return to Paris. Typical of Taunay's youthful works, these pictures include bare tree trunks, soft, dark foliage, and bright skies with drifting, delicate clouds.

The commedia dell'arte enjoyed a long history both as a theatrical form and, because of its colorful and amusing nature, as a subject for painters.[10] Popular Italian theater was very much in vogue in eighteenth-century France, and the well-to-do frequently incorporated the masks of Pierrot, Harlequin, and Columbine into their charades. Clearly, Taunay was responsive to this market and applied his visual imagination to satisfying chang-ing contemporary taste. He not only accommodated popular demand by supplying cabinet pictures of commedia dell'arte scenes, but also provided countless designs to contemporary engravers. Appealing to similar tastes, Taunay also depicted transient entertainers and various types of social gatherings — military halts, fairs, markets, and carnivals featuring puppet shows, trained animals, jugglers, and musicians.[11] In accordance with prevailing tastes, Taunay imposed a neoclassical severity on some of his later genre paintings. For that and for his sensitive depiction of unusual aspects of human behavior and habits, he earned the appellation "The Fontaine of painting, the Poussin of small pictures."[12]

NOTES

1 The treatment was performed by Alfred Jakstas.
2 According to the 1944 sale catalogue.
3 Ibid., and letter of December 4, 1981, from Cynthia Thomas Morehouse (Florence Thompson Thomas's daughter) to the author, in curatorial files.
4 Letter from Cynthia Thomas Morehouse to the author (see note 3).
5 Letter of November 13, 1981, from John R. Thomas to the author, in curatorial files.
6 Rosenberg, verbally to John Maxon, March 1974 (notes in curatorial files); Marandel in the 1976 exhibition catalogue.
7 See, respectively, pls. XL–XLI in Stella Rubinstein-Bloch, *Catalogue of the Collection of George and Florence Blumenthal*, vol. 5, Paris, 1930.
8 The gouache (24.5 x 32.4 cm), once in the Louvre, Cabinet des dessins (RF 3882), was sold at the Galerie Georges Petit, Paris, May 15–18, 1899, no. 298 (ill.). The panel, which measures 29.8 x 35.5 cm, was at the Galerie Bailly, Paris, in 1982.
9 *La Parade foraine* was formerly in the collections of Cailleux and of Philippe Aubertin, both in Paris; see photo, New York, Frick Art Reference Library, 520/a.
10 See Pierre Louis Duchartre, *The Italian Comedy: The Improvisation Scenarios, Lives, Attributes, Portraits, and Masks of the Illustrious Characters of the Commedia dell'Arte*, tr. by Randolf T. Weaver, New York, 1966, an essential work on the subject.
11 Some examples are his drawing *The Puppet Show on the Square* (Amsterdam, Rijksprentenkabinet), the paintings *Scene with Charlatans* and *Village Fair*, pendants once in the Robert de Saint-Victor collection in Paris, and *Carnival Scene* and *The Singer of Ballads and Psalms*, both once owned by baron Léonino. The Amsterdam drawing is illustrated in Jan Wolter Niemeijr and Peter Schatborn, *Franse Tekenkunst van de 18de eeuw uit nederlandse verzamelingen*, exh. cat., Amsterdam, Rijksprentenkabinet, 1974, p. 92, no. 113. For illustrations of the paintings, see the following sale catalogues: Drouot Rive Gauche, Paris, October 27–28, 1977, no. 34 (two items ill.), and Galerie Charpentier, Paris, June 10, 1954, nos. 52–53 (ill.), respectively.
12 "Notice historique sur Taunay," in the Taunay estate sale catalogue, Paris, February 28 and March 1, 1831, p. 8.

Pierre Charles Trémolières

1703 Cholet–Paris 1739

Sancho Panza Being Tossed in a Blanket, 1723/24

Gift of Mr. and Mrs. John W. Clarke, 1977.483

Oil on canvas, 28.9 x 36.8 cm (11³/₈ x 14¹/₂ in.)

CONDITION: The painting is in fair condition. The canvas has an old glue paste lining.[1] The tacking margins have been cut off, and cusping is visible at all edges, indicating that the painting is close to its original dimensions. X-radiography reveals that the lower right corner of the canvas is thin and badly frayed, and that there is a circular tear (2 x 1.5 cm) in the lower left quadrant. There are two holes in the canvas: one at the upper right corner (1.5 x 2 cm), and the other at the center of the bottom edge (1 x 1.5 cm). The painting has an off-white ground. The surface has been badly abraded by cleaning, especially in the dark passages. The impasto, which defines much of the detail in the picture, has been somewhat flattened by the lining process. There is a large loss to the paint and ground layers at the right edge (10 x 3 cm), and a smaller, irregularly shaped loss near the lower right corner (2 x 1 cm). A few minor losses are located along the bottom edge and at the upper left corner. All the losses have been filled and inpainted, and there is additional retouching over most of the shadows, particularly in the drapery folds of the costumes. (infrared, raking light, ultraviolet, x-radiograph)

PROVENANCE: Henri Baderou, Paris.[2] Wildenstein, London, 1950.[3] Sold by Wildenstein to Mr. and Mrs. John Walter Clarke, Chicago, 1976;[4] given to the Art Institute, 1977.

Pierre Charles Trémolières might have been forgotten if his protector, the comte de Caylus, had not written about the artist's life and work.[5] According to this source, Trémolières entered the atelier of Jean Baptiste Vanloo at an early age, and then spent the years 1728 to 1734 at the French Academy in Rome. Returning to France, he remained for a time in Lyons, where he executed a number of religious canvases and portraits. By 1736 he had resettled in Paris, where he pursued a successful academic career. Among the most accomplished paintings from those last years were the decorations he contributed to the Hôtel Soubise in 1738 (now the Archives Nationales).

Trémolières's *Sancho Panza Being Tossed in a Blanket* is indebted in many respects to the works of Charles Antoine Coypel, the celebrated painter, theoretician, and dramatist to whom this sketch was once attributed.[6]

In 1714 Coypel was commissioned by the Gobelins factory to create a set of tapestry cartoons (today in the Musée National du Château de Compiègne) illustrating episodes from *Don Quixote* by Miguel de Cervantes.[7] To insure wide dissemination of his compositions, Coypel had the cartoons engraved under the direction of Louis Surugue, who signed and published the first one in 1723. This engraved suite, entitled *Les Principales Avantures de l'admirable Don Quichotte*, originally was to contain twenty-five engravings, but, under Coypel's direction, another six scenes, based on designs by Trémolières, François Boucher, Jacques Philippe Le Bas, and Charles Nicolas Cochin fils, were added, bringing the total number of plates to thirty-one.[8] These engravings later served as models for another edition of *Don Quixote*, with text, published by Pierre de Hondt in 1746.[9]

In the mid-1970s, Jean François Méjanès recognized the Chicago painting as the model for an engraving by Michel Aubert in the *Don Quixote* illustrations published by Surugue (fig. 1).[10] Trémolières also provided a model (location unknown) for a second plate in this series, engraved by Ravenet, entitled *Sancho Receiving in a Stable the Order of Chevalier*.[11] Since many of the original thirty-one *Don Quixote* engravings were published between 1723 and 1724, it is possible that both paintings were produced in those same years, and were among Trémolières's earliest works.

Because the inscription on the Ravenet engraving reads *Trésmolières Pinxit* and the Aubert engraving after the Chicago painting reads *Tresmolier invenit*, Méjanès raised the possibility that the Chicago picture was a collaboration between Trémolières and Coypel.[12] It is more likely, however, that Trémolières was responsible for both the conception and execution of the Chicago picture.[13] The Trémolières attribution is reinforced by comparison with the artist's *Sketch for "Comedy"* (oil) in The Metropolitan Museum of Art, New York (fig. 2). The Metropolitan sketch was preparatory for the Trémolières painting *Comedy*, which, together with its pendant *Tragedy* (signed and dated 1736), is in the Musée Municipal, Cholet.[14] Although they were created perhaps a decade apart, the Chicago painting and the more refined *Sketch for "Comedy"* are

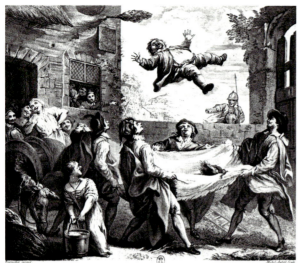

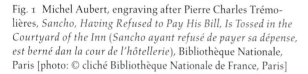

Fig. 1 Michel Aubert, engraving after Pierre Charles Trémolières, *Sancho, Having Refused to Pay His Bill, Is Tossed in the Courtyard of the Inn* (*Sancho ayant refusé de payer sa dépense, est berné dan la cour de l'hôtellerie*), Bibliothèque Nationale, Paris [photo: © cliché Bibliothèque Nationale de France, Paris]

NOTES

1 The thread count of the original canvas is approximately 13 x 13/sq. cm (32 x 32/sq. in.).

2 According to a letter of September 6, 1985, from Pierre Rosenberg to the author, in curatorial files.

3 Records at Wildenstein, London, indicate that they received the painting from Paris in 1950 (letter of November 3, 1981, from Max Harari to the author, in curatorial files).

4 Confirmed by Harari (see note 3).

5 Caylus in *Mémoires inédits sur la vie et les ouvrages des membres de l'Académie royale de peinture et de sculpture*, vol. 2, Paris, 1854, pp. 442–48. Further information on this talented painter has been provided in recent years by an exhibition of his works; see *Pierre-Charles Trémolières (Cholet, 1703–Paris, 1739)*, exh. cat., Musée de Cholet, 1973.

6 The painting was sold to the Clarkes by Wildenstein as a Coypel (see Wildenstein fact sheet, preserved in curatorial files) and bore that attribution when it entered the collection of the Art Institute.

7 The first French translations of *Don Quixote* were made in 1614 and 1618, and, though earlier illustrations exist, Coypel's compositions signaled the beginning of many important eighteenth-century series devoted to the subject.

8 The engravers for the original suite were Louis Surugue, Charles Nicolas Cochin, Michel Aubert, Simon François Ravenet, Bernard François Lépicié, François Joullain, Jean Baptiste Haussard, Charles Nicolas Silvestre, Louise Madeleine Cochin, Nicolas Dauphin de Beauvais, François de Poilly, Pierre Aveline, and Nicolas Henri Tardieu. A set of these engravings, bound with hand-numbered plates, is in the Cabinet des estampes, Bibliothèque Nationale, Paris.

9 M[iguel] de Cervantes, *Les Principales Avantures de l'admirable Don Quichotte, représentées en figures par Coypel, Picart le Romain, et autres habiles maîtres: avec les explications des XXXI planches de cette magnifique collection, tirées de l'original espagnol de Miguel de Cervantes*, The Hague, 1746. The engravers for this edition were Jakob van der Schley, Bernard Picart, Pieter Tanjé, and S. Fakke.

10 Méjanès, verbally (notes in curatorial files). The engraving by Michel Aubert measures 276 x 335 mm; it is inscribed at bottom left: *Tresmolier invenit.*; at bottom right: *Michel Aubert Sculp.*; with the letters: *Sancho ayant refusé de payer sa dépense, est*

stylistically very similar. Both have almost monochromatic, light yellow-brown palettes accented with a few strong colors, particularly red. The artist's creamy brushwork and ropey drapery style can also be seen in the two works. Especially characteristic of Trémolières are the paintings' puppetlike figures, amusingly animated by tilting heads and playful glances.

The subject of *Sancho Panza Being Tossed in a Blanket*, precisely identified on the Aubert engraving, corresponds to volume 1, book 3, chapter 6 of Cervantes's novel. Following the example of his master, Don Quixote, Sancho refused to pay his expenses to an innkeeper. Observing this, several fellows of merry impulse threw Sancho on a blanket and began tossing him into the air. His unhappy shrieks reached Don Quixote, who immediately turned his horse back toward the inn, and from a distance saw sport being made of his loyal squire. Trémolières depicted this incident in the same charming fashion as did he the other scenes in this series of illustrations. The theatrical qualities of the painting—such as the confining architectural backdrop, the concentration of figures in a narrow foreground register, and the exaggerated gestures—suggest aspects of comic drama and probably reflect the interests of Coypel, who no doubt advised Trémolières and the various contributors to the series.

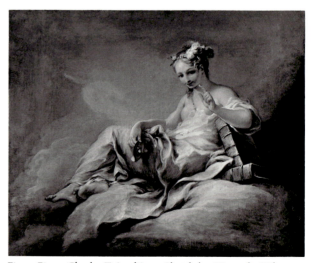

Fig. 2 Pierre Charles Trémolières, *Sketch for "Comedy,"* The Metropolitan Museum of Art, New York, Bequest of Emma A. Scheafer, 1974, The Lesley and Emma Scheafer Collection (1974.356.27)

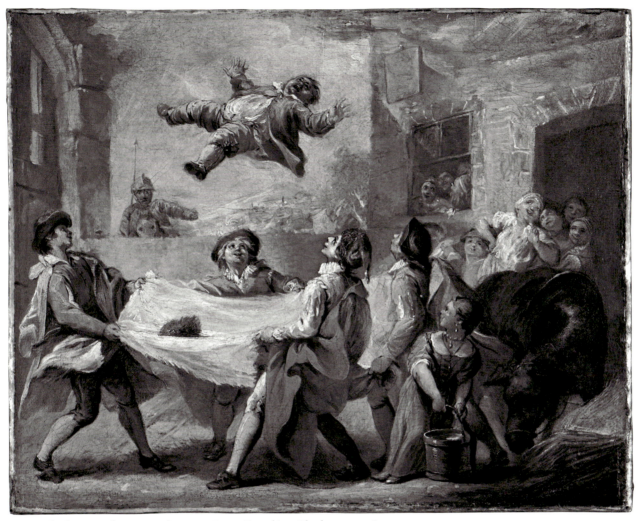

Pierre Charles Trémolières, *Sancho Panza Being Tossed in a Blanket*, 1977.483

berné dans / la Cour de l'hôtellerie / Tom I.er Liv. III, Chap.
XVI. / a Paris chez Dupuis au bas de la rüe de la Vannerie du
côté de la Greve a l'Ange S.t Michel Avec Privilege du Roy. A
later state exists that bears the address: *Roguié rue S. Jacques au*
Boisseau d'Or. See *Pierre-Charles Trémolières . . . 1973* (note
5), no. 11, pl. VI. Another engraving was made, by Pieter Tanjé,
in reverse of the Aubert engraving, and in a vertical format, for
the de Hondt edition; see Cervantes (note 9), pl. III.

11 This sketch illustrates volume 5, book 1, chapter 10 of Cervantes

(note 9); see *Pierre-Charles Trémolières . . . 1973* (note 5),
no. 19, pl. VI.

12 Méjanès, verbal communication to the author, 1983 (notes in
curatorial files).

13 Thierry LeFrançois (verbal communication to the author, 1983;
notes in curatorial files) did not see Coypel's hand in the
Chicago painting.

14 See *Pierre-Charles Trémolières . . . 1973* (note 5), peintures
nos. 13, 14 (both ill.).

Pierre Henri de Valenciennes

1750 Toulouse–Paris 1819

Alexander at the Tomb of Cyrus the Great, 1796

Restricted gift of Mrs. Harold T. Martin, 1983.35

Oil on canvas, 42 x 91.1 cm (16⁹/₁₆ x 35⁷/₈ in.)

CONDITION: The painting is in good condition. It was lined with a synthetic adhesive prior to entering the Art Institute's collection.[1] In 1984 the canvas was relined and, though the painting was not cleaned, the perimeter was filled and inpainted and the surface was revarnished.[2] The original tacking margins have been cut off, and the top, bottom, and left edges are somewhat irregular due to wear. There is slight cusping at all edges, indicating that the painting is close to its original dimensions.[3] The stretcher is 0.5 to 1.0 cm larger than the painting at the top, bottom, and left edges. These areas on the perimeter of the painting have been filled and inpainted. The painting's cream-colored ground is visible through the cracks in the upper right sky. There is a diagonal crease in the paint layer at the upper left corner, and a longer one near the center of the top edge. The paint surface has been somewhat flattened by the lining process and has an uneven, unnatural appearance. Retouching along the perimeter extends downward into the sky along the top edge; numerous smaller areas of retouching are located in cracks throughout the sky and by the shadow of the tombstone at lower right. (infrared, ultraviolet, x-radiograph)

PROVENANCE: See below.

REFERENCES: See below.

EXHIBITIONS: See below.

Mount Athos Carved as a Monument to Alexander the Great, 1796

Restricted gift of Mrs. Harold T. Martin, 1983.36

Oil on canvas, 41.9 x 91.4 cm (16¹/₂ x 36 in.)

INSCRIBED: *P. Valenciennes* / [. . .] *1796* (lower right)

CONDITION: The painting is in good condition. The canvas has an old wax resin lining.[4] The painting was revarnished in 1984 to match the companion piece.[5] The original tacking margins have been cut off. There is cusping on the top and right edges, but none on the bottom or left edges. There is a 1 x 1.5 cm hole in the original canvas in the cliffs in the upper left quadrant, and a 2 cm tear at the far right side of the top edge. A series of linear cracks extends diagonally from the upper right corner. The paint surface has been slightly flattened by the lining process. The surface appears to have been selectively cleaned within the sky in the upper half of the painting. There is abra-

sion in the figures at the left, and in many of the shadows on the foliage and rocks. Retouching covers the diagonal cracks and numerous small areas in the sky, the shadows of the rocks above the figures at the left and along the road at lower right, the dark shadows of the foliage beneath Mount Athos, and the grass beneath the distant trees and in the foreground before the river. (infrared, ultraviolet, x-radiograph)

PROVENANCE: James Hunt (d. 1801), London; sale, Christie's, London, February 5, 1802, nos. 61 and 62.[6] Hunt family, London. Reverend George Augustus Frederick Hart (d. 1873), M.A., Vicar of Arundel, Arundel, Sussex; at his death to his niece Catherine, who apparently disposed of all or part of the collection; sold at Tower House (Hart's home), Arundel, by Sotheby's, May 20–21, 1873, nos. 130–31, to G. Fry for £36 (1983.36) and £25 (1983.35).[7] Alderman Philip Spowart (d. 1945), Berwick-upon-Tweed, from c. 1937; at his death to his widow, Anne Nicholson Spowart (née Wood); given to her nephew, Alan G. Burns, Berwick-upon-Tweed, 1960;[8] sold Henry Spencer and Sons, Retford, Nottinghamshire, November 9, 1978, no. 212 (ill.), to Crozier, acting on behalf of Trafalgar Galleries and Colnaghi, London, 1978;[9] transferred to Colnaghi, New York, 1982; sold to the Art Institute, 1983.

REFERENCES: F. P. Seguier, *A Critical and Commercial Dictionary of the Works of Painters*, London, 1870, p. 211. Ralph N. James, *Painters and Their Works*, vol. 3, London, 1897, p. 154. Werner Oechslin, "Dinocrates and the Myth of the Megalomaniacal Institution of Architecture," *Daidalos* 4 (1982), pp. 12–13 (1983.36 ill.), pp. 22, 26 n. 7. "French Paintings Recently Acquired by The Art Institute of Chicago," *Burl. Mag.* 126 (1984), p. 463, fig. 86 (1983.36). Margaret Smith in *Claude to Corot: The Development of Landscape Painting in France*, exh. cat., New York, Colnaghi, 1990, p. 250, under no. 52, pp. 256 (1983.36 ill.), 258, under no. 55. Martin Warnke, *Political Landscape: The Art History of Nature*, London, 1994, pp. 90, 102 (ill.).

EXHIBITIONS: London, Royal Academy of Arts (Burlington House), *Trafalgar Galleries at the Royal Academy II*, 1979, nos. 23–24. The Art Institute of Chicago, *The Art of the Edge: European Frames, 1300–1900*, 1986, no. 56 (1983.36). Paris, Musée du Louvre, *Egyptomania: L'Egypte dans l'art occidental, 1730–1930*, 1994–95, no. 86 (1983.35), traveled to Ottawa and Vienna.

A leading landscape painter in late-eighteenth-century France, Pierre Henri de Valenciennes was also a learned scholar and theorist. First trained at the Academy in Toulouse, he later studied under the local painter Jean Baptiste Despax. In 1769 Valenciennes

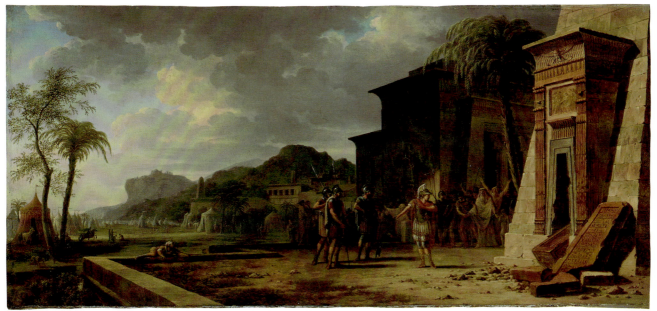

Pierre Henri de Valenciennes, *Alexander at the Tomb of Cyrus the Great*, 1983.35

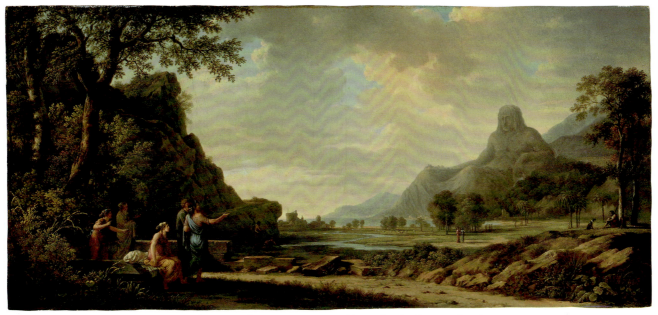

Pierre Henri de Valenciennes, *Mount Athos Carved as a Monument to Alexander the Great*, 1983.36

made his first trip to Italy with his patron Mathias Du Bourg and, upon his return to France, entered the Parisian atelier of the history painter Gabriel François Doyen. Despite this early training, Valenciennes focused his attention on landscape painting throughout his career. In 1779 he again went to Italy, visiting Rome, Naples, Pompeii, and Sicily, and passing through Switzerland before he returned permanently to France in 1784/85. From this time on, he led a successful academic career, was a member of learned societies, and became a foremost landscape theorist. Indeed, the contents of Valenciennes's atelier, inventoried at his death, testify to diverse scholarly interests: in addition to art objects, he collected natural history specimens and had an impressive library. In his paintings and writings, Valenciennes developed a landscape aesthetic that greatly influenced the next generation of landscape painters.[10] Although he shared with Claude Lorrain (see 1941.1020) a love of the Roman *campagna* and an interest in plein-air sketching and the subtleties of light, Valenciennes criticized Claude for representing sites that, though masterfully reproduced, evoked pleasurable feelings rather than stimulating intellectual sentiments. For this reason, Valenciennes preferred and recommended Poussin's heroic landscapes as models.

The Chicago picture, dated 1796, has long been identified with a landscape Valenciennes submitted to the Salon of that year and which was described in the *livret* as "Le Mont Athos, dans la Thrace, taillé en statue d'Alexandre qui tient une ville dans sa main droite et de l'autre verse un fleuve dans la mer."[11] This connection seems dubious, however, since the presumed companion to the Chicago *Mount Athos*, the *Alexander at the Tomb of Cyrus the Great*, was not mentioned in the Salon *livret* or in reviews.[12] That the two paintings were intended as pendants is suggested by their comparable dimensions, similarity of style, and related subject matter (episodes from the life of Alexander the Great).[13] Moreover, the pictures have been documented together for almost two hundred years (see Provenance). It is more likely that another version of the *Mount Athos* theme appeared in the Salon of 1796, perhaps the painting of the subject included in the Valenciennes estate sale of 1819.[14]

The Chicago canvases depict events described in Strabo's *Geography* (14.1.23, 15.3.7)[15] and Plutarch's *Lives* (Alexander, 69, 72): the Mount Athos project that the architect Dinocrates proposed to Alexander and Alexander's visit to the tomb of Cyrus, which he found

despoiled. The latter episode is also recounted in the writings of Vitruvius (*Architecture* 2, preface, 1–3), Quintus Curtius (*History of Alexander*, 10.1.22–42), and Arrian (*Anabasis of Alexander*, 6.29).[16] Though rarely depicted, both episodes were well known in eighteenth-century France, and were mentioned by various writers, including André Félibien and Denis Diderot.[17] It is difficult to determine with certainty which of the ancient and contemporary accounts Valenciennes, who was widely read in the classics, used as his sources.

Although Valenciennes undoubtedly consulted more than one literary source for the *Alexander at the Tomb of Cyrus the Great*, Arrian's detailed description of the episode was probably the painter's primary source. Arrian recorded that Alexander advanced into Persia and found, at Pasargadae, the satrap Orxines in charge:

Alexander . . . was most distressed by the crime committed against the tomb of Cyrus son of Cambyses, since (as Aristobulus relates) he found the tomb of Cyrus broken into and rifled. The tomb of this Cyrus was in the territory of the Pasargadae, in the royal park; round it had been planted a grove of all sorts of trees; the grove was irrigated, and deep grass had grown in the meadow; the tomb itself was built, at the base, with stones cut square and raised into rectangular form. Above, there was a chamber with a stone roof and with a door leading into it so narrow that with difficulty, and after great trouble, one man, and he a small one, could enter. And in the chamber was placed a golden sarcophagus, in which Cyrus' body had been buried. . . . Within the enclosure, and lying on the approach to the tomb itself, was a small building put up for the Magians, who were guardians of Cyrus' tomb, from as long ago as Cambyses, son of Cyrus, receiving this guardianship from father to son. To them was given from the King a sheep a day, an allowance of meal and wine, and a horse each month, to sacrifice to Cyrus. There was an inscription on the tomb in Persian letters; it ran thus, in Persian: "Mortal! I am Cyrus son of Cambyses, who founded the Persian empire, and was Lord of Asia. Grudge me not, then, my monument."

But Alexander, who was anxious, so soon as he should conquer Persia, to visit Cyrus' tomb, finds everything else removed except the sarcophagus and the divan. The robbers had even violated the body of Cyrus, for they had removed the top of the sarcophagus and had thrown out the body; the sarcophagus itself they had tried to render portable, so that they might bear it away, chipping some parts away, and breaking other parts off. Not succeeding in this attempt, however, they left the sarcophagus as it was and went off. . . . Alexander then seized the Magians who were the guardians of the tomb and tortured them that

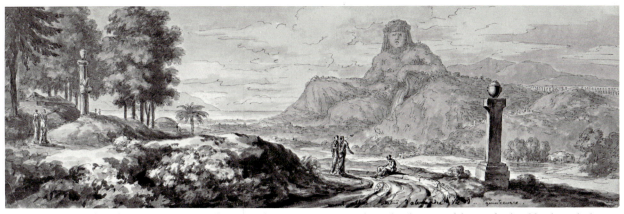

Fig. 1 Pierre Henri de Valenciennes, *Mount Athos Carved as a Monument to Alexander the Great*, folio 33 of a sketchbook marked "Rome," Bibliothèque Nationale, Paris [photo: © cliché Bibliothèque Nationale de France, Paris]

they might reveal the perpetrators; but they even under torture accused neither themselves nor anyone else, nor showed in any way that they were privy to the deed; and so Alexander let them go.[18]

Valenciennes never journeyed to Asia Minor, and so it has been suggested that Simon Célestin Croze-Magnan, his well-traveled student, provided his teacher with descriptions of exotic lands.[19] Certainly Valenciennes was acquainted with contemporary or earlier guidebooks and with architectural histories, and used them when creating the *Alexander at the Tomb of Cyrus the Great.* In fact, he very probably relied upon the copiously illustrated and accessible *Voyages . . . par la Moscovie, en Perse, et aux Indes Orientales* written by the Dutchman Cornelis de Bruyn.[20] Devoting a substantial portion of his *Voyages* to Persepolis and the nearby Naqsh-i

Rustam, de Bruyn described important historical events and monuments and made engraved records. Valenciennes, it would seem, armed with this useful source, imaginatively combined Persian architectural elements illustrated by de Bruyn to create a pastiche appropriate to the Alexandrian legend.

Valenciennes's scene takes place in a terraced area like those at Persepolis. Alexander, accompanied by three soldiers, gestures before the violated tomb of Cyrus the Great. Near the structure appear three magi, one in chains, one kneeling as he is tortured. Above the tomb's portal are two reliefs: the upper one depicts the symbol for the Zoroastrian god Ahuramazda, and the lower one has not been identified.[21] The architectural details around the portal are clearly based on the doorways of the Persian Palace of Darius and Harem of Xerxes.

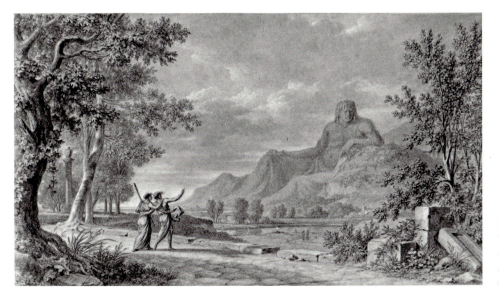

Fig. 2 Pierre Henri de Valenciennes, *Mount Athos Carved as a Monument to Alexander the Great*, private collection, New York

At the tomb's entrance is the sarcophagus of Cyrus; its cover, cast aside at far right, bears a type of cuneiform inscription (mentioned by Arrian, Plutarch, and Strabo), which de Bruyn called "representations of ancient Persian characters."

The structure adjacent to Cyrus's tomb is also a composite of architectural elements from various Persian buildings. Its entablature is based on the doorways of the Palace of Darius and Harem of Xerxes. The large relief is derived from the Guardian Man-Bulls on the eastern doorway of the Gate of Xerxes; between these guardian figures, Valenciennes inserted a column that was apparently inspired by Persian bell-capital columns. For the right elevation of the building, the painter appropriated a row of columns with capitals in the shape of addorsed heads from the portico of a royal tomb facade at Naqsh-i Rustam.[22] Curiously, to this amalgam of Persian elements Valenciennes added a number of distinctly non-Persian elements, such as European tents that form the encampment of Alexander's army, antique Roman architecture with imported obelisks, and, on the distant rocky summit, what appears to be the Castel Sant'Angelo.

Valenciennes seems to have been particularly interested in the theme of the tomb in a landscape. He exhibited his *Landscape with Cicero Discovering the Tomb of Archimedes* (Toulouse, Musée des Augustins) in the Salon of 1787 as his *morceau de reception*.[23] According to Philip Conisbee, Valenciennes "used the discovery of Archimedes' tomb as a conceptual basis for painting a *landscape* which might bear comparison with the historical landscapes of Poussin."[24] Inspired by Poussin's *Et in Arcadia Ego* (Louvre), which bespoke a sentimental return to an earlier period, artists during the latter part of the eighteenth century often included tombs in their landscape compositions. Challenged by theorists' demand for a more intellectual landscape, painters saw the tomb as a way to introduce philosophical issues, to prompt reflection on life's transitory nature. This is underscored in the Chicago *Alexander at the Tomb of Cyrus the Great* by the actions of the figures; paying homage to Cyrus at the grave, Alexander is stirred to contemplate the brevity of his own empire and life.

The subject, or at least the setting, of the other Chicago canvas, *Mount Athos Carved as a Monument to Alexander the Great*, was of interest to Valenciennes for many years. Geneviève Lacambre dated an ink drawing of the subject in a Valenciennes sketchbook (fig. 1) to 1782/84.[25] The sketchbook also contains views (some idealized) of the Roman countryside. It appears that, to create this drawing, the artist added the fanciful image of Mount Athos carved into the form of Alexander to a plein air sketch of the *campagna*. More than ten years later, Valenciennes returned to this early sketch and produced the Chicago work, altering the format and some of the pictorial elements.[26] He rendered the subject a third time in a drawing of 1799–1800 (fig. 2), with still more variations.[27]

Vitruvius, the first writer to describe the Mount Athos project, wrote that the bold young architect Dinocrates, who was eager to secure Alexander's favor, walked to the King's tribunal dressed only in a lion's skin over his shoulder, a poplar wreath on his head, and a club in his hand:

> When this novel spectacle attracted the people, Alexander saw him. Wondering, he commanded room to be made for him to approach, and asked who he was. And he replied: "Dinocrates, a Macedonian architect, who brings you ideas and plans worthy of you, illustrious prince. For I have shaped Mount Athos into the figure of the statue of a man, in whose left hand I have shown the ramparts of a very extensive city; in his right a bowl to receive the water of all the rivers which are in that mountain." Alexander, delighted with his kind of plan, at once inquired if there were fields about, which could furnish that city with a corn supply. When he found this could not be done, except by sea transport, he said: "I note, Dinocrates, the unusual formation of your plan, and am pleased with it, but I perceive that if anyone leads a colony to that place, his judgment will be blamed. For just as a child when born, if it lacks the nurse's milk cannot be fed, nor led up the staircase of growing life, so a city without cornfields and their produce abounding within its ramparts, cannot grow, nor become populous without abundance of food, nor maintain its people without a supply. Therefore, just as I think your *planning* worthy of approval, so, in my judgment, the *site* is worthy of disapproval; yet I want you to be with me, because I intend to make use of your services.[28]

Although Dinocrates's project was never executed, for centuries Vitruvius's account provided fertile ground for interpretation, evaluation, and polemics by artists, architects, and theorists who used its moral and its inherent problems to their advantage. From the fifteenth century on, numerous depictions of Dinocrates and his Mount Athos project were made. To artists and writers, the legend, as presented by Vitruvius, concerned the fundamental notions of the relationship of artist and patron, the self-promotion of the artist, the uniqueness of each project, and, perhaps most important, issues of usefulness and feasibility.[29]

Valenciennes was determined to elevate landscape painting from its lowly status in the academic hierarchy of genres to one commensurate with history painting, and it was largely due to his efforts that the Academy eventually conferred legitimacy on the landscape genre. The choice of a didactic subject — in this case an Alexandrian episode — was not unusual for Valenciennes, who believed that the value of a painting derived from the merit and refinement of the ideas it evinced and the virtues it demonstrated. Landscape paintings, he maintained, should not merely record natural phenomena, but should inspire profound sentiments. Nature called for correction — that is, the addition of appropriately high-minded subject matter. In his *Elémens de perspective*, a practical and spiritual guide for artists, Valenciennes expressed these beliefs and theoretically justified his ambitions for landscape painting.[30] He also stressed the necessity of conjoining landscape with historical subject matter, pointing to the exalted historiated landscapes of Poussin. It is thus no coincidence that there is an affinity between Valenciennes's image of Mount Athos shaped into the form of Alexander and the colossal and imposing figure in Poussin's *Landscape with Polyphemus* (St. Petersburg, Hermitage).[31]

NOTES

1 According to an examination report of March 7, 1983, by Barry Bauman, in conservation files. The thread count of the original canvas is approximately 10 x 11/sq. cm (25 x 28/sq. in.).

2 This treatment was performed by Faye Wrubel. The painting was relined with a sufficient amount of synthetic adhesive to correct the delamination of the lining. Prior to relining, a moisture treatment was performed in an effort to diminish surface irregularities that were already present.

3 The dimensions of the original canvas are approximately 40.6 x 90 cm (16 x 35⁷/₁₆ in.).

4 According to examination report by Barry Bauman (see note 1), the painting had been wax lined to two layers of fabric. The thread count of the original canvas is approximately 8 x 10/sq. cm (20 x 25/sq. in.).

5 This treatment was performed by Faye Wrubel.

6 According to Maria Wilson of Sotheby's (letter of January 9, 1996, to Larry Feinberg, in curatorial files), auction house records show that the pictures were bought for £28 7s. and returned to the Hunt family. Michael Pantazzi (1994–95 exhibition catalogue) was the first to connect the Chicago pictures with those in the Hunt sale.

7 According to an annotated sale catalogue in the British Museum, London. The sale catalogue erroneously records a date of 1798 on *Mount Athos Carved as a Monument to Alexander the Great*. According to Hart's will (dated December 11, 1872, and proved at Chichester, April 19, 1873), the estate was bequeathed to his niece Catherine, wife of John Lord (letter of July 19, 1984, from Patricia Gill, West Sussex Record Office, to Cheryl Washer, in curatorial files).

8 According to a letter of April 4, 1984, from Alan G. Burns to A. G. E. Marriott (Henry Spencer and Sons), and a letter of

February 9, 1988, from Alan G. Burns to the author (copies of both letters are in curatorial files).

9 The buyer's name is specified in a letter of April 10, 1984, from A. G. E. Marriott (Henry Spencer and Sons) to Cheryl Washer, in curatorial files; Clovis Whitfield (Colnaghi, New York) indicated (verbally, February 28, 1984; notes in curatorial files) that at the 1978 sale the paintings had been purchased for Trafalgar and Colnaghi.

10 Among his students were Jean Joseph Xavier Bidauld, Pierre Athanase Chauvin, Jean Victor Bertin, and Achille Etna Michallon. Valenciennes was also much admired in the nineteenth century by Jean Baptiste Camille Corot.

11 *Collection des livrets des anciennes expositions depuis 1673 jusqu'en 1800*, pt. 39, *Exposition de 1796*, Paris, 1871, p. 68, no. 467 (1983.36): "Mount Athos, in Thrace, carved as a statue of Alexander, who holds a city in his right hand, and, from the other, a river flows into the sea." The dimensions of the painting were not recorded.

12 See "Beaux-arts: Sur le Salon de l'an V (1796)," *Mercure français* 26 (10 Frimaire an V [December 1796]), p. 158 (1983.36): *Les Etrivières de Juvenal, ou satire sur les tableaux exposés au Louvre l'an V*, Paris, 1796, p. 9, reprinted in Deloynes, *Catalogue de la collection de pièces sur les beaux-arts*, Paris, 1881, vol. 18, no. 490, p. 841 (1983.36); "Observations sur l'exposition des tableaux au Salon du Louvre 1796," *Mercure de France*, [1796], reprinted in Deloynes (this note), no. 491, p. 978 (1983.36); and "Observations tirées du *Journal général de France* sur l'exposition des Tableaux de 1796 par M^r Ro . . . ," [1796], reprinted in Deloynes (this note), no. 495, pp. 1107–08 (1983.36).

13 The identical French frames on the two works have been variously dated: Paul Levi placed them to 1815/25 (letter of June 28, 1984, to Mary Kuzniar, in curatorial files), Steven Starling (1986 exhibition catalogue) to 1795/1825. They were apparently crafted specifically for the paintings, suggesting that the two pictures were paired early in their history, if only by a collector (see Provenance). For an illustration of the frame of *Mount Athos Carved as a Monument to Alexander the Great*, see the 1986 exhibition catalogue.

14 The sale was conducted in Paris on April 26 and following, 1819; the picture, which was no. 4, sold for Fr 51.50. Manuscript copies of the sale catalogue are preserved in the Bibliothèque d'Art et d'Archéologie, Paris, and the British Museum, London; see also Whitney 1976. The entry in the sale catalogue describes the painting of Mount Athos: "Figure colossale taillée dans le Mont Athos, et representant Alexandre le Grand, tenant d'une main un Fleuve et de l'autre une Ville" (Colossal figure carved in Mount Athos and representing Alexander the Great, holding in one hand a river and in the other a city.) No measurements are listed in the catalogue. The British Museum MS records the sale price.

15 Strabo and Arrian (see below) frequently based their accounts on those of Aristobulus of Cassandreia, who accompanied Alexander on his campaigns, and on Onesicritus, who went with Alexander to Asia. For Aristobulus and the tomb of Cyrus, see Lionel Pearson, *The Lost Histories of Alexander the Great*, Chico, Calif., 1983, pp. 151, 160.

16 In the *Natural History* (6.29), Pliny mentioned Cyrus's tomb guarded by magi without describing the visit; see George N. Curzon, *Persia and the Persian Question*, London, 1892; reprint, London, 1966, vol. 2, p. 81.

17 André Félibien, *Entretiens sur les vies et sur les ouvrages des plus excellens peintres anciens et modernes*, vol. 1, Trevoux, 1725, pp. 80–81. Denis Diderot, *Supplément à l'encyclopédie, ou dictionnaire raisonné des sciences, des arts et des métiers*, vol. 1, Amsterdam, 1776–77, pp. 271, 272.

18 Arrian, *Anabasis Alexandri (Books V–VII), Indica (Book VIII)*,

tr. by E. Iliff Robson, vol. 2, Cambridge, Mass., and London, 1958, pp. 195–99.

19 See Geneviève Lacambre, "Les Paysages de Pierre-Henri de Valenciennes, 1750–1819," *Le Petit Journal des grandes expositions*, no. 30 (1976), n. pag. (1983.36).

20 Cornelis de Bruyn, *Voyages de Corneille Le Brun par la Moscovie, en Perse, et aux Indes Orientales*, Amsterdam, 1718. The first two editions were published in Delft in 1711 and 1714.

21 It may derive from a Roman sarcophagus and depict mourners bidding farewell to the deceased.

22 See, for example, the following plates in de Bruyn (note 20): the terrace, pl. 120; Ahuramazda, pls. 143, 152; doorways, pls. 128, 273; cuneiform, pls. 131–34; Man-Bulls, pls. 121, 123; bell-capital columns, pls. 120–21.

23 Philip Conisbee, "Tombs in Eighteenth- and Early Nineteenth-Century Landscape Painting," *Neoclassicismo*, Genoa, 1971, fig. 17.

24 Ibid., p. 25.

25 Letter of February 29, 1984, from Geneviève Lacambre to Cheryl Washer, in curatorial files. The drawing, which measures 113 x 357 mm, is inscribed along the bottom, at right: *mont athos statué d'alexandre Vie d'* [. . .] *quintecurce*. Valenciennes's inscription on his drawing of this subject is puzzling, since Quintus Curtius did not mention Dinocrates's proposed monument to Alexander.

26 Valenciennes also referred to drawings he had executed years earlier when he painted his *Ancient City of Agrigento* (Louvre) and a *Landscape of Ancient Greece* (Detroit Institute of Arts),

exhibited together at the Salon of 1787; see Paula Rea Radisich, *Eighteenth-Century Landscape and the Work of Pierre Henri de Valenciennes*, Ann Arbor, Mich., 1981, p. 425, no. 7, p. 431, no. 14, respectively. In conceiving both pictures, the artist returned to sheets in a sketchbook (Louvre, Cabinet des dessins) with drawings executed in 1779 in Naples from his memory of ancient sites seen in Sicily; see Geneviève Lacambre, "Pierre-Henri de Valenciennes en Italie: Un Journal de voyage inédit," *Bulletin de la Société de l'histoire de l'art français, année 1978* (1980), pp. 140–43.

27 The drawing, which measures 268 x 482 mm, is signed on a masonry block, at lower right: *Valenciennes*, and dated (according to the French Revolutionary calendar) on another fragment below this: *an 8* (September 23, 1799–September 22, 1800).

28 *Vitruvius on Architecture*, ed. and tr. by Frank Granger, vol. 1, London and New York, 1931, pp. 73, 75.

29 See Oechslin (1982, pp. 7–26), who discussed the various interpretations of this Vitruvian anecdote.

30 P[ierre] H[enri de] Valenciennes, *Elémens de perspective pratique, à l'usage des artistes, suivis de réflexions et conseils à un élève sur la peinture, et particulièrement sur le genre du paysage*, Paris, an VIII [1799/1800]; reprint, Geneva, 1973.

31 See Anthony Blunt, *The Paintings of Nicolas Poussin: A Critical Catalogue*, London, 1966, p. 125, no. 175 (ill.). Valenciennes was probably also influenced by the numerous ancient larger-than-life-sized sculptures of reclining male river gods that he encountered on his travels in Italy.

Claude Joseph Vernet

1714 Avignon–Paris 1789

Morning, 1760

Mr. and Mrs. Martin A. Ryerson Collection, 1933.1101

INSCRIBED: *J. Vernet f 1760* (lower right)

Oil on canvas, 65.7 x 96.8 cm (25⁷⁄₈ x 38¹⁄₈ in.)

CONDITION: The painting is in good condition. It was transferred from the original canvas and glue paste lined to a new linen canvas prior to entering the Art Institute. The painting was cleaned in 1962 and then retransferred to linen with wax resin when it was cleaned again in 1971–72.[1] A pattern of cusping from the original canvas is preserved in the paint layer at all four edges, indicating that the painting is close to its original dimensions.[2] The area between the stretcher and the edge of the paint surface has been filled and inpainted. The painting has a warm red ground that is visible through the cracks in the sky at upper right. The texture of the paint surface has been somewhat diminished by the transfer from the original canvas. Numerous losses along the lower third of the painting have been filled and inpainted. There are a few localized areas of retouching over smaller losses scattered in the background sky and water. (ultraviolet, x-radiograph)

PROVENANCE: Probably commissioned by M. Journû, Bordeaux, 1759.[3] Possibly the baron Schickler, Paris, by 1897.[4] Sold Hôtel Drouot, Paris, February 21, 1910, no. 47, to Théodore Bonjean, Paris.[5] Edmond Noël, Paris; sold Galerie Georges Petit, Paris, May 27, 1924, no. 25 (ill.) to Durand-Ruel, Paris, acting on behalf of Martin A. Ryerson, Chicago, for Fr 23,000;[6] on loan to the Art Institute, 1924–33; bequeathed to the Art Institute, 1933.

REFERENCES: Léon Lagrange, *Les Vernet: Joseph Vernet et la peinture au XVIIIᵉ siècle*, Paris, 1864, p. 342, C.184, p. 364, R.104, p. 385. "La Curiosité," *New York Herald*, Paris ed., May 28, 1924, p. 5. AIC 1925, p. 161, no. 2086. Rose Mary Fischkin, *Martin A. Ryerson Collection of Painting and Sculpture, XIII to XVIII Century, Loaned to The Art Institute of Chicago*, unpub. MS, 1926, Ryerson Library, The Art Institute of Chicago, p. 149. Florence Ingersoll-Smouse, *Joseph Vernet, peintre de marine, 1714–1789: Etude critique suivie d'un catalogue raisonné de son oeuvre peint avec trois cent cinquante-sept reproductions*, vol. 1, Paris, 1926, p. 92, no. 732, fig. 180, vol. 2, p. 15, under no. 873, p. 132. AIC 1932, p. 183. Wilhelm R. Valentiner, *Paintings in the Collection of Martin A.*

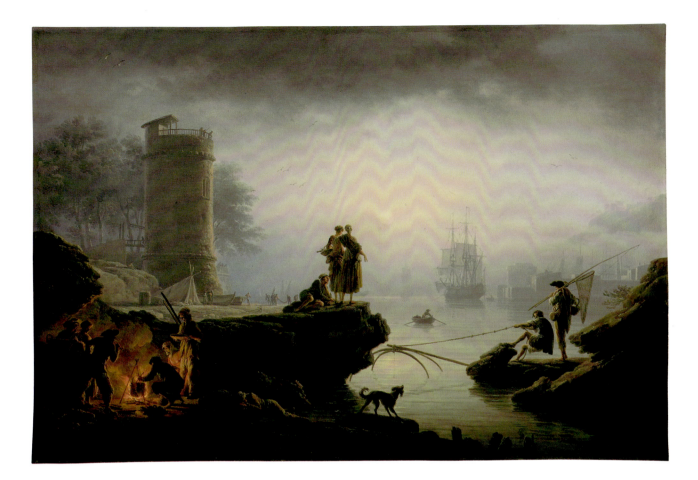

Ryerson, unpub. MS, [1932], Archives, The Art Institute of Chicago, n. pag. AIC 1961, p. 461. Peter Murray, *Dulwich Picture Gallery: A Catalogue*, London, 1980, p. 133, under no. 300. *Le Port des lumières: La Peinture à Bordeaux, 1750–1800*, exh. cat., Musée des Beaux-Arts de Bordeaux, 1989, p. 36, fig. 7. Wright 1991, vol. 1, p. 464, vol. 2, pp. 62, 639.

EXHIBITIONS: Possibly Paris, Ecole des Beaux-Arts, *Les Vernet*, [1897–98], no. 37. The Art Institute of Chicago, *Selected Works of Eighteenth-Century French Art in the Collections of The Art Institute of Chicago*, 1976, no. 10 (ill.).

Claude Joseph Vernet was one of the most celebrated French landscape and marine painters of the eighteenth century. He first trained with his father, then with the history painter Philippe Sauvan. Under the sponsorship of an amateur of broad interests and connections, Joseph de Seytres, marquis de Caumont, Vernet traveled to Italy in 1734 and did not return to France to settle permanently until some twenty years later. In Italy, and particularly in Rome, Vernet developed his artistic style, perhaps as a pupil of Adrien Manglard, a painter of landscapes and seascapes. But he also responded to the manners of Claude Lorrain, Salvator Rosa, and Gaspard Dughet, as well as to those of his contemporaries Gian Paolo Panini, Andrea Locatelli, and Jan Frans van Bloemen (called Orizzonte). Vernet also succumbed to the influence of Nicholas Vleughels, director of the French Academy in Rome, who remarked sadly in 1730 that "il ne se fait plus de peintre de paysage; c'est domage, car c'est une belle partie de la peinture. . . . Peut-être viendra-t-il quelqu'un qui relèvera cette partie, qui est presque éteinte."[7] He subsequently recognized Vernet's penchant for marine painting and urged the young painter to pursue that genre.

From early in his career, Vernet enjoyed a continuous international clientele. His most prestigious commission was from the marquis de Marigny (M. de Vandières, *Surintendent des Bâtiments* and brother of Mme de Pompadour), who engaged the artist to portray the twenty most important military and commercial seaports of France. Vernet, whose reputation as a marine painter was well established by 1740, was eminently suited to the undertaking. He left Italy forever and began work on these canvases in 1753. Although he abandoned the project, incomplete, in 1762, the fifteen paintings he did finish (now in the Louvre and the Musée de la Marine, Paris) are considered among his most outstanding accomplishments.

Despite this demanding task, the artist continued to receive many other commissions, mentioned or listed in his journals and in his *livres de raison*, or account books, which Lagrange called the *Livre de vérité*.[8] These sources document that a "Monsieur Journû" commissioned four pictures from the artist. Noted in one of Vernet's account books is an order, in 1759, for four canvases of 3 *pieds* (97.2 cm) for Journû; and, in his journal, under the year 1760, Vernet recorded receipts of payments from Journû for four pictures.[9] Ingersoll-Smouse reasonably proposed that this commission can be connected with four paintings, comparable in size and executed in 1760, that depict the four times of day: the Chicago *Morning*, signed and dated 1760, and three canvases, the present locations of which are unknown, *Storm at Midday* (*Tempête à midi*), *Evening* (*Le Soir*), and *Fire at Night* (*Incendie de Nuit*).[10] This set of pictures must have pleased Vernet, or have been well received, since copies of all four compositions are known (for the copies of the last three paintings, see figs. 1–3).[11]

Continuing the tradition of Claude Lorrain, who created pendant landscapes or seascapes with contrasting times of day (see 1941.1020), Vernet frequently executed series of four (or even eight) paintings that sensitively captured various atmospheric conditions and effects of light. Vernet would contrast land and sea, night and day, sunset and sunrise, stormy and serene weather, coasts and mountains. In some of these series, including that to which the Chicago picture belonged, Vernet also presented the four elements — the Pythagorean tetrad of earth, air, fire, and water — as manifested in such hostile forces as destructive blazes, downpours, and shipwrecks. His attention to natural phenomena was encouraged early on by Vleughels, who felt that a student could learn best from direct observation.

Much of Vernet's work, the *Ports of France* series especially, is characterized by topographical exactitude.[12] The artist also frequently embellished his paintings with elements from his rich and extensive repertoire of invented motifs, however. Certain features of the Chicago canvas, including the lively dog, the young fisherman with submerged net, the group of figures surrounding a fire, and the round tower, can all be found in earlier marine scenes by Vernet. Yet his masterful sense of composition and the dramatic and varied light in his pictures brought new vitality to old motifs. In *Morning* the vivacious figures are theatrically silhouetted against the silvery tones of early day and enveloped in a misty haze. Although highly picturesque, this

Fig. 1 Copy after Claude Joseph Vernet, *Storm at Midday* (*Tempête à midi*; also known as *Shipwreck at Midday*), Stourhead (The National Trust) [photo: Courtauld Institute of Art, London]

Fig. 2 Copy after Claude Joseph Vernet, *Evening* (*Le Soir*; also known as *A Seaport, Sunset*), Dulwich Picture Gallery, London

Fig. 3 Copy after Claude Joseph Vernet, *Fire at Night* (*Incendie de nuit*; also known as *Fire in a Port at Night*), Musée des Beaux-Arts, Bordeaux [photo: © cliché du M.B.A. de Bordeaux]

type of work, with its accurate recording of transient phenomena and bold, *contre-jour* lighting, influenced numerous landscape painters in the nineteenth century, the German artist Caspar David Friedrich among them.[13]

Notes

1 The 1962 treatment was performed by Alfred Jakstas, and the cleaning and retransferring in 1971–72 was carried out by Timothy Lennon. No record was made of the thread count of the original canvas.

2 The dimensions of the original painting are approximately 63.5 x 96.5 cm (25 x 38 in.).

3 Proposed by Ingersoll-Smouse (1926, vol. 1, p. 92, nos. 732–35). See also Lagrange 1864.

4 Schickler lent a *Le Matin* (*Morning*) and a *Le Soir* (*Evening*) to the 1897–98 Paris exhibition (nos. 37–38), which Ingersoll-Smouse (1926, vol. 1, p. 92, nos. 732–35) connected with the Chicago *Morning* and one of its companion pieces, *Evening*. But the Schickler pictures may instead be the replicas now at the Dulwich Picture Gallery. See note 11, items A and C, below.

5 According to an annotated sale catalogue (Durand-Ruel, Paris), which indicates that the picture was purchased together with nos. 46, 48, and 49 for Fr 15,000. A label with the name Théodore Bonjean and the stock number 6159 was removed from the stretcher or frame in 1971 (preserved in curatorial files).

6 Letters of May 27 and 28, 1924, from Durand-Ruel to Martin A. Ryerson, and receipt, dated May 27, 1924 (all in Archives, The Art Institute of Chicago); and letter of January 26, 1981, from France Daguet (for Charles Durand-Ruel) to the author, in curatorial files. An annotated sale catalogue (Durand-Ruel, Paris) indicates the following prices and buyers for the three paintings that Bonjean had purchased along with *Morning* in 1910: no. 26, *Le Soir* (*Evening*), Fr 26,100, to Mme Hallé; no. 27, *La Tempête* (*Storm [at Midday]*), Fr 8,100, to Rives; no. 28, *La Nuit* ([*Fire at*] *Night*), Fr 8,100, to Roger.

7 Anatole de Montaiglon and Jules Guiffrey, *Correspondance des directeurs de l'Académie de France à Rome avec les surintendants des bâtiments publiée d'après les manuscrits des Archives nationales*, vol. 8, Paris, 1898, p. 131 (letter of August 3, 1730, from Vleughels to d'Antin): "There are no longer landscape painters; it is too bad, because it is a beautiful form of painting. . . . Perhaps someone will come, who will take up this form, which is nearly extinguished."

8 Lagrange 1864, p. 321.

9 Ibid., pp. 342, 385. According to Lagrange, the artist was paid 1,200 *livres* for the four pictures.

10 Ingersoll-Smouse 1926, vol. 1, p. 92, nos. 732–35, figs. 180–83. The four pictures remained together until 1924 (see note 6).

11 The four companion pictures and known copies or replicas after them are as follows:

(A) *Morning*, by Vernet, The Art Institute of Chicago. Copy after the Chicago painting, oil on canvas, 65 x 98 cm, signed at right; sold Galerie Fischer, Lucerne, June 21–22, 1974, no. 413 (ill.); see *Connoisseur* 186 (May 1974), p. 65 (ill.). Copy after the Chicago painting, oil on canvas, 67.6 x 99.7 cm, signed and dated at lower right corner: *J. Vernet* 17[67?], London, Dulwich Picture Gallery; see Ingersoll-Smouse 1926, vol. 2, p. 15, no. 873, and Murray 1980, no. 300 (ill.).

(B) *Storm at Midday* (*Tempête à midi*), by Vernet, companion to the Chicago painting, oil on canvas, 64 x 96 cm, signed at bottom left (poorly visible), 1760, location unknown; see Ingersoll-Smouse 1926, vol. 1, p. 92, no. 733, fig. 181. Copy after Ingersoll-Smouse no. 733, oil on canvas, 62.5 x 95 cm, 1765; see fig. 1 and Ingersoll-Smouse 1926, vol. 2, p. 11, no. 831. Copy after Ingersoll-Smouse nos. 733 and 831, oil on canvas,

76 x 102 cm, 1765, St. Petersburg, Hermitage; see Ingersoll-Smouse 1926, vol. 2, p. 11, no. 832, fig. 216.

(C) *Evening (Le Soir)*, by Vernet, pendant to the Chicago painting, oil on canvas, 64 x 96 cm, signed at lower left and dated: *1760*, location unknown; see Ingersoll-Smouse 1926, vol. 1, p. 92, no. 734, fig. 182. Copy after Ingersoll-Smouse no. 734, oil on canvas, 67.3 x 99 cm, signed and dated: *J. Vernet 1767*, London, Dulwich Picture Gallery; see fig. 2 and Ingersoll-Smouse 1926, vol. 2, p. 15, no. 874.

(D) *Fire at Night (Incendie de nuit)*, by Vernet, companion to the Chicago painting, oil on canvas, 64 x 96 cm, signed at lower right and dated (poorly visible), 1760, location unknown; see Ingersoll-Smouse 1926, vol. 1, p. 92, no. 735, fig. 183. Copy

after Ingersoll-Smouse no. 735, oil on canvas, 66 x 99.5 cm, Musée des Beaux-Arts de Bordeaux; see fig. 3 and *Peintures du dix-huitieme siècle au Musée des Beaux-Arts de Bordeaux*, exh. cat., Paris, Galerie Cailleux, 1969–70, no. 42 (ill.).

Mme B. de Boysson proposed that the two Dulwich pictures, the Hermitage picture, and the Bordeaux painting comprise a set of four, all copied by Jacques Volaire (unpub. M.A. thesis, included in a letter of July 12, 1983, from Gilberte Martin-Mery to the author, in curatorial files).

12 For this series, see Laurent Manoeuvre and Eric Rieth, *Joseph Vernet, 1714–1789: Les Ports de France*, Arcueil, 1994, pp. 43–45.

13 See Werner Hofmann, *Caspar David Friedrich, 1774–1840*, exh. cat., Hamburger Kunsthalle, 1974, pp. 32, 34, 35.

Jacques Antoine Volaire

1729 Toulon–Naples or Lerici after 1793

The Eruption of Vesuvius, 1771
Charles H. and Mary F. S. Worcester Collection, 1978.426

Oil on canvas, 116.8 x 242.9 cm (46 x 95⅝ in.)

INSCRIBED: *Vue de l'Eruption / du mont Vesuve du 14 / may 1771 peinte Sur le / lieu par le Che Volaire.* (bottom, left of center)

CONDITION: The painting is in very good condition. The coarsely woven canvas has a wax resin lining that was added prior to the painting's acquisition by the Art Institute.[1] The tacking margins have been cut off, but cusping is visible at all four edges, indicating that the painting is close to its original dimensions. The canvas is slightly smaller than the present stretcher.[2] The white or off-white ground is visible along the lower right edge, and appears to have been stained with a warm red wash. There is a pronounced overall craquelure. The surface is slightly abraded in the lower foreground, particularly in several of the figures at the left. There are some small losses (0.2 to 1 cm sq.) scattered along the bottom edge, and a few larger losses (2.5 to 5 cm in length) at the top of the volcano and in the sky at upper right. All these losses have been filled and inpainted. There is additional retouching covering some of the cracks in the lower foreground landscape. (ultraviolet, partial x-radiograph)

PROVENANCE: London art market.[3] Gunnar Trägårdh, Gothenburg, Sweden.[4] Sold by Trägårdh to Dr. Sven Langert, Gothenburg, Sweden, in the 1930s;[5] sold by his wife, Majken Langert, Christie's, London, November 26, 1971, no. 85, to Ray Perman, acting on behalf of Cyril Humphris and Herner Wengraf, Ltd., London;[6] sold Sotheby's, London, April 19, 1978, no. 156 (ill.), to Colnaghi, London.[7] Sold by Colnaghi to Richard L. Feigen and Co., New York, 1978.[8] Purchased from Feigen by the Art Institute through the Charles H. and Mary F. S. Worcester Endowment, 1978.

REFERENCES: Ingvar Bergström, "Några Vesuvius-Bilder Från 1700-Talet, Apropos ett Okänt Verk av Jacques Volaire,"

Festskrift till Axel Boëthius, Sverige-Italien n. s., 3 (July 18, 1949), pp. 15–29, fig. 1. Jacques Foucart in *De David à Delacroix: La Peinture française de 1774 à 1830*, exh. cat., Paris, Galeries Nationales du Grand Palais, 1974–75, p. 668, under no. 203. B[enedict] N[icolson], "Current and Forthcoming Exhibitions: General," *Burl. Mag.* 118 (1976), p. 40, fig. 39. Marina Causa Picone, "Volaire," *Antologia di belle arti* 2 (1978), p. 38. Madeleine Pinault in *La Révolution française et l'Europe, 1789–1799*, exh. cat., Paris, Galeries Nationales du Grand Palais, 1989, p. 220, under no. 309. *Fifty Paintings, 1535–1825, to Celebrate Ten Years of Collaboration between the Matthiesen Gallery, London, and Stair Sainty Matthiesen, New York*, London and New York, 1993, p. 170.

EXHIBITIONS: The Detroit Institute of Arts, *The Golden Age of Naples: Art and Civilization under the Bourbons, 1734–1805*, 1981, no. 76, cat. entry by J. Patrice Marandel, traveled to Chicago.

Born to a Toulon family of artists noted for their marine paintings, the young Jacques Antoine Volaire received early guidance from Joseph Vernet (see 1933.1101), who arrived in Toulon in 1754 while he was working on his documentary series, the *Ports of France*. It is not clear how closely these two painters worked together between 1754 and 1756, but by 1756 Volaire had certainly become Vernet's pupil and collaborator.[9] Volaire traveled to Rome in 1764, and to Naples in 1769, where he began to paint his celebrated views of the eruption of Mount Vesuvius and achieved stylistic independence from Vernet in his art. Volaire's oeuvre extended beyond vesuviana, however; prior to his Neapolitan period, he had executed many day scenes, marine scenes, and

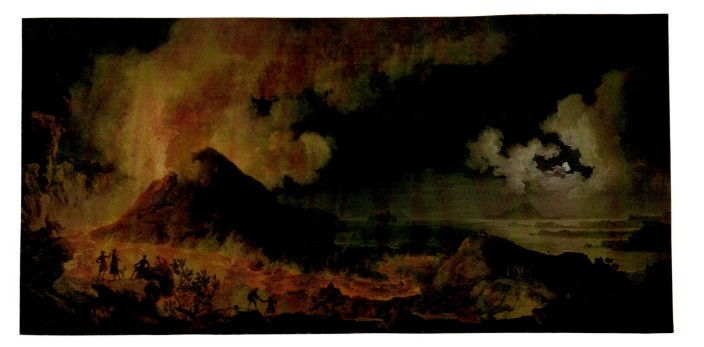

landscapes that attest to his ability to paint lyrical and picturesque compositions.

A serious eruption of Vesuvius occurred in 1771, the year the Chicago painting was created. The volcano had for some time been a major Neapolitan attraction and a source of inspiration for artists, and the spectacular volcanic activity of 1771 was recorded by many travelers on the Grand Tour.[10] For instance, in his *Voyage pittoresque ou description des royaumes de Naples et de Sicilie* (published between 1781 and 1786), the abbé de Saint-Non included an elaborate and dramatic description of Vesuvius.[11] It has been suggested that an engraving in this book—Heinrich Guttenberg's print after an *Eruption of Vesuvius* by Volaire—reproduces the Chicago painting.[12] But J. Patrice Marandel has pointed out that, according to Emile Bellier de la Chavignerie, it was Volaire's *Eruption of Vesuvius in 1771* (location unknown), formerly in the comte d'Orsay collection, that provided the model for Guttenberg's engraving.[13]

Volaire's contemporary depictions of the 1771 eruption and the many other, extremely similar views he executed throughout the decade were the most ambitious works of his early Neapolitan period.[14] In all of these compositions, Vesuvius is seen from a horizontal ridge of Monte Somma, a peak of which rises at left. Beyond this is the Atrio di Cavallo, flooded with lava streaming from the erupting crater. At right another ridge offers a less proximate vantage point to numerous sightseers; beyond this, in most versions, is a view of the Bay of Naples, with the islands of Capri, Ischia, and Procida. The right distance glows beneath a silvery moon, in dramatic contrast to the violence of the left half of the composition, where spectators are silhouetted against the brilliant orange lava flow.

In the Chicago painting, in the lost work reproduced in the Guttenberg engraving, and in versions of the composition in the Hermitage, formerly at Sestieri in Rome, and in a New York private collection, Volaire placed a seated man on the rocks at left.[15] This figure was commonly believed to represent Sir William Hamilton, whose *Observations on Etna, Vesuvius, and Other Volcanoes* was published in London in 1772. However, Marandel (1981 exhibition catalogue) identified this figure as Volaire himself, proposing that the sword lying at the figure's side in the Chicago painting represents the artist's title of "chevalier." Marandel speculated that "Volaire, as if to underline the fact that his compositions were based on the direct observation of nature, represented himself recording the frightening event

on a large sketch pad."[16]

The inscription *sur le lieu* (at the place) on the Chicago canvas is curious. It seems unlikely that, as Marandel suggested, Volaire added it in response to criticisms that his work was routine and done from memory.[17] The Chicago *Eruption of Vesuvius* is one of the painter's earliest portrayals of the subject, and it is likely that Volaire's reputation as a specialist in paintings of eruptions was not widely established in 1771. Moreover he never received much critical acclaim, and objections to his work always seem to postdate the paintings of 1771. In fact, Volaire's first exhibition at the Salon de la Correspondance was not until 1779. That Volaire sustained himself by painting repetitions of Vesuvius not only points to an aspect of contemporary taste, but implies a certain satisfaction on the part of his clientele, many of whom were prominent collectors (such as Sir William Hamilton, Bergeret de Grandcourt, and the marquis de Pestre de Seneff). Thus the phrase *sur le lieu* was probably not written in defense, but was simply intended to emphasize the artist's direct observation of nature, and so serves the same purpose as the inscription on the Hermitage painting, *après nature*. It is therefore likely that the inscriptions on the two paintings are meant to act as glosses to the seated figure—written testimony that the artist painted the volcanic phenomenon as he witnessed it and did not execute the work only in the studio and from memory.[18]

The eighteenth-century fascination with Vesuvius, a volcano that had been dormant for years before activity resumed in 1631, was prompted not only by scientific interests but by philosophical and literary notions of the sublime. Immanuel Kant, in his *Critique of Judgment* (1790), listed "volcanoes in all their violence of destruction" among the objects "we call sublime, because they raise the forms of the soul above the height of vulgar commonplace, and discover within us a power of resistance of quite another kind, which gives us courage to be able to measure ourselves against the seeming omnipotence of nature."[19] As Jacques Foucart has observed, "L'idée de contemplation tout à la fois sécurisante et exaltante est donc fondamentale dans cette analyse du rôle moral de la nature sublime, et tous les *Vésuves* de Volaire montrent justement, d'une manière très significative, des personnages contemplant le grand phénomène naturel de loin et à l'abri."[20] The Chicago painting was thus meant to record not only an extraordinary natural event, but the exalted psychological state of its human witnesses.

NOTES

1 The thread count of the original canvas is approximately 10 x 10/sq. cm (25 x 25/sq. in.).

2 The original canvas measures 114.3 x 240.7 cm (45 x 94³/₄ in.).

3 According to a letter of November 11, 1981, from Ingvar Bergström to the author, in curatorial files.

4 Ibid.

5 Ibid.

6 According to Bergström (see note 3), Mrs. Langert was the vendor at the 1971 sale. Letters from Alex Wengraf to the author (May 12, 1981) and from Margaret Christian (Christie's) to Mary Kuzniar (September 6, 1983; both in curatorial files), confirm that Perman bought the painting for Humphris and Wengraf.

7 According to a letter of September 7, 1983, from Magdalen Elwes (Colnaghi) to Mary Kuzniar, in curatorial files.

8 Ibid., and letter of October 6, 1983, from Elaine M. Banks (Feigen) to the author, in curatorial files.

9 As Causa Picone (1978, p. 28) suggested, the two artists probably collaborated on paintings—Vernet most likely executing the landscapes and Volaire the accessories.

10 See Alexandra R. Murphy, *Visions of Vesuvius*, exh. cat., Boston, Museum of Fine Arts, 1978.

11 Abbé de Saint-Non [Jean Claude Richard], *Voyage pittoresque ou description des royaumes de Naples et de Sicile*, vol. 1, pt. 2, Paris, 1781. See Neil MacGregor, "Le Voyage pittoresque de Naples et de Sicile," *Connoisseur* 196 (October 1977), pp. 130–38, concerning the circumstances surrounding this publication.

12 Abbé de Saint-Non (note 11), pl. 32 (see MacGregor [note 11], p. 132 [ill.]); this connection had been proposed by Bergström (1949, pp. 19–20) and Robert Eigenberger (according to the 1971 sale catalogue, p. 67).

13 See the 1981 exhibition catalogue, p. 207, no. 76. The comte d'Orsay painting, which reportedly measured 3 x 5 *pieds* (97.2 x 162 cm), was shown in the Salon de la Correspondance in 1779; see Emile Bellier de la Chavignerie, "Les Artistes français du XVIIIᵉ siècle oubliés ou dédaignés," *Revue universelle des arts* 21 (1865), p. 188. Jacques Foucart (1974–75, p. 667) suggested that the comte d'Orsay *Eruption of Vesuvius in 1771* may have entered the Louvre by confiscation during the Revolution.

14 See Foucart 1974–75, pp. 667; Causa Picone 1978, pp. 36–38;

and Pinault 1989, p. 220.

15 The Hermitage version measures 104 x 210 cm and is inscribed at bottom: *representation des plus exactes de l'Eruption que le mont Vesuve a fait an 8 du moix[s?] d'oust 1779 peinte d'après nature par le chev. Volaire à Naples 1779* (see Inna S. Nemilova, *The Hermitage: Catalogue of Western European Painting— French Painting, Eighteenth Century*, Moscow and Florence, 1986, p. 444, no. 346 [ill.]). The picture in the Galleria Marcello e Carlo Sestieri in Rome in 1978 measures 131 x 264 cm; see Causa Picone 1978, p. 35, fig. 17. The third painting, in a private collection, New York, measures 105 x 205 cm; for an illustration, see *Fifty Paintings . . .* 1993, p. 171.

16 See the 1981 exhibition catalogue, p. 208. In Volaire's paintings, the title "chevalier" first appeared in connection with the artist's name on the *Shipwreck* in the Nationalmuseum, Stockholm, which is signed and dated *Le che. P. J. Volaire f. in Roma 1765*. It has not been determined why or when this title was conferred on him. Causa Picone (1978, p. 28) wondered whether the title was a reward for Volaire's talent and productivity, or whether it might have been the result of a request by Vernet to the marquis de Marigny. *Shipwreck* is illustrated in Pontus Grate, *French Painting*, pt. II, *Eighteenth Century*, Stockholm, 1994, p. 357, no. 324.

17 Marandel (1981 exhibition catalogue) cited Pierre Henri de Valenciennes, *Elémens de perspective pratique, à l'usage des artistes, suivis de réflexions et conseils à un élève sur la peinture, et particulièrement sur le genre du paysage*, Paris, an VIII [1799/1800]; reprint, Geneva, 1973.

18 The inscription *sur le lieu* also appears on the version in the New York private collection.

19 Immanuel Kant, *Critique of Judgement*, tr. by James Creed Meredith, Oxford, 1986, pp. 110–11.

20 Foucart 1974–75: "The idea of contemplation, at once safe and exalting, is fundamental to this analysis of the moral role of sublime nature, and all the *Vesuvius* paintings by Volaire justly include, in a very significant manner, people contemplating the great natural phenomenon from afar and from shelter." The translation is from the English edition of *French Painting, 1774–1830: The Age of Revolution*, exh. cat., Detroit Institute of Arts, and New York, The Metropolitan Museum of Art, 1975, p. 677.

Jean Antoine Watteau, possibly with the assistance of Jean Baptiste Pater

1684 Valenciennes–Nogent-sur-Marne 1721
1695 Valenciennes–Paris 1736

Fête champêtre, 1718/21

Max and Leola Epstein Collection, 1954.295

Oil on panel (oak), 48.6 x 64.5 cm (19¹/₁₆ x 25³/₈ in.)

CONDITION: The painting is generally in good condition. It was cleaned in 1962 and 1975–76.[1] It was treated again in 1994 in order to address problems in the painting's aesthetic appearance.[2]

The painting is on a cradled oak panel. A repaired horizontal crack, measuring 10 cm, runs from the left edge and is located 2.5 cm from the bottom. A dark, transparent, brown imprimatura, laid over the white chalk ground, is visible in a number of places along the edges of the picture where the covering paint layers are thinly applied. Additionally, there is a light gray imprimatura in the area of the sky and what appears to be underpaint in red lake beneath the figure of the woman in the black dress in the central foreground.[3]

The paint is medium rich, and has extensive drying cracks and wrinkles. Although the painting's natural-resin varnish coating was completely removed in 1975, the paint's pronounced yellow fluorescence under ultraviolet light seems to indicate the

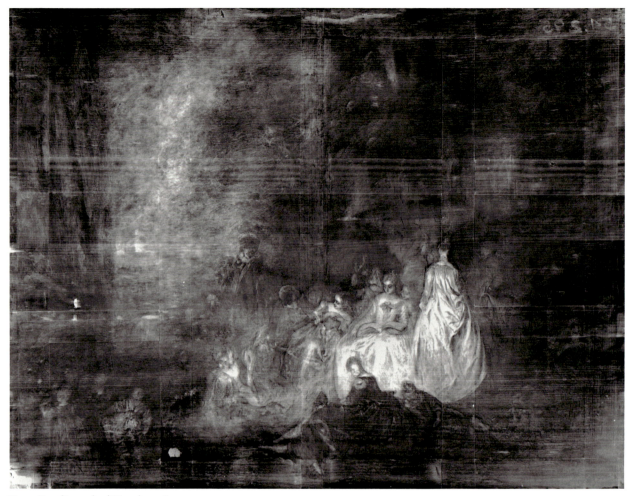

Fig. 1 X-radiograph of *Fête champêtre*, 1954.295

presence of a natural resin component in the medium.

The x-radiograph and *pentimenti* reveal a number of major and minor changes made by the artist that have probably contributed to the formation of cracks and other surface flaws. A standing male figure with a plumed hat, located to the left of the central group, is visible only in the x-radiograph (fig. 1) and was eliminated from the composition by the artist. A number of other changes are visible in the x-radiograph. On close examination the figure of a woman with her back to the viewer and holding a pilgrim's staff can be seen at the lower right. The head and body of the seated female figure with the fan was originally turned in profile, and the position of her arm was altered. The bodice of her dress appears originally to have been a plum color. The figure of the young girl receiving flowers seems to have been originally shown carrying a bundle. The woman looking over the shoulder of the woman holding the sheets of music was at first represented with her hand resting on her companion's shoulder. In the final composition, the contour of the dress of the woman in pink was made slightly wider along its right side and the position of her right ear was adjusted. The face of the man who stands to her right was originally shown in profile and was subsequently turned to face the spectator in three-quarter view. Under magnification a *pentimento* can be seen in the red cape of the kneeling man. Many *pentimenti* of foliage are visible in the sky.

The foreground, most of the landscape elements, parts of the sky, and all but two of the principal figures remain fairly well preserved. However, comparison with a photograph (fig. 2) from the early 1930s (when the painting was in the possession of the Sabin Gallery) shows a group of figures in the middle distance that was significantly altered by cleaning prior to 1976. Two of the seven figures originally found in this area are diminished and five have virtually disappeared. Detail has also been lost in the surrounding architecture and in the landscape. The trees at the upper right of the painting and, particularly, those on either side of the sky have been abraded and much restored, compromising the internal illumination of the painting.

Several figures show varying degrees of damage: the face and arms of the young girl receiving flowers and the flesh tones and hair of the girl with the basket of flowers are abraded; the skirt of the woman with the fan has severe traction cracking and her bodice, arms, and face are damaged; the face of the man in the red costume also suffers from traction cracking and a loss of definition, and there is abrasion in and around his left leg; the face of the seated woman in black is somewhat damaged, and there is traction cracking in her dress; the face of the seated woman with the small dog has lost definition; the costume, face, and hands of the woman in the blue dress are slightly abraded; the figure of the woman looking over the shoulder of

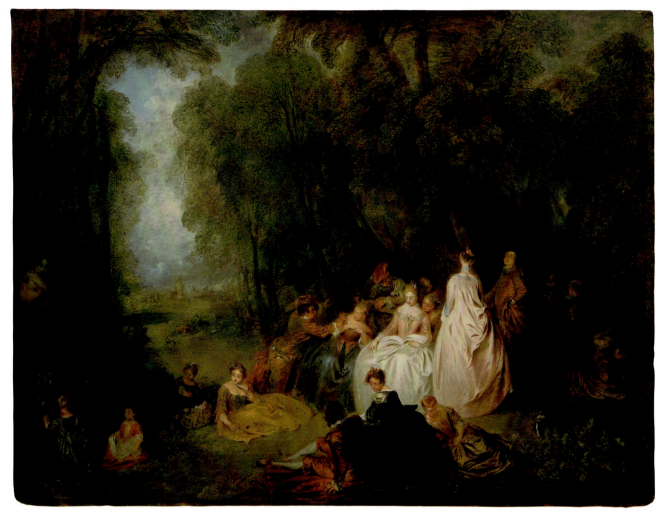

Jean Antoine Watteau, possibly with the assistance of Jean Baptiste Pater, *Fête champêtre*, 1954.295

the woman holding the sheets of music is somewhat damaged, but remains legible; and the face of the standing male figure to the right of the woman in pink is very damaged.

A fragmentary head, next to that of the woman holding the sheets of music, was revealed during the 1975–76 cleaning. It is not possible to determine whether this figure had been painted out by the artist or was removed by a later restorer. (before- and mid-treatment photographs, raking-light photographs, x-radiograph)

PROVENANCE: Probably Jean Baptiste Pierre Le Brun, Paris, by 1773; probably his sale, Pierre Rémy, Paris, December 20, 22, and 23, 1773, no. 117, as Watteau;[4] probably Daniel Saint, Paris, by 1845;[5] probably sold Hôtel des Ventes, Paris, May 4, 1846, no. 57, as Watteau, probably to Richard Seymour Conway, fourth marquess of Hertford, for Fr 4,900.[6] Richard Seymour Conway, fourth marquess of Hertford (d. 1870), Paris;[7] by descent to Sir Richard Wallace, Bt. (d. 1890); at his death to his widow, Lady Wallace (d. 1897);[8] at her death to Sir John E. A. Murray Scott, Bt. (d. 1912);[9] sold Christie's, London, June 27, 1913, no. 134 (ill.), as Pater, to Agnew, London, for 2,415 gns.[10] Sold by Agnew, as Pater, to Walter S. M. Burns, Esq. (d. 1930), North Myms Park, Hatfield, 1919;[11] sold Christie's, London, June 20, 1930, no. 106 (ill.), as Lancret, to Frank T. Sabin, London, for 3,045 gns.[12] Sold by Sabin, as Pater, to Max and Leola Epstein, Chicago, 1934;[13] given to the Art Institute, 1954.

REFERENCES: P[ierre] Hédouin, "Watteau III: Catalogue de son oeuvre," L'Artiste: Revue de Paris 4th ser., 5 (1845), p. 80, no. 137. [Gustave Friedrich] Waagen, Galleries and Cabinets of Art in Great Britain . . . , London, 1857, p. 84. Edmond de Goncourt, Catalogue raisonné de l'oeuvre peint, dessiné et gravé d'Antoine Watteau, Paris, 1875, p. 162. André Joubin, "Un Catalogue de vente illustré par Jules Boilly," Beaux-Arts: Revue d'information artistique 3 (1925), p. 336. Louis Hourticq et al., Le Paysage français de Poussin à Corot à l'exposition du Petit Palais (Mai-Juin 1925), Paris, 1926, p. 144, no. P249. Florence Ingersoll-Smouse, Pater, Paris, 1928, p. 44, no. 81. Hélène Adhémar, Watteau: Sa Vie—son oeuvre, Paris, 1950, p. 241, no. 314. AIC 1961, pp. 350–51. Frederick A. Sweet, "Great Chicago Collectors," Apollo 84 (September 1966), p. 203, p. 205, fig. 39. Ettore Camesasca and John Sunderland, The Complete Paintings of Watteau, New York, 1968, p. 128, no. 2°D. John Ingamells, The Wallace Collection: Catalogue of Pictures, pt. 3, French before 1815, London, 1989, p. 388, no. 118. Wright 1991, vol. 1, p. 454, vol. 2, pp. 62, 607.

EXHIBITIONS: Manchester, City Art Gallery, Art Treasures of the United Kingdom, 1857, no. 29, as Pater. London, Bethnal Green Branch of the South Kensington Museum, Paintings, Porcelain, Bronzes, Decorative Furniture, and Other Works of Art, Lent for Exhibition . . . by Sir Richard Wallace, Bart., M.P., 1872–75, no. 436, as Pater, Pleasure Seekers. Paris, Palais des Beaux-Arts de la Ville de Paris (Petit Palais), Exposition du paysage français de Poussin à Corot, 1925, no. 149, as Pater. The University of Chicago, Renaissance Society, Max Epstein Memorial Exhibition, 1955, no. 13, as Pater. The Art Institute of Chicago, Selected Works of Eighteenth-Century French Art in the Collections of The Art Institute of Chicago, 1976, no. 4, as Imitator of Jean Antoine Watteau.

Considered one of the most gifted draftsmen of all time, Jean Antoine Watteau created the genre of painting known as *fête galante*, scenes of elegant, outdoor gatherings of an amorous nature. These lyrical depictions of well-bred gentlemen and ladies engaged in intimate conversation and music-making came to define the early rococo period of art in France. Watteau was born in the Flemish town of Valenciennes, where he received some initial training before moving, in 1702, to Paris. There he worked first in the studio of the painter Claude Gillot and later with Claude Audran III, a painter of decorative ensembles and the *concierge* (curator) of the Palais du Luxembourg. By 1712 Watteau's stature as an independent artist was such that the Academy was prepared to admit him. However, because of his delay in submitting his reception piece, *Pilgrimage to the Island of Cythera* (Louvre),[14] he was not officially accepted until 1717. Except for stays in Valenciennes (1709–11) and London (1719–20), Watteau worked his entire life in or near Paris, where he established an impressive clientele that included the distinguished collectors Pierre Crozat, Pierre Jean Mariette, and Carl Gustaf Tessin. Although he had only one pupil, Jean Baptiste Pater (see 1973.312), Watteau had many followers and imitators, Nicolas Lancret (see 1948.565), Philippe Mercier (see 1969.333), and Pierre Antoine Quillard among them.

Although *Fête champêtre* has been variously attributed to Lancret, Pater, and to a follower of Pater, careful examination after recent treatment indicates that the painting is most likely a late work by Watteau. The picture is of very high quality and corresponds closely in style, motif, and detail to such later Watteau paintings as *Les Champs Elysées* (London, Wallace Collection), *Fêtes vénitiennes* (Edinburgh, National Gallery of Scotland), and *The Enchanted Isle* (Switzerland, private collection), and would therefore seem to date to the years 1718/21.[15] Information gained from technical examination and from analysis of the picture's condition problems (see Condition), which are similar to problems typically found in Watteau's paintings, also strongly supports the attribution to Watteau. These inherent defects, as well as others caused by later intervention, have distorted numerous areas of the painting and largely account for the picture's neglect by scholars, despite its beauty and distinguished provenance.

Because of the picture's apparent connection with a small sketch by Gabriel de Saint-Aubin, the provenance of the painting can probably be traced back to the third

Fig. 2 *Fête champêtre*, 1954.295 (photograph taken in the early 1930s)

quarter of the eighteenth century. Kindly brought to the author's attention by Pierre Rosenberg, the drawing appears in the margin of a 1773 catalogue (preserved in the Bibliothèque Nationale, Paris) of works placed at auction in Paris by the painter and art dealer Jean Baptiste Pierre Le Brun.[16] The drawing, a black-chalk *croquis* (fig. 3), was quickly executed beside no. 117, a painting attributed to Watteau and described as follows:

> Vingt-six figures de pouces de proportions, occupées a chanter, à jouer & à se promener dans différens endroits d'un Parc très-orné d'arbres. La belle couleur rend ce Tableau un des plus capitaux qui soit connu de ce Maître.[17]

Not only do the sketch and figure count accord with the *Fête champêtre*, but the measurements recorded in the catalogue — seventeen by twenty-three *pouces* (45.9 x 62.1 cm) — roughly correspond as well. While it is possible that Saint-Aubin's drawing reproduces another, lost version of the Chicago composition, the identical number of figures, which includes the very small background figures, makes this unlikely.

Fête champêtre can also probably be identified with *The Concert in the Park* once in the possession of the miniaturist and collector Daniel Saint (1778–1847), and ascribed in the catalogue of his 1846 sale to Watteau.[18] The catalogue describes details identical to those of the Chicago work except that the woman defending herself from the advances of a young man is placed to the right of the other figures in the work; in the Chicago painting, the woman and her suitor appear to the left of the main group of figures. This picture was among forty-one paintings attributed to Watteau in the Saint sale, of

which at least thirty-six were autograph.[19] Pierre Hédouin, who was the first to catalogue Watteau's paintings, apparently viewed *Fête champêtre* when it was in Saint's collection, and had special praise for the picture.[20] In 1857 Gustave Waagen preferred to attribute the work, then in the Hertford collection, to Watteau's only student, Pater, and it was lent to the exhibition *Art Treasures of the United Kingdom,* in Manchester, as a Pater. After the painting passed to Sir Richard Wallace, however, Edmond de Goncourt (1875) reasserted the earlier attribution to Watteau. The painting subsequently appeared in exhibitions and sales ascribed either to Pater or Lancret. Although Gastone Brière (in Hourticq 1926) and Florence Ingersoll-Smouse (1928) rejected these attributions, assigning the picture to an anonymous imitator of Watteau, the painting was accessioned by the Art Institute as a Pater.[21] J. Patrice Marandel (1976 exhibition catalogue) reattributed the painting to an "imitator of Watteau." In 1983 Martin Eidelberg, on the basis of a color transparency, suggested that the picture be reclassified as Pater or school of Pater.[22]

Recent treatment of *Fête champêtre* has made apparent, however, some significant differences in style and technique between it and paintings by Pater. The Chicago painting's lyrical arrangement of figures engaged in subtle interaction contrasts with Pater's typically more sprightly, less carefully composed clusters of figures. The manner in which the figures are embedded in the landscape and enveloped by light and

Fig. 3 Gabriel de Saint-Aubin, sketch after a Watteau painting in the margin of a sale catalogue, Pierre Rémy, Paris, December 20, 22, and 23, 1773, next to no. 117, Bibliothèque Nationale, Paris [photo: © cliché Bibliothèque Nationale de France, Paris]

atmosphere also is less characteristic of Pater than of Watteau. Moreover, the handling of paint, with its complex, Rubenesque interlayering of opaque and transparent colors, does not accord with Pater's technique, which tended to be much more facile and summary. Only the somewhat stiff posture of the woman holding the sheets of music and the generalized handling of her costume and those of the woman in black and the standing woman in pink relate to aspects of Pater's paintings. The treatment of these areas has caused Margaret Morgan Grasselli and others to suggest that this was an unfinished work that Watteau, in the last weeks of his life, permitted Pater to complete, or a work that the young painter decided on his own to finish after his teacher's death.[23] While Pater's intervention is very possible, the appearance of these passages is, to some degree, the result of damages, particularly of a loss of glazes. Taking their condition into account, these areas are not wholly inconsistent with Watteau's manner. Stylistic correspondences with pictures by Pater may be attributed to the fact that Pater based his manner on Watteau's works from this period. In its painterly technique, in fact, this work is much closer to paintings by Nicolas Lancret, but the picture cannot in any other respect be associated with paintings by that artist, nor with the works of any of Watteau's other known followers or imitators.

Rather, comparison of *Fête champêtre* with paintings and drawings by Watteau provides compelling evidence that Watteau himself was responsible for most, if not all, of the picture. In theme, composition, and figural motif, the Chicago painting is very similar to a number of Watteau *fêtes galantes* usually dated to the late teens, such as *Les Champs Elysées* and *Fête in a Park* (*Divertissements champêtres*) (London, Wallace Collection), *The Enchanted Isle, Assembly in a Park* (Louvre), and *Le Bosquet de Bacchus*, a painting that is lost but known from an engraving by Charles Nicolas Cochin.[24] In each case, a group of figures is casually distributed across the foreground while an amorous couple, or pair of couples, drifts toward water or into the forest, presumably for a more private interlude. This activity is gently implied in the present painting as, at far right, one couple enters into the woods while another seems prepared to follow. X-radiography (fig. 1) reveals that this theme of romantic passage or pilgrimage was originally made more explicit in the work. Painted out of the composition were the figures of a man with plumed hat and bagpipes at left—who may have been beckoning

the others to the water in the left background—and a woman, seen from behind and holding a pilgrim's staff in her left hand, who is somewhat difficult to discern in the lower right corner. Perhaps completed not long after Watteau's second version of *The Embarkation for Cythera* (1718/19; Berlin, Schloss Charlottenburg, Staatliche Schlösser und Garten), the Chicago picture at an early stage seems to have echoed it.[25]

Like Watteau's *Cythera* paintings in Berlin and the Louvre, the Chicago composition alludes to the phases of love, as the activities of several couples are orchestrated to represent, in a continuous narration, the romantic progress of one pair. In the *Cythera* pictures, this narrative unfolds from right to left, as childhood innocence gives way to romantic enchantment and courtship, which, in turn, leads to amorous attainment. The direction has been reversed in the Chicago painting, and the staging is even more casual. A trio of very young girls collects flowers at the far left. Seated to the right of this group is an adolescent girl, who assumes a pivotal position—though ostensibly a member of the central group of adults, she looks back to the children. To the immediate right of this figure, and at the left of the main group of figures, a young man makes an unexpected and unwelcome amorous advance toward a young woman. Just beside them another young woman, holding sheets of music in her lap, seems entranced by the music of a guitarist. Standing to the right of this figure, with her back turned to the viewer, a woman in a pink satin gown presumably deliberates the proposition of her male companion, who seems prepared to lead her into the woods at right, following another couple. As in the *Cythera* paintings, the temporal and transitory nature of romance is underscored by the changing autumn leaves and waning afternoon light.

Characteristic of Watteau is the graceful and poetic manner in which the intrigues play out. Indeed, only the unsuccessful pass of the young man at center interrupts the scene's calm—a faux pas that the painter discreetly punctuated with a broken branch in the foliage directly above the would-be suitor's offending arm. A subtle, symbolic gloss such as this would seem to indicate Watteau's authorship, as would the telling alterations the artist made to several figures as he developed the composition.

X-radiography (fig. 1) reveals that the young girl seated at the far left, with her skirt held open to receive flowers, was at first presented more frontally and clutching what appears to have been a large bundle or

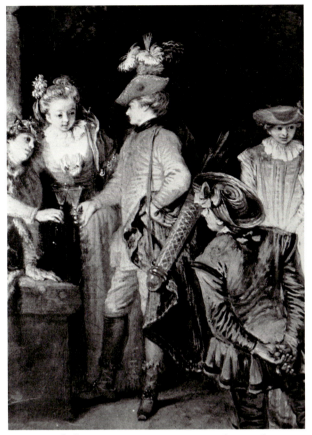

Fig. 4 Detail of Jean Antoine Watteau, *Love in the French Theater*, Staatliche Museen zu Berlin, Preussischer Kulturbesitz, Gemäldegalerie, Berlin [Photo: Jörg P. Anders]

sack. Her final pose is not only more elegant but more poignant, as it parallels that of the woman with the musical score. The x-radiograph shows a significant change in the position of the young woman with the fan, who was originally shown in profile, facing the adults; this emendation emphasizes her pivotal role between the groups of children and adults.

This revision is particularly compelling evidence of Watteau's authorship, since he changed in virtually the same way a very similar figure in the Wallace Collection's *Fête in a Park*. Remarkably, a *pentimento* and x-radiography indicate that a woman in the left middle distance of the Wallace painting was also conceived at an earlier stage of the design process as oriented to the right and facing a group of figures. Such correspondences suggest the workings of a single mind and hand, and a method of composing that is consistent with what is known of Watteau's design process, which involved his intuitively positioning and repositioning on panel or canvas figures derived from his myriad figure drawings.[26]

Among the many other revisions in *Fête champêtre*, perhaps the most significant was made to the head of the

cavalier male figure in the copper-colored costume at right. A *pentimento* on the right side of the man's face indicates that the head was initially represented in profile, and that originally the man would have almost exactly matched, in his pose and the arrangement of his costume, a figure that stands near the center of Watteau's *Love in the French Theater* (fig. 4).[27] In reworking the figure in the Chicago painting, the artist reoriented his head, changed his hat and collar, slightly broadened the torso, and subtly adjusted the left hand to a more elegant position. Scrupulous in rendering hands, especially those of musicians, Watteau also adjusted the left thumb of the guitarist, as is visible even to the naked eye. Additional *pentimenti* and changes visible only in the x-radiograph are noted above in the Condition section.

Because Watteau continually looked to his file of figure drawings, frequently reusing his older studies as

Fig. 5 Detail of Jean Antoine Watteau, *Three Studies of a Woman and a Study of a Hand*, Nationalmuseum, Stockholm

he composed his paintings, certain figures appear, with slight variations, in many of his works. In the Chicago painting, the most prominent recurrent figural motif is the standing woman in pink, which can be connected with a red-chalk drawing in the Nationalmuseum, Stockholm (no. 2824), and which is found in at least one other Watteau painting. Although the central study on the Stockholm sheet (fig. 5) has always been linked with a figure in Watteau's *The Two Cousins* (Louvre), it actually compares more closely with the woman in the Chicago picture, especially in the inclusion of a necklace.[28]

The kneeling man in the Chicago picture and his unwilling companion were cast, with some slight differences in pose, in several Watteau paintings, notably *Assembly in a Park*, *The Enchanted Isle*, *Fêtes vénitiennes*, and *Le Conteur* (c. 1716; Switzerland, private collection).[29] The source for this woman was apparently a graphite and red-chalk study in the British Museum, the model also for the female figures clutching flowers to their chests in *Les Champs Elysées*, *The Two Cousins*, and *Fête in a Park*.[30] Her luckless suitor, with his fine, sensitive features, closely resembles a gentleman seated in the foreground of *Fête in a Park*. This particular facial type occurs infrequently in Watteau's works and, no doubt because of its distinctive, portraitlike aspect, was not imitated by Pater and other Watteau followers, who preferred to emulate the more idealized or caricatured facial types in Watteau's art, such as the guitarist in the Chicago picture.[31] Besides the Stockholm and British Museum drawings, several other surviving studies seem to have been consulted for the Chicago work, including that of a seated man on a sheet preserved in the Musée des Beaux-Arts de Lille (no. 1709) and a drawing of a seated woman in the Musée Condé, Chantilly.[32]

Of Flemish heritage, Watteau studied and assimilated the style and technique of Rubens more profoundly than did any of his French contemporaries and followers. In the Chicago picture, the complex buildup of glazes probably derived from the artist's examination of the paintings of Rubens, particularly those in the Palais du Luxembourg, Paris, and in the collection of the financier Pierre Crozat. Many of the heads and costumes in the work have a relieflike effect, as they have been molded with what seems to have been a viscous paint. This distinctive, sculptural quality is found also in other Watteau paintings on panel, including *Les Champs Elysées* and the Art Institute's *The Dreamer* (*La Rêveuse*) (see 1960.305).

Watteau's employment of a light-colored ground in the Chicago work and several other paintings also may be due to his Flemish background. It appears that light-colored grounds of white or yellow ocher were very rare in France in the seventeenth and eighteenth centuries, and are usually associated with Netherlandish painting.[33] The artist toned the white ground of *Fête champêtre* with a dark brown imprimatura (see Condition), a technique akin to Rubens's use of a gray imprimatura over a chalk ground. Often Watteau, too, used in his paintings a gray imprimatura or ground which, like Rubens's, was permitted to show through transparent glazes and function as a middle tone to model forms.[34] In the Chicago work and other paintings, Watteau, like Rubens, inverted traditional painting practices by placing opaque highlights on top of darker transparent glazes to model faces and hands and to add expressive flourishes to collars and cuffs.[35] He thus executed the painting as he would a highly finished drawing with wash and white heightening—the modus operandi of an artist who, it is reported, felt more comfortable with graphic media than with paints.[36]

Just as Watteau's direct and very individual response to Rubens distinguishes his works from those of his followers, so too does his profound assimilation of elements from Venetian art. Watteau enthusiastically examined and sometimes copied the Venetian Renaissance drawings and paintings he found in Crozat's collection. His admiration for the Venetian treatment of light and atmosphere is apparent in his own rendering of the village in the left background of the Chicago picture. This small rural townscape, which is virtually identical in handling to those in Watteau's *Meeting in the Open Air* (*Réunion en plein air*; 1717/18; Dresden, Gemäldegalerie), *The Music Party* (*Les Charmes de la vie*; c. 1718; London, Wallace Collection),[37] and *Les Champs Elysées*, has the same tower and wooden structures with long, low-pitched roofs that Watteau would have observed in Campagnola prints and drawings. In fact, there is a red-chalk study by Watteau in the Louvre (no. 34657),[38] clearly dependent on a Campagnola landscape, in which the buildings are extremely similar to those in the Chicago picture. While a few of Watteau's followers included Italianate structures in their works, none imitated Venetian art so assiduously.[39]

No less Venetian in spirit is the vibrant sky of *Fête champêtre*. Comparably complex and animated cloud formations can be seen in many other Watteau paintings, such as *Les Champs Elysées*, *Fêtes vénitiennes*,

and the Art Institute's *The Dreamer* (*La Rêveuse*) (1960.305). The lush foliage of *Fête champêtre*, which probably also has its origins in Venetian paintings, and the long, thin, tree trunks match those in numerous paintings by Watteau. The manner of rendering individual leaves in the Chicago picture, so that the paint is pressed outward with the brush to create tiny wedge shapes, has been noted in other paintings by Watteau.[40] Among the other details that point to Watteau's authorship are the treatment of hands and garment folds, the delicately painted plants and grasses in the foreground, and the small background figures and dog. Although this background group was damaged in cleaning prior to 1976 (see Condition), photographs (see fig. 2) exist that show the figures before five were virtually deleted and two were severely abraded.

The Watteau attribution is further corroborated by certain aspects of the Chicago work's condition. The extensive cracking and alligatoring of the present picture is found in the majority of Watteau's paintings, due apparently to his improper use of fast-drying oil paints. According to the comte de Caylus, Watteau was careless in his employment of *huile grasse* (medium-rich paint), neglecting to make the lengthy preparations the technique requires.[41] As a result, slower-drying lower layers of paint in his pictures caused obtrusive wrinkling and cracking in the upper layers. This condition is slightly less pronounced in the Chicago work than it is in some of Watteau's paintings, but it nevertheless alters the general texture of the picture's surface and gives some forms, particularly those the artist reworked, a fractured aspect.[42] These broken forms are especially prominent in *Fête champêtre* because the artist executed the painting in the tighter, more "finished" style he sometimes employed in the late teens and early twenties, in works such as *Italian Comedians* (Washington, D.C., National Gallery of Art), *The Halt During the Chase* (*Rendezvous de chasse*; c. 1720; London, Wallace Collection), and *Gersaint's Shopsign* (c. 1721; Berlin, Schloss Charlottenburg, Staatliche Schlösser und Garten).[43]

L. J. F.

NOTES

1 These treatments were performed by Alfred Jakstas.

2 This treatment was performed by Frank Zuccari.

3 It is unclear whether this application of red lake represents a change in the artist's intention or whether the red was meant to serve as an underdrawing or underpaint. In the adjacent figure of the woman with the red headpiece, red lines are faintly visible along the edges of the arm and torso where the paint has been thinned. A comparable but more extensive underdrawing in red

lake was discovered on Watteau's *Italian Comedians* (c. 1720) in the National Gallery of Art, Washington, D.C. (see Sarah Fisher, "The Examination and Treatment of Watteau's Italian Comedians," in Margaret Morgan Grasselli and Pierre Rosenberg, *Watteau, 1684–1721*, exh. cat., Washington, D.C., National Gallery of Art, 1984, traveled to Paris and Berlin, p. 465; for a reproduction, see p. 441, no. 71).

4 See discussion. Remembered chiefly as the unfaithful and unscrupulous husband of the painter Elisabeth Louise Vigée-Le Brun, Jean Baptiste Pierre Le Brun, was, in fact, one of the most discerning and successful art dealers of the late eighteenth and early nineteenth centuries. For information on Le Brun, see Gilberte Emile-Mâle, "Jean-Baptiste-Pierre Le Brun (1748–1813)—son rôle dans l'histoire de la restauration des tableaux du Louvre," *Mémoires de la Fédération des Sociétés historiques et archéologiques de Paris et de l'Ile-de-France*, pt. VIII (1956), pp. 371–417, and Francis Haskell, *Rediscoveries in Art: Some Aspects of Taste, Fashion, and Collecting in England and France*, New York, 1976, pp. 18–23.

5 See Hédouin 1845, p. 80, and the 1846 sale catalogue.

6 The following description of the painting is given in the sale catalogue:

Dix-neuf personnages diversement groupés animent cette charmante composition. Dans le groupe principal, on remarque parfaitement éclairé, une jeune femme en galant costume, corsage de satin rose et jupe de satin blanc; elle tient sur ses genoux un livre de musique, dans le quel elle paraît chanter; un homme placé près d'elle, et jouant de la guitare, semble l'accompagner. Un peu plus loin un homme et une femme se promènent et causent; à droite une jeune fille se défend des caresses d'un jeune homme. Ce tableau, l'un des plus terminés du maître, a été fait à Nogent-sur-Marne, village qu'habitait Watteau, que s'est plu à représenter sous les habits d'un de ses personnages, le portrait du curé de l'endroit. (Nineteen figures variously grouped animate this attractive composition. In the principal group one notices, perfectly illuminated, a young woman in elegant dress, bodice of pink satin and skirt of white satin; she holds on her knees a book of music, from which she appears to sing; a man placed nearby, and playing a guitar, seems to accompany her. A little further away a man and woman stroll and converse; at right a young woman defends herself from the caresses of a young man. This painting, one of the most finished of the master, was painted at Nogent-sur-Marne, [the] village in which Watteau lived, [and] whose local parish priest is supposedly represented as one of the figures.)

The writer did not count the figures in the left background. It is not possible to confirm whether the picture was executed at Nogent-sur-Marne and includes a portrait of the local priest. Support and dimensions were not recorded in the sale catalogue. The price is recorded by Goncourt (1875) and in annotated sale catalogues in the Frick Art Reference Library, New York, and the Bibliothèque Doucet, Paris. The 4,900 francs the painting sold for was substantially more than the 3,805 francs paid for the preceding lot, Watteau's *La Perspective*. Susan Wise was the first to associate the Chicago picture with the work in the Saint sale. However, she ascribed the Chicago painting to a follower of Pater (unpublished catalogue entry of 1990, in curatorial files).

7 Waagen 1857, pp. 79, 84. It is assumed that Conway bought *Fête champêtre* from Saint because Conway is known to have acquired Watteau's *La Perspective* (Boston, Museum of Fine Arts) at that sale; both works eventually passed from Conway to the collection of Richard Wallace. For a reproduction of *La Perspective*, see Camesasca and Sunderland 1968, pls. IV–V.

8 Waagen 1857, pp. 79, 84.

9 Murray Scott had been Sir Richard Wallace's secretary and was Lady Wallace's residuary legatee; see letter of May 20, 1981,

from John Ingamells to Mary Kuzniar, in curatorial files.

10 According to an annotated sale catalogue at Christie's, London.

11 According to a letter of April 7, 1981, from William Joll (Agnew's) to Mary Kuzniar, in curatorial files.

12 According to an annotated sale catalogue in the Ryerson Library, The Art Institute of Chicago.

13 The painting was received from Sabin on behalf of the Epsteins by the Art Institute; copies of the museum's shipping order and receipt, dated April 27, 1934, are preserved in curatorial files.

14 Reproduced in Grasselli and Rosenberg (note 3), pp. 396–97.

15 See Camesasca and Sunderland 1968, pls. XXV, XXXIV, and Grasselli and Rosenberg (note 3), no. 60 (ill.), respectively.

16 Letter from Pierre Rosenberg to the author of December 1, 1995, in curatorial files. See also Provenance and note 4.

17 "Twenty-six figures, each five *pouces* in size, are engaged in singing, playing, and promenading in various areas of a park highly ornamented with trees. The beautiful color of the painting makes it one of the preeminent works known by this master."

18 See note 6.

19 Also included in the Saint sale, besides Boston's *La Perspective*, were a group of thirty decorative panels (chinoiseries; location unknown) for the Château de la Muette, Paris; *L'Alliance de la musique et de la comédie* (The Fine Arts Museum of San Francisco); versions of *Country Picnic with Two Young Couples* (*La Colation*; location unknown, engraved by Moyreau) and *The Rustic Betrothal* (*L'Accordée de village*; location unknown; prime version in Sir John Soane's Museum, London); *Les Amusements de Cythère* (location unknown; engraved by Surugue); and *Les Agrémens de l'esté* (United States, private collection). Saint's collection of Watteau drawings was sold with the paintings.

20 Hédouin 1845, p. 80.

21 Adhémar and Camesasca, who did not associate the Chicago work with the Saint picture, listed the latter among Watteau's "doubtful paintings"; see Adhémar 1950, p. 241, no. 314, and Camesasca and Sunderland 1968, p. 128, D.

22 Letter of March 9, 1983, from Martin Eidelberg to Susan Wise, in curatorial files.

23 Margaret Morgan Grasselli, verbally to the author on September 19, 1995 (notes in curatorial files). According to Grasselli, Pater was probably responsible for the costumes of the woman with the sheets of music, the woman in pink, the seated woman in black, and the woman to her right, and executed the entire figure of the guitarist. Colin Bailey and Alan P. Wintermute (letters of November 14 and 16, 1995, respectively, to the author, in curatorial files) perceived the touch of Pater (or another artist) in these figures and in the figure to the left of the woman in black. Philip Conisbee (letter to the author of March 14, 1996, in curatorial files) also indicated his belief that the picture was "a Watteau completed or perhaps in some way given cosmetic touches by Pater." Taking into consideration the condition of the painting, Conisbee saw less involvement by Pater than did Grasselli, Bailey, and Wintermute. Edmond and Jules de Goncourt had suspected that the Watteau and Pater had collaborated on paintings; they reported that "a picture which appeared as No. 530 in the sale of the Abbé de Gévigney, keeper of the heraldry section of the Royal Library, a picture in which most of the figures 'were painted by Watteau and the rest by Pater,' would suggest that the pictures left unfinished by Watteau may have been completed by Pater." See Edmond and Jules de Goncourt, *French XVIII Century Painters*, London, 1948, p. 49. For the abbé de Gévigney's picture and other Watteaus presumed to have been finished by Pater, see Ingersoll-Smouse 1928, p. 85, nos. 589–92.

24 *Fête in a Park* and *Assembly in a Park* are reproduced in Camesasca and Sunderland 1968, pls. XX–XXI and XXVII,

respectively, and the engraving after *Le Bosquet de Bacchus* in Emile Dacier and Albert Vuaflart, *Jean de Jullienne et les graveurs de Watteau au XVIII^e siècle*, vol. 3, Paris, 1921, pp. 111–112, no. 265.

25 For a reproduction of the Berlin *Cythera*, see Grasselli and Rosenberg (note 3), no. 62.

26 For Watteau's method of composing his paintings, see comte de Caylus, "La vie d'Antoine Watteau," in Pierre Rosenberg, ed., *Vies anciennes de Watteau*, Paris, 1984, pp. 78–80, and Catheline Perier-D'Ieteren, "La Technique d'execution de Rubens et de Watteau: Filiation et rupture," in *Watteau: Technique picturale et problèmes de restauration*, Série speciale des Annales d'histoire de l'art et d'archéologie de l'Université libre de Bruxelles, Brussels, 1986, pp. 39–40. To explain the extremely similar changes to the figures in the Chicago and Wallace paintings, one would have to imagine a highly unlikely scenario in which a pupil in the artist's shop, seeing Watteau alter a figure in *Fête in a Park*, decided to adjust the same figure in his own painting in almost the same way. Such a course of events is made even more improbable by the biographies written by Watteau's friends, who report that the temperamental painter had only Pater as a pupil, first very briefly after the young artist arrived in Paris from Valenciennes (probably between 1713 and 1716) and, later, in the last month of Watteau's life, probably two or three years after *Fête in a Park* was executed. See Edme François Gersaint, "Catalogue de Feu M. Quentin De Lorangère," in Adhémar 1950, p. 172.

27 Both figures no doubt are based on an early Watteau red-chalk drawing of a man with a glass and quiver, which is now in a private collection in Paris and is reproduced in K. T. Parker and J. Mathey, *Antoine Watteau: Catalogue complet de son oeuvre dessiné*, vol. 1, Paris, 1957, p. 10, no. 56, fig. 56.

28 The figure in the Chicago painting is slightly larger (2 cm in height) than that in the drawing (see Parker and Mathey [note 27], vol. 2, p. 319, no. 637, fig. 637), and the painted dress extends a bit further on the right. The artist probably made this adjustment to cover the right leg of the man standing beside her. Because the male figure's head and upper body had been reoriented, the leg would have seemed awkward if it had been shown in its original, profile position. For an illustration of *The Two Cousins*, see Grasselli and Rosenberg (note 3), p. 356, no. 47.

29 See Grasselli and Rosenberg (note 3), p. 145, fig. 2.

30 See Parker and Mathey (note 27), p. 315, no. 602, fig. 602.

31 Very similar to the head of the suitor is the refined countenance of a man in the shadows at right; Pater and other Watteau followers seldom rendered minor background figures so carefully or skillfully.

32 For illustrations of the Lille and Chantilly drawings, see Parker and Mathey (note 27), vol. 2, p. 312, no. 569, fig. 569, and vol. 2, p. 327, no. 667, fig. 667.

33 See Lola Faillant-Dumas, "Antoine Watteau: Etude au Laboratoire de Recherche des Musées de France," p. 56, and Ségolène Bergeon, Catheline Perier-D'Ieteren, and Claire Ruytinx, "Technique picturale de Watteau, d'après les tableaux du Louvre," p. 64, in *Watteau: Technique picturale . . .* (note 26).

34 Watteau also painted *Autumn* (Louvre; see Grasselli and Rosenberg [note 3], p. 324, no. 34 [ill.]) and The Art Institute's *The Dreamer* (*La Rêveuse*; see 1960.305) over gray grounds. For Watteau's and Rubens's employment of gray grounds and imprimaturas, see Perier-D'Ieteren (note 26), pp. 30–31.

35 For Watteau's use of this unorthodox technique, see Perier-D'Ieteren (note 26), pp. 31–32.

36 According to his friend the art dealer Gersaint, Watteau was frustrated that he could not render in paint effects he achieved with chalk; see "Catalogue raisonné de bijoux, porcelaines, bronzes . . . de M. Angran, Vicomte de Fonspertuis" in

Rosenberg (note 26), p. 44.

37 See Donald Posner, *Antoine Watteau*, London, 1984, pl. 35, and
 Camesasca and Sunderland 1968, pls. XII–XIII, respectively.

38 See Parker and Mathey (note 27), vol. 1, p. 57, no. 432, fig. 432.
 Margaret Morgan Grasselli (letter of November 14, 1995, in
 curatorial files) has kindly pointed out that Watteau may have
 derived this Campagnolesque motif from an Annibale Carracci
 drawing. A Carracci drawing of the same farmhouse, executed
 in pen and brown ink over red chalk, was formerly in the
 Ellesmere collection; see *Catalogue of the Ellesmere Collection
 of Drawings by the Carracci and other Bolognese Masters*,
 pt. 1, Sotheby's, London, July 11, 1972, no. 57 (ill.). It is equally,
 if not more, probable that Watteau was looking at the same
 (lost) Campagnola source as Carracci, whose study is much
 more elaborate than Watteau's.

39 For Italian motifs in the works of Watteau's followers, see
 Martin Eidelberg, "Watteau's Italian Reveries," *GBA* 6th ser.,
 126 (1995), pp. 115–116 and 131.

40 See Ségolène Bergeon and Lola Faillant-Dumas, "The
 Restoration of the *Pilgrimage to the Island of Cythera*," in
 Grasselli and Rosenberg (note 3), p. 462 (esp. fig. 6).

41 See comte de Caylus (note 26), p. 40; Perier-D'Ieteren (note 26),
 p. 41; and Bergeon and Faillant-Dumas (note 40), p. 464 n. 33.

42 For the condition problems inherent in Watteau's paintings, see
 Ségolène Bergeon, "Quelques points de technique picturale,"
 in *Antoine Watteau (1684–1721): Le Peintre, son temps et
 sa legende*, ed. by François Moureau and Margaret Morgan
 Grasselli, Paris and Geneva, 1987, p. 139; Perier-D'Ieteren (note
 26), p. 41; and Bergeon, Perier-D'Ieteren, and Ruytinx (note
 33), p. 78.

43 For an illustration of the Berlin painting, see Grasselli and
 Rosenberg (note 3), no. 73. For a reproduction of the Wallace
 Collection picture, see Camesasca and Sunderland 1968, pls.
 XLIV–XLV. It is possible that Watteau's period in London, where
 he may have adjusted to the tastes of an English clientele, or his
 acceptance into the Academy may have precipitated his tighter,
 late style. Noting that Watteau's later paintings tend to be
 better preserved than his earlier ones, Marianne Roland Michel
 (*Watteau: An Artist of the Eighteenth Century*, New York,
 1984, pp. 207–09) suggested that his participation in the French
 Academy—and criticism of his working methods—may have
 caused him to pay more attention to his technique.

Jean Antoine Watteau

1684 Valenciennes–Nogent-sur-Marne 1721

The Dreamer (*La Rêveuse*), 1712/14

Mr. and Mrs. Lewis Larned Coburn Memorial Collection,
1960.305

Oil on panel, 23.2 x 17 cm (9⅛ x 6¹¹⁄₁₆ in.)

CONDITION: The painting is in good condition. It was cleaned
in 1960.[1] The panel has been thinned to 0.3 cm and cradled.
The relatively thin paint layer, applied over a whitish gray
ground, has a traction craquelure along the left edge and across
the lower foreground due to uneven drying of the rich paint
medium. The paint surface has been slightly damaged by
cleaning, with the most notable abrasion in the shadows of the
red drapery. In 1962 the traction crackle was inpainted and
localized retouches were made on the chin, cheek, and neck,
and in the shadows of the red drapery.[2] The lines of the fan
have also been reinforced. (infrared, stripped state, ultraviolet,
x-radiograph)

PROVENANCE: Possibly the abbé Pierre Maurice Haranger
(d. 1735), canon of Saint-Germain-l'Auxerrois, Paris.[3] Comte
du Barry, Paris; sold Remy and Le Brun, Paris, November 21
and following, 1774, no. 132, for 190 *livres*.[4] Anne Pierre, mar-
quis de Montesquiou, Paris; sold Le Brun, Paris, December 9
and following, 1788, no. 214.[5] Jules Burat (d. 1885), Paris,
1866–85; sold Galerie Georges Petit, Paris, April 28–29, 1885,
no. 109 (ill. with engraving by Léon Gaucherel), as Lancret, to
Laurent-Richard for Fr 7,000.[6] Vincent Claude Laurent-Richard
(d. 1886), Paris; sold Galerie Georges Petit, Paris, May 28–29,
1886, no. 29 (ill. with engraving by Gaucherel), as Lancret, to
Blumenthal for Fr 6,200.[7] Willy Blumenthal, Paris, to at least

1929.[8] Wildenstein, New York, by 1943; sold to the Art
Institute, 1960.

REFERENCES: P[ierre] Hédouin, "Watteau III: Catalogue de
son oeuvre," *L'Artiste: Revue de Paris* 4th ser., 5 (1845), p. 78,
no. 45. Edmond de Goncourt, *Catalogue raisonné de l'oeuvre
peint, dessiné et gravé d'Antoine Watteau*, Paris, 1875, p. 82,
no. 88. John W. Mollett, *Watteau*, New York and London, 1883,
p. 66, no. 88. Paul Leroi, "M. Jules Burat," *L'Art: Revue illus-
trée* 38 (1885), p. 169 (ill. with engraving by Léon Gaucherel,
following p. 171). Paul Eudel, *L'Hôtel Drouot et la curiosité en
1884–1885*, Paris, 1886, pp. 355, 367. Paul Eudel, *L'Hôtel
Drouot et la curiosité en 1885–1886*, Paris, 1887, p. 436. Louis
de Fourcaud, "Antoine Watteau: Scènes et figures galantes
(premier article)," *La Revue de l'art ancien et moderne* 16
(1904), pp. 345, 350 (ill. with engraving by Aveline), 353–54.
Emile Dacier, *Catalogues de ventes et livrets de salons illustrés
par Gabriel de Saint-Aubin*, vol. 2, Paris, 1910, pt. 3, p. 29
(p. 47 of sale cat. facsimile). Emile Dacier, Jacques Hérold, and
Albert Vuaflart, *Jean de Jullienne et les graveurs de Watteau
au XVIIIᵉ siècle*, 4 vols., Paris, 1921–29; vol. 1, Hérold and
Vuaflart, 1929, pp. 117, 178, 264, under no. 166; vol. 3, Dacier
and Vuaflart, 1922, p. 82, under no. 166. Georges Wildenstein,
Lancret, Paris, 1924, p. 117, no. 704, fig. 202 (engraving by
Léon Gaucherel). Louis Réau, "Watteau," in Louis Dimier, *Les
Peintres français du XVIIIᵉ siècle: Histoire des vies et catalogue
des oeuvres*, vol. 1, Paris and Brussels, 1928, pp. 38–39, no. 100.
Hélène Adhémar, *Watteau: Sa Vie—son oeuvre*, Paris, 1950,
p. 219, no. 145, pl. 77. R[aymond] Charmet, "De Watteau à
Prud'hon," in *Arts, spectacles* 567 (1956), p. 14 (ill.). Alexandre

Ananoff, *L'Oeuvre dessiné de Jean-Honoré Fragonard (1732–1806)*, vol. 2, Paris, 1963, p. 195, under no. 1123. I[nna] S. Nemilova, *Watteau et ses oeuvres à l'Ermitage* (in Russian, with French summary), Leningrad, 1964, pp. 87, 92, 158, 173 n. 21, fig. 40. John Maxon, "Some Recent Acquisitions," *Apollo* 84 (September 1966), p. 221, fig. 5. Ettore Camesasca and John Sunderland, *The Complete Paintings of Watteau*, New York, 1968, pp. 113–14, no. 165 (ill.). Giovanni Macchia and E. C. Montagni, *L'opera completa di Watteau*, Classici dell'arte 21, Milan, 1968, pp. 113–14, no. 165 (ill.). Maxon 1970, p. 261 (ill.). Jean Ferré et al., *Watteau*, Madrid, 1972, vol. 1, pp. 206–07, 214, chronology (n. pag.), under "1885," vol. 4, pp. 1111, 1120. Yvonne Boerlin-Brodbeck, "Antoine Watteau und das Theater," Ph.D. diss., Universität Basel, 1973, pp. 171, 176, 318 n. 435. I[nna] S. Nemilova, *The Enigmas of Old Paintings* (in Russian), Moscow, 1973, p. 150, fig. 38. John David Farmer, "A New Painting by François Boucher," *AIC Bulletin* 68, 2 (1974), p. 18 (ill.). Kimio Nakayama, *Watteau* (in Japanese), Tokyo, 1976, p. 107, no. 29 (ill.), pl. 29. *AIC 100 Masterpieces* 1978, p. 67, no. 28, pl. 28. Morse 1979, p. 298. Marianne Roland Michel, *Watteau*, Milan, 1981, p. 42, no. 120 (ill.). Nicole Parmantier, "Watteau, 1684–1721," *Le Petit Journal des grandes expositions* 146 (1984), n. pag. Donald Posner, *Antoine Watteau*, London, 1984, pp. 47, 256, fig. 39. Marianne Roland Michel, *Watteau: An Artist of the Eighteenth Century*, New York, 1984, p. 156, fig. 143. Pascale Thuillant, "L'Exposition des trois tiers (indiscutables, controversables, inacceptables) . . . ou un édifiant dialogue avec Jean Ferré," *L'Amateur d'art* 710 (1984), p. 8. Wolfgang Sauré, "Malerisches Spiel zwischen Sein und Schein: Die Kunst von Jean-Antoine Watteau (1684–1721)," *Die Kunst* 97 (1985), p. 197, fig. 8. Pierre Rosenberg, "Watteau: Le Recueil de Valenciennes," *La Revue du Louvre* 36, 4/5 (1986), p. 288. Margaret Morgan Grasselli, "The Drawings of Antoine Watteau: Stylistic Development and Problems of Chronology," Ph.D. diss., Harvard University, 1987 (Ann Arbor, Mich., University Microfilms, 1988), vol. 1, p. 208, vol. 2, fig. 227. Alan P. Wintermute in *Claude to Corot: The Development of Landscape Painting in France*, exh. cat., New York, Colnaghi, 1990, p. 122. Kimio Nakayama, *L'Oeuvre complet de Watteau* (in Japanese, with captions in French), Tokyo, 1991, pp. 213–14, no. 29 (ill.), 272 (ill.), pl. 29.

EXHIBITIONS: Paris, Société de protection des alsaciens et lorrains demeurés français, *Ouvrages de peinture exposés au profit de la colonisation de l'Algérie par les alsaciens-lorrains au Palais de la Présidence du Corps législatif*, 1874, no. 526. Paris, Galerie Georges Petit, *L'Art du XVIIIᵉ siècle*, 1883–84, no. 145. New York, Wildenstein, *Fashion in Headdress, 1450–1943*, 1943, no. 36. Paris, Gazette des Beaux-Arts, *De Watteau à Prud'hon*, 1956, no. 95. The Baltimore Museum of Art, *Age of Elegance: The Rococo and Its Effect*, 1959, no. 35. The Toledo Museum of Art, *The Age of Louis XV: French Painting, 1710–1774*, 1975–76, no. 120, cat. by Pierre Rosenberg, traveled to Chicago and Ottawa. The Art Institute of Chicago, *Selected Works of Eighteenth-Century French Art in the Collections of The Art Institute of Chicago*, 1976, no. 2. Washington, D.C., National Gallery of Art, *Watteau, 1684–1721*, 1984, no. P26, cat. by Margaret Morgan Grasselli, Pierre Rosenberg, et al., traveled to Paris and Berlin.

Although there is scant contemporary documentation of Watteau's brief life and career (see 1954.295), some information about his works, including *The Dreamer*, is provided by the numerous engravings after his paintings and drawings. Most of these prints were commissioned after the artist's death by his friend Jean de Jullienne (1686–1766), a collector and connoisseur who wished to preserve Watteau's reputation. The many engravings after paintings, at first sold as separate sheets, were bound into two volumes in 1735 and became known as the *Recueil Jullienne*. The 350 engravings after drawings comprise two volumes known as the *Figures de différents caractères*, published in 1726 and 1728, respectively.

The engraving after *The Dreamer* in the *Recueil* may shed light on the painting's early provenance. Also, several works related to the painting appear in the *Recueil* and in *Figures de différents caractères*. In April of 1729, the *Mercure* announced two new engravings by Pierre Aveline, *The Anxious Lover* and *The Dreamer* (fig. 1), which were issued on the same sheet and were

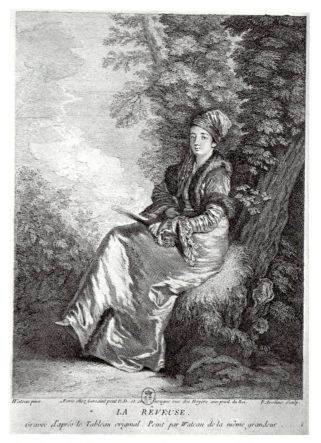

LA RÊVEUSE.

Fig. 1 Pierre Aveline, engraving after Jean Antoine Watteau, *The Dreamer (La Rêveuse)*, Bibliothèque Nationale, Paris [photo: © cliché Bibliothèque Nationale de France, Paris]

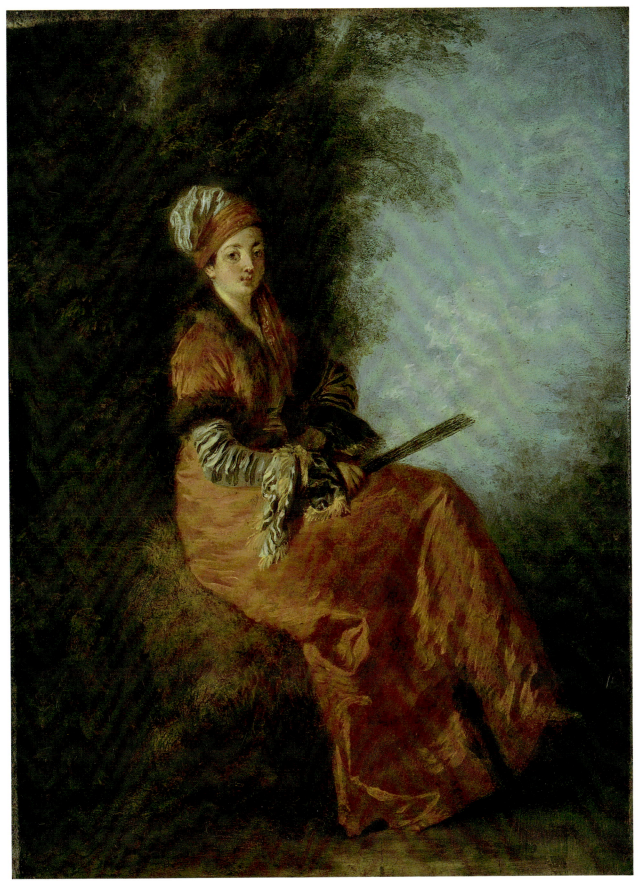

Jean Antoine Watteau, *The Dreamer (La Rêveuse)*, 1960.305 (reproduced actual size)

destined to enhance the *Recueil Jullienne*.[9] This pairing, together with a manuscript note by Pierre Jean Mariette identifying the owner of Watteau's painting *The Anxious Lover* (Chantilly, Musée Condé) as the abbé Haranger, led Jacques Hérold and Albert Vuaflart to suppose that the paintings were pendants and that *The Dreamer* may also have belonged to the abbé.[10] It is likely, however, as Pierre Rosenberg (1984 exhibition catalogue) suggested, that these two paintings were not conceived as pendants, but may have been engraved together because they were in the same collection, probably that of the abbé.[11] Also closely related to the Chicago work was the Watteau painting *The Polish Woman*, lost but known from an engraving by Michel Aubert (fig. 2), which similarly depicted a woman seated in a landscape.[12] In addition, two drawn studies for *The Dreamer* (locations unknown), mentioned by Edmond de Goncourt, were engraved by Jean Audran for the *Figures de différents caractères* (see fig. 3 for one of these).[13]

The attribution of *The Dreamer* to Watteau was undisputed until the late nineteenth century, when Eugène Féral, an expert for the 1885 Burat sale, declared the painting a work by Nicolas Lancret. The Burat sale catalogue, illustrated by Léon Gaucherel's engraving after the painting, contained conflicting opinions concerning the attribution. While Féral gave *The Dreamer* to Lancret in the entry for the sale catalogue, in the introduction Paul Mantz reasonably argued that it is unlikely that Antoine de La Roque, the director of the *Mercure* and a friend of Watteau, would have allowed the authorship of *The Dreamer* to be described incorrectly in the announcement of Aveline's engraving after it.[14]

Nevertheless, when the painting passed through the Laurent-Richard sale a year later, Philippe Burty, in the introduction to the catalogue, followed the opinion of Féral, who was an expert for that sale as well, and declared the painting a Lancret.[15] The Lancret attribution was not unanimously upheld in the following decades. Georges Wildenstein, while including the painting in his Lancret catalogue of 1924, was reluctant to make a firm decision since he had never seen the painting, but believed there was probably some foundation to Jullienne's attribution of the panel to Watteau. Since Louis Réau's publication of the picture as a Watteau in 1928, the attribution to this artist has remained virtually undisputed.[16]

Inna Nemilova (1964, 1973) proposed that the sitter is the well-known actress Charlotte Desmares (1682–1753), who was an art collector. Watteau was introduced to numerous theatrical personalities by Antoine de La Roque, who, in addition to directing the *Mercure*, wrote and produced plays. Nemilova believed that Watteau was particularly intrigued with Desmares and portrayed her holding a mask in *Coquettes* (St. Petersburg, Hermitage).[17] She also thought that this actress was the model for *The Polish Woman*, *The Polish Woman Standing*, and *The Dreamer*.[18] While Marianne Roland Michel (1984) accepted Nemilova's hypothesis, Pierre Rosenberg (1984 exhibition catalogue), agreeing that the same woman is portrayed in all four paintings, nevertheless expressed skepticism that the model was Desmares. A lost pastel portrait of the actress by Charles Antoine Coypel, dating to 1720/25 and known only through François Bernard Lépicié's 1733 engraving, presents a more generously fleshed woman with quite different features.[19] Rosenberg also observed that Desmares was never mentioned in connection with *The Dreamer* in the eighteenth-century literature on the painting. This is particularly significant, since Desmares was still alive when Aveline engraved the painting, and since La Roque, director of the *Mercure* when the engraving was announced, was acquainted with both the actress and the artist.[20]

The dress worn by the woman in the Chicago panel has also been the focus of scholarly interest. Nemilova believed the costume to be Polish, explaining that the cultural and political ties between France and Poland were so strong by the eighteenth century that it was not unusual to find an exchange of fashions between the two countries.[21] While noting that Polish women did wear fur-trimmed robes, Aileen Ribeiro observed that eastern European fashions were influenced by Turkish costumes. She described the clothes in the present painting as "pseudo-Turkish," and saw them as part of the vogue for "turquerie" in Western Europe at that time.[22] Certainly the eighteenth-century reference to the sitter as a seated female Turk would seem to corroborate this view.[23] Whether Watteau derived this type of costume from contemporary ladies' fashions or from the theater, which continually influenced his work, cannot be established.

Donald Posner provided what is perhaps the most cogent explanation for the single-figure composition of *The Dreamer* when he placed it in the context of Watteau's costume pieces. He believed that the idea for the painting grew out of Watteau's activities in the fashion-print industry.[24] In 1709–10 Watteau executed a

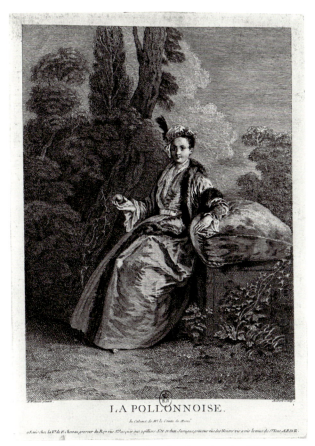

Fig. 2 Michel Aubert, engraving after Jean Antoine Watteau, *The Polish Woman*, Bibliothèque Nationale, Paris [photo: © cliché Bibliothèque Nationale de France, Paris]

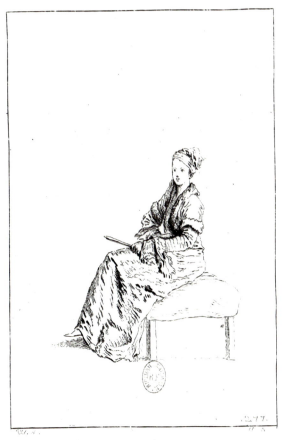

Fig. 3 Jean Audran, engraving after Jean Antoine Watteau, *Woman Seated, in an Oriental Costume, Holding a Fan*, from *Figures de différents caractères*, no. 277, Bibliothèque Nationale, Paris [photo: © cliché Bibliothèque Nationale de France, Paris]

series of fashion plates known as the *Figures de modes*; some five years later, he issued another group of etched single figures in costume known as the *Figures françoises et comiques*. Well acquainted with the engraved fashion plates popularized a century earlier, he modeled his own plates after those by Jacques Callot, Abraham Bosse, Sébastien Leclerc, the Bonnarts, and Nicolas Arnoult. Unlike those artists, however, Watteau abandoned the traditional precise rendering of costume in favor of a sketchlike suggestion of dress. He also seems to have presented generalized types rather than specific persons, and introduced softly foliated landscapes behind his figures. It appears that *The Anxious Lover* in Chantilly may have been based on the *Seated Woman Leaning on a Pedestal* in the *Figures de modes*, and that *The Dreamer* may also have developed from Watteau's fashion print designs, for it is strongly suggestive of another print of a seated woman. Although this latter print was distributed as part of the *Figures françoises et comiques*, the Watteau drawing upon which it was based was probably executed around 1710.[25]

Because *The Dreamer* exhibits the general characteristics of the *Figures de modes*, such as the placement of the subject in a landscape, the rigid posture of the figure, and the nervous, spontaneous brush strokes suggestive of engraved lines, it can probably be dated sometime between the *Figures de modes* and the stylistically more advanced *Figures françoises et comiques*. This would be in keeping with Roland Michel's (1981, 1984) date of 1712/14 for the panel, but a little earlier than the period of 1716/17 to which some scholars have assigned the work.[26]

Notes
1 The 1960 treatment was probably performed by Louis Pomerantz.
2 The painting was treated by Alfred Jakstas.
3 See discussion section. When Watteau died, he left instructions that his drawings should be divided equally among four of his friends: Edme François Gersaint, Jean de Jullienne, Nicolas Hénin, and the abbé Haranger. This indicates a close relationship between the artist and the abbé. For more information on the abbé, see Pierre Rosenberg, "Watteau dessinateur," *Revue de l'art* 69 (1985), pp. 47–54, and Jeannine Baticle,

"Le Chanoine Haranger, ami de Watteau," *Revue de l'art* 69 (1985), pp. 55–68.

4 The painting was not specifically attributed to Watteau in the text of the sale catalogue. The picture is described there as follows: "Une jeune femme Turque assise dans un jardin, sur bois, hauteur 9 pouces, largeur 7 pouces." (A young female Turk seated in a garden, on panel, height 9 *pouces*, width 7 *pouces*.) The measurements given are equal to 24.3 x 18.9 cm. Gabriel de Saint-Aubin illustrated one of the sale catalogues (Paris, Musée du Petit Palais), drawing the outline of a seated woman in the left margin beside no. 132 and noting "Wateau 190 l[ivres]" to the right of the entry. See Dacier 1910 and discussion section. Dacier pointed out that the sketch referred either to *The Dreamer* or to *The Polish Woman* (location unknown), another painting by Watteau. The provenance of the latter picture (see discussion section and note 12) suggests that the Saint-Aubin sketch is after the Chicago painting.

5 The picture is described in the sale catalogue as follows: "Une dame ajustée dans le costume Turc: elle est coëffée d'un bonnet ou turban, la tête tournée de trois quarts sur l'épaule droite, assise sur un tertre dans un fond de paysage. Hauteur 8 pouces 4 lig. largeur 6 pouces. B." (A woman dressed in a Turkish costume; she is wearing a bonnet or turban, the head turned three quarters toward the right shoulder, seated on a mound in a landscape background. Height 8 *pouces* 4 *lig.*, width 6 *pouces*. Panel.) The measurements given are equal to 22.5 x 16.2 cm.

6 According to Eudel (1886), Burat had acquired the painting in 1866 for Fr 950. In the introduction to the 1886 sale catalogue (p. 5), Philippe Burty indicated that Laurent-Richard had purchased the panel at the Burat sale. The price paid is recorded in an annotated 1886 sale catalogue in the Frick Art Reference Library, New York.

7 Rosenberg (1984 exhibition catalogue) listed Willy Blumenthal as the buyer at this sale. The price is recorded in an annotated sale catalogue in the Frick Art Reference Library, New York.

8 Dacier, Hérold, and Vuaflart 1921–29, vol. 1, Hérold and Vuaflart, 1929, p. 178.

9 For these engravings, see, respectively, Dacier, Hérold, and Vuaflart 1921–29; vol. 3, Dacier and Vuaflart, 1922, p. 82, no. 165; vol. 4, Dacier and Vuaflart, 1921, pt. 2, pl. 165; and Dacier, Hérold, and Vuaflart 1921–29; vol. 3, Dacier and Vuaflart, 1922, p. 82, no. 166. There exist two states of the latter engraving, which are identical except for their titles. One is entitled *The Dreamer* (*La Rêveuse*; see fig. 1), and the other *La Solitaire* (see Rosenberg 1986, fig. 5).

10 Pierre Jean Mariette, *Notes mss.*, IX, fol. 191 [9] (Paris, Bibliothèque Nationale). See Dacier, Hérold, and Vuaflart 1921–29; vol. 1, Hérold and Vuaflart, 1929, p. 117; vol. 2, Dacier and Vuaflart, 1922, p. 29. *The Anxious Lover*, measuring 24 x 17 cm, is almost identical in size to *The Dreamer*; for an illustration of *The Anxious Lover*, see Nakayama 1976, fig. 52.

11 When *The Dreamer* was later in du Barry's possession, the Aveline engraving was used as a model for one of the decorative images on a *guéridon*, or round table, commissioned from Dodin and Martin Carlin in 1774 by Mme du Barry. This *guéridon*, now in the Louvre, has a Sèvres porcelain top surface that comprises a circular center plaque and six encircling plaques. The upper left plaque follows Aveline's engraving after *The Dreamer*. The center plaque is a copy in reverse of Carle Vanloo's painting *The Grand Turk Giving a Concert to His Mistress* (London, Wallace Collection), most likely following Claude Antoine Littret's engraving of 1765/66 after it. The images on the other plaques have not been identified. See Serge

Grandjean, "Le Guéridon de Madame Du Barry provenant de Louveciennes," *La Revue du Louvre* 29, 1 (1979), pp. 44–49, figs. 1–2.

12 *The Polish Woman* was in the collection of the comte de Murcé when this engraving was made. The picture later appeared in the François Boucher sale, Paris, February 18–March 9, 1771, and then in the abbé de Gévigney sale, Paris, December 1–29, 1779, no. 533, after which it cannot be traced.

13 Goncourt 1875, p. 252, no. 417, p. 297, no. 656. Three other engravings from the *Figures de différents caractères* (nos. 25, 269, 319) depict a similarly clad woman, who may be the same sitter.

14 See the 1885 sale catalogue, no. 109, with text by E[ugène] Féral. The Gaucherel engraving, which accompanied the entry in the sale catalogue, is oriented in the same direction as the painting, and bears the inscription *Lancret pinx*. For the opinion of Paul Mantz, see p. viii of the catalogue.

15 See the 1886 sale catalogue, p. 5.

16 Ferré (1972) is the exception.

17 Nemilova 1973, p. 152. For more on *Coquettes*, see the 1984 exhibition catalogue, pp. 311–13, no. P29 (ill.).

18 *Polish Woman Standing* is known from a copy in the Muzeum Narodowe, Warsaw (see the 1984 exhibition catalogue, p. 304, fig. 3). Like Louis de Fourcaud ("Antoine Watteau: Scènes et figures théâtrales," *La Revue de l'art ancien et moderne* 15, 84 [1904], p. 204), Nemilova believed that Watteau depicted Desmares as one of the pilgrims (standing left of center, back to the viewer) in the *Island of Cythera* in the Städtische Galerie im Städelschen Kunstinstitut, Frankfurt (illustrated in the 1984 exhibition catalogue, p. 262, no. 9). A plate from Watteau's *Figures françoises et comiques* (see discussion below) is identified as Mlle Desmares playing the role of a pilgrim (illustrated in Dacier, Hérold, and Vuaflart 1921–29, vol. 4, Dacier and Vuaflart, 1921, pl. 59). See also François Moureau in the 1984 exhibition catalogue, p. 478.

19 For an illustration of Lépicié's engraving, see Daniel Wildenstein, "L'Oeuvre gravé des Coypel, I," *GBA* 6th ser., 63 (1964), p. 270, fig. 43. Another portrait of Desmares, by Jean Raoux, passed through the Arsène Houssaye sale, Hôtel Drouot, Paris, May 22–23, 1896, no. 91 (ill.).

20 There is no basis for the identification of a graphite drawing (location unknown) after Aveline's engraving of *The Dreamer* as a portrait of the epistolic writer Lady Mary Wortley Montagu (see *Catalogue of the Miniatures and Portraits in Plumbago or Pencil Belonging to Francis and Minnie Wellesley*, Woking and London, [before 1920], p. 169, and photographs of the drawing in the Witt Library, London, and in the Art Institute's curatorial files).

21 Nemilova 1964, p. 91ff.; 1973, pp. 150–51.

22 Letter of September 23, [1985], from Aileen Ribeiro to the author, in curatorial files.

23 See the 1774 sale catalogue (quoted in note 4).

24 For Watteau's involvement with fashion prints, see Posner 1984, pp. 42–47.

25 *Woman Leaning on a Pedestal* and the other print of a seated woman are illustrated in Dacier, Hérold, and Vuaflart 1921–29, vol. 4, Dacier and Vuaflart, 1921, pls. 50 and 45, respectively.

26 Adhémar (1950) dated the painting to 1716, while Camesasca (Camesasca and Sunderland 1968), Rosenberg (1975–76 exhibition catalogue), and Marandel (1976 exhibition catalogue) all dated it to 1717. More recently, Rosenberg (1984 exhibition catalogue) has concurred with Roland Michel's dating. Grasselli (1987) preferred to assign the painting to the years 1713/16.

Jean Baptiste Wicar

1762 Lille–Rome 1834

Virgil Reading the "Aeneid" to Augustus, Octavia, and Livia, 1790/93

Wirt D. Walker Fund, 1963.258

Oil on canvas, 111.1 x 142.6 cm (43³/₄ x 56¹/₈ in.)

INSCRIBED: *TU MAR[CELLUS ERIS]* (on Virgil's scroll)

CONDITION: The painting is in very good condition. It was cleaned, varnished, and inpainted in 1963 and local retouching was done in 1984.[1] The finely woven canvas has an old glue paste lining.[2] The tacking margins have been cut off the left, top, and bottom edges, but cusping visible at these three edges indicates that the painting is close to its original dimensions. X-radiography reveals holes in the right edge, indicating that it was once used as a tacking margin.[3] There is a 7.6 cm star-shaped tear in the canvas near the center of the bottom edge. The off-white ground is visible through cracks in the paint surface. Coarsely ground white inclusions give a granular surface character in the upper right background. Although the paint layer is generally well preserved, there is some slight abrasion due to past cleaning in the upper right background and in the figures, specifically in the shadows below Virgil's left arm, in the text from which he reads, under the bench on which he sits, on Octavia's hair and left foot, and on Livia's left foot and dress. There are two large circular losses in the lower left quadrant (3.8 x 2 cm each), and two smaller circular losses (1 cm in diameter) in Virgil's hair above his ear. All of these losses have been filled and inpainted. There is additional retouching on the right edge, in the shadows of the drapery around Livia's feet, in the shadows of Augustus's drapery folds, and in the shadows under the bench on which Virgil is seated. Several *pentimenti* are apparent; there are changes in the contour of Virgil's right arm and his left hand, in the position of Octavia's left hand, in the contour of the upper back of Livia's dress, in the back of the chaise longue, and in the folds of the drapery that hangs behind the figures. X-radiography also indicates that there was originally drapery painted at the top of the wall above Augustus's extended arm. (mid-treatment, partial x-radiograph)

PROVENANCE: Possibly in the possession of the artist until his death.[4] Possibly at Wicar's death to his student Giuseppe Carattoli, 1834.[5] Marcello and Carlo Sestieri, Rome.[6] Sold by Carlo Sestieri to the Art Institute, 1963.

REFERENCES: J[ohn] M[axon], "Some Recent Acquisitions," *AIC Quarterly* 57, 4 (1963–64), n. pag. (ill.). Hervé Oursel in *Le Chevalier Wicar: Peintre, dessinateur, et collectionneur lillois*, exh. cat., Musée des Beaux-Arts de Lille, 1984, p. 63, under no. 63.

EXHIBITIONS: The Cleveland Museum of Art, *Neo-Classicism: Style and Motif*, 1964, no. 117, as François Xavier Fabre. The Denver Art Museum, *Great Stories in Art*, 1966 (no cat.). Oshkosh, Wisconsin, The Paine Art Center and Arboretum, *Empire Profile*, 1968 (no cat.), as François Xavier Fabre. Kansas City, Missouri, The Nelson Gallery and Atkins Museum, *The Taste of Napoleon*, 1969 (cat. published as *The Nelson Gallery and Atkins Museum Bulletin* 4, 10 [1969]), no. 24, as François Xavier Fabre. The Art Institute of Chicago, *Selected Works of Eighteenth-Century French Art in the Collections of The Art Institute of Chicago*, 1976, no. 25, as anonymous. New York, Wildenstein, *Consulat—Empire—Restauration: Art in Early XIX Century France*, 1982, p. 99, as French School. The Art Institute of Chicago, *Canova and France*, 1985 (no cat.). The Art Institute of Chicago, *The Art of the Edge: European Frames, 1300–1900*, 1986, no. 26.

The subject of the Chicago painting appears to be based on an account given by Aelius Donatus in his mid-fourth-century *Life of Virgil*. According to Donatus, the emperor Augustus, while away on a campaign against the Cantabri, sent a letter to Virgil, imploring the poet to send him a rough draft or even some verses of the *Aeneid*. Virgil refused the emperor's written request, but, later, after the poem had been properly refined and finished, the author recited three books—the second, fourth, and sixth—for Augustus. The reading of the sixth book elicited an extreme emotional response from Octavia, Augustus's sister, who, upon hearing Virgil's verses concerning her deceased son ("*you* will be Marcellus"; *Aeneid*, 6.884), fainted dead away.[7]

In the Chicago work, the painter has focused on the dramatic response of Octavia to the mention of her mourned son, Marcellus, whose adoption by Augustus and marriage to the emperor's daughter had, before his death, fostered speculation that he had been chosen for the throne. Had that come to pass, Tiberius, the son (by Tiberius Claudius Nero) of Augustus's second wife, Livia Drusilla, would not have succeeded Augustus. It was believed that Marcellus's early death, in 23 B.C., was the result of Livia's scheme to secure the throne for Tiberius.

The subject of Virgil reading the *Aeneid* was treated as early as the seventeenth century (by Pietro da Cortona, for instance),[8] but enjoyed its greatest popularity with neoclassical painters of the late eighteenth and early nineteenth centuries such as Jean Auguste Dominique Ingres, Vincenzo Camuccini, and Jean Joseph Taillasson.

The Chicago version of the theme reveals how, in the last quarter of the eighteenth century, artists began to transform the *exemplum virtutis* into a *tableau vivant*; that is, subjects treated originally for their embodiment of moral principles were handled in a more dramatic and anecdotal manner, increasing their emotional impact and, consequently, their popularity. In the Chicago painting, the artist has exaggerated the responses of the protagonists Augustus, Livia, and Octavia, contrasting their varied reactions to Virgil's words. At the center of the composition, Augustus, with a complex expression of alarm, concern, and noble gratitude, motions toward the impassioned Virgil. Beside him the dispassionate Livia attends to Octavia, who has collapsed from grief.

Combined with this interest in vivifying classical themes was a concern for archeological accuracy. Virtually every feature in the Chicago work has been borrowed from an antique source or makes reference to the culture of the classical world. The scene takes place in the painter's imaginative reconstruction of a room in the emperor's palace on the Palatine Hill; temples and an obelisk can be glimpsed through windows. The table at left reproduces a three-legged Hercules table in the Vatican Galleria dei Candelabri (first century B.C.), and the small statuette on it is modeled after the colossal seated Athena-type figure of Roma (A.D. 117/38) in the gardens of the Villa Medici in Rome.[9]

The painting entered the Art Institute as a work by Jean Baptiste Wicar. It was subsequently given to François Xavier Fabre, and later published as an anonymous work.[10] This author, supported by Pierre Rosenberg, René Verbraeken, and Philippe Bordes, returned the attribution to Wicar, whose posthumous fame as a collector exceeds his renown as an artist.[11] A painter of historical subjects and of portraits, Wicar trained with Louis Jean Guéret in Lille and the engraver Jacques Philippe Le Bas in Paris before entering Jacques Louis David's atelier in 1783. From 1784 until late 1785, Wicar was in Rome with David, who had journeyed there to paint the *Oath of the Horatii* (Louvre). Wicar and another David assistant, Jean Germain Drouais, provided the artist with drawings after the antique. In 1787 Wicar returned to Italy to work on the *Galerie de Florence*, a lavish publication containing engravings after sculptures, paintings, and cameos in the collection of the grand duke of Tuscany.[12] Wicar contributed scores of highly detailed drawings to the project, on which he was engaged for the next several years.

Highly literate and knowledgeable about art, Wicar

Fig. 1 Jean Baptiste Wicar, *Virgil Reading the "Aeneid" to Augustus, Octavia, and Livia*, Musée des Beaux-Arts de Lille

treated the theme of Virgil reading the *Aeneid* on a number of occasions. His best-known version is the large canvas commissioned in 1819 by Giovanni Battista Sommariva and still in his residence, the Villa Carlotta in Cadenabbia.[13] Another version, recorded in the inventory of property drawn up after Wicar's death as "il Quadro rappresentante Virgilio dipinto dal defonto nei primi anni della sua Gioventù," has been tentatively connected by René Verbraeken with the Chicago canvas.[14] According to the document, this painting was bequeathed in 1834 to Wicar's Roman student and fiduciary legatee, Giuseppe Carattoli (1783–1850). It is perhaps significant that the painting was acquired by the museum from a dealer in Rome. Unfortunately, docu-

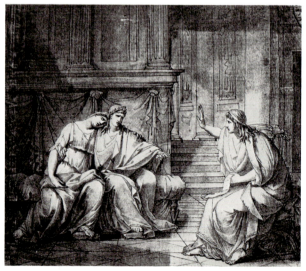

Fig. 2 Jean Baptiste Wicar, *Virgil Reading the "Aeneid" to Augustus and Octavia*, Accademia di Belle Arti "Pietro Vannucci," Perugia, Italy

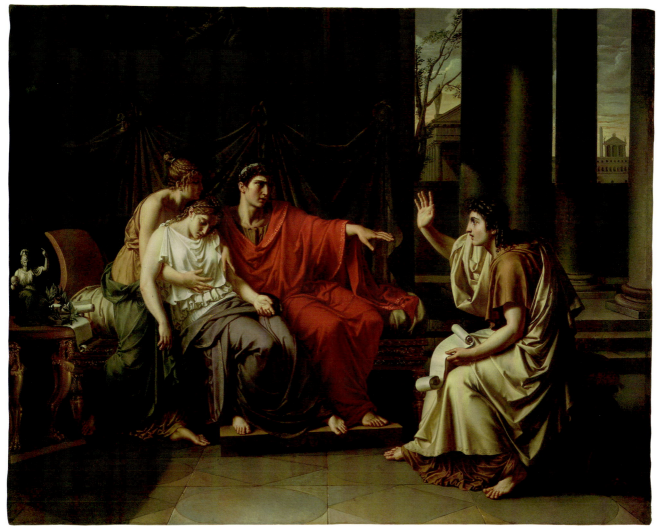

Jean Baptiste Wicar, *Virgil Reading the "Aeneid" to Augustus, Octavia, and Livia*, 1963.258

ments concerning the succession of Giuseppe Carattoli and of his son and heir (and Wicar's godson), Luigi Carattoli (1825–1894), who was the director of the Accademia di Belle Arti in Perugia from 1883 to 1888, have not been found. As a result, the Chicago picture cannot conclusively be identified with the work listed in the inventory.

Although many of Wicar's paintings are now lost, he was a prolific draftsman and a large number of his drawings survive, including numerous preparatory studies for his Virgil compositions. Four of these clearly relate to the Chicago picture and confirm that Wicar was responsible for the painting's design. In a black-chalk drawing in the Musée des Beaux-Arts de Lille (fig. 1), Wicar established the general composition of the Chicago painting, roughly indicating the gestures of the figures and placement of furniture and architectural elements.[15] The lines he has drawn across the top, center, and right side of the sheet indicate changes he wished to make in the figural arrangement and the format of the composition. These emendations appear in the Chicago painting, in which the figures are centered vertically and Virgil has been moved closer to his audience. Another, more finished drawing of the subject by Wicar, in the Accademia di Belle Arti in Perugia (fig. 2), omits the figure of Livia, but corresponds to the Chicago painting in many other respects, including the placement and poses of the two male figures and the architectural divisions of space.[16] Also preparatory for the present work are two sheets with figure studies in the Musée des Beaux-Arts de Lille — one a freely executed black-chalk sketch of Livia, Octavia, and Augustus (fig. 3), the other a crisp outline drawing in graphite for the figure of Virgil (fig. 4).[17] A black-chalk sketch of a seated man, in a recently discovered Wicar sketchbook, appears to be an early preliminary study for the figure of Virgil.[18] Despite the myriad studies that Wicar must have made for the painting, numerous *pentimenti* in the work, visible under normal light and in the x-radiograph (see Condition), reveal that the artist continued to alter his design even at the painting stage. Furthermore, as Larry Feinberg pointed out, these *pentimenti* indicate that the Chicago picture is neither a copy nor a work executed by a Wicar student following the artist's designs.[19]

Various dates have been proposed for the Chicago painting. While Verbraeken advanced a date of 1793/1800, Bordes assigned the work to the years 1785/90.[20] It seems most likely, however, that the work should be placed to 1790/93, that is, to the latter part of the artist's second stay in Italy, which lasted from the spring of 1787 until October of 1793. The preparatory drawings for the Chicago painting compare closely with other sheets that date to 1789/90, such as the study *The Death of Lucretia* (for a painting executed in 1789), and *A Scene from Antiquity*, both in the Musée des Beaux-Arts de Lille.[21] The drapery style employed in the Chicago painting also points to a date in the late 1780s or early 1790s, as it closely resembles that of some of the ancient statuary Wicar copied for the *Galerie de Florence*.[22]

Several references to David's work of the 1780s are found in the present painting. It seems likely, for instance, that Wicar had David's *Belisarius* (Salon of 1781; Musée des Beaux-Arts de Lille) in mind when he conceived the figure of Virgil.[23] Moreover, the swooning Octavia seems to have been inspired by one of the lamenting women in David's *Oath of the Horatii* of 1784 or in his *Lictors Bringing Back to Brutus the Bodies of His Sons* of 1789 (both in the Louvre), and, as Hervé Oursel observed, Livia perhaps derives from the figure of Sabina in the *Oath of the Horatii*.[24] A more direct source for Wicar's figures of Livia and Octavia may be a Herculaneum painting illustrated in Pierre Sylvain Maréchal's *Antiquités*.[25] The execution and colors in the Chicago work are atypical for Wicar, whose palette tended to be darker, even muddied.

NOTES

1 Although there are no treatment reports in the conservation files, mid-treatment color transparencies are dated 1963. It is likely that this treatment was performed by Alfred Jakstas. Discolored retouches near the center of the bottom edge were corrected by Faye Wrubel in 1984.

2 The thread count of the original canvas is approximately 14 x 16/sq. cm (35 x 40/sq. in.).

3 The dimensions of the original canvas are approximately 111.2 x 141 cm (43³⁄₄ x 55¹⁄₂ in.).

4 See discussion section and Giulio Romano Ansaldi, "Documenti inediti per una biografia di G. B. Wicar," in *Atti della Reale Accademia Nazionale dei Lincei* 6th ser., 330, Memorie della classe di scienze morali storiche e filologiche, Rome, 1933, vol. 5, p. 486.

5 Ibid.

6 In a letter of March 21, 1981, to the author, Carlo Sestieri stated that he thought he had acquired the painting in an exchange with Mario Praz. In a subsequent letter, dated September 20, 1983, Sestieri said that he believed he had purchased the painting in Florence (both letters are in curatorial files).

7 "Augustus vero — nam forte expeditione Cantabrica aberat — supplicibus atque etiam minacibus per iocum litteris efflagitaret, ut 'sibi de Aeneide,' ut ipsius verba sunt, 'vel prima carminis υπογραφη vel quodlibet κωλον mitteretur.' cui tamen multo post perfectaque demum materia tres om nino libros recitavit, secundum quartum sextum, sed hunc notabili Octaviae adfectione, quae cum recitationi interesset, ad illos de filio suo versus

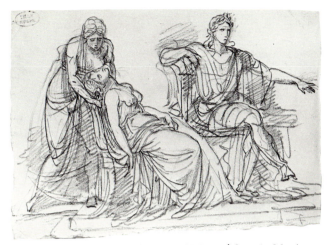

Fig. 3 Jean Baptiste Wicar, *Augustus, Livia, and Octavia*, Musée des Beaux-Arts de Lille

Fig. 4 Jean Baptiste Wicar, *Study for the Figure of Virgil*, Musée des Beaux-Arts de Lille

[*Aen.* vi. 884]: 'tu Marcellus eris,' defecisse fertur atque aegre focilata." *Appendix Vergiliana, recognovit R. Ellis, Vitae Virgilianae antiquae edidit C. Hardie, (Scriptorum classicorum bibliotheca oxoniensis)*, Oxford, 1944–54, pt. 2, *Vita Donati*, Hardie 31–32. (Indeed, Augustus sent a letter [for he happened to be away on the campaign against the Cantabri] belaboring him with pleas — even threats, in jest — asking that 'an early *esquisse* of the poem or any *vers* at all' — those were his words — 'be sent to [him] from the *Aeneid*.' Nonetheless, it was only much later, when the material had been given its proper form, that he recited for Augustus three books in all, the second, the fourth, and the sixth — this last accompanied by a remarkable display on the part of Octavia: when she was present at the recital, the story goes, she fainted dead away at the verses concerning her son — '*you* will be Marcellus' [*Aeneid*, 6.884] — and was revived only with difficulty.) Translation kindly provided by Robert A. Kaster, Department of Classics, The University of Chicago. In the past, this *Life of Virgil* had been attributed to Aelius Donatus by some and to Gaius Suetonius by others. Scholars now generally concur that Aelius Donatus wrote this *Life of Virgil* but that he drew from the work of Gaius Suetonius. The *Commentary on the Aeneid* by Tiberius Claudius Donatus has sometimes erroneously been cited as the source for paintings of the subject.

8 For Pietro da Cortona's treatment of the subject, see Giuliano Briganti, *Pietro da Cortona o della pittura barocca*, Florence, 1982, fig. 234.

9 For the Hercules table, see Georg Lippold, *Die Skulpturen des vaticanischen Museums*, vol. 3, Berlin, 1956, pt. 2, text pp. 161–62, pl. 85, fig. 14; for the figure of Roma, see Cornelius C. Vermeule, *The Goddess Roma in the Art of the Roman Empire*, Cambridge, Mass., 1959, p. 107, no. 49, pl. IX.

10 According to registrar's records. The attribution was changed to Fabre in 1963 (memo of December 17, 1963, from John [Maxon] to [Frederick] Sweet, in curatorial files), and was then changed to the general designation "anonymous, late eighteenth or early nineteenth century" by J. Patrice Marandel (1976 exhibition catalogue).

11 Pierre Rosenberg, verbally, to the author, November 15, 1986; letters of May 25, 1982, and August 23, 1982, from René Verbraeken to the author; and letter of August 25, 1986, from Philippe Bordes to the author (all in curatorial files). Bordes had

earlier rejected the attribution to Fabre (letter of May 8, 1974, to John David Farmer, in curatorial files). Oursel (1984) offered a dissenting view, stating that "le style incisif et haut en couleur n'évoque en rien, à notre avis, l'art de Wicar. Faut-il songer alors à une copie par celui-ci de l'oeuvre d'un confrère travaillant à Rome ou s'agit-il d'une singulière coïncidence?" (The incisive style and intense color do not in any way evoke, in our opinion, the art of Wicar. Should one think of this then as a copy by this artist of one of the works of a colleague working in Rome, or are we dealing with a singular coincidence?)

12 *Tableaux, statues, bas-reliefs et camées de la Galerie de Florence et du Palais Pitti, dessinés par Wicar, peintre, et gravés sous la direction de C. L. Masquelier, ex-pensionnaire de l'Académie de France à Rome; avec les explications, par Mongez, membre de l'Institut de France, Classe des Sciences et Arts*, Paris, 1819. Many of the drawings for the *Galerie de Florence* are listed by Fernand Beaucamp, *Le Peintre lillois Jean-Baptiste Wicar (1762–1834): Son Oeuvre et son temps*, vol. 2, Lille, 1939, pp. 687–89.

13 Beaucamp (note 12), vol. 2, p. 633, no. 34, p. 503 (ill.).

14 See Ansaldi (note 4), document XC, p. 481ff., "Spiegazione di Fiducia emessa Dal Sig.ʳ Giuseppe Carattoli," dated May 17, 1834; and p. 486: "A painting representing Virgil painted by the deceased in the first years of his youth." The document is preserved in the Archivio di Stato in Rome. Beaucamp (note 12), vol. 2, p. 638, no. 58, also listed the picture. For Verbraeken's remarks, see letter of August 23, 1982, to the author, in curatorial files. Verbraeken very kindly provided valuable guidance during the research on the Chicago painting.

15 See Beaucamp (note 12), vol. 2, p. 664, no. 139, and Oursel 1984, pp. 63–64, no. 63 (ill.).

16 Maria Vera Cresti (in *Cento disegni dell'Accademia di Belle Arti di Perugia, XVII–XIX secolo*, exh. cat., Rome, Villa della Farnesina alla Lungara, 1977, pp. 97–99, no. 76 [ill.]) incorrectly associated this drawing with the Sommariva painting. The sheet was given by Luigi Carattoli to the Accademia di Belle Arti in 1894.

17 For the first drawing, see Oursel 1984, p. 64, no. 64 (ill.). The second drawing is catalogued by the Musée des Beaux-Arts de Lille as "inv. provisoire no. Q." Another drawing in Lille, representing the figures of Augustus and Livia nude, though it corresponds in some respects more closely to the Sommariva

picture (for example, its right-to-left orientation), may be an early study for the Chicago painting (ibid., pp. 64–65, no. 65 [ill.]).

18 For a reproduction of this work, see Margot Gordon and Marcello Aldega, *Jean-Baptiste-Joseph Wicar Drawings*, Rome, 1995, fig. 69, no. 120r, p. 95.

19 Verbally to the author, July 14, 1995.

20 Letters of May 25, 1982, from Verbraeken to the author, and of August 29, 1995, from Bordes to Larry Feinberg, in curatorial files.

21 See Annette Scottez in *Le Chevalier Wicar: Peintre, dessinateur, et collectionneur lillois*, exh. cat., Musée des Beaux-Arts de Lille, 1984, pp. 39–40, no. 25 (ill.), and p. 52, no. 43 (ill.), respectively.

22 *Galerie de Florence* (note 12); see particularly vol. 1, *L'Empereur Auguste* and *Prêtresse de la Fidélité*, vol. 2, *Personnage Consulaire, Femme Inconnue*, and *Junon*, and vol. 3, *Agrippine* and *Faustine Jeune*.

23 See Luc de Nanteuil, *David*, New York, 1990, pl. 5.

24 Oursel 1984, p. 64. For David's *Oath of the Horatii* and *Lictors Bringing Back to Brutus the Bodies of His Sons*, see Nanteuil (note 23), pls. 8, 12, respectively.

25 Pierre Sylvain Maréchal, *Antiquités d'Herculanum . . .* , vol. 6, Paris, 1780, pl. 108.

CATALOGUE
British Paintings

William Artaud

1763 London 1823

The Woman Accused of Adultery, c. 1791

Gift of the Friends of American Art, 1915.488

Oil on canvas, 128.4 x 102.2 cm (50½ x 40¼ in.)

CONDITION: The painting is in poor condition. It was cleaned in 1949, and again in 1973, when an old glue paste lining was removed and replaced with a wax resin one.[1] The previous stretcher, presumably replaced when the picture was first lined, was not original. A drawing in the conservation file documents that it had vertical and horizontal cross supports, whereas diagonal cracks at the corners of the picture suggest that the original stretcher had corner braces. The tightly woven canvas has a twill weave. The tacking margins have been cut off, but x-radiography reveals cusping on the right and left edges, indicating that the painting is close to its original dimensions.

The ground is off-white. The canvas weave has become pronounced and the paint layer flattened as a result of the lining process. The paint surface is severely abraded. This is most apparent in the figure at the far right and in the background, where the architecture visible in the reproductive engraving (fig. 1) has been almost obliterated. The white dress of the adulteress is the only area that remains intact. The mother and child to the right of her head and the reclining male figure between her and the figure of Christ had been overpainted, and emerged during the 1973 cleaning. There is a wide-aperture drying craquelure throughout most of the upper background. Numerous small (0.2 to 1.0 cm) paint and ground losses are scattered along the perimeter. These losses have been filled and inpainted. Ultraviolet examination reveals extensive retouches over much of the surface, particularly in the shadows of the drapery folds, around the head of the adulteress, on the reclining figure, and over the drying craquelure in the background. Much of the retouching is discolored. (infrared, mid-treatment, ultraviolet, partial x-radiograph)

PROVENANCE: Commissioned by Thomas Macklin, London.[2] Sold Langdon's, London, February 18, 1807, no. 111, for £7 10s.[3] Probably Henry Seymour Berry, baron Buckland, Buckland, Bwlch, Breconshire, Wales.[4] T. J. Blakeslee, New York, by 1911. Sold to Robert Vose Galleries, Boston, 1911.[5] Sold by Vose Galleries to the Friends of American Art, 1915, as Benjamin West. Given to the Art Institute, 1915.

REFERENCES: The Art Institute of Chicago, *Friends of American Art, Fifth Year Book*, Chicago, 1914–15, p. 167 (ill.). AIC 1917, p. 153. AIC 1920, p. 47, no. 431. AIC 1922, p. 49, no. 431. AIC 1923, p. 49, no. 431. AIC 1925, p. 157, no. 431. AIC 1932, p. 176. *Art in America: A Complete Survey*, ed. by Holger Cahill and Alfred H. Barr, Jr., New York, 1934, p. 21 (ill.). A. C. Sewter, "The Life, Work, and Letters of William Artaud, 1763–1823," M.A. thesis, University of Manchester, 1951, p. 14, no. 6. AIC 1961, p. 481. Esther Sparks, "Three Narrative Paintings by Benjamin West in the Collection,"

AIC Bulletin 68, 4 (1974), pp. 7–8 (ill.). Gloria Groom, "Art, Illustration, and Enterprise in Late Eighteenth-Century English Art: A Painting by Philippe Jacques de Loutherbourg," *AIC Museum Studies* 18 (1992), pp. 130, 133–35, fig. 7. Kim Sloan, "William Artaud: History Painter and 'Violent Democrat,'" *Burl. Mag.* 137 (1995), pp. 78–79, fig. 17.

EXHIBITIONS: London, Gallery of Poets, Pall Mall, *Fourth Exhibition of Pictures, Painted for Mr. Macklin by the Artists of Britain, Illustrative of the British Poets, and the Bible*, 1791, no. 50. London, Poets' Gallery, Fleet Street, *Fifth Exhibition of Pictures, Painted for Mr. Macklin by the Artists of Britain, Illustrative of the British Poets, and the Bible*, 1792, no. 50. London, Poets' Gallery, Fleet Street, *Sixth Exhibition of Pictures, Painted for Mr. Macklin by the Artists of Britain, Illustrative of the British Poets, and the Bible*, 1793, no. 50. Philadelphia, Pennsylvania Museum of Art, *Benjamin West, 1738–1820*, 1938, no. 50, as Benjamin West. Urbana, University of Illinois (Illini Union Building), on loan, 1941–56, as Benjamin West.

When it entered the collection of the Art Institute in 1915, this work was attributed to Benjamin West. Jane Dillenberger correctly identified it as the work of William Artaud in 1974, on the basis of the reproductive engraving after it in the illustrated Macklin Bible (fig. 1).[6] It was first published as by Artaud in 1992, when

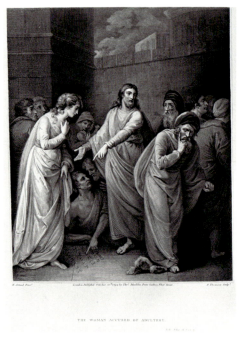

Fig. 1 Paton Thomson, engraving after William Artaud, *The Woman Accused of Adultery*, British Museum, London [photo: © British Museum, London]

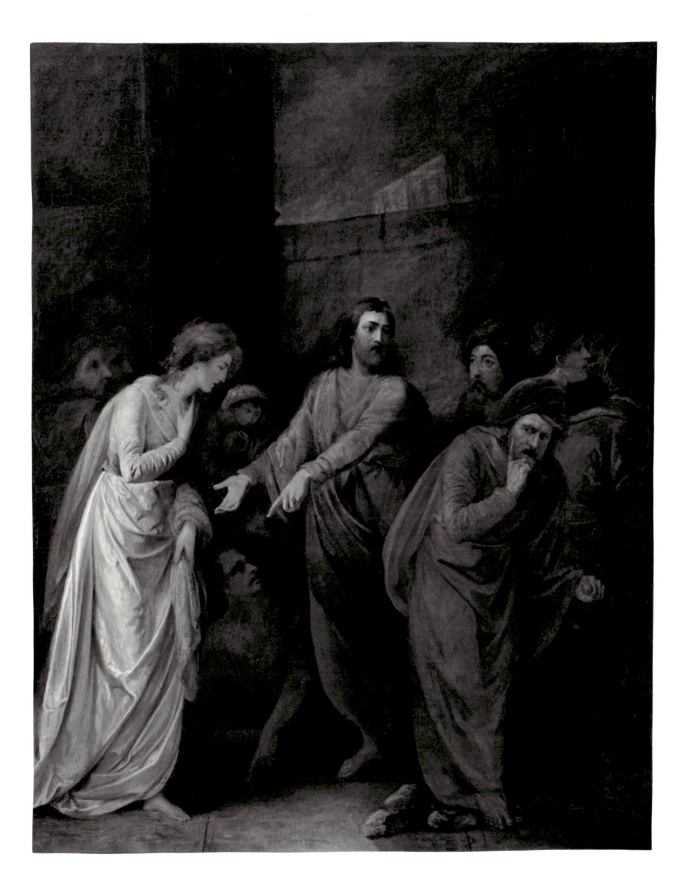

Gloria Groom discussed it in relation to another painting commissioned for the Macklin Bible, Philippe Jacques de Loutherbourg's *The Destruction of Pharaoh's Army* (see 1991.5).[7]

Artaud is a marginal figure whose career as a portrait and history painter has remained largely unstudied.[8] His father was French, a jeweler who had settled in London, and his mother was English. He attended the Royal Academy Schools from 1778, winning a gold medal there in 1786. In the early 1790s, he was commissioned by the print publisher Thomas Macklin to paint eight subjects from English poetry and the Bible for exhibition and publication as engravings as part of Macklin's Poets' Gallery and his Bible project. Artaud spent most of the years 1796 to 1798 in Rome studying classical art, toward the end with the support of a Traveling Studentship from the Royal Academy, then moved via Florence and Venice to Dresden, where he stayed for a further year. While he was away, Joseph Farington reported that he was "a violent Democrat," and his letters and drawings of this period reveal revolutionary sympathies.[9] From the time of his return to London, in 1799, he made his living principally as a portraitist, making regular painting tours of the Midlands and North of England. Perhaps because of his political radicalism and earnest Unitarian beliefs, he attracted a middle- rather than upper-class clientele; he enjoyed neither wealth nor fame, and died in obscurity. Throughout his career he aspired to become a history painter, composing many figure subjects in a Fuseli-like manner, though taking few of them beyond the drawing stage.

The Macklin Bible, for which *The Woman Accused of Adultery* was commissioned by Thomas Macklin, was a deluxe illustrated publication featuring engravings after pictures by a variety of contemporary artists. The engravings were published periodically between 1791 and 1800.[10] Artaud contributed five works to the Macklin Bible: *Moses Meeting His Wife and Sons* (Pittsburgh, Museum of Art, Carnegie Institute;[11] engraving published 1792), *Hagar and Ishmael* (engraving published 1794), *The Widow's Mite* (engraving published 1794), *Belshazzar's Feast* (engraving published 1796), and the present work, which was engraved by Paton Thomson and published on October 20, 1794 (fig. 1). The size of *The Woman Accused of Adultery* seems to have been the standard one for Macklin pictures, most of which measured roughly 50 by 40 inches. It was shown in Macklin's own exhibition rooms, the Poets' Gallery, from 1791 to 1793. Certain details visible in the

engraving have been lost in the painting in its present, damaged state, most significantly the mock-Hebrew letters written by Christ on the ground.

The scene is from an encounter between Christ and the Pharisees in the Temple at Jerusalem, as described in John 8.2–11. According to this account, the Pharisees brought before Christ a woman who had been caught committing adultery, an offense punishable under Jewish law by stoning. Since the Romans had forbidden the Jews to impose death penalties, the Pharisees thought they could lure Christ into expressing a view that would compromise him:

> 5 Now Moses in the law commanded us, that such should be stoned: but what sayest thou?
> 6 This they said, tempting him, that they might have to accuse him. But Jesus stooped down, and with his finger wrote on the ground, as though he heard them not.
> 7 So when they continued asking him, he lifted up himself, and said unto them, He that is without sin among you, let him first cast a stone at her.
> 8 And again he stooped down, and wrote on the ground.
> 9 And they which heard it, being convicted by their own conscience, went out one by one, beginning at the eldest, even unto the last: and Jesus was left alone, and the woman standing in the midst.
> 10 When Jesus had lifted up himself, and saw none but the woman, he said unto her, Woman, where are those thine accusers? Hath no man condemned thee?
> 11 She said, No man, Lord. And Jesus said unto her, Neither do I condemn thee: go, and sin no more.

Despite its severely abraded condition, the Art Institute's picture can readily be related to *Moses Meeting His Wife and Sons*, mentioned above, which is Artaud's only other contribution to the Macklin Bible that has so far been traced. The two works share a friezelike arrangement of figures before an insubstantial theatrical background, a tendency for the figures' poses to appear unstable, and a reliance on prominent hand gestures, portraitlike heads, and elegantly languid female figures.

NOTES

1 The treatments were performed by Leo Marzolo and Alfred Jakstas, respectively. The average thread count of the original canvas is 18 x 12/sq. cm (45 x 30/sq. in.).
2 At Macklin's death in 1800, a sale of his possessions was conducted by Peter Coxe, Burrell and Foster, London, May 5–10, 1800, and May 27–30, 1801. *The Woman Accused of Adultery* was not offered for sale. It may have been one of the pictures previously disposed of by lottery, in 1797, to settle Macklin's debts; for this lottery, see Sven H. A. Bruntjen, *John Boydell, 1719–1804: A Study of Art Patronage and Publishing in Georgian London*, New York and London, 1985, pp. 119,

154–55. A copy was sold in the 1800 sale in a single lot (no. 39) with a copy after Philippe Jacques de Loutherbourg's *Christ Appeasing the Storm* as part of a group of twenty copies after Macklin Bible pictures, possibly reduced replicas made to aid the engravers in their work.

3 Described as the sale of "A Gentleman ready to embark for India"; see *The Index of Paintings Sold in the British Isles during the Nineteenth Century*, vol 2, pt. 1, ed. by Burton B. Fredericksen, Santa Barbara, Calif., 1990, pp. 21, 105; the price is from an annotated sale catalogue at the Victoria and Albert Museum, London.

4 According to Vose Galleries stockbooks; information kindly supplied by Sheila Dugan in a letter to Martha Wolff of December 6, 1994, in curatorial files.

5 Ibid.

6 Letter to David Farmer of November 2, 1974, in curatorial files.

Jerry Meyer had earlier expressed doubt about the attribution to West (letter to Esther Sparks of December 3, 1973). Sparks (1974, pp. 7–8) persisted in regarding at least the figure of the adulteress as the work of West.

7 Groom 1992.

8 Sewter's 1951 thesis is based on material provided by Artaud's collateral descendants. See also Jennifer C. Watson, "William Artaud and 'The Triumph of Mercy,'" *Burl. Mag.* 123 (1981), pp. 228–31, and Sloan 1995.

9 *The Diary of Joseph Farington*, ed. by Kenneth Garlick and Angus Macintyre, vol. 2, New Haven and London, 1978, p. 485 (January 28, 1796); see also Sloan 1995, pp. 76–85.

10 For further details about the project, see the entry for the Art Institute's other Macklin Bible picture, *The Destruction of Pharaoh's Army* by de Loutherbourg (1991.5).

11 Watson (note 8), fig. 65.

Sir William Beechey

1753 Burford, Oxfordshire–Hampstead 1839

Mark Pringle, c. 1797

Gift of Spencer H., Stuart, and Waldo H. Logan in memory of Mr. and Mrs. Frank G. Logan, 1944.700

Oil on canvas, 76.2 x 63.8 cm (30 x 25⅛ in.)

CONDITION: The painting is in fair condition. It was cleaned in 1965, when an old glue lining was removed and replaced with a wax resin one.[1] The tacking margins of the tightly woven twill-weave fabric have been cut off, but cusping is visible on all four sides.[2] The painting appears to have a warm, ocher-colored ground. The paint surface has been somewhat flattened by lining and is abraded throughout. Traction craquelure is visible on the sitter's right shoulder, in the shadow under his collar, and on his left shoulder. There are retouches on both his eyes, his right nostril and cheek, his upper lip, the upper right side of his collar and lapel, and the left side of his forehead. There are *pentimenti* covered by larger passages of overpaint behind his collar and shoulder on the left side of the painting. The contour of the coat was apparently changed here. X-radiography reveals areas of dense paint in the lower left corner and along the bottom edge in the center. The latter may possibly have been a hand, presumably painted out by the artist. Microscopic examination of the lower left corner reveals underlying traces of red and blue paint in the cracks which are similar to those in the landscape at the right. (infrared, ultraviolet, x-radiograph)

PROVENANCE: Arthur Tooth and Sons, London, by 1919.[3] Probably Frank G. Logan (d. 1937), Chicago; probably at his death to his widow, Jeanette Hancock Logan (d. 1943), Chicago; given to the Art Institute by her sons Spencer H. Logan, Stuart Logan, and Waldo H. Logan, 1944.

REFERENCES: AIC 1961, p. 219. John Wilson, "The Romantics, 1790–1830," in *The British Portrait, 1660–1960*, intro. by Sir Roy Strong, Woodbridge, 1991, p. 268, pl. 257.

Sir William Beechey was one of the leading society portraitists of the generation after Sir Joshua Reynolds and Thomas Gainsborough. He attended the Royal Academy Schools from 1774 and made his debut at the Academy exhibition in 1776. His early works are small-scale portraits and conversation pieces much indebted in style to Johann Zoffany, from whom he received some of his training. In 1782 he left London to set up practice in Norwich, where he successfully pursued a grander type of life-sized portraiture. From the time of his return to London in 1787, he maintained an acrimonious professional rivalry with John Hoppner, although both were soon outshone by the younger and more brilliant Thomas Lawrence. All three men enjoyed royal patronage: Hoppner was official portraitist to the Prince of Wales from 1789, Lawrence to George III from 1792, and Beechey to Queen Charlotte from 1793. Beechey was rewarded with a knighthood in 1798 and in the same

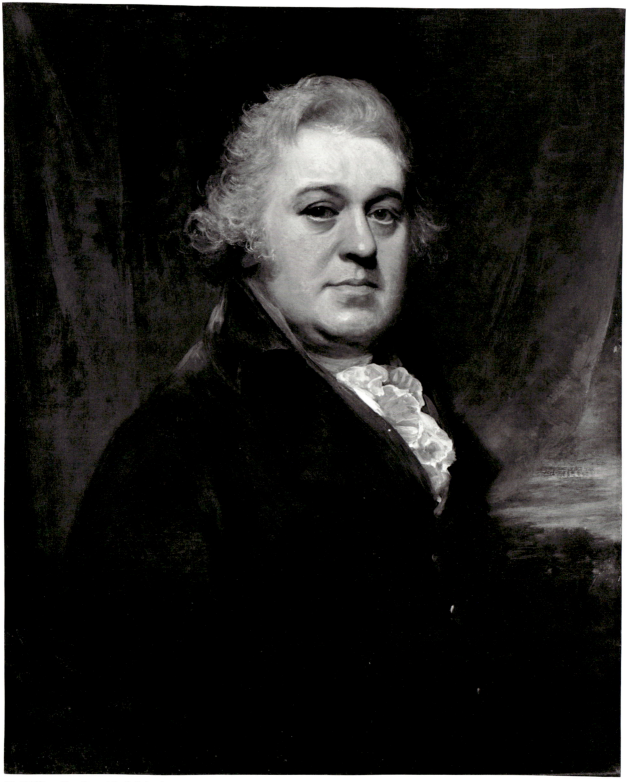

Sir William Beechey, *Mark Pringle,* 1944.700

year won election to the Royal Academy. His reputation as an artist was for solidity rather than dash. According to Joseph Farington, John Opie dismissively described Beechey's portraits as being "of that mediocre quality as to taste & fashion, that they seemed only fit for sea Captains & merchants: whereas Lawrence and Hoppner had each of them a portion as it were of gentility in their manners of painting."[4]

The sitter in the Art Institute's portrait was neither sea captain nor merchant, but a prominent landowner in the Borders region of Scotland, which lies south of Edinburgh, along the border with England. A label from the old lining of the canvas identifies him as Mark Pringle of Clifton, Haining, and Fairnilee.[5] Born in 1754, he was the only son of John Pringle of Crichton, Midlothian, and Anne Rutherford. He was educated at Edinburgh and Cambridge, trained as a lawyer, and admitted advocate in 1777. He made a Grand Tour in 1777–78. From 1782 he held the Scottish legal appointments of deputy judge advocate and clerk of the courts martial. In 1786 he inherited his maternal grandfather's estate of Fairnilee, Selkirkshire, and succeeded his granduncle John Pringle as member of Parliament for that county. On the death of his granduncle, in 1792, he inherited a large fortune and the additional estates of Clifton, Roxburghshire, and The Haining in Ettrick Forest, Selkirkshire. In 1794 he built a new house at The Haining and in the following year he married Anne Elizabeth Chalmers, daughter of the solicitor Robert Chalmers of Larbert and Musselburgh. They had three children, John (who enlarged and remodeled The Haining), Robert, and Margaret Violet. Pringle continued to serve as member of Parliament for Selkirkshire until 1802 and died at Bath in 1812, aged fifty-eight.[6]

The portrait was presumably made as a pendant to that of Mrs. Pringle, now at The Baltimore Museum of Art, which is signed with a monogram and dated 1797 (fig. 1).[7] The canvases are the same size and the portraits evidently by the same hand, to judge by the treatment of light and shade and the texture of the paint surface. The sitters are posed so that they would appear turned toward each other if the portraits were hung as was customary, with the husband on the left and the wife on the right. As clients of Beechey, the Pringles were in highly prestigious company. At the Royal Academy exhibition of 1797, he showed portraits of the queen, the Prince of Wales, and four royal princesses. His series of three-quarter-length portraits of the princesses, whom he was tutoring in art, are among his most sensitive

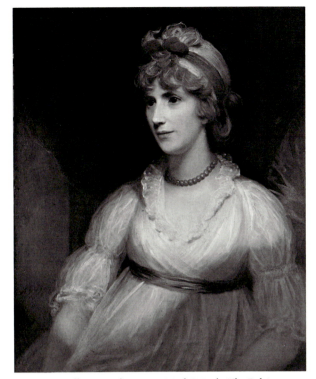

Fig. 1 Sir William Beechey, *Mrs. Mark Pringle*, The Baltimore Museum of Art: The Helen and Abram Eisenberg Collection, BMA 1967.36.1

works (Royal Collection).[8] In the same year he was also engaged on his most ambitious composition, the monumental *George III at a Review* (exhibited at the Royal Academy in 1798; destroyed; formerly Royal Collection).[9] His fee for the Pringle portraits was probably thirty guineas apiece.[10]

When the portrait of Mr. Pringle was given to the Art Institute in 1944, it was erroneously attributed to John Hoppner, which is the fate of countless unsigned British portraits of the period. This attribution survived until 1986, when the Hoppner authority John Wilson pointed out its connection with the portrait in Baltimore and its proper attribution to Beechey.[11]

Notes

1 This treatment was performed by Alfred Jakstas, who also surface cleaned the painting in 1964.

2 The average thread count of the canvas is 12 x 20/sq. cm (32 x 48/sq. in.). The conservation file includes a fragment of the old lining canvas and a paper label bearing the following inscription: 44 / *Portrait of Mark Pringle* / *Clifton & Haining &* / *Fairnilee he mar* / *ried Ann Chalmers & they* / *had 2 sons &* / *1 daughter, vis* / *John, Robert, & Margaret.*

3 According to the mount of a photograph in the Witt Library, London.

4 *The Diary of Joseph Farington*, ed. by Kenneth Garlick and Angus Macintyre, vol. 2, New Haven and London, 1978, pp.

289–90 (January 7, 1795). On Beechey's career, see William
Roberts, *Sir William Beechey, R.A.*, London and New York, 1907.

5 See note 2.

6 For biographies of Pringle, see Alexander Pringle, *The Records
of the Pringles or Hoppringills of the Scottish Border*,
Edinburgh and London, 1933, p. 178; and Sir Lewis Namier and
John Brooke, *The History of Parliament: The House of
Commons, 1754–1790*, vol. 3, New York, 1964, pp. 333–34.
Mrs. Pringle's beauty was admired by Sir Walter Scott (see *The
Journal of Sir Walter Scott*, ed. by W. E. K. Anderson, Oxford,
1972, p. 551 [April 20, 1829]).

7 The portrait in Baltimore measures 29³/₄ x 24¹/₂ in. A label
affixed to the stretcher gives the following information: *Portrait
of Mrs. Mark Pringle née Chalmers [. . .] whose only /
daughter Margaret married / Archibald Douglas [. . .] after the
death of her / two brothers and wife of [. . .] / of Clifton & [. . .]
née Ann Chalmers / m. 1795.* Information kindly supplied by

Sona Johnston in a letter of April 18, 1994, in curatorial files.
This portrait was also with Arthur Tooth and Sons, London,
according to the mount of a photograph in the Witt Library,
London.

8 For this series, see Oliver Millar, *The Later Georgian Pictures
in the Collection of Her Majesty the Queen*, London, 1969,
pp. 8–9, nos. 665–70, pls. 163–68.

9 Ibid., pp. 6–7, no. 660, pl. 161.

10 Opie's remarks recorded in the Farington diary (see note 4)
were occasioned by Beechey's "having raised his price to thirty
guineas a head." Beechey seems not to have exhibited the
Pringle portraits. All the sitters in his exhibited male portraits
from 1797 to 1803, even those who were anonymous at the
time, were identified from catalogues, press reviews, and other
contemporary sources by William Roberts (see Roberts [note 4],
pp. 267–70). Pringle was not among them.

11 Letter to Richard Brettell of March 7, 1986, in curatorial files.

British

Fashionable Figures, with Two Women Holding Fans, 1733/35

Gift of Mr. and Mrs. Richard T. Crane, Jr., 1925.1682a

Oil on plaster, mounted on aluminum honeycomb panel,
81.4 x 153.5 cm (32¹/₁₆ x 60⁷/₁₆ in.)

CONDITION: The mural fragment is in poor condition. It is a
segment of a painting on a plaster and wood lath wall, and was
removed from no. 75 Dean Street, London, in 1919. The mural
had been restored in situ in 1912.[1] The segment was transferred
at the Art Institute to the present aluminum honeycomb panel,
backed by wood, in 1976–77, when it was also cleaned, var-
nished, and inpainted.[2] A wide crack extends vertically from the
upper left background through the second figure from the left.
Another, narrower crack extends upward diagonally from that
one, passing through the head of the seated woman at center.
Other, less severe cracks cross through the torso of the woman
holding the fan at right. There are a few smaller cracks and
losses at the upper right and left corners and at the top edge
on the left. All of the cracks and losses have been filled and
inpainted. The off-white, coarse-textured plaster support of the
painting is apparent through the severely abraded paint surface,
particularly in the central background, in the fan held by the
woman at right, and in some of the drapery of the central seated
woman. Ultraviolet-light examination reveals retouching over
much of the background, the flesh of the two central women
and of the man between them, the area around the face of the
woman at left, and part of the man's head at right. (infrared,
ultraviolet)

PROVENANCE: See below.

REFERENCES: See below.

Fashionable Figures, with a Man in Turkish Costume, 1733/35

Gift of Mr. and Mrs. Richard T. Crane, Jr., 1925.1682b

Oil on plaster, mounted on aluminum honeycomb panel,
81.6 x 168.3 cm (32¹/₈ x 66¹/₄ in.)

CONDITION: The mural fragment is in poor condition. As with
the companion piece (1925.1682a), this segment of a painting
on a plaster and wood lath wall was removed from no. 75 Dean
Street, London, in 1919. It had been restored in situ in 1912, and
was cleaned, varnished, and inpainted in 1976–77 at the Art
Institute, at which time it was also transferred to the present
aluminum honeycomb panel with a wooden backing.[3] There
are three major cracks in the plaster support through the full
height of the fragment. The first extends vertically through the
face of the man second from the left, and the other two extend
diagonally, one downward to the right through the second fig-
ure from the right, and the other downward to the left through
the figure wearing the turban. There are also less severe cracks
that do not pass through the figures. In addition, there are
large losses at the right and left edges. All of the cracks and
losses have been filled and inpainted. The off-white, coarse-
textured plaster support is visible through the severely
abraded paint surface. Its thinned appearance is most evident
in the background between the figures and in the dark parts
of their costumes where the pebbly texture remains exposed.
Ultraviolet-light examination reveals retouching over much
of the flesh, particularly in the women. The retouches are
crude and in some cases seriously discolored. (infrared, mid-
treatment, ultraviolet)

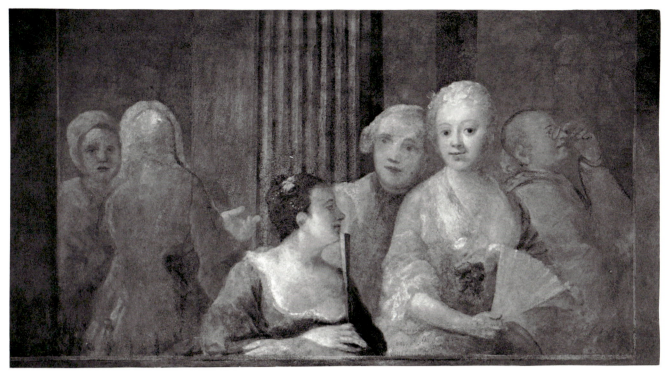

British, *Fashionable Figures, with Two Women Holding Fans*, 1925.1682a

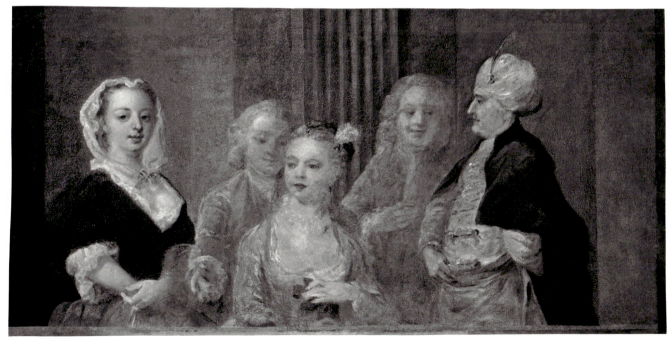

British, *Fashionable Figures, with a Man in Turkish Costume*, 1925.1682b

PROVENANCE: Part of a decorative scheme for the main staircase of no. 75 Dean Street, Soho, London, built by builder-carpenter Thomas Richmond and first occupied by Bulstrode Peachey Knight, who leased the house from 1733.[4] The house bought by H. H. Mulliner in 1912; the mural decoration removed in 1919 in preparation for the house's demolition, which took place in 1923.[5] Acquired with the bulk of the interior fittings of the house by Monday, Kern, and Herbert, London, 1919.[6] W. and J. Sloane and Co., New York, by 1921, to 1925.[7] Bought by Mr. and Mrs. Richard T. Crane, Jr., and given to the Art Institute, together with many of the fittings of the house, 1925.

REFERENCES: Richard Redgrave and Samuel Redgrave, *A Century of Painters of the English School*, vol. 1, London, 1866, pp. 59–61; 2d ed., 1890, pp. 24–25. "A Real Antique in Soho," *Spectator* (London) 4, 408 (December 21, 1912), pp. 1052–53. J. M. W. Halley, "Sir James Thornhill's House in Soho," *Architectural Review* 33 (1913), pp. 52–54 (ill.). "A Georgian House in Danger," *Times* (London), January 9, 1914, p. 9. Gilbert R. Redgrave, "The Wall-Paintings Fifty Years Ago," letter to the editor, *Times* (London), January 13, 1914, p. 10. W. J. Fraser, "Evidence from Leases," *Times* (London), January 14, 1914, p. 11. "The Georgian House in Soho," *Times* (London), January 15, 1914, p. 9. "The Georgian House in Soho: Contract Not Yet Signed: Drawings of the Door and Staircase," *Times* (London), January 16, 1914, p. 47. Guy Francis Laking, letter to the editor, *Times* (London), January 16, 1914, p. 47. "Georgian House Saved," *Times* (London), January 17, 1914, p. 8. "The Georgian House in Soho: Position of the Owner," *Times* (London), January 19, 1914, p. 5. Edward Warren, F.S.A., letter to the editor, *Times* (London), January 20, 1914, p. 9. Walter Crane, letter to the editor, *Times* (London), January 23, 1914, p. 7. May Morris, letter to the editor, *Times* (London), January 26, 1914, p. 6. "The Georgian House in Soho," *Times* (London), March 11, 1914, p. 6. "The Hogarth House in Soho: Vandalism Far Advanced," *Times* (London), May 3, 1919, p. 9. W. and J. Sloane, *The Fittings of a Famous English House Known as The Hogarth House, Existing in the Once Fashionable Locality of Soho in London*, New York, 1921, n. pag. (ill. of reconstruction and elevation). "Fittings of a Famous English House," *American Architect—Architectural Review* 123 (1923), pp. 267, 270, 272. Sydney de Brie, "From Soho to New York," *Country Life* 47, 4 (1925), pp. 86–90 (ill. of reconstruction). Christopher Hussey, "Painted Staircases at 8, Clifford Street and 76, Dean Street," *Country Life* 101, 2617 (1947), p. 468. Ralph Dutton, *The English Interior, 1500–1900*, London, 1948, pp. 92–93, fig. 67. John Harris, "English Rooms in American Museums," *Country Life* 129, 3353 (1961), p. 1326. Reginald Colby, "44, Grosvenor Square, The Residence of Lady Illingworth," *Country Life* 130, 3360 (1961), p. 193. F. H. W. Sheppard, ed., *The Survey of London*, vols. 33–34, *The Parish of St. Anne, Soho*, London, 1966; vol. 33, pp. 15, 221–26, 228, 330–31; vol. 34, pls. 104a–d; 105a–c. Desmond Fitz-Gerald, "The Mural from 44 Grosvenor Square," *Victoria and Albert Museum Yearbook* 1 (1969), pp. 146–51, figs. 5, 6. Edward Croft-Murray, *Decorative Painting in England, 1537–1837*, vol. 2, London, 1970, pp. 234, no. 13, 303, under no. 5. F. H. W. Sheppard, ed., *The Survey of London*, vol. 40, *The Grosvenor Estate in Mayfair*, London, 1980, pp. 155, 158.

These mural fragments were part of an illusionistic architectural decoration in which the figures appeared behind balustrades under an arcade covering two sides of the main staircase of a London townhouse, no. 75 Dean Street. The two groups of figures now at the Art Institute occupied the two bays on the longer side of the staircase, while a third group occupied a bay on the shorter side, over the base of the stairs (see figs. 1–2).

A tradition dating from the early nineteenth century claimed no. 75 Dean Street as the sometime residence of the history painter Sir James Thornhill, and led to erroneous attributions of the murals there to Thornhill and his son-in-law, William Hogarth.[8] It was largely owing to this tradition that the proposed demolition of the house in 1914 became the subject of controversy, resulting in the issuance of a temporary preservation order and the holding of a hearing before a select committee of the House of Lords. In the end the committee failed to confirm the preservation order.[9] In 1919 the murals were cut into segments and removed, together with the extensive wooden interior fittings, and in 1923 the house was demolished.[10] Both murals and fittings were bought for the Art Institute from the furniture gallery W. and J. Sloane in New York, still on the strength of the house's supposed association with Thornhill and Hogarth, although doubts about this had already been raised at the time of the preservation order of 1914.[11] Most of the fittings, including the staircase, were installed in reconstructed rooms at W. and J. Sloane's and later at the Art Institute, but the murals seem never to have been reconstructed. The purely architectural parts of the murals, as well as the third group of figures, seem not to have survived.[12]

The idea that Hogarth may have had a hand in the decoration of no. 75 Dean Street was given authority by Redgrave and Redgrave (1866). They also gave the first account of the work's state of preservation:

> The picture has been painted in oil on the walls, which have been plastered with a somewhat rough surface, then deeply saturated with oil, and painted over with a full pencil. It would be a work of great difficulty to remove the paintings, which are in a good condition, and though the browns are a little broken up, the work is, on the whole, remarkably fresh and pure.[13]

By the time of the second edition of the Redgraves' book (1890), the murals' condition had evidently deteriorated. The description of the murals as "remarkably fresh and pure" was removed and the following added:

Fig. 1 Staircase and hall at no. 75 Dean Street, London
[photo: courtesy of the Greater London Record Office]

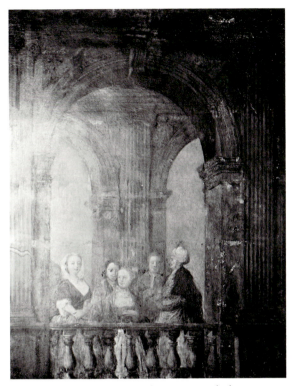

Fig. 2 *Fashionable Figures, with a Man in Turkish Costume*,
1925.1682b, shown in situ at no. 75 Dean Street, London
[photo: courtesy of the Greater London Record Office]

They would now require a careful restoration, partly because an injudicious endeavor has been made to preserve them by glueing brown paper over the figures, and partly because of the inevitable wear and tear they have undergone in their position.[14]

The condition of the fragments now at the Art Institute, further damaged by removal from the wall, by abrasion, and by repeated restoration (see Condition), is obviously poor. Nevertheless, they do retain vestiges of the lively touch that struck the Redgraves and others as Hogarthian. They have apparently not been exhibited or even reproduced in their dismantled state, although they have been mentioned frequently in the literature on eighteenth-century English decorative painting.

Whereas the Redgraves exercised a modicum of caution in invoking the name of Hogarth in connection with the murals, later writers discussed them as if they were fairly securely attributable to him, whether working alone or jointly with Thornhill, and the Art Institute installed the paneling as that of "The Hogarth House."[15] In 1948 Ralph Dutton was more cautious, but still associated the paintings with Hogarth.[16] In 1961 John Harris proposed an alternative attribution to William Kent, a far more plausible idea that was endorsed by Edward

Croft-Murray, who catalogued the murals as by Kent and dated them to c. 1727 in his authoritative book on English decorative painting.[17] However, evidence against both the Hogarth and the Kent attributions had emerged in the volumes of the *Survey of London* devoted to the Parish of St. Anne in Soho, published in 1966. The *Survey* demonstrated not only that the tenancy of the house was unconnected to Thornhill or Hogarth, but also that its fitting-up occurred in 1733–35, almost certainly too late for Kent plausibly to have been involved in the decoration.[18] In 1969 Desmond Fitz-Gerald pursued a connection to a slightly earlier painted staircase, from no. 44 Grosvenor Square, now in the Victoria and Albert Museum, and suggested that both might be by John Laguerre.[19]

As the exhaustive research of the *Survey of London* established, much of the west side of Dean Street was redeveloped from 1731 as part of the Pitt estate. The building lease for no. 75 was taken by the carpenter-builder Thomas Richmond, who in 1733 assigned it to Bulstrode Peachey Knight, a landowner in Sussex and Hampshire as well as a member of Parliament. It was presumably for Knight that the new house was fitted up and decorated between 1733 and 1735. He was its first,

brief occupant in the latter year. Afterward the house was privately occupied by various landed tenants until the early nineteenth century, when, in keeping with changing residential patterns in London, it was occupied by a succession of firms of craftsmen and brought into commercial use.[20] No connection exists with Thornhill, who died in 1734, or with Hogarth, who lived in nearby Leicester Fields.

The damaged condition of the murals makes attribution difficult. While the possibility of Thornhill's or Hogarth's participation can be readily dismissed, the connection to the work of William Kent deserves careful consideration. The conception of the staircase decoration at no. 75 Dean Street was clearly derived from the King's Staircase at Kensington Palace, painted by Kent in 1725–27.[21] It too features fashionable and exotic figures under a fictive arcade, and the woman who taps a fan delicately on her chin in the central bay of the longer wall at Kensington is repeated almost exactly in 1925.1682a. The illusionistic ceiling oculus with fictive balustrade that forms part of the Kensington decoration was also echoed at no. 75 Dean Street.[22] The shaky anatomy and soft, seemingly boneless hands of the figures in the Chicago fragments do bear some stylistic resemblance to those in Kent's paintings. On the other hand, Kent's figures in the murals at Kensington and elsewhere are considerably more active and Italianate in pose. Furthermore, Kent is not the only contemporary source quoted in the Dean Street murals. The turbaned man at the right of 1925.1682b is borrowed from a print after Jean Antoine Watteau's *Fêtes vénitiennes*, as is evident from the details of his costume and the reversal of his pose in relation to the original, now in the National Gallery of Scotland, Edinburgh. The engraving after the Watteau, by Laurence Cars, was published in the summer of 1732, shortly before work on the Dean Street interior began.[23]

It seems highly unlikely that, at that point in his career, Kent would have participated in a project such as the decoration of Mr. Knight's new house in Soho, which, substantial and elegant though it may have been, was nevertheless unexceptional compared to the major commissions he received after the decoration of Kensington Palace. In any case, in the 1730s he devoted himself less to painting than to the arts of design, in which he was undoubtedly more gifted and successful.[24]

Fitz-Gerald's suggestion that the Dean Street decorations, along with those of another painted staircase, now in the Victoria and Albert Museum, London, may be by

John Laguerre is an intriguing one. The Victoria and Albert staircase, which came from no. 44 Grosvenor Square and is datable to about 1727, also shows fashionable figures behind a fictive balustrade.[25] Fitz-Gerald based his tentative attribution of the two schemes to Laguerre on their similarity to works by his better-known father, Louis Laguerre, who painted murals at Petworth, Blenheim, and elsewhere, and the likelihood that works in Louis's style executed after his death in 1721 might be by his son.[26] John Laguerre certainly practiced as a decorative painter, and is recorded as the author of a lost staircase decoration at no. 48 Grosvenor Street,[27] but no work of that kind has survived with a secure attribution to him. Indeed, his known work is limited to four paintings of scenes from the ballad opera *Hob in the Well* at the Yale Center for British Art, New Haven.[28] These are delicately and freely painted, but the differences of technique and genre make comparison difficult. We know that Thomas Richmond, who built no. 75 Dean Street, also built houses in Grosvenor Square.[29] It may well have been through connections in the building trade that a decorative painter such as John Laguerre obtained commissions. It must be said, however, that the case for his authorship of the Victoria and Albert mural, whose figures bear a closer stylistic resemblance to those of Louis Laguerre, is by far the stronger. In other words, even if that case were proven, it would not necessarily follow that the Chicago fragments are John Laguerre's work too. Given their poor state of preservation and the paucity of surviving examples of what was probably a common type of work, the Chicago fragments should be regarded as by an anonymous British painter well versed in the decorative fashions of his day.

NOTES

1 See Sheppard 1966, vol. 33, p. 223; see also fig. 1 of this entry and Sheppard 1966, vol. 34, pl. 105a, which show the mural decoration before the restoration in 1912, and ibid., pl. 105c, which shows it afterward.

2 The transfer and treatment were performed by Alfred Jakstas.

3 See note 2.

4 See Sheppard 1966, vol. 33, pp. 221–22, noting that the house was first assessed for rates in 1735, the year in which Knight apparently took occupancy. He died shortly thereafter, though members of his family continued to occupy the house until 1750. The tenancy history of no. 75 Dean Street is fully outlined in the *Survey of London*, and there is no evidence to support the tradition (discussed below) linking the house and its decoration to Sir James Thornhill and William Hogarth. For Knight and the Peachey family, see also *The History of Parliament*, vol. 2, *The House of Commons, 1715–1754*, ed. by Romney Sedgwick, London, 1970, pp. 327–28.

5 See Sheppard 1966, vol. 33, pp. 223–24, describing the protracted efforts to save the house.

6 See *Times* 1919.

7 See W. and J. Sloane 1921; *American Architect—Architectural Review* 1923, p. 270; de Brie 1925, pp. 86–90; and report dated October 16, 1947, by Meyric Rogers, former Curator of Decorative Arts at the Art Institute (copy in curatorial files).

8 The tradition was current at least as early as 1833, when the walls of the staircase were described as "embellished with beautiful paintings, supposed to have been executed either by Hogarth or Thornhill, in their first stile [*sic*]" in the prospectus for the sale of the property held when the Pitt family's lease expired; a copy of the prospectus is in the Public Record Office, London. See also Sheppard 1966, vol. 33, pp. 210, 224.

9 For the controversy, which was seen as a test of the Ancient Monuments Act of 1913, see Sheppard 1966, vol. 33, pp. 223–24, and the series of articles and letters in the *Times* cited in the References.

10 See *Times* 1919.

11 Sheppard 1966, vol. 33, p. 224.

12 This is suggested by the photograph of the staircase as it was set up by Sloane; see *American Architect—Architectural Review* 1923, p. 269 (ill.). Meyric Rogers's 1947 report, cited in note 7, indicates that all the fittings from the house were sent from Sloane's to the Art Institute, but that most of the material from the upper floors was sent on to the Cranes' residence, Castle Hill, in Ipswich, Massachusetts, in 1927. The segments of plasterwork shipped to the museum included the fictive architecture, but according to the report of W. A. Warner, the museum's architect, made in 1927 and quoted by Rogers, "Very little of the painted stone work courses were in any state of preservation, quantities being merely powder, but a few pieces in excellent condition and amply sufficient to give the pattern and color have been saved." The task of finally setting up the ground floor of the house fell to Rogers, who examined the remaining fragments and in his 1947 report stated that "all the fragments which had any significance as to quality and decorative style were saved with the idea of exhibiting them suitably mounted on the gallery at the head of the stairway. . . . The rest of the material was discarded as being completely useless." The third group of figures was apparently among the fragments that did not survive, although the exact point at which they were lost is unclear.

13 Redgrave and Redgrave 1866, p. 61.

14 Redgrave and Redgrave 1890, p. 25.

15 See *American Architect—Architectural Review* 1923, de Brie 1925, and Hussey 1947. Although the stairwell and ground floor rooms were installed as "The Hogarth House," it is clear from Rogers's 1947 report (note 7) that he doubted the attribution to Hogarth.

16 Dutton 1948, pp. 92–93.

17 Harris 1961, p. 1326; and Croft-Murray 1970, p. 234, no. 13.

18 Sheppard 1966, vol. 33, pp. 221–26, based in part on an analysis of the rate books for the parish.

19 Fitz-Gerald 1969, pp. 146–51.

20 The first commercial occupants were the gold- and silversmiths Rundell, Bridge and Rundell; they and subsidiary companies were in the house from 1801 to 1834; see Sheppard 1966, vol. 33, p. 222.

21 Croft-Murray 1970, pp. 28, 234, no. 14, 99, pl. 41; and Michael I. Wilson, *William Kent: Architect, Designer, Painter, Gardener, 1685–1748*, London, 1984, pp. 51–55, figs. 8–9. Croft-Murray and others point out the debt of Kent's Kensington staircase to Charles Le Brun's *Stairway of the Ambassadors* at Versailles and to the decorations of Agostino Tassi, Carlo Saraceni, and others in the Sala Regia of the Quirinale Palace in Rome; see Anthony Blunt, *Art and Architecture in France, 1500–1700*, 2d ed., Harmondsworth, 1973, pp. 337–38, fig. 279; and Giuliano Briganti, *Il Palazzo del Quirinale*, Rome, 1962, figs. 30, 31.

22 The ceiling mural does not survive; a photograph made by the Historic Buildings Survey of the London County Council is preserved in the Greater London Record Office (copy of photograph in curatorial files).

23 Donald Posner, *Antoine Watteau*, London, 1984, pl. 50. For the engraving by Cars, see Emile Dacier and Albert Vuaflart, *Jean de Jullienne et les graveurs de Watteau au XVIIIᵉ siècle*, vol. 3, Paris, 1922, pp. 9–10, no. 6; vol. 4, Paris, 1921, pl. 6.

24 For Kent's career, see Croft-Murray 1970, pp. 229–33.

25 The Grosvenor Square decoration is illustrated in Fitz-Gerald 1969 (figs. 2, 4). See also Sheppard 1980, pp. 155–58, fig. 39, pl. 44d.

26 Croft-Murray (1970, p. 303, no. 5) listed the decoration at no. 44 Grosvenor Square as anonymous, but did note that its style was closer to Louis Laguerre's Saloon at Blenheim than to Kent's work at Kensington.

27 See Sheppard 1980, pp. 47, 155. The staircase is described as "Wainscotted Rail'd high with Oak and the rest painted in a Composed Order with figures and Trophies done by John Legare [*sic*]" (p. 47).

28 Fitz-Gerald 1969, pp. 149–51, figs. 10, 11.

29 See Sheppard 1980, p. 155, which corrects the erroneous statement in Sheppard 1966, vol. 33, p. 222, that Richmond actually built no. 44, but documents his involvement in other Grosvenor Square houses, including no. 45. Rented first to Sarah, duchess of Marlborough, for her grandson, and later to Lord Chesterfield, no. 45 also featured a painted staircase.

British

Family in a Room, c. 1765
Gift of Emily Crane Chadbourne, 1951.205

Oil on canvas, 71.1 x 91.1 cm (28 x 35⅞ in.)

CONDITION: The painting is in fair condition. It has received three superficial cleanings since it entered the museum, the most recent in 1964.[1] The canvas has an old glue lining, and the tacking margins have been cut off. Pronounced cusping is visible at the right and left edges, and minimal cusping at the top and bottom edges.[2] The ground is off-white. There is a small, irregularly shaped loss at the upper left corner of the fireplace, which has been filled and inpainted. The paint surface has been flattened, and some shrinking of the paint film has occurred in the face of the older man seated at the right, as a result of the lining process. A diagonal scratch extends from the chin of the young man to the corner of the mantelpiece. It and some of the cracks in the faces have been subtly retouched. The paint layer is slightly abraded throughout, especially in the dress and hair of the older woman seated at center, and in the dark passages between the figures seated around the table. The flesh tones of the female figures and the young man at the left appear to have faded. The true condition of the paint surface is difficult to assess because of an obscuring, discolored natural resin varnish. (x-radiograph)

PROVENANCE: Leggatt Brothers, London, by 1927.[3] On loan to the Art Institute from Emily Crane Chadbourne, Washington, D.C., 1932–51; given to the Art Institute, 1951.

REFERENCES: AIC 1961, p. 487.

EXHIBITIONS: Hartford, Connecticut, Wadsworth Atheneum, *Pictures within Pictures*, 1949–50, no. 50, traveled to Andover, Massachusetts.

The dress of the sitters, who are presumably father, mother, and six children, suggests that the work was executed in the 1760s. By 1927, when it was with Leggatt Brothers, it had acquired an attribution to the German-born painter Johann Zoffany (1733–1810), who settled in England probably by the autumn of 1760 and stayed until 1772, when he left for a period in Italy. This attribution was accepted by the Art Institute when the work entered the collection, and firmly supported by W. G. Constable.[4] There is certainly some resemblance to the work of Zoffany. The arrangement of figures gathered around a table near the family hearth, the attention paid to decorative details such as the mantelpiece and painting above, the design on the rug, and the lace and frills of the ladies' dresses, as well as other particulars of the poses and staging, recall, for instance, Zoffany's *Lord Willoughby de Broke and His Family* of about 1766/68.[5]

On the other hand, these features had been standard ingredients of the British conversation piece at least since Hogarth in the 1730s, and Zoffany was merely the leading exponent of the form, among many others, in the 1760s. Although the dress of the woman on the right of the Chicago painting is painted with evident skill, most of the work is fairly clumsy in execution. The

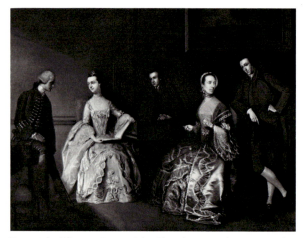

Fig. 1 John Thomas Seaton, *The Chambers Family*, private collection [photo: courtesy of Christie's, London]

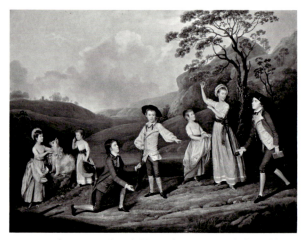

Fig. 2 Hugh Barron, *The Children of George Bond of Ditchleys*, Tate Gallery, London

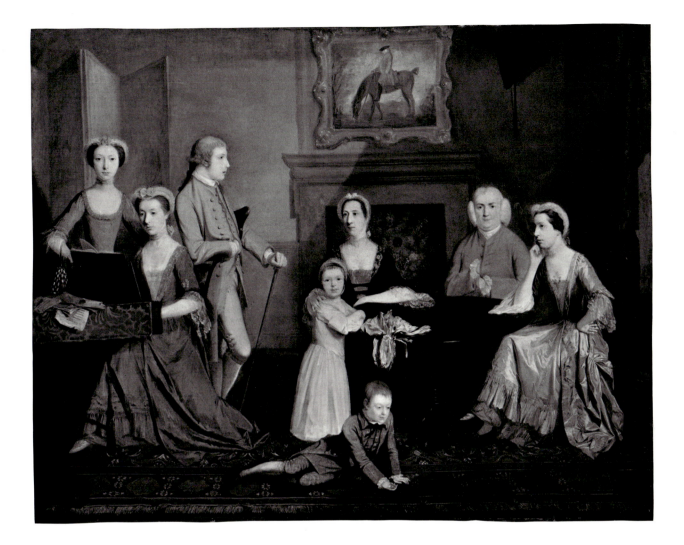

figures are stiff, and posed as if studiously ignoring each other. The artist has avoided painting hands wherever possible, even to the extent of showing the older man with both hands in his coat. He has also given the woman on the right odd shoes, one of which looks like a man's. These faults make the attribution to such a polished professional as Zoffany seem highly unlikely, and indeed the Art Institute has catalogued the work as merely "British School" since 1980.

The artist in question was surely a lesser figure of the period, working under Zoffany's influence, probably in the provinces. David Posnett has tentatively suggested an attribution to John Thomas Seaton (active 1758–1806).[6] This seems to be at least reasonably possible; compare, for instance, Seaton's group portrait of the Chambers family, exhibited at the Society of Artists in 1763 (fig. 1). There are clear points of similarity, although the Seaton shows a markedly daintier touch,

finer modeling, and a more sophisticated treatment of light than the Chicago picture. Another candidate for the attribution is Hugh Barron (c. 1745–1791), whose child portraits in *The Children of George Bond of Ditchleys* of 1768 (fig. 2) may connect with those in the Chicago picture. The similarity is far from decisive, however, and may show no more than that minor artists painting children at about the same time can come up with comparable results. The attribution of the Chicago *Family in a Room* will probably remain an open question until some securely attributed work comes to light that shares not just its general characteristics but its quirks.

A young woman on the left plays a keyboard instrument (another commonplace activity in British conversation pieces); among the pieces of music on it is a sheet headed "Nancy." This may be a clue to the woman's name.

NOTES

1 The painting was surface cleaned and repaired by Leo Marzolo in 1952; cleaned and the frame regilded by Knoedler's in 1954, at the request of Mrs. Chadbourne; and treated in 1964 by Alfred Jakstas.

2 The average thread count of the original canvas is 10 x 12/sq. cm (26 x 30/sq. in.).

3 According to the mount of an old photograph in the Witt Library, London.

4 Letter of November 21, 1951 (copy in curatorial files).

5 Formerly Woodley House, Kineton, Lord Willoughby de Broke; see Mario Praz, *Conversation Pieces, A Survey of the Informal Group Portrait in Europe and America*, University Park, Pa., and London, 1971, p. 104, fig. 64.

6 Letter to the author of June 5, 1989 (copy in curatorial files).

British

Portrait of a Lady, Possibly of the Stanley Family, c. 1780

Gift of Mr. and Mrs. Robert Andrew Brown, 1964.197

Oil on canvas, 81.3 x 67.3 cm (32 x 26½ in.)

CONDITION: The painting is in fair condition. It was cleaned at the Art Institute in 1964.[1] The canvas has an old glue lining, and the tacking margins have been cut off. Cusping is visible at the top and sides; the absence of cusping at the bottom edge, together with the slight deviation from the standard size of 35 x 27 in., suggests that the canvas may have been cut at the bottom. There are two parallel vertical tears approximately 3.5 cm apart that extend down the center length of the canvas, intersecting the face and entire figure. These may have been caused by pressure on the stretcher bar, but the width of the present stretcher bar does not correspond with the distance between the tears, suggesting that the stretcher is not original. The ground is white or off-white. There is extensive loss to the ground and paint layers associated with the tears, and a small loss near the bottom center edge. These losses have been heavily overpainted, and are discolored and disfiguring. Scattered losses in the background and along the bottom edge have been retouched. The paint layer has been flattened by lining. Artist's changes in the outline of the sitter's skirt, the left sleeve, and the background landscape, both to the left and the right of the figure, are visible in the x-radiograph (fig. 1). (mid-treatment, x-radiograph)

PROVENANCE: Possibly Henry Labouchere, first Lord Taunton (d. 1869), Quantock Lodge, near Bridgwater, Somerset.[2] Probably Edward James Stanley (d. 1907), and then his widow, Mary Dorothy (d. 1920), daughter of Lord Taunton, Quantock Lodge, near Bridgwater, Somerset. Captain Eric Villiers; sold by him to Arthur Tooth and Sons, London, April 11, 1930; sold to Theodore Dickinson, October 3, 1930.[3] Mr. and Mrs. Robert Andrew Brown, Libertyville, Illinois; given to the Art Institute, 1964.

The damaged condition of this work, especially in the area of the face, makes any attribution speculative. The traditional attribution to Johann Zoffany (1733–1810), given in an inscription on a label attached to the stretcher,[4] seems within the realm of possibility. In the pose of the figure and treatment of the dress, the work is comparable, for instance, to Zoffany's portrait of Matilda Cleveland, datable to 1777.[5] As the Zoffany authority

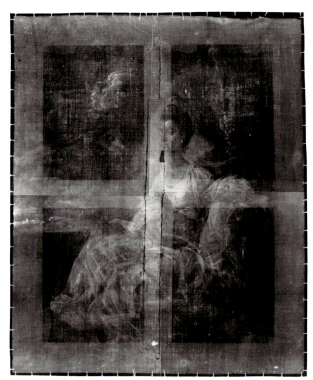

Fig. 1 X-radiograph of *Portrait of a Lady, Possibly of the Stanley Family*, 1964.197

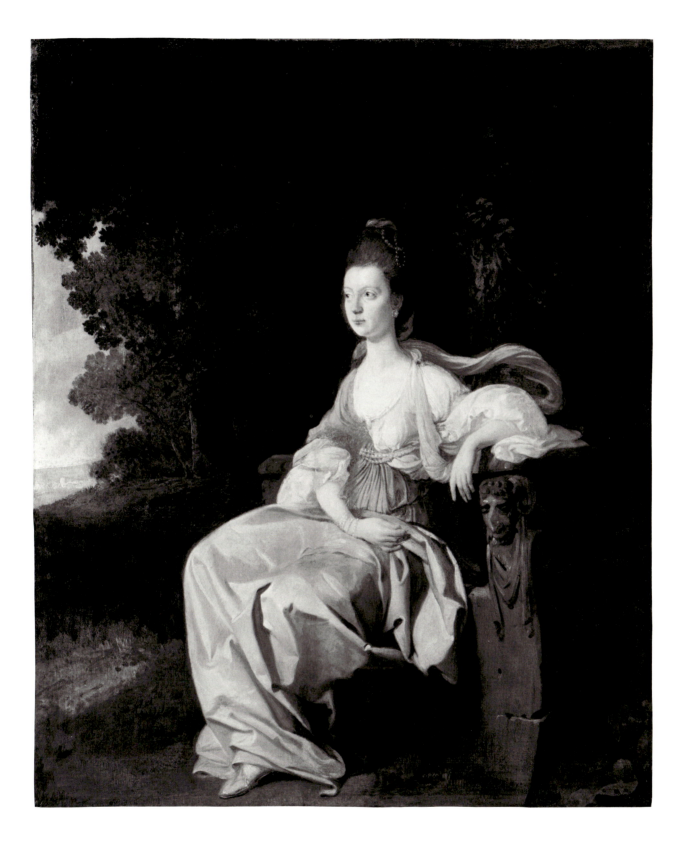

Mary Lightbown (formerly Webster) has pointed out, however, the overall quality of the work seems below Zoffany's standard, and the characterization of the head, even allowing for its disfigurement, lacks his clarity and firmness.[6] Despite the label and what was probably a fairly old attribution to him, the work seems more likely to have been painted by a younger or less accomplished contemporary working in a Zoffany-like vein.

The most likely candidates are John Hamilton Mortimer (1740–1779) and Francis Wheatley (1747–1801). While the treatment of the landscape background and the prominence of the grotesque head on the armrest of the stone bench suggest Mortimer, the facial type is closer to Wheatley, whose portraits in the Zoffany manner also feature picturesque garden furniture. On the whole, Wheatley appears the slightly stronger possibility. The decorative handling of the foliage and the treatment of the face, especially the eyes, are certainly reminiscent of Wheatley portraits of the later 1770s, such as those of Stephen Sullivan and Lord Spencer Hamilton.[7] On the other hand, the absence of any closely comparable female portraits by him makes the attribution impossible to affirm with any confidence.

The identity of the sitter is also problematic. The label on the stretcher calls her "a lady of the Stanley family" and states that the portrait was in the collection of the Whig politician and connoisseur Lord Taunton of Quantock Lodge. This may all be true, in which case there is insufficient evidence to associate the portrait with any particular family named Stanley. But it seems more likely that the work belonged in fact to Lord Taunton's son-in-law Edward James Stanley, who be-

came master of Quantock Lodge after Taunton's death. The author of the label probably assumed that all works of art at Quantock Lodge were collected by Taunton, whereas the portrait in question came later, with Stanley. He was the son of Edward Stanley of Cross Hall, Lancashire, and the lady in the portrait may have been some earlier member of that family.[8]

NOTES
1 The painting was treated by Alfred Jakstas. The average thread count of the original canvas is 15 x 15/sq. cm (38 x 38/sq. in.). A typed label on the back of the stretcher bears the following inscription: *PORTRAIT OF A LADY OF THE STANLEY FAMILY BY J. ZOFFANY, R.A. / FROM THE COLLECTION OF LORD TAUNTON, QUANTOCK LODGE, SOMERSETSHIRE.* A label on the back of the frame bears the following inscription: *ARTHUR TOOTH & SONS / DEALERS IN WORKS OF ART, / 155 NEW OLD BOND STREET / LONDON / ESTABLISHED 1842.*
2 From a label on the stretcher (see note 1).
3 Information from the stock book of Arthur Tooth and Sons, London, dated November 1, 1923, to April 6, 1935, Archives of the Getty Center for the History of the Arts and the Humanities, Santa Monica, California.
4 See note 1.
5 See Oliver Millar, *Zoffany and His Tribuna*, London and New York, 1966, pl. 27; and Mary Webster, *Johann Zoffany, 1733–1810*, exh. cat., London, National Portrait Gallery, 1976, p. 65, no. 83 (ill.).
6 Letter to the author of June 23, 1988 (copy in curatorial files).
7 For the Sullivan portrait, see Ellis K. Waterhouse, *The Dictionary of British Eighteenth-Century Painters in Oils and Crayons*, Woodbridge, Suffolk, 1981, p. 407 (ill.). For the Hamilton portrait, see Oliver Millar, *The Later Georgian Pictures in the Collection of Her Majesty the Queen*, London, 1969, p. 136, no. 1173, pl. 80; and Mary Webster, *Francis Wheatley*, London, 1970, p. 124, no. 24 (ill.).
8 For a family history, see Peter Draper, *The House of Stanley; Including the Sieges of Lathom House*, Ormskirk, 1864, pp. 330–35. Edward James Stanley's great aunts Betty (b. 1753) and Catherine (Mrs. John Morritt; b. 1759) were about the right age at the time the portrait was painted.

Agostino Brunias

Active 1752–1810

View on the River Roseau, Dominica, 1770/80

Gift of Emily Crane Chadbourne, 1953.14

Oil on canvas, 84.1 x 158 cm (33 1/8 x 62 3/16 in.)

CONDITION: The painting is in very good condition. It was cleaned in 1975–76, when the previous glue paste lining was replaced with a wax resin one.[1] The canvas consists of three horizontal fabric strips whose edges abut each other.[2] The

largest, central piece of canvas may have been stretched and prepared separately, since the ground on that section is denser than on the other two strips and the edges abutting the strips at top and bottom show cusping.[3] How the strips were joined together is unclear, since there is no evidence of stitching. X-radiography reveals dense fill material beneath the original paint that extends over the joins. This indicates that the three canvas strips were joined and filled before the picture was painted. In addition, there is cusping on the right and left sides, and more subtle cusping at the top and bottom. There are no

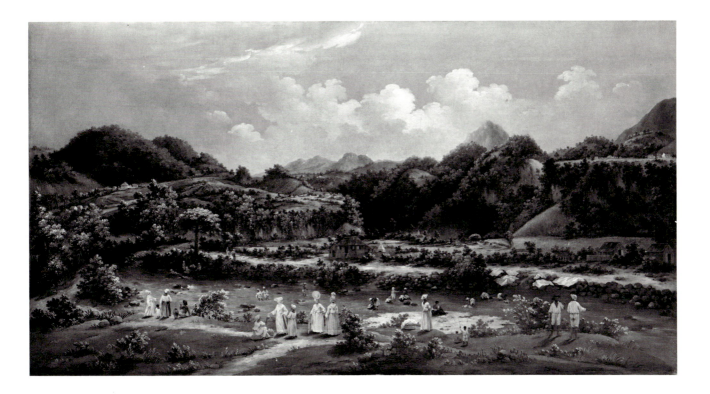

tacking margins. The ground is cream-colored. The canvas weave has become pronounced due to the lining process. There is some thinning of the sky in the upper third of the painting due to previous cleaning. Otherwise the tactile quality of the surface is fairly well preserved. X-radiography reveals a few minor losses to the paint and ground layers along the joins of the canvas strips. These have been filled and retouched. There is additional retouching at the right and left edges of the painting. The retouches are somewhat discolored. (infrared, ultraviolet, partial x-radiograph)

PROVENANCE: Emily Crane Chadbourne, Stone Ridge, New York, by 1952; given to the Art Institute, 1953.

REFERENCES: AIC 1961, p. 61. Hans Huth, "Agostino Brunias, Romano: Robert Adam's 'Bred Painter'," *Connoisseur* 151 (December 1962), p. 269, fig. 6.

EXHIBITIONS: The Art Institute of Chicago, *Selected Works of Eighteenth-Century French Art in the Collections of The Art Institute of Chicago*, 1976, no. 22.

This painting entered the Art Institute with an attribution to Richard Wilson and the title *American Plantation*. The present attribution and subject were established by Hans Huth, former Curator of Decorative Arts at the Art Institute, whose 1962 article on Brunias remains the fullest account of the artist's life and work.[4] Agostino Brunias (sometimes spelled "Brunais") was

first recorded in 1752, when he won a prize from the Accademia del Disegno di San Luca in Rome for a painting entitled *Tobias and the Angel*. In 1756 he was taken up by the architect Robert Adam and employed to make drawings for Adam's scholarly publication on the ruins of Diocletian's Palace at Spalato in Dalmatia. It was Adam who first brought Brunias to England, where he

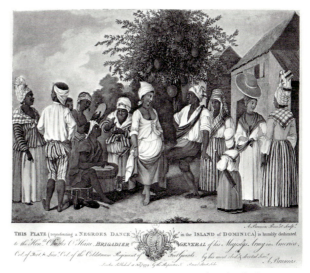

Fig. 1 Agostino Brunias, *Negroes Dance in the Island of Dominica*, Bibliothèque Nationale, Paris [© cliché Bibliothèque Nationale de France, Paris]

worked for him and other architects, painting decorative panels and ceilings.[5] He showed pictures at the London exhibitions from 1763. In the 1770s he went to the West Indies, where he painted views and scenes of local life for colonial officials, notably the British Governor of the island of Dominica, Sir William Young, Bt. Brunias was back in London by 1777, when he exhibited a West Indian market scene at the Royal Academy. His last showing at the Academy was in 1779, with two views of Dominica. He published a number of prints, also of West Indian subjects.

As Huth pointed out, there are close similarities between the figure groups in the Art Institute's painting and those in Brunias's prints. In particular, a pair of women in conversation on the far right of a print called *Negroes Dance in the Island of Dominica* (fig. 1) appears with only slight differences of dress and pose in the pair of women in the central foreground of the painting. The painting would appear to be unusual in Brunias's work in the sense that most of his prints and other known paintings, which turn up with some frequency in the salerooms, are genre scenes dominated by figures, rather than landscapes. The decorative treatment of the vegetation and mountains relates to the backgrounds in these other works, however, and a pair of paintings by Brunias that do feature fairly extensive landscape elements provide telling points of comparison.[6]

Since the Chicago picture shows a river scene and Brunias's recorded West Indian subjects include a view of the River Roseau on Dominica, Huth sent a photograph of the picture to Mr. J. O. Aird, Honorary Secretary of the Victoria Memorial Museum in Dominica, who confirmed that the view was indeed along the River Roseau, on the Bath Estate. In his article Huth reproduced a modern photograph of the site that convincingly resembles the Art Institute's picture, especially in the fairly distinctive line of the hills.[7] When Brunias was there, Dominica was a recent British colonial acquisition, seized from France during the Seven Years' War and officially ceded by the French under the Treaty of Paris in 1763. In 1770 it ceased to be one of a number of British islands governed from Grenada and became a separate colony with its own Governor, Sir William Young, who was succeeded in 1774 by Thomas Shirley. The economy of the island was based largely on its coffee plantations, with some cultivation of sugarcane and other crops.

Whether Brunias would have executed such a work while in Dominica or after returning to England, on the basis of sketches made on the spot, is a matter for speculation, although the need to make the best of things in a place where artists' materials were not easily obtained might explain the unusual construction of the canvas (see Condition). It has been suggested that the Art Institute's is one of the two views of Dominica that Brunias showed at the Royal Academy of 1779, *A View of the River of Roseau in the Island of Dominica*.[8] Given that he may well have painted a number of views along the Roseau, however, and that eighteenth-century views were so often painted in more than one version, the idea is questionable at best.

NOTES
1 The treatment was performed by Alfred Jakstas.
2 The height of the uppermost canvas strip is approximately 9.5 cm (3¾ in.), that of the center approximately 63.5 cm (25 in.), and that of the bottom section approximately 11 cm (4¼ in.).
3 The average thread count of the central canvas is approximately 13 x 13/sq. cm (32 x 32/sq. in.), while that of the top and bottom is somewhat larger, approximately 14 x 14/sq. cm (35 x 35/sq. in.), indicating slightly finer canvas.
4 Huth 1962, pp. 265–69.
5 For an example of Brunias's decorative paintings for Adam, see John Hardy, "Robert Adam and the Furnishing of Kedleston Hall," *Connoisseur* 198 (July 1978), pp. 196–207, pl. B.
6 Sold Sotheby's, London, May 28, 1981, no. 240 (ill.).
7 Huth 1962, fig. 7.
8 AIC 1961, p. 61. For the paintings exhibited in 1779, see Algernon Graves, *The Royal Academy of Arts: A Complete Dictionary of Contributors and Their Work from Its Foundation in 1769 to 1904*, vol. 1, London, 1905, p. 321. *A View of the River of Roseau in the Island of Dominica* is no. 33.

William Cuming

1769 Dublin 1852

A Lord Mayor of Dublin, c. 1800

A. A. Munger Collection, 1922.2196

Oil on canvas, 228.7 x 141.6 cm (90^{1}/$_{16}$ x 55^{3}/$_{4}$ in.)

CONDITION: The painting is in fair condition. It was cleaned in 1979–80, when an old glue paste lining was removed and a new wax resin one was attached.[1] The original tacking margins have been cut off. Cusping is slight and visible only at the right edge, making it difficult to determine if the painting has been cut down. There are fills 1 to 1.5 cm wide at the right, top, and bottom edges. The ground appears to be off-white, with red underpainting in some areas of the figure. The paint layer is fairly well preserved in the sitter's face. Numerous losses, varying in size from 1 to 15 cm in length, are scattered across the surface. The largest of these are located in the hand of the statue and the adjacent drapery, below the sitter's waist, and on the footstool. Most of the losses have been filled and inpainted. The paint texture has been flattened by the lining process, particularly in the impasto on the sitter's stock and lace cuffs. When the picture entered the collection of the Art Institute, an indecipherable inscription was noted on the footstool, but this is no longer visible. (infrared, mid-treatment, ultraviolet)

PROVENANCE: Archibald Ramsden, London and Leeds; sold Christie's, London, February 2, 1917, no. 189, to Frank T. Sabin, London, for 180 gns.[2] Ehrich Galleries, New York; sold to the Art Institute, 1922.[3]

REFERENCES: "Copley's Portrait of Lord Mayor of London Is Acquired by the Chicago Art Institute," *American Art News* 20, 30 (1922), p. 1 (ill.). *American Magazine of Art* 13 (1922), p. 489 (ill.). M. B. W., "Portrait of Brass Crosby, Lord Mayor of London, by Copley," *AIC Bulletin* 15, 5 (1922), cover (ill.), pp. 66–67. AIC 1923, p. 61, no. 564. AIC 1925, pp. 81 (ill.), 131, no. 564. Suzanne LaFollette, *Art in America*, New York and London, 1929, ill. opp. p. 54. Theodore Bolton and Harry Lorin Binsse, "John Singleton Copley, Probably the Greatest American Portrait Painter, Here for the First Time Appraised as an Artist in Relation to His Contemporaries," *Antiquarian* 15 (December 1930), p. 116. AIC 1932, pp. 101 (ill.), 147. "American Art Notes: American Art in Retrospect," *Connoisseur* 90 (October 1932), pp. 282–83 (ill.). Harry B. Wehle in *An Exhibition of Paintings by John Singleton Copley*, exh. cat., New York, The Metropolitan Museum of Art, 1936, p. 9. AIC 1961, pp. 83–84. Elaine Kilmurray, *A Dictionary of British Portraiture*, ed. by Richard Ormond and Malcolm Rogers, vol. 2, London, 1979, p. 55.

EXHIBITIONS: The Art Institute of Chicago, *A Survey of American Painting from the Permanent Collection of the Art Institute*, 1932 (no cat.), as Copley. The Art Institute of Chicago, *A Century of Progress*, 1933, no. 411, as Copley. The Art Institute of Chicago, *A Century of Progress*, 1934, no. 368, as Copley.

When this portrait appeared on the London art market in 1917, the sitter was said to be Brass Crosby, the famed Lord Mayor of London who was imprisoned in the Tower of London for defending the right of the press to publish parliamentary debates. The work was attributed to the American painter John Singleton Copley—an attribution that persisted until 1979, when it was rejected by the authority on Copley, Jules Prown.[4] The sitter's regalia were afterward identified correctly as those of a Lord Mayor of Dublin rather than London, and the portrait reattributed to the Irish painter Robert-Lucius West on the basis of some similarities to a supposed West portrait of Alderman Richard Manders.[5] The West attribution was laid aside in favor of the present attribution to William Cuming in 1988 by Desmond Fitz-Gerald, Knight of Glin, who drew attention to distinctive features of style that the work shares with Cuming's portrait of Lord Charlemont (fig. 1), such as the blocky treatment of light and shade in the hands.[6]

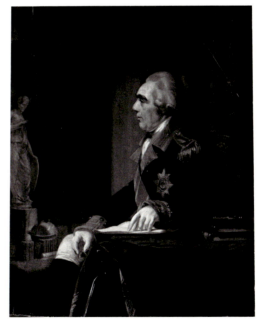

Fig. 1 William Cuming, *James Caulfield, First Earl of Charlemont*, National Gallery of Ireland, Dublin [photo: courtesy of the National Gallery of Ireland, Dublin]

Trained in the Dublin Society's Schools, where he won a silver medal, Cuming established himself in the Dublin of the 1790s as a painter of civic, theatrical, and society portraits. He was considered particularly successful with female sitters. In 1823 he was one of the founding members of the Royal Hibernian Academy, and in 1829 was elected president. He resigned in 1832 and, though he continued to take some interest in Academy affairs, retired from the profession of painting. Being of independent means enabled him to spend much time traveling on the continent, and his output as an artist was relatively small. Cuming never married, living for most of his life with his sister Elizabeth. His circle of friends included many prominent Irish artistic and literary figures, notably Thomas Moore.[7]

The identity of the sitter in the portrait is elusive. The robes, chain of office, mace, and sword are certainly those of a Lord Mayor of Dublin, and are depicted with considerable accuracy.[8] The statue of Justice on the right, which may be an actual object or a purely symbolic one, suggests the figure of Justice that appears as a supporter to the right in the arms of the City of Dublin. Its prominent position in the portrait may indicate that the sitter was a lawyer or judge by profession. According to Walter Strickland, Cuming painted portraits of two Lord Mayors of Dublin: that of Henry Gore Sankey, commissioned by the Corporation in 1792, and that of Charles Thorp, painted in 1801 at the expense of the Guild of

Merchants and presented to the Aldermen of Dublin.[9] Strickland noted that both were in a fire at the Dublin City Hall in 1908, stating that the portrait of Sankey was salvaged and restored, and that of Thorp destroyed.[10] Confusingly, the sitter in what appears to be the only Cuming portrait of a Lord Mayor still preserved in Dublin is identified as Charles Thorp (fig. 2).[11] Perhaps Strickland was mistaken about which portrait survived the fire, or perhaps the current identification of the Dublin portrait is incorrect. There is some facial resemblance between the sitters in the Dublin and Chicago portraits, and they could represent the same man at different ages. In this connection, it is interesting to note that Cuming exhibited what may have been a second, considerably later portrait of Charles Thorp at the Royal Hibernian Academy exhibition of 1831.[12] On the other hand, the Chicago portrait may be simply an unrecorded portrait of another Lord Mayor of Dublin.

NOTES

1 There is no treatment report in the museum's conservation files, but a series of photographs documents the treatment. The average thread count of the original canvas is approximately 10 x 9/sq. cm (25 x 23/sq. in.).

2 Recorded in an annotated sale catalogue at Christie's, London.

3 Receipt dated May 4, 1922, in Archives, The Art Institute of Chicago.

4 Recorded in a memorandum by Milo M. Naeve following a conversation with Jules Prown of December 3, 1979 (in curatorial files).

5 For the portrait of Manders, see Anne Crookshank and the Knight of Glin, *The Painters of Ireland, c. 1660–1920*, London, 1978, p. 177, fig. 163. The Knight of Glin later identified this as the work of Hugh Douglas Hamilton rather than West (see note 6).

6 Letter to the author of June 8, 1988, in curatorial files.

7 The fullest account of Cuming's life and work remains Walter G. Strickland, *A Dictionary of Irish Artists*, vol. 1, Dublin and London, 1913, pp. 242–47.

8 See Walter G. Strickland, "The Civic Insignia of Dublin," *Journal of the Royal Society of Antiquaries of Ireland* 6th ser., 12 (1922), pp. 117–32, pls. II, III, and VII; and Claude Blair and Ida Delamer, "The Dublin Civic Swords," *Proceedings of the Royal Irish Academy* 88C (1988), pp. 87–142, who corrected the dating of the Great Sword, identifying it as the one given by Henry IV to the city of Dublin in the first years of the fifteenth century. The existing arrangement of ornaments on the sword's scabbard differs slightly from that shown in eighteenth- and early-nineteenth-century portraits of Lord Mayors, including the present one, and Blair and Delamer suggested that the sword was refurbished and the ornaments rearranged prior to George IV's visit to Dublin in 1821.

9 Strickland (note 7), p. 246.

10 Ibid.; for a report of the fire in the City Hall and a list of damaged mayoral portraits, see the *Times* (London), November 12, 1908, p. 7.

11 Information on this work and other mayoral portraits in Dublin was kindly supplied by Ethna Waldron, Curator, Hugh Lane Municipal Gallery of Modern Art, Dublin.

12 Strickland (note 7), p. 246.

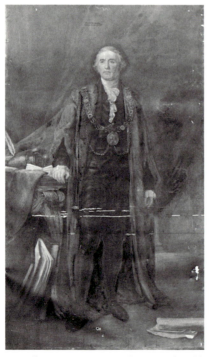

Fig. 2 William Cuming, *A Lord Mayor of Dublin (Identified as Charles Thorp)*, Mansion House, Dublin

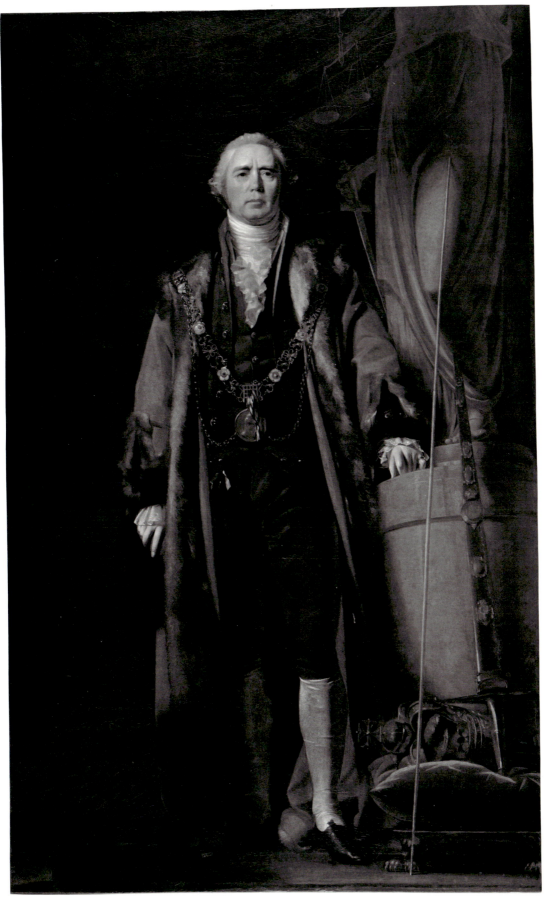

William Cuming, *A Lord Mayor of Dublin*, 1922.2196

Arthur Devis

1712 Preston, Lancashire–Brighton, Sussex 1787

Thomas Lister and His Family, 1740/41

Gift of Emily Crane Chadbourne, 1951.203

Oil on canvas, 115.1 x 103.8 cm (45⁵/₁₆ x 40⁷/₈ in.)

CONDITION: The painting is in fair to good condition. It was cleaned in 1964, when an old glue lining was removed and replaced with a wax resin one.[1] The top and bottom tacking margins have been incorporated with the painting, whereas the right tacking margin has been reduced in width, cut off near the bottom, and the remnant incorporated with the painting. Cusping along this edge confirms that the painting could not have been substantially reduced in size. Somewhat more canvas may have been trimmed from the left side, as indicated by the jagged edge visible in the x-radiograph. The ground is white or off-white. The paint surface has fine vertical cracks occurring at close intervals, which suggest that the canvas may have been rolled inward at some stage. There is abrasion in the faces of the man at the far left and the two girls, in the grass between the girls, in the house, and in the clouds. The cricket players and the animals in the distance have been thinned by cleaning. A *pentimento* is visible between the main house and the stables to the left. There is some inpainting in the older daughter's white dress, and there are minor retouches elsewhere to fill small losses. (infrared, ultraviolet, x-radiograph)

PROVENANCE: Presumably commissioned by the principal sitter, Thomas Lister (d. 1745) of Gisburne Park, near Clitheroe, Lancashire.[2] By descent to Thomas Lister, fourth baron Ribblesdale (d. 1925), Gisburne Park, until at least 1913.[3] Emily Crane Chadbourne, Washington, D.C., by 1932; on loan to the Art Institute, 1932–51; given to the Art Institute, 1951. Offered for sale, Sotheby's, London, November 18, 1987, no. 33 (ill.), bought in, and Sotheby's, New York, January 12, 1989, no. 148 (ill.), bought in.

REFERENCES: *Catalogue of Paintings at Gisburne Park Belonging to the Right Hon. Lord Ribblesdale*, Clitheroe, 1853, p. 8, lobby, no. 11. Rev. Henry Lyttelton Lyster Denny, *Memorials of an Ancient House: A History of the Family of Lister or Lyster*, Edinburgh, 1913, p. 134, ill. opp. p. 136. Edgar P. Richardson, "Conversation for the Eye," *Art News* 47 (March 1948), p. 57 (ill.). "The Editor's Attic: English Conversation Pieces," *Antiques* 54 (1948), p. 118 (ill.). Letter from Hans Huth, "Collectors' Questions: Georgian Family Group," *Country Life* 126, 3275 (December 10, 1959), p. 1143 (ill.). Letter from Lt.-Col. Frederick Lister, "Correspondence: Georgian Family Group," *Country Life* 127, 3279 (January 7, 1960), pp. 29–30. AIC 1961, p. 59. Ellen Gates D'Oench, "Arthur Devis (1712–1787): Master of the Georgian Conversation Piece," Ph.D. diss., Yale University, 1979 (Ann Arbor, Mich., University Microfilms, 1984), pp. 45–47, 65, 141, 182 n. 31, p. 274, under no. 8, p. 367, under no. 103, pp. 367–69, no. 104, p. 394, under no. 125, p. 458, under no. 205, p. 470, under no. 223, fig. 27. John Harris, *The Artist and the Country House: A History of Country House and Garden View Painting in Britain, 1540–1870*, London, 1979, p. 218, no. 235 (ill.). *Polite Society by Arthur Devis, 1712–1787: Portraits of the English Country Gentleman and His Family*, exh. cat., Harris Museum and Art Gallery, Preston, and National Portrait Gallery, London, 1983–84, pp. 12, 29–30, 41. Geoffrey Beard, *The Compleat Gentleman: Five Centuries of Aristocratic Life*, New York, 1993, p. 66, fig. 42.

EXHIBITIONS: Detroit Institute of Arts, *English Conversation Pieces of the Eighteenth Century*, 1948, no. 22, as Joseph Francis Nollekens, *Family Group in a Landscape*. New Haven, Yale Center for British Art, *The Conversation Piece: Arthur Devis and His Contemporaries*, 1980, no. 4, cat. by Ellen Gates D'Oench.

As early as 1810, when it was listed in an inventory of Gisburne Park, *Thomas Lister and His Family* was believed to be the work of Arthur Devis's fellow painter of conversation pieces, Joseph Francis Nollekens.[4] The painting still bore this attribution when it entered the Art Institute on loan in 1932, although it had lost its identity and was no longer connected with the Lister family.[5] Recent research, particularly the work of Ellen Gates D'Oench, has restored the connection to the Listers and attributed the work beyond reasonable doubt to Devis. It is the earliest of the Art Institute's fine group of pictures by Devis, and was painted for an important member of the group of Tory squires from the neighborhood of Preston who were his first patrons.

Devis specialized almost exclusively in conversation pieces, small-scale portraits, usually showing family groups, with carefully rendered domestic and park settings. His typically doll-like figures, which reflect his dependence on a half-scale lay figure, are posed with a studied informality. Devis was the son of a Preston carpenter and shopkeeper who was a member of the town council. He apparently received his training in London in the studio of Peter Tillemans, a Flemish painter of

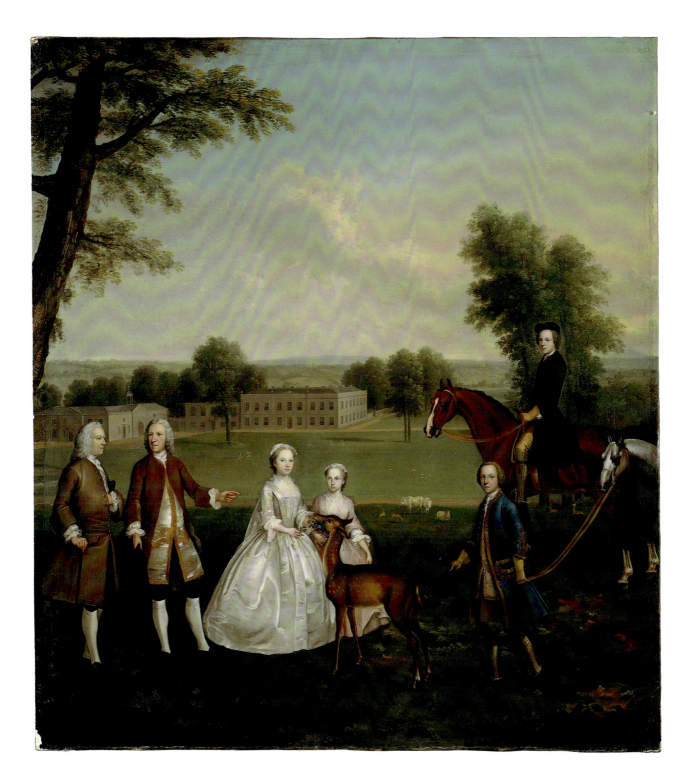

sporting pictures and country-house views. Around 1737 he set up his own portrait practice, working mainly for clients from the North, although by 1742 he was established in London. He married in 1742. Of his twenty-two children, two of his sons, Thomas Anthony and Arthur William, worked in his studio and also became artists. Devis reached the height of his career in the 1750s, his reputation declining throughout the 1760s and 1770s. From 1761 on, he exhibited works at the distinctly unprestigious Free Society of Artists, of which he was elected president in 1768. In 1777–78 he cleaned and restored the Painted Hall in the Greenwich Hospital, and in 1783, by this date completely out of fashion, he retired to Brighton.

The attribution of the Chicago picture was much debated after it was placed on long-term loan to the Art Institute in 1932. It was exhibited in Detroit in 1948 under the name of Nollekens, but the catalogue noted that it had "lately been attributed by C. H. Collins Baker to Arthur Devis."[6] Sydney Pavière, author of *The Devis Family of Painters*, suggested that the picture be designated simply as English, c. 1740, noting, "I am certain that [it] . . . is not by Arthur Devis. I should date it by the costume as 1740, or maybe earlier, and it could in that case be by Nollekens."[7] In 1959 Hans Huth published the portrait in *Country Life* with a letter asking for information. It was recognized by Lt.-Col. Frederick Lister, whose reply (1960) re-established the identity of the sitters and the fact that the work had been attributed to Nollekens when still in the Lister family's possession. The Nollekens attribution was finally laid to rest in the 1970s, when the Nollekens authority Michael Liversidge gave his opinion against it and D'Oench revived Collins Baker's attribution to Devis.[8]

D'Oench's attribution of the work to Devis, which was accepted officially by the Art Institute in 1980, seems to be wholly convincing. She pointed out that the subsequent reputation of Nollekens's son, the sculptor Joseph Nollekens, made the name a far more familiar and enduring one than Devis's. It would be more likely, therefore, to be attached by a family to a portrait whose actual authorship had been forgotten. "Nollekens's rococo curving forms and sketchy paint handling," she wrote, "bear little relationship to the stiff postures of the figures, their linear outlines, or the smooth finish of this canvas."[9] As D'Oench also pointed out, there are features of the work in question that are distinctive to Devis: the horse's head jutting into the picture at the right and the treatment of the lace on the girls' dresses,

the patterns of which were drawn with a sharp instrument into a thinly applied layer of white paint while it was still wet.[10]

Thomas Lister (1688–1745) was from a family long associated with the town of Clitheroe, which he represented as Tory member of Parliament from 1713 until his death. In 1724 he rebuilt Lower Hall, Gisburne (sometimes spelled Gisburn), a property bought by his father, and transferred the family seat there from Arnoldsbigging. His wife, Catherine, daughter of Sir Ralph Assheton, Bt., died in 1728. According to Denny (1913), the Chicago portrait shows Lister with his agent Mr. Pigot. These are clearly the two men on the left; there seems no clear indication which is which, although Lister (1960) stated that the man at the far left is Pigot, which would mean that Thomas Lister is second from the left. Lister's daughter Anne (1722–1755) is shown feeding a deer in the center, flanked by her younger sister, Mary (d. 1758). His sons Thomas (1723–1761) and Nathaniel (1725–1793) appear on the right, respectively walking and on horseback.[11] The boys were pupils at Westminster School at this time, and both carved their names into the back of the Coronation Chair in Westminster Abbey.[12] Thomas succeeded to his father's seat in Parliament in 1745, and continued to live at

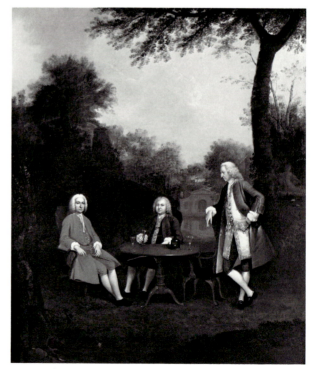

Fig. 1 Arthur Devis, *James, Fourth Earl of Barrymore, Richard Shuttleworth, and Thomas Lister*, private collection [photo: courtesy of Christie's, London]

Gisburne until his death at the age of thirty-eight. Nathaniel purchased and lived at Armitage Park, near Lichfield, Staffordshire, although he too served as member of Parliament for Clitheroe from the death of his brother, in 1761, until 1773. Devis painted another portrait of Nathaniel around 1755–57 (location unknown).[13] The buildings in the background of the portrait are recognizable as Gisburne. A game of cricket is being played on the grass in front of the house. The park was well known for its herd of wild cattle of the White English breed, three of which appear in the middle distance.[14]

Gisburne is about twenty miles northeast of Devis's native Preston, and he probably gained this and other commissions from the Listers through a family connection: his stepmother, Anne Blackburne Devis, was a cousin of Thomas Lister's late wife.[15] In a slightly earlier portrait (fig. 1), which D'Oench described as Devis's earliest-known conversation group, he painted Lister with two of his friends and fellow Tories, James, fourth earl of Barrymore, member of Parliament for Wigan, and Richard Shuttleworth, member of Parliament for Lancashire.[16] (The likeness of Lister, who is standing on the right, is unfortunately not sufficiently distinctive to solve the problem of which figure represents him in the Chicago painting.)

As a member of Parliament, Lister voted consistently against the Whig government and was associated with the extreme wing of the Tory party that advocated the restoration of the Stuarts to the British throne. His friends Lord Barrymore and Richard Shuttleworth were ardent Jacobites, and Barrymore led English support for the Young Pretender's ill-fated attempt to seize the crown in 1745. As D'Oench and Stephen Sartin have remarked, the Preston area was a Jacobite stronghold at this time; the artist's father had powerful connections through his position on the Tory-controlled town council, and most of Devis's early patrons were of the Tory and Jacobite persuasion.[17]

NOTES

1 The treatment was performed by Alfred Jakstas. The thread count of the original canvas is 16 x 16/sq. cm (40 x 40/sq. in.).
2 The painting is listed in an 1810 inventory of Gisburne Park (Gisburne Papers, Leeds Archaeological Society). See also Harris 1979; and 1980 exhibition catalogue entry by D'Oench, p. 44, no. 4.
3 Denny 1913.
4 See note 2.
5 According to registrar's records.
6 Collins Baker gave his opinion in a letter to Hans Huth of January 13, 1948, in curatorial files.
7 Letter to Hans Huth of December 29, 1950, in curatorial files.
8 For more information on Nollekens, see Michael Liversidge, "An Elusive Minor Master: J. F. Nollekens and the Conversation Piece," *Apollo* 95 (January 1972), pp. 34–41. Liversidge's opinion against the Nollekens attribution is cited in a footnote to D'Oench's entry on the picture in the 1980 exhibition catalogue. In 1979 John Harris hedged his bets with a double attribution to "Arthur Devis and J. F. Nollekens (?)," asserting that "The horses are very good indeed, too good either for Devis or Nollekens, and might be by Thomas Spencer . . . although Nollekens, as a pupil of Tillemans, may have been a better horse painter than hitherto believed and could have collaborated with Devis on this picture." D'Oench recorded her opinion in favor of Devis in a handwritten note of May 4, 1978, in curatorial files, as well as in her 1979 dissertation and in the 1980 exhibition catalogue.
9 1980 exhibition catalogue.
10 D'Oench 1979, p. 47, and 1980 exhibition catalogue.
11 Denny 1913, and 1980 exhibition catalogue.
12 Denny 1913.
13 D'Oench 1979, pp. 366–67, no. 103.
14 Lister 1960.
15 1980 exhibition catalogue.
16 D'Oench 1979, pp. 45, 274, no. 8.
17 1980 exhibition catalogue, p. 21; Sartin in *Polite Society* 1983–84, pp. 29–30.

Sir John Shaw and His Family in the Park at Eltham Lodge, Kent, 1761

Gift of Emily Crane Chadbourne, 1951.206

Oil on canvas, 134.3 x 199.1 cm (52¾ x 78⅜ in.)

INSCRIBED: *Artʳ Devis. fe. / 1761* (lower left)

CONDITION: The painting is in fair condition. It was cleaned in 1979–80, when an old glue paste lining was removed and replaced with a wax resin one.[1] The pre-treatment report indicates that the tacking margins were cut off prior to the previous lining. The canvas, which was prepared with an off-white ground, shows slight cusping along the top and bottom edges, indicating that the picture is close to its original dimensions.

A 1980 photograph taken after cleaning reveals numerous tears through the lower quarter of the canvas. The most extensive is a complex horizontal tear through Lady Shaw's skirt, extending from below the smallest child's shoes to the grass beyond the chair on which they are seated. Smaller tears or areas of loss to the paint and ground layers are located on the back cushion of the carriage, in the grass at the lower left edge, in the grass in

front of the child with the dog, beneath Sir John Shaw's chair, and through the reclining boy's stockings. Numerous other smaller losses are scattered along the bottom edge.

The paint surface has been somewhat flattened by lining. Much of the surface has also been abraded by cleaning. This abrasion is particularly noticeable in the vignette of the haymakers in the middle distance, in the tent at the left, and in the darker foliage of the background trees, where it diminishes the illusion of distant space in the picture. There are several small passages of traction cracking in the hair of each figure, around the dog, and in the darker parts of the foreground grass. Some of the traction cracking in the grass has resulted in blistered islands of paint. All of the losses in the tears, the abraded foliage and grass, the upper left sky, and all of the cracks in the area of the horse have been retouched. Stretcher-bar cracks along the top and left edges and along the entire perimeter of the canvas have been overpainted. Most of the retouching is noticeably discolored. The signature and date at the lower left are only faintly legible in normal light, but can be readily deciphered with infrared photography. (infrared, infrared detail, mid-treatment, ultraviolet, x-radiograph)

PROVENANCE: Presumably commissioned by the principal sitter, Sir John Shaw, fourth Bt. (d. 1779), Eltham Lodge, Kent. William and Sutch by 1926.[2] Sold by William and Sutch to Leggatt Brothers, London, 1926.[3] Sold by Leggatt Brothers to Emily Crane Chadbourne, Washington, D.C., 1926;[4] on loan to the Art Institute, 1932–51; given to the Art Institute, 1951.

REFERENCES: "Eighteenth-Century England," *Life* 5 (October 25, 1948), p. 30 (ill.). Sydney H. Pavière, *The Devis Family of Painters*, Leigh-on-Sea, 1950, pp. 29, 34, 60, no. 146. AIC 1961, p. 127. Ellen Gates D'Oench, "Arthur Devis (1712–1787): Master of the Georgian Conversation Piece," Ph.D. diss., Yale University, 1979 (Ann Arbor, Mich., University Microfilms, 1984), pp. 308, 379, 489, no. 251, fig. 150.

EXHIBITIONS: London, Free Society of Artists, 1763, no. 53, as *A Family with a View of the Gentleman's House*. Detroit Institute of Arts, *English Conversation Pieces of the Eighteenth Century*, 1948, no. 21, as Joseph Francis Nollekens, *Family in a Park*. New Haven, Yale Center for British Art, *The Conversation Piece: Arthur Devis and His Contemporaries*, 1980, no. 39, cat. by Ellen Gates D'Oench.

For more than forty years after this work was first lent to the Art Institute in 1932, the identity of the sitters was unknown and the attribution a matter for speculation. Before the painting was cleaned in 1979–80, the signature and date, which are now faint but legible, were hidden under discolored varnish. Devis was therefore only one of the attributions suggested, along with Joseph Francis Nollekens, Philippe Mercier, and Robert Pyle. The work was catalogued under Nollekens in the Detroit exhibition of 1948, but the entry recorded that it had "lately been attributed by C. H. Collins Baker to Arthur

Devis." The situation became no clearer when Sydney H. Pavière (1950) noted the attribution in *The Devis Family of Painters* merely as one that he doubted. Writing in 1951, W. G. Constable questioned the Nollekens attribution on the grounds that the figures, especially the two boys, were inferior to ones known to be from Nollekens's hand. "I suspect an early copy," he concluded, "perhaps from an original by Nollekens; but possibly by someone else."[5] As for the setting and sitters, a valuable lead was provided by Arthur Oswald of *Country Life* in 1960, when he suggested that the house in the background might be Eltham Lodge in Kent.[6] But this seems not to have been followed up with further research at that time.

The problems of attribution and the identification of the sitters were solved by Ellen Gates D'Oench in her 1980 exhibition catalogue. She traced the records of the painting's purchase by Leggatt Brothers in 1926, at which time it was entitled *The Shaw Family of Eltham Lodge* and noted as bearing Devis's signature. This enabled her to identify the work as the one exhibited by Devis as *A Family with a View of the Gentleman's House* at the Free Society of Artists in 1763. Catalogues to that exhibition belonging to Horace Walpole and John Sheepshanks are both annotated to the effect that the unnamed family was Sir John Shaw's and the setting was his estate at Eltham.[7]

Eltham Lodge survives, and the building in the background of the Art Institute's picture is recognizable as a view of its north or entrance front. It was built for Sir John Shaw, first Bt., a prosperous vintner whose support for Charles II during his exile won him royal favor and a baronetcy after the Restoration. He leased the Eltham estate from the Crown beginning in 1663, and moved into the newly completed Lodge in 1664 or 1665. Among the earliest known designs of Hugh May, Eltham Lodge is an outstanding example of the domestic architecture of the early Restoration and is of considerable importance in the history of English architecture as the forerunner of the typical Georgian house. The refined handling of classical forms shows an intelligent response to Inigo Jones's Queen's House, and the use of brick reflects May's experience of recent Dutch architecture on a trip to the Netherlands in 1656. The Shaw family retained the lease on Eltham until 1839. The park is now a golf course, and the Lodge is the clubhouse of the Royal Blackheath Golf Club.[8]

The principal sitter in the Art Institute's portrait is Sir John Shaw, fourth Bt. (1728–1779), great-grandson of the first baronet of the same name. Devis painted a

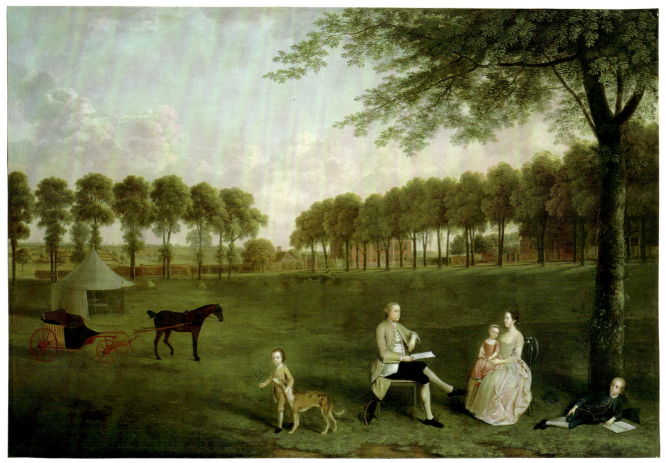

Arthur Devis, *Sir John Shaw and His Family in the Park at Eltham Lodge, Kent*, 1951.206

single portrait of him in 1757, which D'Oench (1980 exhibition catalogue) has described as "too bland or unspecific in facial characteristics to indicate more than a generalized likeness to the man in this conversation piece." Here he is shown with his second wife, the heiress Martha Kenward (1730–1794), and his three sons. The boy lying on the grass to the right is John Shaw (1750–1761), his short-lived son by his first wife, Elizabeth, who died in 1750. As D'Oench (1980 exhibition catalogue) noted, the reclining pose is unique in the artist's work, and may indicate the boy's ill health in what was the last year of his life — or perhaps even that the likeness is posthumous. The other two boys were the offspring of Sir John's second marriage, which took place in 1752. On the left, with his arm around a dog, is John Gregory Shaw (1756–1831), who inherited Eltham Lodge but lived at Kenward, Kent. Sitting on his mother's knee is John Kenward Shaw, later Brooke (1758–1840), who was to become a local vicar.[9]

NOTES
1 The treatment was performed by Alfred Jakstas. The thread count of the original canvas is 14 x 14/sq. cm (34 x 34/sq. in.).
2 See the 1980 exhibition catalogue, pp. 64–65, no. 39; and letter of August 22, 1979, from D'Oench to Wallace Bradway, in curatorial files.
3 Ibid.
4 Ibid.
5 Letter of November 21, 1951, in curatorial files.
6 Letter to Hans Huth of February 10, 1960, in curatorial files.
7 Farmington, Lewis-Walpole Library, 49/3885 and 49/3885.1. Pavière (1950, p. 29) cited the annotation in Walpole's catalogue, but without making the connection to the Art Institute's picture. For a discussion of Walpole's annotations to catalogues, see Hugh Gatty, "Notes by Horace Walpole, Fourth Earl of Orford, on the Exhibitions of the Society of Artists and the Free Society of Artists, 1760–1791," *Walpole Society* 27 (1939), pp. 55–88.
8 See H. Avray Tipping, "Eltham Lodge, Kent, the Property of the Crown," *Country Life* 46, 1179 (1919), pp. 168–74, 210–17; Olive Cook, *The English Country House: An Art and a Way of Life*, London, 1974, pp. 121–22, 124, fig. 118; and Bridget Cherry and Nikolaus Pevsner, *The Buildings of England—London 2: South*, Harmondsworth, 1983, pp. 302–04.
9 See R. R. C. Gregory, *The Story of Royal Eltham*, Eltham, 1909, pp. 49–51, 225–58.

Portrait of a Man, 1763

Gift of Emily Crane Chadbourne, 1951.207

Oil on canvas, 76.5 x 64.1 cm (30⅛ x 25¼ in.)

INSCRIBED: *Art: Devis fe. 1763* (lower center)

CONDITION: The painting is in good condition. It was cleaned in 1987, when a brittle glue paste lining was removed and replaced with a new glue paste lining to diminish surface irregularities.[1] The stretcher is not original and extends approximately 1.5 cm beyond the top edge of the original canvas. The resulting narrow band has been filled and inpainted. The tacking margins have been cut off, but cusping at top and sides indicates that the image was not substantially larger. There is a tan-colored ground, which is visible through the green glazes in the lower foreground. The paint surface is well preserved, apart from a fine craquelure visible in the sitter's face and in the upper two-thirds of the composition. There are retouches that minimize local abrasions scattered throughout the sky, in the sitter's left calf, and in the grass to the left of the sitter. (infrared, ultraviolet, x-radiograph)

PROVENANCE: Probably the Hon. Frederick Wallop (1870–1953), London.[2] Palser and Sons, 1919.[3] Sold by Palser and Sons to Agnew, London, 1919.[4] Sold by Agnew to Ehrich Galleries, New York, 1919.[5] Sold by Ehrich Galleries at Anderson Galleries, New York, November 8–9, 1922, no. 116, to A. C. Bower for $370.[6] Emily Crane Chadbourne, Washington, D.C., by 1932; on loan to the Art Institute, 1932–51; given to the Art Institute, 1951.

REFERENCES: Sydney H. Pavière, *The Devis Family of Painters*, Leigh-on-Sea, 1950, pp. 45, 67, nos. 61–63. AIC 1961, p. 127. Ellen Gates D'Oench, "Arthur Devis (1712–1787): Master of the Georgian Conversation Piece," Ph.D. diss., Yale University, 1979 (Ann Arbor, Mich., University Microfilms, 1984), pp. 138, 471, fig. 131.

EXHIBITIONS: New Haven, Yale Center for British Art, *The Conversation Piece: Arthur Devis and His Contemporaries*, 1980, no. 42, cat. by Ellen Gates D'Oench.

The identity of the sitter is unknown. The landscape in the background, which appears to be near the seacoast, may show part of his estate. The work was probably originally paired with a portrait of the man's wife, who would have been shown in a pose complementing that of her husband, perhaps against a matching landscape. Ellen Gates D'Oench has noted that the male figure standing cross-legged next to a sundial appears frequently in Devis's work, beginning with his *John Warde of Squerrye's Court* (1749; private collection).[7]

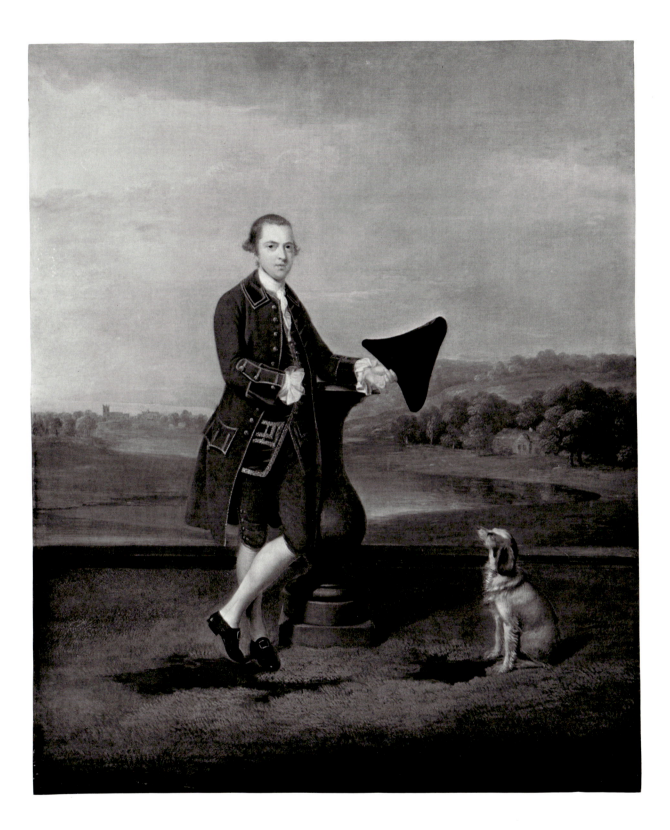

The relaxed grace of this stance, which echoes Peter Scheemakers's celebrated cross-legged statue of Shakespeare in Westminster Abbey (1740), made it a popular choice for portraits of English country gentlemen in their natural element. It appears, for instance, in Gainsborough's nearly contemporary *William Poyntz* (1762; Althorp, Collection of the Earl Spencer).[8] The placing of the right hand in the waistcoat was also a commonplace of gentlemanly deportment: see Joseph Highmore's *Freeman Flower* (1987.262.4). The presence of the dog implied that the sitter was one to inspire fidelity and devotion—and also that he pursued sports, which was another mark of social standing.

Although Devis continued to practice portraiture until 1780, the present painting is one of his last known works bearing a dated signature. D'Oench's list of his works contains three others dated 1763, two dated 1764, one dated 1765, and none with later dates.[9] This probably suggests that a falling off in his output of portraits occurred as his reputation waned toward obscurity in the 1760s and 1770s.

NOTES

1 The treatment was performed by Frank Zuccari. The thread count of the original canvas is 18 x 18/sq. cm (48 x 48/sq. in.).

2 In a letter to Hans Huth of January 13, 1948 (in curatorial files), C. H. Collins Baker stated, "This picture I knew when it was in the Fred Wallop collection and according to an old note of mine, it is signed and dated 1763. Of course I cannot verify this in the photograph." Frederick Wallop was the sixth son of the fifth Earl of Portsmouth.

3 See the 1980 exhibition catalogue, p. 66, no. 42, and letter from Gabriel Naughton (Agnew's) to the author of March 19, 1993, in curatorial files.

4 See note 2.

5 See note 2.

6 According to an annotated sale catalogue, Ryerson Library, The Art Institute of Chicago. D'Oench (1980 exhibition catalogue) listed the buyer as A. C. Bower.

7 See D'Oench 1979, p. 433, no. 166; and the 1980 exhibition catalogue (ill.).

8 For Scheemakers's memorial to Shakespeare and its sources and influence, see David Piper, *The Image of the Poet: British Poets and Their Portraits*, Oxford, 1982, p. 79–90, fig. 81. For Gainsborough's full-length portrait of William Poyntz, exhibited at the Society of Artists in 1762, see John Hayes, *Gainsborough: Paintings and Drawings*, London, 1975, pl. 56.

9 See the 1980 exhibition catalogue, pp. 80–94.

John Thomlinson and His Family, 1745
Joseph and Helen Regenstein Foundation Fund, 1956.130

Oil on canvas, 60.9 x 101.9 cm (24 x 40⅛ in.)

INSCRIBED: *ADevis fe 1745* (lower left, below edge of carpet)

CONDITION: The painting is in good condition. The canvas has an old glue lining that was added before the painting entered the collection.[1] The tacking margins have been cut off. Two canvas fragments inscribed with the names of the sitters are attached to the stretcher; they may have been saved from a previous lining fabric.[2] The off-white ground is exposed at the lower right edge, and a slightly cupped, wide-interval craquelure is visible overall. The paint surface is generally well preserved, but there is some abrasion in the faces, and those of the two younger women have been rather densely retouched. There is some additional retouching covering some of the cracks at the lower right, in the boy's suit, and over the right end of the archway. The signature and date are faintly legible in normal light, but can be readily deciphered with infrared photography. (infrared detail, x-radiograph)

PROVENANCE: Commissioned by the principal sitter, John Thomlinson (d. 1767), London, for £26 5s.[3] By descent to Major Henry Howard, 34 Nevern Square, London (offered for sale, Christie's, London, December 18, 1931, no. 80, bought in), until at least 1937.[4] Arthur Tooth and Sons, London, 1948–56.[5]

Purchased from Tooth by the Art Institute through the Joseph and Helen Regenstein Foundation Fund, 1956.

REFERENCES: A. S. Turberville, ed., *Johnson's England: An Account of the Life and Manners of His Age*, vol. 2, Oxford, 1933, ill. opp. p. 154. Sydney H. Pavière, "Biographical Notes on the Devis Family of Painters," *Walpole Society* 25 (1936–37), p. 121, pl. 41b. "The Devis Exhibition: Eighteenth-Century English Painting," *Illustrated London News* 190 (March 20, 1937), p. 503 (ill.). Wilmarth Sheldon Lewis, *Three Tours through London in the Years 1748, 1776, 1797*, New Haven, 1941, ill. opp. p. 20. *Art News* 47 (June 1948), p. 3 (ill.). Sydney H. Pavière, *The Devis Family of Painters*, Leigh-on-Sea, 1950, pp. 34, 57, no. 131, p. 65, pl. 1 (ill.). Sacheverell Sitwell, "The World of Arthur Devis," *Saturday Book* 12 (1952), p. 96 (ill.). AIC 1961, p. 126. Ellen Gates D'Oench, "Arthur Devis (1712–1787): Master of the Georgian Conversation Piece," Ph.D. diss., Yale University, 1979 (Ann Arbor, Mich., University Microfilms, 1984), pp. 71, 407, 419–21, 435, no. 152, fig. 55.

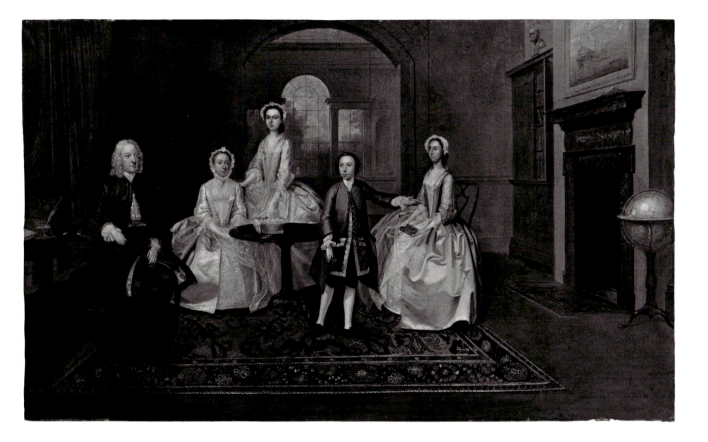

EXHIBITIONS: Preston, Harris Museum and Art Gallery, *Work by Lancashire Artists*, 1937, no. 4. London, Arthur Tooth and Sons, *Recent Acquisitions*, 1948, no. 2. New Haven, Yale Center for British Art, *The Conversation Piece: Arthur Devis and His Contemporaries*, 1980, no. 13, cat. by Ellen Gates D'Oench.

The sitters are identified in inscriptions in ink on two canvas labels stuck on the stretcher, probably fragments cut from the original tacking margin or a previous lining fabric (see Condition). John Thomlinson was a London merchant. According to a note on the portrait published in the Christie's sale catalogue of 1931, which was presumably supplied by Thomlinson's descendant Major Henry Howard, Thomlinson was of East Barnet and Queen Street, Cheapside; this probably meant that his home was at East Barnet and his office in Queen Street. Thomlinson owned vessels trading with the West Indies and New Hampshire, and was Deputy Paymaster of the expedition of volunteers that in 1745 took Louisbourg, Cape Breton, Canada, from the French. Thanks to the research of Ellen Gates D'Oench, it is also known that he was agent in Britain for the assembly of New Hampshire. From 1745 onward, he held considerable government contracts for supplying troops in North America, and in 1754 he became a director of the London Assurance Company.

To the right of Thomlinson in the portrait sits his wife, Mary, who was the daughter of Thomas Grainger of Hammersmith. The boy in the portrait is their son, also named John, who was thirteen or fourteen years old when the work was painted. He later joined his father's business. In 1757 he married Elizabeth Mary Young, sister of the famous agricultural theorist and traveler Arthur Young; after her death in the following year,

he married Sarah Warden of Cuckfield Park, Sussex, whose portrait had also been painted by Devis (location unknown). He was member of Parliament for Steyning in Sussex from 1761 until his early death, in 1767, the year in which his father also died.[6] The inscriptions on the labels identify the young women in the portrait as Mrs. Thomlinson's nieces. Seated on the right is Miss Grainger, later Mrs. Allen, and standing in the center of the group is Miss Bourke, later Mrs. Smith. These must have been the daughters, respectively, of a brother and a sister of Mrs. Thomlinson.

The globe on the right probably alludes to the family's mercantile interests, and the younger John Thomlinson's gesture in that direction suggests his intention to follow the same career as his father. The seascape above the mantel reinforces the idea, perhaps showing one of Thomlinson's own ships. The bust of Homer on the bookcase may be meant to subtly liken the enterprise of sea trade to an odyssey.

The Thomlinson family lived in and near London, had no known connections in the North of England, and were probably among the first clients Devis attracted in the London market. Though noted as being based in London as early as 1742, having possibly settled there a year or two before that date, the artist continued for some time to depend on patronage from his native Preston and the surrounding area. D'Oench observed that he received few commissions from northern clients from 1745 onward, however, and attributed the change to the decision of his father, whose social position in Preston seems to have played a vital part in securing commissions for Devis, to move to London himself in 1744.[7] D'Oench (1980 exhibition catalogue) also noted the influence on the composition of the Thomlinson portrait of the work of Charles Philips, a fellow painter of conversation pieces who was the artist's neighbor.

Along with the painting, the Art Institute acquired an original receipt, dated August 10, 1745, documenting Devis's payment for the work: "For Painting a Picture wth. five Figures. &c. £26.5s.0d. Paid the 10 Augt 1745."[8] This is the earliest known record of the price paid for a Devis portrait. It indicates a fee of five guineas per figure, which D'Oench (1980 exhibition catalogue) described as "a not inconsiderable sum for a commission early in the artist's London career."

NOTES
1 The thread count of the original canvas is 8 x 12/sq. cm (20 x 32/sq. in.).
2 The fragments are inscribed as follows: *Mr. Thomlinson / Mrs. Thomlinson / Mr. Thomlinson junr. their son—speaking / Lady standing up—Miss Bourke (afterwards / Mrs. Smith) sister of Mrs. Blake* and *Lady sitting—Miss Grainger (afterwards / Mrs. Allen) nieces of old Mrs. Thomlinson. / painted by Devis / c. 1744*, respectively.
3 According to a receipt acquired when the Art Institute purchased the painting (see discussion section). The receipt, once in the Art Institute's Archives, has been missing since 1978. A photocopy was kindly supplied by Ellen Gates D'Oench.
4 See the 1937 exhibition catalogue.
5 See *Art News* 1948; and the 1980 exhibition catalogue, p. 49, no. 13.
6 Biographical information compiled by D'Oench (1979, pp. 419–21, and 1980 exhibition catalogue).
7 D'Oench 1979, pp. 60, 67.
8 See note 3.

Henry Fuseli

1741 Zurich–London 1825

Milton Dictating to His Daughter, 1794

Preston O. Morton Memorial Purchase Fund for Older Paintings, 1973.303

Oil on canvas, 121.2 x 118.7 cm (47 3/4 x 46 3/4 in.)

CONDITION: The painting is in fair condition. It was cleaned in 1973, when an old glue paste lining was replaced by a wax resin one.[1] The tacking margins of the original canvas have been cut off, but cusping at the top and bottom edges indicates that the painting is close to its original dimensions.[2] X-radiography reveals that the artist painted this image over at least one entirely different composition (fig. 1).

The paint layer has suffered from previous treatment and from problems attributable to Fuseli's habit of layering one painting over another. The entire surface appears to have been somewhat flattened by lining and abraded by cleaning. There are large areas of wide drying cracks in the area of the seated daughter, across the bottom edge of the composition, in the space between Milton's legs and the standing daughter, and in the upper right corner. There are stretcher bar cracks at the right and left edges and across all four corners. There are finer cracks throughout. Most of the drying cracks have been inpainted, particularly in the figure at left. The mid-treatment photograph, taken before the drying cracks were inpainted,

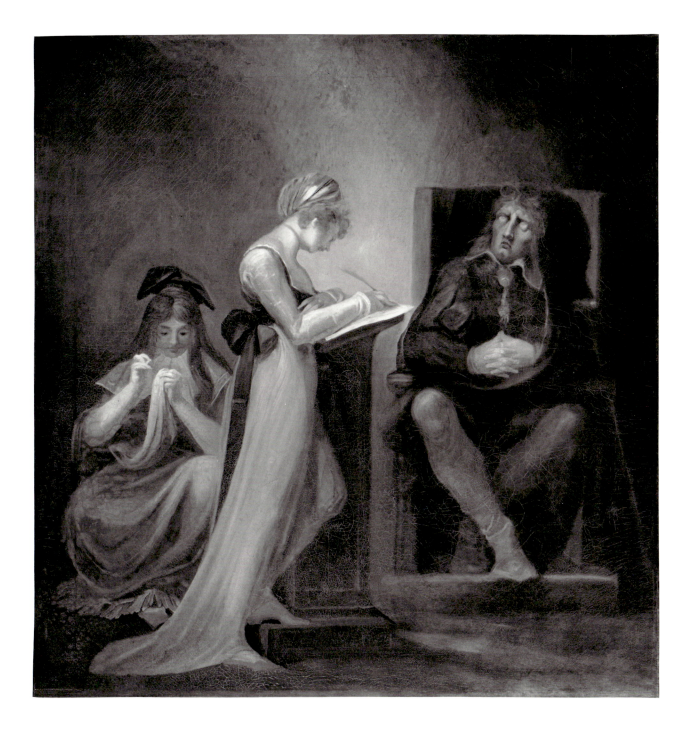

reveals dark paint beneath the surface of the seated girl, whereas other areas of cracking disclose a light underlayer. There are further retouches over all of the stretcher bar cracks, over the cracks in the head of the standing daughter, over the lower part of her dress, and on Milton's face. The contour of Milton's right elbow and upper arm was evidently altered. (infrared, mid-treatment, ultraviolet, x-radiograph)

PROVENANCE: Sent by the artist to William Roscoe, Liverpool, in 1800, apparently in exchange for funds already advanced by Roscoe.[3] Sold by Roscoe before August 20, 1802, possibly to John Stuart, first marquess of Bute (d. 1814).[4] John Crichton-Stuart, second marquess of Bute (d. 1848), by 1831.[5] Ernest Permain, London, 1930, possibly on consignment; offered for sale, G. and L. Bollag, Zurich, March 28, 1930, no. 56 (ill.), bought in;[6] sold in London to Galerie Bollag, Zurich, March 10, 1932.[7] Private collection of Léon Bollag (d. 1958), Zurich. Estate of Léon Bollag; then, from 1968, his son Max Bollag, Zurich.[8] Sold by Max Bollag to E. V. Thaw and Co., New York, by February 1973; sold to the Art Institute, 1973.

REFERENCES: John Knowles, *The Life and Writings of Henry Fuseli, Esq., M.A., R.A.*, vol. 1, London, 1831, p. 221. Arnold Federman, *Johann Heinrich Füssli: Dichter und Maler, 1741–1825*, Zurich and Leipzig, 1927, p. 172. David Irwin, "Fuseli's Milton Gallery: Unpublished Letters," *Burl. Mag.* 101 (1959), p. 436 n. 1. Hugh Macandrew, "Henry Fuseli and William Roscoe," *Liverpool Libraries, Museums, and Arts Committee Bulletin* 8 (1959–60), p. 47. Hugh Macandrew, "Selected Letters from the Correspondence of Henry Fuseli and William Roscoe of Liverpool," *GBA* 6th ser., 62 (1963), pp. 210, 215, 225. Gert Schiff, *Johann Heinrich Füsslis Milton-Galerie*, Schweizerisches Institut für Kunstwissenschaft Zürich, Schriften Nr. 5, Zurich and Stuttgart, 1963, pp. 13, 18, 20, 108–11, 113 (ill.), 116, 139, 158, no. 40. Marcia R. Pointon, *Milton and English Art*, Toronto, 1970, pp. 251–52, 260. Gert Schiff, *Johann Heinrich*

Füssli, 1741–1825, Zurich and Munich, 1973, vol. 1, pp. 166, 177, 221–23, 524, no. 921, p. 542; vol. 2, fig. 921. "La Chronique des arts," *GBA* 6th ser., 83 (1974), p. 131, fig. 419. John David Farmer, "Henry Fuseli, Milton, and English Romanticism," *AIC Bulletin* 68, 4 (1974), pp. 14–19 (ill.). David H. Weinglass, ed., *The Collected English Letters of Henry Fuseli*, Millwood, N.Y., 1982, pp. 117, 127, 155, 167–68, 213, 217–18, 224, 250. Peter Tomory, "Henry Fuseli's *Milton When a Youth*," *Art Bulletin of Victoria* 27 (1986), p. 27. Gloria Groom, "Art, Illustration, and Enterprise in Late Eighteenth-Century English Art: A Painting by Philippe Jacques de Loutherbourg," *AIC Museum Studies* 18 (1992), p. 129, fig. 6. David H. Weinglass, *Prints and Engraved Illustrations by and after Henry Fuseli: A Catalogue Raisonné*, Aldershot, England, and Brookfield, Vt., 1994, p. 310, under no. 264.

EXHIBITIONS: London, Milton Gallery, 1799–1800, no. 40. Zurich, Kunsthaus, *Johann Heinrich Füssli, 1741–1825*, 1969, no. 52. Milwaukee, University of Wisconsin, *John Milton, Related Art*, 1974 (no cat.).

Though born in Switzerland, Fuseli made his career mainly in Britain and played an important part in the development of British Romantic art. He was the son of the Zurich portrait painter and writer on art Johann Caspar Füssli, who saw that his son received a humanistic education. After a brief career as a Zwinglian minister in Zurich, Fuseli and his friends Johann Caspar Lavater and Felix Hess left the city in 1762 as a result of their political activities. The friends traveled through Germany, stopping in Berlin, where Fuseli studied art theory.[9] In 1764 he established himself in London, where he continued his studies and worked as a translator, making the first English translation of Johann Joachim Winckelmann's *Reflections on the Painting and Sculpture of the Greeks*. Encouraged by Joshua Reynolds (see 1922.4468), he moved to Rome in 1770, where he immersed himself in classical art and the work of Michelangelo, the "sublime" nature of which he sought to emulate in his own drawings and paintings. Although his work in Rome was largely confined to drawings, he achieved a substantial reputation through his influence on an international group of young artists working there and through his literary contacts with the leaders of the nascent German Romantic movement.

Fuseli left Rome in 1778, reaching London in 1779, after a brief stay in Zurich. He made his name as a painter at the Royal Academy exhibition of 1782 with *The Nightmare* (Detroit Institute of Arts),[10] and for the rest of his career championed the cause of historical art, that is, the treatment of subjects from mythology, history, and great literature, in opposition to the prevailing

Fig. 1 X-radiograph of *Milton Dictating to His Daughter*, 1973.303

taste in Britain for portraiture and landscape. After contributing several pictures to John Boydell's Shakespeare Gallery, he decided in 1790 to produce and exhibit his own Milton Gallery, a project that occupied most of his time and energy through the 1790s but met with little success. Also in 1790, Fuseli was elected to the Royal Academy, where he held the posts of Professor of Painting from 1799 and Keeper from 1804; his *Lectures on Painting* were published in 1801. Fuseli's intellect and high-mindedness commanded the respect of his contemporaries, including his friend William Blake (1757–1827), and the powerful elements of fantasy, horror, and eroticism in his work have been admired in this century by adherents of Expressionism and Surrealism.

Milton Dictating to His Daughter is one of the series of Miltonic themes painted by Fuseli for his Milton Gallery. Whereas its predecessor, Boydell's Shakespeare Gallery, was an anthology of works by different artists, the Milton Gallery was to consist of Fuseli's works alone. It was conceived originally in connection with a new luxury edition of Milton's works to be published by Fuseli's friend Joseph Johnson.[11] When Johnson abandoned this project, the artist determined to execute a series of pictures on his own. Without a related publication to produce income, he was hard pressed to support himself while working on the series, although he hoped to reap substantial profits when his Milton Gallery opened to the public. It was only with the financial support of a group of wealthy friends that he was able to bring the project to completion. The Milton Gallery opened to the public, in rooms on Pall Mall rented from Christie's, on May 20, 1799. The original exhibition comprised forty pictures; a further seven were added in the second exhibition, which was opened in March of the following year. Unfortunately, the gallery was a dismal financial failure; few pictures were sold, attendance was poor, and the artist was forced to close it for good on July 18, 1800. It did enhance Fuseli's critical reputation and prestige among his fellow artists, however, and his appointment as Professor of Painting at the Royal Academy was concurrent with its opening.

The majority of Fuseli's Miltonic works were illustrations to the poet's writings, but the exhibition also included a group of three biographical subjects, the final three items listed in the catalogue to the inaugural exhibition. In addition to *Milton Dictating to His Daughter* (no. 40), there were scenes of Milton as a boy being educated by his mother (no. 38), and a legendary episode in which he lay asleep under a tree while a student at Cambridge and was watched by a mysterious, muselike Italian lady (no. 39).[12] Typically, Fuseli was particularly interested in the poet's relations with the women in his life, and two further Miltonic works that he painted around the same time, though not exhibited in the Milton Gallery, have subjects featuring Milton's first and second wives.[13] Milton was a heroic figure in British literature, and as such an attractive source of subject matter for an artist who was committed to the establishment of a distinctively British school of history painting. Milton was a natural choice with which to follow up the success of Boydell's Shakespeare Gallery and had a particular appeal for Fuseli in that he fulfilled certain requirements of the Romantic hero as well. He was a genius who suffered both political persecution and physical disablement, and a good deal was known about his complicated personal and emotional life, which was intriguingly bound up with his work as a writer.

John Milton (1608–1674) led a retired, literary life until the turbulent decade of the 1640s, when he supported Cromwell in the Civil War, defended the execution of Charles I, and served as Latin secretary to the newly founded Council of State, devoting his energies as an author mainly to pamphleteering on religious, civil, and domestic issues. During this time his eyesight began to fail, and by 1651 he was totally blind. For the rest of his life he could read and write only through others. With the restoration of Charles II in 1660, Milton went briefly into hiding, and was arrested, fined, and released.

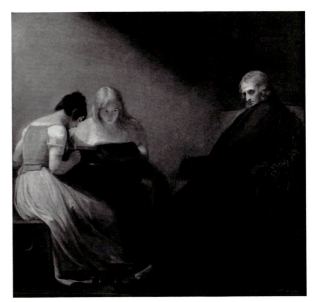

Fig. 2 George Romney, *Milton Dictating to His Daughters*, private collection

He then returned to the composition of poetry and completed his greatest work, *Paradise Lost*. Milton had four children by his first wife, a son who died in infancy and three daughters: Anne, who was disabled, Mary, and Deborah. Among those who served as the poet's assistants in the last period of his life were his daughters Mary and Deborah, whom he trained to read aloud to him from the classics — apparently without themselves understanding Greek or Latin — and, in the case of Deborah at least, to take dictation.

By choosing the subject of Milton dictating to his daughter for his Milton Gallery, Fuseli may have been defending the poet's character as well as honoring his genius. The uneasy relationship between Milton and his daughters had become a point of controversy between the poet's critics and defenders. While Fuseli was working on his Milton Gallery, the poet William Hayley published his biography of the poet (1794), in which he sought to address the unflattering comments on Milton as a man and as a poet made by Samuel Johnson in his *Lives of the English Poets* (1779–81). In particular, Hayley protested against the story repeated by Johnson that Milton did not permit his daughters to learn to write, correctly stating that John Aubrey's early memoir of the poet calls the youngest daughter, Deborah, his amanuensis.[14] This, Hayley added, was "a circumstance of which my friend Romney has happily availed himself to decorate the folio edition of this life with a production of his pencil."[15] In *Milton Dictating to His Daughter*, Fuseli was making the same point about Milton's parental attitude that Hayley made in his biography, and that Romney reinforced in the painting (fig. 2) used in engraved form to illustrate Hayley's text.

The painting by Romney, which dates from 1793, was probably the first pictorial treatment of the subject. Gert Schiff accorded Fuseli's painting in the Milton Gallery this distinction, dating it to 1793 on the basis of a misdated letter from Fuseli to his friend and patron William Roscoe; in fact, the letter dates the painting to 1794.[16] Moreover, another letter to Roscoe indicates that it was finished by April 1794, which means that it postdates the Romney by at least a few months.[17] In both works a stream of light from above suggests the poet's divine inspiration and the idea of spiritual vision transcending physical blindness. Milton himself used such an image in his invocation in book 3 of *Paradise Lost* (11.51–55). As Schiff pointed out, Fuseli's version of the subject avoids Romney's sentimental treatment, giving us none of the becoming meekness and charm with which

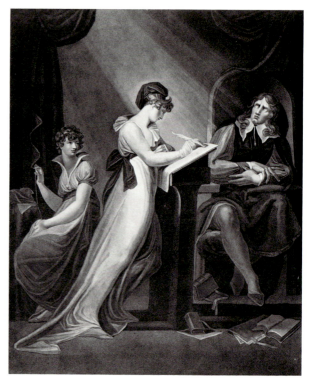

Fig. 3 Moses Haughton, engraving after Henry Fuseli, *Milton Dictating to His Daughter*, British Museum, London [photo: © British Museum, London]

Romney imbued the daughters. Fuseli also differentiated more strongly between the two girls, who are presumably the poet's younger daughters, Mary and Deborah. It must be Mary who is shown stolidly absorbed in her sewing, while the more favored Deborah stands gracefully at her writing desk as the dominant figure in the composition. On a symbolic level, Fuseli seems to have cast the daughters, especially Mary, as part of the world of physical limitations above which Milton's genius soared. The point is made in the contrast between their downward looks, attentive to the merely mechanical activities of sewing and taking dictation, and his inspired, upward gaze.

Fuseli painted another version of this subject, which was engraved by Moses Haughton in 1806 (fig. 3); the present whereabouts of the painting are unknown.[18] This has led some scholars to hesitate in identifying the Art Institute's picture as the original version of the subject shown as no. 40 in the Milton Gallery.[19] Although the issue is impossible to resolve beyond all question, it seems virtually certain that the Art Institute's painting, and not the work shown in Haughton's engraving, was the original. The dimensions given by Fuseli for the original canvas in a letter of August 9, 1796, indicate a painting that is almost square;[20] this matches the Art

Institute's painting but not the engraved work, which is considerably taller than it is wide. Whereas the costume in the Art Institute's version is vaguely historical, the engraved version of the subject shows Mary Milton with pertly tousled hair, a smaller collar, and the puffed sleeves that were fashionable shortly after 1800, when the engraving was published. In all likelihood, the engraving reproduces the painting of the subject that Fuseli exhibited at the Royal Academy, also in 1806.

In the engraved version of *Milton Dictating to His Daughter*, there is a greater extent of floor below and space above the figures, with added books at Milton's feet and curtains in the upper part of the composition. By far the most significant difference, however, lies in the sweeter attitudes of the daughters, especially Mary. In the Art Institute's version, Mary is absorbed in her work, apparently oblivious to the great poetry being created in the same room; in the engraving, she looks up attentively at her father. Both daughters have also become better-looking in the engraving. With the print market in mind, and following the failure of the Milton Gallery and the difficulty of selling his original version of the subject, the artist seems to have reworked the composition along pleasanter lines. His newer version of *Milton Dictating to His Daughter* has none of the tension of the original, showing instead the harmonious domestic mood of Romney's treatment of the subject.

X-radiography reveals that, like many of Fuseli's works, *Milton Dictating to His Daughter* was painted over at least one other composition (fig. 1). The underlying forms include a female face, what may be a waving arm, and a pair of bare feet near the lower edge of the canvas that bears no relation to the Miltonic subject and seems to belong to a foreshortened, reclining figure. These traces are not sufficiently legible to guess their subject or subjects with any confidence, but they do recall known Fuseli compositions of scenes from *A Midsummer Night's Dream* such as the large *Titania's Awakening* of 1785–89.[21]

NOTES

1 The treatment was performed by Alfred Jakstas. The average thread count of the canvas is 15 x 13/sq. cm (38 x 35/sq. in.).

2 The present stretcher is modern, and the previous stretcher, discarded when the picture was relined in 1973, was not the original either. It had a vertical and a horizontal cross-support through the center, whereas diagonal cracks at all four corners indicate that the painting was originally mounted on a stretcher with corner braces.

3 Letters from Fuseli to Roscoe show that he received £200 from Roscoe on July 23, 1800, that he sent the picture to him on August 7, and that his suggested price was thirty guineas

(Weinglass 1982, pp. 217–18, 224).

4 Fuseli wrote to Roscoe on August 20, 1802, congratulating him on the "disposal" of four pictures, including the one in question, of which he seems to have been especially proud, but he did not mention the names of the buyers (Weinglass 1982, p. 250). According to the annotated catalogue of the Milton Gallery published in 1831 by John Knowles, Fuseli's early biographer, the owner of the work in 1831 was the second marquess of Bute (Knowles 1831, vol. 1, p. 221). In the absence of any record of the work changing hands between 1802 and 1831, it seems possible that the collector to whom Roscoe sold it was his grandfather, the first marquess, who died in 1814.

5 See note 4.

6 According to a letter from Max Bollag to the author of January 24, 1994, in curatorial files.

7 According to letters from Max Bollag to the author of December 15, 1993, and January 24, 1994, in curatorial files.

8 See note 7.

9 The events of Fuseli's life are described in detail in Schiff 1973.

10 Schiff 1973, vol. 1, p. 496, no. 757, vol. 2, fig. 757.

11 Schiff 1963, p. 10, and Schiff 1973, vol. 1, p. 161. Revenues would have been generated by the book, by charging admission to the exhibition, and ultimately by the sale of individual paintings and reproductive engravings. For similar projects, organized by the publisher Thomas Macklin, see the entry on de Loutherbourg's *Destruction of Pharaoh's Army*, 1991.5.

12 These other two pictures are in the Hotel Euler, Basel, and the National Gallery of Victoria, Melbourne, respectively (discussed and illustrated in Schiff 1973, vol. 1, p. 522, no. 916, vol. 2, fig. 916; vol. 1, p. 523, no. 918, vol. 2, fig. 918; see also Tomory 1986).

13 These are *Milton's First Wife, Mary Powell, Pleading with Him for Forgiveness* (Liverpool, Walker Art Gallery) and *Milton's Vision of His Second Wife* (Basel, Dreyfus Collection); see Schiff 1973, vol. 1, p. 523, no. 919, vol. 2, fig. 919; vol. 1, pp. 523–24, no. 920, vol. 2, fig. 920, respectively.

14 See *The Poetical Works of Milton with a Life of the Author by William Hayley*, ed. by William Hayley, vol. 1, London, 1794, p. cxii. For the report of the daughters' inability to write, credited to a daughter of Deborah Milton, see Samuel Johnson, *Lives of the English Poets*, vol. 1, London, 1964, p. 94. Milton's life had been documented in several earlier biographies and memoirs that are conveniently collected in Helen Darbishire, *The Early Lives of Milton*, London, 1932. Aubrey's notes are reprinted in Darbishire, and include the statement "Deborah was his Amanuensis, he taught her Latin, & to read Greek . . . to him" (p. 2). Hayley (*Poetical Works*, vol. 1, pp. cvii-cxiv) also sought to justify the circumstances of Milton's will, in which his daughters are described as "unkind" and "undutiful." The will, written down after Milton's death and contested by his daughters, was not published until 1791 (see Darbishire, pp. xxxiv, l-li; and *Poetical Works*, vol. 1, pp. cvii-cviii).

15 *Poetical Works* (note 14), vol. 1, p. cxii.

16 Schiff 1963, pp. 13, 110, 158, 139 n. 351; and Schiff 1973, vol. 1, p. 524, no. 921. The letter carelessly dated by Fuseli February 16, 1793, is actually postmarked February 16, 1795; see Weinglass 1982, pp. 126–28, for the letter and its correct date. Fuseli mentioned *Milton Dictating to His Daughters* [*sic*] among the pictures "finished during the Course of the Last Year," that is, presumably, 1794.

17 Letter to Roscoe of April 30, 1794; see Weinglass 1982, pp. 116–18.

18 Unless there was a third version, it was presumably this picture that Benjamin Robert Haydon (1786–1846) remembered seeing in Fuseli's studio; see *The Diary of Benjamin Robert Haydon*, ed. by Willard Bissell Pope, vol. 3, Cambridge, Mass., 1963, p. 18 (April 21, 1825).

19 Macandrew (1963, p. 225 n. 14) and Pointon (1970) maintained
 that the painting now in the Art Institute could be either no. 40
 in the Milton Gallery or the presumably later version of the
 subject exhibited at the Royal Academy in 1806. Schiff (1973)
 and Schiff and Weinglass (manuscript revision of Schiff's cata-
 logue raisonné, kindly made available to the author) accepted
 with reservations the probability that the Art Institute's picture
 was no. 40 in the Milton Gallery.

20 Weinglass 1982, p. 155. The dimensions are given as "3 feet 23,
 by 3 feet 22"; these are puzzling figures, but probably descrip-
 tive of a square canvas. Assuming them to mean 59 x 58 inches,
 Schiff inferred that the Art Institute's painting must have been
 cut down. The composition does not appear cropped, however,
 and x-radiography indicates that the work is close to its original
 dimensions (see Condition).

21 Winterthur, Kunstmuseum; see Schiff 1973, vol. 2, fig. 754.

Sketch for "The Oath on the Rütli," 1779/81
Female Figure (verso), 1785/90

Anonymous Gift, 1980.170

Oil on canvas; present stretcher: 76 x 67.5 cm (29^{15}/$_{16}$ x 26^{9}/$_{16}$ in.); irregular edges of the original canvas: 72.7 x 57.8 cm (28^{5}/$_{8}$ x 22^{3}/$_{4}$ in.); edges of the *Oath on the Rütli* image: 65.1 x 54.3 cm (25^{5}/$_{8}$ x 21^{3}/$_{8}$ in.)

CONDITION: The two paintings are executed on the recto and verso of a single piece of canvas. The *Sketch for "The Oath on the Rütli"* is in very good condition; the *Female Figure*, which has a more complicated layering structure, has had more damage and retouching. The whole work was cleaned and edge lined in 1976–77.[1] The original edges were extremely worn and fragmented, as is apparent from the pre-treatment photographs taken in 1976 and from the x-radiograph (figs. 1–3). Cusping on the bottom and sides (when viewed from the recto) indicates that the canvas was initially stretched close to its present dimensions.[2]

The Oath on the Rütli on the recto is painted over an off-white ground layer that is visible on all four sides and extends approximately 4 cm beyond the image on the top and bottom edges, and 2.5 to 3 cm on the right and left edges. Drips of brown paint on the off-white ground extend along the bottom edge and are presumably original (see fig. 1). The paint layer is well preserved. A pattern of horizontal cracks across the upper half of the painting suggests that it may have been rolled at one time. There is some minor abrasion of the paint layer in the upper left background, and possibly in the extended right arm of the central figure. There are a few minor losses in the figures: in the central figure's right shin, the right side of his chest, and the upper left of his head; in the left figure's right foot and leg; and in the right figure's ankle. There are a few other small losses in the background at the center right and left edges, and near the lower right corner. All of the losses have been inpainted. The pre-treatment and ultraviolet photographs show a series of lines encircling the waist of the figure at the left. These are no longer apparent on the surface of the painting.

The *Female Figure* on the verso is oriented at ninety degrees to the recto so that its lower edge is the recto's right edge; the image covers the canvas to the edges, leaving no border. It has a more complex layering of three superimposed stages of work and appears to have been painted on unprimed canvas. The first image painted on this side of the canvas was a half-length female figure, visible in the x-radiograph (fig. 3). It is vertically

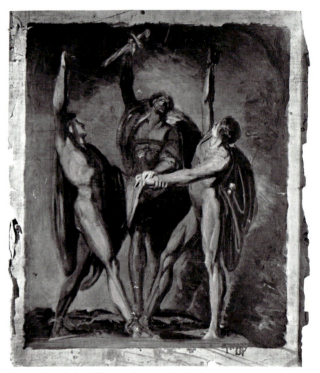

Fig. 1 *Sketch for "The Oath on the Rütli,"* 1980.170 (photograph taken in 1976, before treatment)

oriented in the direction opposite to *The Oath on the Rütli* on the recto, hence the bottom edge of this figure corresponds to the only edge of the canvas that is without cusping. The facial features and drapery folds appear very dense in the x-radiograph. The impasto of the underlying brushwork is still evident through the paint layers applied over it, particularly where the head of the *Female Figure* covers areas of drapery. Microscopic examination of the surface reveals as many as seven or eight different colors superimposed. At one examined point, they include gray, white, red, pink, possibly another red layer, black, and finally the yellow on the surface representing the hair of the *Female Figure*. Painted over the half-length figure and visible in the ultraviolet photograph and the pre-treatment photograph (fig. 2) is a second vertically

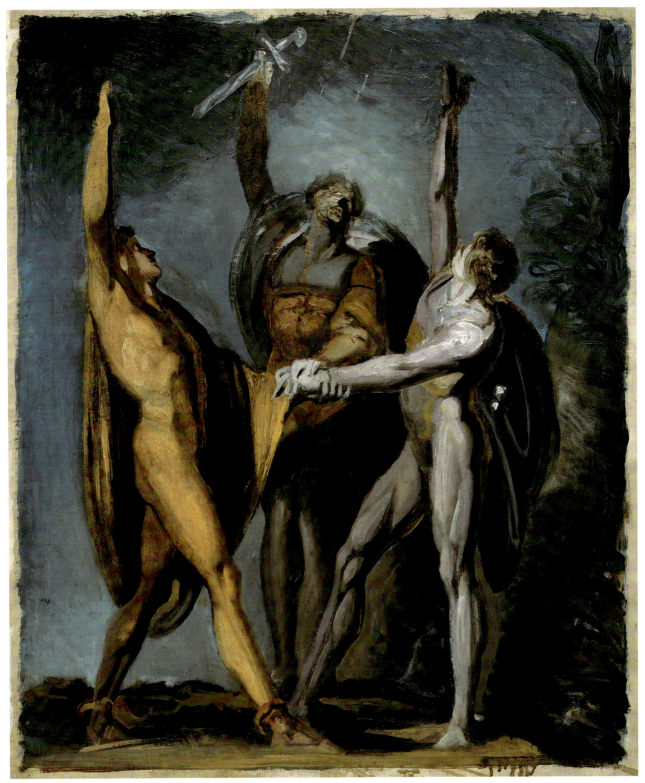

Henry Fuseli, *Sketch for "The Oath on the Rütli,"* 1980.170

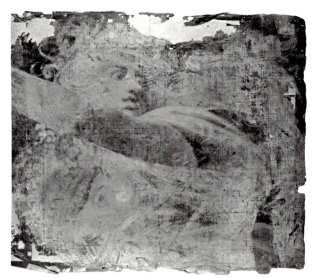

Fig. 2 *Female Figure* (verso), 1980.170 (photograph taken in 1976, before treatment)

head running in the direction opposite to the image just discussed. It is painted in three-quarter view. This figure must have been painted just below the present surface layer since it had begun to show through the surface and was suppressed during the 1976–77 treatment. A smooth, handlike shape is also visible in the lower right corner of the pre-treatment photograph.

Given its complex layering, the paint surface of the verso is fairly well preserved, aside from a general age craquelure. Shrink drying of the thick paint film is particularly marked in the breasts and face of the *Female Figure*. There is retouching on her forearm, on the near side of her nose and cheek, in her right eye, and in the background to the right of the head. A whitish film trapped in the interstices of the brushwork in the hair above the shoulder of the *Female Figure* may be the remains of the surface film that obscured the picture before the 1976–77 treatment. (pre-treatment, infrared, ultraviolet, x-radiograph)

PROVENANCE: Transferred from the Department of Prints and Drawings to the Department of European Painting and accessioned as an anonymous gift, 1980.[3]

REFERENCES: Frederick N. Bohrer, "Public Virtue and Private Terror: A Two-Sided Oil Sketch by Henry Fuseli," *Zeitschrift für Kunstgeschichte* 53 (1990), pp. 89–106 (ills.).

EXHIBITIONS: Bern, Bernisches Historisches Museum and Kunstmuseum, *Zeichen der Freiheit: Das Bild der Republik in der Kunst des 16. bis 20. Jahrhunderts*, 1991, no. 4.

The freely sketched version of *The Oath on the Rütli* on the recto of this double-sided canvas must have been made in preparation for Fuseli's first major painting commission, a subject of nationalistic importance from Swiss history painted for the Zurich Rathaus in 1779–81

(fig. 4). The image of a dynamic female figure on the verso seemed to the late Gert Schiff and to David Weinglass to be a fragment cut from a larger painting and to be datable on the grounds of style to the later 1780s. This led them to the conclusion that *The Oath* was a record or replica of the large painting rather than a preparatory work.[4] In fact, careful examination of the canvas and the images layered on it, as well as comparison to other studies for *The Oath*, indicates that the Art Institute's sketch was indeed part of Fuseli's preparation for this important commission.

The oil sketch for *The Oath* is surrounded by a fairly even, unpainted margin of canvas covered only with a ground (see fig. 1). The most likely explanation for this circumstance is that the canvas was stretched for use on the other side, and that Fuseli painted the sketch through the "window" created at the back by the stretcher bars. The drips over the edge of the margin at the lower right are consistent with such a procedure, being presumably the result of wet paint running down between stretcher and canvas. The side with the sketch for *The Oath* is the only one prepared with a ground (see Condition), which means that the canvas must have been stretched inside out. Fuseli must have elected initially to paint on the other, raw side of the canvas, perhaps to achieve a pronounced texture in the paint surface.

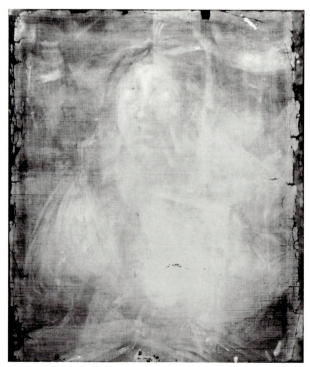

Fig. 3 X-radiograph of 1980.170 (viewed with *Sketch for "The Oath on the Rütli"* inverted)

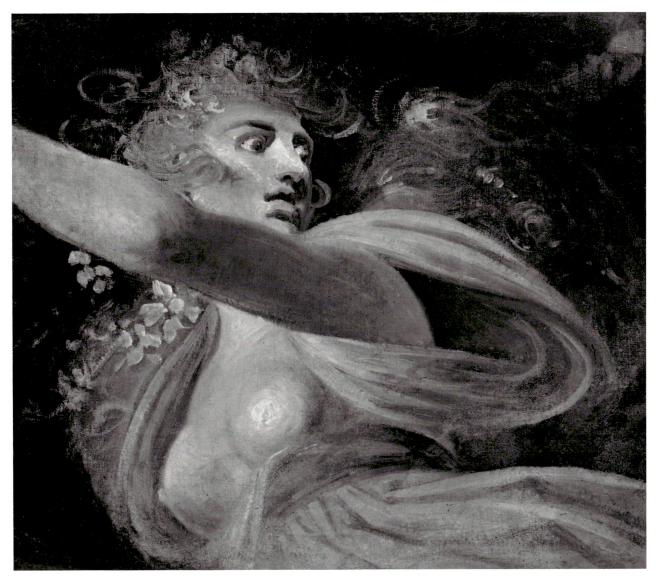

Henry Fuseli, *Female Figure* (verso), 1980.170

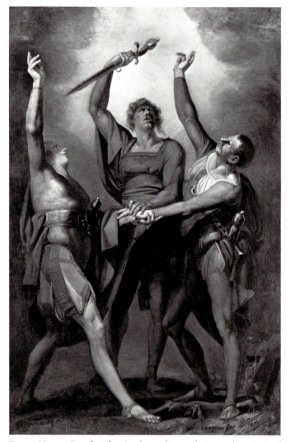

Fig. 4 Henry Fuseli, *The Oath on the Rütli*, Kunsthaus Zürich

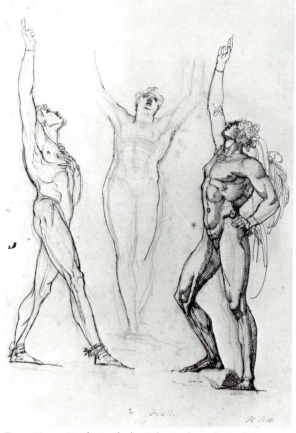

Fig. 5 Henry Fuseli, *Study for "The Oath on the Rütli,"* Kunstsammlungen zu Weimar

The original campaign of work was not the *Female Figure* now visible on that raw side of the canvas, however, but another half-length female figure that lies beneath it and is visible only in the x-radiograph (fig. 3). Judging from the texture and density of the paint, this figure was worked up to a fairly full degree. The head and shoulders are covered in drapery and the large, upturned eyes convey a rapt expression. Not only the earliest image the verso bears, but also the most complete in itself, it may have been a historical subject or a portrait. In Zurich and on his return to London, Fuseli made a number of portraits of young women from his Zurich circle. Indeed, the image bears a compelling resemblance to the drawing known as *Martha Hess as Silence*, which probably dates from shortly after Fuseli's stay in Zurich.[5] Later the artist overpainted this image at least twice, possibly after first unstretching the canvas. His reworkings included an exotic head, among other things (see fig. 2), and finally the *Female Figure*. That the *Female Figure* is not a fragment cut from a larger whole is evident from the self-contained character of

the underlying image and, more importantly, from the pattern of weave distortion clearly visible in the x-radiograph, which indicates conclusively that the canvas was stretched close to its present size and shape before it was ever painted on. It is no fragment, but rather a rejected work recycled; its prime image was overpainted like a palimpsest with experimental figures that may or may not relate to larger compositions, and it was turned around for sketching on the back, which conveniently happened to have a ground, when the artist was working out a major commission. Given the artist's propensity to rework his canvases, it is probable that more such complicated layerings would emerge were x-radiography to be performed on other Fuseli paintings.

Whether the sketch for *The Oath* was done before, between, or after the overpaintings on the other side of the canvas is impossible to determine from examination of the object alone. That it was made as a preparatory work rather than a replica, apparently the only instance of the artist's using an oil sketch in preparation for a larger picture, can be established by comparison with the

final painting and two preparatory drawings.

The large picture of *The Oath on the Rütli* (fig. 4) was commissioned by highly placed citizens of Zurich during Fuseli's stay there in 1778–79.[6] The work was to commemorate the formation of the "Perpetual League," an alliance between the three original cantons of Switzerland—Unterwalden, Uri, and Schwyz. Representatives of the cantons met on the Rütli, a meadow on the western shore of the Urnersee, in 1291 to swear a defensive pact against the emerging power of the Hapsburgs. Schiff noted that the representatives of the cantons were identified in early accounts as Arnold von Melchtal of Unterwalden, Walter Furst of Uri, and Werner Stauffacher of Schwyz.[7] Furst was regarded as the leader of the trio, and Schiff maintained that Fuseli followed pictorial and literary tradition in placing him in the center, clothed in garments evoking his knightly status. He identified the figures at the left and right as von Melchtal and Stauffacher respectively. The swearing of the oath had long been part of Swiss national legend and folklore, one of the representatives of Schwyz having been Wilhelm Tell. In Fuseli's time it carried a powerful symbolic charge among nationalists as the first step toward a longed-for union between the cantons, which then formed only a loose confederation. This goal was eventually achieved not through internal accord but through the intervention of Napoleon, who established the Helvetic Republic as a French puppet state.

It is a measure of the importance of this commission for Fuseli that *The Oath on the Rütli* is the only canvas in the extensive body of his known paintings that he signed and dated.[8] The earliest stage of Fuseli's preparation for the large picture is represented by a drawing in Weimar (fig. 5).[9] A more fully worked out drawing in Zurich (fig. 6), inscribed *Zurico 79*, is a step closer to the finished work in showing the men clasping their left hands together in front of them as well as raising their right arms; a wooded setting is summarily indicated.[10] The Art Institute's oil sketch includes the changes in the Zurich drawing and introduces a sword in the right hand of the central figure, an open sky behind his head, and a more dynamic pose for the figure on the right, whose head is now turned away from profile view, all of which are features that also occur in the large painting. It seems reasonable to infer that the oil sketch was the final preparatory stage, made after the drawings and immediately before the large picture was begun in London in 1779. The disposition of the figures remains essentially the same in the oil sketch and the final painting, apart from the arrangement of the men's feet; the facial features and costumes are more fully worked out in the painting, and the tree has been entirely banished from the background in favor of a dramatic burst of light.

Fuseli's representation of the oathtaking has roots in a local iconographic tradition. Schiff cited Christof Murer's etching, of which Fuseli owned an impression, showing the representatives of the three cantons raising their right hands as they stand before a tree.[11] In works by other Zurich artists of the sixteenth and seventeenth centuries, the three confederates clasp hands beneath parting clouds, as they do in Fuseli's finished painting.[12] Fuseli transformed this local tradition, making his figures more dynamic and universal.

As stated above, Schiff and Weinglass concluded that the Art Institute's oil sketch was a record of *The Oath* painted in the late 1780s, the date they assigned to the *Female Figure* on the basis of its broader painting style. Though incorrect in their dating of *The Oath* and in their view that the *Female Figure* on the verso is a fragment, their dating of the latter to the late 1780s, based on the artist's breadth of handling, is plausible. The figure appears to be reacting to something not shown and, though not literally a fragment, she may well relate to a part of a larger composition in some way, probably

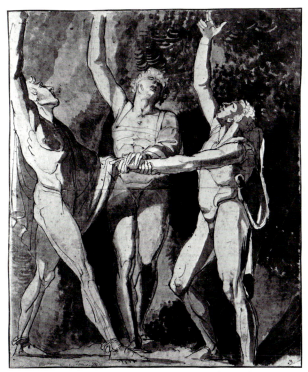

Fig. 6 Henry Fuseli, *Study for "The Oath on the Rütli,"* Kunsthaus Zürich

as a study. Schiff has pointed out a similarity of pose to that of a terrified fairy on the left side of *Titania's Awakening* in the Kunstmuseum, Winterthur.[13] Yet the *Female Figure* appears too adult to be a fairy. Rather she may represent an idea for another figure in a *Midsummer Night's Dream* subject or some other composition. On the other hand, she may be no character in particular, merely a study of terror. In the absence of any evidence other than the appearance of the work itself, the issue will remain a matter for speculation.

NOTES

1 The treatment was performed by Alfred Jakstas to facilitate double-sided viewing of the canvas in a mat. The junction of the edge strips and canvas was overpainted with off-white paint on the recto, and with a black paint on the side of the *Female Figure*. In 1991 the edge lining was extended by Jill Whitten to eliminate planar distortions, and to make it possible again to mount the canvas on a stretcher.

2 The thread count of the canvas is approximately 11 x 12/sq. cm (28 x 30/sq. in.).

3 The canvas was discovered, unstretched, among the holdings of the Department of Prints and Drawings in 1976. It is possible that it came to the Art Institute in 1922 or 1943 as part of the Gurley Bequest, a large collection of drawings, many of which remained unaccessioned until recently; compare the provenance of Fuseli's *Heads of Damned Souls from Dante's "Inferno"* (1992.1531).

4 Letter from Gert Schiff to the author of July 28, 1988, in curatorial files; and manuscript entry written in collaboration with David Weinglass for the forthcoming revised edition of Gert Schiff's catalogue raisonné, kindly made available to the author. The entry on the Art Institute painting in the 1991 exhibition catalogue, no. 4, follows their argument.

5 Gert Schiff, *Johann Heinrich Füssli, 1741–1825*, Zurich and Munich, 1973, vol. 1, pp. 154, 509, no. 849, vol. 2, fig. 849; sold Christie's, London, April 25, 1995, no. 51 (ill.).

6 For this picture, now on loan from the Zurich Rathaus to the Zurich Kunsthaus, see Schiff (note 5), vol. 1, pp. 94–98, 437, no. 359. More recent literature is given in the 1991 exhibition catalogue, no. 3. The source of the commission is unclear, though Johann Caspar Lavater seems to have been involved as an intermediary.

7 Schiff (note 5), vol. 1, p. 96.

8 Ibid., vol. 1, p. 95.

9 Ibid., vol. 1, pp. 95, 445, no. 411, vol. 2, fig. 411; the drawing passed from Lavater into Goethe's collection.

10 Ibid., vol. 1, pp. 95–96, 445, no. 412, vol. 2, fig. 412.

11 Ibid., vol. 1, pp. 95–96; the etching was from a pair of broadsheets, printed from six plates, showing the origin of the Swiss Confederacy. For this etching, see *Hollstein's German Engravings, Etchings and Woodcuts, 1400–1700*, compiled by Robert Zijlma, vol. 29, Roosendaal, The Netherlands, 1990, p. 124, no. 12 (ill.); and the 1991 exhibition catalogue, no. 53.

12 This tradition, particularly in the work of Zurich stained-glass designers and goldsmiths, is discussed by Thea Vignau-Wilberg in her article "Zur Ikonographie des Rütlischwurs im 17. Jahrhundert," *Zeitschrift für schweizerische Archäologie und Kunstgeschichte* 32 (1975), pp. 141–47. See also a design for the interior of a cup by Hans Peter Oeri II, illustrated in Eva-Maria Lösel, *Zürcher Goldschmiede Kunst vom 13. bis zum 19. Jahrhunderts*, Zurich, 1983, p. 269, no. 426e, pl. 94.

13 Letter of July 28, 1988 (note 4). For an illustration of the painting in Winterthur, see Schiff (note 5), vol. 2, fig. 759. Bohrer (1990, pp. 98–106), identified the *Female Figure* as a fragment of a painting of Psyche, the fable of Cupid and Psyche being a subject that we know Fuseli painted around 1780. The idea of the figure as Psyche, startled at hearing the invisible Cupid moving in her bedchamber, or perhaps discovering the identity of her mystery lover by holding a lamp over him as he sleeps, is plausible. Bohrer's argument is flawed, however, since the work is not a fragment and probably dates to the late 1780s.

Head of a Damned Soul from Dante's "Inferno," 1770/78
Head of a Damned Soul from Dante's "Inferno" (verso), 1770/78

Leonora Hall Gurley Memorial Collection, 1992.1531

Oil on canvas, edges irregular, approx. 40.6 x 29.8 cm (16 x 11³/₄ in.)

INSCRIBED: *Heinrich Fuessly / 1741–1825*[1] (verso, lower left)

CONDITION: The two paintings are executed on the recto and verso of a single piece of finely woven canvas. Both are in excellent condition. They were selectively cleaned in 1991 and edge lined in 1992.[2] The unprimed canvas has no tacking margins or evidence of cusping, and it is unclear whether the work was ever attached to a stretcher.[3]

The image on the recto of a head thrown back is painted directly on the raw canvas, which has no ground. The dark area covering much of the background above and to the left of the head is a stain that has soaked into the unprimed canvas from the head painted on the verso. The paint is applied in broad masses of light and dark. Its texture is well preserved. The dark areas have a somewhat glossier appearance than the lighter areas.

The head with closed eyes on the verso is also painted directly on the raw canvas. The paint is laid in with the same broad brushwork, producing a dramatic tonal effect. The tactile quality of the paint is also well preserved. Traces of yellowed

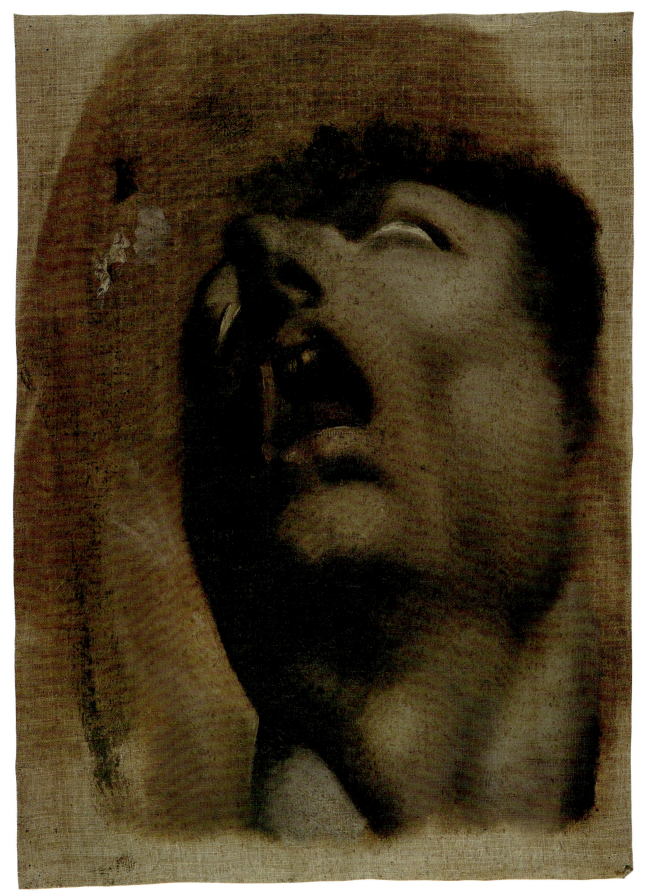

Henry Fuseli, *Head of a Damned Soul from Dante's "Inferno,"* 1992.1531

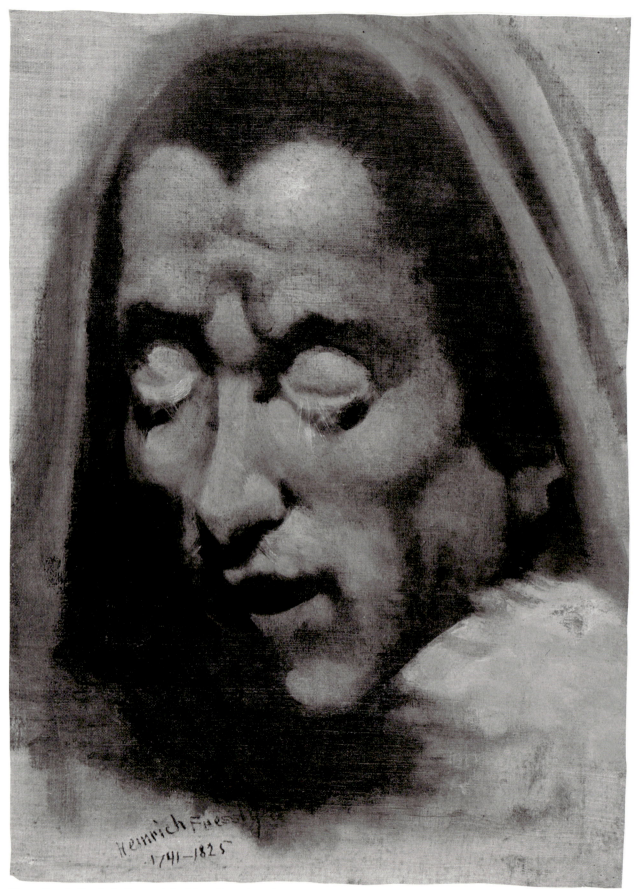

Henry Fuseli, *Head of a Damned Soul from Dante's "Inferno"* (verso), 1992.1531

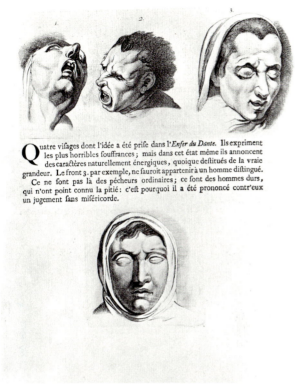

Q uatre viſages dont l'idée a été priſe dans l'*Enfer du Dante*. Ils expriment les plus horribles ſouffrances; mais dans cet état même ils annoncent des caractères naturellement énergiques, quoique deſtitués de la vraie grandeur. Le front 3. par exemple, ne ſauroit appartenir à un homme diſtingué. Ce ne ſont pas là des pécheurs ordinaires; ce ſont des hommes durs, qui n'ont point connu la pitié: c'eſt pourquoi il a été prononcé contr'eux un jugement ſans miſéricorde.

Fig. 1 *Quatre visages dont l'idée a été prise dans "l'Enfer du Dante,"* engraving after Henry Fuseli from Johann Caspar Lavater, *Essai sur la physiognomie*, vol. 2, The Hague, 1783, p. 260

natural resin varnish are visible in the lighter areas of the brushwork, particularly on the forehead. A few small areas of retouching in the shadow to the left of the face, in the eyebrows, and on the nose and chin date from the 1991 treatment.

PROVENANCE: Sold Puttick and Simpson, London, October 23, 1914, no. 236, to William F. E. Gurley (d. 1943), Chicago;[4] bequeathed to the Art Institute, 1943; transferred from the Department of Prints and Drawings to the Department of European Painting, 1990; accessioned, 1992.

REFERENCES: David H. Weinglass, "'Kann uns zum Vaterland die Fremde werden?' In der Emigration: Johann Heinrich Füssli," *Neue Zürcher Zeitung*, November 23–24, 1991, p. 67. David H. Weinglass, *Prints and Engraved Illustrations by and after Henry Fuseli: A Catalogue Raisonné*, Aldershot, England, and Brookfield, Vt., 1994, pp. 41, 95, under nos. 50, 83.

T hese expressive heads, painted on either side of an unprimed piece of canvas, were reproduced as engraved illustrations in the expanded second edition of Johann Caspar Lavater's renowned *Physiognomische Fragmente*, published in French under the title *Essai sur la physiognomie* in 1781–86. They appear in volume two, which was published in 1783. They and two others, for

which corresponding painted studies appear not to survive, are described as "Quatre visages dont l'idée a été prise dans *l'Enfer du Dante*" (fig. 1). None of them appeared in the first edition of Lavater, which was published in German, with numerous illustrations, in 1775–78. All four were re-engraved with slight variations for the English edition published with Fuseli's assistance in 1789–98.[5] The present canvas was rediscovered among the holdings of the Department of Prints and Drawings in 1990, and its relation to Lavater was recognized shortly afterward by David Weinglass.[6]

Johann Caspar Lavater (1741–1801) was an intimate friend of Fuseli's from their student days together under Johann Jakob Bodmer and Johann Jakob Breitinger, who nurtured the beginnings of the "Sturm und Drang" movement in Zurich. In the 1770s, when Lavater was preparing the first edition of his great physiognomic study, Fuseli was in Italy. The artist's published letters make it clear that Lavater was eager to get specimens of his friend's work to illustrate his book, and that Fuseli found the task onerous. Their interests were essentially at odds. Lavater was concerned with insights into individual character revealed by the study of skull structure, while Fuseli wished to express universal passions through facial expression and action.[7] The first edition of Lavater contained only one illustration after Fuseli, described in the text as the head of a dying man (fig. 2).

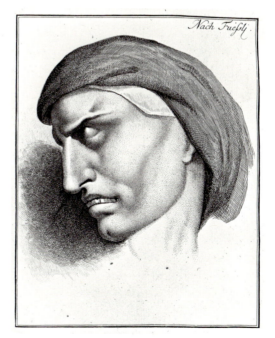

Fig. 2 Johan Rudolf Schellenberg, *Head of a Dying Man*, engraving after Henry Fuseli from Johann Caspar Lavater, *Physiognomische Fragmente*, vol. 4, Leipzig and Winterthur, 1778, p. 415 [photo: courtesy of The Newberry Library, Chicago]

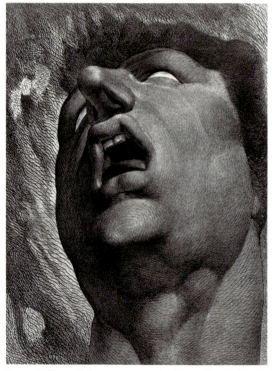

Fig. 3 William Blake, engraving after Henry Fuseli, *Head of a Damned Soul from Dante's "Inferno,"* British Museum, London [photo: © British Museum, London]

As Gert Schiff noted, this head is based on that of a figure rising from his grave at the lower left of Michelangelo's *Last Judgment*, with the orientation reversed probably as a result of the printing process.[8] The simple tonal conception of this engraved head is close to the heads at the Art Institute, and the technique of the oil sketch provided by Fuseli must have been strikingly similar. In his accompanying text, Lavater stated: "Mit sieben Pinselzügen ist das Original auf einer rauhen Leinwand siebenmal sprechender als in dieser Copie entworfen."[9] Fuseli's sketch of the "dying man" does not survive, but its connection to the Art Institute's heads, also executed broadly on raw canvas and similarly engraved in reverse as illustrations to Lavater, seems obvious. As we shall see, the Art Institute's heads were also, to greater and lesser degrees, inspired by Michelangelo. The three works might well have been produced during the same campaign of painting in Rome, perhaps with others along the same lines, although whether directly for Lavater or not is unclear.

The question of the date and function of the Art Institute heads is complicated by the fact that all of the surviving preparatory works for the second edition of Lavater are drawings rather than oil sketches.[10] Fuseli

spoke of providing drawings in letters of 1771, 1775, and 1778 to Lavater, and in the last of these proposed using black and white or three colors on oiled paper in order to work out the designs as clearly as possible, presumably for the engravers to follow.[11] At least some of the drawings he proposed sending to Lavater were to be careful copies made for the engravers using his more spontaneous studies as models. Fuseli hinted at such a process of replication in the letter of 1775 mentioned above:

> Zeichnungen, und wie ich sie dir versprochen, sollst du haben, in der gegebene Zeit war es unmöglich, weil ich in derselben genötigt war, ein Gemälde zu endigen. Um dich aber nicht zu lange warten zu lassen, will ich sie dir zu dreien und vieren senden. Du magst dir selber vorstellen, welch ein tröstlicher Zeitvertrieb es für mich sein muß, meine Ideen wieder zu kopieren. Kein Anderer kann es für mich tun.[12]

Certainly this letter provides evidence that the Art Institute's heads need not have been used directly for the engravings in Lavater, or made with the illustration of Lavater in mind. More likely, they were existing works chosen by Fuseli as suitable, then copied by him for Lavater's engravers in the form of drawings. Copies of them may have been among the drawings Fuseli promised to send Lavater from Rome. It is equally possible that he brought these drawn copies from Rome to Zurich in 1778–79. That the oil studies were translated into careful drawn copies before being engraved is suggested by variations between the paintings and the engravings, notably the inclusion of a shroudlike head covering in the engraved head corresponding to the recto of the Art Institute canvas.

Fuseli was dissatisfied with the engravings in the second edition of Lavater and attempted to correct them in the English version, where, in some instances, a facsimile of the plate from the second edition was included for purposes of comparison.[13] In the case of the heads from Dante, the features are more angular in the English edition, and more shroudlike drapery is added around the first head, placing them at a further remove from the originals. The steeply foreshortened head on the recto of the Art Institute canvas was also engraved by William Blake, dramatically silhouetted against a background of flames (fig. 3). In cropping the head on the right side and showing hair instead of a covering of drapery, Blake seems to have been working from the Art Institute head rather than from either of the engravings.[14]

In both the French and English editions of his book, Lavater associated the four engraved heads with Dante's

Inferno. There can be no doubt that the connection to Dante was the artist's idea and not Lavater's own. Fuseli was an enthusiastic reader of Dante from the time of his studies under Bodmer in Zurich, and the *Divine Comedy*, particularly the *Inferno*, was an important source of dramatic subjects for him during his years in Rome.[15] Although Wolfgang Hartmann has attempted to identify the four engraved heads with particular individuals whose fates are described in the *Inferno* and *Purgatorio*, it seems more likely that they were conceived as studies in expressions of suffering inspired by Dante.[16] Fuseli was a passionate admirer of Michelangelo as well as of Dante; indeed, in his lecture entitled "Invention" delivered at the Royal Academy, he compared his two heroes, going so far as to suggest that in the *Last Judgment* Michelangelo personified Dante's fiends and that the "astonishing groups" of the lunette of the *Brazen Serpent* were inspired by canto 24 of the *Inferno*.[17] It is hardly surprising, therefore, to find prototypes in Michelangelo for Fuseli's heads from Dante. Generally, the shroudlike coverings of the engraved figures resemble those of Michelangelo's resurrected souls. More particularly, the verso head of the Art Institute canvas, engraved as no. 3 in Lavater, with its closed eyes and emphatically curved cheekbones, forehead, and hairline, appears to be a copy from a minor head in the upper right portion of the *Last Judgment* (curiously, that of a member of the elect),[18] a borrowing almost as explicit as that of the "dying man." The recto head, engraved as no. 1 in Lavater, recalls the foreshortened heads of Jonah and Haman in the Sistine Chapel ceiling,[19] although the similarities are not exact, and both of the Michelangelo heads face to the right. Apparently Fuseli had immersed himself in the work of Michelangelo to such a degree that he could create an essay in his manner that was like a copy, though not strictly dependent on any particular prototype. In any case, the Art Institute's heads clearly have more to do with his responses to Dante and to Michelangelo than with the task of illustrating Lavater.

NOTES

1 The inscription appears to be in William Gurley's hand (see Provenance).

2 The painting was cleaned by Cynthia Kuniej to eliminate severe blanching that had occurred in the dark shadows of the face on the recto and over much of the verso, particularly in the dark passage at the lower left. The edge lining was added by Jill Whitten in order to mount the canvas for double-sided viewing in the frame.

3 The thread count of the canvas is approximately 16 x 16/sq. cm (40 x 40/sq. in.).

4 The canvas was part of a group of nineteen works by Fuseli acquired by Gurley as nos. 235 and 236 of this sale. They were described in the sale catalogue under a general heading of "Original Drawings by H. Fuseli" as "Illustrations to Milton's Poems." When they arrived at the Art Institute in 1944 as part of Gurley's bequest, they were not individually accessioned, but the heads can be identified from Gurley's own index cards preserved in the Department of Prints and Drawings.

5 The full text reads, in the English edition: "Four faces the idea of which has been taken from Dante's Hell. They express the most horrible sufferings; but even in this state they announce characters naturally energetic, though destitute of true greatness. Forehead 3, for example, could not possibly belong to a distinguished man. Those are not ordinary sinners; they are men rugged and relentless, who never knew what pity was; and therefore judgement without mercy has been pronounced against them." See Johann Caspar Lavater, *Essays on Physiognomy: Designed to Promote the Knowledge and the Love of Mankind*, tr. by Henry Hunter with an intro. by Fuseli, vol. 2, London, 1789–98, p. 290. For recent literature on Lavater's work, see Joan K. Stemmler, "The Physiognomical Portraits of Johann Caspar Lavater," *Art Bull.* 75 (1993), pp. 151–67.

6 Letter from David Weinglass to Gloria Groom of October 29, 1990, and note from David Weinglass dated May 6, 1992, both in curatorial files.

7 For the letters, see *Heinrich Füssli, Briefe*, ed. by Walter Muschg, Basel, 1942, pp. 161–79. On the relationship between the two men, see Marcia Allentuck, "Fuseli and Lavater: Physiognomical Theory and the Enlightenment," *Studies on Voltaire and the Eighteenth Century* 55 (1967), pp. 89–112; and Gert Schiff, *Johann Heinrich Füssli, 1741–1825*, vol. 1, Zurich and Munich, 1973, p. 112.

8 Schiff (note 7), vol. 1, pp. 83, 630, no. 1735, vol. 2, fig. 1735. For the Michelangelo figure, see Charles de Tolnay, *Michelangelo: Sculptor, Painter, Architect*, Princeton, 1975, fig. 175. Lavater's text makes no mention of Fuseli's source for the head. For unknown reasons, the plate was not included in subsequent editions of his book. Another possible example of this kind of work is a head in oils in the Kunstsammlungen zu Weimar (inv. nr. G 985); see Schiff, vol. 1, p. 437, no. 361, vol. 2, fig. 361. This head is traditionally, and obscurely, identified as Ugolino. For an engraving after it made in 1779 by J. H. Lips, one of Lavater's engravers, see Weinglass 1994, p. 35, no. 38 (ill.).

9 Johann Caspar Lavater, *Physiognomische Fragmente*, vol. 4, Leipzig and Winterthur, 1778, p. 415: "The original is sketched with seven brushstrokes on a raw canvas seven times more expressively than in this copy." Lavater's full commentary on this type, which he entitled *Sterbender Schmerz*, is given in Schiff (note 7), vol. 1, p. 630, no. 1735. The similarity in technique was first pointed out in Weinglass's note (see note 6).

10 For these preparatory drawings, including some probably made for the purpose of illustrating Lavater but not engraved, see Schiff (note 7), vol. 1, pp. 112, 460–62, 631, nos. 497–510, 1741, vol. 2, figs. 497–510, 1741. Most are in pencil, though red and black chalk are also used.

11 *Briefe* (note 7), pp. 166, 174–75, 178–79.

12 Ibid., pp. 174–75: "Drawings you shall have, and as I promised you; it was impossible in the stated time because at the same [time] it was necessary for me to finish a painting. But in order not to keep you waiting too long, I want to send you three or four. You can well imagine what a merry pastime it must be for me to copy my ideas out again. No one else can do it for me." Fuseli's letter is from March 1775, and Weinglass (1994, p. 35) noted that J. R. Schellenberg charged Lavater for engraving the "dying man" in April of the same year.

13 Schiff (note 7), vol. 1, pp. 497–99, nos. 765–88, vol. 2, figs. 765–88, vol. 1, pp. 528–32, nos. 947–72, vol. 2, figs. 947–72.

14 A panel painting of the same head (oil on panel, 38 x 30.5 cm; sold Sotheby's, London, October 4, 1978, no. 304), corresponding to the Blake engraving in all details and oriented in the same direction, is more likely a copy by an unknown hand after the engraving than an elaborated painting of the same subject by Fuseli himself, as David Weinglass suggested in his 1992 note (note 6) and in Weinglass 1994, p. 95, under no. 83. He suggested that the Art Institute panel was Blake's model, identifying the subject as Ruggiero degli Ubaldini, Archbishop of Pisa, referring to the description of a Fuseli in Sir Thomas Lawrence's drawings sale (Christie's, London, May 20–21, 1830, no. 162) as "The Head of the Archbishop of Pisa, in oil; from the Inferno of Dante." This last work, known only from the Lawrence sale, could well have been another example of the same type of head study as the Art Institute canvas. For further suggested identifications of the heads as specific characters from Dante, see note 16.

15 Wolfgang Hartmann, "Die Wiederentdeckung Dantes in der deutschen Kunst: J. H. Füssli, A. J. Carstens, J. A. Koch," Ph.D. diss., Rheinische Friedrich-Wilhelms-Universität Bonn, 1969, pp. 23–24.

16 Hartmann (note 15), pp. 56–58, speculated that head no. 1 in Lavater (see fig. 1) might be Camicion dei Pazzi, whom Dante described as having lost both ears to the cold (*Inferno*, canto 22, 11.52–53). He tentatively associated no. 2 with Bocca degli

Abati (*Inferno*, canto 22, 11.97–98, 103–05), and identified the third and fourth heads as those guilty of envy whose eyes were sewn shut with wire in the *Purgatorio* (canto 13, 11.58–62), though acknowledging that the *Inferno* was Fuseli's more usual inspiration. Weinglass (note cited in note 6) accepted Hartmann's identification of the third and fourth heads; for his suggestion regarding the identity of the first head, see note 14.

17 For the text of Lecture III, "Invention," see John Knowles, *The Life and Writings of Henry Fuseli, Esq., M.A., R.A.*, vol. 2, London, 1831, pp. 164–65. This connection was noted by Hartmann (note 15), p. 28; see also Schiff (note 7), vol. 1, pp. 99–100, who suggested that during his stay in Rome Fuseli may have planned a Dante cycle using the structure of the Sistine frescoes.

18 Tolnay (note 8), fig. 170 at the upper right.

19 Ibid., figs. 70 and 81. Interestingly enough, Fuseli considered the figure of Haman to be a notable instance in which Michelangelo's "sublime conception" came directly from Dante (Lecture III, in Knowles [note 17], p. 165). Hartmann (note 15; p. 56), compared the engraving of head no. 1 to Jonah, and Peter Tomory (*The Life and Art of Henry Fuseli*, New York and Washington, 1972, p. 164, fig. 166) compared it less convincingly to a figure in *The Brazen Serpent*, both without knowing the painted original.

Thomas Gainsborough

1727 Sudbury, Suffolk–London 1788

Mrs. Philip Dupont, c. 1778

Charles H. and Mary F. S. Worcester Collection; through prior gifts of Mr. and Mrs. Denison B. Hull, Mr. and Mrs. William Kimball, and Mrs. Charles McCulloch, 1987.139

Oil on canvas, 77.2 x 64.5 cm (30^3/$_8$ x 25^3/$_8$ in.)

CONDITION: The painting is in excellent condition. It has an old glue paste lining. The stretcher is not original; it extends approximately 0.5 to 1 cm beyond the top, right, and left edges of the original canvas, where the lined canvas incorporates the remnants of the tacking margins.[1] The off-white ground is visible where the artist has allowed it to show through the fichu in the lower half of the portrait. The paint surface is exceptionally well preserved, and the fine craquelure and stretcher creases on all of the edges are not visually disturbing. There is a small area of retouching on the lower left jowl. (x-radiograph)

PROVENANCE: Presumably painted for Philip Dupont (d. 1788), Sudbury. By descent to his grandson Richard Gainsborough Dupont (d. 1874), also of Sudbury, by 1856;[2] sold Wheeler and Westoby, Sudbury, May 29, 1874, no. 127, to J. H. Chance for 36 gns.[3] J. H. Chance to at least 1887.[4] Probably William Carr (d. 1925), Ditchingham Hall, Norfolk.[5] His son Brigadier William Greenwood Carr, D.S.O. (d. 1982), Ditchingham Hall, Norfolk,

by 1955.[6] By descent to his daughter, Annabel Mary, Countess Ferrers. Richard L. Feigen, New York, 1986; sold to the Art Institute, 1987.

REFERENCES: George Williams Fulcher, *Life of Thomas Gainsborough, R.A.*, London, 1856, p. 206. Walter Armstrong, *Gainsborough and His Place in English Art*, London, 1898, p. 194. M. H. Spielmann, "A Note on Thomas Gainsborough and Gainsborough Dupont," *Walpole Society* 5 (1915–17), p. 100. J. W. Goodison, *Fitzwilliam Museum, Cambridge: Catalogue of Paintings*, vol. 3, *British School*, Cambridge, 1977, p. 82, under no. 915. Hugh Belsey, *Gainsborough's Family*, Sudbury, 1988, pp. 19 (ill.), 20, 24 n. 14, 38, 62.

EXHIBITIONS: Ipswich Fine Art Club, *Works by Gainsborough, Constable, and Old Suffolk Artists*, 1887, no. 129, as "Mrs. Phillip Dupont, Wife of the Artist's Nephew [*sic*]." Sudbury, *Gainsborough's House* (opening exhibition), 1961, no. 13.

Gainsborough was the eighth and youngest child of a cloth merchant of Sudbury, Suffolk. At the age of thirteen, he was sent to London to receive an artistic training and became a pupil of the French draftsman and

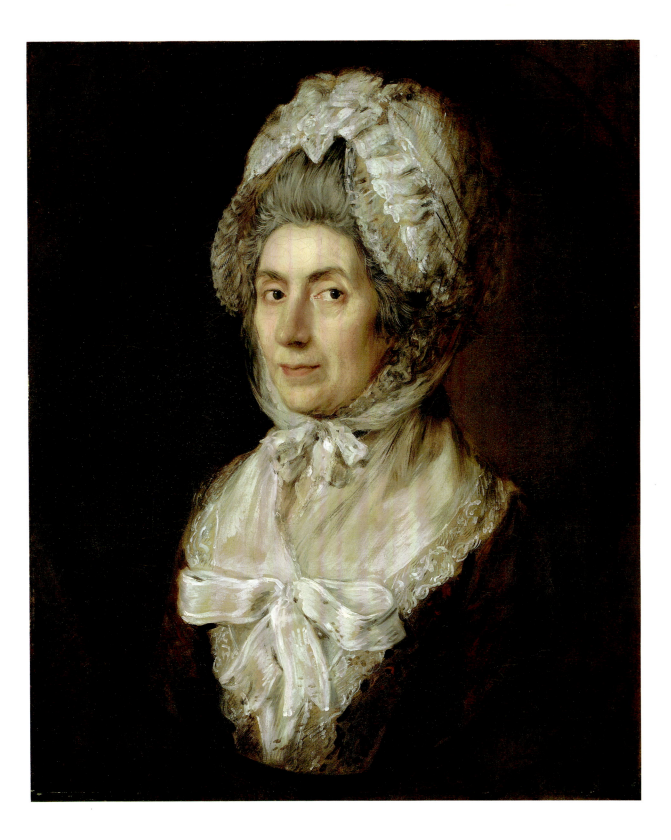

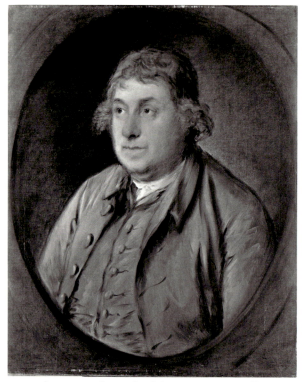

Fig. 1 Thomas Gainsborough, *Philip Dupont(?)*, Fitzwilliam Museum, Cambridge

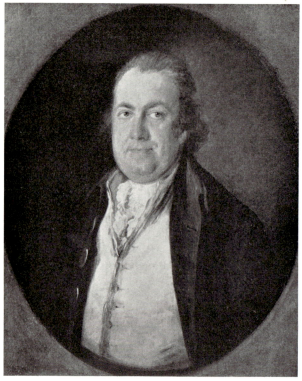

Fig. 2 Thomas Gainsborough, *Philip Dupont*, location unknown [photo: sale catalogue, Parke-Bernet, New York, May 4, 1950, no. 99]

engraver Hubert Gravelot. He established his own studio around 1745. His early paintings were landscapes in the Dutch tradition, along with small-scale portraits that reveal the influence of Francis Hayman. In 1748 he set up a portrait practice in his native Sudbury, moving to nearby Ipswich in 1752, then to the fashionable resort of Bath in 1759. At Bath he attracted a much wealthier, more sophisticated clientele, for whom he painted works of an increasing grandeur. He exhibited in London at the Society of Artists from 1761 and at the newly formed Royal Academy from 1769. In 1774 he settled in London, taking a tenancy of the west wing of Schomberg House, Pall Mall. In the 1780s he received commissions to paint George III, Queen Charlotte, and other members of the Royal Family. No other British artist of the day could match him for painterly brilliance, and his reputation was equaled only by that of Sir Joshua Reynolds (see 1922.4468), his great contemporary and first President of the Royal Academy. Though he made his living mainly as a portraitist, he also painted rustic scenes, both picturesque landscapes and nostalgic "fancy pictures" of country children.

Gainsborough's portraits of his family are among his most tender and intimate. This work shows the second-eldest of his four sisters, Sarah (1715–1795), whom he called Sally. She was the wife of Philip Dupont, a carpenter seven years her junior. They married at the church of St. Gregory's, Sudbury, on May 6, 1745, and lived in Sudbury for the rest of their lives. Their son Gainsborough Dupont, born in 1754, was apprenticed to Gainsborough in 1772 and employed in his Bath and London studios for sixteen years, the only pupil and assistant he is known to have had. Sarah Dupont acted as Gainsborough's agent in Sudbury by providing funds to their eldest brother, John, a penniless inventor nicknamed "Scheming Jack." In a letter of September 29, 1783, for instance, Gainsborough instructed her carefully to pay out the three guineas he had sent for John in weekly installments over a six-month period.[7]

The brushwork in the portrait and the dress and hairstyle of the sitter are all characteristic of the artist's early years in London. Hugh Belsey has suggested a date of about 1777–79, which is supported by the particular similarity of the work to the portrait of Gainsborough's wife now at the Courtauld Institute Galleries, dated by John Hayes to about 1778.[8] This would mean that the sitter was in her early sixties when she sat for the work, which seems consistent with her appearance.

Because Gainsborough Dupont copied his uncle's works, and his own paintings are in much the same style, the two men's work has often been confused. Indeed, when Ellis Waterhouse saw *Mrs. Philip Dupont* in 1955, he doubted the attribution to Gainsborough and inscribed the back of a photograph of the work with an attribution to Gainsborough Dupont, which explains its absence from his Gainsborough catalogue of 1958.[9] The photograph shows the portrait to have been under a layer of discolored old varnish at the time, the removal of which has revealed a subtlety of technique and characterization well beyond the known works of Gainsborough Dupont.

The work belongs to a sizeable group of family portraits painted by Gainsborough in the 1770s, all about the same size and contained within fictive oval niches.[10] Among the other examples are two that have been identified as showing the sitter's husband, Philip Dupont. Both appeared in the 1874 sale of Richard Gainsborough Dupont's collection, as did the Art Institute portrait.[11] One of these, now in the Fitzwilliam Museum, Cambridge (fig. 1), was paired with the Chicago painting in this sale and was also bought by J. H. Chance. The other can almost certainly be identified with a portrait that appeared on the art market in 1950 and is now untraced (fig. 2).[12] Since there is no strong facial resemblance between these two male portraits, it seems probable that one or the other has been misidentified. As Hugh Belsey has suggested, the one that seems to match best with the portrait of Mrs. Dupont as a possible pendant is not the Fitzwilliam portrait, which was paired with it in 1874, but the other work (fig. 2).[13] The latter seems on stylistic grounds to have been executed about the same time as the Chicago portrait, around 1778, whereas the Fitzwilliam portrait is probably from the early 1770s. The fact that both male and female sitters are facing to the left suggests that the two works may not have been conceived by the artist as a specific pair, but as part of the larger series of family portraits.

NOTES

1 The fold lines of the tacking margins are clearly visible in the x-radiograph, and the dimensions excluding the tacking margins are 76.2 x 62.5 cm. The average thread count of the original canvas is 18 x 16/sq. cm (48 x 40/sq. in.).

2 See Fulcher 1856.

3 A label from the 1874 auction is attached to the stretcher. The catalogue gives the sitter as "Mrs. Philip Dupont, wife of the above," the preceding number being "Mr. Philip Dupont, the artist's nephew [*sic*]." The price is marked in an annotated catalogue at Gainsborough's House, Sudbury. For the buyer, see Algernon Graves, *Art Sales*, vol. 1, London, 1918, p. 328, and Goodison 1977, p. 82.

4 See the 1887 exhibition catalogue. A label from this exhibition is attached to the stretcher.

5 Countess Ferrers has suggested that the picture was probably acquired by her grandfather, William Carr, when he enlarged Ditchingham Hall around 1911 (letter to Martha Wolff of August 22, 1993, in curatorial files).

6 See note on the back of a photograph in the Waterhouse Archive, Paul Mellon Centre, London.

7 *The Letters of Thomas Gainsborough*, ed. by Mary Woodall, London, 1963, p. 59, no. 22.

8 Belsey 1988, p. 19; John Hayes, *Gainsborough: Paintings and Drawings*, London, 1975, p. 219.

9 See note 6 above. For his catalogue, see Ellis K. Waterhouse, *Gainsborough*, London, 1958, pp. 50–125.

10 For some examples, see Belsey 1988, pp. 21, 31, 35, 39, 61, 63, 80 (ills.).

11 Nos. 126 and 131. The dimensions are given as 24½ x 30 in. and 24½ x 26 in.

12 A label from the 1874 sale on the stretcher of the Fitzwilliam portrait identifies it as lot 126. This information was kindly supplied by Janie Munro of the Fitzwilliam Museum in a letter of January 26, 1994, to the author, in curatorial files. She also noted that Graves's manuscript notebook of Gainsborough sales, formerly belonging to Ellis Waterhouse, has the following entry for no. 131 in the Sudbury sale: "Philip Dupont 3/4 sold at Dupont's sale at Sudbury May 29/74 for £34.13.0 to Henry Graves & Co. and then Oct. 14/75 to Louis Huth, Esq." Louis Huth's is the first name in the provenance for the untraced portrait of Philip Dupont (fig. 2) as given in the 1950 Parke-Bernet sale catalogue, suggesting that this and no. 131 in the 1874 Sudbury sale are indeed the same painting. The smaller size given in the 1874 sale catalogue, 24½ x 26 in., as opposed to the 30 x 25 in. given in the 1950 sale catalogue, may be an error or the result of the work's having been differently framed at that time.

13 Belsey 1988, p. 20. The Chicago and Fitzwilliam pictures are not in identical frames.

Gawen Hamilton

c. 1697 near Hamilton, Scotland–London 1737

Thomas Walker and Peter Monamy, c. 1735

A. A. Munger Collection, 1926.264

Oil on canvas, 61.6 x 53.3 cm (24¼ x 21 in.)

CONDITION: The painting is in fair condition. It has not been treated since it entered the Art Institute. The canvas has an old glue paste lining. The tacking margins have been cut off, but cusping is visible on all four sides. X-radiography reveals that the bottom, right, and left edges were once folded and used as tacking margins.[1] The thinly applied paint layer, covering a grayish white ground, has been flattened by the lining process. It has also been somewhat abraded by previous attempts at cleaning. This is especially evident in the wig of Thomas Walker, in dark areas such as the legs of both men, and in the painting on the easel. There are extensive remnants of a darkened varnish beneath the upper continuous varnish layers, further indicating an unsuccessful cleaning. Examination in ultraviolet light reveals overpaint along the lower left and bottom edges. (x-radiograph)

PROVENANCE: Sold Christie's, London, March 22, 1902, no. 43, as Hogarth with seapiece by Monamy, to Holmes for 33 gns.[2] Ernest Brown and Phillips, Leicester Galleries, London; sold to the Art Institute, 1926.[3]

REFERENCES: Austin Dobson, *William Hogarth*, London, 1902, p. 172. A. M. Frankfurter, "Art in the Century of Progress," *Fine Arts* 20 (May 1933), p. 25 (ill.). R. B. Beckett, *Hogarth*, London, 1949, p. 45. AIC 1961, p. 59. Gabriele Baldini and Gabriele Mandel, *L'opera completa di Hogarth pittore*, Classici dell'Arte, Milan, 1967, p. 103, under no. 110.

EXHIBITIONS: The Art Institute of Chicago, *A Century of Progress*, 1933, no. 195, as Hogarth. The Art Institute of Chicago, *A Century of Progress*, 1934, no. 141, as Hogarth. Detroit Institute of Arts, *English Conversation Pieces of the Eighteenth Century*, 1948, no. 17, as Hogarth. Hartford, Connecticut, Wadsworth Atheneum, *Pictures within Pictures*, 1949–50, no. 23, as Hogarth; traveled to Andover, Massachusetts. Greater London Council, Kenwood, The Iveagh Bequest, *The French Taste in English Painting during the First Half of the Eighteenth Century*, 1968, no. 33, as attributed to Hogarth and Peter Monamy.

Another, closely similar version of this double portrait (fig. 1; 24 x 19 in.) was bought by the thirteenth earl of Derby at the sale of Horace Walpole's collection at Strawberry Hill in 1842, where it was catalogued as a Hogarth; the sitters were identified as the patron Thomas Walker and the painter Peter Monamy, and

the seascape on the easel was said to have been painted by Monamy himself.[4] A clipping with the description of the Derby picture from the Strawberry Hill catalogue is attached to the stretcher of the Art Institute's picture, which misled later cataloguers into thinking the latter came from that collection.[5] In fact, the provenance of the Art Institute's version of the portrait before its appearance in an anonymous sale at Christie's in 1902 is unknown. The existence of more than one version is not unusual with small-scale group portraits, a version being painted for each of the sitters. It seems reasonable to suppose that they are more or less contemporary works by the same artist, and there is nothing to suggest which may have been executed first.

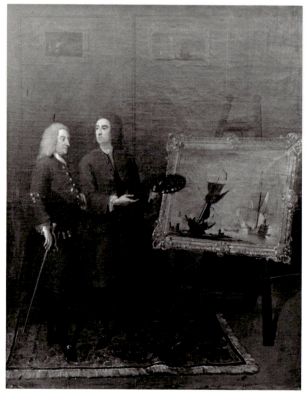

Fig. 1 Here attributed to Gawen Hamilton, *Thomas Walker and Peter Monamy*, private collection [photo: courtesy of the owner]

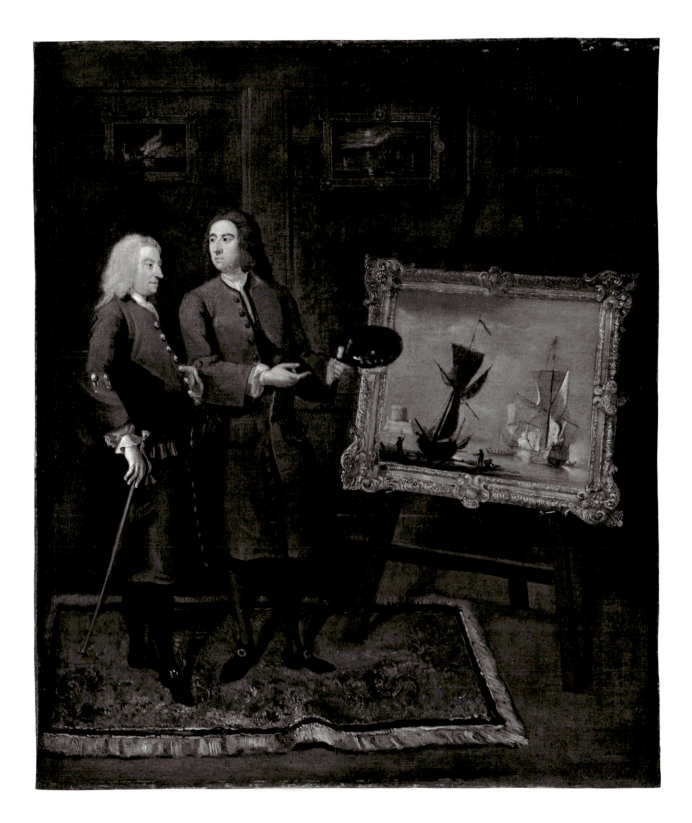

The identification of the sitters in the Strawberry Hill catalogue is completely plausible. Thomas Walker was a Commissioner of Customs and collector of Italian and Dutch pictures. He had a taste for marine painting, and George Vertue noted, after visiting his house in 1740, that he owned fourteen seascapes by Van de Velde.[6] Whether this was Willem Van de Velde the Elder (1611–1693) or Younger (1633–1707) is unclear. Both had moved to Britain from the Netherlands in 1672, and they may both have been represented in Walker's collection. In any case, Walker's liking for that particular genre of painting surely had everything to do with his being portrayed here as patron, or potential patron, of the leading British seascape painter of the day.

A native of Jersey in the Channel Islands, Peter Monamy (1681–1749) derived his style from that of Van de Velde the Younger. All three of the pictures shown in the portrait, on the easel and on the wall in the background, are highly characteristic of Monamy's work, though not identifiable with any single picture.[7] The selection displays the range of effects of which he was capable, from the large seascape on the easel with a battleship firing off its cannons, to the smaller night scenes on the wall illuminated by fire or moonlight. Indeed, the portrait seems to have been designed, at least in part, as an advertisement for Monamy's skills. Nineteenth-century descriptions of Lord Derby's version (fig. 1) record Monamy's signature on the largest of the pictures within the picture, although this is no longer visible.[8] Whether the Strawberry Hill catalogue was correct in attributing the seascape in Lord Derby's portrait to Monamy, and whether the same portion of the Art Institute's picture might be his work too, are impossible to determine. In the case of the Art Institute's painting, there is certainly no technical evidence of a second hand.

The traditional attribution of the Art Institute's portrait to Hogarth, based upon the attribution to him of Lord Derby's portrait in the Strawberry Hill sale, no longer seems tenable.[9] There are certainly points of similarity with Hogarth's conversation pieces of the 1730s, but none seems to transcend the inevitable resemblance between the works of artists operating within such a circumscribed genre at the same time. Besides, Hogarth would surely have invented less predictable poses for his sitters than those in the work in question. The possibility of a reattribution to Hogarth's more pedestrian contemporary Gawen Hamilton was first broached by Brian Allen, author of a forthcoming catalogue raisonné of Hogarth's works.[10] The figures of

Walker and Monamy certainly show the stiffness of pose that characterizes Hamilton's known portraits, and Monamy's rather obvious gesture toward his own painting echoes that of the sculptor John Michael Rysbrack toward a bust in what is probably Hamilton's most important work, *A Club of Artists* of 1734–35 (London, National Portrait Gallery).[11] Finally, the Art Institute's portrait includes what seems to have been a quirk of Hamilton's, the rucking of a carpet near the foreground. This can also be seen in his *Thomas Wentworth, Earl of Strafford, and His Family*, signed and dated 1732 (Ottawa, National Gallery of Canada), and *Edward Harley, Third Earl of Oxford and His Family* of 1736 (Edward Harley, Esq.).[12]

Gawen Hamilton was a Scot who, according to Vertue, received his training under a minor bird painter named Wilson. By 1725 he had settled in London, apparently seeking patronage at Greenwich.[13] In the 1730s he established himself as a leading exponent of the conversation piece; he was Hogarth's chief rival in that field, and the two artists are frequently confused. Vertue, who also appears in *A Club of Artists*, remarked that "his [Hamilton's] paintings of Conversations [with] small figures are agreable [sic] and [show] much variety and correctness of mode and manner of the time and habits. He may well be esteemed a rival to Hogarth, having as much justness, if not so much fire."[14] Hamilton died young and was buried in the churchyard of Saint Paul's, Covent Garden. He had been living in the Covent Garden area for some years.

NOTES

1 The average thread count of the original canvas is 18 x 12/sq. cm (45 x 20/sq. in.). There are two paper labels attached to the back of the stretcher. The one at the upper right is inscribed *W. Hogarth* in ink, and a printed text on the other, at the top center, reads as follows: *Monamy, the painter, sh[o]wing . . . to his patron Thomas / Walker, Esq; the Figures are by Hogarth, the Sea Piece in the / picture is by Monamy. A present from Richard Bull, Esq.* It is identical to the text of the entry for the related work in the Strawberry Hill sale (see note 4) of 1842, and must have been cut from a catalogue of the sale (see discussion). A pencil inscription on the upper left corner of the stretcher reads: *N° 27 E/S.*

2 Annotated sale catalogue, Ryerson Library, The Art Institute of Chicago.

3 Transcription of receipt, Archives, The Art Institute of Chicago. The acquisition may have been prompted by the gift of the so-called Hogarth House in 1925; see entries for *Fashionable Figures, with Two Women Holding Fans* (1925.1682a) and *Fashionable Figures, with a Man in Turkish Costume* (1925.1682b).

4 That Lord Derby's picture was bought at the Strawberry Hill sale (George Robins at Strawberry Hill [Twickenham, near

London], April 25 and following, 1842, on day 22, no. 96) is confirmed by George Scharf, *A Descriptive and Historical Catalogue of the Collection of Pictures at Knowsley Hall*, London, 1875, pp. 183–84, no. 354; see also the anonymous article, "The Private Collections of England. No. LXVII–Knowsley Hall, Prescot," *Athenaeum* 2860 (August 19, 1882), col. 260. The attribution to Hogarth is maintained by the current owner.

5 See the 1933 exhibition catalogue, no. 195, and the 1934 exhibition catalogue, no. 141. The catalogue of the sale on March 22, 1902, makes no such claims and the error may have originated with Dobson (1902, p. 172). For the description attached to the stretcher of the Chicago painting, see note 1.

6 See *Vertue Note Books* in *Walpole Society* 24 (1935–36), p. 178. On Walker, see also *Hogarth*, exh. cat., London, Tate Gallery, 1971, no. 36.

7 For instance, the large picture on the easel shares common elements with the signed *British Man O'War Firing a Salute* sold at Christie's, London, July 7, 1967, no. 33 (ill.), and the *Ships Becalmed off Portsmouth*, also signed, that was with John Mitchell in 1953; see *Apollo* 57 (March 1953), ill. opp. p. 110. For the seascape with a blazing ship on the left, compare the signed pictures sold at Christie's, London, November 19, 1982, no. 62 (ill.), and April 22, 1983, no. 24 (ill.).

8 See Scharf (note 4) and the anonymous *Athenaeum* article

(note 4). That no signature is now visible was kindly communicated by the present owner in a letter of January 7, 1994, to Martha Wolff, in curatorial files.

9 The Art Institute's attribution of the picture to Hogarth was changed to "British School" in AIC 1961.

10 Letter to the author of May 9, 1988, in curatorial files. This attribution is also supported by Elizabeth Einberg (letter to the author of January 10, 1989, in curatorial files).

11 See John Kerslake, *National Portrait Gallery: Early Georgian Portraits*, London, 1977, pp. 340–42, pl. 951.

12 For the painting in Ottawa, see Myron Laskin, Jr., and Michael Pantazzi, *Catalogue of the National Gallery of Canada, Ottawa: European and American Painting, Sculpture, and Decorative Arts*, vol. 1, Ottawa, 1987, pp. 132–33, fig. 197; for the Harley painting, see *Manners and Morals: Hogarth and British Painting, 1700–1760*, exh. cat., London, Tate Gallery, 1987, no. 64 (ill.).

13 See Hilda F. Finberg, "Gawen Hamilton, an Unknown Scottish Portrait Painter," *Walpole Society* 6 (1917–18), pp. 51–58, which gives excerpts from Vertue's account of Hamilton's life. Evidence that Hamilton was in London as early as 1725 is provided in John Ginger's article "New Light on Gawen Hamilton: Artists, Musicians, and the Debtors' Prison," *Apollo*, n. s., 136 (1992), pp. 156–60.

14 Finberg (note 13), p. 53.

John Theodore Heins, Sr.

1697–Norwich 1756

Family Group on a Terrace, c. 1740

Gift of Emily Crane Chadbourne, 1951.204

Oil on canvas, 94.6 x 120.6 cm (37½ x 47½ in.)

CONDITION: The painting is in fair to good condition. The lightweight, finely woven canvas has an old glue paste lining that was added before the picture entered the Art Institute. The tacking margins have been cut off. Cusping is visible on all sides, suggesting that the canvas is close to its original dimensions.[1] The cream-colored ground is readily visible through the thinly painted surface. There are large passages of cracked, cupped, and insecure paint in the upper right section of the sky and portico, and in the lower left, at the horizon line. X-radiography reveals several losses in these areas measuring as large as 3 cm in length, some of which have not been filled. The coats of the man on the left and the boy on the right as well as the dark footwear worn by several of the figures are slightly abraded. The paint layer is otherwise fairly well preserved with localized passages of discolored retouching in the dogs, the white skirts, the portico, the foliage, and the background sky. The surface is additionally disfigured by a relatively thick layer of discolored varnish and an obscuring layer of grime. (x-radiograph)

PROVENANCE: Emily Crane Chadbourne, Washington, D.C.; on loan to the Art Institute, 1932–51; given to the Art Institute, 1951.

REFERENCES: Ralph Edwards, "Conversation Pieces in Search of a Painter," *Apollo* 66 (October 1957), pp. 90 (ill.), 91. AIC 1961, p. 59. Aileen Ribeiro, *The Dress Worn at Masquerades in England, 1730 to 1790, and Its Relation to Fancy Dress in Portraiture*, New York and London, 1984, ch. 2, fig. 14.

This work entered the collection attributed to Joseph Francis Nollekens, a Flemish portraitist working in England in the 1730s and 1740s. The idea was a reasonable one, supported by distinctive points of similarity with securely attributed works by Nollekens, such as his *Conversation Piece of Five Figures in a Garden* of 1740 (New Haven, Yale Center for British Art).[2] The Art Institute's picture lacks Nollekens's dainty, almost miniaturist touch, however, especially in the treatment of the faces. The attribution to him was questioned by Ralph Edwards (1957), who noted the painting's foreign air and suggested that it was the work of some other immigrant artist. The Art Institute's designation of the picture was

changed to "British School" in the 1960s.

The attribution to Heins was first suggested by Elizabeth Einberg in 1989.[3] Heins was of German origin, but spent most of his life in Norwich. He settled there around 1720, and became the city's leading resident portrait painter. He also worked as a mezzotint engraver. His son of the same name was a miniaturist and topographical etcher.[4] The attribution of the Art Institute's painting to him is based on comparison with two works that are signed and dated: *Musical Party at Melton Constable* of 1734 (private collection) and *An Allegory of Trade* of 1743 (fig. 1).[5] These show precisely the same beady-eyed stylization of facial features and naive fondness for obvious perspectival lines that characterize the Art Institute's picture. Most strikingly, the treatment of the cracked pavement in the Yale picture seems identical to that of the terrace floor in the Chicago painting. The painting of the foliage in the two works is similar, as is the stagelike conception of figures grouped against an architectural setting with statuary. The date of c. 1740 given here for the Chicago picture is based on the Yale picture's inscribed date of 1743, and on the figures' dress.

Given its technical limitations, the Chicago work shows an unexpected wit and sophistication in its iconography. It seems to have been composed in part as a variation on the theme of Rubens's *The Garden of Love*, the prime version of which is in the Prado.[6] The grand portico to the right is an almost exact quotation, the lovers approaching from the left allude to the couple in a similar position in the Rubens, and the boys blowing bubbles are perhaps intended as comic earthbound equivalents to Rubens's fluttering cupids. The work was surely painted to celebrate a son's introducing his intended bride to his family, and was presumably commissioned by his father, represented as the turbaned figure holding out his hand in welcome. The relevance of the Garden of Love idea is obvious. The artist may have also intended a gentle reference to the seventeenth-century Dutch tradition of Vanitas imagery, reminding us of the transience of all earthly things: extinguished candles and boys blowing bubbles are typical Vanitas images, although their meaning is perhaps less easy to relate to the scene in question. In these respects, the work well illustrates the flow of ideas and traditions from the Low Countries into early British conversation pieces.

NOTES
1 The average thread count of the original canvas is 16 x 16/sq. cm (40 x 40/sq. in.).
2 See *Manners and Morals: Hogarth and British Painting, 1700–1760*, exh. cat., London, Tate Gallery, 1987, no. 104 (ill.).
3 Letter to the author of January 10, 1989, in curatorial files.
4 For Heins's career, see Trevor Fawcett, "Eighteenth-century Art in Norwich," *Walpole Society* 46 (1976–78), esp. pp. 73–75.
5 For the *Musical Party*, see *Manners and Morals* (note 2), no. 70 (ill.).
6 Heins probably knew the engraving by Peter Clouwet rather than this or a painted variant; see Annegrit Glang-Süberkrüb, *Der Liebesgarten: Eine Untersuchung über die Bedentung der Konfiguration für das Bildthema im Spätwerk des Peter Paul Rubens*, Kieler Kunsthistorische Studien 6, Frankfurt, 1975, pp. 94–98, fig. 15. For the Rubens, see Peter Sutton, *The Age of Rubens*, exh. cat., Boston, Museum of Fine Arts, 1993, no. 31 (ill.).

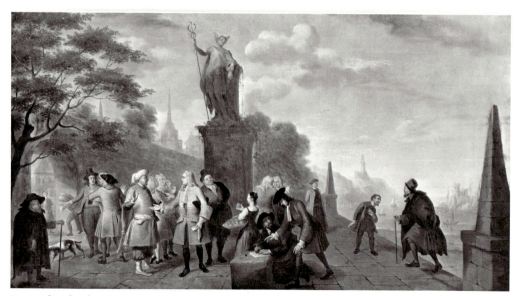

Fig. 1 John Theodore Heins, Sr., *An Allegory of Trade*, Yale Center for British Art, New Haven, Paul Mellon Collection

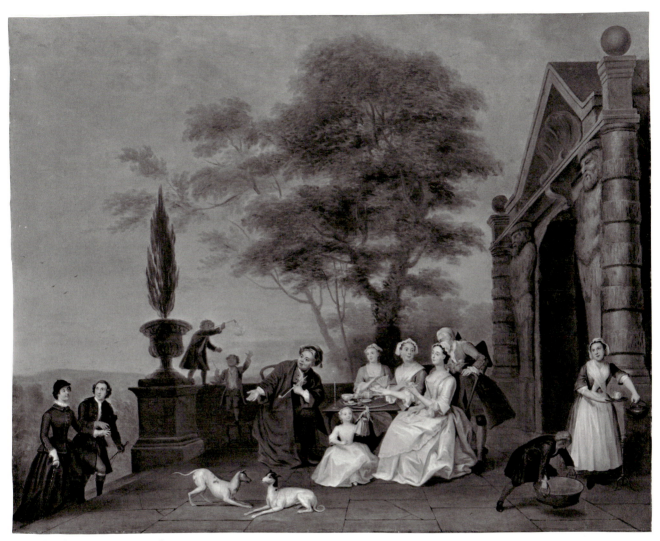

John Theodore Heins, Sr., *Family Group on a Terrace*, 1951.204

Joseph Highmore

1692 London–Canterbury 1780

Mrs. Freeman Flower, 1747

Bequest of John and Dorothy Estabrook, 1987.262.3

Oil on canvas, 91.5 x 71.1 cm (36 x 28 in.)

INSCRIBED: *Jos. Highmore / pinx: 1747* (lower left)

CONDITION: The painting is in fair condition. It has an old glue paste lining, and the original tacking margins have been cut off.[1] Cusping is visible only at the bottom edge. Three complex tears are apparent in the x-radiograph: the longest, measuring 14 cm, is centered above the head; another, measuring 11 cm, is located in the right background; and the shortest, measuring only 5 cm, is in the lower right corner. The light gray ground is visible through the thin paint layer in the face, which is slightly abraded. The transitions describing the forms have been lost in the right cheek and chin. The paint surface has become somewhat flattened due to the lining process. The sitter's dress is generally well preserved. The tears have been inpainted, and there is scattered retouching on the nose, chin, chest, ribbon, right hand, and in the background. The frame is original to the painting, but has been overpainted. (x-radiograph)

PROVENANCE: See below.

REFERENCES: See below.

EXHIBITIONS: See below.

Freeman Flower, 1747

Bequest of John and Dorothy Estabrook, 1987.262.4

Oil on canvas, 91.4 x 71 cm (36 x 27^{15}/$_{16}$ in.)

INSCRIBED: *Jos. Highmore / pinx: 1747.* (lower left)

CONDITION: The painting is in good condition. It has an old glue paste lining, and the original tacking margins have been cut off.[2] Cusping is visible on all sides except the bottom, suggesting that the canvas is close to its original dimensions. A 3 cm vertical tear on the nose is apparent in the x-radiograph. The light gray ground is visible through the thin paint layer in the face and hair, which are slightly abraded. The transitions describing the forms in the face have been lost, especially around the nose. The paint surface has become somewhat flattened due to the lining process. The sitter's dress, landscape, and sky are well preserved. There is scattered retouching on the brow, nose, hair, left jowl, and background. The frame is original to the painting, but has been overpainted. (x-radiograph)

PROVENANCE: Freeman Flower (d. 1794), from 1747.[3] By descent to his daughter, Lydia, Mrs. Samuel Shore. Bequeathed by her to her second cousin Dr. Whittaker, "Whittaker of Belmount."[4] Sold Pearson's, Winchester, December 13, 1977, no. 570, the pair, to Agnew, London;[5] sold March 21, 1979, to John N. Estabrook, Chicago.[6] Bequeathed by John and Dorothy Estabrook to the Art Institute, 1987.

REFERENCES: Elizabeth Einberg and Judy Egerton, *The Age of Hogarth: British Painters Born 1675–1709*, Tate Gallery Collections, vol. 2, London, 1988, p. 64, under no. 25 (1987.262.4). Warren Mild, *Joseph Highmore of Holborn Row*, Ardmore, Pa., 1990, between pp. 262 and 263 (both ill.).

EXHIBITIONS: London, Agnew, *Three Centuries of British Paintings*, 1978, nos. 48 and 50.

Highmore was a portrait painter who ventured occasionally into the depiction of literary and biblical subjects. The son of a prosperous coal merchant, he initially studied law, taking up the profession of painting only when his law studies were concluded in 1714. He studied at Kneller's Academy and later at the St. Martin's Lane Academy. He set up as a painter in 1715 and married in 1716. In 1732 he traveled to the Low Countries to see the paintings of Rubens and Van Dyck, and in 1734 visited Paris. The vein of elegance and wit in his work bears witness to a taste for the French Rococo. In 1744 he painted a remarkable series of twelve scenes, afterward engraved and published, from Samuel Richardson's novel *Pamela*. He reached the summit of his achievement as a history painter with his *Hagar and Ishmael* of 1746, painted for presentation to the Foundling Hospital. In 1761 he retired from painting, moved from London to Canterbury, and devoted the rest of his life to theoretical writings on art, philosophy, and religion.

The present portraits of Mr. and Mrs. Freeman Flower are typical of Highmore's work of the 1740s, and have been accepted as such by Alison Shepherd Lewis.[7] They are matched and balanced in the usual manner for pendant portraits of man and wife. Though looking out at the spectator, the couple turn toward one another; their backgrounds suggest a continuous parkland, and their deportment bespeaks ease and self-confidence on his part, a sprightly grace on hers. His stance is virtually

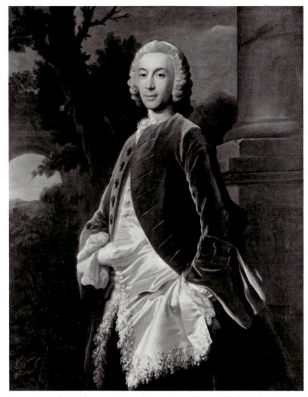

Fig. 1 Joseph Highmore, *Gentleman in a Brown Velvet Coat*, Tate Gallery, London

a commonplace of British portraiture of the mid-eighteenth century, its fashionability borne out by the fact that Highmore used it exactly, along with exactly the same coat and waistcoat, for another male portrait of the same year, the Tate Gallery's *Gentleman in a Brown Velvet Coat* (fig. 1).[8] The sitter in the Tate portrait is painted to the same scale as Freeman Flower but on a larger canvas, with the result that a more extensive background is included and the man's waistcoat is seen down to its lower edge.

David Mannings has related this pose to the principles of etiquette described in François Nivelon's *The Rudiments of Genteel Behavior*, published in 1737.[9] It is illustrated in the first of Nivelon's plates, which are engravings by Louis-Philippe Boitard after Bartholomew Dandridge, and extolled by him at some length:

The Head erect and turnd [sic], as in this Figure, will be right, as will the manly Boldness in the Face, temper'd with becoming Modesty; the Lips must be just join'd to keep the Features regular; the Shoulders must fall easy, and be no farther drawn back than to form the Chest full and round, which will preserve the true Proportion of the Body, but if they are too far drawn back, the Chest will

appear to [sic] prominent, the Arms stiff and lame, and the Back hollow which will intirely [sic] spoil the true Proportion, and therefore must be carefully avoided; the Arms must fall easy, not close to the Sides, and the Bend of the Elbow, at its due Distance, will permit the right Hand to place itself in the Waistcoat easy and genteel.[10]

Freeman Flower (1714–1794) and Martha Dawson (1718–1767) were married on September 27, 1742.[11] They had a daughter, Lydia, later Mrs. Samuel Shore, who appears to have been their only child. Their place of residence at the time the portraits were painted is unknown. By 1787, when he drew up his will, Freeman Flower was living in Clapham, Surrey, and owned property in Surrey, Yorkshire, Lincolnshire, Nottinghamshire, and elsewhere.[12]

NOTES

1 The average thread count of the original canvas is 12 x 14/sq. cm (30 x 35/sq. in.).
2 The average thread count of the original canvas is 12 x 14/sq. cm (30 x 35/sq. in.).
3 Highmore's usual fee for "kit-kat" portraits such as those of Mr. and Mrs. Flower was 15 guineas apiece (see Alison Shepherd Lewis, "Joseph Highmore, 1692–1780," Ph.D. diss., Harvard University, 1975 [Ann Arbor, Mich., University Microfilms, 1984], p. 8).
4 A label perhaps from the back of the original canvas of the portrait of Mrs. Flower, now stuck across the frame and stretcher, is inscribed as follows: *Portrait of Martha Dawson / Mrs. Freeman Flower / born 2 Augt. 1718 / died 5 Novr. 1767 / Mar. D. F. Flower Esq. / 27. Sept. 1742 / Mother of Mrs. Shore— / who left these pictures / to Dr. Whittaker—also / Sister to Jane Dawson, 1st wife / of John Buck Esq. of Townhill / Father of Mrs. Whittaker * / * mother of Dr. Whittaker.* Another, stuck on the stretcher, is inscribed as follows: *Martha Dawson, sister to my / maternal great grandmother. / born 1718. Died 1767 / Married Mr. Flower (see Pedigree) / (written by—Whittaker of Belmount).*
5 Letter of March 19, 1993, from Gabriel Naughton (Agnew's) to the author (copy in curatorial files).
6 See note 5.
7 Letter to the author of May 30, 1988, in curatorial files. The portraits are not included in Lewis's dissertation (see note 3) because they were unknown to her at the time.
8 See Einberg and Egerton 1988, pp. 62–64, no. 25.
9 David Mannings, "A Well-Mannered Portrait by Highmore," *Connoisseur* 189 (June 1975), p. 117. See also Robin Simon, *The Portrait in Britain and America with a Biographical Dictionary of Portrait Painters, 1680–1914*, Oxford, 1987, pp. 69–76.
10 Cited in Mannings (note 9), p. 117.
11 From a label (see note 4) and Agnew's 1978 exhibition catalogue.
12 Public Record Office, London (PROB 11/1303). The will is dated December 7, 1787, with a codicil dated June 25, 1793. It was proved on March 4, 1798. The will also states that his sole executrix and chief beneficiary was his daughter. Several charities were to receive donations under its provisions, notably the Presbyterian Fund for the Relief of Dissenting Ministers.

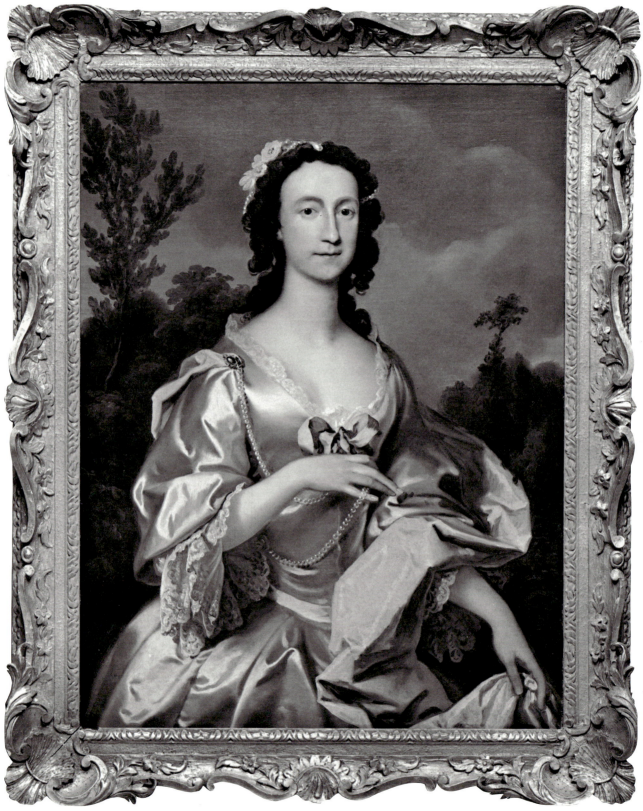

Joseph Highmore, *Mrs. Freeman Flower*, 1987.262.3

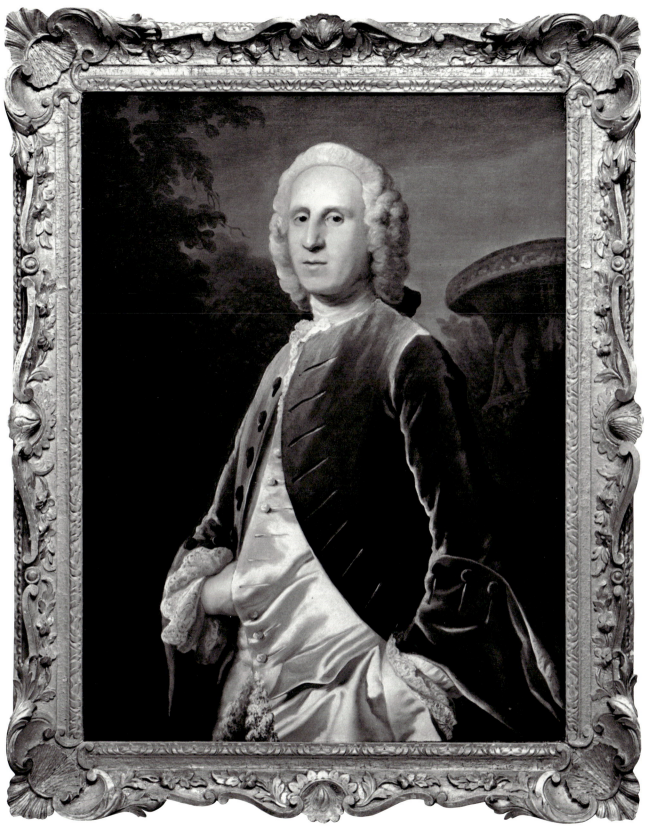

Joseph Highmore, *Freeman Flower*, 1987.262.4

Thomas Hudson

1701 Devonshire–Twickenham 1779

John Van der Wall, c. 1745

Gift of Mr. and Mrs. Richard Reed Armstrong, 1980.611

Oil on canvas, 127.3 x 101.9 cm (50⅛ x 40⅛ in.)

CONDITION: The painting is in good condition. It has an old glue paste lining, and the tacking margins have been cut off.[1] There is cusping visible on all edges, indicating that the painting retains its original dimensions. The white ground is visible along the lower edge. The paint surface is generally well preserved. The contours of the hair at the back of the head and the fingers on the right hand have been strengthened. There are scattered patches of retouching throughout the background around the figure. Some abrasion is visible in the upper left background, and there are minor losses and abrasion along the lower edge. (x-radiograph)

PROVENANCE: Admiral Sir Walter Cowan, Bt., K.C.B., D.S.O., M.V.O. (d. 1956), by 1931.[2] By descent to his daughter Miss M. Cowan; offered for sale, Sotheby's, London, November 22, 1967, no. 45, bought in at £400;[3] sold by her to Agnew, London, May 14, 1969.[4] Sold on the same day by Agnew to Mr. and Mrs. Richard Reed Armstrong, Chicago;[5] given to the Art Institute, 1980.

REFERENCES: Aileen Ribeiro, *The Dress Worn at Masquerades in England, 1730 to 1790, and Its Relation to Fancy Dress in Portraiture*, New York and London, 1984, p. 190, ch. 3, pl. 12.

EXHIBITIONS: The Art Institute of Chicago, *The Art of the Edge: European Frames, 1300–1900*, 1986, no. 68.

Hudson moved to London in the mid-1720s to study under Jonathan Richardson the Elder (see 1933.798), whose daughter he married. His early work followed Richardson's style, and when his old master retired in 1740, Hudson took over his practice.[6] Hudson's heyday was in the 1740s and 1750s, during which he was one of the most successful portraitists in Britain. For the most part, his works are graceful but impersonal, highly competent but lacking in variety and invention. His popularity lay in his appeal to the most conservative taste. Like many busy portraitists of this period, he employed a "drapery man" to paint the dress of his sitters, especially the leading specialist in that field, Joseph Vanhaeken. He also had many apprentices, including the young Joshua Reynolds (see 1922.4468) in 1740–43, and Joseph Wright of Derby in 1751–53 and 1756–57. He visited Paris and the Low Countries in 1748, after

which his work showed occasional affinities to Dutch portraiture of the seventeenth century, and traveled to Rome in 1752. His practice declined in the 1760s with the rise of his former pupil Reynolds, and he retired in 1767, living most of the rest of his life at his villa on the Thames at Twickenham.

There are elements of this portrait that are not completely typical of Hudson. As Ellen Miles has pointed out, the figure is smaller than usual in relation to the overall size of the canvas, and the treatment of the face is more delicate, with shorter brush strokes and softer shadows. She has nevertheless concluded that the similarities to known Hudsons are sufficient to support the traditional attribution of the work to him.[7] Given the number of British portraitists working in a similar manner at this time, most of them obscure and elusive, there inevitably remains some room for doubt; on balance, however, the Hudson attribution seems reasonable.

The sitter is shown wearing a costume inspired by Van Dyck's portraits of Charles I and his courtiers, which was a type of guise frequently adopted by eighteenth-century gentlemen in Britain for both portraits and masquerade balls. As an avid collector of Van Dyck drawings and prints after his works, Hudson made a particular specialty of portraying sitters in Van Dyck dress. Here the sitter holds a mask like those worn to fashionable masquerades. This same prop occurs in Vandyckian portraits securely attributed to Hudson, such as that of James, Lord Strange.[8] Moreover, both the latter and the Art Institute's portrait by Hudson of John Newton (see 1985.263), in which the sitter is also in Van Dyck dress, feature a red sword-belt closely similar to the one worn by Van der Wall. This adds some support to the attribution of the Van der Wall portrait to Hudson, though it cannot be taken as definitive evidence in view of Hudson's practice of using a "drapery man" who also worked for other painters.

There is some confusion over the identity of the sitter

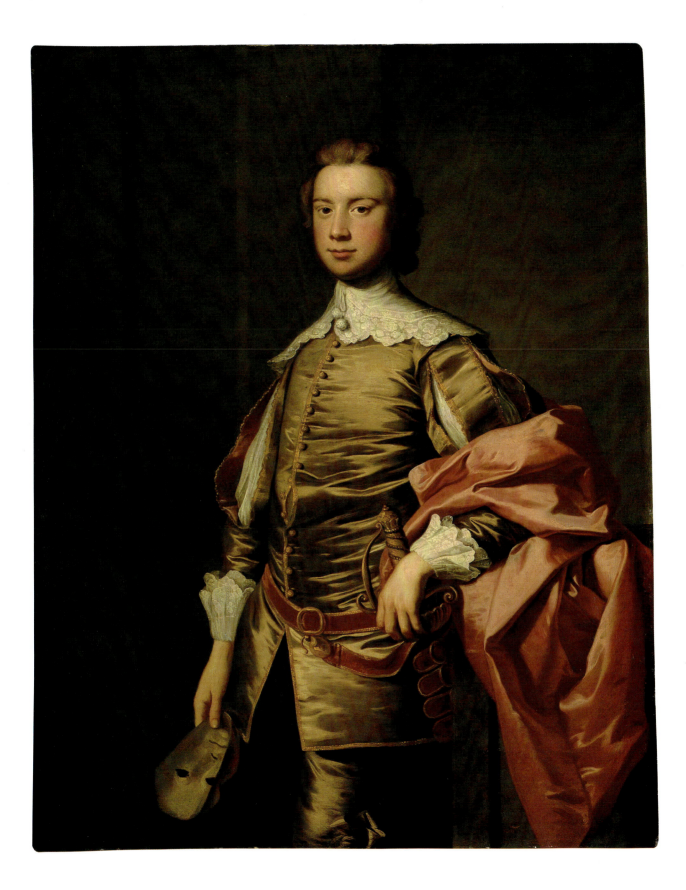

in the portrait. In the 1967 sale catalogue he is called Samuel Vandewall and described as an eminent merchant who in 1744 married the widow of Harris Neate, a West India merchant of London.[9] The fresh-faced youth shown here appears rather too young to be an eminent merchant married to a widow with two children. More recently he has been identified not as Samuel but as John Van der Wall, presumably the son of Samuel from a previous marriage, and this seems the more plausible identification even though its origins are unclear.[10] In 1748 Hudson's former pupil Reynolds painted a portrait of Samuel Van der Wall's stepchildren from his wife's previous marriage. This and a contemporaneous portrait of a child he and his wife had together are among the younger artist's earliest commissioned portraits.[11]

NOTES

1 The average thread count of the original canvas is 16 x 10/sq. cm (40 x 26/sq. in.).
2 A label on the stretcher is inscribed as follows: *The Property of / Admiral Sir Walter Cowan / Received Dec 1931.* According to information from Miss M. Cowan, recorded in a letter of May 14, 1969, from William Plomer (Agnew's) to Richard Reed Armstrong (copy in curatorial files), the picture was in the Cowan family by c. 1800, probably by descent through a collateral relation of the Van der Wall family.
3 The published sale results list the work as having been bought by "Stevenson," but since it was Miss Cowan's to sell to Agnew's in 1969, there was almost certainly no real buyer.
4 Letter from Gabriel Naughton to the author of March 19, 1993, in curatorial files.
5 See note 4.
6 For Hudson's career, see Ellen Miles and Jacob Simon, *Thomas Hudson, 1701–1779, Portrait Painter and Collector: A Bicentenary Exhibition*, exh. cat., Greater London Council, Kenwood, The Iveagh Bequest, 1979.
7 Miles initially found the attribution unconvincing on the basis of a photograph (letter to the author of May 16, 1988, in curatorial files), but then revised her view after examining the work at the Art Institute in October 1990.
8 Sold Christie's, London, November 20, 1987, no. 87 (ill.). For a discussion of Van Dyck costumes worn by men for masquerades and in portraits, see Ribeiro 1984, pp. 187–204.
9 The surname, which is evidently of Dutch origin, is spelled differently in different sources. For convenience it is generally given here as Van der Wall.
10 William Plomer referred to the sitter as John, son of Samuel Van der Wall, in his letter of May 14, 1969 (see note 2), perhaps following information provided by the previous owner of the portrait, Miss Cowan.
11 See Ellis K. Waterhouse, *Reynolds*, London, 1941, pp. 37, 119, pl. 10; and Christie's, London, April 15, 1994, no. 13 (ill.). It may have been through Hudson's contacts with the Van der Wall family that Reynolds secured these commissions.

John Newton, c. 1757/60

Gift of Arthur B. Logan, 1985.263

Oil on canvas, 127 x 101.6 cm (50 x 40 in.)

CONDITION: The painting is in good condition, even though it is a fragment of a larger canvas that once included Mrs. Newton seated at the right side (see figs. 1–2 and discussion). The old glue paste lining was probably added when the picture was cut down and part of Mrs. Newton's figure, encroaching into the lower right corner, was overpainted. X-radiography reveals that this overpainted section includes the lower part of her satin gown and her right hand holding a rose (fig. 2). The rose is still visible to the naked eye as a ghostly form. X-radiography also reveals that the left edge of the painting was once a tacking margin and has since been overpainted, possibly to better center the male figure on the reduced canvas. The other tacking edges have been cut off, but slight cusping is visible at the top and bottom edges.[1] The canvas has a small dent in the background almost halfway down the left edge.

The ground is off-white, though a reddish brown stain is visible through the thinly painted surface in the background at the upper right corner. The paint layer is fairly intact, except for numerous small localized losses at the upper left corner that are due to the removal of an old inscription identifying Newton and his wife (see fig. 1).[2] A 6.4 cm vertical scratch in the paint layer to the upper left of the sword handle has been inpainted. There are discolored retouches where the inscription was removed, scattered throughout the costume, and in the background at the upper right. In addition, the surface is disfigured by discolored varnish and grime embedded in the interstices of the brushwork. The paint layer has become somewhat flattened due to the lining process. All of the edges are slightly gouged and worn. (partial x-radiograph)

PROVENANCE: Thomas John Henry Vincent Lane, King's Bromley Manor, Lichfield; sold Sotheby's, London, December 8, 1926, no. 118, as Cotes, to De Casseres for £56.[3] Leggatt Brothers, London; sold to Howard Young, 1927.[4] Anderson Galleries, New York.[5] Wally Findlay Galleries, Chicago;[6] sold to Arthur B. Logan, Chicago, March 8, 1955; given to the Art Institute, 1985.

REFERENCES: Aileen Ribeiro, *The Dress Worn at Masquerades in England, 1730 to 1790, and Its Relation to Fancy Dress in Portraiture*, New York and London, 1984, pp. 138–39, 153, 155, 352–53, 356, and intro. to ch. 3, pl. 6.

T his was originally the left two-thirds of a double portrait showing the sitter and his wife, as is evident from an old photograph (fig. 1). An inscription, now removed, identified them as John Newton and his

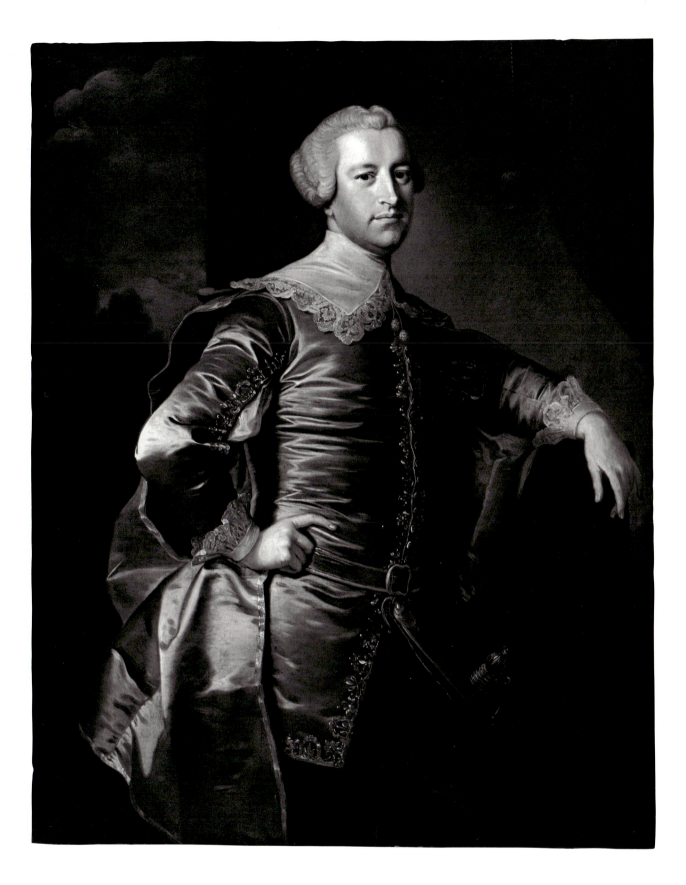

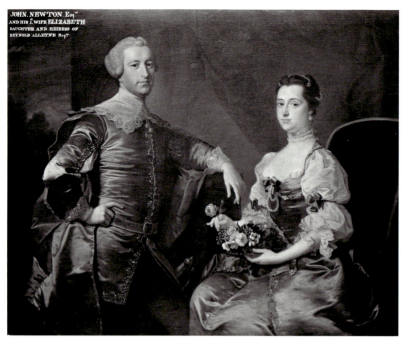

Fig. 1 Thomas Hudson, *John Newton and His Wife Elizabeth* (photograph taken in 1926)

Fig. 2 Partial x-radiograph of *John Newton*, 1985.263

first wife, Elizabeth, daughter and heiress of Reynold Alleyne. According to Ellis Waterhouse, these were the Newtons of Irnham, Lincolnshire.[7] A John Newton, the son of Brailesford and Elizabeth Newton, was baptized at Irnham on August 17, 1716, and died in 1789. No other has been found.[8]

According to Waterhouse, the original canvas was cut down by Leggatt Brothers, who destroyed the rest and sold the figure of John Newton alone to Howard Young in 1927.[9] It seems curious that Leggatt's would not have also preserved the figure of the wife for separate sale as a bust-length portrait, but there is no evidence that it survived and therefore no compelling reason to doubt the accuracy of Waterhouse's statement. When sold at Sotheby's in 1926, the original double portrait was attributed to Francis Cotes. The date of the reattribution of the present fragment to Hudson is unknown, although Waterhouse certainly recognized it as a Hudson, and it appeared as such at the Anderson Galleries in New York.[10] The attribution is now supported without reservation by the authority on Hudson, Ellen Miles.[11]

Like many eighteenth-century British portraits, including the earlier portrait of John Van der Wall above (1980.611), this work deliberately evokes the paintings of Van Dyck. The costume of both husband and wife was a fanciful recreation of seventeenth-century dress, and

even Newton's hand-on-hip pose recalls conventions of deportment from over a century earlier. Hudson painted a number of male portraits using similarly Vandyckian costume and more or less the same pose. For instance, virtually the only difference in the pose between Newton's portrait and that of William Bouverie, later earl of Radnor, lies in the index finger of the latter's right hand, which is bent rather than extended.[12]

As Aileen Ribeiro has pointed out, Elizabeth Newton's costume, with its broad neckline, ribbon-tied sleeves, and pearls and jewels strung across the bodice, was one of many derivations from what was thought to be a Van Dyck portrait of the wife of Rubens, then in the Walpole collection. (Now in the Gulbenkian Foundation in Lisbon, this is today considered to be a portrait of an unknown woman by Rubens himself.)[13] In its adaptation of this seventeenth-century fashion, Mrs. Newton's costume followed the same pattern as did that in Hudson's grand full-length portrait of Mary Panton, duchess of Ancaster, which is dated 1757.[14] A closely comparable seated version is his portrait of Lady Catherine Brydges.[15] Such fanciful costume evoked the fashionable pleasures of masquerade balls as well as the elegance and ease of Van Dyck's portraits. Hudson himself would have painted the faces and hands in the work, and would at least have indicated the positions of the

figures, but the details of the costume might well have been executed by a "drapery man."

Since the portrait of the Duchess of Ancaster was probably Hudson's first venture in the particular line of Van Dyck dress used with Mrs. Newton,[16] the portrait of the Newtons probably dates to 1757 or after. A date in this relatively late period of the artist's career is supported by the distinctive wig worn by John Newton. It is in the style known as *aile de pigeon* (pigeon's wing), which was popular from the mid-1750s into the early 1760s.[17]

NOTES

1 The average thread count of the original canvas is 14 x 14/sq. cm (34 x 34/sq. in.).
2 Information from the inscription is recorded on a typed label that is attached to the stretcher bar. It reads as follows: *JOHN NEWTON. ESQ. / Painted by THOMAS HUDSON / MARRIED ELIZABETH, DAUGHTER AND HEIRESS OF REYNOLD ALLEYNE, ESQ. / FROM THE COLLECTION OF T. J. H. V. LANE, ESQ., KING'S BROMLEY MANOR, LICHFIELD.*
3 Annotated sale catalogue, Ryerson Library, The Art Institute of Chicago.
4 According to an inscription by Ellis Waterhouse on the back of a photograph of the work in its present state, Waterhouse Archive, Paul Mellon Centre, London.
5 From an undated and unidentified newspaper clipping, a copy of which was kindly supplied to the author by Ellen Miles.

6 According to a note from Arthur B. Logan of December 7, 1989, in curatorial files.
7 See note 4.
8 Letters of February 16 and June 22, 1994, from Dr. G. A. Knight of the Lincolnshire Archives to the author (curatorial files).
9 See note 4. The original canvas measured approximately 127 x 157.5 cm.
10 See note 5.
11 Letter to the author of May 16, 1988 (copy in curatorial files).
12 Signed and dated 1749, collection of the earl of Radnor. See Ellen Miles and Jacob Simon, *Thomas Hudson, 1701–1779, Portrait Painter and Collector: A Bicentenary Exhibition,* exh. cat., Greater London Council, Kenwood, The Iveagh Bequest, 1979, no. 43 (ill.); the catalogue entry points out the repetition of the pose in four further examples. See also Ribeiro 1984, pp. 189–90.
13 Ribeiro 1984, pp. 144–57, esp. p. 153. For the influence of the portrait, see also John Steegman, "A Drapery Painter of the Eighteenth Century," *Connoisseur* 97 (June 1936), pp. 309–15; and Stella Mary Pearce, "The Study of Costume in Painting," *Studies in Conservation* 4 (1959), pp. 136–37. For the identity of the sitter, see Hans Vlieghe, "Some Remarks on the Identification of Sitters in Rubens's Portraits," *Ringling Museum of Art Journal* 1 (1983), p. 108 (ill.).
14 Ribeiro 1984, ch. 3, pt. 1, pl. 29; and Miles and Simon (note 12), no. 58 (ill.).
15 Collection of J. H. S. Lucas-Scudamore; see Ribeiro 1984, ch. 3, pt. 1, pl. 36.
16 See Miles and Simon (note 12), no. 58: "[it is] difficult to be certain that the Duchess of Ancaster was the first of this type, although her superior status, the full-length size of the portrait and the fact that it was engraved suggest this."
17 Information kindly provided by Aileen Ribeiro in a letter to Martha Wolff of November 17, 1993, in curatorial files.

Angelica Kauffman

1741 Chur, Switzerland–Rome 1807

Mrs. Hugh Morgan and Her Daughter, c. 1771

Gift of Mrs. L. E. Block, 1960.873

Oil on canvas, mounted on pressboard panel, 63.2 x 76.3 cm (24⅞ x 30 in.)

CONDITION: The painting is in fair condition. Before it came to the Art Institute, the canvas was mounted on a pressboard panel with a white lead and linseed oil adhesive. The picture was subsequently cleaned, varnished, and inpainted at the Art Institute in 1961–62.[1] The original tacking margins have been trimmed, but cusping visible at the right and left edges indicates that the painting is close to its original dimensions. Furthermore, what appears to be the original stretcher has been attached to the back of the board; it matches the dimensions of the canvas and also the pattern of stretcher bar creases.[2] Fragments of the original tacking margins remain attached to the

side of the stretcher, suggesting that the painting had not previously been lined. The ground is off-white. The paint surface has been flattened by the mounting process. Pronounced overall drying craquelure disturbs the unity of the picture. The cracks have been extensively retouched. There is considerable abrasion in the girl's face and dress, in the dog, and throughout the background landscape. Examination in ultraviolet light reveals extensive retouches in these areas, particularly in the upper right quadrant. (x-radiograph)

PROVENANCE: Probably Mrs. Hugh Morgan, Cottles Town and Cork Abbey, Ireland, and by descent to her daughter Catharine, Mrs. Robert Stearne Tighe, Mitchells Town, Ireland.[3] Possibly Tighe family, Ashgrove, Ellesmere, Shropshire, to around 1924.[4] Mrs. Leigh E. Block, Chicago; given to the Art Institute, 1960.

EXHIBITIONS: Allentown, Pennsylvania, Allentown Art Museum, *The World of Benjamin West,* 1962, no. 56.

Angelica Kauffman, the daughter and pupil of a Swiss painter of religious subjects, worked in Britain from 1766 to 1781. She studied in Florence and Rome, where she formed friendships with leading neoclassical painters, among them Nathaniel Dance and Benjamin West, and painted a portrait of Johann Joachim Winckelmann, the seminal theorist of this movement. She was elected to the Accademia di San Luca in Rome in 1765. Invited to Britain in 1766, she won enormous popularity with her charming, discreetly neoclassical paintings of subjects from literature and history. She also painted decorative pictures for interiors designed by Robert Adam and other architects, and maintained a flourishing portrait practice. She was the most accomplished and successful woman artist in Britain, celebrated for what was seen as a woman artist's special ability to capture feminine graces in her sitters. Her many distinguished friends and admirers included Joshua Reynolds, with whom she was rumored to have had a love affair. She was a founding member of the Royal Academy in 1768. In 1781 she married fellow artist Antonio Zucchi and settled with him in Rome, where she continued to paint portraits of British clients and maintained a fashionable salon frequented by Goethe and Canova.

In 1771 Kauffman spent six months in Ireland and painted a number of portraits of leading members of Irish society, including the viceroy, Lord Townshend. The present portrait is a product of that visit, although it may have been painted after the artist's return to England. A label attached to the stretcher, perhaps transcribed from an older label or from the back of the canvas, identifies the sitters as Catharine, Mrs. Hugh

Morgan, daughter of Philip Tisdal, with her only child, also named Catharine, later Mrs. Tighe.[5] Philip Tisdal was a prominent Irish politician, representing Dublin University in the Irish Parliament and serving under Townshend as secretary of state. Since Kauffman painted a portrait of Philip Tisdal in 1770 before her trip to Ireland, it is probable that the Tisdals were among those friends who encouraged her visit.[6] In any event, the artist was entertained by the Tisdals during her stay and painted several portraits of members of the family. Chief among these was a large group portrait showing Philip Tisdal seated in the center with his granddaughter leaning against his knee, his wife to the right, and his two daughters to the left (fig. 1).[7] The granddaughter is clearly the same girl who appears in the Art Institute's portrait, and she is posed almost identically. Her mother appears at the far left of the group playing a lyre, also in a pose that relates to the Art Institute's portrait of her, though not as exactly as her daughter's. It seems reasonable to suppose that the more complicated group portrait was planned first. For the intimate portrait of mother and daughter, Kauffman may have simply borrowed and adapted from the larger project. Angela Rosenthal cites the Tisdal group portrait as one of three of the artist's large family portraits begun in Ireland and finished in England.[8] Whether executed in Ireland during Kauffman's stay of 1771 or afterward in England, the Art Institute's painting is certainly consistent in style with other maternal portraits painted by Kauffman in the early 1770s. For a mother-and-daughter group posed similarly, with the sitters holding flowers and wearing similarly fanciful versions of classical costume, see the signed *Lady Rushout and Her Daughter* of 1773.[9]

Kauffman painted the younger Catharine Morgan again some fifteen years later, when she was in her early twenties and had become Mrs. Tighe. Under June 1786 in her memorandum of paintings, the artist noted, "For Mrs. Morgan of Ireland, the two portraits in one single picture of Mr. and Mrs. Teigh—full length figures of about 18 inches—Mr. Teigh's wife is Mrs. Morgan's daughter."[10] Kauffman was in Rome at the time, and the couple perhaps sat for her there on a honeymoon trip. This portrait was recently on the London art market.[11]

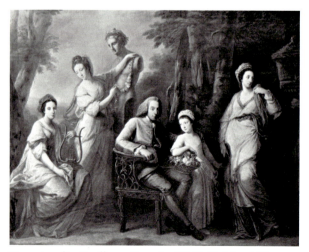

Fig. 1 Angelica Kauffman, *Portrait of Philip Tisdal and His Family*, private collection, Ireland

Notes

1 The treatment was performed by Alfred Jakstas.
2 A label attached to the stretcher is inscribed, in ink, as follows: *Angelica Kauffman / Portrait group of Catharine, daughter & heiress of the Rt. / Hon. Philip Tisdall [sic] + widow of Col. Hugh Morgan of Cottles Town / + Cork Abbey, + her only child Catha-*

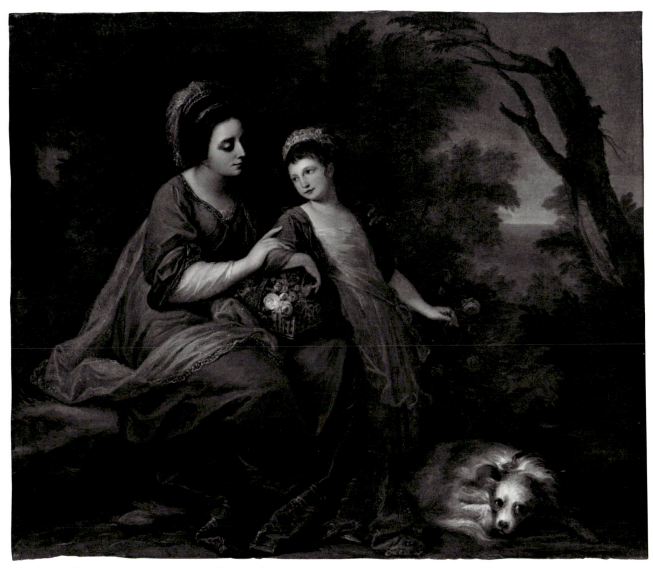

Angelica Kauffman, *Mrs. Hugh Morgan and Her Daughter*, 1960.873

rine, afterwards Mrs. Tighe, with *Painted 1770* added in pencil.

3 The details given on the label attached to the stretcher (note 2) suggest that the painting descended from Mrs. Morgan to her daughter, but there is no firmer evidence.

4 See Lady Victoria Manners and G. C. Williamson, *Angelica Kauffman, R.A.: Her Life and Her Works,* New York, 1924, p. 29. Manners and Williamson refer rather vaguely to Kauffman portraits of the Tisdal family, to which Mrs. Morgan belonged, that were "until lately" in the possession of the Tighe family. The Art Institute's portrait may have been among these.

5 See Condition and note 2.

6 A half-length portrait of him signed and dated 1770 was sold at Sotheby's, London, March 11, 1953, no. 34; information kindly supplied by Angela Rosenthal. Wendy Wassyng Roworth first drew the author's attention to Kauffman's connection to the Tisdal family in a letter of June 16, 1991 (copy in curatorial files); she and Angela Rosenthal provided much additional information based on their wide knowledge of Kauffman's life and work. On Tisdal's career and connections, see his entry in the *DNB,* vol. 19, under "Tisdal, Philip."

7 The Tisdal group portrait measures 60³/₄ x 75 in.; see Angela

Rosenthal in *Angelica Kauffman: A Continental Artist in Georgian England,* ed. by Wendy Wassyng Roworth, London, 1992, pp. 105, 199; and "The Antique Dealers' Fair and Exhibition," *Apollo* 22 (September 1935), p. 167 (ill.).

8 Rosenthal (note 7), p. 105. In a letter of March 11, 1995, to Martha Wolff, Rosenthal noted that Kauffman made preparatory studies of Philip Tisdal and his wife (New York, Pierpont Morgan Library; see Munich, Galerie Arnoldi-Livie, *Vom Manierismus bis in die Goethezeit. Bilder und Zeichnungen,* 1982, nos. 41a and b [both ill.], where the sitters are misidentified). Presumably other sketches were made of Catharine Morgan and her daughter.

9 Sold Christie's, London, July 17, 1992, no. 7A (ill.).

10 Translated and transcribed in Manners and Williamson (note 4), p. 151. Their text corrects Kauffman's original "Madame Morghen," but retains her misspelling of Teigh for Tighe. The author is grateful to Wendy Wassyng Roworth for her comments on this notation.

11 Philips, London, May 10, 1983, no. 27 (ill.); and later with Colnaghi.

Philippe Jacques de Loutherbourg

1740 Strasbourg–Hammersmith 1812

The Destruction of Pharaoh's Army, 1792

Restricted gifts of the Old Masters Society, Mrs. P. Kelley Armour and Mr. and Mrs. William B. Graham through the Old Masters Society; gift of Richard L. Feigen; Alexander A. McKay, Mr. and Mrs. Donald Patterson, and Mr. and Mrs. Murray Vale endowments; through prior acquisitions of Max and Leola Epstein, William O. and Erna Sawyer Goodman Fund through Friends of American Art, Mrs. Robert Hall McCormick in memory of Robert Hall McCormick, and Dellora A. Norris, 1991.5

Oil on canvas, 127 x 102.3 cm (50 x 40½ in.)

INSCRIBED: *P. I. de Loutherbourg, R.A. / 1792* (on rock, lower right)

CONDITION: The painting is in very good condition. It was cleaned in 1989–90.[1] The canvas has an old glue paste lining. The tacking margins have been cut off, but cusping on all four sides indicates that the painting is close to its original dimensions. There are two L-shaped tears, the first measuring approximately 4.5 x 4.5 cm, in the extended hand of the bearded figure to the left of Moses, and the other measuring 4.5 x 5 cm, in Moses' chest. There are two irregularly shaped holes measuring approximately 4.5 x 2.5 cm located side by side in the gray cloud to the left of Moses. X-radiography reveals a few smaller holes in the background measuring only 1 x 2 cm or less. All of these damages have been reinforced with patches on the back of the lining fabric, indicating that they may be more recent than the lining itself.[2] The white ground is visible where the artist has allowed it to show through the thinly painted background landscape. The paint surface is generally well preserved. Examination in ultraviolet light reveals that the inpainting is confined to the losses discussed above. The sketchy brushwork above the army drowned by the waves at the left edge appears unusually dark in ultraviolet light, but this is not due to retouching. The tonal contrast between this area and the adjacent water may have been caused by cleaning damage and the removal of a thin surface glaze. Microscopic examination of the dark brushwork reveals age cracks through this passage that are consistent with the surrounding surface. The rocks in the central foreground have also been slightly abraded. (x-radiograph)

PROVENANCE: Commissioned by Thomas Macklin (d. 1800), London.[3] International Galleries, Chicago, 1963–64. Sold by them to Jackie Proler, Houston, Texas, 1964.[4] Sold Christie's, New York, May 31, 1989, no. 118. Richard L. Feigen and Co., New York, 1989–91. Sold by Feigen to the Art Institute, 1991.

REFERENCES: T. S. R. Boase, "Macklin and Bowyer," *Journal of the Warburg and Courtauld Institutes* (1963), p. 167. Rüdiger Joppien, "Mythology, Religion, History," in *Philippe Jacques de Loutherbourg, R. A., 1740–1812*, exh. cat., Greater London Council, Kenwood, The Iveagh Bequest, 1973, n. pag.

Morton D. Paley, *The Apocalyptic Sublime*, New Haven and London, 1986, p. 55. Gloria Groom, "Art, Illustration, and Enterprise in Late Eighteenth-Century English Art: A Painting by Philippe Jacques de Loutherbourg," *AIC Museum Studies* 18 (1992), pp. 125–35, fig. 1.

EXHIBITIONS: London, Poets' Gallery, Fleet Street, *Sixth Exhibition of Pictures, Painted for T. Macklin, by the Artists of Britain; Illustrative of the British Poets, and the Bible*, 1793, no. 71. Houston, Congregation Emmanu-El, *Festival of the Bible in the Arts*, 1964, no. 10.

De Loutherbourg was an important figure in the development of Romantic landscape painting in Britain, and his command of dramatic natural effects inspired many younger painters, including Turner. Though born and educated in France, he made his artistic career largely in Britain. He studied in Paris with the history painter

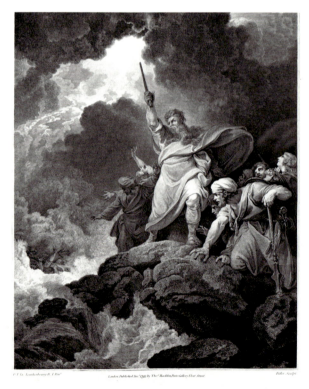

Fig. 1 James Fittler, engraving after Philippe Jacques de Loutherbourg, *The Destruction of Pharaoh's Army* [photo: courtesy of The Newberry Library, Chicago]

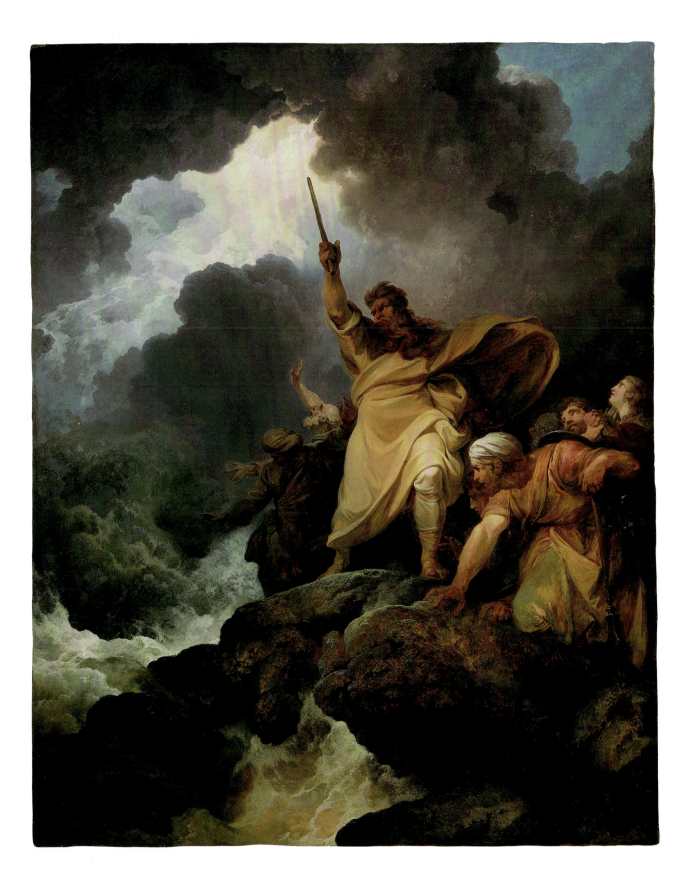

Carle Vanloo, with the engraver Johann Georg Wille, and finally in the studio of François Joseph Casanova, the painter of battle and shipwreck scenes. He made his debut at the Paris Salon in 1763, winning the admiration of Diderot. His reputation in Parisian artistic circles rose rapidly, and he was elected to full membership in the Academy in 1767. In 1771, apparently fleeing an unhappy marriage, he settled in London. He became set designer at David Garrick's Drury Lane Theatre, where he raised stage decor to new heights of illusionism. At the same time, he continued to paint the landscape subjects for which he had been known in Paris, expecially scenes of natural violence—storms, avalanches, and waterfalls. He married an Englishwoman in 1774. In 1781 he was elected a Royal Academician and gave up working for the stage as such, though continuing to experiment with spectacle and illusion in his "Eidophusikon" (image of nature), a theater without actors in which moving sets, ingenious lighting, and sound effects recreated natural phenomena. In 1786 he befriended the mysterious freemason Count Cagliostro, an association that led him to a brief career as a mystic and faith healer. Forced by public opposition to abandon this activity in 1789, de Loutherbourg resumed painting and was invited by the print publisher and entrepreneur Thomas Macklin to paint scriptural subjects to be engraved for the illustrated Macklin Bible.[5]

The Destruction of Pharaoh's Army was one of de Loutherbourg's Macklin Bible pictures. Macklin's scheme was among several launched in the 1780s and 1790s to promote British history painting, the first and best known being John Boydell's Shakespeare Gallery.[6] Macklin published a prospectus announcing the Bible project in 1789. He commissioned biblical paintings from various contemporary artists and showed the results in a series of exhibitions at his own gallery, known as the Poets' Gallery from an earlier publishing venture along the same lines called "The British Poets." The gallery had opened in Pall Mall in 1788 and later moved to Fleet Street. Macklin used the exhibitions at the Poets' Gallery to attract buyers for single engravings after the paintings and, more importantly, subscribers to the two illustrated publications. The engravings for the Bible project were published one by one in separate numbers, each image accompanied by a text, with the parts designed to be bound together in groups as the several volumes of a luxurious illustrated Bible. The order in which numbers were issued was determined by commissioning and publishing considerations rather

than by their place in the Bible. The first appeared in 1791 and the series was completed in 1800, shortly before Macklin's death. The final work contained seventy-one full-page engravings from commissioned paintings, and numerous half-page vignettes as headpieces and tailpieces. Macklin paid his contributors on a sliding scale, offering high sums to command the work of the most prestigious artists. Accordingly, Sir Joshua Reynolds (see 1922.4468) received 500 guineas for the single most celebrated contribution to the project, his *Holy Family* of 1788–89 (now in the Tate Gallery, London), while Henry Fuseli was paid £80 for his *Vision of Saint John* (location unknown).[7] Among other notable contributors were Angelica Kauffman, John Opie, and Benjamin West. The Art Institute's painting *The Woman Accused of Adultery* by William Artaud (see 1915.488) is also a Macklin Bible picture. The dominant presence in the project as a whole, however, was de Loutherbourg, who contributed seventeen paintings and more than one hundred designs for vignettes.[8]

The Destruction of Pharaoh's Army is dated 1792. It was shown at the Poets' Gallery in 1793, and the engraving was published in December of that year (fig. 1). The painting fits Macklin's standard canvas size of 50 by 40½ inches for exhibited pictures, for both the Bible and the British Poets projects.[9] Macklin clearly worked with the artists to select subjects that would suit their styles; the present subject exemplifies de Loutherbourg's preference for catastrophic and awe-inspiring events in which the power of nature expresses the power of God. His other Macklin Bible subjects include *The Deluge, The Ascent of Elijah, The Angels Destroying the Assyrian Camp, Christ Appeasing the Storm,* and *The Shipwreck of Saint Paul.*

The subject of *The Destruction of Pharaoh's Army* is based on the biblical account of the crossing of the Red Sea (Exod. 14). According to the story, Moses led the Israelites out of slavery in Egypt on the start of their journey to the Promised Land. When they reached the Red Sea with Pharaoh's army in pursuit, Moses extended his hand and a wind parted the waters to allow them to pass through. When they reached the opposite shore, God commanded Moses to stretch out his hand over the sea once more "that the waters may come again upon the Egyptians, upon their chariots, and upon their horsemen" (Exod. 14.26).

De Loutherbourg follows the tradition of showing Moses with a long, flowing beard and hair raised off his forehead to suggest the description of him in the Vulgate

as "horned." The rod in his hand, which seems to act as a lightning conductor for God's power, is the one he would later use to strike water from a rock as the Israelites crossed the desert (Exod. 17.1–7). The canonical representation of Moses was the sculpture by Michelangelo;[10] it was almost certainly from this work that de Loutherbourg derived the facial features of his main figure, certain details of his costume, such as the leg covering and sandal, and the pose of at least the lower half of his body. The poses, physiognomies, and composition of the Chicago picture also appear indebted to Michelangelo's Sistine Chapel ceiling frescoes.[11]

NOTES

1 The painting was treated by Marco Grassi.
2 The average thread count of the original canvas is approximately 11 x 11/sq. cm (28 x 28/sq. in.).
3 The work may have been one of the many Bible pictures disposed of by lottery in 1797 to settle Macklin's debts; see Sven H. A. Bruntjen, *John Boydell, 1719–1804: A Study of Art Patronage and Publishing in Georgian London*, New York and London, 1985, pp. 119, 154–55. It was not in the posthumous sales of his possessions on May 5–10, 1800, or May 27–30, 1801.

4 Information kindly supplied by R. Stanley Johnson of R. S. Johnson Fine Art (formerly International Galleries), in a letter of November 17, 1994, in curatorial files.
5 For details of de Loutherbourg's biography, see Joppien 1973 and G. Lavallet-Haug, "Philippe-Jacques Loutherbourg (1740–1813)," *Archives alsaciennes d'histoire de l'art* 16, n. s. 1 (1948), pp. 77–133.
6 The Macklin Bible has not yet been the subject of a monographic study. For information on the project, see Boase 1963; Joppien 1973; Rüdiger Joppien, "Ein biblisches Gemälde Philippe Jacques de Loutherbourgs im Wallraf-Richartz-Museum," *Wallraf-Richartz-Jahrbuch* 36 (1974), pp. 191–98; Bruntjen (note 3), pp. 120–21; and Richard Hutton, "Robert Bowyer and the Historic Gallery: A Study of the Creation of a Magnificent Work to Promote the Arts in England," Ph.D. diss., University of Chicago, 1992 (Ann Arbor, Mich., University Microfilms, 1994), pp. 74–78, 127–30.
7 For Reynolds's painting, see Boase 1963, p. 164, fig. 23c; and Ellis K. Waterhouse, *Reynolds*, London, 1941, pl. 291b. For Fuseli's relations with Macklin, see Gert Schiff, *Johann Heinrich Füsslis Milton-Galerie*, Zurich and Stuttgart, 1963, pp. 50–51.
8 Six additional full-page engravings after de Loutherbourg were included in the volume devoted to the Apocrypha that was added to the Bible in the edition brought out by Cadell and Davies in 1816; see Joppien 1974 (note 6), pp. 193–94, 196 n. 9.
9 Ibid., p. 194.
10 See Charles de Tolnay, *Michelangelo: Sculptor, Painter, Architect*, Princeton, 1975, figs. 95–97.
11 Ibid., figs. 69–90.

George Morland

1763 London 1804

Trepanning a Recruit, c. 1790

Gift of Mr. and Mrs. John Walter Clarke, 1987.92.3

Oil on canvas, 54 x 43.5 cm (21¼ x 17⅛ in.)

INSCRIBED: *Cumberland / House / D. Irwin / from Carlisle* (on sign at upper left)

CONDITION: The painting is in very good condition. It has an old glue paste lining, and the original tacking margins have been cut off.[1] Cusping is visible only along the bottom edge. A 1 cm horizontal tear on the lower center edge is apparent in the x-radiograph. The off-white ground is visible through cracks in the paint layer, which has been somewhat flattened by lining. There is slight abrasion in the faces and hair of the seated figures and in the flesh tones of the woman, and some retouching in the dark shadows of the drapery and foliage and in the faces of the seated men. (x-radiograph)

PROVENANCE: Sold by the artist to Henry Hare Townshend (d. 1827), Busbridge Hall, near Godalming, Surrey, and later Downhills, near Tottenham; sold Christie's, London, June 9, 1827, no. 44, as a pair with *The Deserter Pardoned*, to Lake for 19½ gns.[2] Sold Christie's, London, May 7, 1842, no. 121, to Roe for 18 gns.[3] Samuel Addington, London, by 1880;[4] sold Christie's, London, May 22, 1886, no. 88, to Colnaghi for

305 gns.[5] Lt. Col. A. Heywood-Lonsdale, Shavington, Market Drayton; sold Christie's, London, October 24, 1958, no. 91, to the Fine Art Society, London, for £240.[6] Sold by the Fine Art Society to John Walter Clarke, Chicago, 1960;[7] given by Mr. and Mrs. Clarke to the Art Institute, 1987.

REFERENCES: William Collins, *Memoirs of a Painter, Being a Genuine Biographical Sketch of that Celebrated Original and Eccentric Genius, the Late Mr. George Morland*, vol. 2, London, 1805, p. 43. J. Hassell, *Memoirs of the Life of the Late George Morland; with Critical and Descriptive Observations on the Whole of His Works Hitherto before the Public*, London, 1806, p. 94. George Dawe, *The Life of George Morland, with Remarks on His Works*, London, 1807, pp. 73, 88–89, 235–36 (reprinted as *The Life of George Morland, with an Introduction and Notes by J. J. Foster*, London, 1904, pp. xxxi, 38, 46–47, 124, 155). Ralph Richardson, *George Morland: Painter, London, 1763–1804*, London, 1895, pp. 42, 52–53. J. T. Nettleship, *George Morland and the Evolution from Him of Some Later Painters*, London, 1898, p. 16. J. T. Herbert Baily, "George Morland: A Biographical Essay," *Connoisseur*, extra number, no. 1 (1906), pp. 21, 126, 132. Sir Walter Gilbey, Bt., and E. D. Cuming, *George Morland: His Life and Works*, London, 1907, pp. 75–76.

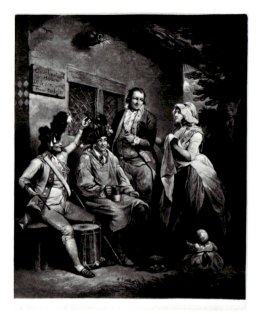

Fig. 1 George Keating, mezzotint after George Morland, *Trepanning a Recruit*, British Museum, London [photo: © British Museum, London]

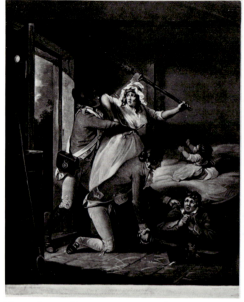

Fig. 2 George Keating, mezzotint after George Morland, *Recruit Deserted*, British Museum, London [photo: © British Museum, London]

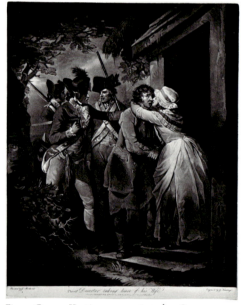

Fig. 3 George Keating, mezzotint after George Morland, *Deserter Taking Leave of His Wife*, British Museum, London [photo: © British Museum, London]

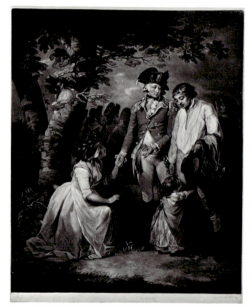

Fig. 4 George Keating, mezzotint after George Morland, *The Deserter Pardoned*, British Museum, London [photo: © British Museum, London]

George C. Williamson, *George Morland: His Life and Works*, London, 1907, pp. 41–42, 113, 131, 175. David Henry Wilson, *George Morland*, London and New York, 1907, pp. 73–75, 184, 195. David Winter, "George Morland (1763–1804)," Ph.D. diss., Stanford University, 1977 (Ann Arbor, Mich., University Microfilms, 1981), pp. 38, 169, no. P25, fig. 17. Joan W. H. Hichberger, *Images of the Army: The Military in British Art, 1815–1914*, Manchester, 1988, p. 133.

EXHIBITIONS: London, Royal Academy of Arts, *Exhibition of Works by the Old Masters, and by Deceased Masters of the British School*, 1880, no. 42.

This work is the first scene in Morland's four-part series *The Deserter*, which was engraved and published in mezzotint reproductions (figs. 1–4),[8] and was one of the narrative and moralizing series that established the artist's reputation. The son and grandson of artists, Morland was trained from an early age in the family profession. After concluding a grueling apprenticeship under his father in 1784, he worked briefly as a portrait painter in Margate, traveled to northern France, and

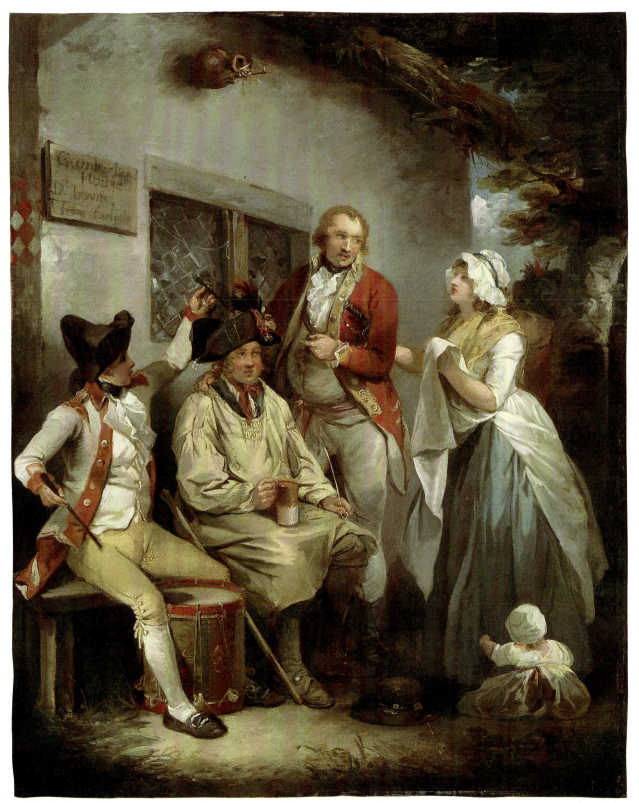

George Morland, *Trepanning a Recruit*, 1987.92.3

established himself in London around 1786 as a painter of domestic genre pictures. These often formed narrative and moralizing series or pairs in the manner of Hogarth, and appear to have been painted not on commission but for agents or print publishers. Around 1790 Morland changed direction, turning to the picturesque landscape and rustic low-life subjects he was to pursue for the rest of his career. He was a famously colorful and convivial character who indulged his taste for drink, sport, and jokes without regard for propriety or the limits to his means. He lived in squalor and enjoyed the company of low-life characters like those who people his paintings, avoiding ties to patrons and collectors. In 1799 he was arrested and committed to a debtors' prison for two years, which he spent painting to pay off his creditors, and he died in a sponging house aged only forty-one. Morland worked in a rapid, improvisatory manner that became increasingly erratic as his health and fortunes declined.

The four paintings in the *Deserter* series were engraved in mezzotint by George Keating and published by John Raphael Smith in 1791 (figs. 1–4). In the first scene, which is the subject of the Art Institute's painting, a simple young man, wearing the smock of a farm laborer, is approached by army recruiters outside a country alehouse and lured, despite his wife's entreaties, into enlisting. In the second scene, *Recruit Deserted*, he is being arrested at home for desertion; a soldier pulls him out from under the bed as another restrains his wife, who is brandishing a broom. The third, *Deserter Taking Leave of His Wife*, shows the couple at their cottage door, the recruit manacled and about to be led away by the soldiers; and the fourth, *The Deserter Pardoned*, shows a kindly officer reuniting them, the wife kneeling gratefully before him—the baby who appears in the first two scenes has now grown into a toddler, indicating the passage of as much as a year since the arrest. Despite its comic overtones, the series seems to play to contemporary distrust of recruitment practices and army life.[9]

For a while Morland held the unlikely post of constable for the St. Pancras Ward. This brought him into contact with military men looking for deserters and, according to his biographer George Dawe, provided him with the opportunity to ensure the accuracy of the *Deserter* series:

> Just as he was about to begin his four pictures of the Deserter, a serjeant, drummer, and soldier, on their way to Dover in pursuit of deserters, came in for a billet. Morland

seeing that these men would answer his purpose, accompanied them to the Britannia, and treated them plentifully, while he was earnestly questioning them on the modes of recruiting, with every particular attendant on the trial of deserters by court martial, and their punishments. In order that he might gain a still better opportunity for information, he provided his new acquaintances with ale, wine, and tobacco, took them to his house, and caroused with them all night, employing himself busily in sketching, making enquiries, and noting down whatever appeared likely to serve his purpose; nor was he satisfied with this, for during the whole of the next day, Sunday, he detained them in his painting-room, and availed himself of every possible advantage which the occasion afforded.[10]

According to another early biographer of the artist, J. Hassell, the painting includes the likeness of a dissolute companion of Morland's named Irwin:

> The recruit and recruiting-serjeant are the portraits of a Mr. Irvoin [*sic*], an early acquaintance of Morland, who, in a very short space of time finished his career in this world, by attempting to pursue those dissipations in which this artist set the example, or, to use the expression of Morland himself, '*this was the first man he ever killed.*'[11]

Dawe also related that Irwin lived for a while at the artist's house, obtained money on account for him from his wealthier brother, and helped sell his pictures. The two men finally quarreled and went their separate ways, soon after which Irwin died of drink.[12] There is no way to verify that Irwin's likeness is included, but the sign on the inn does read: *Cumberland / House / D. Irwin / from Carlisle.* The full significance of this is elusive.

Paintings related to the third and fourth scenes from the series are known,[13] but whether these and the Art Institute painting are the originals from which the mezzotints were made is open to question. The two other paintings that relate to the series both have inscribed dates of 1792, the year after the mezzotints were published. This would suggest that they are not the originals but later versions, in which case the same might be true of the Art Institute's picture. On the other hand, the inscribed dates may be misleading. David Winter dated the Chicago painting and *The Deserter Pardoned* to 1788/89, arguing that the date on the latter is false— and he would presumably have extended his argument to the painting *Deserter Taking Leave of His Wife* had it been known to him.[14] Since no scene from the series exists in more than a single corresponding painting, it is certainly tempting to assume that the known paintings are Morland's originals. But it remains at least possible that any or all of them are versions—though undoubt-

edly, judging from their quality, autograph ones. The mezzotint and painting of *Trepanning a Recruit* correspond quite closely, but the facial expressions of the characters are rendered more specifically in the print: the recruit appears more oafish, his wife prettier, and the soldier to the left more impish. As John Barrell has pointed out, engravers of Morland's works frequently gave greater narrative point to the faces or prettified Morland's rather blank facial types.[15] For a pair of paintings executed jointly by Morland and John Rathbone, see *Landscape with Figures Crossing a Bridge* (1962.967) and *Landscape with Fisherman and Washerwoman* (1962.968).

NOTES

1 The average thread count of the original canvas is 13 x 12/sq. cm (32 x 30/sq. in.). The text from the 1886 sale catalogue is pasted to the strether; a handwritten label attached to it reads as follows: *G. MORLAND / 88 TREPANNING A RECRUIT. / 20½ in. x 16½ in. / Exhibited at Burlington House. 1880 / Engraved*, with the handwritten notation *from Christie's [also?] / [c . . . May?] 22nd 188[6?]*.

2 Annotated sale catalogue, Christie's, London; the other two paintings in the *Deserter* series were sold together as no. 45 to

Norton for 17 gns. The pictures by Morland in the sale were described on the catalogue title page as having been "selected and purchased by the late Proprietor from the Easel of the Artist." See Dawe 1807, pp. 235–36.

3 Annotated sale catalogue, Christie's, London. No. 122 in this sale was Morland's *The Deserter Pardoned* (bought by Walsh).

4 Lent by him to the Royal Academy exhibition.

5 Annotated sale catalogue, Christie's, London.

6 Annotated sale catalogue, Ryerson Library, The Art Institute of Chicago.

7 Letter to the author of January 24, 1993, from Andrew McIntosh Patrick, Director of the Fine Art Society, in curatorial files.

8 Each measures 52.7 x 45.1 cm (20¾ x 17¾ in.).

9 See Hichberger 1988, pp. 122–37, which deals with the themes of recruitment, enlistment, and desertion in the period after Waterloo.

10 Dawe 1807, pp. 88–89. Gilbey and Cuming (1907, p. 72) provide some support for the claim that Morland served as a constable.

11 Hassell 1806, p. 94.

12 See Dawe 1807, pp. 65–66, 89–90.

13 *Deserter Taking Leave of His Wife*, oil on canvas, 54.6 x 44.1 cm (21½ x 17⅜ in.); sale, Christie's, London, July 15, 1988, no. 56 (ill.). *The Deserter Pardoned*, oil on canvas, 52.1 x 43.2 cm (20½ x 17 in.); Bath, Holburne of Menstrie Museum.

14 Winter 1977, p. 169.

15 John Barrell, *The Dark Side of the Landscape: The Rural Poor in English Painting, 1730–1840*, Cambridge, 1980, pp. 108–13, 117–22.

James Northcote

1746 Plymouth–London 1831

Mrs. Allan Maconochie, 1789

Gift of Mr. and Mrs. Denison B. Hull, 1974.390

Oil on canvas, 76.4 x 63.6 cm (30¹/₁₆ x 25¹/₁₆ in.)

INSCRIBED: *J^s. Northcote. Fecit. 1789* (in red paint, at lower left on fictive oval frame)

CONDITION: The painting is in very good condition. It has a glue paste lining, and the tacking margins have been cut off.[1] The off-white ground is visible where the artist has allowed it to show in the hair and in the background at the upper right. There are two small tears in the hair at the upper left, which have been filled and inpainted. The paint surface is generally well preserved, but has been flattened somewhat by lining, especially in the ribbons on the hat and in the drapery folds of the black stole. The paint surface is slightly abraded around the tears, in the hat brim at the upper right, and within the background at the upper right. The surface has been selectively cleaned in the face, hair, hat, and fichu. There are minor retouches over some cracks in the face. (x-radiograph)

PROVENANCE: Allan Maconochie (d. 1816), later first Lord Meadowbank, husband of the sitter.[2] By descent to Sir Evan Maconochie; sold Christie's, London, December 17, 1926, no.

128, as *Mrs. Alexander Maconochie*, to Agnew, London, for 900 gns.[3] Sold by Agnew to Horace Trumbauer, November 1927, and bought back by Agnew, December 1927.[4] Sold by Agnew to F. W. Clayton, March 1928.[5] F. C. Daniell, London, by 1932.[6] Neumans, Paris, 1936. Daniel H. Farr Co., New York, also in 1936.[7] Mrs. Norman Armour, Jr., New York; sold Parke-Bernet, New York, January 25, 1958, no. 289 (ill.), to Newhouse Galleries, New York, for $1,900. Sold by Newhouse to Mr. Denison B. Hull, Winnetka, 1960;[8] given to the Art Institute by Mr. and Mrs. Denison B. Hull, 1974.

REFERENCES: Stephen Gwynn, *Memorials of an Eighteenth Century Painter*, London, 1898, p. 273, no. 250. John Wilson, "The Romantics, 1790–1830," in *The British Portrait, 1660–1960*, intro. by Roy Strong, Woodbridge, 1991, pp. 245–46, pl. 233.

EXHIBITIONS: Vienna, Vereinigung bildender Künstler Wiener Secession, *Meisterwerke englischer Malerei aus drei Jahrhunderten*, 1927, no. 61 (ill.). Exeter, Royal Albert Memorial Museum and Art Gallery, *Works by Early Devon Painters*, 1932, no. 271, as *Mrs. Alexander Maconochie*.

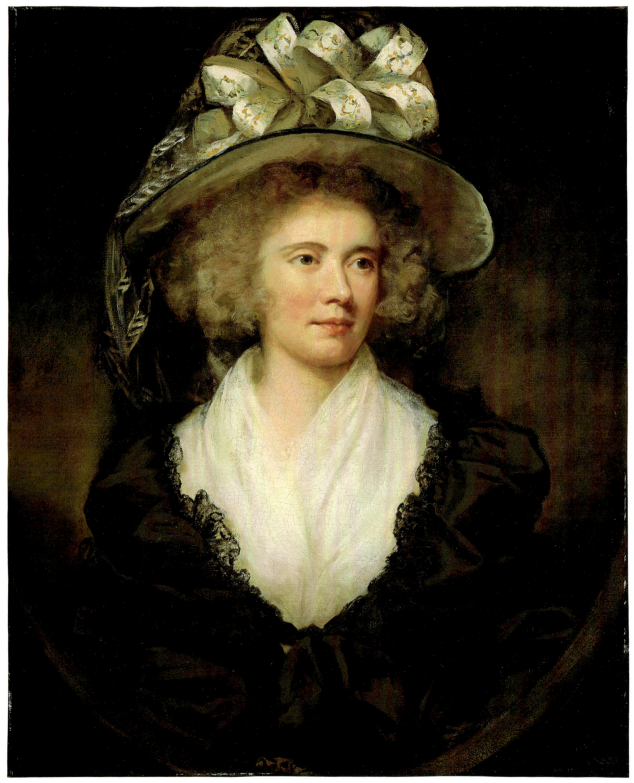

James Northcote, *Mrs. Allan Maconochie*, 1974.390

Despite the opposition of his father, a Plymouth watchmaker, Northcote left for London in 1771 to pursue a career as an artist. He became an assistant in the studio of Sir Joshua Reynolds (see 1922.4468) and shortly afterward moved into his master's house as a lodger. His intimate acquaintance with Reynolds was the basis for his two-volume biography of him, published in 1813–15. While working for Reynolds, the young Northcote attended the Royal Academy Schools and from 1773 showed portraits at the Academy's annual exhibitions. After a brief spell working as a portraitist in his native Devonshire, he left for Italy, in 1777, to study classical and Renaissance art, developing a special admiration for the work of Titian. He returned to London in 1780, where he worked as a portraitist for the rest of his life. In the late 1780s, the Shakespeare Gallery promoted by John Boydell gave him the opportunity to paint historical subject matter, although his subsequent work in that vein enjoyed limited success. He became an Associate of the Royal Academy in 1786 and a full Academician the following year. He was celebrated for his colorful table talk, some of which was published by his friend William Hazlitt in 1830 as *Conversations of James Northcote*.

The subject of this portrait is Elizabeth Maconochie, later Lady Meadowbank, wife of the distinguished Scottish judge Allan Maconochie. The erroneous former identification of the sitter as Mrs. Alexander Maconochie, first published in the 1926 sale catalogue, presumably arose out of a confusion between her and the wife of her eldest son. Elizabeth Maconochie was the third daughter of Robert Welwood of Garvock and Pitliver, Fifeshire, and granddaughter of Sir George Preston, fourth Bt., of Valleyfield, Perthshire. She married Maconochie, then an advocate and lay representative of the burgh of Dunfermline at the Scottish General Assembly, on November 11, 1774. From 1779 to 1796 he was Professor of Public Law and Law of Nature and Nations at the University of Edinburgh. In 1796 he became an ordinary Lord of Session, taking his title of Lord Meadowbank from the name of his family's estate in Midlothian, and in 1804 was appointed a Lord of Justiciary. They had four children, all sons, the eldest of whom, Alexander, also became a judge. The portrait is a pendant to that of Maconochie himself painted by Northcote in the same year (fig. 1). This is roughly the same size as the portrait of Mrs. Maconochie, employs the same device of enclosing the likeness within a fictive oval niche, and is similarly signed and dated 1789.[9] The

two works appear consecutively in the artist's own list of his works, under the year 1789, as "Mrs Mac. Connor" and "Mr Mac. Connor."[10] In the manner customary with pendant portraits of married couples, the sitters face in different directions, so that they can be made to look toward one another when the portraits are hung together.

The portrait of Mrs. Maconochie is an outstandingly fresh and animated example of Northcote's portraiture. Its robust, painterly execution, especially in the treatment of the black silk stole, shows a clear debt to the work of his master and mentor, Reynolds. In this respect it is comparable, for instance, to Reynolds's *Miss Gideon and Her Brother, William*, painted in 1786–87.[11] Northcote painted the work at a time when Reynolds was losing his eyesight, and the question of who was to succeed him as Britain's foremost portraitist was on the mind of every younger practitioner. The succession was to pass Northcote by, falling briefly to the younger John Hoppner, then to the still younger, much more brilliant Thomas Lawrence.

NOTES

1 The average thread count of the original canvas is 14 x 14/sq. cm (32 x 32/sq. in.).
2 The artist's own list of his works contains a note under 1788 that he raised his price for portraits in that year to fifteen guineas a

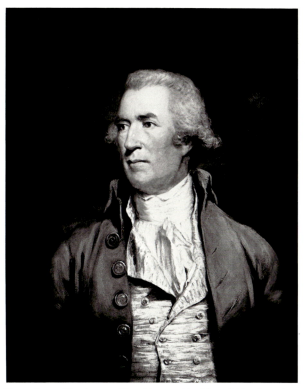

Fig. 1 James Northcote, *Allan Maconochie*, City of Aberdeen Art Gallery and Museums Collections

head. This was probably the price of the present work. See Gwynn 1898, p. 273.

3 Annotated sale catalogue, Ryerson Library, The Art Institute of Chicago.

4 According to Agnew's stock books; see letter of March 19, 1993, from Gabriel Naughton to Malcolm Warner, in curatorial files.

5 See note 4.

6 See the 1932 exhibition catalogue.

7 This and the previous location are indicated on annotated mounts of photographs in the Witt Library, London.

8 Information kindly supplied by Adam Williams, Newhouse

Galleries, in a letter of September 29, 1993, in curatorial files.

9 Oil on canvas, 77.6 x 62.7 cm (30½ x 24⅝ in.). The work was no. 129 in the sale of Sir Evan Maconochie, 1926 (see Provenance); it was bought by Gooden and Fox for 360 guineas.

10 Gwynn 1898, p. 273. The misspelling of the name Maconochie is probably Northcote's own rather than the result of faulty transcription.

11 Collection of the viscount Cowdray; see Nicholas Penny, ed., *Reynolds*, exh. cat., London, Royal Academy of Arts, 1986, no. 142 (ill.).

Sir Henry Raeburn

1756 Stockbridge–Edinburgh 1823

Portrait of a Man with Gray Hair, 1810/1820

Gift of Charles Deering McCormick, Brooks McCormick, and Roger McCormick, 1962.961

Oil on canvas, 73.6 x 62.8 cm (29 x 24¾ in.)

CONDITION: The painting is in good condition. It was surface cleaned at the Art Institute in 1963.[1] The twill-weave canvas has an old glue paste lining.[2] The original tacking margins have been cut off, but cusping is visible on the right and left edges, indicating that the painting is close to its original dimensions. The canvas weave has become somewhat pronounced due to the lining process. The ground is off-white. The paint surface is slightly abraded in the shadows of the sitter's face. Examination in ultraviolet light reveals small local retouches on the sitter's right eyelid, under his right eye, on his chin, on the left side of his neck, and on his stock. Microscopic examination reveals traces of retouching in the man's dark coat and background. An aged natural resin varnish is covered by a mat synthetic varnish that obscures the definition of forms, particularly in the dark areas.(x-radiograph)

PROVENANCE: Chauncey McCormick, Chicago (d. 1954).[3] At his death to his widow, Marion Deering McCormick. Given to the Art Institute by their sons Charles Deering McCormick, Brooks McCormick, and Roger McCormick, 1962.

REFERENCES: Morse 1979, p. 220.

Raeburn was the son of a fairly prosperous textile-mill owner in Stockbridge, outside Edinburgh. He was orphaned at an early age and placed by his uncle in George Heriot's Hospital, Edinburgh, where he spent most of his childhood. He was apprenticed to an Edinburgh goldsmith in 1772 and continued to work for him

at least until 1778. His work during this time probably involved the painting of miniature portraits and vignettes in watercolor. As a painter of portraits in oil, he appears to have been almost entirely self-taught. In 1784 he spent a couple of months in London working in the studio of Sir Joshua Reynolds (see 1922.4468), and from there traveled to Rome, where he spent two years. His Roman stay increased his knowledge of the art of the past, and no doubt enhanced his prestige on his return to Scotland, but had little obvious effect on his style. From the time of his return in 1787 to Edinburgh, where he lived for the rest of his life, he enjoyed increasing success and rose during the 1790s to become indisputably the leading portraitist in Scotland. On the death of John Hoppner in 1810, he became the only serious rival in Britain to Thomas Lawrence and briefly considered moving to London. He exhibited regularly in Edinburgh at the Associated Society of Artists, of which he became President in 1812. He was elected a member of the Royal Academy in London in 1814, knighted by George IV in 1822, and, in the last year of his life, appointed the King's Limner for Scotland.

Raeburn's style is highly painterly, but without the flashiness that characterizes the work of Lawrence and other British portraitists of the Romantic period. His brushwork has a life of its own: bold, unblended strokes, which read as such on the surface, surprise the viewer by creating naturalistic effects of flesh, hair, and cloth when seen at a certain distance. But the form of the

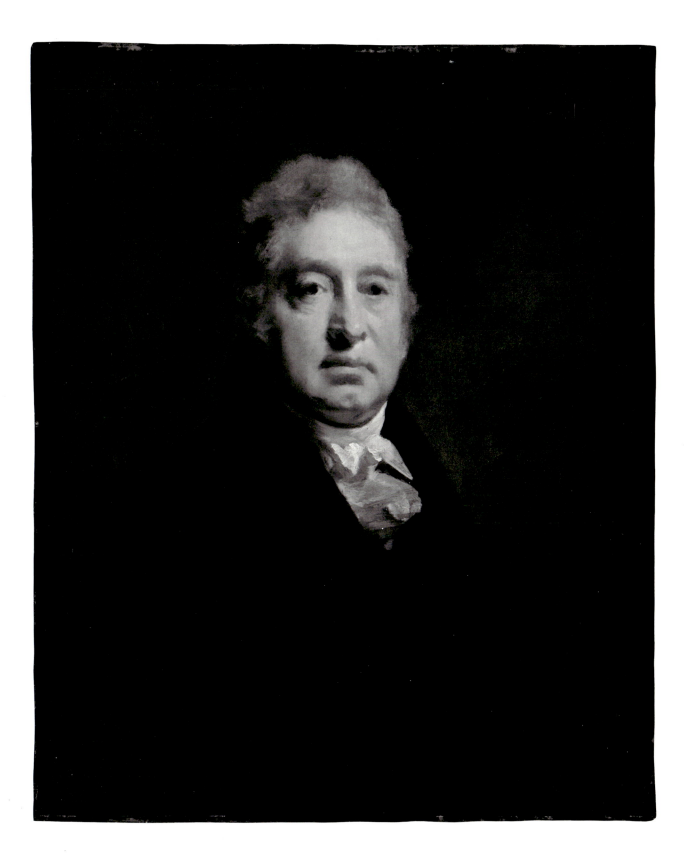

strokes, characteristically straight and even, suggests the steady recording of facts rather than dash, common sense rather than virtuosity. The effects of lighting, which Raeburn generally arranged to create strong contrasts between lit and shadowed areas rather than gentle transitions, are rendered with particular care and skill. His critics attacked him for lack of finish and, more justifiably, for his loose grasp of anatomy. His lack of formal training and habit of improvising on the canvas without working out poses beforehand no doubt contributed to this fault. His admirers, including David Wilkie, compared him to the great painterly portraitists of the seventeenth century. Writing of the similarities between British artists and Velázquez, Wilkie remarked that "of all Raeburn resembles him most, in whose square touch in heads, hands, and accessories, I see the very counterpart in the Spaniard."[4]

The changes in Raeburn's style over the course of his career are subtle and elusive, which makes his portraits difficult to date from their appearance alone. This portrait of an unidentified man relates fairly clearly, however, to the artist's work of the 1810s. Many of his bust-length male portraits of that period show just such an emphatic tonal scheme, with the head strongly illuminated against an only slightly modulated dark background, and a white stock, painted in a few deft strokes, standing out against a summarily rendered dark coat. These simple effects can be contrasted with the more elaborate lighting seen in his earlier portraits, such as the Art Institute's *Robert Brown of Newhall* (see 1980.74). The sitter in the present portrait comes across as a strong, almost tangible presence. Duncan Macmillan has related these tendencies in Raeburn's work after 1810 to the artist's deepening interest in Rembrandt.[5]

NOTES
1 The treatment was performed by Alfred Jakstas. The stretcher is inscribed in crayon as follows: *Chauncey McCormick*. There are also several labels on the back of the stretcher, which read as follows: *34309* (handwritten), *12445* (printed), *No. 13910 / PICTURE* (printed), and *No. 1258 / PICTURE* (printed, with *Raeburn* and *81530* added by hand). Another label, on the frame, is inscribed N223 (handwritten).
2 The average thread count of the original canvas is 20 x 18/sq. cm (50 x 45/sq. in.).
3 See note 1.
4 Quoted in David and Francina Irwin, *Scottish Painters at Home and Abroad, 1700–1900*, London, 1975, p. 147, from Allan Cunningham, *The Life of Sir David Wilkie*, vol. 1, London, 1843, pp. 504–05. The Irwins' chapter on Raeburn remains the fullest and most reliable account of his career.
5 Duncan Macmillan, *Painting in Scotland: The Golden Age*, Oxford, 1986, pp. 134–35.

Eleanor Margaret Gibson-Carmichael, 1802/03

Bequest of Mrs. Florence Thompson Thomas in memory of her father, John R. Thompson, Sr., 1973.314

Oil on canvas, 119.4 x 95.2 cm (47 x 37½ in.)

CONDITION: The painting is in very good condition. It has an old glue paste lining. The tacking margins have been cut off, but slight cusping on the top and bottom edges suggests that the canvas is close to its original dimensions.[1] The ground is off-white. There is a 15 x 9 cm T-shaped tear in the upper left corner of the painting. The tear and a small flake loss in the center of the girl's dress have been filled and inpainted. There are areas of cracked and cupped paint in the foliage at the upper left, and at the center right edge. The paint layer is slightly abraded throughout. The surface is somewhat obscured by a relatively thick, discolored varnish layer. (partial x-radiograph)

PROVENANCE: Commissioned by the sitter's father, Sir John Gibson-Carmichael of Skirling, sixth Bt. (d. 1803). By descent to Sir Thomas David Gibson-Carmichael, eleventh Bt., first baron Carmichael (d. 1926); sold Sotheby's, London, June 8–10, 1926, no. 496 (ill.), to Duveen, Paris and New York, for £8,800.[2] Mrs. John R. Thompson, Sr., Chicago, by 1930;[3] sold Parke-Bernet, New York, January 15, 1944, no. 33 (ill.), to her daughter, Florence Thompson Thomas (d. 1972), Palm Beach, Florida; bequeathed to the Art Institute, 1973.

REFERENCES: Sir Walter Armstrong, *Sir Henry Raeburn*, London and New York, 1901, pp. 92 (ill.), 98. James Greig, *Sir Henry Raeburn, R.A.: His Life and Works with a Catalogue of His Pictures*, London, 1911, pp. 5 (ill.), 38, 41. Alfred M. Frankfurter, "Paintings by Raeburn in America," *Antiquarian* 14, 1 (1930), p. 33 (ill.). Morse 1979, p. 219.

EXHIBITIONS: London, Colnaghi, *Pictures of the Early English and Other Schools in Aid of King Edward's Hospital Fund*, 1905, no. 8.

Eleanor Margaret Gibson-Carmichael was born in 1801, the only child of Sir John Gibson-Carmichael, sixth Bt., and his wife, Janet, née Hyndford. Sir John took the additional surname of Carmichael in conformity with the entail of their home, Skirling, which passed to him from the family of his paternal grandmother. Skirling is about twenty-five miles south of

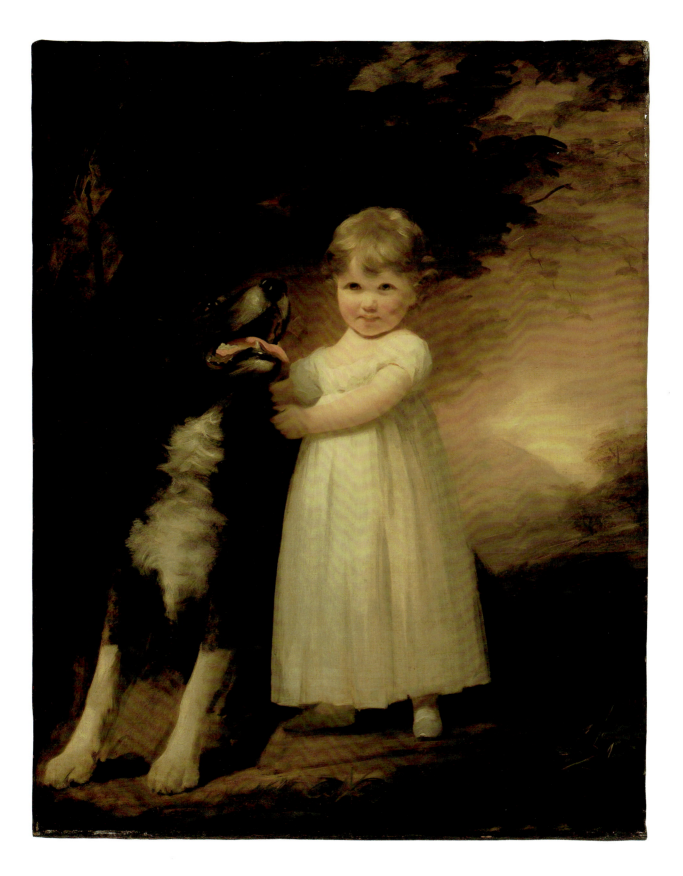

Edinburgh. The portrait is datable to 1802/03 on the basis of the girl's age, which must be about eighteen months. Her father died on November 5, 1803, aged only thirty, and was succeeded in the baronetcy by his brother, Thomas; her mother was married again, in 1806, to the twelfth baron Elphinstone. Eleanor married Alexander Begbie in 1828, and died in 1883.[4]

In its deftness and economy of technique, and the sure eye it reveals for interesting light effects, the Art Institute's portrait of Eleanor Gibson-Carmichael is an outstanding and characteristic example of Raeburn's work. The treatment of the light falling downward across the girl's face, throwing a shadow across her eyes, and the sense of a golden glow suffusing the whole scene are especially natural and impressive. The work is executed on a plain-weave canvas, although Raeburn normally preferred a twill weave. According to the Raeburn scholar David Mackie, the artist's use of a plain weave seems to be concentrated in his work of the first decade of the nineteenth century.[5]

Dogs are common enough in British portraits, but the Newfoundland at the girl's side plays a larger part than usual, both literally and symbolically. First, it helps establish the tininess of her stature. Since it looks up as if awaiting its master's command, it suggests an element of mild parody: the "master" is a little girl.[6] On another level, its presence gently likens the child's world to the world of the pet, both of them innocents, dependents, and objects of affection. As an image of childhood, *Eleanor Margaret Gibson-Carmichael* shows Raeburn inevitably measuring himself against Reynolds, whose child portraits were among his most celebrated and best-loved works. Raeburn would have been familiar particularly with the examples in the collection of the duke of Buccleuch at Bowhill, a short trip from Edinburgh, and these seem to have had a direct bearing on the conception of the Art Institute's painting. Among the numerous Reynolds portraits at Bowhill are *Elizabeth, Duchess of Buccleuch with Lady Mary Scott*; *Charles, Earl of Dalkeith*; and *Lady Caroline Scott as "Winter,"* all of which show children with dogs.[7] As Francina Irwin has pointed out, Raeburn took the first of these as the model for his early portrait *Mrs. Ferguson of Raith and Her Two Children*,[8] and the pose of Eleanor Gibson-Carmichael contains a distinct echo of that of Lady Mary Scott. But perhaps the strongest debt is to the mock-allegorical portrait of Mary's sister Caroline as the personification of Winter. The frontal simplicity of the pose in which Reynolds portrayed his sitter and the extreme simplification he brought to her facial features provided Raeburn with a compelling model of childish charm.

An autograph replica of *Eleanor Margaret Gibson-Carmichael* on the reduced scale of 30 by 25 inches is recorded in the Gibson-Carmichael family collection.[9] Raeburn also painted portraits of the girl's father, Sir John Gibson-Carmichael (currently on loan from T. M. Wheeler-Carmichael to the Scottish National Portrait Gallery, Edinburgh), his brother Sir Thomas, and Sir Thomas's wife.[10]

NOTES

1 The average thread count of the original canvas is 14 x 14/sq. cm (35 x 35/sq. in.). A typed label on the back of the stretcher bears the following inscription: *SIR HENRY RAEBURN, R.A. (1756-1823) / PORTRAIT OF MISS ELEANOR GIBSON-CARMICHAEL. (1801-1883). / From the collection of the late / LORD CARMICHAEL OF SKIRLING, K.C.M.G. / illustrated in armstrong's "raeburn", / p. 92; and in greig's "raeburn", p. 5. / engraved by scott bridgewater.* There are four other labels on the stretcher, which read as follows: *[D?]OUANE / PARIS / CENTRALE* (stamp); *28612* (handwritten in ink); *No* (printed) *[...]310B / 40 x 50 / Duveen Brothers* (in pencil); *[...] / Portrait / Raeburn.*

2 Annotated sale catalogue, Ryerson Library, The Art Institute of Chicago.

3 Frankfurter 1930, p. 33.

4 Peter Townend, ed., *Burke's Genealogical and Heraldic History of the Peerage, Baronetage, and Knightage*, 105th ed., London, 1970, pp. 482–83.

5 Letter to the author of January 23, 1991, in curatorial files.

6 In this respect the Raeburn could almost have been meant as a parody of Reynolds's *John Campbell, First Baron Cawdor* (1778; Cawdor Castle, Scotland; see Desmond Shawe-Taylor, *The Georgians: Eighteenth-Century Portraiture and Society*, London, 1990, p. 66 [ill.]). Eleanor Gibson-Carmichael's dog is virtually identical in breed, markings, and pose to Lord Cawdor's, which Cawdor is shown commanding with an outstretched arm to fetch some distant object.

7 Collection of the Duke of Buccleuch and Queensberry, Bowhill, Scotland. For reproductions, see Francina Irwin, "Early Raeburn Reconsidered," *Burl. Mag.* 115 (1973), p. 242, fig. 69, and Nicholas Penny, ed., *Reynolds*, exh. cat., London, Royal Academy of Arts, 1986, p. 276, no. 104, and fig. 77.

8 Irwin (note 7), p. 242, figs. 68–69, p. 243.

9 Armstrong 1901; Greig 1911; afterward in the possession of Sir Thomas David Gibson-Carmichael, eleventh Bt.

10 See *The Concise Catalogue of the Scottish National Portrait Gallery*, compiled by Helen Smailes, Edinburgh, 1990, pp. 58, 61 (ill.), and the 1926 sale catalogue, nos. 495, 497, and 498, respectively.

Adam Rolland of Gask II, 1800/10
Louise B. and Frank H. Woods Purchase Fund, 1977.5

Oil on canvas, 198.5 x 152.6 cm (78 1/8 x 60 1/8 in.)

CONDITION: The painting is in fair condition. The twill-weave canvas has a wax resin lining that was attached before the picture was acquired by the Art Institute.[1] The original tacking margins have been cut off, but cusping is visible on all edges, indicating that the picture is close to its original dimensions. It has a thin, cream-colored ground. The surface is disrupted by extensive drying cracks through virtually all of the dark areas, probably due to a bituminous component in Raeburn's paint mixture. It is slightly abraded throughout, although parts, such as the books and writing materials on the table, are especially well preserved. There is a small (1.5 cm long), crescent-shaped loss in the curtain at the upper right. In the areas of thick impasto, the paint has been somewhat flattened by the lining process, which has also made the canvas weave more pronounced. All of the drying cracks have been inpainted, but remain apparent. There is additional retouching on the top of the sitter's hair, both of his eyelids, the bridge of his nose, his upper lip and chin, the first two fingers of his left hand, his shirt, the back of the chair, and in the upper right and left background. The irregularities of the picture's surface are exaggerated by the varnish, which saturates it unevenly.

PROVENANCE: By descent in the sitter's family to his nephew, Adam Rolland of Gask III (d. 1837), then to the latter's son, Adam Rolland of Gask IV (d. 1890).[2] Given or bequeathed by him to the Society in Scotland for the Propagation of Christian Knowledge, after 1876. On deposit from the Society at the National Gallery of Scotland, Edinburgh, 1891–1976; sold by the Society, 1976.[3] Julius Weitzner, London, 1976–77; sold to the Art Institute, 1977.

REFERENCES: Sir Walter Armstrong, *Sir Henry Raeburn*, London and New York, 1901, p. 111. James Greig, *Sir Henry Raeburn, R.A.: His Life and Works with a Catalogue of His Pictures*, London, 1911, p. 58. Frank Rinder and W. D. McKay, *The Royal Scottish Academy, 1826–1916*, Glasgow, 1917, p. 322. William Roberts, *Adam Rolland of Gask*, Art Monographs, London, 1919, p. 9. T. C. F. Brotchie, *Henry Raeburn, 1756–1823*, London and New York, 1924, p. 96. Huntington, New York, The Heckscher Museum, *Catalogue of the Collection: Paintings and Sculpture*, Huntington, 1979, p. 132. Morse 1979, p. 220.

EXHIBITIONS: Edinburgh, Royal Academy National Galleries, *The Works of Sir Henry Raeburn, R.A.*, 1876, no. 72.[4]

Adam Rolland of Gask II was a distinguished and successful lawyer (Gask was the name of his family estate near Dunfermline). He was born in 1734, studied at Edinburgh University, and was admitted to the Faculty of Advocates in 1758.[5] Throughout his career he practiced exclusively as a consulting and writing counsel. He was a cultivated man, a zealous Presbyterian, and well known in Edinburgh society for the quaint formality of his dress and demeanor. Sir Walter Scott used him as the model, "in the external circumstances but not in frolick or fancy," for the character of Mr. Counsellor Paulus Pleydell in *Guy Mannering*, published in 1815.[6] But the most vivid description of him appears in the *Memorials* of Henry, Lord Cockburn, published in 1856:

> His dresses, which were changed at least twice every day, were always of the same old beau cut; the vicissitudes of fashion being contemptible in the sight of a person who had made up his own mind as to the perfection of a gentleman's outward covering. The favourite hues were black and mulberry: the stuffs velvet, fine kerseymere, and satin. When all got up, no artificial rose could be brighter or stiffer. He was like one of the creatures come to life again in a collection of dried butterflies. I think I see him. There he moves, a few yards backwards and forwards in front of his house in Queen Street; crisp in his mulberry-coloured kerseymere coat, single-breasted; a waistcoat of the same with large old-fashioned pockets; black satin breeches with blue steel buttons; bright morocco shoes with silver or blue steel buckles; white or quaker-grey silk stockings; a copious frill and ruffles; a dark brown, gold-headed, slim cane, or a slender green silk umbrella: every thing pure and uncreased. The countenance befitted the garb: for the blue eyes were nearly motionless, and the cheeks, especially when slightly touched by vermilion, as clear and as ruddy as a wax doll's; and they were neatly flanked by two delicately pomatumed and powdered side curls, from behind which there flowed, or rather stuck out, a thin pigtail in a shining black ribbon. And there he moves, slowly and nicely, picking his steps as if a stain would kill him, and looking timidly, but somewhat slyly, from side to side, as if conscious that he was an object, and smiling in self-satisfaction. The whole figure and manner suggested the idea of a costly brittle toy, new out of its box. It trembled in company, and shuddered at the vicinity of a petticoat. But when well set, as I often saw him, with not above two or three old friends, he could be correctly merry, and had no objection whatever to a quiet bottle of good claret. But a stranger, or a word out of joint, made him dumb and wretched.[7]

Rolland retired from the legal profession in the 1790s, still in good health, and afterward served as Deputy Governor of the Bank of Scotland. He never married. Despite increasing deafness, he maintained a warm interest in public affairs well into old age. He died in

1819 at his home in Queen Street, bequeathing some £13,000 to public institutions.

Raeburn painted several portraits of Rolland, apparently spanning a fairly long period.[8] The Art Institute's example belongs to a group of three full-length portraits in which the sitter appears at about the same relatively advanced age and, with some variations, against the same setting. Of the other two, the one closer to the Art Institute's painting—taller, but with only minor differences of detail—is in the collection of the Bank of Scotland.[9] The third shows the set of the sitter's head slightly differently, his left hand resting on the table rather than at his cheek, the quill in the inkstand rather than in his right hand, and different arrangements of books on the table and curtains in the background; its present whereabouts are unknown.[10] It seems impossible to determine the order in which these three might have been painted, although the last-mentioned makes Rolland appear slightly more aged and may therefore be the latest. By the time of the Raeburn exhibition of 1876, both the Art Institute's and the Bank of Scotland's versions of the portrait belonged to the sitter's great-nephew, Adam Rolland of Gask IV. It was probably on his death in 1890 that they were separated, the Art Institute's going to the Society in Scotland for the Propagation of Christian Knowledge, and the other passing eventually to Adam Rolland of Gask IV's grandson, Sir George Rainy, whose executors sold it out of the family in 1946.[11] It seems likely that these two similar works were both executed for the sitter's family. The third in the group was lent to the 1876 exhibition by the Misses Abercrombie and sold in 1925 by the Trustees of a Miss Abercrombie and a Miss Agnes Bruce, who may or may not have been relatives of the sitter as well.[12] It has been noted that Raeburn appears to have been especially willing to make replicas and versions of his works, as a way of supplementing his income, following the heavy financial losses he incurred in the collapse of his son Henry's business in 1808.[13]

Raeburn's portraits are notoriously difficult to date on stylistic grounds. The date given above for this work is based largely on the sitter's age—he appears to be in his sixties or seventies—and on the large scale of the work, which suggests a time when the artist was well established and receiving fairly grand commissions. The painting closely resembles Raeburn's portrait of another elderly lawyer, William MacDonald of St. Martin's (Philadelphia Museum of Art), which is datable to c. 1803.[14] MacDonald's portrait is identical in size to Rolland's and shows him seated in the same chair, which was presumably in Raeburn's studio. Its setting also consists mainly of a table and curtains, although the table is laden with papers rather than books, and the sitter's attitude and expression suggest speech rather than inspired meditation.

NOTES

1 The average thread count of the original canvas is approximately 10 x 6/sq. cm (25 x 15/sq. in.).
2 For the provenance of the work in the Rolland family, the author is indebted to an exchange of correspondence on the subject between Ellis Waterhouse, then director of the National Gallery of Scotland, and James Byam Shaw of Colnaghi (letters of March 30 and April 4, 1949, in files of the National Gallery of Scotland, Edinburgh; copies in curatorial files).
3 According to a letter from Lindsay Errington of the National Gallery of Scotland to John Maxon of November 4, 1976, in curatorial files.
4 According to Roberts (1919, p. 9), the work was also exhibited at a dealer's gallery in Edinburgh in 1859, but this is unverified. "In a notice of the picture in an Edinburgh paper," he added, "it was stated that the great Sir Robert Peel once saw it, and was so much struck by its merits that he offered £1000 for it, simply as a specimen of the Master, but from the portrait being in the possession of the family, the offer could not be entertained." Portraits by Raeburn of Adam Rolland of Gask II were shown at the Scottish Academy exhibition of 1850 (no. 1) and the Royal Scottish Academy exhibition of 1863 (no. 63), but since the lenders were not named, it is impossible to tell which they were.
5 Sir Francis J. Grant, *The Faculty of Advocates in Scotland, 1532–1943* (Scottish Record Society, vol. 74), Edinburgh, 1944, p. 182.
6 See *The Journal of Sir Walter Scott*, ed. by W. E. K. Anderson, Oxford, 1972, p. 599 (June 19, 1830). Scott had just seen one of Raeburn's portraits of Rolland at Luscar, a Rolland family home, but it is impossible to determine which one.
7 Henry Cockburn, *Memorials of His Time*, ed. and with an intro. by Karl F. C. Miller, Chicago and London, 1974, pp. 340–41.
8 In addition to the seated, full-length portraits described in the discussion, a portrait showing Rolland as a considerably younger man, half length, seated and facing to the left, holding a book in his lap (oil on canvas, 88.3 x 67.9 cm) was sold at Sotheby's, New York (Arcade Auction), July 22, 1993, no. 62 (ill.).
9 Oil on canvas, 182.7 x 147.2 cm. By descent in the sitter's family to Sir George Rainy; his executors' sale, Christie's, London, October 25, 1946, no. 109, to Colnaghi, London. Sold by Colnaghi to Ray Livingston Murphy (d. 1953), New York, 1953; Murphy estate, 1953–85. Sold Christie's, London, November 22, 1985, no. 82 (ill.), to the Bank of Scotland.
10 Sold Christie's, London, June 26, 1925, no. 72, to Arthur Tooth and Sons, London, for 1700 gns. Leggatt Brothers, London, by 1926. The mount of a photograph of the work in the Witt Library, London, is inscribed "Lord Dulverton Coll."
11 See note 9.
12 See note 10.
13 See David and Francina Irwin, *Scottish Painters at Home and Abroad, 1700–1900*, London, 1975, pp. 156–57.
14 See Richard Dorment, *British Painting in the Philadelphia Museum of Art from the Seventeenth through the Nineteenth Century*, Philadelphia and London, 1986, pp. 265–67 (ill.).

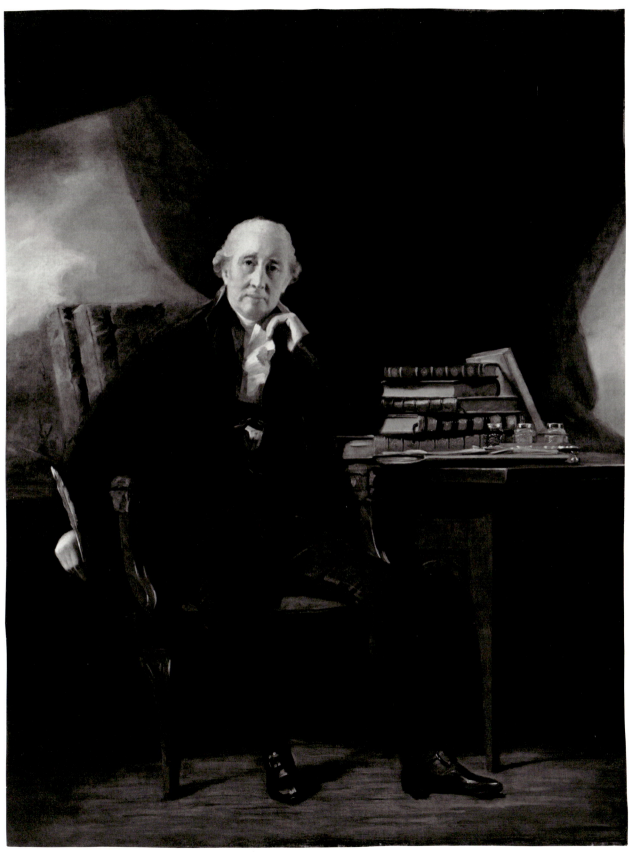

Sir Henry Raeburn, *Adam Rolland of Gask II*, 1977.5

Robert Brown of Newhall, 1792

Bequest of Evelyn Marshall Suarez in memory of her son, Marshall Field, 1980.74

Oil on canvas, 73.6 x 62.8 cm (29 x 24³/₄ in.)

CONDITION: The painting is in fair condition. The twill-weave canvas has an old glue paste lining, and the tacking margins have been cut off.[1] Cusping is visible on the top edge. The ground is white or off-white. The paint layer has been somewhat flattened by the lining process and is also severely abraded, particularly in the background at right, presumably as the result of an earlier cleaning attempt. Examination in ultraviolet light reveals extensive retouching on the left side of the sitter's face, in his hair, on his coat, and in the background at the right. The sitter's right eye has been rather crudely retouched. There is additional scattered retouching throughout the background at left. X-radiography reveals rapidly sketched strokes apparently laying in a head to the right of the sitter. (x-radiograph)

PROVENANCE: By descent in the Brown family to the sitter's grandson, Horatio Robert Forbes Brown.[2] Mrs. William Hayward, New York, by 1924;[3] on consignment to Knoedler, New York, 1924. Sold to Marshall Field III, Huntington, Long Island, 1924.[4] Evelyn Marshall Suarez, formerly Mrs. Marshall Field III (d. 1979), Easton, near Syosset, Long Island, and New York;[5] bequeathed to the Art Institute in memory of her son, Marshall Field IV, 1980.

REFERENCES: Sir Walter Armstrong, *Sir Henry Raeburn*, London and New York, 1901, p. 97. James Greig, *Sir Henry Raeburn, R.A.: His Life and Works with a Catalogue of His Pictures*, London, 1911, p. 39. Richard Pratt, *David Adler*, New York, 1970, p. 164, pl. 124.

EXHIBITIONS: New York, Knoedler, *Loan Exhibition of Pictures by Raeburn*, 1925, no. 13.

This, the earliest of the Raeburns in the Art Institute's collection, shows the artist's already well-developed ability to suggest intelligence and thought in his sitter's features. He seems to have been uncomfortable with the pomp and grandeur of aristocratic portraiture, and among his male sitters succeeded best with the lawyers, men of letters, and academics who formed such a significant part of his clientele. Robert Brown was both a lawyer and a man of letters. The son of a Glasgow merchant, he was admitted to the Faculty of Advocates in Edinburgh in 1780. He married Elizabeth, daughter of Alexander Kerr, and their son Hugh Horatio Brown also became a lawyer.[6] Robert Brown's principal literary achievements were the plays *Mary's Bower* (published 1811), *Henry, Lord Darnley*, and *John, Earl of Gowrie* (both published c. 1823–24).[7] His estate of Newhall was to the south of Edinburgh, near Penicuik. He died in 1834.

The portrait is identified as that of Robert Brown and dated 1792 in an old inscription on a label on the stretcher.[8] With its broad, blocky brushwork—Raeburn's "square touch," in David Wilkie's memorable phrase[9]— the work accords readily with other works of the artist's early maturity, and the inscribed date seems completely plausible. In the treatment of the head, stock, and coat, it can be compared, for instance, to the portrait of Sir John Clerk in the celebrated double portrait *Sir John and Lady Clerk of Penicuik*, painted in 1791.[10] As in much of his work, Raeburn's characteristic twill-weave canvas serves as a unifying element, its texture showing through the paint surface over most of the image. Another typical feature is the treatment of the face in a considerably softer technique than that used on the rest of the figure: the most radical economies of brushwork are reserved for the hair, the coat, and the piece of paper in the sitter's hand, which presumably is a legal document.

Both Armstrong (1901) and Greig (1911) recorded an engraving after this work by W. H. Lizars, but no impression has come to light. A later portrait of Robert Brown attributed to Raeburn, showing him with his son in an outdoor setting, was on the London art market in 1927.[11]

NOTES

1 The average thread count of the original canvas is 13 x 20/sq. cm (32 x 50/sq. in.). A handwritten label on the back of the stretcher reads as follows: *Robert Brown / of Newhall 1792 / by Henry Raeburn.* A printed label reads: *No. 4 [?] / PICTURE.* Five further printed labels, on the back of the frame, read as follows: *No. 41811 / FRAME; No. 22593; No. 21498; No. 15150;* and *No. 16318.*

2 Armstrong (1901) gave the owner as "Mr. Brown," and Greig (1911) as "H. Brown." On Horatio Brown, see *DNB 1922–1930*, under "Brown, Horatio Robert Forbes."

3 Melissa De Medeiros, librarian at Knoedler (letter of January 6, 1995, in curatorial files) identified the label *No. 15150* as having been assigned when the painting was received by Knoedler from Mrs. Hayward.

4 Information kindly supplied by Melissa De Medeiros; see note 3.

5 For a photograph of the library at Easton, showing the portrait hanging over the mantelpiece, see Pratt 1970, pl. 124.

6 See Sir Francis J. Grant, *The Faculty of Advocates in Scotland, 1532–1943* (Scottish Record Society, vol. 74), Edinburgh, 1944, pp. 21–22.

7 See Ralston Inglis, *The Dramatic Writers of Scotland*, Glasgow, 1868, p. 21.

8 See note 1.

9 Quoted in David and Francina Irwin, *Scottish Painters at Home and Abroad, 1700–1900*, London, 1975, p. 147, from Allan Cunningham, *The Life of Sir David Wilkie*, vol. 1, London, 1843, pp. 504–05.

10 Dublin, National Gallery of Ireland, from the Beit Collection; see Irwin (note 9), pl. 62.

11 Sold by Colnaghi at Robinson and Fisher, London, June 16, 1927, no. 190. From a photograph in the Witt Library, London.

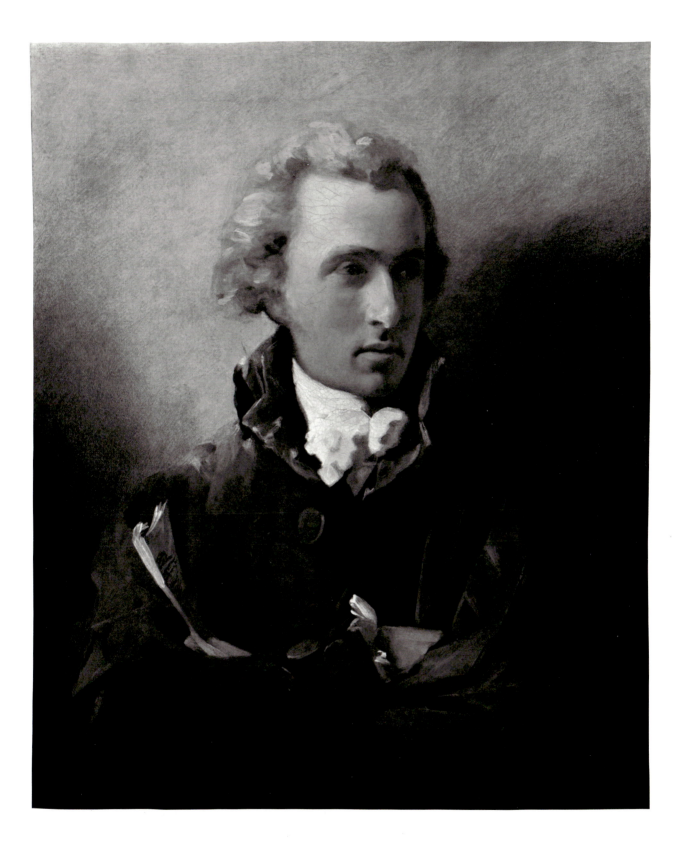

John Rathbone and George Morland

c. 1750 Cheshire–London 1807
1763 London 1804

Landscape with Figures Crossing a Bridge, 1790/1800

Gift of Walter T. Fisher, 1962.967

Oil on panel, 30.2 x 41 cm (11$^{15/16}$ x 16$^{1/8}$ in.)

INSCRIBED: *Rathbone / & / Morland* (in brown paint, in trees near right edge)

CONDITION: The painting is in very good condition. It has not been treated since it entered the museum's collection. The panel has a slight convex warp and a pronounced horizontal wood grain that is visible through the thinly painted surface. The ground layer is cream-colored with a pink cast. A fine vertical scratch, 8 cm long, in the paint and ground layers is visible in the sky above the dead tree. The paint layer appears to have been slightly thinned by cleaning in the trees at the upper left. Traces of a natural resin varnish remain over the foliage at the lower corners. Two vertical drips have etched the varnish to the right of center and to the left of the dead tree. The signature is thin and worn, but appears to be original. A band of brighter blue paint that had been covered by the frame rabbet suggests that the blue of the sky has faded. (x-radiograph)

PROVENANCE: See below.

Landscape with Fisherman and Washerwoman, 1790/1800

Gift of Walter T. Fisher, 1962.968

Oil on panel, 30.4 x 40.8 cm (12 x 16$^{5/16}$ in.)

INSCRIBED: *J. R. / G Morland* (in red paint, lower right)

CONDITION: The painting is in very good condition. It has not been treated since it entered the museum's collection. The panel has a slight convex warp and a pronounced horizontal wood grain that is visible through the thinly painted surface. The ground layer is cream-colored with a pink cast. A fine curved scratch, 4 cm long, in the paint and ground layers is visible in the clouds above the trees just left of center. Localized retouching over this scratch is discolored. Traces of a natural resin varnish remain over the foliage. The signature, which is better preserved than that of 1962.967, appears to be original. A band of brighter blue paint that had been covered by the frame rabbet suggests that the blue of the sky has faded. (x-radiograph)

PROVENANCE: Walter T. Fisher, Winnetka, Illinois; given to the Art Institute, 1962.

REFERENCES: J[ohn] M[axon], "Recent Acquisitions," *AIC Quarterly* 57, 4 (1963/64), n. pag. (1962.968 ill.).

This pair of landscapes is the work of John Rathbone, with the figures added by George Morland. The delicately atmospheric landscape style is consistent with the body of Rathbone's work, and the figures, though small, are distinctively Morlandesque. Rathbone was a prolific painter of landscapes in both oil and watercolor. Before settling in London, he was based for periods in Preston and Manchester, where he acquired the far-fetched nickname of "the Manchester Wilson." From 1785 until his death, he regularly showed works at the Royal Academy, often exhibiting views of picturesque scenery in the Lake District or Wales. Morland was not only his occasional collaborator but also, reputedly, a boon companion (Morland's work and character are discussed under 1987.92.3 above).[1] Rathbone seems fairly commonly to have enlisted other artists to supply figures for his landscapes, even though those in works signed by him alone appear competently executed. Another of his collaborators was Julius Caesar Ibbetson.[2]

NOTES
1 Rathbone showed a view in the Harrow Road with figures by Morland at the Royal Academy in 1792; see Algernon Graves, *The Royal Academy of Arts: A Complete Dictionary of Contributors and Their Work from Its Foundation in 1769 to 1904*, vol. 6, London, 1906, p. 238. For another example of their collaboration, see the *Wooded Landscape with Gypsies*, sold at Christie's, London, June 27, 1980, no. 89 (ill.).
2 A pair of Rathbone landscapes on panel with figures by Ibbetson were with Leger Galleries, London, in 1976 (photographs in the Witt Library, London).

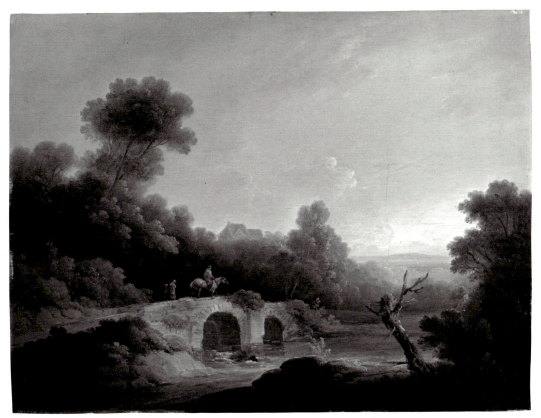

John Rathbone and George Morland, *Landscape with Figures Crossing a Bridge*, 1962.967

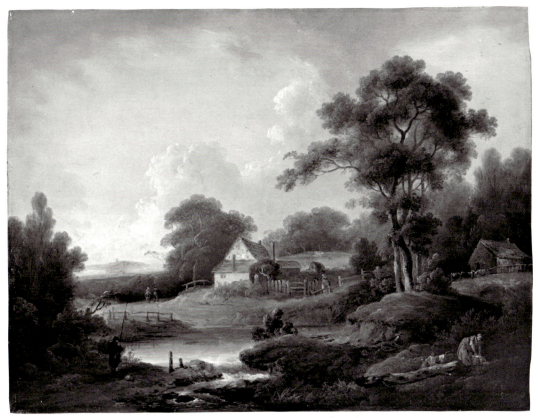

John Rathbone and George Morland, *Landscape with Fisherman and Washerwoman*, 1962.968

Sir Joshua Reynolds

1723 Plympton, Devon–London 1792

Lady Sarah Bunbury Sacrificing to the Graces, 1763–65

Mr. and Mrs. W. W. Kimball Collection, 1922.4468

Oil on canvas, 242.6 x 151.5 cm (95½ x 59¾ in.)

CONDITION: The painting is in fair condition. It was cleaned at the Art Institute in 1977–78, when a glue paste lining was replaced with a wax resin one.[1] Presumably when the glue paste lining was applied, the original tacking margins were extended to enlarge the picture to its present dimensions. The original dimensions of the painting were approximately 237.6 x 146 cm. The tacking margins, 2.5 cm wide at the top, bottom, and right and 3 cm wide at the left, have been filled and inpainted, as have a T-shaped tear (16.5 x 7.2 cm) in the background above Lady Sarah's head and a smaller (6.3 cm), vertical tear to the right of the first. The canvas was prepared with an off-white ground. Some areas of the paint surface have been severely abraded by previous cleaning, especially in the background architecture, the foliage, and the figures of the Three Graces. Examination in ultraviolet light reveals extensive overpainting in all of these areas except for the foliage. The paint surface is better preserved in Lady Sarah's dress and in her acolyte's head, which remains in a very good state. A variation in the color of the flesh between Lady Sarah and her acolyte may indicate that the tonal qualities of the paint have been somewhat altered by time or treatment. There is localized retouching scattered through the lower drapery folds of Lady Sarah's dress, and a more concentrated area to the left of her acolyte's face. A few relatively small areas of wide drying cracks are apparent in some of the shadows. The numerous *pentimenti* include shifts in the placement of Lady Sarah's left shoulder and arm, which were higher, as were her right hand and forearm. X-radiography reveals that Lady Sarah's libation dish was formerly lower with her index finger raised, that her acolyte's dish was slightly higher, and that the knot of hair at the top of Lady Sarah's coiffure was added in the course of work. Examination with infrared reflectography reveals underdrawing in a dry medium in the architecture and the Three Graces, whose heads and shoulders have been repositioned. These changes are also detectable through the thinned paint surface. (infrared, mid-treatment, ultraviolet, partial x-radiograph)

PROVENANCE: Commissioned by Sir Thomas Charles Bunbury, sixth Bt. (d. 1821), husband of the sitter, apparently for 250 gns.[2] By descent to his nephew's grandson, Sir Henry Charles John Bunbury, tenth Bt., Barton Hall and Mildenhall, Suffolk, to at least 1905.[3] Charles J. Wertheimer (d. 1911), London, by 1908;[4] sold Christie's, London, May 10, 1912, no. 63, to Sulley.[5] Henry Reinhardt Gallery, New York and Chicago. Sold by Reinhardt to Mrs. W. W. Kimball (d. 1921), Chicago, 1915;[6] on loan to the Art Institute from 1920; bequeathed to the Art Institute, 1922.

REFERENCES: Pierre Jean Grosley, *A Tour, to London; or, New Observations on England, and Its Inhabitants*, tr. by Thomas Nugent, vol. 2, London, 1772, p. 39. William Jackson, *The Four Ages, Together with Essays on Various Subjects*, London, 1798, pp. 172–73. Edward Edwards, *Anecdotes of Painters who have resided or been born in England with remarks on their productions*, London, 1808, p. 189. James Barry, *The Works of James Barry, Esq., Historical Painter*, vol. 1, London, 1809, p. 22. John Heneage Jesse, *George Selwyn and His Contemporaries*, vol. 2, London, 1843, ill. (engraving of detail by J. Cook) opp. p. 88. William Cotton, *Sir Joshua Reynolds and His Works*, London, 1856, p. 100. William Cotton, *A Catalogue of the Portraits Painted by Sir Joshua Reynolds, Knt., P.R.A.*, London, 1857, p. 12. Charles Robert Leslie and Tom Taylor, *Life and Times of Sir Joshua Reynolds, with Notices of Some of His Contemporaries*, vol. 1, London, 1865, pp. 247–48, 250. Algernon Graves and William Vine Cronin, *A History of the Works of Sir Joshua Reynolds, P.R.A.*, vol. 1, London, 1899, pp. 124–25. Sir Walter Armstrong, *Sir Joshua Reynolds, First President of the Royal Academy*, London and New York, 1900, ill. (photogravure) opp. p. 20, pp. 167, 196. Sir Walter Armstrong, *Sir Joshua Reynolds, First President of the Royal Academy*, London and New York, 1905, p. 204, ill. opp. p. 204. Alfred Lys Baldry, *Sir Joshua Reynolds*, vol. 1, London and New York, 1905, p. xxix. Max Osborn, *Joshua Reynolds*, Bielefeld and Leipzig, 1908, p. 110, fig. 85. Freeman O'Donoghue, *Catalogue of Engraved British Portraits Preserved in the Department of Prints and Drawings in the British Museum*, vol. 3, London, 1912, p. 309. *The Year's Art 1913*, compiled by A. C. R. Carter, London, 1913, p. 371. "Mrs. Kimball Buys a Reynolds," *American Art News* 14, 5 (1915), p. 1 (ill.). "The Kimball Collection," *AIC Bulletin* 14, 5 (1920), pp. 75 (ill.), 77. AIC 1920, p. 60, no. 765. AIC 1922, p. 65, no. 765. AIC 1923, p. 65, no. 765. AIC 1925, pp. 29 (ill.), 150, no. 765. W. T. Whitley, *Artists and Their Friends in England, 1700–1799*, vol. 1, London, 1928, p. 209. AIC 1932, pp. 83 (ill.), 169. Edgar Wind, "Humanitätsidee und heroisiertes Porträt in der englischen Kultur des 18. Jahrhunderts," in *Vorträge der Bibliothek Warburg 1930/1931: England und die Antike*, ed. by Fritz Saxl, Berlin and Leipzig, 1932, pp. 217–18. Ellis K. Waterhouse, *Reynolds*, London, 1941, pp. 12, 55–56, 101. Charles Mitchell, "Three Phases of Reynolds's Method," *Burl. Mag.* 80 (1942), p. 40. Nikolaus Pevsner, "Heritage of Compromise: A Note on Sir Joshua Reynolds Who Died One Hundred and Fifty Years Ago," *Architectural Review* 91 (1942), pp. 37–38 (ill.). AIC 1945, p. 34. AIC 1948, p. 31. "Loan Exhibition of Great Portraits Sponsored by Friends of the Institute,"

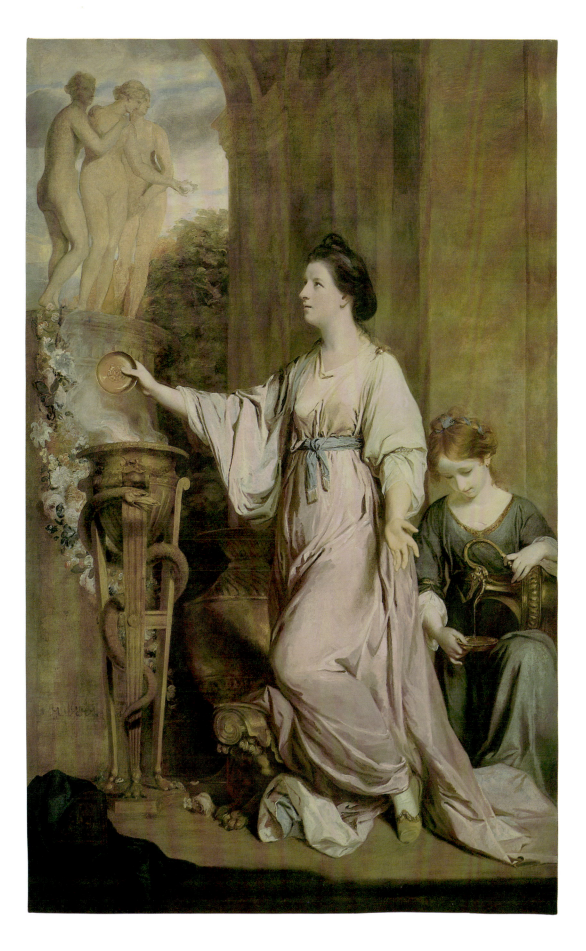

Bulletin of The Minneapolis Institute of Arts 41 (1952), p. 152.
Ellis K. Waterhouse, *Painting in Britain, 1530 to 1790*, London,
1953, pp. 168, 187, pl. 131. AIC [1956], p. 32. Nikolaus Pevsner,
The Englishness of English Art, London, 1956, pp. 52–53, fig.
23. Derek Hudson, *Sir Joshua Reynolds: A Personal Study*,
London, 1958, pp. 85, 175. Joseph T. A. Burke, "Romney's Leigh
Family (1768): A Link between the Conversation Piece and the
Neo-Classical Portrait Group," *Annual Bulletin of the National
Gallery of Victoria* 2 (1960), pp. 10 (ill.), 11, 13. AIC 1961,
p. 399. David Irwin, *English Neoclassical Art, Studies in
Inspiration and Taste*, London, 1966, pp. 77, 88, 152, 155, pl. 88.
Frederick A. Sweet, "Great Chicago Collectors," *Apollo* 84
(September 1966), pp. 195–96. Ann Hope, "Cesare Ripa's
Iconology and the Neoclassical Movement," *Apollo* 86 (October
1967), suppl. 9, "Notes on British Art," p. 4. Maxon 1970, pp. 60
(ill.), 61, 285. Wilmarth Sheldon Lewis, *See for Yourself*, New
Haven, 1971, pp. 60–70 (ill.). Anita Brookner, *Greuze: The Rise
and Fall of an Eighteenth-Century Phenomenon*, London,
1972, p. 112. Ellis K. Waterhouse, *Reynolds*, Oxford and New
York, 1973, pl. 37, p. 177. David Piper, ed., *The Genius of British
Painting*, London and New York, 1975, p. 166 (ill.). Joseph
Burke, *English Art, 1714–1800*, Oxford, 1976, p. 206. Morse
1979, pp. 236–37 (ill.). Aileen Ribeiro, *The Dress Worn at
Masquerades in England, 1730 to 1790, and Its Relation to
Fancy Dress in Portraiture*, New York and London, 1984, p. 272,
ch. 5, fig. 44. Richard Dorment, *British Painting in the Phila-
delphia Museum of Art from the Seventeenth through the
Nineteenth Century*, Philadelphia and London, 1986, p. 294,
under no. 82. Robin Simon, *The Portrait in Britain and
America, with a Biographical Dictionary of Portrait Painters,
1680–1914*, Oxford, 1987, pp. 76, 84, 103, 139, pl. 22, fig. 96.
Albert Boime, *Art in an Age of Revolution, 1750–1800*,
Chicago and London, 1987, p. 200, fig. 3.5. *AIC Master Paint-
ings* 1988, p. 43 (ill.). Malcolm Warner, "The Sources and
Meaning of Reynolds's *Lady Sarah Bunbury Sacrificing to the
Graces*," *AIC Museum Studies* 15 (1989), pp. 7–19, figs. 1, 5.
Desmond Shawe-Taylor, *The Georgians: Eighteenth-Century
Portraiture and Society*, London, 1990, pp. 165–72 (ill.). Renate
Prochno, *Joshua Reynolds*, Weinheim, Germany, 1990, pp.
84–85, fig. 50. John Hayes, *The Portrait in British Art:
Masterpieces Bought with the Help of the National Art
Collections Fund*, exh. cat., London, National Portrait Gallery,
1991, pp. 21, 100, under no. 33, fig. 14. Peter Cannon-Brookes,
ed., *The Painted Word: British History Painting, 1750–1830*,
exh. cat., London, Heim Gallery, 1991, p. 55, under no. 13.
Martin Postle, "The Golden Age, 1760–1790," in *The British
Portrait, 1660–1960*, intro. by Roy Strong, Woodbridge, 1991,
p. 193, pl. 180. Stephen Butler, *Gainsborough*, London, 1992,
p. 7 (ill.). AIC 1993, p. 141 (ill.). Katherine Hart, *James Gillray:
Prints by the Eighteenth-Century Master of Caricature*, exh.
cat., Hanover, N. H., Hood Museum of Art, 1994, pp. 11–12,
fig. 2. Martin Postle, *Sir Joshua Reynolds: The Subject Pictures*,
Cambridge, 1995, p. 312.

Exhibitions: London, Society of Artists, 1765, no. 104, as
"A lady sacrificing to the graces, whole length." London, Royal
Academy of Arts, *Works by the Old Masters and Deceased
Masters of the British School*, 1908, no. 153. The Minneapolis
Institute of Arts, *Great Portraits by Famous Painters*, 1952,

no. 22. Detroit Institute of Arts, *Romantic Art in Britain:
Paintings and Drawings, 1760–1860*, 1968, no. 6, traveled to
Philadelphia. The Art Institute of Chicago, *European Portraits,
1600–1900, in The Art Institute of Chicago*, 1978, no. 8. Lon-
don, Royal Academy of Arts, *Reynolds*, 1986, no. 57, cat. by
Nicholas Penny, entry by David Mannings.

The son of a schoolmaster, Reynolds moved to London
in 1740 to study under Thomas Hudson, then, from
1743, worked for periods as an independent portraitist in
London and in his native Devon. In 1749 Commodore
Augustus Keppel invited Reynolds to accompany him to
the Mediterranean and Italy, an opportunity he seized
with enthusiasm and exploited to the full; he remained
in Italy until 1752, immersed himself in the study of
classical and Renaissance art, and laid the foundations
for a highly distinguished career as both artist and theo-
rist. After his return to London, he painted a showpiece
portrait of Keppel in a pose derived from the *Apollo
Belvedere* (Rome, Museo Vaticano), and his work from
that point onward was full of learned and ingenious
allusions to the art of the past.[7] A member of the literary
circle around Samuel Johnson, Reynolds commanded
respect not only for his skill as a painter, but also for his
intellect and professional poise, qualities that equipped
him well for the presidency of the new Royal Academy,
which he held from its foundation in 1768 until his
death. In his presidential "Discourses" (delivered annu-
ally until 1772 and thereafter biennially), he urged the
students of the Academy Schools to follow in the ideal-
izing tradition of art stemming from Renaissance Italy.
His own genius lay less in history painting itself, how-
ever, than in the adaptation of narrative ideas, poses,
and costumes from the "higher" branches of art to the
practice of portraiture. He was knighted in 1768 and
appointed Principal Painter to the King in 1784.

When Reynolds's portrait of Lady Sarah Bunbury was
shown at the annual exhibition of the Society of Artists
in 1765, it was the fullest expression to date of his ability
to fuse portraiture and history painting in a manner
highly flattering to his female sitters. Lady Sarah, born
Lady Sarah Lennox (1745–1826), was the fourth daugh-
ter of the second duke of Richmond, and grew up with
her eldest sister, Caroline, Lady Holland, at Holland
House, Kensington. A celebrated beauty, she attracted
the attention of the future King George III when she was
only fifteen. He evidently wished to marry her, but was
persuaded that it would be imprudent to choose an
Englishwoman as his future queen.[8] Instead he was
betrothed to a German princess, Charlotte Sophia of

Mecklenburg-Strelitz, and Lady Sarah was one of the bridesmaids at their wedding in 1761. On June 2, 1762, then aged seventeen, she married Thomas Charles Bunbury; he succeeded to his baronetcy in the following year. Bunbury was apparently more attentive to his racehorses than to his wife, and in 1769 Lady Sarah eloped with her cousin Lord William Gordon after giving birth to an illegitimate daughter. She never returned to Bunbury, in spite of his willingness to take her back, and they were divorced in 1776. In 1781 she was married again, to Captain the Hon. George Napier; by him she had eight more children, three of whom had illustrious careers in the British Army. Mrs. Henry Thrale remarked cattily of Lady Sarah that she "never *did* sacrifice to the Graces; her face was gloriously handsome, but she used to play cricket and eat beefsteaks on the Steyne at Brighton."[9]

Lady Sarah is shown dressed in a loose, vaguely Roman costume, making a sacrifice before an altar of the Three Graces. Half-kneeling, she pours from her libation dish or *patera* into a flaming tripod; an acolyte prepares a further libation or perhaps a bowl of water in which Lady Sarah will wash her hands as the next part of the ritual. The portrait was warmly praised by contemporaries.[10] The idea of presenting a portrait as a sacrifice scene came naturally at a time when allusion to the devotions of the ancients was virtually a commonplace of European art and literature, especially to an artist whose mind was as steeped in antiquity as Reynolds's. It has been suggested that the artist was influenced in his portrait of Lady Sarah by the French

painter Joseph Marie Vien, several of whose paintings of young women of ancient Greece making offerings were exhibited in the Paris Salons of the early 1760s and popularized through engravings.[11] For the basic staging of the work, with the celebrant holding out a *patera* over flames and a statue on a plinth behind serving as the object of devotion, Reynolds doubtless referred to a Roman sacrifice scene such as the relief on the Arch of Constantine showing the Emperor Trajan sacrificing to Diana.[12]

In his *Anecdotes of Painters*, published in 1808, Edward Edwards remarked that with this work Reynolds "introduced into his portraits a style of gallant compliment, which proved that as a painter he well knew how to ensure the approbation of the distinguished fair."[13] The compliment lay in the implication that Lady Sarah shared the qualities of beauty, charm, naturalness, and generosity that were associated with the deities she is shown worshiping. The sculptural group seems to be coming alive for the occasion, and the Graces themselves to be responding in a kindly manner to their devotee; the central one seems to be holding out a wreath in exchange for Lady Sarah's libation. Reynolds would have derived the general appearance of the Three Graces from the standard classical precedent, the *Borghese Graces*, now in the Louvre, although the figure on the right clearly alludes to the *Venus de' Medici* in the Uffizi.[14] In showing them turned more or less in the same direction rather than alternately, however, he departed from almost all artistic images of the Graces. It is as if the Borghese Graces had rearranged themselves to include

Fig. 1 Relief showing the Three Graces and a fourth female figure, engraving from Bernard de Montfaucon, *L'Antiquité expliquée et représentée en figures*, Paris, 1719, vol. 1, pl. 110

Fig. 2 Tripod, engraving from Bernard de Montfaucon, *L'Antiquité expliquée et représentée en figures*, Paris, 1719, vol. 2, pl. 52

Lady Sarah in their circle, and were offering her the wreath as a symbol of her initiation as a fourth Grace.

The phrase "sacrifice to the Graces" was in common parlance among educated people as a classical expression of the eighteenth-century principle of being charming at all costs.[15] There also existed a tradition in both literature and art of complimenting women by likening them to a fourth Grace.[16] Of particular importance here is a relief showing the Graces with a fourth female figure who may be a bride, inscribed *AD SORORES IIII* ("To the Four Sisters"), that was published in Bernard de Montfaucon's vast illustrated encyclopedia of the ancient world, *L'Antiquité expliquée et representée en figures* (fig. 1).[17] We know Reynolds consulted this work, since the tripod at which Lady Sarah makes her sacrifice (fig. 2), the *acerra* or incense box in the lower left corner, and the *praefericulum* or ceremonial pitcher held by the acolyte are all derived from Montfaucon's illustrations.[18]

To modern taste, the idea of casting a young Englishwoman as the fourth Grace may seem slightly absurd, and it is tempting to "excuse" Reynolds by regarding the absurdity as deliberate, in other words, to read the portrait as mock-heroic.[19] We all know, as Reynolds's audience knew, that the scene is make-believe and the compliment overstated. But the mock-heroic deals in a far more pronounced mismatch of form to content. A mock-heroic portrait would be one in which the trappings of greatness made the sitter look ignominious, as in Reynolds's early parody of Raphael's *School of Athens* with likenesses of English *milordi* in Rome.[20] With Lady Sarah, we are surely meant to read the casting as with, rather than against type, the overstatement as charming rather than ridiculous. We take the image to reflect some of the qualities the lady possessed though not their exact measure. This is what Edwards meant when he described the compliment contained in

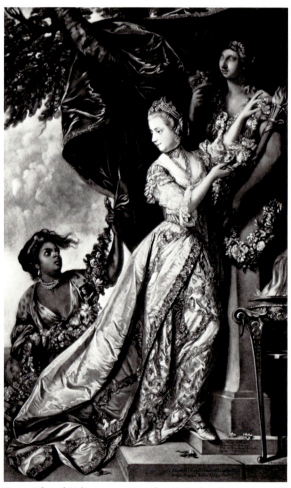

Fig. 3 Edward Fisher, mezzotint after Sir Joshua Reynolds, *Lady Elizabeth Keppel Decorating a Statue of Hymen with Flowers*, British Museum, London [photo: © British Museum, London]

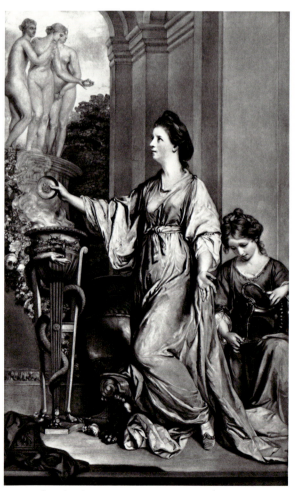

Fig. 4 Edward Fisher, mezzotint after Sir Joshua Reynolds, *Lady Sarah Bunbury Sacrificing to the Graces*, Fitzwilliam Museum, Cambridge

Lady Sarah's portrait as "gallant."

As Desmond Shawe-Taylor has pointed out, there is an element of playacting in the work that may echo the amateur theatricals put on by Lady Sarah and her circle.[21] It is interesting to note that for one of these performances, a play about Jane Shore performed at Holland House, with Lady Sarah and her intimate friend Lady Susan Fox-Strangways taking the female roles, Lady Sarah's costume, in this case fifteenth-century rather than classical, was borrowed from another of the antiquarian works published by Montfaucon.[22]

It is highly probable that many of the visitors to the Society of Arts exhibition in 1765 knew that Lady Sarah had attracted the admiration of the young king. Reynolds's decision to exhibit such a "gallant compliment" to the lady very likely reflects a shrewd assessment of the attention it would receive. The portrait was engraved in mezzotint by Edward Fisher (fig. 4), the mezzotint perhaps forming a pair with another by Fisher after Reynolds's *Lady Elizabeth Keppel Decorating a Statue of Hymen with Flowers* (fig. 3).[23] In the latter portrait, exhibited at the Society of Arts in 1762, the sitter is shown honoring the god of marriage in the bridesmaid's dress she had worn, along with Lady Sarah, at the king's wedding in 1761.

Beginning with Reynolds's biographers C. R. Leslie and Tom Taylor, the figure of the acolyte has frequently been interpreted as a portrait of Lady Sarah's friend Lady Susan Fox-Strangways.[24] As Nicholas Penny has pointed out, the acolyte in fact bears little physical resemblance to Lady Susan and it is unlikely in any case that she would be cast in such a lowly role.[25] It is far more probable that the acolyte is a generalized ancillary figure, a supposition confirmed by other Reynolds portraits, such as his *Mrs. Peter Beckford* (Port Sunlight, Lady Lever Art Gallery), where a similar figure is even more emphatically subordinated.[26] The portrait of Mrs. Beckford is one of a number of Reynolds's subsequent works that are indebted to his portrait of Lady Sarah Bunbury. Another is the portrait of Sir Charles Bunbury's sister Annabella Blake as Juno.[27] A painting of a sacrifice scene attributed to Angelica Kauffman, clearly based on the Reynolds, but with a statue of Minerva substituted for the Graces and a table for the acolyte, is in the Fundación Colección Thyssen-Bornemisza, Madrid.[28]

NOTES

1 The painting was treated by Alfred Jakstas. The average thread count of the original canvas is 14 x 15/sq. cm (35 x 38/sq. in.).

2 From the artist's ledgers, Fitzwilliam Museum, Cambridge. See Malcolm Cormack, "The Ledgers of Sir Joshua Reynolds," *Walpole Society* 42 (1968–70), pp. 112, 145; and David Mannings in the 1986 exhibition catalogue, no. 57. The artist's pocket book for 1763, in which the first and most important sittings were probably recorded, is lost. In 1764, appointments with Lady Sarah are recorded under June 28 and 29, although the first was probably social and the second was canceled; further appointments are recorded under January 17 and 22, 1765. The record of payments is complicated by the fact that Lady Sarah's husband commissioned and paid for portraits of himself and other family members around the same time. To summarize, it seems that the price for the portrait was 250 guineas — described by Mannings as "much more than was normal for a whole-length portrait at that date" — and that Bunbury made the payment between 1769 and 1773, possibly in several installments, even though Lady Sarah had eloped with Lord William Gordon in 1769.

3 Armstrong 1905, opp. p. 204.

4 1908 exhibition catalogue, no. 153.

5 1986 exhibition catalogue, no. 57.

6 See *American Art News* 1915.

7 For the *Portrait of Commodore Keppel*, now in the National Maritime Museum, Greenwich, see the 1986 exhibition catalogue, no. 19. Reynolds's use of this source and his originality in so doing have recently been debated; see Simon 1987, pp. 78–81, and Martin Postle, "An Unpublished Letter by Sir Joshua Reynolds," *Apollo* 141 (June 1995), p. 11–18.

8 For Lady Sarah and George III, see the memoir of Henry Fox printed in The Countess of Ilchester and Lord Stavordale, *The Life and Letters of Lady Sarah Lennox, 1745–1826*, vol. 1, London, 1901, pp. 26–30, 46–51, and Lady Sarah's own letters to her close friend Lady Susan Fox-Strangways, ibid., pp. 99–109. That the young prince did entertain the hope of marrying Lady Sarah and was persuaded against it in the winter of 1759/60, before the death of his grandfather George II, is clear from his correspondence with his tutor Lord Bute; see *Letters from George III to Lord Bute, 1756–1766*, intro. by Romney Sedgwick, London, 1939, esp. pp. 37–39. For biographies of Lady Sarah, see Ilchester and Stavordale (this note) and the 1986 exhibition catalogue, pp. 214, 224–26, under nos. 48 and 57.

9 H. L. Piozzi, formerly Thrale, *Autobiography, Letters, and Literary Remains*, ed. by A. Hayward, 2d ed., vol. 2, London, 1861, p. 173n.

10 For positive reactions to the picture in the 1765 Society of Arts exhibition, see Grosley 1772, p. 39; Barry 1809, p. 22; and Lewis 1971, p. 67, for Walpole's favorable note.

11 See Burke 1960, pp. 11, 14; Brookner 1972, p. 112; and Robert Rosenblum, "Reynolds in an International Milieu," in the 1986 exhibition catalogue, pp. 48–49. For Vien's sacrifices *à la grecque*, see Thomas W. Gaehtgens and Jacques Lugand, *Joseph-Marie Vien, Peintre du Roi (1716/1809)*, Paris, 1988, pp. 78–86 and nos. 175, 182–186 (ill.).

12 For engravings after the Arch of Constantine relief, see Warner 1989, p. 14, fig. 9, and Phyllis Pray Bober and Ruth Rubinstein, *Renaissance Artists and Antique Sculpture: A Handbook of Sources*, London and Oxford, 1986, no. 182e-viii (ill.). David Mannings (1986 exhibition catalogue) has pointed out that the portrait also echoes seventeenth-century Italian painting, especially in the similarity of the setting to that of Pietro da Cortona's fresco of Saint Bibiana refusing to sacrifice to pagan idols (Rome, Santa Bibiana) and in the Guido Reni-like treatment of Lady Sarah's features. For the fresco, which was engraved by G. B. Mercati, see Giuliano Briganti, *Pietro da Cortona, o, della pittura barocca*, 2d ed., Florence, 1982, pp. 167–70, no. 12, pl. 38.

13 Edwards 1808, p. 189.

14 See Warner 1989, p. 13, figs. 7–8. On the *Borghese Graces*, see
 also Sylvia Pressouyre, "Les Trois Grâces Borghèse du Musée
 du Louvre: Un Groupe antique restauré par Nicolas Cordier en
 1609," *GBA* 6th ser., 71 (1968), p. 148, fig. 1. For the *Venus de'
 Medici*, see Francis Haskell and Nicholas Penny, *Taste and the
 Antique: The Lure of Classical Sculpture, 1500–1900*, New
 Haven and London, 1981, pp. 325–28, no. 88, fig. 173.

15 See, for example, *Letters Written by the late right honourable
 Philip Dormer Stanhope, Earl of Chesterfield, to his Son, Philip
 Stanhope . . .* , vol. 1, London, 1774, p. 326, letter 112.

16 Reynolds could have come across the idea in certain Italian and
 French medals or in the poetry of Edmund Spenser. For a fuller
 discussion of these precedents, see Warner 1989, pp. 10–11.

17 Montfaucon was a Benedictine scholar of the community of
 Saint-Maur. The initial five two-part volumes of his work were
 published in Paris in 1719 and five supplementary volumes
 appeared in 1724. David Humphreys's English translation,
 Antiquity Explained, and represented in sculptures, was pub-
 lished in London in 1721–22 and 1725.

18 The *acerra* is illustrated in vol. 2 of the French edition of
 Montfaucon, pl. 55, and the *praefericulum* is illustrated in vol.
 2 of the supplement to the French edition, pl. 13. The latter is
 in fact not antique, but a sixteenth-century design engraved by
 Agostino dei Musi in 1531 (see J. F. Hayward, *Virtuoso Gold-
 smiths and the Triumph of Mannerism, 1540–1620*, London,
 1976, p. 338, pl. 12; the author is grateful to Anthony Radcliffe
 for kindly bringing this to his attention).

19 See, for example, David Mannings in the 1986 exhibition cata-
 logue. For an earlier statement of many of the ideas expressed in
 this paragraph, see Warner 1989, p. 15.

20 Dublin, National Gallery of Ireland; see the 1986 exhibition
 catalogue, p. 20 (ill.).

21 Shawe-Taylor 1990, pp. 166–68.

22 See Horace Walpole's letter of January 22, 1761, in *Horace
 Walpole's Correspondence with George Montague*, vol. 9, pt. 1,
 ed. by W. S. Lewis and Ralph S. Brown, Jr., New Haven, 1941,
 p. 335: "Lady Sarah was more beautiful than you can conceive,
 and her very awkwardness gave an air of truth to the part, and
 the antiquity of the time, which was kept up in her dress,
 taken out of Montfaucon." The reference is presumably to
 Montfaucon's renowned compendium published in England
 as *A Collection of Regal and Ecclesiastical Antiquities of
 France . . .* , London, 1750.

23 This portrait is at Woburn Abbey; see Waterhouse 1941, p. 50,
 pl. 76, and the 1986 exhibition catalogue, under no. 44. For the
 mezzotints, see John Chaloner Smith, *British Mezzotinto Por-
 traits, Being a Descriptive Catalogue of These Engravings from
 the Introduction of the Art to the Early Part of the Present
 Century*, vol. 2, London, 1884, pp. 487–88 and 498–99, nos. 6
 and 36. Both mezzotints measure 59.4 x 36.8 cm. Nicholas
 Penny suggested that they may have been published together
 (1986 exhibition catalogue, p. 226, under no. 58).

24 Leslie and Taylor 1865, vol. 1, p. 247. This led some commenta-
 tors to relate the inclusion of the Graces to Ripa's *Iconologia*,
 in which they are presented as symbols of the joys of friendship
 or *Amicitia*; see Hope 1967, p. 4, and Frederick Cummings in
 the 1968 exhibition catalogue, no. 6.

25 1986 exhibition catalogue, under no. 58.

26 Waterhouse 1941, p. 73, pl. 235, and 1986 exhibition catalogue,
 no. 132.

27 With Heim Gallery, London, in 1991 (see Hayes 1991, no. 13).
 This and the Chicago portrait remained together in the Bunbury
 and Charles Wertheimer collections.

28 See *Angelika Kauffmann und ihre Zeitgenossen*, exh. cat.,
 Bregenz, Austria, Vorarlberger Landesmuseum, 1968,
 no. 454 (ill.).

Sir Thomas Rumbold, Bt., 1788

A. A. Munger Collection, 1955.1202

Oil on canvas, 126.7 x 101.3 cm (49⅞ x 39⅞ in.)

CONDITION: The painting is in fair condition. It was surface
cleaned and varnished in 1962.[1] The twill-weave canvas has an
old glue paste lining, and the tacking margins have been cut
off.[2] Cusping is visible on the right, left, and top edges, indi-
cating that the painting is close to its original dimensions. There
is an irregularly shaped 4 x 1.5 cm tear in the papers on the
table at the lower left corner.

The painting has an off-white ground. The paint surface has
been flattened by the lining process and is abraded, particularly
in the sitter's wig, the shadows of his coat, and the landscape at
the left. A disturbing drying craquelure is apparent throughout
the drapery, in the shadows of the tablecloth, and scattered
throughout the sitter's coat. There are minor retouches in the
landscape and on the sitter's coat, left cheek, chin, eyes, and
mouth. The discrepancy between the color of the face, which
appears slightly greenish, and the hands, which are warmer in
tone, possibly indicates some fading or overcleaning in the face.
X-radiography suggests that the artist made slight adjustments
in the sitter's stock, the left lapel of his jacket, and his left hand.
There is a natural resin varnish underlying a layer of synthetic
varnish, which is now mat in appearance. (partial x-radiograph)

PROVENANCE: Sir Thomas Rumbold, first Bt.(d. 1791), Wood-
hall Park, Watton, Hertfordshire, 1788. By descent to his
grandson Thomas Henry Rumbold (d. 1882); at his death to
his widow, Mrs. Thomas Henry Rumbold (d. 1932); offered for
sale, Sotheby's, London, May 14, 1930, no. 93 (ill.), bought in.[3]
Her heirs; sold Sotheby's, London, October 13, 1954, no. 167
(ill.), to Agnew.[4] Sold by Agnew, London, to William R. Kent,
March 1955, and bought back from Kent, November 1955.[5] Sold
by Agnew to the Art Institute, 1955.

REFERENCES: Algernon Graves and William Vine Cronin,
A History of the Works of Sir Joshua Reynolds, P.R.A., vol. 2,
London, 1899, p. 846. Sir Walter Armstrong, *Sir Joshua
Reynolds, First President of the Royal Academy*, London and
New York, 1900, p. 227. Ellis K. Waterhouse, *Reynolds*, London,
1941, pp. 80, 96. *Apollo* 61 (February 1955), cover (ill.). AIC
[1956], p. 32; 1961, p. 399. Morse 1979, p. 236.

EXHIBITIONS: Chicago, The Art Institute of Chicago, *The Art
of the Edge: European Frames, 1300–1900*, 1986, no. 71.

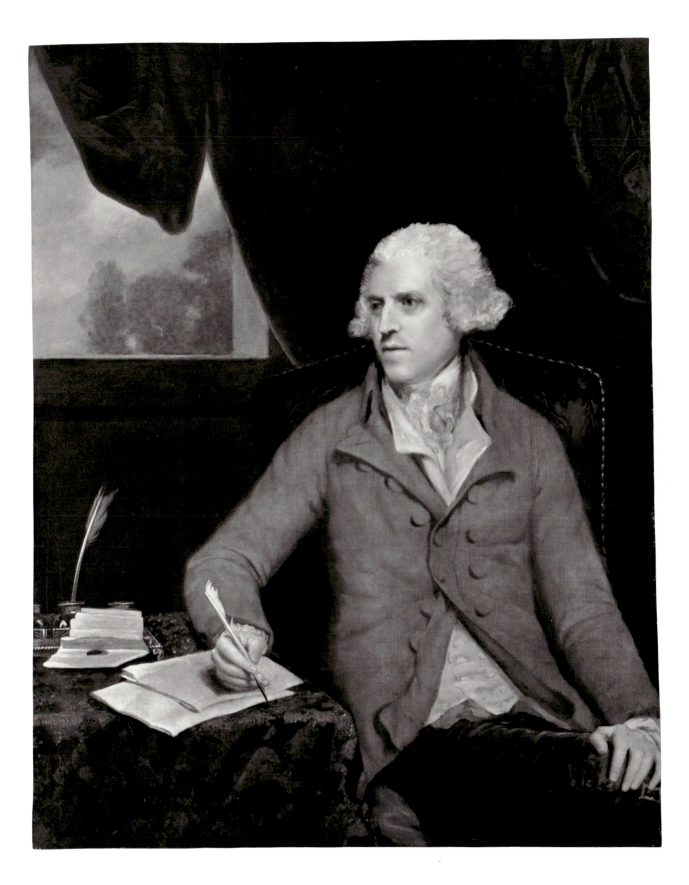

Thomas Rumbold (1736–1791) came from a family with close associations with the East India Company, and joined the company himself in 1752. After transferring from the civil to the military service, he distinguished himself at the siege of Calcutta and was severely wounded at the battle of Plassey, where he served as an aide-de-camp to Robert Clive. He rejoined the company's civil service in 1763, rose to become a member of the Council of Bengal, and, like other high-ranking company officials, amassed a large fortune. He returned to England in 1769, and in 1770–74 sat as member of Parliament for New Shoreham. In 1774 he was returned as member for Shaftesbury, but lost his seat for flagrant bribery. He returned to India in 1777 as Governor of Madras, after protracted lobbying for the position. It was becoming evident at this time that British interests and responsibilities in India had outgrown the administrative capacity of the East India Company. This, combined with the self-enrichment of men such as Rumbold, was the cause of serious concern at home. Rumbold was created a baronet in 1779 for his handling of actions in India against the French, but on returning to England early in 1781 found himself at the center of a scandal, accused of corruption and mismanagement. His conduct was condemned following an inquiry by a parliamentary committee; although discussion of his case in Parliament continued, it was eventually abandoned and no action was taken against him. Rumbold was able to speak on his own behalf after buying a seat at Yarmouth on the Isle of Wight, which he held from 1781 to 1784. He continued to sit in Parliament as member for Weymouth from 1784 until 1790. He died in 1791, aged fifty-five.[6]

Reynolds's pocketbook shows that Rumbold and his fifteen-year-old son, Thomas Henry, sat for the painter in July 1788.[7] Neither portrait is mentioned in the ledgers in which the artist kept accounts, but this is not unusual. The dimensions of both canvases correspond to a standard portrait size, the "half-length," for which Reynolds would normally have charged one hundred guineas at this time.[8]

NOTES

1 The treatment was performed by Alfred Jakstas.
2 The average thread count of the original canvas is 20 x 16/sq. cm (50 x 40/sq. in.).
3 That the picture was bought in is suggested by the fact that it was put up for sale in 1954 by Mrs. Rumbold's heirs.
4 Annotated sale catalogue, Ryerson Library, The Art Institute of Chicago.
5 According to Agnew's stock books; information kindly supplied by Gabriel Naughton in a letter to the author of March 19, 1993, in curatorial files.
6 For Rumbold's biography, see *DNB*, vol. 17, under "Rumbold, Sir Thomas"; *The History of Parliament: The House of Commons, 1754–1790*, ed. by Sir Lewis Namier and John Brooke, vol. 3, Oxford, 1964, pp. 381–84; and Lucy S. Sutherland, *The East India Company in Eighteenth-Century Politics*, Oxford, 1952, esp. pp. 288–89, 297–98.
7 See Charles Robert Leslie and Tom Taylor, *Life and Times of Sir Joshua Reynolds*, vol. 2, London, 1865, p. 525. The portrait of the younger Rumbold was offered for sale, Sotheby's, London, November 18, 1987, no. 56 (ill.), bought in.
8 Malcolm Cormack, "The Ledgers of Sir Joshua Reynolds," *Walpole Society* 42 (1968–70), p. 105.

Jonathan Richardson the Elder

1665 London 1745

Sir Andrew Fountaine, c. 1710

Gift of the Antiquarian Society, 1933.798

Oil on canvas, 76.2 x 64 cm (30 x 25 3/16 in.)

CONDITION: The painting is in poor condition. It was cleaned at the Art Institute in 1964–65, when an old glue paste lining was replaced with a wax resin one and added strips around all four edges were removed.[1] The canvas in its enlarged state measured 125.8 x 100.3 cm (fig. 1).[2] It is unclear exactly when the strips, which changed the portrait from a bust to a three-quarter length, were added. However, it is certain that the picture was initially painted in a smaller format employing a fictive oval frame. An x-radiograph taken before the strips were removed revealed cusping on the upper and right edges of the original canvas, and a different pattern of cusping at the top, right, and left edges of the added strips. X-radiography also indicated that the joins between the center canvas and the added strips had been filled with a dense material, and that

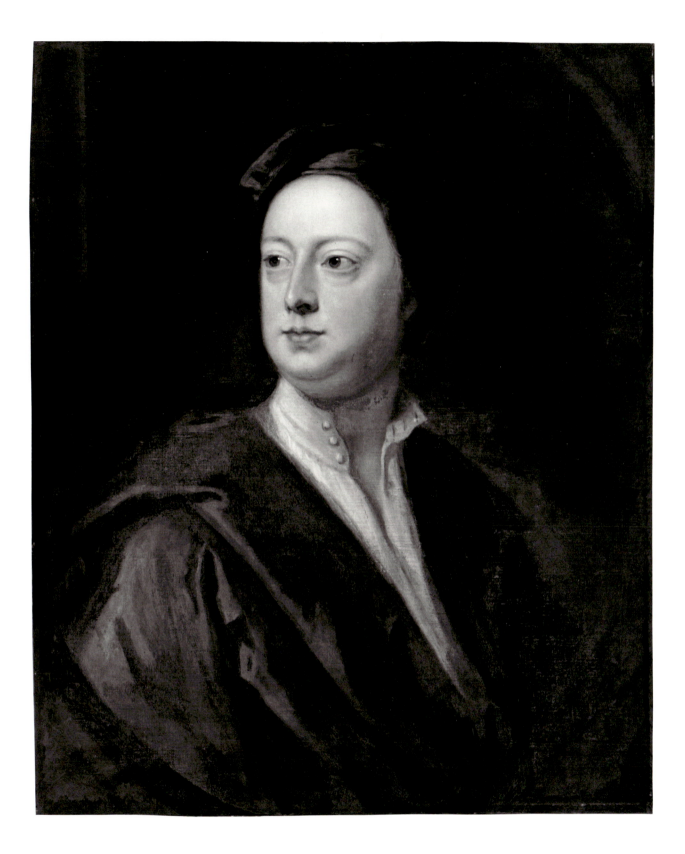

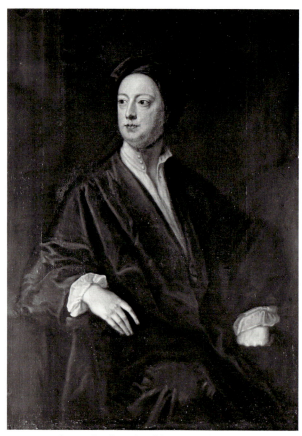

Fig. 1 Jonathan Richardson the Elder, *Sir Andrew Fountaine*, 1933.798 (photograph taken before 1964–65 treatment)

REFERENCES: Prince Frederick Duleep Singh, *Portraits in Norfolk Houses*, ed. by Rev. Edmund Farrer, vol. 1, Norwich, 1927, p. 216, no. 16. *Connoisseur* 88 (December 1931), p. vii (ill.). *AIC Bulletin* 30, 1 (1936), cover (ill.), p. 7 (ill.). *English Doorways and Architectural Woodwork of the Eighteenth Century in the Collections of The Art Institute of Chicago*, Chicago, 1940, n. pag. (ill.). The Antiquarian Society of The Art Institute of Chicago, *A Pictorial Review of Notable Objects in Its Collections and Notes on the Society's Aims and History*, Chicago, 1951, n. pag. (ill.). Helen Comstock, "The Connoisseur in America — Work of the Antiquarian Society of Chicago," *Connoisseur* 130 (October 1952), p. 148. AIC 1961, p. 59.

EXHIBITIONS: London, Christie's, *Art Treasures Exhibition*, organized by the British Antique Dealers' Association, 1932, no. 248. The Art Institute of Chicago, *The Antiquarian Society of The Art Institute of Chicago: The First One Hundred Years*, 1977, nos. 136 and 325, as British School, *Portrait of Richard Gipps*.

Fig. 2 *Sir Andrew Fountaine*, 1933.798, shown in situ at West Harling Hall, Norfolk [photo: curatorial files, Department of European Decorative Arts, The Art Institute of Chicago]

the tacking margins of the added strips had been cut off. According to a conservation report by Louis Pomerantz dated 1957, the painting had a double lining. The first lining was perhaps attached to secure the enlargement, and the later one for support.

The warm sienna-colored ground is visible through the severely abraded paint surface in the background and drapery in the lower half of the painting. Abrasion here appears to be due to the removal of overpaint, which covered the fictive oval surround and the edges of the added strips. The face and cap are fairly intact, but the entire paint layer has been flattened by lining. There are extensive retouches in the folds of the blue drapery, in the shadows of the white shirt, and on the neck and left jowl. Those on the neck under the chin are noticeably discolored. All of the edges have been overpainted. There is a white paste residue from the lining process on the right shoulder and over the lower right quadrant. (infrared, ultraviolet, partial x-radiograph before treatment, full x-radiograph after treatment)

PROVENANCE: Probably Richard Gipps (d. 1743), West Harling Hall, Norfolk. Sir Edmund Nugent, Bt. (d. 1928), West Harling Hall, Norfolk, by 1908.[3] Forestry Commission.[4] Acton, Surgey, Ltd., London, by 1931;[5] sold to the Antiquarian Society for presentation to the Art Institute, 1933.

This portrait was acquired as part of a chimneypiece ensemble from West Harling Hall in Norfolk (fig. 2) and was mistakenly thought to represent Major Richard Gipps, who built West Harling Hall in the years after 1725.[6] The portrait was originally bust-length in a fictive oval surround, but at an unknown date it was expanded by the addition of extra pieces of canvas, probably so that it would fit the chimneypiece format. These additions changed the work to a three-quarter length, and the unknown artist responsible for them seems also to have partly overpainted the original portrait, masking its oval surround, altering the pattern of folds in the draperies, and adding hands. Although these changes may have been old, perhaps even contemporaneous with the installation of the carved chimneypiece in West Harling Hall, the pieces were detached and the overpaint removed when the work was treated by Alfred Jakstas in 1964–65.

The portrait was ascribed simply to the British School from the time it entered the Art Institute until some time after 1964–65, when it was, surprisingly, associated with Thomas Gainsborough (see 1987.139).[7] This was confidently dismissed by Hugh Belsey in 1985, who suggested an attribution to Richardson.[8] The portrait had already been tentatively given to Richardson by Duleep Singh, who described it in 1908,[9] and this idea is convincingly supported by comparison to informal likenesses by him, such as that of George Vertue at Wimpole Hall (fig. 3).

A pupil of John Riley from about 1688 to 1691, Richardson was a leading painter of the generation between Kneller and Hogarth. He is better known today for his writings on art than for his workmanlike but repetitive portraits. In 1711 he was involved with Kneller in setting up London's first Academy, a forerunner of the Royal Academy. His main publications were *An Essay on the Theory of Painting* of 1715, which proved an inspiration to the young Reynolds (see 1922.4468), and *An Account of Some of the Statues, Bas-Reliefs, Drawings, and Pictures in Italy* of 1722, written in collaboration with his son and fellow portraitist Jonathan Richardson the Younger; the latter text was much used as a guide by British aristocrats on the Grand Tour. The elder Richardson was the teacher and father-in-law of Thomas Hudson (see 1980.611) and a noted collector of old master drawings. He retired from painting in 1740.

The present identification of the sitter also comes from Duleep Singh, who presumably recorded the tradi-

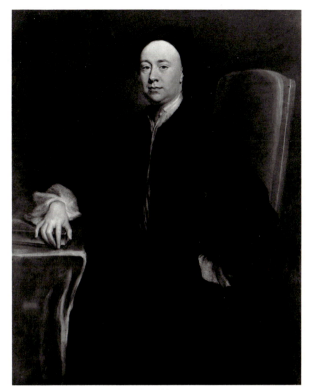

Fig. 3 Jonathan Richardson the Elder, *George Vertue*, Wimpole Hall (The National Trust) [photo: Courtauld Institute of Art, London]

tional identification at West Harling.[10] Sir Andrew Fountaine (1676–1753) was one of the most sophisticated and respected connoisseurs of his day.[11] Knighted by William III in 1699, he succeeded to his family estate of Narford in Norfolk on the death of his father, in 1706. Fountaine was appointed Vice-Chamberlain to Princess (later Queen) Caroline in 1725, and two years later became Warden of the Mint, a position he held for the rest of his life. He traveled widely in Europe, building up his celebrated collection of antiquities, objets d'art, pictures and books. In the words of Jonathan Richardson the Younger, he was "one of the keenest *virtuosi* in *Europe*, and out-*Italianed* the *Italians* themselves."[12] His circle of eminent friends included Leibnitz, Cosimo III, grand duke of Tuscany, and Jonathan Swift. Known portraits of Fountaine, including busts by François Roubiliac at Wilton House and Narford[13] and a conversation piece by Hogarth in the Philadelphia Museum of Art,[14] are not sufficiently similar in type and date to confirm that he was the subject of the Art Institute portrait. Fountaine and Major Richard Gipps, the builder and owner of West Harling, were closely contemporary Norfolk gentlemen, but no more concrete connection between them has been established.

NOTES

1 The painting was treated in 1964–65 by Alfred Jakstas and had previously been cleaned by Leo Marzolo, in March 1950.

2 The average thread count of the small canvas is 14 x 15/sq. cm (37 x 38/sq. in.), and the thread count of the added strips recorded from an old x-radiograph is 13 x 15/sq. cm (35 x 38/sq. in.; see discussion).

3 Duleep Singh (1927, p. 216) recorded the portraits at Harling Hall on June 18, 1908.

4 According to a letter of December 5, 1933, from Frank Surgey to Bessie Bennett (in curatorial files, Department of European Decorative Arts and Sculpture).

5 Advertised as with Acton, Surgey, Ltd., in *Connoisseur* 1931.

6 See Duleep Singh 1927, p. 216, under no. 19; and Francis Blomefield, *An Essay towards a Topographical History of the County of Norfolk*, reprint, vol. 1, London, 1805, p. 307.

7 In the catalogue of the 1977 exhibition, no. 325, it is dated to c. 1760 and described as by "a local artist familiar with the works of William Hogarth, Jonathan Richardson and Thomas Gainsborough."

8 Letter to Mary Kuzniar of August 23, 1985, in curatorial files.

9 See note 3.

10 The previous identification of the sitter as Major Richard Gipps seems to have arisen out of a confusion with the unattributed portrait of Gipps at West Harling that is listed on the same page of Singh's book (1927, p. 216, no. 19).

11 For Fountaine's life, see the entry on him in the *DNB* (under "Fountaine, Sir Andrew") and Richard Dorment, *British Painting in the Philadelphia Museum of Art from the Seventeenth through the Nineteenth Century*, Philadelphia and London, 1986, pp. 163–71, under no. 40.

12 Jonathan Richardson, Jr., *Richardsoniana: or, Occasional Reflections on the Moral Nature of Man . . .* , London, 1776, pp. 331–32.

13 Margaret Whinney, *Sculpture in Britain, 1530 to 1830*, rev. by John Physick, Harmondsworth, 1988, pp. 214, 456, pl. 150. The bust at Wilton House is dated 1747.

14 See Dorment (note 11), pp. 163–71, no. 40 (ill.). The Hogarth dates from about 1730/35.

George Romney

1734 Dalton-in-Furness–Kendal 1802

Mrs. Francis Russell, 1785–87

Mr. and Mrs. W. W. Kimball Collection, 1922.4469

Oil on canvas, 127.6 x 101.9 cm (50¼ x 40¼ in.)

CONDITION: The painting is in good condition. It was cleaned, varnished, and inpainted at the Art Institute in 1964.[1] The tacking margins have been cut off, but cusping on all four sides indicates that the painting is close to its original dimensions. The ground is white. Some areas of the paint surface have been abraded by previous cleaning, particularly in the background landscape and in the sitter's hat and hair. There is some loss of volume and definition in the drapery folds because of a slight thinning of the paint surface. The tactile quality of the paint is better preserved in the sitter's face, which remains in a very good state. A few relatively small areas of wide drying cracks are visible at the left edge of the sitter's face and in the upper right background above the hat brim. These have been inpainted. There is additional retouching on the left side of the sitter's nose, her left eye, the underside of her hat brim at left, and her skirt at the lower left corner between her right hand and the rose. X-radiography (fig. 1) reveals changes that are, in some cases, also apparent on the surface. The sitter's shoulders were originally broader and her throat more covered. In the x-radiograph her hat is crowned by a plume. The paint covering the plume appears continuous with the background foliage. The

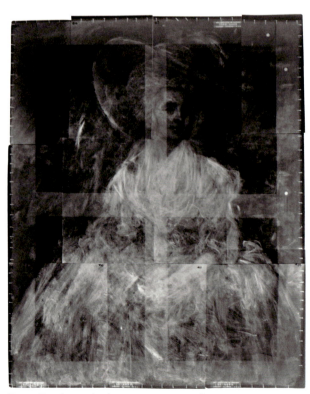

Fig. 1 X-radiograph of *Mrs. Francis Russell*, 1922.4469

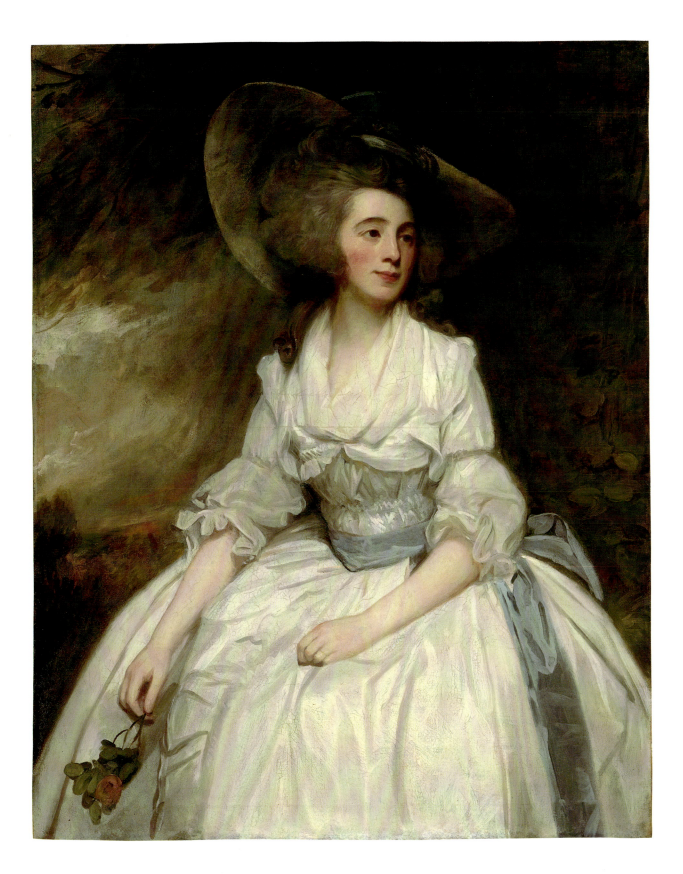

forms of the hat and hair appear to have been adjusted repeatedly by the artist and successive restorers, and it is difficult to determine the artist's intentions. The hat had certainly been painted out when the picture was acquired by the Art Institute and was revealed again in the 1964 treatment (see discussion). Patches of blue sky are visible through the hat above the sitter's right shoulder. The present high crown of the hat and the hair and ribbon overlapping the hat brim appear old, but may not be original. (before treatment, infrared, ultraviolet, x-radiograph)

PROVENANCE: Francis Russell, from 1787.[2] Francis C. Simpson; sold Christie's, London, May 8, 1897, no. 45 (ill.), to Charles Wertheimer for 2,300 gns.[3] Mrs. W. W. Kimball, Chicago (d. 1921); on loan to the Art Institute from 1920; bequeathed to the Art Institute, 1922.

REFERENCES: W. Roberts, "The Art Sales of 1897," *Magazine of Art* 21 (1898), pp. 139, 140 (ill.). Humphry Ward and W. Roberts, *Romney, a Biographical and Critical Essay with a Catalogue Raisonné of His Works*, London, 1904, vol. 1, p. 106; vol. 2, pp. 137–38. AIC 1920, p. 60, no. 766. "The Kimball Collection," *AIC Bulletin* 14, 5 (1920), pp. 72 (ill.), 77. AIC 1923, p. 65, no. 766. AIC 1925, pp. 32 (ill.), 151. AIC 1932, pp. 84 (ill.), 169. C. H. Collins Baker, *British Painting*, London, 1933, p. 285. AIC 1961, pp. 402–03. Frederick A. Sweet, "Great Chicago Collectors," *Apollo* 84 (September 1966), p. 195.

EXHIBITIONS: The Art Institute of Chicago, *A Century of Progress*, 1933, no. 204. The Art Institute of Chicago, *A Century of Progress*, 1934, no. 152, pl. 27.

Romney worked for his father, a Lancashire cabinetmaker and joiner, until the age of twenty-one. In 1755 he was apprenticed to the itinerant painter Christopher Steele, and from 1757 he practiced as an independent portraitist in the North of England. Realizing the limitations of the provincial market, he moved to London in 1762, visited France in 1764, and studied classical and Renaissance art in Rome from 1773 to 1775. Back in London from 1775, he enjoyed immense popularity as a painter of fashionable society portraits, rivaling even Reynolds and Gainsborough (see 1922.4468 and 1987.139). Though dependent on portraiture, he aspired to the painting of scenes from history, myth, and literature, but few of his many sketches of such subjects were ever realized on canvas. In 1782 he met Emma Lyon, the future Lady Hamilton, and over the next four years painted her in a series of pictures blending portraiture and history painting, in which she appears as characters from classical literature, Shakespeare, and other elevated sources. He also contributed to John Boydell's Shakespeare Gallery. He suffered a series of strokes in the 1790s and his work declined. In 1798 he retired to Whitestock Hall, near Kendal, where he died in 1802.

The sitter in the Art Institute's portrait was Anne Russell, née Kershaw, daughter of the Vicar of Leeds and Canon of Ripon. Her husband, Francis Russell, was a lawyer. He was admitted to Gray's Inn in 1764, and is recorded in the *Law List* for 1781 and 1782 as an attorney of Red Lion Square and the Duchy Office of Gray's Inn (the office of the Duchy of Lancaster).[4]

Mrs. Russell's name appears on the list of Romney's clients for 1785 drawn up from a missing volume of his diary by his son, the Reverend John Romney.[5] Her portrait was presumably begun in that year. The artist's ledger records that it was sent off on November 10, 1787, and paid for in full on March 11, 1788; the price was forty guineas.[6] Romney's diary contains seventeen references to a Mrs. Russell coming for sittings in the years 1786–87, but some are probably to Mrs. Henry Russell, whom he was also painting at the time.[7]

As the portrait now appears, Mrs. Russell is wearing her hat unusually far back on her head, but with her hair in a ribbon, as it would normally appear if she were hatless.[8] This odd combination is almost certainly a distortion of the artist's intentions. The x-radiograph (fig. 1) shows the line of the hat brim uninterrupted by the hair, which is frizzier above the forehead, the crown decorated by a large plume, and other changes (see Condition). It is difficult to recover the artist's original conception. Perhaps the most likely sequence of events is that he decided against the hat when it was still unfinished and overpainted it, showing his sitter in the final portrait as bareheaded and wearing the hair ribbon; then the remnants of the hat, which, over time, had become more visible as *pentimenti*, were misunderstood and reinforced as part of later restoration efforts. Although the hat does not appear in the reproduction of the work in the Christie's sale catalogue of 1897, this area had very probably already been repainted by that date. The hat may have been revealed at some earlier point, when the awkward, high crown was perhaps added and the hair retouched, only to be painted out again and revealed once more in its present unconvincing form when the picture was cleaned at the Art Institute in 1964.

NOTES
1 The treatment was performed by Alfred Jakstas. The average thread count of the original canvas is 18 x 16 sq. cm (45 x 40/sq. in.).
2 According to Ward and Roberts 1904, vol. 2, p. 137, and Christie's 1897 sale catalogue.
3 Annotated sale catalogue, Christie's, London.

4 Information on Russell's career kindly supplied by Theresa Thom, Librarian, Honourable Society of Gray's Inn Trust Fund, in a letter of April 25, 1994, in curatorial files. His appointments to the Duchy of Lancaster were Surveyor of Lands and Woods, south of Trent; Sworn Attorney in Court for the Crown; Receiver of the Rents for Yorkshire and Nottinghamshire; and Secretary to the Chancellor of the County Palatinate, according to Ward and Roberts (1904, vol. 2, p. 137). The relationship to the duke of Bedford claimed in the catalogue of the 1897 sale at Christie's could not be substantiated.

5 Ward and Roberts 1904, vol. 1, p. 106.

6 Ibid., vol. 2, p. 137.

7 Itemized in Ward and Roberts 1904, vol. 1, pp. 108–09, 111–13; vol. 2, p. 138.

8 Aileen Ribeiro noted in a letter of November 3, 1994 (in curatorial files), that the angle of the hat should look more like that of Mrs. Hallett's in Gainsborough's *Morning Walk* in the National Gallery, London; see John Hayes, *Gainsborough: Paintings and Drawings*, London, 1975, pl. 157. For similar changes to a sitter's headdress in a Romney of the same period, his portrait of Lady Arabella Ward, see John Hayes, *British Paintings of the Sixteenth through Nineteenth Centuries*, The Collections of the National Gallery of Art: Systematic Catalogue, Washington, D.C., 1992, pp. 240–42, with x-radiograph.

John Russell

1745 Guildford–Hull 1806

Portrait of a Man in a Tricorn Hat, 1767
Bequest of John and Dorothy Estabrook, 1987.262.2

Oil on canvas, 76 x 64 cm (29⁷/₈ x 25³/₁₆ in.)

INSCRIBED: *J. Russell pinxt / 1767* (in red paint, at lower left on fictive oval frame)

CONDITION: The painting is in good condition. It has an old glue paste lining that was added before the picture entered the collection.[1] The tacking edges have been cut off, but there is cusping on the top, right, and left edges, suggesting that the painting is close to its original dimensions. It has a white ground. The paint surface has been marginally abraded by cleaning in the face, hair, and hat. The impasto in the lace has been slightly flattened by the lining process. There are two areas of localized paint and ground loss: one on the neck, measuring 0.5 x 2 cm, and the other on the man's right shoulder, measuring 3 x 2.5 cm. There are also a few smaller losses scattered in the background. These losses and other small areas on the right point of the sitter's hat, the right front of his coat, his right cuff, and the bend of his left elbow have been retouched. Microscopic examination reveals that the inscribed date is 1767, although it has been cited as 1787 in recent sales. (x-radiograph)

PROVENANCE: Probably Col. Thorburn, Kirkfell, Upper Norwood, by 1894.[2] Sold Christie's, London, May 12, 1919, no. 27, jointly to Knoedler and Colnaghi and Obach.[3] Sold by them to Sir Samuel Waring, London, October 1920.[4] Sold Christie's, London, December 10, 1971, no. 133, to Hutchinson for 200 gns.[5] Sold Sotheby's, London, December 13, 1972, no. 125, to Loren for £180.[6] Sold Philips, London, March 12, 1973, no. 34, to John Estabrook, Chicago; bequeathed by John and Dorothy Estabrook to the Art Institute, 1987.

A painter of fashionable portraits and "fancy subjects," Russell studied under Francis Cotes from about 1760 to 1767 and, like his master, worked mainly in pastel. In 1764 he experienced a religious conversion and became an outspoken Methodist. He exhibited regularly and abundantly at the Royal Academy from 1769 until his death, becoming an Associate in 1772, the same year he published his book on pastel technique, *Elements of Painting With Crayons*, and a full Academician in 1788. In 1790 he was appointed Crayon Painter to the King and the Prince of Wales. Though based in London, he spent a number of months in most years traveling and producing portraits in the provinces, after 1790 largely in Yorkshire. His later pastels are characterized by facility and charm.

The Art Institute's portrait is among the earliest and most impressive examples of Russell's occasional work in oil. It is dated 1767, the year in which he left Cotes's studio to set up his own portrait practice. He spent part of that year with his family in his native Guildford, and his diary records portrait sittings with a number of Guildford residents. The gentleman in the Art Institute's portrait may well be one of these, but there is no evidence pointing to any particular individual.[7] Russell's

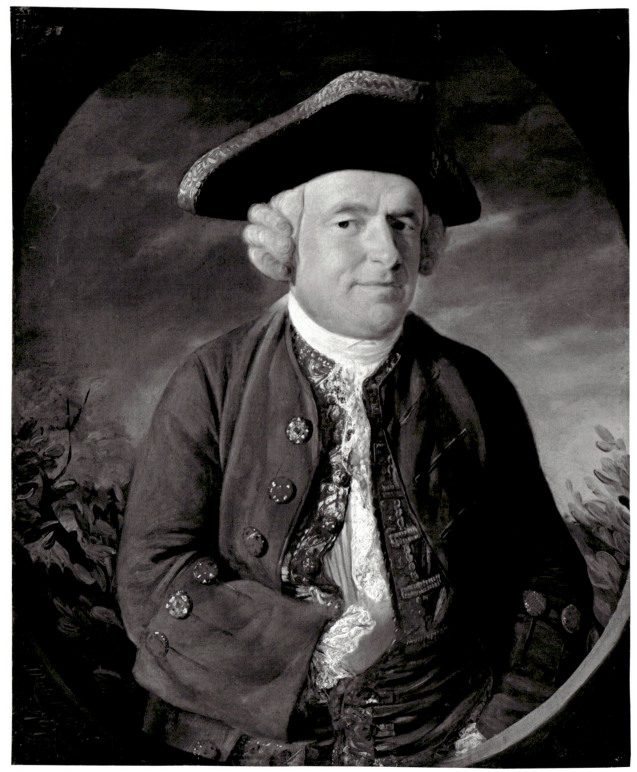

John Russell, *Portrait of a Man in a Tricorn Hat,* 1987.262.2

early portraits were praised for their naturalness,[8] and the Art Institute's portrait is remarkable for the same quality. The slight turn of the head, along with the set of the eyes and mouth, impart a sense of character, intelligence, and skepticism.

NOTES

1 The average thread count of the original canvas is approximately 11 x 13/sq. cm (28 x 32/sq. in.).
2 In his list of Russell's works, George C. Williamson recorded a portrait in Col. Thorburn's collection showing "An old gentleman in claret and gold coat, and three-cornered hat, unknown. 30 x 25. Oil. 1767." (*John Russell, R.A.*, London, 1894, p. 166). He stated (pp. 119–22) that this work and two other oils were acquired from Pratt, Guildford, who bought them at "the Russell sale," presumably the artist's sale at Christie's, London, February 14, 1807. The portrait in question cannot be identified among the 125 lots in the sale since no dates or dimensions were given in the catalogue.
3 This information was kindly provided by Melissa De Medeiros, Librarian at Knoedler, in a letter to Martha Wolff of September 6, 1994, in curatorial files.
4 See note 3.
5 Annotated sale catalogue, Ryerson Library, The Art Institute of Chicago. In this and subsequent sales, the date is erroneously given as 1787.
6 Annotated sale catalogue, Ryerson Library, The Art Institute of Chicago.
7 See Williamson (note 2), pp. 17, 129–31.
8 Horace Walpole described Russell's portrait of two eskimos shown at the Royal Academy in 1768 as "very natural"; see Algernon Graves, *The Royal Academy of Arts: A Complete Dictionary of Contributors and Their Work from Its Foundation in 1769 to 1904*, vol. 6, London, 1906, p. 390.

Benjamin West

1738 Springfield, Pennsylvania–London 1820

The Death of Procris, 1770, retouched 1803

Gift of William O. Cole, 1900.445

Oil on panel, 32.4 x 41.2 cm (12³⁄₄ x 16¹⁄₄ in.)

INSCRIBED: *B. West / 1770* (lower left corner), *Retouched. 1803.* (along lower edge, left of center)

CONDITION: The painting is in good condition. It was cleaned and retouched in 1973.[1] The 0.6 cm thick mahogany panel of South American origin is beveled on all four sides and has an off-white ground.[2] Narrow wood strips of considerable age have been nailed to all four sides of the panel. The paint surface is generally well preserved, although some abrasion has occurred in the yellow foliage at the right. There is an extensive drying craquelure throughout, which may have occurred shortly after the painting was executed. X-radiography and examination in raking light reveal some changes made by the artist: the upper contour of Cephalus's robe has been extended along his shoulder and upper arm to cover parts of the landscape, the drapery folds over his head have been straightened, and his knee has been made smaller. A detailed comparison with Matthew Liart's engraving of 1771 (fig. 1) indicates that these changes had occurred by the time the engraving was made. According to the inscription, West retouched the painting thirty-three years after its execution, but it is difficult to assess exactly what the retouching consisted of. Traces of overpaint removed during the 1973 cleaning suggest that the howling dog in the undergrowth to the right of Cephalus was once painted out. In addition, the right breast of Procris has been heavily retouched and appears somewhat altered from the form visible in the x-radiograph. Whether these changes were part of West's retouching or the work of later hands is unclear. There is additional later inpainting in Procris's drapery, hair, and right arm, and in the foliage at the upper right. In the inscription *Retouched. 1803.*, the date appears abraded and perhaps overpainted. (infrared, ultraviolet, x-radiograph)

PROVENANCE: Benjamin West (d. 1820). By descent to his sons, Raphael Lamar West and Benjamin West, Jr.; sold Robins, London, May 22–25, 1829, no. 63, to W. J. Ward for 34 gns.[3] Mrs. Albert F. West, wife of the artist's great-grandson; sold Christie's, London, March 18–19, 1898, no. 133. William O. Cole; given to the Art Institute, 1900.

REFERENCES: "Benjamin West, Esq., President of the Royal Academy, Etc.," in *Public Characters of 1805*, London, 1805, p. 567. "Biographical Sketch of Benjamin West, Esq., President of the Royal Academy, Etc., Etc.," *Universal Magazine* 3 (June 1805), p. 531. Joel Barlow, *The Columbiad: A Poem*, Philadelphia, 1807, p. 435 n. 45 (list of West's works). "A Correct Catalogue of the Works of Benjamin West, Esq.," *La Belle Assemblée, or Bell's Court and Fashionable Magazine* 4 (1808), suppl., p. 18. John Galt, *The Life, Studies, and Works of Benjamin West, Esq., President of the Royal Academy of London*, vol. 2, London, 1820, p. 231. AIC 1904, p. 202, no. 342. AIC 1907, p. 214, no. 342. AIC 1910, p. 193, no. 342. AIC 1913, p. 149, no. 342. AIC 1914, p. 139, no. 342. AIC 1917, p. 160, no. 544; AIC 1920, p. 55, no. 544. AIC 1925, pp. 82, 157, no. 544. AIC 1932, pp. 102, 176, no. 00.445. AIC 1961, p. 481. Esther Sparks, "Three Narrative Paintings by Benjamin West in

the Collection," *AIC Bulletin* 68, 4 (1974), pp. 6–7 (ill.).
Ruth S. Kraemer, *Drawings by Benjamin West and His Son
Raphael Lamar West*, exh. cat., New York, Pierpont Morgan
Library, 1975, p. 66, under no. 131, p. 83, under no. 205. John
Dillenberger, *Benjamin West: The Context of His Life's Work
with Particular Attention to Paintings with Religious Subject
Matter*, San Antonio, 1977, p. 179, no. 406. Helmut von Erffa
and Allen Staley, *The Paintings of Benjamin West*, New Haven
and London, 1986, p. 228, under no. 116, p. 242, no. 150 (ill.).
Peter Cannon-Brookes in *The Painted Word: British History
Painting, 1750–1830*, exh. cat., Heim Gallery, London, 1991,
p. 60, under no. 20.

EXHIBITIONS: London, Royal Academy of Arts, 1771, no. 214.
London, West's Gallery, 1822–28, no. 35.[4] The Art Institute of
Chicago, *A Century of Progress*, 1933, no. 429, as *Troilus and
Cressida*. Minneapolis, University of Minnesota, University
Gallery, *American Painting, Seventeenth, Eighteenth, and
Nineteenth Centuries*, 1939, no. 42, as *Troilus and Cressida*.
Saginaw Museum, Michigan, *American Paintings from Colo-
nial Times until Today*, 1948, no. 67, as *Troilus and Cressida*.

West was self-taught and began his career as a portrait
painter, working in Philadelphia and New York. In 1760
he traveled to Italy, visiting Rome, Florence, Parma,
Bologna, and Venice, where he studied classical, Renais-
sance, and Baroque art firsthand. In Rome he came
under the influence of the German Neoclassical painter
Anton Raphael Mengs. In 1763 he settled in London,
where he remained for the rest of his career. His pictures
of elevating subjects from antiquity, which were
indebted to a variety of models, including Mengs and
Nicolas Poussin (see 1930.500), won him fame with
remarkable speed, and, by the end of the 1760s, he was
the foremost history painter in Britain. In 1768 he was a
founding member of the Royal Academy. His *Death of
General Wolfe* (Ottawa, National Gallery of Canada),
which was exhibited at the Royal Academy in 1771,
showed a contemporary event in the heroic mode nor-
mally reserved for subjects from mythology, the Bible,
history, and literature, and was hugely successful. In the
1770s, the Neoclassical coolness of West's early style
gave way to a windblown theatricality typical of the
beginnings of British Romantic painting. He enjoyed an
abundance of royal patronage under George III; from
1778 to 1801, he worked on grand decorative projects
for the newly restored and refurbished Windsor Castle.
In 1792 he was elected Reynolds's successor as president
of the Royal Academy, and as such remained the vener-
able leader of the British artistic establishment until
his death. Although he never returned to his native
shores, West's studio was a mecca for American artists

in Europe, a number of whom were his pupils and
assistants.

The Death of Procris was shown in 1771 at the same
Royal Academy exhibition as *The Death of General
Wolfe*. The story of Cephalus and Procris, the moral of
which is that marital jealousy and mistrust can end
in disaster, is recounted in Ovid's *Metamorphoses*
(7.795–866). When Cephalus and Procris were newly
married, Cephalus put his wife's chastity to the test by
attempting to seduce her while disguised as another
man. She was outraged, but the couple were eventually
reconciled, and she presented him with the gifts of a
miraculously swift hunting hound and a javelin. Years
later, while hunting, Cephalus made a sensuous invoca-
tion to the zephyr, the gentle west wind, which someone
overheard and misinterpreted as addressed to a nymph
with whom he was in love. The person told Procris, who
sought out her husband in the woods and, hiding nearby,
heard him make another, similar invocation. When
she let out a moan of despair and rustled some leaves,
Cephalus mistook her for a wild animal and killed her
with the very javelin she had given him. As she died, she
begged him not to let "Zephyr" take her place as his
wife. He then realized her fatal mistake and told her the
truth, at which she passed away in apparent content-
ment. West depicted the moment after her death, with
the fatal javelin lying in the foreground pointed toward
her breast.

An engraving after West's picture by Matthew Liart,
entitled *Cephalus Lamenting the Death of Procris*

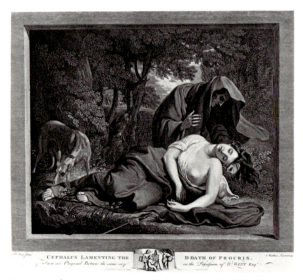

Fig. 1 Matthew Liart, engraving after Benjamin West, *The Death
of Procris*, Fogg Art Museum, Cambridge, Mass., Gift of Belinda
L. Randall from the collection of John Witt Randall [photo: cour-
tesy of the Fogg Art Museum, Harvard University Art Museums]

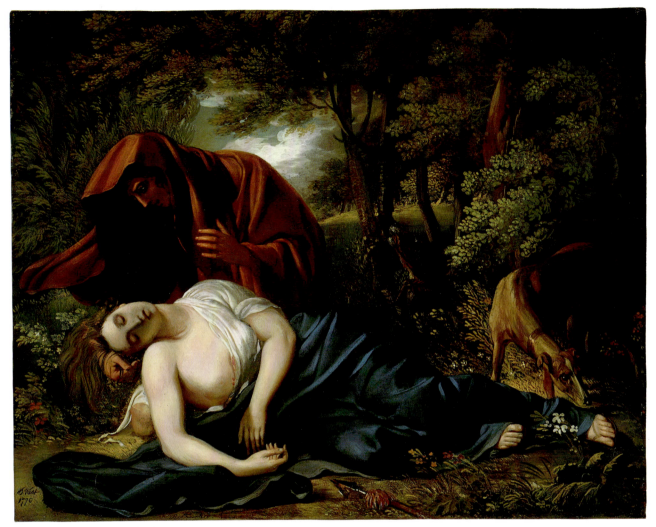

Benjamin West, *The Death of Procris*, 1900.445

(fig. 1), was published on December 13, 1771, that is, later in the same year in which the original work was first exhibited. It was published as a pair to Liart's engraving after another painting by West, *Venus Lamenting the Death of Adonis* (1768, retouched 1819; Pittsburgh, Carnegie Institute), which was then in the collection of Sir William Young.[5] The engraved images are both reversed and surrounded by identical fictive frames. They relate closely to one another in both design and subject: in *Venus Lamenting the Death of Adonis*, the beautiful youth Adonis has similarly been killed in a hunting accident and is mourned by his lover. Although the prints are identical in size, the paintings differ greatly, which led von Erffa and Staley (1986) to suggest that the Chicago picture may have been made as a sketch for an unrealized pendant to the Pittsburgh picture, on the same relatively large scale of 157.5 by 172.5 cm. It seems more likely, however, that the Chicago painting was an "engraver's picture," that is, painted expressly to be engraved as a companion to the *Venus and Adonis*, but without any larger version being realized. This idea is supported by the fact that the Chicago painting corresponds almost exactly to the print in size, and by the survival of what appears to be the engraver's tracing of part of the composition.[6] As such, the work is comparable to West's small replicas of his *William Penn's Treaty with the Indians* (Chicago Historical Society) and *The Death of General Wolfe* (location unknown), which we know to have been made as engraver's pictures, and which are also, unusually, on panel.[7]

The inscription *Retouched. 1803.* is similar to many others on paintings by West. As von Erffa and Staley have pointed out, repainting earlier works became one of the artist's main activities from 1800 on, and some examples even bear two "Retouched" dates in addition to the date of the original work. When criticized by the

Royal Academy for submitting a picture for exhibition in 1803 that had already been shown in 1776 (*Hagar and Ishmael*; New York, The Metropolitan Museum of Art), West argued that he had changed it so completely by retouching that it was now a new work; he added that the records of retouching campaigns inscribed on his paintings bore witness to his desire "to leave the few works I have done as perfect as was in my power to make them."[8] Comparison with Liart's engraving suggests that West made no substantial changes to *The Death of Procris* in 1803, except perhaps to paint out the howling dog now revealed again by cleaning (see Condition).

NOTES

1 The painting was treated by Alfred Jakstas. The retouches later discolored, and were corrected by Karin Knight in 1985.
2 A sample of the wood was identified by the Forest Products Laboratory in Madison, Wisconsin (letter to Alfred Jakstas of August 7, 1973, in conservation files).
3 See von Erffa and Staley 1986 and Algernon Graves, *Art Sales*, vol. 3, London, 1921, p. 329. It seems probable that Ward was acting on behalf of West's sons, since the painting later appeared in Mrs. Albert F. West's sale.
4 After the artist's death, his sons built a gallery for the display of his remaining works in the garden of his home and studio at 14 Newman Street. For further details, see von Erffa and Staley 1986, pp. 150–51, 161. The Chicago work appears as no. 35 in the several catalogues of the gallery issued between 1822 and 1828.
5 Von Erffa and Staley 1986, pp. 45 (ill.), 228, no. 116. For Liart's prints, see Cannon-Brookes 1991, nos. 16 and 20. The title of the print, *Cephalus Lamenting the Death of Procris*, was retained when the painting was shown in West's Gallery in the 1820s (see note 4). When the painting was given to the Art Institute, it was incorrectly identified as representing Troilus and Cressida.
6 New York, Pierpont Morgan Library, no. 1970.11:243 (see Kraemer 1975). The plate size of the engraving is 43.3 x 55 cm, and the image within the fictive frame measures 33 x 41 cm, virtually the same as the painting. The fact that the engraving was made to correspond in size to the painting is actually mentioned in the inscription below the title: "From an Original Picture the same size in the Possession of B. West Esqr."
7 Von Erffa and Staley 1986, p. 208, no. 87; Herbert Furst, "Art News and Notes," *Apollo* 9 (April 1929), p. 261 (ill.).
8 Von Erffa and Staley 1986, pp. 136–38.

Portrait of a Man, 1790/99
Gift of the Family of Byron L. Smith, 1916.209

Oil on canvas, 127 x 102 cm (50 x 40⅛ in.)

INSCRIBED: *Benjamin West 179[. . .]* (along the stick of sealing wax on the inkstand to the left), *G [. . .]* (on the page behind the inkstand)

CONDITION: The painting is in fair condition. It was cleaned in 1921 and treated in 1941.[1] The canvas has an old glue paste lining and the tacking margins have been cut off.[2] There is cusping visible on all edges, indicating that the painting retains its original dimensions. X-radiography reveals two L-shaped

tears in the background at the upper left, measuring 4 x 4 and 6 x 7 cm respectively, and a small 0.5 cm hole to the right of the sitter's chin. There are distortions in the canvas at the upper right and left corners and extending horizontally across the surface. The ground is off-white. Paint and ground losses within the tears and hole and scattered along the top edge have been filled and retouched. The background at the upper left and the sitter's dark suit are severely abraded. The impasto in the costume and on the inkstand has been somewhat flattened as a result of the lining process. The paint surface is disfigured

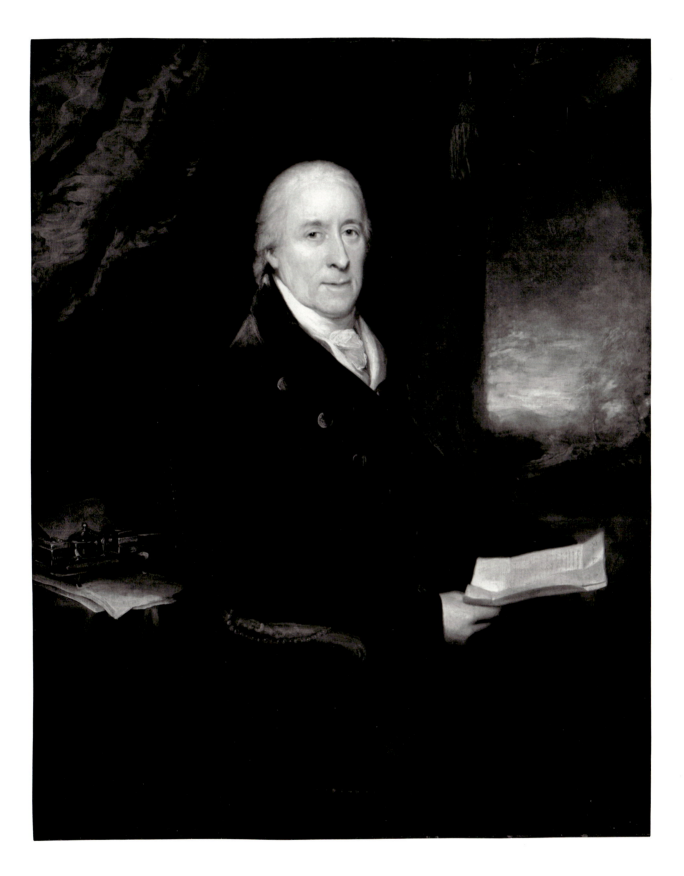

by a thick, darkened, and uneven layer of natural resin varnish, which distorts the image and masks the location of the retouches. (x-radiograph)

PROVENANCE: Ehrich Galleries, New York, 1916. Sold by Ehrich Galleries to the Friends of American Art and presented to the Art Institute, 1916;[3] transferred to the Byron L. Smith Collection, 1918.[4]

REFERENCES: AIC 1917, p. 153, no. 432. Frederic Fairchild Sherman, "The Art of Benjamin West," Art in America 6 (April 1918), pp. 156, 157 (ill.). Ehrich Galleries, One Hundred Early American Paintings, New York, 1918, p. 154 (ill.). Friends of American Art, Sixth Year Book, Chicago, 1918, p. 27 (ill.). AIC 1920, p. 55, no. 557. AIC 1922, p. 59, no. 557. AIC 1923, p. 59, no. 557. AIC 1925, pp. 82 (ill.), 157, no. 557. Russell Walton Thorpe, "Benjamin West," Antiquarian 7 (November 1926), p. 41 (ill.). AIC 1932, pp. 102 (ill.), 176. AIC 1961, p. 481. Helmut von Erffa and Allen Staley, The Paintings of Benjamin West, New Haven and London, 1986, pp. 575–76, no. 734 (ill.).

EXHIBITIONS: Stockholm, Academy of Arts, Utställning av Amerikansk Konst, 1930, no. 110 (ill.). Philadelphia, Pennsylvania Museum of Art, Benjamin West: 1738–1820, 1938, no. 42. Urbana, University of Illinois (Illini Union Building), on loan, 1941–51.

The attribution of this portrait to West was accepted by von Erffa and Staley in their 1986 catalogue raisonné of West's paintings, and can be readily supported by comparison with other portraits by West of the 1790s, such as his Portrait of Samuel More of 1796 (London, Royal Society of Arts).[5]

According to the catalogue of the Philadelphia exhibition of 1938, this work was "Said to be the portrait of Dr. Homan, physician to George IV." No decisive evidence for or against this identification has come to light since that time, although von Erffa and Staley noted that the name of Dr. Homan does not appear in the published correspondence of either George IV or George III.[6] The same authors observed that by the 1790s West was painting portraits "only occasionally and then often of family or personal friends."[7] The date inscribed after West's signature on the stick of sealing wax on the table is scarcely legible. The third digit is a nine, but the fourth digit is too obscure to be identified with any confidence. Von Erffa and Staley recorded it as a four, although it seems to echo the third digit and may be another nine.

NOTES
1 The latter, unspecified treatment was performed by Leo Marzolo.
2 The average thread count of the original canvas is 11 x 10/sq. cm (28 x 24/sq. in.).
3 Day Book 7, p. 126, Registrar's office, The Art Institute of Chicago.
4 Day Book 8, p. 145, Registrar's office, The Art Institute of Chicago.
5 Von Erffa and Staley 1986, p. 535, no. 666 (ill.).
6 Ibid., p. 575.
7 Ibid., p. 24.

Queen Philippa at the Battle of Neville's Cross, c. 1789
Gift of Vincent Carney, 1972.1153

Oil on canvas, 39.1 x 52.7 cm (15³/₈ x 20³/₄ in.)

CONDITION: The painting is in poor condition. It was cleaned in 1971–72 before it was given to the Art Institute.[1] At that time an old glue paste lining was removed and replaced with a wax resin one.[2] X-radiography reveals what appear to be tack holes at the bottom and sides. This, combined with the fact that pronounced cusping is visible on the upper edge while less prominent cusping is visible on the bottom, left, and right edges, suggests that the tacking margins have been incorporated into the painting at the bottom and sides. Microscopic examination of the edges reveals unpainted ground underlying overpaint on the perimeter of the original canvas.

The off-white ground is visible through the severely abraded paint surface, especially in the brown glazes at the lower right and in the gray wash at the upper left. Two distinct patterns of drying craquelure are evident, but not visually disfiguring.

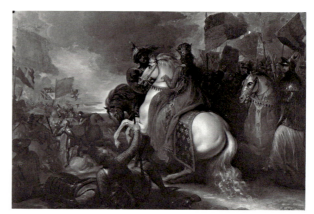

Fig. 1 Benjamin West, Queen Philippa at the Battle of Neville's Cross, The Royal Collection [photo: © Her Majesty Queen Elizabeth II]

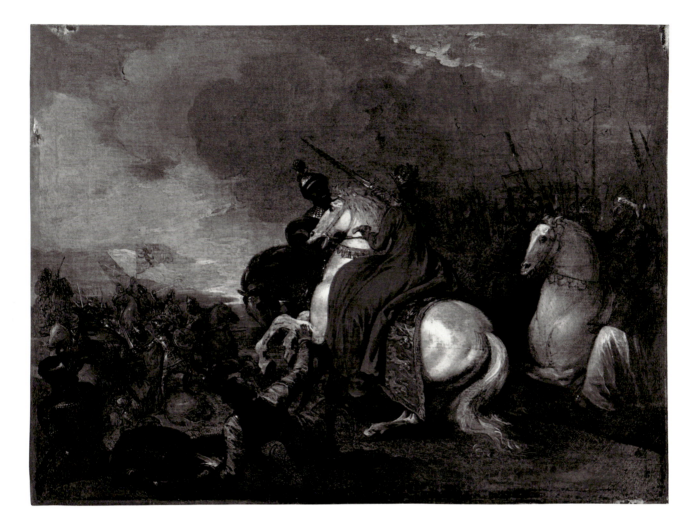

There are extensive retouches overall, except in parts of the white horses and in the clouds. The paint layer has been flattened by lining. (infrared, ultraviolet, reverse before lining, x-radiograph)

PROVENANCE: Benjamin West (d. 1820). By descent to his sons, Raphael Lamar West and Benjamin West, Jr.; sold Robins, London, May 22–25, 1829, no. 110, to W. J. Ward for £68.[3] W. J. Ward to at least 1833.[4] Sold at a house sale in Dubuque, Iowa, 1971, to Vincent F. Carney, Rochelle, Illinois;[5] given to the Art Institute, 1972.

REFERENCES: "Benjamin West, Esq., President of the Royal Academy, Etc.," in *Public Characters of 1805*, London, 1805, p. 565. "Biographical Sketch of Benjamin West, Esq., President of the Royal Academy, Etc., Etc.," *Universal Magazine* 3 (June 1805), p. 530. "A Correct Catalogue of the Works of Benjamin West, Esq.," *La Belle Assemblée, or Bell's Court and Fashion-able Magazine* 4 (1808), suppl., p. 17. John Galt, *The Life, Studies, and Works of Benjamin West, Esq., President of the Royal Academy of London*, vol. 2, London, 1820, p. 227. Oliver Millar, *The Later Georgian Pictures in the Collection of Her Majesty the Queen*, vol. 1, London, 1969, p. 133, under no. 1160. Esther Sparks, "Three Narrative Paintings by Benjamin West in the Collection," *AIC Bulletin* 68, 4 (1974), pp. 5 (ill.), 7. John Dillenberger, *Benjamin West: The Context of His Life's Work with Particular Attention to Paintings with Religious Subject Matter*, San Antonio, 1977, pp. 170, 202, 206. Helmut von Erffa and Allen Staley, *The Paintings of Benjamin West*, New Haven and London, 1986, pp. 196–97, no. 62 (ill.).

EXHIBITIONS: London, West's Gallery, 1822–28, no. 112.[6] London, British Institution, 1833, no. 3. The Arts Club of Chicago, *The Horse as Motif, 1200 B.C.–1966 A.D.*, 1975, no. 36.

This sketch is related to one of a series of eight pictures painted for George III to decorate the Audience Chamber at Windsor Castle, which West worked on between 1786 and 1789. According to West's early biographer, John Galt, the choice of subjects for the series arose from a conversation between the artist and the king. West reflected upon the way Italian painters had been employed "to illustrate monkish legends . . . while the great events in the history of their country were but seldom touched." The king thought of Edward III, the builder of Windsor Castle, and said that "the achievements of his splendid reign were well calculated for pictures, and would prove very suitable ornaments to the halls and chambers of that venerable edifice."[7] As Mark Girouard has pointed out, the commission was an important moment in the growing taste in Britain for the Middle Ages and for the medieval code of chivalry, a national, Christian alternative to the values of the classical tradition.[8] Another aspect of this trend was the development of the Gothic Revival in architecture.

The paintings in the series celebrate Edward III's victories against France at the beginning of the Hundred Years' War and his role as the founder of the Order of the Garter; the ceremonies related to this order were held at Windsor. The Audience Chamber at Windsor Castle was later rebuilt by George IV and the pictures hung elsewhere, but a watercolor by Charles Wild gives an indication of their original arrangement and effect.[9] The three largest pictures in the group measure approximately 114 by 177 inches each, and are entitled *Edward III with the Black Prince after the Battle of Crecy*, *The Institution of the Order of the Garter*, and *Edward, the Black Prince, Receiving John, King of France, Prisoner, after the Battle of Poitiers*.[10] The legendary but no less patriotic and chivalric subject of *Saint George and the Dragon*, depicting the patron saint of the Order of the Garter, hung over the chimney.[11] The remaining four historical scenes are on a less monumental scale. Three of them, the picture to which the present sketch relates and two others, *Edward III Entertaining His Prisoners* and *The Burghers of Calais*, measure approximately 39 by 72 inches and apparently functioned as overdoors.[12] West's main reference texts for the project seem to have been David Hume's *History of England* (1754–62) and Jean Froissart's *Chronicles of England, France, Spain, and the Adjoining Countries*. Roy Strong has shown that the artist derived many touches of medieval detail for the series from recent publications on historical dress and armor by Joseph Strutt.[13]

The subject of *Queen Philippa at the Battle of Neville's Cross* is the battle between the English and Scottish armies that took place on October 17, 1346. While Edward III was fighting in France, a Scottish force under King David II (David Bruce), an ally of the French, invaded England from the north. Edward's queen raised an army under the command of Henry, the second Lord Percy. At a battle fought at Neville's Cross, near Durham, the Scots were defeated and King David was taken prisoner. According to Hume, Queen Philippa rode through the English ranks before the battle and "exhorted every man to do his duty, and to take revenge on these barbarous ravagers. Nor could she be persuaded to leave the field, till the armies were on the point of engaging."[14]

In both the present sketch and the large picture (fig. 1), West seems to have condensed the beginning, middle, and end of the battle into a single image. Queen Philippa addresses her army on the right; the battle is already raging in the middle ground on the left; and King David appears prominently in the foreground, unhorsed, fighting on foot, and presumably near surrender. His royal banner of a rampant lion is seen above his head and to the left, near another bearing the diagonal cross of Saint Andrew, patron saint of Scotland. The massed English and Scottish armies are only summarily indicated in the sketch, although some details have probably been lost as a result of abrasion. Especially sketchy are the standards and armorial bearings of the English army. Some of the participants in the battle can nevertheless be identified by referring to the large picture, where their arms are represented in greater detail, and to the narrative key to the composition provided by West for the king, which was reprinted in Britton and Brayley's *Beauties of England and Wales* (1801).[15] These are Lord Percy, immediately behind the queen; John de Stratford, the Archbishop of Canterbury, on the white horse to the right; and Lord Hay, lying dead in the lower left foreground. Also among the combatants, identifiable in the large picture but not in the sketch, are the Bishop of Durham, the Archbishop of York, the Bishop of Lincoln, Sir Geoffrey Chernels, Sir Robert Neville, Lord Mowbray, and Lord Roos. West's specific account of those present at the battle strongly suggests that he consulted Froissart, where they are enumerated, as well as the more cursory description given by Hume.

The large, finished version of *Queen Philippa at the Battle of Neville's Cross* is dated 1789. George III paid 500 guineas for it.[16] Apart from the addition of further

heraldic details, the composition follows the principal lines of the sketch, with only a few minor changes: the queen no longer wields a sword, her profile is obscured by flowing hair, and the arrangement of lions and fleurs-de-lis in the royal arms on her saddlecloth is reversed. West made an oil sketch on about the same scale as the present work for each of the pictures in the series, presumably before obtaining the king's approval to proceed with the large work. In some cases he also made other small versions, apparently reduced replicas. Such a replica existed for this composition as well, but its present whereabouts are unknown.[17] Either the large picture or the replica was exhibited at the Royal Academy in 1793.[18]

For a sketch related to another of West's decorative schemes for Windsor Castle, see *The Expulsion of Adam and Eve from Paradise* (1984.175).

NOTES

1 The painting was treated by Alfred Jakstas.
2 The average thread count of the original canvas is 18 x 20/sq. cm (45 x 50/sq. in.). The pre-treatment examination report indicates that the painting was "extremely damaged." The present stretcher dates from the 1972 relining.
3 Dillenberger 1977, p. 206, no. 110; von Erffa and Staley 1986, p. 196, no. 62.
4 Lent by Ward to the British Institution in that year; see Algernon Graves, *A Century of Loan Exhibitions*, vol. 4, London, 1914, p. 1647, no. 3.
5 According to a letter from Vincent F. Carney to Esther Sparks of July 7, 1973, in curatorial files. He also stated that the picture had been acquired around 1970 from Hanzel Galleries, Chicago, but this cannot be verified.
6 For more information, see Exhibitions in the entry for West's *The Death of Procris* (1900.445).
7 Galt 1820, pp. 51–52. For a fuller account of the genesis of the

series, see von Erffa and Staley 1986, pp. 192–93, under no. 56.
8 Mark Girouard, *The Return to Camelot: Chivalry and the English Gentleman*, New Haven and London, 1981, pp. 19–24.
9 For Wild's watercolor, see David Watkin, *The Royal Interiors of Regency England from Watercolors First Published by W. H. Pyne in 1817–1820*, London, 1984, pp. 29 (ill.), 30; and Millar 1969, fig. VIII.
10 Millar 1969, vol. 1, pp. 133–35, nos. 1162–64; vol. 2, fig. 126; and von Erffa and Staley 1986, pp. 95 (ill.), 194, 199–202, nos. 58 (ill.), 67, and 74 (ill.). These largest pictures in the group are now on loan from the Royal Collection to the New Palace of Westminster (Houses of Parliament).
11 Millar 1969, vol. 1, p. 130, no. 1151; von Erffa and Staley 1986, p. 399, no. 412 (ill.).
12 Millar 1969, vol. 1, p. 133, nos. 1159–61; vol. 2, pls. 127–28; von Erffa and Staley 1986, pp. 195–96, 197–98, 201–02, nos. 61, 64, 72. For their placement in the room, see Wild's watercolor cited in note 9.
13 West relied most heavily on Strutt's *The Regal and Ecclesiastical Antiquities of England*, London, 1777, and his *Honda Angel-cynnan; or, A Compleat View of the Manners, Customs, Arms, Habits, Etc. of the Inhabitants of England . . .* , London, 1774–76; see Roy Strong, *Recreating the Past: British History and the Victorian Painter*, New Haven and London, 1981, pp. 81–85.
14 David Hume, *History of England*, London, 1803, pp. 153–54. That Queen Philippa was present at the battle has been described as "exceedingly doubtful" (*DNB*, vol. 15, under "Philippa of Hainault").
15 John Britton and Edward Wedlake Brayley, *The Beauties of England and Wales; or, Delineations, Topographical, Historical, and Descriptive of Each County*, vol. 1, London, 1801, pp. 223–41. *Queen Philippa at the Battle of Neville's Cross* is described in detail on pp. 224–25.
16 Von Erffa and Staley 1986, pp. 195–96, no. 61.
17 Ibid., p. 197, no. 63 (ill.).
18 The work exhibited, no. 74, was listed by its title alone, whereas no. 16 in the same exhibition, *King Edward III Embracing His Son, Edward the Black Prince, after the Battle of Cressy*, was described specifically as painted for the Audience Chamber at Windsor; see Algernon Graves, *The Royal Academy of Arts: A Complete Dictionary of Contributors and Their Work from Its Foundation in 1769 to 1904*, vol. 8, London, 1906, p. 215.

The Expulsion of Adam and Eve from Paradise, 1791, retouched 1803

George F. Harding Collection, 1984.175

Oil on canvas, 48.6 x 72.9 cm (19 1/8 x 28 11/16 in.)

INSCRIBED: *B West. 1791. / retouched. 1803.* (in the clouds, near left edge)

CONDITION: The painting is in poor condition. It was cleaned in 1983, when an old glue lining was replaced with a wax resin one.[1] The tacking margins have been cut off.[2] There is cusping along all four edges, indicating that the canvas is close to its original dimensions. The paint surface has suffered from the effects of past treatment and from West's frequent practice of reworking his paintings after an interval of several years. X-

radiography (fig. 1) and microscopic examination show that Eve's body was originally covered by an animal skin from waist to ankle and her torso by another, more diaphanous garment. Her hair extended further down her back in the area now filled with furry animal skin. In addition, light radiated from the clouds along the top center edge of the painting. These areas were presumably painted over by West himself. There is considerable drying craquelure throughout. The sky, Adam's figure, the angel's head, and the shadows in the angel's drapery are severely abraded. The impasto in the angel's drapery has been flattened as a result of the lining process, and there are some

Fig. 1 X-radiograph of *The Expulsion of Adam and Eve from Paradise*, 1984.175

small, scattered flake losses in the same figure. A few additional minor losses in the background along the top edge have been retouched but not filled. Further retouching covers the losses, the drying cracks, and the dark shadows in the drapery of the angel, the background at right, and the perimeter. The retouching covering Adam's figure is particularly discolored. (before treatment, infrared, ultraviolet, x-radiograph)

PROVENANCE: Benjamin West (d. 1820). By descent to his sons, Raphael Lamar West and Benjamin West, Jr.; sold Robins, London, May 22–25, 1829, no. 88, to Hayes for 43 gns.[3] Possibly Henry Graves and Son, London.[4] Samuel Putnam Avery, New York. Sold by Avery to Thomas B. Clarke, New York, by 1891; sold American Art Galleries, New York, February 14–18, 1899, no. 355, to Harry W. Watrous for $200.[5] Harry W. Watrous to at least 1922.[6] Sold by Watrous to M. A. Newhouse and Son, St. Louis.[7] Sold by Newhouse to George F. Harding, Jr. (d. 1939), Chicago, 1926; The George F. Harding Museum, Chicago; transferred to the Art Institute, 1982.

REFERENCES: "Benjamin West, Esq., President of the Royal Academy, Etc.," in *Public Characters of 1805*, London, 1805,

p. 566. "Biographical Sketch of Benjamin West, Esq., President of the Royal Academy, Etc., Etc.," *Universal Magazine* 3 (June 1805), p. 530. Joel Barlow, *The Columbiad: A Poem*, Philadelphia, 1807, p. 435 n. 45 (list of West's works). "A Correct Catalogue of the Works of Benjamin West, Esq.," *La Belle Assemblée, or Bell's Court and Fashionable Magazine* 4 (1808), suppl., p. 17. John Galt, *The Life, Studies, and Works of Benjamin West, Esq., President of the Royal Academy of London*, vol. 2, London, 1820, p. 229. Jerry D. Meyer, "Benjamin West's Chapel of Revealed Religion: A Study in Eighteenth-Century Protestant Religious Art," *Art Bull.* 57 (1975), p. 264. John Dillenberger, *Benjamin West: The Context of His Life's Work with Particular Attention to Paintings with Religious Subject Matter*, San Antonio, 1977, pp. 62, 174, 196, 201, 206, 214, fig. 36. Nancy L. Pressly, *Revealed Religion: Benjamin West's Commissions for Windsor Castle and Fonthill Abbey*, exh. cat., San Antonio Museum of Art, 1983, under no. 7. Helmut von Erffa and Allen Staley, *The Paintings of Benjamin West*, New Haven and London, 1986, pp. 286–87, no. 233 (ill.), p. 581. Cynthia J. Mills in Ellen Miles, *American Paintings of the Eighteenth Century*, The Collections of the National Gallery of Art: Systematic Catalogue, Washington, D.C., 1995, pp. 335–36, fig. 1.

EXHIBITIONS: London, Royal Academy of Arts, 1805, no. 86. London, West's Gallery, 1822, no. 73.[8] Philadelphia, Pennsylvania Academy of the Fine Arts, *The Thomas B. Clarke Collection of American Pictures*, 1891, no. 192. Chicago, World's Columbian Exposition, *Exhibit of Private Collections*, 1893, no. 2861b. New York, Brooklyn Museum, *Exhibition of Paintings and Drawings by Benjamin West and of Engravings Representing His Work*, 1922, no. 23.

The subject of this painting is the familiar story from the Old Testament (Gen. 3.8–24). After Adam and Eve had been tempted by the serpent to eat the fruit of the tree of knowledge, God punished them by expelling

Fig. 2 Benjamin West, *The Expulsion of Adam and Eve from Paradise*, National Gallery of Art, Washington, D.C., Avalon Fund and Patrons' Permanent Fund [photo: © 1995 Board of Trustees, National Gallery of Art, Washington, D.C.]

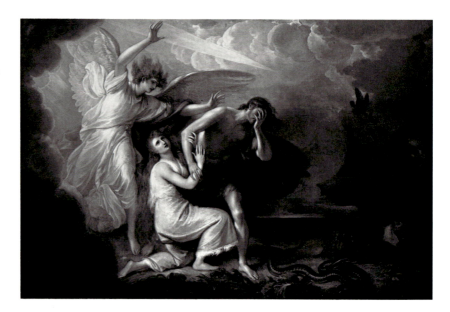

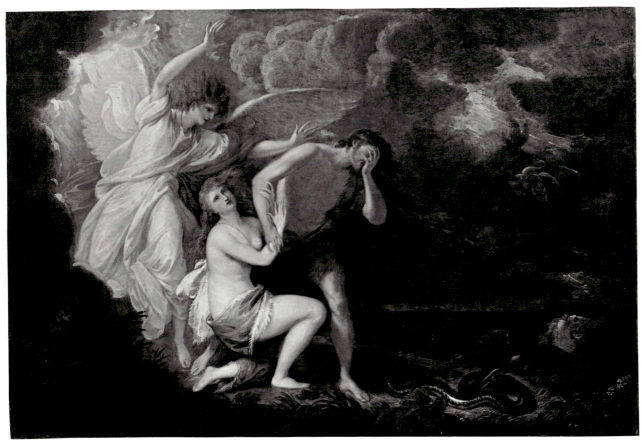

Benjamin West, *The Expulsion of Adam and Eve from Paradise*, 1984.175

them from the Garden of Eden. They then knew good and evil, as well as remorse and shame. Eve was condemned to subservience and the pains of childbearing, Adam to hard work, and the serpent to moving on its belly and eating dust. When the picture was exhibited at the Royal Academy in 1805, the following lines, slightly modified from the King James version of the Bible, were quoted in the catalogue:

> Ver. 21. Unto Adam also, and to his wife, did the Lord God make coats of skins, and clothed them.
> Ver. 22. And the Lord God said, Behold, the man is become as one of us, to know good and evil. And now, lest he put forth his hand and take also of the tree of life, and eat and live for ever.
> Ver. 23. Therefore the Lord God sent him forth from the garden of Eden to till the earth, whence he was taken.

The couple is shown in attitudes of distress as the archangel Michael expels them from the garden. The general gloom of the background reflects the fallen state of the world, as do vignettes of animals preying on one another—an eagle attacking a heron, a lion chasing two horses.[9]

The work was painted as a sketch for one of the large pictures of biblical subjects that West made for King George III to decorate a royal chapel at Windsor Castle. When the project was initiated, apparently in 1779, the intended destination of West's pictures was the seventeenth-century chapel built by Hugh May on a site corresponding to the western half of what is now Saint George's Hall. As recent studies have demonstrated, the original plan seems to have been that West should paint sixteen pictures to replace the existing decorations by Antonio Verrio as part of a general refurbishment supervised by the king's architect, Sir William Chambers.[10] This is reflected in six drawings for the scheme, datable to around 1780, showing the pictures fairly fully worked out by West within a classical framework.[11] It was a massive undertaking for West, involving one canvas measuring 216 by 144 inches, another of 210 by 114 inches, four of about 150 by 120 inches, one of 72 by 108 inches, and nine of 48 by 96 inches He exhibited his first completed picture for the chapel, *Christ Healing the Sick* (150 by 120 inches, location unknown), at the Royal Academy in 1781, and continued to work on the project for another twenty years. He would show pictures at the Royal Academy as they were completed, then store them in his studio in readiness for their eventual installation at Windsor.

Over those twenty years the plans for the royal chapel decorations changed, although exactly how they changed is difficult to determine. West showed compositions not included in the architectural drawings at the Royal Academy exhibitions of the early 1790s, including the large *Adam and Eve* (fig. 2) in 1791. Then, in a list and accompanying letter of 1797, he indicated to the king that the completed series would consist of twenty-six works, an increase of ten over the number indicated in the drawings.[12] At about this time, the plans for the royal chapel in the castle were revised from a refurbishment of the old royal chapel to a prospective new chapel to be created by converting a different part of Windsor Castle, the Horn Court, and West's enlarged scheme must have been intended for this location.[13]

In 1796 Sir William Chambers had been replaced as the king's architect by James Wyatt. Unfortunately for West, Wyatt strongly opposed the idea of West's decorative scheme, and on August 15, 1801, informed West of the king's wish that his work "should be suspended until further orders."[14] On the following day, West drew some diagrams showing a yet larger scheme, with thirty-two of his pictures, some marked "Finished" and others merely "Designed,"[15] presumably in an attempt to rescue the situation, but no "further orders" came. West was paid for the paintings and they became the property of the Crown, but they remained in the artist's studio until after his death. One of them, *The Last Supper* (now in the Tate Gallery, London), was presented by George IV to the newly founded National Gallery in 1828.[16] At the same time, ownership of the rest was transferred to the artist's sons and heirs, who promptly put them up for auction and dispersed the group.

The large version of *The Expulsion of Adam and Eve from Paradise* (fig. 2) is dated 1791, and was exhibited at the Royal Academy that year with a note in the catalogue that it was "for His Majesty's Chapel, Windsor."[17] No such composition appears in the drawings for the scheme of around 1780. Indeed the only provision in that scheme for a picture of this size and shape (72 by 108 inches) would have been the space immediately above the altar designated for *The Last Supper*. In the 1801 diagrams of the enlarged scheme for the converted Horn Court, an "Adam" is included on the altar wall to the right of *The Last Supper*, with the corresponding space on the other side left blank and a huge space above, occupying the rest of the wall, labeled "Crucifixion"; the latter painting, which would have measured at least 18 by 27 feet, was never executed.[18] This diagram is our nearest indication of the intended location of the larger

work for which the Chicago picture is a sketch.

As part of his normal working method, West painted an oil sketch before embarking upon a major composition, and sketches exist for almost all of his royal chapel subjects. The Chicago sketch bears two dates, 1791 and 1803. As was his frequent practice, West retouched the work after a lapse of years. He exhibited it in its retouched state at the Royal Academy in 1805. The x-radiograph (fig. 1) of the sketch reveals its original appearance before West's retouches, making it clear that he followed his sketch quite faithfully when working up the large picture. For example, both the earlier state of the sketch and the large painting show Eve modestly clothed in animal skins; the flesh of her upper body and right leg was painted over the skins, presumably in 1803. The beam of light issuing from the clouds was probably suppressed in the sketch at the same time. West's changes to the figure of Eve may have been made in response to criticism of the large picture when it was exhibited at the Royal Academy in 1791. Several reviewers found fault with her clothing, one referring sarcastically to the skins as "a fringed petticoat."[19] It is possible too that for reasons of decorum West refrained from showing Eve seminude in the royal context of the intended chapel decoration, but felt less constraint when retouching the sketch, especially after the abandonment of the chapel scheme. In any case, the retouching of the sketch accounts in part for the rather rough and unnatural texture of Eve's flesh.

A drawing at the Pierpont Morgan Library, New York, has been tentatively associated with the composition, perhaps representing a first idea, but the poses of the figures correspond only very loosely to those in the oil sketch and large picture.[20]

For a sketch related to a different decorative scheme at Windsor Castle, see *Queen Philippa at the Battle of Neville's Cross* (1972.1153).

NOTES

1 The painting was treated by Barry Bauman.
2 The average thread count of the original canvas is 15 x 15/sq. cm (37 x 37/sq. in.).
3 Von Erffa and Staley 1986, p. 286, no. 233.
4 Ibid.; the source for ownership of the picture by Graves and Son and by Samuel Putnam Avery is the mount of a photograph in the Frick Art Reference Library, New York (letter from Allen Staley to the author of December 1, 1994, in curatorial files).
5 Von Erffa and Staley 1986, p. 286, no. 233.
6 See the 1922 exhibition catalogue, no. 23.
7 See letter of April 15, 1994, from Joan Pope (Newhouse Galleries) to Martha Wolff, in curatorial files.
8 For more information, see Exhibitions in the entry for West's *The Death of Procris* (1900.445).
9 For a discussion of West's treatment of this subject in relation to the Bible, Milton's *Paradise Lost*, and illustrated editions of that poem, see Mills 1995, pp. 334–40.
10 The most authoritative discussions of the history of the project are Pressly 1983, pp. 15–25, and von Erffa and Staley 1986, app. I, pp. 577–81. Following the testimony of Galt 1820, p. 53, previous scholars believed that the paintings were intended from the outset as decorations for a new chapel occupying the Horn Court.
11 One drawing is in the Yale Center for British Art, New Haven, and the others are in the Royal Library, Windsor. The Yale drawing and two of the Windsor sheets are reproduced in von Erffa and Staley 1986, pp. 577–79.
12 See ibid., p. 579, and *The Later Correspondence of George III*, ed. by A. Aspinall, vol. 2, Cambridge, 1963, p. 593, no. 1575.
13 Noted in *The Windsor Guide; Containing a Description of the Town and Castle; the Present State of the Paintings and Curiosities in the Royal Apartments . . . ,* printed for C. Knight, Windsor, 1804, p. 54. West's enlarged scheme is also alluded to in C. Knight, *Short Sketches of the Lives of the Most Eminent Painters, Whose Works are Exhibited in the Royal Palaces, at Windsor, Kensington, and Hampton Court; Intended as a Supplement to the Pocket Companions to These Places,* Windsor, c. 1798, p. 30: "Mr. West has also been long employed on a work that will render his name eminently distinguished . . . ; we mean the History of Revealed Religion, in thirty large pictures, designed for the King's new intended Chapel at Windsor."
14 See the letter from West to George III cited in Galt 1820, pp. 193–94, and *The Diary of Joseph Farington*, ed. by Kenneth Garlick and Angus Macintyre, vol. 6, New Haven and London, 1979, pp. 2336–37 (May 31, 1804).
15 Swarthmore, Pennsylvania, Swarthmore College, Friends Historical Library; see von Erffa and Staley 1986, p. 580 (ill.).
16 Von Erffa and Staley 1986, pp. 352–53, no. 344 (ill.).
17 For this picture, see Mills 1995, pp. 334–40.
18 See note 15. Another work in the 72 x 108 in. format that West may well have thought of as a pendant to *Adam and Eve* was *The Deluge* (location unknown; von Erffa and Staley 1986, pp. 286–87, no. 234). It was shown at the same Royal Academy exhibition as the large *Adam and Eve* (fig. 2), and its sketch (Williamstown, Williams College Museum of Art; von Erffa and Staley 1986, p. 287, no. 235) appeared in the same 1805 exhibition as the Chicago sketch for *Adam and Eve*.
19 The reviews are cited by Mills 1995, p. 340.
20 Ruth S. Kraemer, *Drawings by Benjamin West and His Son Raphael Lamar West*, exh. cat., New York, Pierpont Morgan Library, 1975, p. 32, no. 50 (ill.).

List of Previous Owners

Acton, Surgey, Ltd.
 Jonathan Richardson the Elder, 1933.798
Addington, Samuel
 George Morland, 1987.92.3
Agnew
 Arthur Devis, 1951.207
 Joseph Highmore, 1987.262.3
 Joseph Highmore, 1987.262.4
 Thomas Hudson, 1980.611
 James Northcote, 1974.390
 Sir Joshua Reynolds, 1955.1202
 Jean Antoine Watteau, possibly with the assistance
 of Jean Baptiste Pater, 1954.295
Algranti
 Laurent de La Hyre, 1976.292
Anderson Galleries
 Thomas Hudson, 1985.263
Antiquarian Society
 Jonathan Richardson the Elder, 1933.798
Anton
 French, 1981.66
Arcade Gallery
 Attributed to Philippe Mercier, 1969.333
Armour, Mrs. Norman, Jr.
 James Northcote, 1974.390
Armstrong, Mr. and Mrs. Reed
 Thomas Hudson, 1980.611
Aubert, Louis
 Jean Baptiste Oudry, 1977.486
Aubry
 Baron Antoine Jean Gros, 1990.110
Audard, E.
 French, 1981.66
Avery, Samuel Putnam
 Benjamin West, 1984.175
Baderou, Henri
 Pierre Charles Trémolières, 1977.483
Barry, comte du
 Jean Antoine Watteau, 1960.305
Baudry, A.
 Jacques Louis David, 1963.205
Belays
 Hubert Robert, 1900.382
 Hubert Robert, 1900.383
 Hubert Robert, 1900.384
 Hubert Robert, 1900.385
Dr. Benedict and Co.
 François Boucher, 1931.938
Benisovich, Michel Nicolas
 Joseph Siffred Duplessis, 1975.137
Berwick, first baron
 Attributed to Philippe Mercier, 1969.333

Beveridge, Mrs. Albert J.
 Nicolas Lancret, 1948.565
Blakeslee, T. J.
 William Artaud, 1915.488
Block, Leigh
 Jean Honoré Fragonard, 1977.123
Block, Mrs. Leigh
 Angelica Kauffman, 1960.873
Blumenthal, Willy
 Jean Antoine Watteau, 1960.305
Bollag
 Henry Fuseli, 1973.303
Galerie Bollag
 Henry Fuseli, 1973.303
Bonjean, Théodore
 Claude Joseph Vernet, 1933.1101
Bourdier
 Jean Baptiste Deshays, 1979.540
Boussairolles, baron de
 Nicolas Bertin, 1979.305
Boussod, Valadon, and Co.
 After Jean Baptiste Pater, 1973.312
Bower, A. C.
 Arthur Devis, 1951.207
Brender de Berenbau, Rosa Maria
 Jacques Blanchard, 1963.43
Brewster, Robert D.
 Sébastien Bourdon, 1959.57
Brissonet (or Briçonnet)
 Eustache Le Sueur, 1974.233
Ernest Brown and Phillips
 Gawen Hamilton, 1926.264
Brown
 Sir Henry Raeburn, 1980.74
Brown, Mr. and Mrs. Robert Andrew
 British, 1964.197
Bryan, Michael
 Nicolas Poussin, 1930.500
Buckland, baron
 William Artaud, 1915.488
Bunbury
 Sir Joshua Reynolds, 1922.4468
Burat, Jules
 Jean Antoine Watteau, 1960.305
Burns, Alan G.
 Pierre Henri de Valenciennes, 1983.35
 Pierre Henri de Valenciennes, 1983.36
Burns, Walter S. M.
 Jean Antoine Watteau, 1954.295
Buron
 Jacques Louis David, 1963.205
Bute
 Henry Fuseli, 1973.303

Ehrich Galleries
 William Cuming, 1922.2196
 Arthur Devis, 1951.207
 French, 1924.1042
 The Master of the Children's Caps (Le Maître aux
 Béguins), 1923.415
 Benjamin West, 1900.445
Epstein, Max and Leola
 Jean Baptiste Santerre, 1954.303
 Jean Antoine Watteau, possibly with the assistance
 of Jean Baptiste Pater, 1954.295
Estabrook, John N. and Dorothy
 Joseph Highmore, 1987.262.3
 Joseph Highmore, 1987.262.4
 John Russell, 1987.262.2
Farr, Daniel H.
 James Northcote, 1974.390
Richard L. Feigen and Co.
 Thomas Gainsborough, 1987.139
 Philippe Jacques de Loutherbourg, 1991.5
 Jacques Antoine Volaire, 1978.426
Féral, Eugène
 Jean Baptiste Deshays, 1979.540
Field, Delia Spencer (Mrs. Marshall Field I)
 Nicolas Lancret, 1948.565
Field, Marshall, III
 Sir Henry Raeburn, 1980.74
Wally Findlay Galleries
 Thomas Hudson, 1985.263
Fine Art Society
 George Morland, 1987.92.3
Fisher, Walter T.
 John Rathbone and George Morland, 1962.967
 John Rathbone and George Morland, 1962.968
E. A. Fleischmann Gallery
 Nicolas Poussin, 1930.500
Fleury
 Jacques Louis David, 1967.228
Flower, Freeman
 Joseph Highmore, 1987.262.3
 Joseph Highmore, 1987.262.4
Fontanel, Abraham
 Nicolas Bertin, 1979.305
Forestry Commission (U.K.)
 Jonathan Richardson the Elder, 1933.798
Frank, Robert
 Sébastien Bourdon, 1959.57
Frat, Pauline
 Baron Antoine Jean Gros, 1990.110
Friends of American Art
 William Artaud, 1915.488
 Benjamin West, 1900.445
Fry, G.
 Pierre Henri de Valenciennes, 1983.35
 Pierre Henri de Valenciennes, 1983.36
Fox, Charles
 Nicolas Lancret, 1948.565

François, M. L.
 Hubert Robert, 1900.382
 Hubert Robert, 1900.383
 Hubert Robert, 1900.384
 Hubert Robert, 1900.385
Gates
 Attributed to Jean François Millet,
 called Francisque Millet I, 1970.1008
Geddes, Andrew
 Nicolas Poussin, 1930.500
Gibson-Carmichael
 Sir Henry Raeburn, 1973.314
Gilmor
 Sébastien Bourdon, 1959.57
E. Gimpel
 Nicolas Lancret, 1948.565
Ginain, Mme Léon
 French, 1981.66
Gipps, Richard
 Jonathan Richardson the Elder, 1933.798
Gould, George J.
 After Jean Baptiste Pater, 1973.312
 Nicolas Antoine Taunay, 1973.313
Gramont, comte de
 Eustache Le Sueur, 1974.233
Henry Graves and Son
 Benjamin West, 1984.175
Groult, Camille
 Jean Honoré Fragonard, 1977.123
 French, 1924.1042
Gurley, William F. E.
 Henry Fuseli, 1980.170
 Henry Fuseli, 1992.1531
Haranger, Pierre Maurice
 Jean Antoine Watteau, 1960.305
Harding, George F., Jr.
 Benjamin West, 1984.175
George F. Harding Museum
 Benjamin West, 1984.175
Hart, George Augustus Frederick
 Pierre Henri de Valenciennes, 1983.35
 Pierre Henri de Valenciennes, 1983.36
Hayes
 Benjamin West, 1984.175
Hayward, Mrs. William
 Sir Henry Raeburn, 1980.74
Heddle
 Hubert Robert, 1900.382
 Hubert Robert, 1900.383
 Hubert Robert, 1900.384
 Hubert Robert, 1900.385
Heim Gallery, London
 Sébastien Bourdon, 1975.582
 Joseph Siffred Duplessis, 1975.137
 Eustache Le Sueur, 1974.233
 Jean Baptiste Oudry, 1977.486
Galerie Heim, Paris
 French, 1981.66

Charles Sedelmeyer
 The Master of the Children's Caps (Le Maître aux
 Béguins), 1923.415
Seigneur, Alexandrine Marie Louise
 Jacques Louis David, 1963.205
Arnold Seligmann, Rey, and Co.
 Sébastien Bourdon, 1959.57
 Claude Gellée, called Claude Lorrain, 1941.1020
 Jean Baptiste François Desoria, 1939.533
Sessa, duc de
 Hubert Robert, 1900.382
 Hubert Robert, 1900.383
 Hubert Robert, 1900.384
 Hubert Robert, 1900.385
Sestieri
 Jean Baptiste Wicar, 1963.258
Shaw, Sir John, fourth Bt.
 Arthur Devis, 1951.206
Shore, Mrs. Samuel
 Joseph Highmore, 1987.262.3
 Joseph Highmore, 1987.262.4
Sichel, E.
 After Jean Baptiste Greuze, 1969.109
Simpson, Francis C.
 George Romney, 1922.4469
Sirén, Osvald
 The Master of the Children's Caps (Le Maître aux
 Béguins), 1923.415
W. and J. Sloane and Co.
 British, 1925.1682a
 British, 1925.1682b
Smirnoff Gallery
 Nicolas de Largillière, 1987.57
Society in Scotland for the Propagation of Christian Knowledge
 Sir Henry Raeburn, 1977.5
Spowart, Philip
 Pierre Henri de Valenciennes, 1983.35
 Pierre Henri de Valenciennes, 1983.36
Stanley, Edward James
 British, 1964.197
Stern, Agnes W.
 French, 1967.587
Strauss, Jules
 Jean Baptiste Deshays, 1979.540
Suarez, Evelyn Marshall (formerly Mrs. Marshall Field III)
 Sir Henry Raeburn, 1980.74
Sulley
 Sir Joshua Reynolds, 1922.4468
Taunton, baron
 British, 1964.197
Ters d'Espagnat
 Hubert Robert, 1900.382
 Hubert Robert, 1900.383
 Hubert Robert, 1900.384
 Hubert Robert, 1900.385
E. V. Thaw and Co.
 Henry Fuseli, 1973.303

Thomas, Florence Thompson
 After Jean Baptiste Pater, 1973.312
 Sir Henry Raeburn, 1973.314
 Nicolas Antoine Taunay, 1973.313
Thomlinson, John
 Arthur Devis, 1956.130
Thompson, John R., Sr.
 After Jean Baptiste Pater, 1973.312
 Nicolas Antoine Taunay, 1973.313
Thompson, Mrs. John R., Sr.
 Sir Henry Raeburn, 1973.314
 After Jean Baptiste Pater, 1973.312
 Nicolas Antoine Taunay, 1973.313
Thorburn
 John Russell, 1987.262.2
Tighe, Mrs. Robert Stearne
 Angelica Kauffman, 1960.873
Arthur Tooth and Sons
 Sir William Beechey, 1944.700
 British, 1964.197
 Arthur Devis, 1956.130
Townshend, Henry Hare
 George Morland, 1987.92.3
Trafalgar Galleries
 Pierre Henri de Valenciennes, 1983.35
 Pierre Henri de Valenciennes, 1983.36
Trägårdh, Gunnar
 Jacques Antoine Volaire, 1978.426
Trumbauer, Horace
 James Northcote, 1974.390
Turgot, Jacques
 Eustache Le Sueur, 1974.233
Van Diemen Galleries
 François Boucher, 1931.938
Vermeer Gallery
 Jean Baptiste Santerre, 1954.303
Viancini, Ettore
 Laurent de La Hyre, 1976.292
Vincens, Emil
 Baron Antoine Jean Gros, 1990.110
Vogüe, Melchior, marquis de
 François Boucher, 1973.304
Robert Vose Galleries
 William Artaud, 1915.488
Wallace, Julie Castelnau, Lady
 Jean Antoine Watteau, possibly with the assistance
 of Jean Baptiste Pater, 1954.295
Wallace, Sir Richard, Bt.
 Jean Antoine Watteau, possibly with the assistance
 of Jean Baptiste Pater, 1954.295
Wallop, the Hon. Frederick
 Arthur Devis, 1951.207
Walters, Mrs. Henry
 After Jean Baptiste Greuze, 1969.109
Ward, W. J.
 Benjamin West, 1900.445
 Benjamin West, 1972.1153

List of Paintings by Accession Number

1977.483 Pierre Charles Trémolières, *Sancho Panza Being Tossed in a Blanket*

1977.486 Jean Baptiste Oudry, *Still Life with Monkey, Fruits, and Flowers*

1978.423 Attributed to Charles Poërson, *Christ on the Cross with Mary Magdalen*

1978.426 Jacques Antoine Volaire, *The Eruption of Vesuvius*

1979.305 Nicolas Bertin, *Christ Washing the Feet of His Disciples*

1979.540 Jean Baptiste Deshays, *Saint John the Baptist Preaching in the Desert*

1980.74 Sir Henry Raeburn, *Robert Brown of Newhall*

1980.170 Henry Fuseli, *Sketch for "The Oath on the Rütli"* and *Female Figure*

1980.611 Thomas Hudson, *John Van der Wall*

1981.66 French, *Portrait of a Woman Artist*

1982.1378 After Jean Restout, *Saint Hymer in Solitude*

1983.35 Pierre Henri de Valenciennes, *Alexander at the Tomb of Cyrus the Great*

1983.36 Pierre Henri de Valenciennes, *Mount Athos Carved as a Monument to Alexander the Great*

1984.175 Benjamin West, *The Expulsion of Adam and Eve from Paradise*

1985.263 Thomas Hudson, *John Newton*

1987.57 Nicolas de Largillière, *Self-Portrait*

1987.92.3 George Morland, *Trepanning a Recruit*

1987.139 Thomas Gainsborough, *Mrs. Philip Dupont*

1987.262.2 John Russell, *Portrait of a Man in a Tricorn Hat*

1987.262.3 Joseph Highmore, *Mrs. Freeman Flower*

1987.262.4 Joseph Highmore, *Freeman Flower*

1990.110 Baron Antoine Jean Gros, *Portrait of the Maistre Sisters*

1991.5 Philippe Jacques de Loutherbourg, *The Destruction of Pharaoh's Army*

1992.1531 Henry Fuseli, *Heads of Damned Souls from Dante's "Inferno"*

1994.430 Jean Baptiste Greuze, *Lady Reading the Letters of Heloise and Abelard*

List of Artists

FRENCH AND BRITISH PAINTINGS
FROM 1600 TO 1800
IN THE ART INSTITUTE OF CHICAGO
A CATALOGUE OF THE COLLECTION

Designed by Bruce Campbell

Typeset in Aldus by Paul Baker Typography, Inc., Chicago, Illinois,

with display type on cover and title page in Arrighi

Duotone negatives by Robert J. Hennessey, Middletown, Connecticut

Color separations by Elite Color Group, Providence, Rhode Island

Printed in an edition of 1500 copies by Meridian Printing,

East Greenwich, Rhode Island